11/04

WMP.

DATE DUE			
+5			
02	04	06	
02	04	06	
02	04		
02	04	05	
8-15-07			

GAYLORD PRINTED IN U.S.A.

Also by Joel Lobenthal

Radical Rags: Fashions of the Sixties

Tallulah!

THE LIFE AND TIMES
OF A LEADING LADY

Joel Lobenthal

1❿ ReganBooks
Celebrating Ten Bestselling Years
An Imprint of HarperCollins*Publishers*

For my family and friends,

WHO MUST FEEL BY NOW AS IF THE
BANKHEADS THEMSELVES ARE RELATIVES.

Photograph Credits: Pages xiv, xvi, 26, 52, 176, 205, 207, 284, 296, 307, 326, 361, 368, 408, 414, 430: Photofest; pages 7, 18: Alabama Department of Archives and History, Montgomery, Alabama; page 71: Stage Photo Co.; pages 119, 158, 198, 212, 396: Corbis; page 172: Keystone Photo, courtesy of Cal Schumann; pages 222, 316: courtesy of Stephan Cole; page 235: Vandamm Studio, courtesy of Billy Rose Theatre Collection, the New York Public Library for the Performing Arts, Astor, Lenox and Tilden Foundations; page 258: courtesy author's collection; page 259: UPI; page 340: courtesy of Dick Van Patten; page 480: courtesy of Robert Henderson; page 503: courtesy author's collection; page 520: courtesy of Cal Schumann.

HarperCollins books may be purchased for educational, business, or sales promotional use. For information please write: Special Markets Department, HarperCollins Publishers Inc., 10 East 53rd Street, New York, NY 10022.

FIRST EDITION

Designed by Kris Tobiassen

Printed on acid-free paper

Library of Congress Cataloging-in-Publication Data

Lobenthal, Joel.
 Tallulah : the life and times of a leading lady / Joel Lobenthal.—1st ed.
 p. cm.
 Includes bibliographical references and index.
 ISBN 0-06-039435-8 (alk. paper)
 1. Bankhead, Tallulah, 1902–1968. 2. Actors—United States—Biography. I. Title.

PN2287.B17L63 2004
791.4302'8'092—dc22
[B] 2004050915

04 05 06 07 08 WBC/QWF 10 9 8 7 6 5 4 3 2 1

Contents

Acknowledgments

I wish there were a way to acknowledge all the people who have inspired, supported, or encouraged me over the many years since I first began researching this book. Instead of pretending to be able to do that, I will restrict myself to those connected most closely to the work at hand:

For their help in tracking down leads and research sources, I am grateful to Tony Grillo, Marie Ellerbe Hancock, Richard Lamparski, Richard Lillie, Nicholas Lobenthal, Lydia Lobenthal, Francis Mason, Benjamin McFall, Patrick McGilligan, John Morrone, Andrea Sweidler, Glenn Shadix, David Stenn, the late Raymond Mander, Joe Mitchenson, and Bart Williams.

Research assistance was supplied by Michael Hauser, Barbara Hughes, Bob Levin, and Cindy Mindell.

Liz and Dick Turner's hospitality in London was a joy. Marvin Hoshino tirelessly extended his graphics expertise.

My agent, Kathy Anderson, has an astute understanding of the genre of biography as well as the nature of this biography. Cal Morgan, Lina Perl, Brian Saliba, Bridie Clark, and Adrienne Makowski at ReganBooks supplied wise editorial counsel. Joan Brookbank was a valued confidante during my early thinking about this book.

The friends, colleagues, and family members of Tallulah Bankhead who shared their recollections with me are enumerated in the chapter notes. I am so grateful for their generosity. My many friends in the Soka Gakkai International are so sage and constructive.

The staffs of the following institutions have been indispensable:

In London: the Victoria and Albert Theatre Collection, the Colindale Newspaper Library, the British Library Manuscripts Collection, the Metropolitan Police Service, Records Management Branch.

In New York: Actors' Equity, Lincoln Center Library of Performing Arts, General Reference Collection of the New York Public Library, the Players' Club Library, the Theater Collection at the Museum of the City of New York.

In Connecticut, the Beineke Library at Yale University in New Haven; in California, the San Francisco Performing Arts Library; in Washington, D.C., the Library of Congress, and the FBI Freedom of Information Service; in Alabama, the Tallulah Bankhead Historical Society, Alabama Department of Archives and History; in Massachusetts, Reference and Special Collections, Somerville Public Library.

Over the years, many friends and family members have read one or more chapters and given their reactions. My mother, Shirley Lobenthal, made many insightful comments. Charmane Spahr and my father, Joseph Lobenthal, read through the entire manuscript and gave honest and unsparing criticism.

Introduction

When I began to research the life of Tallulah Bankhead as a college fresh-
man, little did I realize that twenty-five years later this book would come to
fruition. At that time I wasn't really sure what kind of project would even-
tually result. But after my first research trip to London in August 1978, I be-
came convinced that there was a need for a new appraisal of Tallulah that
would acknowledge her often paradoxical emotional, sexual, and intellec-
tual dimensions while also studying in depth her fifty-year career on stage,
screen, radio, and television.

Armed with beauty, talent, intelligence, and social pedigree, Tallulah was
a woman who lived without boundaries. She was perhaps the most contro-
versial actress of her time. Her behavior so challenged social and moral con-
ventions that the public's reaction to her persona ultimately overshadowed
her long and varied career. The prejudice of Tallulah's era has been perpetu-
ated in the biographies written to date. The conventional wisdom is still that
her career was fatally compromised by her inability to do more than "play
herself." But this is actually what most stars seem to do: repeating, with vari-
ations, a consistent theatrical persona. We see this most obviously in film but
also in the careers of great stage stars as well. Tallulah may have blurred the
borders, but the criticism of this tendency throughout her career was likely
exacerbated by disapproval of her offstage behavior.

I have attempted to avoid the moralistic tone that characterizes many
chronicles of her career. The fact that Tallulah chose to act in plays that
were primarily personal vehicles has been interpreted as almost an unfor-

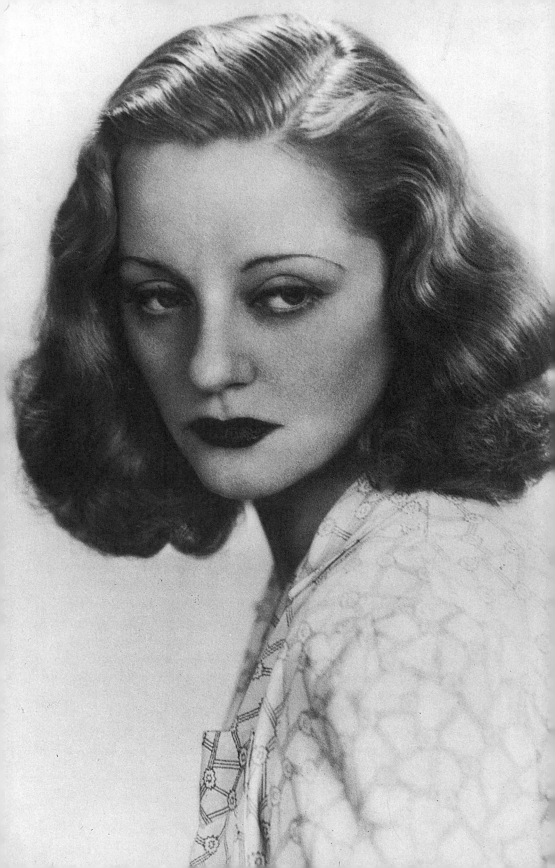

givable sin. But this was again typical of most performers determined to be a success in commercial theater. While the plays she picked were rarely great, I discovered as I read through many of the unpublished scripts she had performed that they were more interesting and substantive than they have been widely portrayed. Today they transmit as fascinating cultural artifacts. And Tallulah's roles fit a consistent profile that was emblematically alluring, humorous, autonomous, and unconventional.

Since most of these plays haven't been staged since her final performance, I've attempted to re-create them. Quotes from these scripts and her reviews evoke her stage work and reveal the widely mixed and vehement responses she aroused. "The charge that they're biased and prejudiced is of no consequence," Tallulah writes about critics in her autobiography. "Criticism is the distillation of bias and prejudice."

To some extent, Tallulah's behavior, inexplicably bizarre as it often seemed, can be traced to the traumatic circumstances of her youth. Her mother died as a result of complications from her birth, while her father was depressed and drunk during much of her early childhood. She responded to the baffling and disruptive events of her childhood with a tyrannical need to control her environment. Tallulah and her sister were locked in a take-no-prisoners rivalry for their father's attention; this may in part explain their compulsively seductive behavior with men. Tallulah became determined to win her family's admiration by becoming a theatrical star, thus fulfilling a dream that both her parents had been forced to give up. After her father's death, Tallulah clung to and broadcast the notion that he had been her guiding light during his life and beyond—her autobiography is dedicated "For Daddy." But rather than simply accept Tallulah's publicly expressed version of their relationship, as many writers have seemed to do, I looked directly at the letters they exchanged, and much to my surprise the truth they contained was a very different one. Tallulah's worshipful postmortem surely was motivated in part by guilt over their troubled and in many ways unresolved relationship. Attempting to set the record straight is another reason to revisit her now.

Tallulah had many professional failures for a wide spectrum of reasons— not least of which, I am convinced, was an underlying self-destructiveness fueled by guilt over her role in her mother's death. Had she been a different woman, she might have made more of her talent, but the fact remains that Tallulah was not only one of the most colorful women of her time, she was also one of its most arresting theatrical personas. Being able to finally chronicle what she did achieve, as well as what she could not, has been as stimulating for me as I hope it will be to the reader.

Part I

1902–1930

Just starting out, 1919

Lace Curtains

"When I was twelve years old I used to think it was the best sport in the world to give impressions of my step-mother. At that time dad said severely: 'The place for people to give impersonations is on the stage!' and so the seed was planted."

The opening years of the twentieth century were a time of intense reaction in the American South, the inauguration of the Jim Crow doctrine of "separate but equal." Amid an attempted restoration of the prewar civil order, whites who possessed any degree of power could live as if they were antebellum plantation owners. Statues of Confederate heroes appeared in courthouse squares. There was a new sense of identification with the settlers of the Old South, a nostalgic, recidivist affinity with the lost cause. Integral to this mood was a renewed investment in the prewar vision of the elite white Southern woman and her consecrated purity, passivity, and dependency. Yet bright women chained into the rigid and puritanical society of the upper-class South found ways to express themselves and to make waves. The words that came out of Tallulah Bankhead's mouth would register shock to new extremes, but her dialogue had been primed by women talking out long before she was born in 1902. "All the Bankhead women were outspoken," said Kay Crow, who married Charles Crow, son of Tallulah's cousin Marion Bankhead. But it was the men who stepped up

to public platforms. Tallulah was the first woman in her family to bestow her performances not just on friends and family, but to exhibit herself for pay—to seize a public pulpit.

She was named for her grandmother, Tallulah Brockman Bankhead, whose parents believed they had conceived her during a stopover at Tallulah Falls in northern Georgia. Tallulah Brockman married John Hollis Bankhead in 1866. He had served as captain in the Confederate Army, and to the end of his days he was called "Captain John" by the family. After the surrender he ran a cotton mill and was warden of a prison in Wetumpka, Alabama. Mrs. Bankhead had given birth to Marie, John Jr., and Louise before Tallulah's father, William Brockman Bankhead, was born in 1874. In 1887, Captain John was elected to the House of Representatives, beginning a thirty-three-year career in Congress.

Both John and Tallulah Bankhead were formidable, but their styles were different. Mrs. Bankhead was driven around Washington by a liveried chauffeur. Captain John, however, devoutly took the streetcar every day to the Capitol. "Grandaddy would say 'Ain't,'" Tallulah recalled to author Richard Lamparski in 1966. "And my grandmother used to be furious. She'd say, 'Honey, Captain John, you know better than to say 'ain't'!' He said, 'Tallulah—first of all, it's an old Elizabethan word, perfectly legitimate; second, if I didn't say "Ain't" I wouldn't get a farmer's vote in the whole state!'"

Their son Will Bankhead was moody, high-strung, and nurtured theatrical ambitions that could not be achieved. Will followed his older brother, John, to the University of Alabama, where he was president of the class of 1892 and won a Phi Beta Kappa key, and then followed John to the law school at Georgetown University in Washington, D.C.

In 1897, he went to New York with two friends to set up a brokerage office, which limped along perilously. "My life in New York has been more of a struggle than I have heretofore known," he wrote in his diary in January 1898. But he managed to attend the theater frequently, filling his diary with jottings on what he had seen, and he brewed with the desire to take his love of oratory to the theatrical stage. He happened upon an advertisement in a trade paper announcing openings in a Boston theatrical stock company, and coining a fictitious resume, he was hired. He sent word to his mother and left for Boston.

As a teenager, Mrs. Bankhead herself had enjoyed performing in private theatricals to raise money for the Confederacy, and as a young man, Captain John loved to recite Shakespeare with his neighbors on his farmhouse

porch in west Alabama. But a career in the theater was not what they envisioned for Will. Sitting on the Boston Commons, buffeted by the winter chill, he read his mother's letter demanding that he return. "And so I decided this little country boy had better go home," he told Tallulah many years later.

Tallulah's mother, Adelaide Eugenia Sledge, was "Ada" to her friends and family, but "Gene" to her husband. She was just as high strung as Will and just as keen on the stage. The younger of two daughters, Adelaide grew up in Como, a small town in northern Mississippi. She never knew her mother, who succumbed to infection soon after delivering her in 1880; her father subsequently remarried. Her grandfather had amassed a small fortune and he doted on his lovely young granddaughter. As a teenager, she was sent to Paris, returning with trunks full of couture clothes that rustic Como offered few opportunities to display. But Adelaide thought nothing of donning a Paris gown to trundle off down the dirt roads of the town.

Her education was slightly more ambitious than one would have expected of a woman of her time and class. At fifteen, she spent one year at the Salem Female Academy in North Carolina, which had been founded by Moravians in the eighteenth century. She took all the required courses: Latin, math—arithmetic, algebra, and geometry—French history, physical geography, and "miscellaneous," which that year meant grammar, composition and dictation, natural history, penmanship.

Her father paid extra every quarter so that Adelaide could also avail herself of vocal lessons and a class in elocution, and Adelaide performed in several school performances. In the early 1940s, a classmate of Adelaide's came backstage to see Tallulah and told her that she had inherited her talent from her mother, citing as evidence Adelaide's ability to faint on cue whenever a certain young Moravian doctor appeared in her vicinity. Upon her return home, Adelaide soon had all the local girls in town arranged in tableaux vivants or dancing in the Grecian gambols that were the rage in the 1890s culture out of which sprang Isadora Duncan. In 1950, Tallulah received a letter from a Margaret DuBois Smith of Tuscumbia, Alabama, who recalled her friendship with Adelaide fifty years earlier:

> I well remember how she loved to doll up in picture hats and long dress [sic] worn at that date and walk about her bedroom—reciting poetry— and parts of novels saying "I am an actress." I was thrilled in watching her. Her acting came so natural—no effort—She certainly missed her calling—then you came along to do what was in her heart.

But a dramatic career was all but impossible for a woman of Adelaide's class. After becoming engaged to a rich Virginia planter, Adelaide was visiting one of her future bridesmaids in Huntsville, Alabama. She and Will met while she was staying at the McGee Hotel with two girlfriends. "It was truly a case of love at first sight," he confided to his diary. He began visiting her on weekends at her aunt's house in Courtland, Alabama. She broke her engagement to the planter and married Will in Memphis. The marriage came "to the great annoyance of her family," Tallulah writes. However, her father presented the newlyweds with a magnificent carriage drawn by two resplendent chestnut mares.

Captain John and Mrs. Bankhead did not attend the wedding, but they seem to have approved of Will's choice. "We send today a gift of love on your bridal occasion," Mrs. Bankhead wrote Adelaide. "We extend you a warm enclosure in our family circle." She signed her note "Mother and Father." In a letter sent from Washington a day after the nuptials, she asked Adelaide to "write me a letter & describe your presents, it will give me great pleasure and tell me all about your wedding. . . ."

Will practiced law in Huntsville and was elected in 1900 to the Alabama state legislature. Adelaide and Will's first daughter, Evelyn Eugenia, was born in January 1901, and Tallulah Brockman exactly one year later. Shortly after Tallulah was delivered, Adelaide contracted peritonitis, an infection of the lower abdominal cavity, exactly as her own mother had done shortly after giving birth to her. Margaret DuBois Smith wrote that Adelaide had summoned her and her sister: "She talked at length to us & looked so pretty—after three weeks of illness. . . ." Age twenty-one, Ada died the following night. After receiving Holy Communion from the family reverend, Ada spoke regretfully about leaving her infant daughter, then "seemed to trustfully submit to the will of God."

The family and Tallulah herself liked to feel that she was destined to be someone to be reckoned with since conception. Years later, Tallulah produced for a reporter a letter her mother had written to her father: "From the number of kicks I feel, don't rule out the prospect of *twins*." Will's sister Marie later said that in her dying moments Ada had said to her, "Tallulah will never lack for friends."

At this point Adelaide's extended family seemed to largely disappear from Tallulah's life, although Eugenia Bankhead later mentioned she had

Eugenia and Tallulah (*right*).
William Bankhead with his two young daughters.

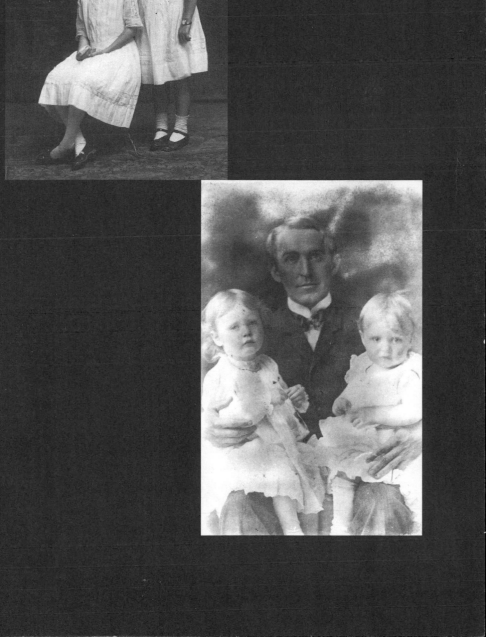

known Adelaide's sister Clara May. Eventually a portion of the Sledge farm—now fallen on hard times—was bequeathed jointly to Eugenia and Tallulah, for whom Will managed it during the 1930s. Throughout her life, Tallulah treasured what information she could discover about her mother, but not much seems to have been available: "My knowledge of Mother's family is sketchy," Tallulah writes. For many years Will was so bereaved that he was hardly able to speak to his daughters about her.

The two girls were sent to live with Will's sister Marie in Montgomery. Marie was married to Dr. Thomas Owen, who was archivist for the state of Alabama and a trusted lieutenant in the Bankhead reelection machine. They had a son, Thomas, who was eight years older than Tallulah. Marie wrote a social column for the *Montgomery Advertiser*. Kay Crow described her as "a wonderfully outgoing woman who would speak her mind about everything. She could just say things that would stop you in your tracks."

For the next decade Tallulah and Eugenia lived alternately with Marie and with their grandparents in Jasper when Congress was in recess. Will was "disconsolate for years after Mother died," Tallulah said in 1944. He stayed in Huntsville, salving his sorrow with liquor until he was summoned to Jasper to join his brother John's law practice.

Tallulah declared as a child and an adult that she was her grandfather's favorite of all his grandchildren, and she considered her grandmother a second mother, even addressing her as "Mama." But Tallulah believed her father favored Eugenia. Eugenia was frail throughout childhood. When she was three years old, she came down with measles and whooping cough simultaneously, which left her temporarily blinded. She was treated by a Montgomery doctor who proscribed any exposure to sunlight. For months Eugenia was forced to play at night and sleep in the daytime; she was then taken to Washington for further treatment. By the age of six, her vision was substantially restored. But her sight was never very keen; and as an adult, one eye, perhaps as a result of a separate condition altogether, wandered noticeably.

From an early age, Tallulah demonstrated a boisterousness at odds with the codes of gentility. Zora Ellis, a former schoolmate in Jasper, recalled walking to and from elementary school with Tallulah; when Tallulah's funny bone was tickled, she would fall to the sidewalk laughing raucously. Alternately, Tallulah could pitch tantrums so frightening that her grandmother would douse her with buckets of cold water.

"Never make yourself conspicuous," Will counseled her. "It's bad

form, bad manners." But on occasions he imparted a quite different and equally compelling message. When she was five Will took her to Birmingham to have her tonsils removed. During the operation the doctor accidentally cut into her uvula, to which one of Tallulah's doctors later attributed the low timbre of her voice. As a reward for her courage, Will took her to a vaudeville show. A chanteuse sang songs that Tallulah recalled as "slightly risqué," recalling the line "And when he took his hat I wondered when he'd come again." Tallulah absorbed the songs and performed them later. "Daddy was fascinated by my impersonation."

Sometimes he would come home under the influence, wake her up, bring her downstairs in her nightgown, stand her up on the table in the dining room, and ask her to give her impersonation of the songbird. She loved being on top of the world: the dining room was only used for large family dinners. Will's approval came in great gales of laughter. One night he came home with most of the University of Alabama Glee Club. Again she was summoned and again she performed.

At Sunset, the Bankhead's late-Victorian wedding-cake house in Jasper, Eugenia and Tallulah poked around their relatives' old clothes packed away in the attic, making up dramas to suit the costumes they found. Tallulah sought out a more public forum for performance from her earliest years. Among friends and strangers, she specialized in cartwheels, back bends, mimicry, and song-and-dance routines, and relished her roles in school performances. She read enthusiastically and her father's love for Shakespeare inspired her to commit a number of soliloquies to memory. In a play put on by the fourth-grade class, Tallulah wore a kerchief around her head to impersonate a black mammy. "It wasn't the leading part, but she stole the show," Zora Ellis recalled, "and had every intention of stealing the show."

But schoolwork presented problems. "I was too tense and restless to concentrate on paper," she recalled in middle age. Tallulah's outlandish name—said to mean "terrible" as in "mighty" in Indian dialect—was a handicap. "I used to hate it so as a child," she recalled in 1966. "It would break my heart, because you'd meet kids and they'd say 'What's your name?' 'Mary,' 'Louise,' 'Virginia?' And I'd say, 'Tallulah,' and they'd go 'Ha, ha, ha,' and you know how sensitive children are."

Will and his father continued to hatch business schemes during their government career, yet success largely eluded them. "Daddy never made much money, either as lawyer or government servant," Tallulah wrote. "He had no instinct for business." Nevertheless they led a privileged existence;

Democratic hegemony across the South guaranteed that sitting politicians were an elite. Labor was cheap, and Sunset swarmed with black servants with whom the family maintained close relationships that mirrored the prewar era. Will Bankhead recorded in the diaries he kept in law school and during a short stint practicing in New York a full allegiance to the bigotry of his time and place.

Tallulah's friend Stephan Cole recalled that while Tallulah had "fish pride" about being a Southerner, she was ashamed of the way blacks were treated there. "I never went through any of that, thank God," she insisted in 1966, revealing the enlightened liberalism of her family with the example of Willie Mae Gollach, daughter of the Bankhead's cook, who was permitted to sleep on the sleeping porch with Eugenia and Tallulah.

Mrs. Bankhead's strongest expletive was *hussy,* a word she considered so inflammatory that it could never be used in front of her grandchildren. She told the girls that religion and politics were taboo subjects in a social setting, but at dinner with just the family Tallulah said, "that's all we talked about!" Most of it was incomprehensible to her, but she recalled the mounting anxiety at home as election time approached. Then as now, it was not uncommon for Southern politicians to retain their seats for decades. A Democratic nomination all but assured election; nevertheless, competition for the nomination could be fierce. The Bankhead family never quite got over Captain John's defeat in 1905 by Richmond Pearson Hobson, the young naval lieutenant who had been lionized for his conduct during the Spanish American War. The following year, however, Bankhead was elected to the Senate.

Recalling her childhood, Eugenia would invariably portray herself as the perpetual victim of her younger sister. Eugenia was "very meek," as a girl, and by the time they were preteens, Tallulah weighed exactly double what Eugenia did. "I used to lock myself in the bathroom every time Daddy left until he came home from lunch," Eugenia recalled. "If I didn't she'd break into the room and be twisting my arm." Eugenia kept a copy of a Rover Boys adventure story in the dirty clothes hamper and a blanket in the linen chest; "as soon as Daddy left I made myself a little bed and read until he came home."

"All right, Nothin' Much," Will would say, "I'm home now; you can come out."

David Herbert, a friend of the two Bankhead sisters, recalled being told by Eugenia that as children they were once each given a duckling. Both girls took the pets to bed with them. During the night Tallulah dis-

covered that she had rolled over her duck and killed it. So she put her dead duck in Eugenia's bed and took Eugenia's live duck, and put it in her bed. "In the morning, Eugenia was given hell for killing the duck."

"She'd say, 'Let's seesaw,'" Eugenia recalled. "I'd say 'All right.' 'Let's put this plank out of the barn window.' She was so much heavier that she got about that much plank. And to balance it I got the rest of the plank out the barn window. I was having a wonderful time . . . sailing through the air, like a man on the flying trapeze. Her feet were just bouncing off the ground a little like that." But once the dinner bell rang, Tallulah bolted into the house, and "there I was in the compost heap and Sister was at the dining room table."

Following that incident, Will built a round seesaw for them. Tallulah told Eugenia to push. "Somehow it caught up with me," Eugenia recalled, "and knocked me on the guinea pig cage, where I proceeded to step on a plank with a rusty nail." In retaliation she picked up a discarded Coke bottle and hit Tallulah over the head with it. "Aunt Louise and Daddy rushed out to find us both lying covered with blood and guinea pigs."

At night she would read to Tallulah by the light of a candle stuck into a Coke bottle. "When she was very disagreeable I'd read her *The Hound of the Baskervilles,* which is one of A. Conan Doyle's most *terrifying* things. I'd say 'Ooooohhh . . . ' blow the candle light out and grab her . . . she thought the Hound of the Baskervilles had her by the throat." But the sisters' mutual dependence was as strong as their conflicts. "We really loved each other very, very much in those days," Eugenia recalled in 1971.

It would have been difficult for any child not to retain a terrible guilt about Adelaide's death, while her father's subsequent tailspin only served to heighten Tallulah's feelings of culpability. She also learned from Will during her childhood that he had originally hoped his second child would be a boy. As an adult, Tallulah was partial to the color "baby boy" blue because she said it was her father's favorite color; she connected that to his wanting a boy. Indeed, Tallulah's lifelong usurpation of masculine stances and prerogatives could be interpreted as a subconscious attempt to give Will the son he had wanted.

Eugenia and Tallulah were deprived of Will's active presence a good deal of the time and his behavior made them afraid that they could lose him, as they had their mother. Eugenia told Lee Israel, author of 1972's *Miss Tallulah Bankhead,* that both girls had seen him on occasion weaving round drunkenly, toting a gun and vowing to join their mother. Not sur-

prisingly, Tallulah was an anxious girl. In 1928 she said that "the mere thought of policeman, burglars, and ghosts" during her childhood had ensured "a night of sleepless fear, half suffocated beneath the bed-clothes."

Tallulah's extraordinarily aggressive demands for attention throughout her life would indicate that she felt she had been overlooked and short-changed as a girl. In 1964, when Tallulah filmed her final movie, costar Stefanie Powers was astonished at Tallulah's ability to plunge instantly into a scene requiring sobs, bloodshot eyes, and a red nose, and then instantly recover her composure and her normal appearance. Tallulah did this not once but numerous times, as coverage angles of the scene were filmed. Powers asked Tallulah what her secret was. Tallulah told her that as a girl she had taught herself to cry "because it was the only way she could get attention in the house."

Her feelings of familial neglect were undoubtedly all the more pronounced when the family decided that the strictness of a boarding school would be good for the two sisters. In the fall of 1912, they were sent to the Convent of the Sacred Heart in Manhattanville, New York. The Bankheads were variously Methodist and Presbyterian, but Will insisted the girls be raised Episcopalian in deference to the faith that Adelaide had practiced, and so on Sundays in Jasper, they attended services at an Episcopal chapel set up in a loft over a feed store. Mrs. Bankhead did not approve of Catholicism, but Sacred Heart made sense because Will's sister Louise was living nearby at the time and because there were few other boarding schools that accepted elementary-school-age children.

Sacred Heart was the first of five schools Tallulah would attend in the next five years. "We were always about three weeks late at school," she recalled, "and left three weeks too soon, 'cause we wouldn't come up 'till Congress adjourned or Congress convened, and so I always didn't know where I was." Tallulah had decided that she would not submit to Yankee ridicule about her name. "I didn't realize, being very young, that you were registered in and naturally everything had to be applied and accounted for. Students asked me what my name was, and I'd say, 'Elizabeth,' but of course the teachers—'Madam' they were called at Sacred—would say, "Tallulah Bankhead," and I'd have to say 'here.'"

"If you go to New York, please do not fail to see the children," Will wrote his father in Washington. "They are awful homesick." That Christmas, Will himself came to New York and took the girls to a Broadway matinee of *The Whip,* a blood-and-thunder melodrama replete with a simulated horse race and train wreck. The girls were stirred to such a frenzy that they

wet their panties. A couple of months later, Louise took them to see David Belasco's production of *A Good Little Devil,* starring Mary Pickford, with Lillian Gish in a supporting role. It was much quieter: a fairy tale transferred from the Paris stage concerning a blind girl whose sight is restored by fairies. It was then, Tallulah later recalled, that she made up her mind: she would be an actress.

At Sacred Heart, Tallulah acquired a facility in French, but her frequent transgressions of school regulations stood in marked contrast to Eugenia's impeccable behavior. At the end-of-term commencement, the girls wore white veils and carried white lilies. Tallulah's behavior, however, merited a short black veil and she was forbidden a flower. At the sight of Louise and Will, Tallulah burst into tears.

In the fall of 1913, Eugenia and Tallulah moved on to the Mary Baldwin Seminary in Staunton, Virginia. Tallulah's cousin Marion, daughter of John Bankhead Jr., was attending and they would be close to their grandparents. However, more disciplinary infractions by Tallulah led to the girls being withdrawn in January 1914. "They could not fit in," Marion Bankhead recalled in a letter to Lee Israel, and disrupted the other students by eating together in their beds late at night. Tallulah "resented the fact her acting ambitions were unnoticed" and she was turned down for the school play. In January, they transferred to the Convent of the Visitation in Washington, where Eugenia continued to outshine Tallulah. "There's no denying that I was the ugly duckling, thanks to my fat and my pimples," she writes in her autobiography. Eugenia was "an excellent student, I was an indifferent one. Sister was the party girl. I was the homebody. She liked to be up at the crack of dawn. I liked to lie in bed and meditate on the future."

That year, Will married Florence McGuire, a Jasper native who had worked as his secretary. She was then twenty-five, fourteen years his junior. Florence McGuire was "a woman of charm and honesty," Tallulah notes in *Tallulah.* But naturally she was resented by both Eugenia and Tallulah. In a 1922 interview Tallulah alluded to tensions: "When I was twelve years old I used to think it was the best sport in the world to give impressions of my step-mother. At that time dad said severely: 'The place for people to give impersonations is on the stage!' and so the seed was planted." Yet Florence did her best to forge a relationship with the girls.

Eugenia's illness had delayed her entry into school, and therefore she and Tallulah had always been in the same class. In the fall of 1915 the family decided that the girls should be separated for the first time. Eugenia was

enrolled into Miss Margaret Booth's school in Montgomery, while Tallulah was sent to the Holy Cross Academy in Maryland. Alone for the first time, she wept continuously for a month and refused to eat. "Aunt Marie gets a frantic phone call from my grandmother," Eugenia recalled, " 'Get Eugenia up here, Tallulah's starving to death.' " Eugenia was sent north: "Sister greeted me with joy. I think she probably ate half a hog that day."

That fall the Bankheads suffered a tragedy when Louise's son William Perry, a college student, died of walking typhoid. On November 15, Tallulah wrote her grandmother:

> I received your lovely letter telling me all about the funeral and I also received a dear letter from Aunt Louise. It must have been beautiful with those lovely flowers but oh how sad. A boy so bright, so young and handsome to be snaped [sic] away in all his youth and glory. It must have been an awful shock to Ola [his fiancée] but dear Aunt Louise her sorrow is greater than any. In the middle of the night I find my self crying to think I will never see dear Billy again and oh I loved him better than I could have loved a brother. But we will all see him again in heaven but that seems so far off. Poor Aunt Louise she has had her troubles not in showers but in storms with just a little sunshine now and then but I am afraid the sun will never shine brightly as it did.

A year later, the girls moved to the Fairmont Seminary in Washington, which allowed them to move back in with their family. Tallulah lived with her grandparents, Eugenia with Will and Florence, in two apartments at 1868 Columbia Road in Columbia Heights, a fashionable district popular with politicians and diplomats. Tallulah began piano and violin lessons and played in the Fairmont commencement ceremony. For a time she even entertained the idea of becoming a concert musician.

Adolescence brought a remarkable transformation: Tallulah's looks began to outshine Eugenia's. Her skin recovered from a siege of acne. Her hair brightened into a vibrant ash blond that complemented the bright blue, almost sapphire-colored eyes she had inherited from her father. Her stepmother encouraged her to diet, and she slimmed down considerably.

In 1914, Will had made his first bid for the House of Representatives. He was defeated in part because of allegations made about his drinking. But although Will never became a teetotaler, his extended binge following Adelaide's death was now finally over. In 1916, gerrymandering by the Bankheads led to the creation of a new congressional district from which

Will now ran for representative. The same Hobson who had defeated Captain John had now shifted districts to run a campaign that announced itself as a crusade against the Bankhead machine. But this time the Bankheads prevailed, and Will began what would become twenty-four years in the House of Representatives.

Tallulah had made her theatrical ambitions known to the family. Submerged in movie magazines, Baudelaire, and *Madame Bovary,* she paid no heed when Mrs. Bankhead began plotting an ambitious marriage. "Grandmother was very old-fashioned," Tallulah recalled in 1938. "She wasn't against the theatre, but she never could see why a woman should want to work if she didn't have to."

The teenage Prince of Wales was making a state visit to Washington. Mrs. Bankhead insisted that Tallulah join her and the family to greet him at a reception. "Since nothing in the world was good enough for her Tallulah she felt fate had brought her my Prince Charming." Tallulah herself was furious because it meant missing an episode of the serial *The Exploits of Elaine,* but her grandmother "was no one to monkey with, once she'd made up her mind."

Washington's bon ton lined up to pay homage to the teenage heir apparent, but were perplexed about the correct way to genuflect. Mrs. Bankhead elected to bestow upon the prince a curtsy that "brought her nose to the rug," Tallulah recalled. "She seemed to be submitting her head to the ax. Her overlong salute blocked traffic for three minutes." Florence Bankhead was daunted by her mother-in-law's performance. "Billy, I am not going to curtsy to that little boy," she told Will. "I'd just feel a fool and what's more, I'd look a fool."

In its June 1917 issue, *Picture Play* magazine announced that it was launching a beauty contest that would award the winners a role in a film produced by Frank Powell, who was credited with discovering Theda Bara and Blanche Sweet, who were both at the peak of their fame. With her stepmother's encouragement, Tallulah sent in a photo. The results were announced in the September issue. Tallulah's photograph was reproduced along with eleven other winners. But Tallulah had neglected to write her name on the photo she submitted, and her application and envelope had been lost. She sent in a duplicate photo to prove her identity.

In 1919, *Photoplay* interviewed Mrs. Bankhead, who recounted Will's ambition to go on the stage. "However, I stopped him before he got very far. He was studying law and I wanted that to be his profession. But the ambition of her father that I nipped in the bud broke out in Tallulah, who

has always been perfectly determined to be an actress. She had promised to wait until she was older . . . but things happened that just took matters right out of our hands."

"The family thought that if I had no talent the best cure would be to let me on the stage," Tallulah explained in a 1921 interview, "and if I really had talent, why the stage was the place for me." It seems, too, that any qualms Will might have had would only have subjected him to accusations of hypocrisy from Tallulah. He had continued to encourage her interest in the theater, taking her since she'd starting attending schools in the D.C. area to performances by the resident stock company at Polit's Theatre as well as at Keith's vaudeville house. Furthermore, in 1915, Lois Wilson, an Alabama native, had won at age nineteen a beauty contest that launched her on a career in silent films. Will had been one of the contest judges. Tallulah also remembered the contest and later referred to Wilson as "my father's godchild."

Captain John's was the deciding vote. He "never objected to my acting," Tallulah explained years later. "To him it was just another public career; it was carrying on the Bankhead name."

"He was the finest judge of character I ever knew," Marie recalled in 1931, "and he had every confidence that Tallulah had a *force* in her from her very childhood." He, too, was given to theatrical gestures. "When the more conservative members of the family hesitated about giving approval to her 'going on the stage,'" Marie recounted with an equal flair for effect, "the old man, with flashing eyes, and emphatic gesture declared: 'Stand back, all of you. This is my job. Tallulah shall have her chance!'"

At fifteen, Tallulah put formal schooling behind her and left for New York.

Debutante

"I am going to make good with a bang! Wait and see. Then you will be proud of your bad little girl with her bad little temper."

A chaperone for Tallulah was mandatory, and it had been decided that Aunt Louise would accompany her to New York. Louise was now separated from her second husband, Arthur Lund, with whom she had lived in New York, but Lund was still living there and they remained in close contact. Louise's surviving child, a girl, was now married. Louise was racked with guilt over her insistence that her late son had been too young to marry his sweetheart, Ola Davis. And so she brought Ola to New York as well, hoping to launch her on a singing career. The three moved into an apartment at 341 West Forty-fifth Street, adjacent to the midtown theater district. Louise was preoccupied, too, with the possibility of communicating with her dead son and she insisted that Tallulah and Ola regularly accompany her to spiritualist meetings.

The promised movie contract in a Frank Powell production turned out not to be a Frank Powell production at all because Powell had gone bankrupt. Instead Tallulah was going to appear in a Mutual Film Corporation production directed by Dell Henderson entitled *Who Loved Him Best?* Miraculously, the film survives at the Library of Congress in excellent con-

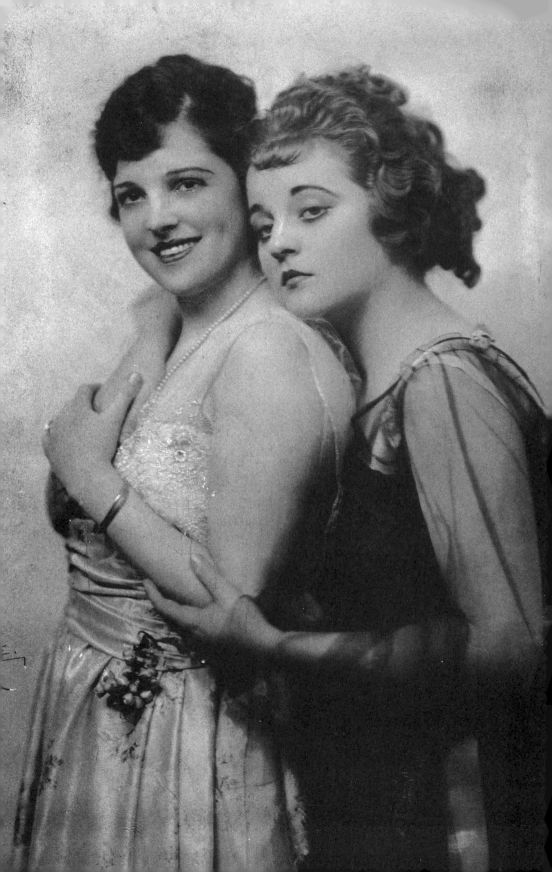

dition. Watching it today, one would never know that this was Tallulah's professional acting debut. She looks as if she had been acting all her life.

The film stars Edna Goodrich, at the time one of Mutual's leading actresses. She plays movie star Dora Dane (a flashback shows her discovery in a garment factory). Dora rejects a producer's marriage proposal because she is in love with a young sculptor, George Steele. Steele is convinced that he's burned out and fritters away his time with bohemian amusements. Dora campaigns to get George back to the grindstone while contending with a rich widow who enjoys patronizing young artists and who seems to have designs on George.

Tallulah plays "Nell," one of George's bohemian friends. Her role is peripheral to the plot, but she is front and center screen in several scenes. She is first seen at an art gallery opening, enthusing with friends over the works on display. Next she gets a sequence all to herself, running up the stairs to George's studio ahead of her friends. She pauses at his door, satisfies herself that he's home, and then bursts in to congratulate him. Rather than *bursting* in, one could just as easily say *bouncing* in: throughout the film Tallulah evinces many stylistic hallmarks of the adorably impulsive World War I ingenue. Commanding the screen alone outside George's studio, she magnetizes the viewer and rewards the camera's scrutiny.

Once inside George's studio, Nell finds that he is talking with Dora, who is irate when Nell's friends troop in boisterously. "You pretend to be his friend but you want to ruin him," Dora insists, and shows the lot of them the door. Dora is determined that George buckle down to work on an entry for a sculpture competition on the theme "American Militant."

In a later scene at the "Greenwich Village Bazaar," Tallulah as Nell wears a harlequin costume, blows on a tin horn, kicks up her heels, and perhaps overdoes her madcap vivacity just a bit. By contrast, in the climactic scene she skillfully subdues herself: Dora, furious at finding George and the widow kissing at the Bazaar, has smashed his competition statue before the startled gaze of Nell and her friends. Then Dora reveals that it is really an identical statue created by George's best friend, who has been secretly copying his work. Nell and her gang listen in astonishment to Dora's confession, then file out buzzing about what has just happened. George and Dora are left alone in an embrace at the final fade-out.

Who Loved Him Best? didn't receive much attention when it was released in February 1918, just after Tallulah's sixteenth birthday. It was one

Tallulah with Ola Davis, 1917.

half of a double bill at the New York Theatre on Forty-fifth Street and Broadway. "That just tells about what sort of film this is," *Variety* snickered. A fascinating artifact today, it was then only one in an avalanche of five- and six-reel feature films flooding the market. Tallulah's family realized as much and were willing to stake her for the longer haul. Will wrote, "My dearest Tallulah: You are certainly going at this thing like you meant business and I am betting on you and backing you to my limit. . . ." But the primary backing still came from Captain John.

Tallulah had been paid twenty dollars a day for her work on *Who Loved Him Best?* However, she tore up her first paycheck "because I thought it a terrible thing to be paid for doing something that I had enjoyed." Louise picked up the pieces and tried to tape the check back together. Financial security was "not a Bankhead characteristic," Louise's sister Marie would say in 1932.

Tallulah claimed that Louise was more interested in furthering Ola's career than her own. But Ola herself was much less ambitious and soon returned to Alabama. Looking for a smaller apartment, Louise steered her niece to the Algonquin Hotel on Forty-fifth Street between Fifth and Sixth Avenues. Tallulah later claimed that Louise had no idea that the Algonquin was the city's leading theatrical watering hole, but Tallulah suddenly found herself at the hub of Broadway and the film industry. A constellation of New York's sharpest and cruelest wits—known as the Algonquin "Round Table"—held court in the dining room at lunch. At after-theater supper, the lobby and dining room were filled with performers eating after their shows. Many stars also lived there or kept apartments there to rest in on matinee days. Tallulah was afraid that starchy Louise would immediately relocate when she realized what she had stepped into; however, Louise "enjoyed the floor show as much as I did," Tallulah recalled of that passing parade of celebrities.

A letter from Mrs. Bankhead to Tallulah survives that must have been written soon after Tallulah and Louise settled at the Algonquin. It is an extraordinary jumble of anxious injunction, pedestrian news, religious fervor, and homiletic counsel: "Precious heart," she advised Tallulah, "be unselfish and do as many little acts of kindness as possible, and it will in return bring joy to you." Eugenia, who was preparing for her coming out, was about to take dance lessons every Friday night. But Washington was snowbound, and as a result Mrs. Bankhead was going out very little. New York, she could have assumed, would only be more frigid. "Keep your feet well protected, for fear of dread pneumonia. My beautiful sister at 23 died in 3 days. . . ." She implored Tallulah to "dedicate your spirit to God, our

heavenly father." She felt sure that her dead grandson William Perry, Louise's son, was "in his Heavenly home where no harm can come to him."

The Bankheads did their best to rally support for Tallulah by writing letters to a network of business contacts in New York. Tallulah put her political training to work to ingratiate herself with the celebrities populating the hotel: she ogled, and all but stalked, her favorite stars. Ann Andrews had been born into West Coast society and was enjoying a success on the Broadway stage. "I instinctively liked her the minute I met her," Andrews recalled in 1982, "and she was so intelligent and so amusing that we became great friends." Andrews was impressed by Tallulah's thirst for knowledge, a drive completely independent of her failures at school. "Everyone has an aura," Andrews related, "and Tallulah had an aura of the mind— *extraordinary.*" Tallulah's conversation, her grasp of current events, was impressive. "She always knew everything that was going on," Andrews recalled. Straitened by her small allowance, Tallulah went to local newsstands and asked, "May I borrow this?" Publication by publication, she worked her way through that week's crop. Tallulah was at that time "without a doubt the healthiest human being I have ever known," Andrews recalled. "Her vitality was just unheard of. When she started in New York it seemed her feet could hardly stay on the ground."

After weeks of pursuing leads, Tallulah finally found work. She was summoned by the Schubert office to play a silent role, a "walk-on," in *The Squab Farm,* a new play by husband and wife Fanny and Frederic Hatton, a popular playwriting team. The Hattons' *Lombardi Ltd.,* a farce set in the fashion world, was currently enjoying a long run. *The Squab Farm* sent up the foibles of the movie industry. Lowell Sherman played an unscrupulous director, and Alma Tell was a star who shocked her studio by refusing to put on a revealing costume for the camera. Tallulah was "Gladys Sinclair," one of a flock of young starlets, toothsome young chicks at the squab farm.

She was lonely and disoriented during the tryouts in Connecticut and New Jersey. Ignorant of one of the theater's oldest superstitions, she whistled in the communal dressing room and was rebuked severely by her roommates. Julia Bruns, who played the role of a temperamental film diva, took pity on Tallulah and invited her to share her dressing room, which further alienated Tallulah's colleagues.

On March 13, *The Squab Farm* opened in New York at the Bijou Theatre on Forty-fifth Street, next door to the Morosco, where *Lombardi Ltd.* was ensconced. Three days later, Tallulah had nothing but glad tidings to

report to her grandmother: "Your little namesake is now a full fledge [sic] actress. I have made my debut on Broadway and am so crazy about the stage. I have just returned from the matinee and I can't wait to go back for the evening performance."

A portrait of Tallulah was published in the March 17 edition of the Sunday *Morning Telegraph,* headlined SOCIETY GIRL GOES ON STAGE. As thrilled as Tallulah was, the publicity did as much harm as good, for there is probably nothing more handicapping for an actress than to look like a society dilettante. Furthermore, the piece described her as the star of *The Squab Farm,* which did not go over at all well with Alma Tell.

Theatre magazine reported that in *The Squab Farm,* "the selfishness, vanity and rapacity of the idols of the screen were laid bare with unflinching realism and rare comic verve." But the play closed after four weeks. *Photoplay* stated that it was precisely that irreverence that doomed the comedy. "The fans didn't like to see their screen idols burlesqued, even by the privileged Hattons."

Tallulah believed that the curtain had also rung down on her theatrical ambitions. However, Russian director Ivan Abramson had seen the play and offered her a part in his picture *When Men Betray.* In it she played a woman raped by her sister's fiancé. It was released in June. *Motion Picture News* reported that "as the foolish girl rudely awakened," she had acted "with sincerity and feeling." Tallulah was ecstatic at a mention by Harriet Underhill of the *Tribune.* "Miss Tallulah Bankhead is new to the screen and she proves the truth of the theory that brains are better than experience."

Tallulah's career in silent films had been launched. Scouting for a leading woman for his new star, Tom Moore, Samuel Goldwyn found Tallulah and hired her for *Thirty a Week,* in which she played a wealthy girl in love with her family's new chauffeur. Released in October 1918, *Thirty a Week* was quickly dismissed, but Tallulah and Moore were commended by *Moving Picture World* for their "excellent acting."

During the final months of World War I, Louise decided to join the Red Cross in Europe as a nurse's aide. Marie was sent up to New York to oversee Tallulah, and accompanied her on a round of interviews with film executives in December. The family insisted Tallulah return with Marie to Washington for Christmas. In Washington, Bobby Carrere—"the great beau of Washington, he couldn't make up his mind about Sister or me"— took Tallulah to see James Barrie's bittersweet fantasy *Dear Brutus.* Eighteen-year-old Helen Hayes had a prominent role. Tallulah had first

seen Hayes act with a stock company in Washington; she was envious that Hayes had been onstage since age six.

The Bankheads allowed Tallulah to return to New York unsupervised only after Will came and conferred with Frank Case, owner of the Algonquin. She was given an allowance of fifty dollars per week, of which twenty-one dollars went toward her room at the hotel. Will told Case that if Tallulah was not in by midnight she was not to be allowed in until morning. "One night, there was a ring at my bell," Ann Andrews recalled with a chuckle. "And there was Tallulah. She'd been locked out. Could she spend the night with me?"

It was at the Algonquin that Tallulah first met British actress Estelle Winwood, who remained one of her closest friends until the day she died. Winwood had emigrated to New York in 1916 to appear in a play called *Hush* and had immediately established herself as a Broadway favorite. One night over supper at the Algonquin she went over to say hello to Ethel Barrymore. "And there was this Tallulah," Winwood recalled in 1982. "And I looked at her in astonishment. I'd never seen anybody so pretty. I said, 'Oh, my God—who are you?'" Tallulah informed her that she'd seen her latest play sixteen times.

Several nights later, Winwood was attending a party in an Algonquin suite. She was the last guest to leave, when the host "got me by the wrist and pulled me back and said, 'Oh, no, you don't, Estelle.' I said, 'What do you mean?' He said, 'Oh, no, you've been kidding me, and flirting with me the whole evening, you're not going.' I said, 'How dare you.' You know, very British . . . as though I was the most important person in the world. Well we had a fight and I kicked and screamed and he carried me to his bedroom and he got me on that bed and he had an affair with me."

It was three o'clock in the morning, and she was afraid of a pregnancy, and asked herself whom she knew in the hotel who could help. She remembered the name Bankhead and knocked on Tallulah's door. Tallulah was awake and invited her in. "I don't know whether you'll like me to come in, when I tell you what I've come for." Winwood asked if she had a douche bag; Tallulah didn't know what she meant. In that case, Winwood said, did Tallulah have an enema bag? As it turned out she did. Winwood explained what had just happened and Tallulah showed her to the bathroom. "I had a good washout and then I said 'Goodnight' and that was the beginning of a great friendship."

"I molded her in a way to get into being Tallulah Bankhead," Winwood

claimed, "which she never would have been if it hadn't been for me." Perhaps Winwood exaggerated her influence—but there's no question that her impact on Tallulah was genuine. Tallulah was eighteen years younger, "and she used to take notice of what I said. I terribly often bullied her, told her she was a fool. And she didn't mind at all. Thought she was, I think. And so she always would do something that I would advise her."

Jobyna Howland was another older actress who assumed something of a motherly role toward Tallulah. Howland usually played character roles in comedy and went on to give some priceless renditions of comic battle-axes in films in the early 1930s. Six feet tall, Howland possessed a wind-in-the-chimney voice from which issued commands that the most stalwart might find hard to resist.

Over the holidays in Washington, Tallulah had insisted that the family buy her a low-cut evening gown in which to shine at parties, but attending the theater with Bobby Carrere, Tallulah lost her nerve and wouldn't remove her wrap all evening. So did her behavior during these early days at the Algonquin swing between extremes. "She behaved so madly stupidly," Winwood complained. "Like for instance, you're sitting here on this sofa, and there might be three other people over there, and she'd come in and flounce around. What for? Nobody cared about her then. She wasn't Tallulah Bankhead. She was just a girl." Tallulah craved attention, and her posturing and posing made sure she was noticed. Yet part of her wanted to be looked at so that she could hide, disappear, as it were, behind the facade her flamboyant behavior constructed. She insisted on reaping a particular type of boggled attention that could deflect a natural shyness many people would notice over the course of her life.

Her poses and her pranks earned her the affectionate condescension of the Algonquin Round Table. "I was in a way sometimes kind of their pet," Tallulah recalled in 1966, "'cause I was such an idiot. I put on this big act; I was so nervous all the time they thought I was putting on airs, and it was sheer nerves."

She experimented with her look, patterning her appearance after whoever was her idol of the moment. Tallulah had decided that Mary Pickford's ringlets could look well on her and submitted her thick wavy hair to be coiled into Pickford's sausage curls. Permanent waving was in its infancy and the result was rather crude. Casting managers "said that she didn't look right," Dorothy Dickson recalled in 1982. Dickson and Carl Hyson were a very popular husband-and-wife ballroom dance team, who performed in their own "Palais Royale" nightclub and on Broadway. They

lived at the Algonquin. "I took her to Ziegfeld"—Dickson danced in the *Follies* of 1917 and 1918—"but Ziggy wouldn't have anything to do with her. He just wasn't interested at all."

Early in 1919 Tallulah spent two weeks with a stock company in West Somerville, Massachusetts, which played twelve performances of a different play each week. On February 9 she wrote Captain John from the Hotel Woodbridge, describing her plunge into a grueling work schedule. She had already opened in a new role the previous Monday afternoon, with only nine hours of rehearsal. She was rehearsing the role of a French girl for the following week's offering while performing the first play at night. Rehearsals were nine to twelve noon, followed by a lunch break, a matinee, dinner, and then an evening performance. "I am nearly dead now. . . ." she wrote. She had been asked to stay on for the balance of the season but protested that the work would "kill me." She said, too, that the management wanted her to replace the current leading lady, who had befriended her.

West Somerville was clearly too far from the Great White Way for Tallulah's comfort. Yet Somerville was "a very large place as far as people go but no conveniences at all. I have a room in the only hotel here which is the tourist home. No private bath. I climb three flights of stairs. There is nothing here at all but I am working very hard for the experience. . . ."

Back in New York, Tallulah won a role in a new film, *The Trap,* which was released at the end of the summer. The film was one more undistinguished melodrama, this time starring Olive Tell, whose sister Alma had starred in *The Squab Farm.* In *The Trap,* Tell plays a schoolteacher who unwisely marries a Yukon gambler. He is a heel who uses her sister, played by Tallulah, as a pawn to wreak havoc on his wife.

While filming *The Trap,* Tallulah was instructed to have dinner with a family named Cauble every evening when she got back from the studio. Mrs. Cauble was miffed that Tallulah would not accept her suggestions that she spend the night. "I felt that she got to the hotel in time to have supper with 'Jobena' [Howland] (some actress) and her looks prove to me that she has kept late hours."

Aunt Louise had returned from overseas late in 1918, after a surfeit of relief workers in Italy scuttled her plan to serve with the Red Cross. She would subsequently write her father: "I wish to do all the good I can—that I may build my future life as high and happy as possible." Now she determined to make Tallulah the object of her good works, but Tallulah herself had other ideas. James Julian, a friend of the Bankhead family whose office

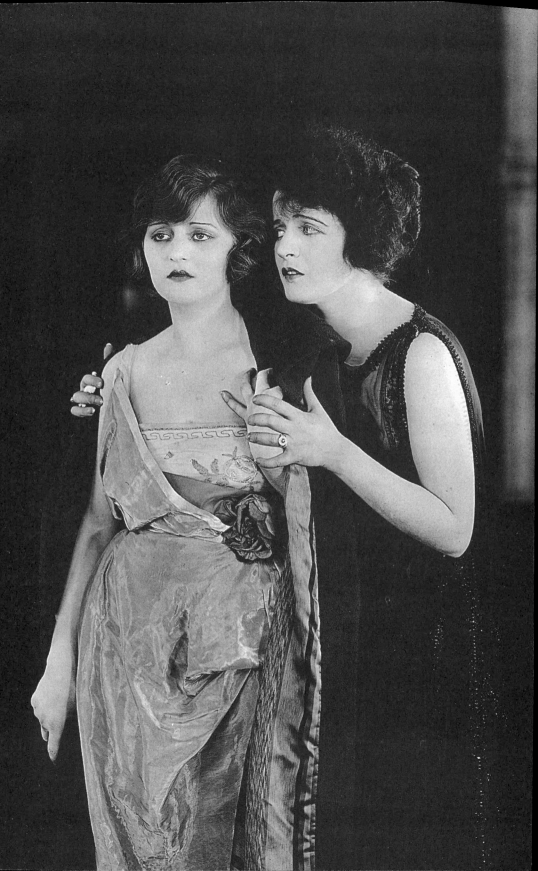

was just down the block from the Algonquin, insisted on monitoring Tallulah's activities as much as she allowed. On March 19, 1919, he wrote to Tallulah's grandfather that she seemed "to be getting obstreperous again" with Louise. A month later, Louise was in Washington, writing to her father in Jasper to share her conviction that Tallulah was going to hell in a handbasket. She copied out a letter from Mrs. Cauble, in which she described Tallulah as more nervous than any other young person she'd ever known. Louise added her own convictions to Mrs. Cauble's appraisal:

> Mrs. Cauble's letter is only a repetition of the manner in which Tallulah treats all who have undertaken to help her. The history of my efforts,— she tried to discredit by telling all of you it was Ola, my partiality to Ola & etc. which was a great injustice to me and was not true. Florence took her turn and said it was hell and she would never do it again. Sister Marie tried her and tho under most pleasant circumstances she said it was "hell" too—

Not long after *The Trap* opened to mediocre reviews, Tallulah wrote Will that Goldwyn had invited her to his office and tried to interest her in more film roles. Will urged her to pursue films: "It is a fine thing to contemplate how powerful a factor the screen has become on the thought and conduct of the world, and how great the possibilities it offers to you—my daughter." But Tallulah's sights were set firmly and exclusively on the stage. "I am giving up pictures to go on the legitimate stage as that means so much more to me," she wrote Will. *The Trap* was the last movie she made for almost a decade.

Live theater remained not only the more prestigious entertainment medium, but the dominant one in New York City, despite the fact that the silent movie industry was also still largely based in the city. The Broadway theater district stretched from Herald Square to Columbus Circle; by comparison with today, the number of theaters operating and plays produced was staggering.

Louise had informed her father that she had not shared Mrs. Cauble's letter with her mother because "she worries so about her granddaughters." As summer approached; Tallulah began to dread every day's mail delivery. She was convinced that her grandmother would recall her summarily as she had years earlier recalled Will from his theatrical adventure in Boston.

With Olive Tell in *The Trap*.

Thanks to Jobyna Howland, however, Tallulah was about to speak her first words on Broadway. Howland was appearing with Estelle Winwood in Rachel Crothers's *A Little Journey* at the Little Theatre on Forty-fourth Street. Crothers was one of the most important playwrights on Broadway; her play *39 East* was running simultaneously across the street at the Plymouth. Howland told Tallulah that she had recommended her to Crothers, who was casting a touring company of *39 East*. Howland warned Tallulah not to put on the vampish makeup she customarily applied, for Tallulah would be reading for the role of a sweet young thing living in a Manhattan boardinghouse.

Although at the time Tallulah's wardrobe was meager, "in those days I felt stark naked unless I had my hat and gloves on." As she began reading, however, her gloves made it difficult to turn the pages of the onionskin paper script. Paralyzed with nerves, she could not get her gloves off. Crothers interrupted her reading, and Tallulah burst into tears, astoundingly at the very moment the part called for them.

This is the story told by Tallulah in her autobiography. To her family she wrote a different story—without any mention of Jobyna Howland—about how she had buttonholed Crothers's production associate Mary Kirkpatrick, who was an acquaintance of the Bankheads. Perhaps the Bankheads had made it clear to Tallulah that they disapproved of Howland, after Mrs. Cauble's dubious allusion to her.

However she procured the job, it was a substantial one. Tallulah was hired to act opposite Sidney Blackmer on weekends during the summer, when leads Constance Binney and Henry Hull would be taking long weekends. In the fall she and Blackmer would begin an eight-month tour of the play across the United States. She wrote Captain John: "I am going to make good with a bang!!! Wait and see. Then you will be proud of your bad little girl with her bad little temper. But it has come in handy in this play. I have to get so mad! Please come and see me."

Crothers always directed her own plays, and she lavished encouragement and attention on Tallulah during rehearsals. "Crothers was not interested in men," Andrews said, "and I think she sort of had a crush on Tallulah." Tallulah reported to her family cheering words from the playwright, who "told me today that I would be a great actress, that I had a spark that few people had, that she never had to tell me anything because I instinctively knew what to do. . . ." But there was "a lot I've got to learn about the work that I don't know and I'm going to work awfully hard."

Blackmer was just out of the army and at the start of his distinguished

career on stage and in film. He, too, hailed from the South. Tallulah and he rehearsed their scenes together while taking rides through Central Park in a horse-drawn carriage. On July 25 they made their debuts. A cast change so fleeting would have been unlikely to be reviewed at all extensively; nevertheless, an unidentified review at the Shubert Archive in New York states that "Tallulah Bankhead gave to her performance as Penelope Penn the idyllic beauty which it demands." But their run was interrupted after Tallulah's third weekend onstage, when the cast was directed to strike by the recently formed Actors' Equity Association. Equity was attempting to limit the largely untrammeled power producers enjoyed over actors. Tallulah plunged into the agitations, handing out programs at benefits that were held regularly to support the unemployed.

Captain John dutifully coughed up a hundred-dollar pledge that Tallulah committed at one of the Equity rallies. But the family did not expect her to become embroiled in public controversy. "Why are you an Equity member?" a *Billboard* reporter would ask her two years later. She "looked aghast" and was reported to reply, "Why, I really can't discuss it. . . . I know I ought to be ashamed to admit it, but I don't know enough about the principles and the inside to say anything about Equity. All I do know is that I belong to it and I think it is right and that it is the best thing not only for actors, but for managers too."

While ushering at one rally, Tallulah suddenly felt nauseated and rushed home to the Algonquin. She woke up to find herself being carried on a mattress to an ambulance that sped her to St. Elizabeth's Hospital. Her appendix had burst. Peritonitis had already set in. Will's permission was needed for an operation because she was underage. He motored through the night from Washington, arriving at the hospital at 3:00 A.M. After six weeks, Tallulah emerged "charged with the conviction that I had all but given my life for a cause." The strike had ended and the actors had prevailed. Tallulah went to Washington to recover.

The *39 East* tour was scheduled to begin in October, but Tallulah experienced sudden trepidation. "I decided that to tour was to court oblivion. Did I leave New York just when I had spoken my first words on its stage, my goose might be cooked. I might spend the rest of my life in Ann Arbors and Springfields and Terre Hautes." She procured a note from a Washington doctor explaining that she was not yet well enough to travel. "It was a cheap trick, shockingly unprofessional," Tallulah admitted, and yet not without some tactical sagacity on the part of the success-obsessed seventeen-year-old. For live theater was so abundant throughout the

country at that time that an actress could find herself working regularly very far from Broadway, too far for Tallulah's comfort. Young actors were sometimes warned not to turn into "Coast Defenders," not to spend too much time availing themselves of the many opportunities in live theater across the country. The case of Frank Hopkins was cited: Hopkins was a popular actor on the West Coast who made a huge hit on Broadway in 1918 in a play called *Lightnin'*. But by then he was already seventy years old.

In 1951, Tallulah recalled that during her Algonquin days she was so afraid that she might miss a phone call bringing her next job that she felt uneasy even about accepting invitations to weekend house parties. Nevertheless, having lied about her health, she was now required to absent herself from New York and malinger in Washington. She didn't return until late in the year. Back in New York she snuck night after night into the Empire Theatre to see Ethel Barrymore impersonate Lady Helen Hatton, a fallen English noblewoman, in Zoë Akins's *Déclassée*. Tallulah's imitation of Barrymore became the flagship of a fleet of imitations that she honed to enhance her desirability as a guest at tony theatrical parties. Tallulah wangled as many invitations as she could, assisted by Winwood and her other friends.

Frank Crowinshield was editor of the monthly *Vanity Fair* and president of the prestigious Coffee House Club on West Forty-fifth Street. He also regularly threw large parties on behalf of his boss, publisher Condé Nast. Crowinshield became a great booster of Tallulah's. Andrews recalled one party where Barrymore and Tallulah were both present. Tallulah was asked to perform her imitations. "She wouldn't do Ethel because she knew Ethel would raise hell," and so Tallulah complied by coming up with a tepid imitation of Ethel's brother Lionel.

Tallulah had crushes on numerous men in New York, and in own her recollection "more than once I trembled on the brink of compliance." But she was inhibited by the fear that a single wrong move on her part could mean recall by the family. Always implicit in the communications from home was the need for Tallulah to be vigilant against the ever-present danger of moral impropriety. "I love you so dearly," Mrs. Bankhead wrote Tallulah. "It seems impossible for you ever to disappoint me and shatter my hopes." Mrs. Bankhead could hardly have imagined that the "vile seducer" so frequently portrayed in the literature of her youth would turn out in Tallulah's case to be another woman.

In all probability, Tallulah's love affair with Eva Le Gallienne was her

first with a member of either sex. Le Gallienne was three years older than Tallulah, and already well established on her long and distinguished career. She had already acted with Ethel Barrymore and had had an affair with the great Russian actress Alla Nazimova, also an idol of Tallulah's. Ann Andrews recounted that Le Gallienne had begun to make overtures to Tallulah, to send her notes at the Algonquin, but Tallulah was leery. Eventually, however, she asked "a youngish man" who frequented the hotel: "What is it the lesbians do?" So he said, "Well, I'll tell you. Tomorrow go upstairs, take a bath"—at that point Tallulah was sharing a bath, "so under the arms it was rather high at times," Andrews recalled—"get in bed and I'll come see you." Later Tallulah described humorously to Andrews her suitor arriving, taking off his coat and gloves, and proceeding to show her what lesbians did. "Well, I guess it worked, because then she gave in to Le Gallienne." Tallulah, however, found the Norwegian-British actress rather dour. After Le Gallienne left on a tour, Tallulah complained, "Oh, for God's sake, she's been writing me letters every day. Ann, I could never become a lesbian, because they have no sense of humor!"

Tallulah herself alluded to her affair with Le Gallienne to some friends later in life, but many of those who knew her best never disclosed how actively bisexual she was throughout much of her adult life. This may have been due to the taboos of the day or they may actually not have really known, for Tallulah felt the need to compartmentalize her life, and didn't always wish to see the various compartments overlap. Even after Tallulah's death, Winwood, for one, adamantly denied to any and all that Tallulah had ever had a relationship with a woman. Over the course of her life, however, Tallulah would find any number of gay women whose sense of humor she found more than acceptable.

Making Her Way

"The part was very unattractive. The girl had nothing to do but talk . . ."

It was a brouhaha not over sex but about Tallulah's prospects as an actress that seems to have come closest to inciting the family's recall. Early in 1920, on the recommendation of producer Al Woods, Sam Harris hired Tallulah for *The Hottentot,* a new comedy he was producing starring William Collier, one of Broadway's most popular comedians. Writing her grandfather with the happy news, Tallulah specified that she had signed "an Equity contract" to star opposite Collier. She was floored when, after rehearsing for two days, the stage manager told her she was being dismissed.

Bankhead family spy James Julian got wind of the firing and called Henry Bankhead, Will's younger brother. Henry had served in the army since 1898 and after returning home from World War I was stationed on Governors Island. Together, Julian and Henry Bankhead confronted Tallulah. "She will not tell me the truth about anything," Henry wrote Captain John on January 8. "After Julian had told me the facts that she was not in the play she, in his presence looked me in the eye and said she was rehearsing and she was going to open in it. I can depend on nothing she says. She seems to resent being asked any questions about her work or prospects."

Eugenia had come to New York to visit Tallulah. The more the sisters eluded any parental deputy, the more their fun together was undoubtedly enhanced. "I will keep my eye on the girls was much as I can," Henry wrote his father, "but it is difficult for me to catch them at their hotel."

But Tallulah was finally forced to admit that she had been dismissed. "You don't know how I hated to write you this," Tallulah wrote Captain John soon after. "I wanted to spare you any anxiety and I thought I would wait until I had started in something else—but you kept wanting to know." She told them that Collier, who was then fifty-five, felt that she was too young to play opposite him. This was very likely true, but Tallulah's severance had also mentioned her voice not being strong enough. That angered her. She had deliberately read casually when she heard the way Collier and the other actors were speaking—this, of course, being what most actors do on the first days of a rehearsal period.

Tallulah assured her family that "it is all for the best because it turned out to be a farce instead of a comedy and there is a lot of difference." One wonders whether Tallulah at that tender age shared the traditional prejudice against the crudeness of farce—or was she appealing to a prejudice she knew her family would harbor? Tallulah leavened her news with a slighting reassessment of her role. "The part was very unattractive. The girl had nothing to do but talk, not one good scene, emotional or comedy."

On January 20, Will arrived in New York to attend to business on behalf of the U.S. Shipping Board, and to do his own reconnaissance on Tallulah. He wrote Florence that Tallulah had reserved a room for him at the Algonquin, but the next morning his brother Henry visited him at the hotel and invited him to stay with him "not only to be with him but to save some expense." Will consulted with a Mr. Rhinack, who promised to introduce Tallulah to producer Lee Shubert, and another man, in charge of casting for prominent producer John Golden, who told him that Tallulah was indeed being considered for two roles. These assurances were sufficient for Will to allow Tallulah to remain in New York, and soon she was writing her grandfather again: "I know you were very much disappointed about the play and you did not scold or show your disappointment. Thank you for your kindness. . . ."

"If you can't get what you want take what you can get," Will wrote her. "Idleness around the hotel is not to be desired." It was undoubtedly to placate her family that Tallulah returned to West Somerville to play a supporting role in a play called *The Five Million,* during the week of February 12. Soon after she returned to New York, Aunt Marie came north to visit

her. "Tallulah needs new clothes," Will wrote from Washington. "You go shopping with her. Buy comfortable and durable things. . . . I am delighted that you are with her."

In January, Tallulah had been to see the legendary producer/director David Belasco, and she held out to her family the possibility that an engagement with him might be in the offing. After passing through New York on her way to a vacation in the Midwest, Mrs. Bankhead gently warned Tallulah to expect more intrusions. "If I had not left N.Y. so shortly after you ditched me at the Biltmore, I should have been to see thee. As it was I left to visit out here and did not even have a chance to ring you. In about two weeks I shall be back in N.Y. . . . and shall pounce on you . . . 'cause I am anxious to talk with thee. Your Belasco news is stunning. I think you have at last found the genius to bring out all your best powers. Congratulations!!"

The family was relieved when Tallulah moved out of the Algonquin and in with Henry and his family on Governors Island. But their stresses continued: Captain John had been confined to his bed for a month with the grippe. "I think your heart and your purse both need a rest, Honey," Tallulah wrote him. "I'm afraid I have taxed them both too much." He was expected to recover until he suddenly worsened and died on March 1, 1920, aged seventy-eight.

A portrait of Tallulah hung opposite his bed and he had enjoyed contemplating it during his last days. He had encouraged her theatrical ambitions and she may have been, as Tallulah claimed, his favorite grandchild. But that did not prevent him from seeing her with clarity. Three months before he died, he had described Tallulah to a friend as "a peculiar child . . . self-reliant to a fault, perhaps, and always thinks her plans are best."

After Captain John's death, Tallulah wrote her bereaved grandmother that "when I have done something very big and worth while on the stage I will send for you and we will have a dear little apartment and live together and you can come and see my play. Won't it be nice. . . ."

By April, Tallulah was drawing a salary once more, creating her first speaking role on Broadway. George Tyler, one of the most important producers of the day, had commissioned Zoë Akins to construct *Footloose,* a contemporary revision of *Forget Me Not,* a great melodrama staple of the 1880s and '90s. Before the war, Akins had been a reporter for the magazine *McClure's,* where she became a friend and protégée of Willa Cather, who was then editor. She also wrote modernistic poetry and poetry criticism. With the war, however, she had become a commercial playwright who

consistently devised strong women's roles. Akins and Tallulah's mentor Jobyna Howland were reputedly lovers. Both Howland and Sidney Blackmer, Tallulah's costar in *39 East,* had talked up Tallulah to Akins, who had also seen and been impressed by Tallulah's mimicry at parties of Barrymore's performance in Akins's own *Déclassée.* Fifteen years later, Akins, in her screenplay for the film *Morning Glory,* would use the teenage Tallulah as a model for the character of eccentric aspiring actress Eva Lovelace, played on screen by Katharine Hepburn. Akins knew how to write showy parts for stars, and on Broadway the star system dominated all. Today, when we no longer have any such thing as a star actor who performs primarily onstage, it is intriguing to review the annals of great theatrical stars who are now entirely forgotten. One of the more intriguing is Emily Stevens, who was to play the lead in *Footloose.* She was the niece of another great star, Mrs. Fiske. Stevens had scored a tremendous hit in 1911's *The Unchastened Woman,* as a society vampire who tries to woo a young architect away from his slum-reform ideals and his young wife. In *Footloose* she was again playing a predatory adventuress, who descends upon the home of her dead son's wife and her family. Tallulah was her young daughter-in-law, tear-ridden throughout all three acts of the melodrama. It was a perfect specimen of the "well-made play" that dominated late-nineteenth century theater, in which human life was aggressively manipulated into a regulated grid of revelations, misunderstandings, confrontations.

Tallulah was sick to her stomach on the first day of rehearsals. To her surprise, Stevens told her that she, too, was physically ill not only at rehearsals and opening nights but before every single performance. This depressed Tallulah further. (Stevens, who committed suicide eight years later, at age forty-five, may not have given Tallulah the most balanced representation of theater temperament.) Valuable tips could also be absorbed from noted British actor O.P. Heggie, who directed *Footloose* in addition to costarring as the villain.

On May 7, Tallulah wrote her grandmother thanking her for "your sweet letter and the 'love gifts.'" Mrs. Bankhead was going to spend some time in Jasper. "I am glad for your sake that you are going south," Tallulah wrote. "I think the change will be very good for you and you will be happier. . . . Tomorrow is 'Mothers Day!' your own day, mamma Darling. . . . You are my mother and I love you with all my heart."

"We have been rehearsing night and day," Tallulah informed her. "We open Monday night at the Greenwich Village Theater New York City. I am awfully nervous about it. Say a big prayer for me."

Audiences of 1920 expected a less evident footprint of the author's machinations than *Footloose* supplied. Tallulah claimed that the script had been rushed into production prematurely. Akins had a great deal on her plate at the moment, and had not even finished the second act when they started rehearsals. On May 11, the *Telegram* stated that, "Not even Miss Akins can make 'Footloose' contemporaneous with the present generation, which has known Ibsen and Strindberg and the later Pinero. . . ." But Kenneth MacGowan in the *Globe* cast a jaundiced eye on the relative merits of one era as judged by its successor. "It is still a barren trick play, and the trick happens to be the old and hence obvious, where those of our present crops of trick plays like 'The Sign on the Door' [a yarn of murder and adultery] are still new."

Tallulah's work was praised. The *New York Times* noted that "If there was an individual success scored . . . it went to Tallulah Bankhead. . . . Miss Bankhead plays with considerable power, and sustains a difficult role with real skill."

Will was thrilled at her notices and relieved that she was making some money: "My expenses have been awfully heavy," he wrote on May 20, "and I am *strained* most always, so you must help me by not wasting any of your own money, now that you are making something."

On the same day, Tallulah wrote her grandmother assuring her by implication that she was avoiding midnight suppers at the Algonquin: "When I come all the way back from the Greenwich Village Theatre which is way downtown I am so tired I flop into bed." The Greenwich Village was considered a Broadway house although it stood at the corner of Seventh Avenue South and West Fourth Street. Tallulah's ride downtown on the Sixth Avenue elevated subway gave her a glimpse into tenements bordering the "El." She found it a sobering glimpse at an urban poverty more squalid than her own often pinched existence. But Tallulah remained hungry often enough. In fact, Tyler complained to Akins that the stage manager was up in arms because Tallulah was furtively gobbling food onstage that was reserved for Stevens's character to nibble on.

Tallulah described observing Stevens onstage and off as "an education beyond that I could have gained in a drama school." Many accounts of Tallulah's life and career written since her death chastise her for not attending drama school, and even seem to offer this as an explanation for the later vicissitudes of her career. But Tallulah's decision to forgo formal training was hardly unusual in that day and age. In those days, as Steve Vineberg reports in his study of "Method" acting, "the teaching of acting was still in its

infancy, and still a highly individualized process." When Tallulah said in a 1921 interview that she felt that the stage itself was the best place to acquire technique and experience, she was voicing a belief that was common—while not unanimous—in her day.

Tallulah was in such a hurry to prove herself to her family that acting school may have seemed a gratuitous delay. She could also have been leery of anything that reminded her of her dismal experiences with formal education. But the same vagaries that had plagued her in school afflicted her from her first days on Broadway. Andrews recalled a friend telling her about performing a scene with Tallulah, who had gone on automatic pilot. She was supposed to describe another character's white teeth and curly hair, but instead said that he had white hair and curly *teeth*. No one in the audience laughed. Tallulah delivered the line with absolute conviction, born of what her colleague thought was an equally total obliviousness of the words she was speaking.

An even more disruptive incident occurred not long after *Footloose* opened. Incredibly, she walked out of a matinee during an intermission, thinking that the performance was over. Her understudy finished the performance. Akins issued a dry reprimand: "I hear sometimes that the theatre is bad for a pure young girl; but not half so bad as a pure young girl is for the theatre." Tallulah was chastened by the experience, but recounting the story in her 1952 autobiography, she admitted it was not the last time she had been disoriented by the disciplined repetition of a theatrical run. "I've done that since, removed my make-up and started to leave the theater halfway through a play. Usually this happens after months in the same role, when I've lost all sense of time, of the words I'm speaking, of the act I'm in."

Footloose found an audience, and Tallulah remained with the cast until September, by which time the play had moved uptown to the Little Theatre on West Forty-fourth Street. But she continued to arouse her family's anxiety. "I have waited and waited to hear from you for weeks," Will wrote on June 29, "but not a line from you." Instead he had received a telegram from Henry stating that she needed two hundred dollars to pay her months-old Algonquin arrears. "I don't wish to seem harsh," Will reproached Tallulah, "but there is absolutely no excuse on earth for you treating me with the indifference and neglect you have, and I am deeply hurt and want you to know it. . . . You know that I am always willing to assist you to the very limit of my ability, but what I resent is that you do not take me into your confidence, and really treat me like I was an outsider."

He was upset that she had been forced to take a pay cut—which may have been impressed on the cast to keep the play running through the summer doldrums that set in before theaters were air-conditioned. He had come to see the Algonquin as a fetid den of indolence. "You have been stuffed up in that Algonquin until a change is absolutely essential."

They were pleased when Tallulah sent word that she had moved into an apartment at 685 Madison Avenue with a young woman whose last name was Smith. The Bankheads liked Miss Smith, whom they met when she passed through Washington, Will describing her in a letter to Tallulah he wrote on August 13 as a "very attractive, common sense young woman" who had written Mrs. Bankhead a note which pleased her very much. Will advised Tallulah to do the same, since "you are always *first* in her mind and she wants frequent word from you." He included an admonition she would have done well to heed: "I hope you are not smoking too many cigarettes as they are mighty bad for you, your nerves and looks too. . . ."

Henry had told Will that Tallulah looked pale; Will wanted her to stay with Henry's wife in the upstate New York mountains once *Footloose* closed: "If you haven't enough money let me know and I will scrape some up for you." Or she could come stay with them; as he did most summers, he rented a house in the Washington, D.C., environs. "We would be mighty happy to have my baby girl here, where you could do as you pleased—eat and sleep and read and be *nursed*."

But *Footloose* continued to run and Tallulah was also enjoying the presence of her sister in New York. During her coming out season in Washington, Eugenia had met Morton Hoyt, the dissipated scion of a prominent family. They eloped that very same day. Their families demanded that the marriage be annulled, but later in 1920 they were remarried in a lavish wedding in Bar Harbor, Maine. Tallulah could not attend because of *Footloose,* but the Hoyts moved to Manhattan and were living on Central Park South. Tallulah wrote her grandmother on October 19:

> Sister and Morton are so happy. I see them every day and sister is a very neat and tidy little house wife. She won't let me leave a thing on the floor. You should feel very pleased Mamma dear because it is all from your good influence and training and although we were stubborn kiddies and didn't like picking up our nighties your little scoldings did not go for nothing for we are all profiting by them now and are very thankful to our only little Mamma.

Footloose still had a month to run when Tallulah left in September. Stevens was planning a tour that would begin in November, and perhaps Tallulah still did not want to tour. The management would have wanted her replacement to receive the imprimatur of at least a few weeks on Broadway. Perhaps she had already heard that she had a chance for a role in a much more distinguished property: George Bernard Shaw's *Heartbreak House,* about to be presented by the Theatre Guild. The Guild was then the most prominent rebuke Broadway offered to the profit-driven product that dominated its stages. On a nonprofit basis before a subscription audience, the Guild presented a roster of adventurous new plays, many imported from the art theaters of Europe. It was no less unscrupulous, however, than its more profit-minded brethren. The Guild had an unpleasant habit of letting performers rehearse roles that were already committed to actors not yet available to start work.

Tallulah recounts that she was led to believe she had an excellent shot at the part of Effie Dunn—the meaty role of a young woman by turns idealistic, pragmatic, and disillusioned—in Shaw's slapstick tragedy of civilization at the breaking point. She lit candles at St. Patrick's Cathedral and recited the Stations of the Cross. But after rehearsing for two days she was dismissed. She learned that she had been only a stopgap until Elizabeth Risdon could begin work. Risdon was a Guild regular who had also played Tallulah's sister in *Footloose.* Tallulah's sense of betrayal was so stinging that for years she vowed she would never again work for the Guild, a vow she kept until 1945.

"I'm a Lesbian. What Do You Do?"

"And while blondes are supposed to be fickle and changeable, here is one who knows her own mind—at least knows what she wants in the way of a career, and won't be satisfied until she gets it."

Mrs. Bankhead dressed nattily and loved the finest things. In her dressing room closet were arrayed rows of exquisite shoes that she accessorized with matching silk stockings. Tallulah had inherited her grandmother's tiny feet—a mark of caste for women in the South—and particularly since her grandmother was now wearing mourning could not help asking: "If you have any shoes or stockings that you don't need and it is not too much trouble I wish you would send them to me as I am rather destitute again."

Tallulah's association with Miss Smith seemed to have ended. She was living alternately at the Algonquin or sharing Estelle Winwood's digs at the Great Northern Hotel on West Fifty-seventh Street. "I have missed you so much my dear little mamma," Tallulah wrote, "and I love you better than any one in the world." As always in her letters to Mrs. Bankhead, it is all but impossible to separate Tallulah's genuine emotion from the overkill she deemed necessary to preempt interference by her family. Mrs.

Bankhead's health had begun to fail. "My dear little Mamma is much too charming and wonderful to ever be the least bit ill," Tallulah assured her.

In Tallulah's next play, Rachel Crothers's *Nice People,* she was able to display for the first time her flair for the caustic repartee of high comedy. Tallulah was Hallie Livingston, a young Manhattan playgirl, false friend of the heroine, Theodora Gloucester, who was played by Francine Larrimore, another of Crothers's favorite interpreters. "Teddy" defies her father and takes a late night joyride to the country with her boyfriend, Scotty, where they are stranded by a storm in her country house, but conveniently chaperoned by Billy Wade, a young farmer who happens to be passing by. Billy's values put to shame the butterflies with whom Teddy has been carousing and she elects to give up her spoiled, selfish city ways and remain with Billy in Arcadia.

Hallie Livingston reveals her treachery in a host of pungent lines. In act 1, she tells Teddy that her pearls are "marvelous—simply marvelous. No wonder Scotty wants you." In act 2, Teddy's gang troops out to the country to try to persuade her to marry Scotty and thereby save her good name. Hallie drips with venomous sympathy when Teddy remains adamant. "No matter how ghastly people are to you or how many drop you and cut you completely you just musn't mind. You must be brave." Hallie knows that Teddy and Scotty aren't in love with each other. She knows just what Scotty is made of and what it would take to hook him. "All you need is money to make you perfect," she tells him, vanishing in a cloud of insouciant bravado with the promise to "see you very soon, old man!"

During the first two weeks of January 1921, *Nice People* tried out in Springfield, Massachusetts, and in Baltimore. Then Crothers began to re-cast it, replacing the interpreters of Teddy's father, her aunt, and her fellow playgirl Eileen, who was now portrayed by the up-and-coming Katharine Cornell. The new cast tried out the play again in Providence in mid-February.

On February 12, Tallulah wrote her grandmother that she and Winwood were thinking of renting a furnished apartment on Forty-eighth Street between Fifth and Madison Avenues. One week later, Tallulah's Aunt Louise dropped dead while shopping on a vacation in Miami. The previous five years had been filled with sorrow and disappointment for Louise, some of it generated by Tallulah. A great deal of enmity had developed over the past three years between her and Louise. Writing Mrs. Bankhead on February 28, Tallulah was intent on reassuring her bereaved grandmother about the state of her own health. "I feel awfully well and strong and am keeping

good hours, and no cigarettes so don't worry your sweet self about my health. But take care of your own Mamma Darling. . . ."

Nice People's New York opening was postponed twice because the new Klaw Theatre on Forty-fifth Street remained unfinished. Last-minute preparations precluded (or became a convenient excuse to postpone) a planned visit to Washington. "I have been busy every minute with rehearsals and fitting of clothes for the opening," she wrote her grandmother, "so won't be able to come down this weekend but the very first chance I get I will."

Crothers's work suffered the strain of her concern with women's issues of the day and her equally strong determination to adhere to formulas that determined commercial success. The more highbrow critics were particularly offended that Crothers's Teddy could possibly be outraged that no one in her jaded set believed that she hadn't slept with Billy. Teddy's combination of naïveté and precocity "might have daunted Shakespeare," O. W. Firkins wrote in the *Weekly Review,* but "it has no terrors for Miss Crothers."

Writing in the *Bookman,* S.G.H. declared that "It is a pleasant and mythical world in which Miss Crothers lives and pays her income tax, and she serves a happy public which prefers anything to an artistic truth and finds satisfaction in her service. Standing room only almost any night, of course . . ." The reviewer knew whereof he spoke: *Nice People* immediately took off after opening on March 2 and ran through the fall, after which Larrimore began touring it extensively. It continued to be a favorite of regional theaters throughout the 1920s.

As always, Crothers had cast her play meticulously. "All the assisting parts are well played," wrote *Theatre* magazine. "Tallulah Bankhead deserves much praise for her Hallie Livingston." *Vanity Fair* described her as "too pretty to be suspected of the claws she uses so effectively . . . the despair of her elders and the delight of the audience as the catty little Hallie." Tallulah was emboldened by the attention she received. *Zit's Weekly Newspaper* ran a short profile in which it quoted her as saying, "And while blondes are supposed to be fickle and changeable, here is one," speaking of herself, "who knows her own mind—at least she knows what she wants in the way of a career, and who won't be satisfied until she gets it."

Hallie Livingston was not Tallulah Bankhead, though Tallulah surely took cues from her as she developed her personal style. "I prefer a character part to any other role, if the character is just true to life," Tallulah told a reporter. "I want emotional roles. The eternal ingenue means nothing in

my life. Many actresses never like to give the public the impression that they are anything but sweet young things and they won't accept a role that doesn't show them to advantage. I don't mind playing the role of a cat if I can just convince the public for the duration of the play that I am a cat." In her mind, the boundaries were as yet distinct. "I want always to play my role, not play Me," Tallulah explained. "When people meet me offstage and seem surprised that I don't say sarcastic things to everyone every other sentence, I always feel flattered and happy, for I feel that I am really successful in creating a character."

But Tallulah was intent on becoming notorious; she had started in motion the construction of a persona that she could hardly have realized would swiftly imprison her. Rather than hide her sexual iconoclasm, she began incorporating it into her social pleasantries. "Hello, my name is Tallulah Bankhead," she told a guest at writer Heywood Hale Broun's apartment. "I'm a lesbian. What do you do?" In part because of her own palaver, *Broadway Brevities,* a slick-papered monthly that chronicled New York's amusements, was able with impunity now to make repeated references to Tallulah's alleged lesbian romances. Tallulah, Winwood, Le Gallienne, and Blythe Daly—a young actress who was the very social daughter of theater star Arnold Daly—were termed the "Four Horsewomen of the Algonquin," a gloss on Rudolph Valentino's film *The Four Horsemen of the Apocalypse.*

Winwood, however, was neither gay nor bisexual. She lived to age 101 and indulged in many things but rarely to the point of excess. And she was certainly discreet; Tallulah's lack of circumspection alarmed her from the first. "Dear girl," Winwood warned her, "you go too far, you go too far."

During *Nice People*'s run, Crothers made Tallulah Larrimore's understudy for the lead role. After Larrimore came down with a bad case of flu, Tallulah spent several weeks rehearsing Larrimore's part by day but not knowing which part she was going to play at night. Larrimore's condition was erratic and Tallulah couldn't be sure until she arrived for the performance. "I have been a nervous wreck," she wrote her grandmother.

During the summer, Tallulah shared a brownstone apartment next to Carnegie Hall with Beth Martin, an aspiring actress who was the daughter of opera singer Ricardo Martin. Her parents were divorced and she lived with her mother at the time, but her mother was traveling in Europe.

Before giving her permission to come to New York, Will had made Tallulah promise to abstain completely from alcohol, which she says in her autobiography was motivated by fear that his own problems with alcohol "might be hereditary." However, when Beth Martin brought home some

port one evening for them to try, both she and Tallulah got violently drunk. They suffered hangovers the next day, and after that, Tallulah was more resolute than ever about staying away from liquor. But true to her determination to feign worldliness, at parties she instead asked for cocaine, at that point a particularly fashionable drug. Eventually her bluff was called, and she was given some, and thus forced to fumble her way through a self-initiation in sniffing the drug. At another penthouse party, she again asked for cocaine but was given heroin, which made her throw up in the cab on the way home to Beth Martin's apartment. She was forced to miss two performances of *Nice People*. Tallulah told the management that she had come down with food poisoning.

Such is Tallulah's account of what she describes as the sum total of her drug use in New York, but Winwood later said to Denis Brian, author of 1972's *Tallulah, Darling*, "Don't believe a word Tallulah says about it. . . . She was taking cocaine like mad at one time." Cocaine supplies a feeling of invincibility that would have allayed the considerable anxieties that lay underneath Tallulah's seemingly assured, decidedly aggressive, and sometimes extraordinarily risky social behavior. She continued to use cocaine all her adult life.

It was through Beth Martin that Tallulah met the Honorable Napier Alington—called "Naps" by his friends—the man she frequently described in later years as the love of her life. Martin was acquainted with Jeffrey Homsdale, later the Earl of Amherst, who was writing a theatrical column for the *Morning World*. Homsdale had come to New York with his lover Noël Coward, who was several years away from his breakthrough success with the play *The Vortex* and was having miserable luck trying to peddle his scripts to New York producers.

One night Homsdale phoned Alington from Beth Martin's apartment and invited him over. Ever on the prowl, Alington raced uptown in a cab, a bottle of gin in the pocket of the coat he'd thrown over his pajamas. Alington tried to get Tallulah into bed and she declined reluctantly. Within a week, she claimed, he had asked her to marry him, a proposal she regarded as nothing more than a gambit by a practiced seducer. Tallulah had resolved that marriage would wait until she had made her mark in the theater. But nevertheless she was infatuated. She had a decided fondness for British men; Tallulah recalled decades later that before going to England she'd known "quite a few of the boys at the British Embassy" in New York.

Twenty-five years old, Alington was the son of Feodorowna Yorke, daughter of the sixth Earl of Hardwicke, and of Sir Humphrey Napier Sturt

Alington. The Alingtons' London home at 38 Portland Square was "the hub of the big wheel of Edwardian fashion," according to Sonia Keppel's memoir, *Edwardian Daughter*. Alington's father was friends with King Edward and shared the favors of the monarch's mistress, Mrs. Gertrude Keppel, who was Sonia's mother. The Alingtons also spent time in the country at Crichel, their enormous estate in Dorset, where Lady Alington kept a private dairy. Lord Alington also owned substantial tracts of East End London slums, where once a year he was burned in effigy by his tenants.

The Alingtons had lost a boy and girl in infancy; Napier's brother Gerald Philip Montague had died in 1918 at age twenty-five of wounds suffered during World War I. Alington could have served but did not, because he was tubercular. He had been sent to New York by his family to study banking, but preferred to devote his energies to extracting as much pleasure as he could out of the city's high and low life. He had stayed first with Mrs. Cornelius Vanderbilt on Fifth Avenue, but soon found a Greenwich Village apartment more compatible.

Alington was tall, the way Tallulah inevitably preferred her men, and had a face that suggested androgynous fragility and a faunlike sensuality. He was intelligent, witty, aesthetically informed. His voice always seemed to be harboring a chuckle; his charm was legendary.

Tallulah's affair with Alington coincided with her first starring role on Broadway. Rachel Crothers had allowed Katharine Cornell to leave *Nice People* so that she could play the lead in *A Bill of Divorcement,* with which she began four decades of Broadway stardom. The playwright likewise allowed Tallulah to leave before the run had ended because she, too, had another job; in this case, a new play entitled *Everyday* that Crothers had written especially for her. Tallulah took a week's rest before starting to work on the role of Phyllis Nolan, another Crothers heroine who turns her back on the crass and the superficial. Asked by a reporter whether she missed having her own children, Crothers replied, "I feel that they are all my daughters, all these girls. I am a universal mother. I love them all and love to study them. I think that the younger generation is the greatest marvel of the world."

Crothers joined a chorus of homegrown voices skewering American corruption, American provincialism. Sinclair Lewis's *Main Street* had appeared one year earlier, and reviewing *Everyday,* the *Baltimore News* opined that the theme of "the eternal Main Street . . . seems in a fair way to displace the eternal triangle in our dramatic literature." In *Everyday,* Phyllis Nolan returns from a yearlong tour of Europe to find herself disenchanted

with her small hometown in the Midwest. Her father, a judge, has selected a husband for her. The prospective husband, however, is indicted for profiteering and conspiracy, while Phyllis runs off with John McFarlane, her father's private secretary, an aspiring artist whose background is humble. The Baltimore critic did not believe that Phyllis Nolan's future happiness was at all assured, however. "For the thing which our Main Street writers really object to is not merely the stupidity of a small town but the stupidity of life itself, which is much harder to get away from."

Again, Crothers's casting was blue chip: Henry Hull was McFarlane, while so distinguished an actress as Lucille Watson was on hand to play the supporting role of a friend of the Nolan family whose dance-mad, stock-market-speculating children epitomize postwar materialism.

After trying out in Atlantic City, Baltimore, and Washington, *Everyday* opened at the Bijou Theatre on November 16, 1921. In the *American,* Alan Dale wrote that "Miss Crothers is usually freighted with a message to humanity," and in *Everyday* she had gone "hot and heavy after ideals." Opinion was divided about whether she had been able to incorporate her message into a coherent dramatic resolution. But the critics liked Tallulah: the *Christian Science Monitor* noted that "Miss Bankhead's ability to appear like a being from a plane loftier than the littleness of the Nolans made her an ideal choice for the Phyllis role."

"Miss Bankhead looks ravishing," *Variety*'s "Lait" attested, "and has a dramatic quiver in her larynx that should be worth a fortune in a reasonable play." Indeed Tallulah would parlay her particular throb with great effectiveness over the course of her career, but like everything else about Tallulah's acting, it was controversial. Senior critic John Ranken Towse of the *Morning Post* didn't think she was wielding it effectively: he described her as giving "an altogether sincere and sympathetic portrayal of the part, though at times a vocal catch marred her diction."

Tallulah and Alington were spending a great deal of time together: they danced into the early morning at Reisenweber's, a palatial nightclub on Columbus Circle, and brunched at the Brevoort Hotel on lower Fifth Avenue. Tallulah was so smitten that once again her professionalism was compromised. Alington was not political, but was in many ways a conventional product of his class; he "had great respect and affection for the Royal Family," Tallulah notes. The script of *Everyday* required Tallulah's Phyllis Nolan to answer a question about her tour of Europe by saying, "Oh, well, kings and queens are really kind of a joke. The most interesting person I met was a prostitute." Tallulah was afraid that Alington might be offended

should he be in the audience. She kept leaving out the line until her job was in jeopardy. But *Everyday* closed before matters could come to a head, after a run of only thirty performances. One can only wonder whether Tallulah would actually have relinquished a job rather than risk a possible slight to him.

Tallulah's first shot at stardom might have taught her a bitter truth about the theater. While there was nothing obscure or experimental about *Everyday*, it was a more substantial play than *Nice People,* treating with greater honesty conflicts of parent and child, old and new, provincialism and sophistication, material and spiritual. But *Nice People* flourished while *Everyday* closed after three weeks. Perhaps the ambivalent ending was off-putting to audiences, but there may simply have been no logical explanation for the play's premature demise. As much as failure, success in the entertainment world is often arbitrary, and over the course of her career Tallulah would give some of her best performances in plays that failed.

Her disappointment over the play was compounded by the fact that not long after *Everyday* closed, Alington went back to England, leaving Tallulah "devastated," she writes in *Tallulah.* "Memories of our hours together haunted me." She joined the cast of the play *Danger,* written by Cosmo Hamilton, which had opened in December. Tallulah succeeded Marie Goff in the role of an ambitious British woman who marries a brilliant lawyer. She tells him on their honeymoon night that she has no time for sex but is interested only in fostering his career and basking in reflected glory. She reconsiders only when he takes up with his secretary, who offers herself "as a substitute outlet for his pent-up emotions," as one critic declared, and proceeds to lives in sin.

In *Danger,* Ruth Hammond had a comic role as a Cockney maid. Hammond had already seen one of Tallulah's silents. "There's someone!" she thought to herself when Tallulah appeared on the screen. H. B. Warner, a leading man in silent films, was returning to the stage after two years' absence, and he directed *Danger* as well. Tallulah would "listen if he had anything to tell her," Hammond recalled in 1991, "but she knew as much about acting as he did, knew about that character, anyway." Yet although Tallulah played the part "awfully well," Hammond felt that she was miscast: she was too young, and "I couldn't envision her being the frigid wife in real life; I couldn't imagine that at all!"

Tallulah went into the part on January 23, 1922, and played it for the remaining four weeks of its run. In April, she began rehearsing for a starring

role in a new comedy, *Her Temporary Husband*. As the play was due to begin tryouts in Connecticut on May 9, Mrs. Bankhead was failing rapidly. On Saturday, May 6, Tallulah cabled her grandmother that she would soon be coming down for the weekend, but according to a newspaper report, she went to visit her in Washington the very next day, before traveling to Stamford. Mrs. Bankhead died four days later at the age of seventy-eight. Tallulah had apparently neglected to let her family know her itinerary before she left Washington, and so the Bankheads were forced to contact Estelle Winwood in New York and ask for Tallulah's address on tour so that they could notify her. Mrs. Bankhead's remains were taken to Jasper for burial next to her husband.

Tallulah's love for her grandparents informed her lifelong solicitude for and sensitivity to the feelings of the elderly. She would flout much of what her grandmother had taught her, but Mrs. Bankhead's Southern belief in decorum would remain a lasting standard for Tallulah—one that she would criticize herself for not upholding.

Tallulah's run with *Her Temporary Husband* was brief, and the cause for this brevity mysterious. The play was originally scheduled to open on Broadway on May 22, but didn't arrive until August. Many Manhattan theaters closed during the summer, and it was not uncommon for plays to open on the road in June, then heed their reviews and close for the summer to repair and revise before a fall opening on Broadway. When *Her Temporary Husband* opened on Broadway it was not Tallulah but instead her friend Ann Andrews who played the lead. Tallulah may have reconsidered her involvement in the play, or the producers may have reconsidered her.

Tallulah found solace in work and activity. In June she spent two weeks in Baltimore with a stock company, the George Marshall Players. She acted in two tried-and-true farces, one from Broadway, Claire Kummer's *Good Gracious, Annabelle,* and one from Paris via Broadway, Sasha Guitry's *Sleeping Partners.* "Her eyes alone were worth the price of admission," the *Baltimore News* wrote about her appearance in the Kummer play. The good impression she made in the city lingered, for in November, she went down there again to perform with a bevy of major stars at an Actors' Fund benefit.

In July, she began rehearsing for a new play by Martin Brown, a former actor and hoofer who had become a successful playwright. In *The Exciters,* Tallulah played one of her most interesting roles: Rufus Rand, a reckless daughter of privilege, president of a society of thrill-hungry young women

whose identification badge is a gun tucked into the garter belt. *The Exciters* mixed drawing-room comedy with knockabout crime adventure, a fusion that was found problematic by some critics and perhaps by audiences as well. But it is this blend that makes it interesting reading today. The play opens as Rufus is preparing to go out with her parents, her fellow Exciter Ermintrude, and her cousin Lexington. Rufus is not excited about her impending marriage to a dullard she's known all her life.

After they're gone, the maid, Vaughan, admits a burglar who calls himself "Five minute Dan McGee." She has recruited him for a heist of Mrs. Rand's pearls. Vaughan is in love with him and doesn't suspect that he is really a detective. The family returns unexpectedly. Rufus has crashed her car and is in critical condition. Her uncle's will left Rufus $2 million, to be paid to her on the day she marries a man of whom her father entirely approves. But if Rufus dies single, the money reverts to an unnamed political party. Rufus and her family believe she is fatally injured, and to save the overextended finances of the Rand clan the half-delirious Rufus complies readily when Dan comes out of hiding and offers to marry her, provided he and Vaughan are allowed to escape prosecution.

But Rufus recovers, and before she will go through with the divorce her parents are urging on her, she demands to have the chance to converse consciously with her husband. When he is summoned, she implores him to go straight, and follows him to the headquarters of Vaughan's gang, a bureau that sells crime ideas to would-be crooks. When Vaughan realizes that Rufus and Dan are mightily attracted to each other, she tries to frame them with her and Dan's crime bosses. Dan decides to blow his cover and battles his way out, with Rufus's assistance.

Tallulah's role gave her a very wide diapason. She was cheeky—"You look like a human rummage sale," she tells Lexington, when they are both on the mend from the car accident. She was earnest when pleading with Dan to shake his thieving ways, and heroic when trapped with him in the gangsters' lair. There was a provocative moment when Tallulah as Rufus pulled up her skirt and Dan stealthily plucked the revolver tucked into her garter belt. There was also what must have been a very entertaining exchange when Rufus devolves into street slang to fool the ruffians.

When Rufus learns that Dan is really good, the thrill is suddenly gone; Brown traded on an ancient conceit memorably exploited by Sheridan in *The Rivals* of 1775. "I've never been so disappointed since the day I was born." She is all for going back to her fiancé, but he has now decided she is too hot to handle. But Dan returns through Rufus's window in full bandit

disguise, tears off his mask, and without having to exercise too much persuasion, is about to exercise his conjugal rights as the curtain falls.

The Exciters opened in Atlantic City on August 20, then moved on to Washington, where one critic remarked that Tallulah, "with deftness and remarkable skill," had given Rufus "an engaging touch of reality . . . fascinating even though it were a bit Freudian in tone." The edge of conflict or neurosis would have been altogether appropriate. What made Rufus a provocative heroine was her evident motivation by forbidden stirrings she simply cannot repress.

Tallulah had made impressive strides since arriving in New York five years earlier, devoid of any professional experience. To the theatrical public at large, she was a promising actress who had sparked the interest of some of the leading playwrights and producers on Broadway. To insiders in the theater community, she was also a dashing character whose pranks and didoes provided amused chat for those in the know. She had already assembled around her something of a cult following that encompassed theatrical and nontheatrical constituencies. When The Exciters opened at the Times Square Theatre on September 22, Blythe Daly rushed at the Globe's S. Jay Kaufman and, "putting her two hands firmly on our necktie, said: 'If you don't say she is great I'll kill you!'" Daly was one of many partisans who were in the opening-night audience. Alan Dale wrote in the American:

> It seemed a pity that Tallulah Bankhead had a lot of silly friends in the theatre who gave her an ovation before she had done a thing, because she really did a great deal. She was charming. She was beautifully dictioned. She had a fine sense of comedy. She had chic, allure, and dominancy. But she had been too much applauded before the play had started. A real case of "Save me from my friends."

Whatever the composition of the audience, Tallulah was always fearsomely nervous on opening nights. A Tribune reporter—probably Bertie Rascoe, the paper's "sophomoric Young Intellectual" and a friend of Tallulah's—went backstage "to see if Miss Bankhead would deliver a few of the bon mots for which she is famed. . . . We have seen many stars after a first night, but never have we seen one who reacted in this strange fashion." Whereas onstage Tallulah had been "nonchalant and insolent or brilliant or haughty, but always complete mistress of herself and the situation," now she was wandering about her dressing room as if she were sleepwalking. "Was I terrible?" she kept repeating, and then burst into tears.

The Exciters certainly spun a racy, topical story, and Hollywood immediately recognized its possibilities; the next year it reached the screen, starring Bebe Daniels in Tallulah's role. But it lasted only a month on Broadway. Once again, Tallulah learned the unpredictability of theatrical fortune. "'The Exciters' closed last night," the *Tribune* reported on October 22. "It had been strongly touted as a hit before reaching Broadway, which proves once more that you never can tell. . . ."

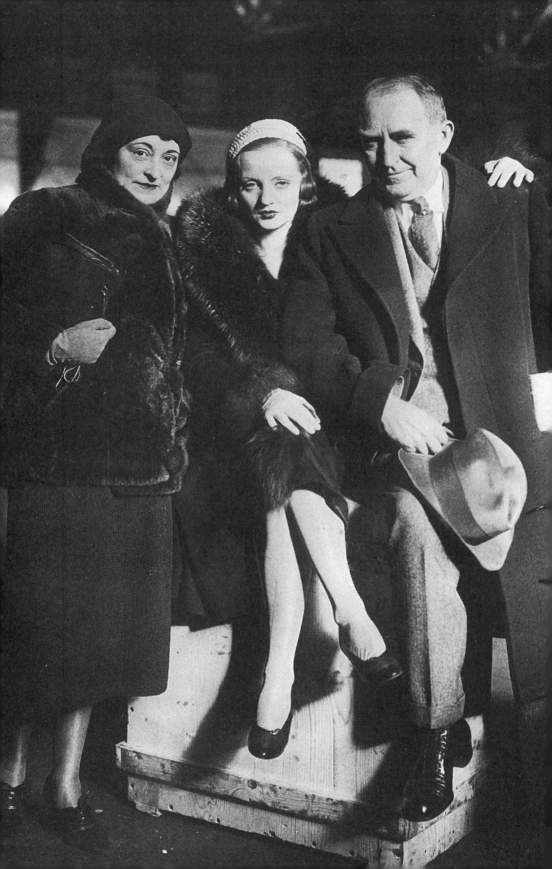

Madcaps in London

"I thought I was going to Mars . . ."

At one of Frank Crowinshield's parties in the fall of 1922, Estelle Winwood introduced Tallulah to British impresario Charles Cochran. Every year Cochran visited New York, scouting for properties to import. Suitably impressed, he considered presenting Tallulah in London as either the waif in *Seventh Heaven* or the streetwalker waif in *Rain,* two enormous hits that had recently opened in New York. But he discovered that the rights to both plays were already spoken for. He left New York promising to keep an eye out for a suitable showcase; with him went a photo by Ira Hill, court photographer for the *Follies,* in which Tallulah gazed through a pictorialist mist.

In December, Tallulah received a telegram; a letter followed soon after. On Cochran's recommendation she had been offered the lead in *The Dancers,* a new play starring Sir Gerald du Maurier, England's preeminent actor/director. Several weeks later, after Tallulah had made all arrangements and told everyone in her world, another telegram came: du Maurier had changed his plans. An actress named Dorothy Dix had been engaged. "They were frightened of taking a chance on me," Tallulah later recalled.

Tallulah with her father and stepmother.

She dared not admit to many in her success-conscious crowd that she'd been rejected sight unseen. But as always, she consulted Winwood. "You never got this telegram," she instructed Tallulah. She advised Tallulah to report to work as planned. Either she would be reinstated, Winwood reasoned, or another opportunity would present itself.

Even on Winwood's counsel, Tallulah might not have considered so risky a move had she not recently seen famed astrologer Evangeline Adams, J. P. Morgan's trusted sibyl. Adams advised her that her future lay across the Atlantic: "Go if you have to swim." But it was the prospect of seeing Napier Alington again—he had not written her once in the months since he'd returned home—that Tallulah admitted was her secret reason for being hell-bent on getting to England.

Tallulah had told her father that all expenses had been guaranteed, as indeed they had been when Cochran's offer was first made. Gingerly, she approached General T. Coleman du Pont, her grandfather's former colleague in the Senate, "a wise old man who loved the theater." She hemmed and hawed until du Pont told her to jot down the amount she wanted. In turn, he would write the amount he thought she *should* ask. Her bid was $1,000, his $1,500: du Pont chose not to raise her figure.

I'M COMING ANYWAY, Tallulah wired Cochran. Cochran volleyed back a plea for her not to come, citing that postwar inflation had brought a slump in theater production: IT'S TOO MUCH OF A RISK. I DON'T WANT TO BE RESPONSIBLE FOR YOU TAKING THE CHANCE. Resistance, as always, only steeled Tallulah's resolve. She booked passage on the next available ship.

Will came up to New York because she wasn't of age to get her passport. She must have leveled with him somewhat, because in a letter to his sister Marie, he shared his belief that Tallulah's expenses had been guaranteed, but wrote that she had no more than "a fair chance of being engaged" by du Maurier. "She had gotten somewhat 'fed up' in New York," Will wrote Marie, "and some of the disappointments she had met—and I thought it only fair to give her this extra chance. If her expectations do not materialize, she will at least have had the *sight* of England, etc."

Colonel du Pont saw to it that Tallulah left on January 6 in high style. He hosted a dinner the night of her departure in his suite at the old Waldorf-Astoria. Will was there, and General Pershing, who had commanded the American expeditionary force in World War I. From the Waldorf, at Fifth Avenue and Thirty-fourth Street, du Pont's chauffeur drove them west to the Hudson River piers where the S.S. *Majestic* would set sail at midnight. A delegation of theater friends came to the pier to cheer her

off. The *New York Herald* noted that "Tallulah Bankhead sailed for London yesterday, though her plans concerning just what she will do in London are rather indefinite."

"I thought I was going to Mars; I was scared to death," Tallulah recalled in 1963. Crossing the Atlantic, she soothed her qualms by throwing herself around the ballroom floor until, danced into euphoria, she wired Cochran again that she was on her way. She was a few weeks shy of her twenty-first birthday when the *Majestic* steamed into Southampton. She had reckoned without the vigilance of British immigration officials, and her answers to their reconnaissance efforts bore out her customary belief that disinformation was the best policy. "At first she explained that her father was one of the American House of Representatives and had given her money to come over and see England, that she had no occupation, did not know how long she would stay or where," the chief immigration office vouchsafed in a report dated January 13, 1923. When he asked her whether she was chaperoned or had any friends either in England or on the ship, she called over an Oxford undergrad she had met on the way over. Tallulah's cavalier "made a great fuss about Miss Bankhead being interrogated and threatened to report the matter." Finally she divulged that she was trying to find work with Cochran and would be lodged temporarily at the Ritz. The officer later questioned a steward on the ship who "divulged certain details which confirmed my suspicion that she was not traveling on a liner for the first time and made male friends very quickly." Tallulah was told to register the next day at London's central police station.

From Southampton, Tallulah took a train to Paddington Station in London, where Cochran met her and drove her to the Ritz Hotel. The first-class room she took was way beyond her means, but the Ritz's gilt and pastel lobby, and the luxurious dining room overlooking Green Park, provided an appropriate backdrop for her conquering mission.

There was no time to waste, for *The Dancers* had already begun rehearsals. Cochran took her to a matinee of *Bulldog Drummond,* the play du Maurier was just wrapping up. During the intermission Cochran brought her backstage.

"Well, I'm here," Tallulah told her would-be leading man.

Du Maurier was polite but unrepentant. Cochran, however, "was a showman with a gambling urge," Tallulah writes in *Tallulah.* "He looked upon my rejection as a personal defeat." The intrepid impresario decided another meeting with du Maurier must be arranged. This occurred after an evening performance, giving Tallulah a chance to don the one evening

gown she owned and to let down her hair, which had been hidden under a hat the prior day. The tawny tresses of a flapper Rapunzel cascaded down Tallulah's back; du Maurier was entranced. His daughter, future novelist Daphne, was visiting her father backstage. After a long chat, Tallulah and Cochran sailed out. Teenage Daphne turned to her father and reportedly said, "Daddy, that's the most beautiful girl I've ever seen in my life."

But Tallulah still had no job. Back at the Ritz the next day, she began a letter to Winwood. "Dear Estelle, I wish to tell you I'm here at the Ritz, and I've got sixty dollars left. I don't know whether to commit suicide . . . Wait a minute. The telephone's just rung." It was Viola Tree, coauthor with du Maurier of *The Dancers,* calling to say that a contract was waiting on du Maurier's desk.

In 1982, sixty years after the play's final curtain, eighty-nine-year-old Una Venning sat in a suburban living room cluttered with knickknacks and poured out vivid recollections of *The Dancers,* in which she had acted with du Maurier, Tallulah, and Audry Carten. Carten played the third lead and would be one of Tallulah's closest friends all through her London years.

Venning and the cast knew only that actress Dorothy Dix had been rehearsing Tallulah's part and then one day Dorothy wasn't there. Work had been canceled that day and the next. The following morning they were summoned back to the theater without a clue about what was happening.

At the head of a short stairway leading from the dressing rooms to the stage appeared Tommy Lovell, du Maurier's stage manager. With him was a young woman, dressed in a plain navy blue reefer coat. There was a slant to her matching beret, which covered all but a few vagrant locks of gold roguish hair.

"Ladies and gentlemen," Lovell intoned, "this is Miss Tall-u-lah Bankhead."

"I can't tell you what a sensation it made," Venning said with a laugh. No one had heard of her, but Tallulah's name—that honeyed tripwire of syllables—was "unbelievable."

The cast was later told a spurious story that du Maurier, displeased with Dix, had fired off an SOS to Cochran. Cochran had alerted him to a beautiful young American actress allegedly in Paris. Dix, however, "certainly wasn't bad," Venning told me. "She wasn't a tepid actress at all. Tallu was a million times better, but we didn't know we were going to have anything like *that!*"

Perhaps du Maurier told Tallulah that Dorothy Dix hadn't come up to par; probably, however, Tallulah really believed that she had usurped a

British actress on her home ground. But that morning she faced what must have seemed like a tribunal—a circle of strangers, some of them distinguished veterans in British theater's chummy conclave, while she was an outsider, an unknown, and a foreigner.

"Howdy!" Tallulah saluted the cast. Her robust Americanism disarmed them, but not as much as what followed. "On my sacred word of honor," the still incredulous Venning recalled, Tallulah asked, *"Now, where do I go to spend a penny?"*—British slang for "go to the bathroom." "This was something that was *never* said in front of men," Venning insisted. "Today, of course, you'd go in with them! The cast was horrified, let me tell you."

"Will you meet the cast first?" Lovell asked Tallulah while a few nervous titters escaped from the actors.

"Yes, please," she said, and went around shaking hands.

Dorothy Dickson, Tallulah's friend from the Algonquin, was in London, too, starring in the British production of Ziegfeld's *Sally.* Tallulah contacted Dickson immediately after learning that *The Dancers* was finally hers. Dickson invited her to breakfast at her home on Chesterfield Street in Mayfair, London's ancient aristocratic stronghold.

"She was really beginning life again," Dickson said. Tallulah had several letters of introduction to important people in the British theater firmament, but she knew no one in the city apart from Dickson, with whom she shared her considerable anxiety. Yet as they talked, Dickson thought how well Tallulah looked. The misbegotten Mary Pickford curls were gone. Tallulah had returned to her natural wave. Gone, too, was the vampish makeup she'd affected at the Algonquin. Now and for the rest of her life, Tallulah trusted her bone structure and offstage usually wore very little makeup besides lipstick. "She had found her type, her look," recalled Dickson.

"It is the ambition of every young actress to be with Sir Gerald," Cochran had written Tallulah in New York. At fifty, du Maurier was virtually the leader of the British theater profession. He was the forerunner of a long succession of English "actor/managers" who, perpetuating a tradition dating back at least to the commedia dell'arte troupes of the 1500s, dominated British theater throughout the Victorian era and well into the 1920s. Actor/managers built, bought, or rented their own theaters. They produced and directed the plays in which they starred and stamped their ensembles with their own acting style. Du Maurier had commandeered Wyndham's Theatre in 1910 and had kept it humming since that time, aided by coproducer Frank Curzon and business manager Tommy Vaughan.

"Women adored him," Venning recalled, "and rushed madly to see

him" despite, or because, du Maurier was far from the conventional leading man. His face was strange and gaunt, sloping down from large blue eyes to a blunt nose, knobby chin, lips one might call stealthy. "A fascinating face," recalled Venning, "albeit *no* pretensions to good looks. And a lithe, lovely body."

Du Maurier was the son of one of the fin de siècle's great celebrities, novelist and cartoonist George du Maurier. But it had taken du Maurier ten years onstage to become a star, when in 1906 he took on the role of Raffles in the play of the same name written by E. W. Hornung and Eugene Presby. Raffles had been the hero of a series of enormously popular detective yarns written by Hornung. He was a social pillar who also happened to be a safecracker. Since that time, du Maurier continued to draw London in tailor-made plays that touched on subversive glints underneath an impeccable facade. Du Maurier left a handful of films made in the last few years before his death in 1934; although by then somewhat battered, his charm and authority are inimitable.

The Dancers was a sophisticated melodrama revisiting the "social" and "problem" plays that Ibsen and Shaw had introduced at the turn of the century. Rather than trust-busting or venereal disease or women's rights, *The Dancers* concerned the furor over dancing, more particularly, women's dancing, and their losing control and being uncontrollable—a controversy that could be traced back to ancient Greece and the maenads. Just before World War I it flared up again, with the advent of ragtime and the inauguration of afternoon tea dances, where young matrons often went to shop for gigolos moonlighting as dancing partners. The hue and cry had been tamped down in New York by the eminently married couple Irene and Vernon Castle, the leading ballroom dance team of the era. They preached the respectability of the new dance; they lived it. They extolled the new steps as good for the health. To prove it they opened Castle House in Manhattan, a strictly chaperoned dance salon for the children of high society.

Now, after the war, the blare and din of jazz and its dances were under fire. Oddly enough, these were less suggestive than the turkey trot and bunny hug of the war years. Partners were no longer clinched together in closed holds, but these new dances were just as controversial in their frenzied gyrations and the spell they cast over the war-ravaged upper crust. In 1991, Frances Donaldson recalled those days, when her father, Frederick Lonsdale, had been one of London's foremost comic playwrights. Lon-

don's beau monde "shuffled around the floors from teatime until dawn," Donaldson writes, "returning to their homes as the water carts cleaned the streets."

The Dancers offered arguments pro and con. Flanking du Maurier were two different dancers: Acts 1 and 4 told the tale of Maxine Hoff, a cabaret dancer who was in Venning's words "the haphazardly easy-going, wild kind of girl." This was Tallulah's role. Acts 2 and 3 concerned "Una Lowry," a child of high society who frequented private parties and the ballrooms of respectable hotels. But it was this society girl, played by Audry Carten, who would come to grief. Maxine, in contrast, was unlettered, without pedigree, but was able to use dance to pilot her to love, fame, and social eminence.

Maxine was sustained by a duality that Tallulah would make her own. She was a saloon dancer who realized herself through a free heeding of the appetites. Yet her affections were "not easily-won" as *The Stage* would later observe. Though Maxine was "somewhat of a siren," as Cochran had written Tallulah, "she must be a lady."

"That first day Tallulah was only reading the script casually, of course," Venning recalled. "The next day we had a more serious rehearsal and she was immediately doing things with the part. She seemed much more at home, and very eager. Apparently she was wildly excited about coming to London. And Gerald was obviously bewitched. He thought this was just the goods."

Directing her, du Maurier was able to impose a little fine tuning on Tallulah's exuberance. The keynote of du Maurier's own acting was his understatement; his films reveal a near-Kabuki-like economy of gesture and emotion. "She picked up everything Gerald said at once," Venning recalled. "She never had to try and do it wrong and try again. Tallu was what we call a natural."

Du Maurier inspired not only additional control but additional release: both resources equally essential to an actor's technique. Tallulah recalled in 1928: "Although naturally temperamental I used to feel almost awkward when playing emotional parts which called for tears." She found it a great comfort when she discovered that du Maurier "always wept—real tears, even at rehearsal. As we had to cry a good deal, we two together flooded the theater every night!"

But the cast had no inkling of reticence on Tallulah's part as they watched their newest member get the feel of her scenes and sketch the

dances she would perform. Indeed they were riveted by her apparent and very un-British lack of inhibition. In the cast was Nigel Bruce, one of the day's leading actors, who later enjoyed a long career in Hollywood. Bruce felt a bit rattled by Dix's departure: he fretted that it was not a good sign for the success of the new play. But his worries about the fate of *The Dancers* were soon allayed.

"Well," he observed to Venning, "we *have* got a pebble on the beach, haven't we?"

By now she was "Tallu" to almost everyone in the cast, and she and Audry Carten had become boon companions. When Carten was offered the second star dressing room, a small but private room, she asked that it be given to Tallulah. Needless to say, Tallulah accepted. Carten, Venning, and bit player Doris Cooper (sister to West End star Gladys Cooper) shared the larger room next door. "But we were in and out of each other's rooms all the time," Venning remembered.

In *Gerald,* Daphne du Maurier's biography of her father, she writes that "The pathetic, attractive, and strangely bewildered post-war product" that Carten played in *The Dancers* was "more or less built upon herself." Like Tallulah, Carten suffered the early death of her mother and the neglect of a distant father. He had left Carten and three siblings in the care of a nanny, and eventually remarried. He was wealthy, but when it came to money, as with his attention, no more than a trickle was given to his children.

When Audry had arrived at Wyndham's in 1920, Venning was already there, having been a consistent feature of du Maurier's casts since 1914. Venning watched Carten gain attention for a series of minor parts in successive du Maurier runs. Ten years older than Audry, Venning had come to love her like a tormented daughter or a younger sister who was plagued by doubt, stage fright, insomnia. When sleep eluded Carten, Venning was willing to drive with her thirty miles outside London into the countryside. Together they'd picnic under the stars, and then, in the wee hours, turn Audry's car home again.

The Dancers had been written to boost Audry to stardom. Du Maurier had sketched it out, but Viola Tree had done most of the actual writing, with Audry "very much in mind." Well before the play opened, Tree had taken Tallulah under her wing as well, and no mentor's plumage could have been more resplendent. Then in her late thirties, Viola was the eldest of Sir Herbert Beerbohm Tree's three daughters. He had been the Edwardians' greatest actor/manager. Author and actress, Viola was "weird beyond words," recalled Venning, who was frequently baffled by Tree's cryptic

asides and her airy oblivion where the rest of the world was concerned. "But Viola had a wonderful nature in many, many ways, and she was a great artist, a very cultured artist, an intellectual." Tree made several brief but unforgettable appearances in film in the years before her death in 1938, proving her persona to be every bit as singular as Venning had described.

Tree was married to drama critic Alan Parsons. "Hubert Parsons" was the pseudonym picked to shield Tree and du Maurier's joint authorship of *The Dancers,* a slyly joined amalgam of Viola Tree's married name with a variant of her father's first name.

Daphne would later regret that her father never again collaborated with Tree. She saluted the polyphony wrought by two complementary sensibilities: "Gerald with his sense of drama, Viola with her sense of culture; Gerald with his eye for effect, Viola with her literary restraint; Gerald with his flair for public taste, Viola with her intellectual grasp of what is good and what is bad in art."

Tree shepherded Tallulah around her special isthmus of stage and society almost from the first day's rehearsal. Years later, the great Edwardian star Mrs. Patrick Campbell recalled to a friend of Tallulah's dining one night at Ciro's before *The Dancers* had opened. Ciro's was a soigné supper club entered by way of a balcony with a sprinkling of tables. Stairs spilled down to the main dining room. "Mrs. Pat" was sitting downstairs, the room crammed with stage folk, exquisitely groomed and dressed. Suddenly a rustle ran through the crowd. Stella Campbell looked up. In all her fifty-eight years, she had rarely seen so fresh a picture of female beauty as Tallulah was presenting, standing at the head of the stairs like the mount of Olympus, surveying the province that she clearly intended to rule. Nobody knew who she was, but the diners were riveted.

Tree and her friends "were sort of staggered by Tallulah," Venning remembered, and naturally, Tallulah did her best to make sure they kept staggering. At one party, Venning continued, "Tallulah turned a cartwheel and had nothing on underneath!" Nudity was the most effective weapon in her arsenal of shock tactics. She had already learned how to keep people at a distance by bringing them often indecently close.

And yet, cartwheels to the contrary, Venning considered not Tallulah but Audry the more reckless of the two. It was Audry who indoctrinated Tallulah into a dizzy world of pranks and put-ons. Venning described a game called "Wind." In the parlance of the day, one would "wind" somebody the way one would con them today. Walking along the street, they would spot a likely victim:

"Monica! Oh!"

"Pardon, I'm not Monica."

"Oh how stupid of me, oh yes, but you know *me*! Goodness, you remember those picnics we used to have. And my brother—he was mad about you!"

Minutes of leg-pulling might be capped with: "Well, I've never been so hurt! I know it's a long time, but it seems so awful that *you* of all people could forget me!"

"And do you know, in the end," Venning recalled, "the poor woman had given her name and tried to remember the picnics!"

Another favorite gambit was the gate-crash. Tallulah and Audry would arrive disguised at a party to which they had not been invited, eavesdrop on the guests, and the next day report back to their host or hostess a tell-tale conversation that proved that they had crashed the festivities. There didn't seem to be a single wrinkle that Tallulah and Audry—with Venning's assistance—couldn't and wouldn't work out. They might be musicians, or conjurers, perhaps adjunct help summoned specially for a gala, but Venning always stayed outside, idling the engine of Carten's getaway car. They never went as guests and they always promised to be back before long.

"It was my intent to curb, and if possible, protect them from real disaster," Venning explained. "I fondly imagined myself to be some sort of bulwark. I was a Mrs., and I'd gotten this quite definite feeling that I was respectable." By 1923 her husband, eminent actor Malcolm Cherry, was critically ill and support for her small daughter was solely in her hands. "My husband was alive, but he was a complete nothing. I was the breadwinner and it was pretty grim, I can tell you." It was grimmer still for a woman mindful of propriety to know that her husband was moldering in terminal syphilis contracted during his tour of duty in World War I. Du Maurier had arranged for a weekly stipend to be sent to her from the Actor's Benevolent Fund, which he headed. "Money mattered terribly," she said.

Two girls looking for mother surrogates, Audry and Tallulah found Venning game and they, in turn, were protective toward her. "Ten pounds off her salary!" Carten and Bankhead would call to each other, a warning cry not to be too rambunctious or they would incite a fine from du Maurier. (In the days before British Actors' Equity, producers were able to summarily deduct salary for alleged infractions.) "We mustn't go too far," they reminded each other. "Una mustn't have ten pounds off her salary."

They learned that Venning's mother's maiden name was Percy, and so the two madcaps dubbed her "Miss Percy." "We like it," they sniffed, "it's so

precious and persnickety." And they took it in stride when Venning marshaled her stiff-backed Irish propriety against them. After her husband died in 1925, Venning enjoyed a lengthy marriage with playwright Gordon Hamilton-Gay. Already during *The Dancers* in 1923, she was receiving the squiring-around-town attention of several eligible men. "Una never knows us when she's with her beaux," Audry and Tallulah teased her. "Jolly right I didn't!" Venning recalled.

Naps

"When I was twenty-one I dreamed of being a star, and then marrying a rich man I was in love with, and having three sons, and racehorses, and gambling all night, and being a good wife and mother."

S ailing to London, Tallulah had envisioned the probability of Napier Alington calling at her hotel and had carefully plotted her response. She would let him wait a half hour in the lobby and then greet him with the frostiest of receptions. A few days after she arrived, Alington did call at the Ritz, but now Tallulah's resolve vaporized instantly. "I started to walk down the stairs slowly to collect myself, the lift would have been too quick," she recalled a decade later to *Picturegoer Weekly,* without saying who her gentleman caller was. "Then I started to run. Down the stairs I went, two at a time, and when I saw him standing in the hall, I simply squealed 'darling' in a high-pitched treble, rushed through the crowd of guests, and servants, and threw myself right into his arms. I'm afraid it rather shook the Ritz, and that young man rather more."

Alington's father had died not long after Napier returned to England, and he inherited the title as well as Crichel, the family seat, which became a consuming interest of his. He and Tallulah resumed their affair immediately, although this was hardly the last time that he would be discomfited by her. Although privately louche—"no one was too discreet for Napier,"

said their mutual friend David Herbert—he was repulsed by public breaches of etiquette.

Like Tallulah, Alington had been deprived of emotional ballast and balance. His upbringing was not unusual for its time and place but would not be called ideal. His older brother Gerald had tried to separate himself from the family, but after his war injury was forced to return to Crichel, confined to a wheelchair. In *Edwardian Daughter,* Sonia Keppel describes Gerald Alington, months away from death yet needled incessantly by his own father; Lord Alington acted so callously that Mrs. Keppel upbraided him in no uncertain terms.

Lady Alington, on the other hand, was said to have indulged her children hopelessly. It was bruited about that Napier and Lois, her two youngest children, were perhaps the product of a different union by Lady Alington; they were dark and rather Latin-looking, whereas her older children were fair and much more retiring. Lois, recalled by Herbert as "full of charm and like a Bacchante," departed so far from the family's insistence on external propriety that she ventured briefly into film acting in the early 1920s.

With Alington, Tallulah inaugurated a pattern of pursuing most vigilantly men who were the least attainable. Tallulah could have seen in him a mirror of both herself and her father. He was as reckless as Tallulah knew herself to be and as distant as Will had been throughout much of her childhood. "Napier was impossible," Herbert said. "He was a divine man, I adored him, he was a great friend, but he never could be faithful to anybody." He was also bisexual, with "a very feminine streak," as Herbert recalled. Tallulah, however, preferred to compete romantically with men than with other women, and certainly Alington's exotic sexual proclivities may have attracted her. "Didn't he used to like being humiliated and all that sort of thing?" Douglas Fairbanks Jr. asked in 1992. "Being a dog at the table and having his food served on the floor?"

Perhaps Alington did not enchant Tallulah and his other friends and admirers as much as disarm them, initiate them beyond noblesse oblige into a world where time's constraints could be bent any which way he chose. He was often hours, sometimes even days, late. "It was as if he'd bought time up, felt he could throw it about or dispense with it altogether," gallery owner Rex Nankivell recalled to playwright Kieran Tunney in his 1972 *Tallulah, Darling of the Gods.* On the way to an appointment, Alington might suddenly indulge an urge to smell every flower in his garden, despite the delay it occasioned.

Alington's need to live in a world of his own apparently drew him to

narcotic refuges, or perhaps drugs were one reason for his detachment. During Alington's lengthy stays in Paris, "he got very much in the hands of the opium smokers," Herbert recalled. "The old Princess Murat, Cocteau, the Marquis de Chamdon. Napier was smoking opium like mad."

He was "obsessed with death," reports Anthony Busby, who is writing a biography of Napier's sister Lois, "extremely aware of his own fragile health and mortality." But he seemed to prefer defying death by doing nothing to postpone it and instead mining every day for as much sensual gratification as it could provide. He frequented a spa in Switzerland, but violated every rule of the cure that was administered. Alington drank heavily as well. Going out with him would have made it more difficult for Tallulah to keep her promise to her family not to drink. Her father had advised her to drink a glass of champagne as a precaution against seasickness on her trip to England. In her mind the drink may thus have seemed entirely harmless. She later claimed that champagne was the only alcohol she imbibed during her eight years in London, but she did drink a great deal of it. One of her favorite expressions was "and champagne was running in the scuppers," and so it usually was wherever Tallulah happened to be cavorting, although when she was younger, liquor never became the problem it did in later years.

"Tallulah opens in London at Wyndham [sic] Theatre tonight with Sir Gerald du Maurier," Will wrote to Marie on February 15, 1923. "I have a letter from her full of happiness and hope. She is perfectly charmed with England and has received many nice social attentions from some persons of distinction. I wish you would write to her."

When the curtain rose on the first act of *The Dancers,* the audience saw a saloon in the wilds of British Columbia, a hangout for the ripsnorting locals. Sitting onstage was Tallulah, about to perform a cabaret turn on the saloon floor, decked out in fringed buckskin and a half-moon Russian *kakoshnik* headdress sprouting a half-moon of feathers. Tallulah's solo was a whirligig of canonically "Injun" steps mixed with a lot of Charleston and a little ballet thrown in, too, for which du Maurier had insisted Tallulah report to Ballets Russes choreographer Léonide Massine for lessons. (In later years she frequently boasted that Massine had told her she could have been a great ballerina; then she usually twirled into a sample of what the world had missed.)

Venning called Tallulah's dance solo "magnificent . . . *completely* uninhibited." Her exhibition over, Tallulah would plunge into the ensemble revels on the dance floor, cheered on by half the cast. Since many of them

didn't have speaking parts in the first act, they were positioned onstage in their street clothes playing customers in the nightclub. "It will be just as well," one of the stage directions suggested, "if the actors in this scene have been smoking and drinking for five minutes before the curtain rises, to get the effect of having been there for the day and a thick smoke from all their pipes and cigarettes." Du Maurier often provided an extra treat by planting visiting celebrities. Venning was delighted when one night she found John Barrymore sharing her table.

The actors onstage applauded, murmured the latest gossip, and asked themselves, "What's Tallu doing tonight?" No two performances were ever the same. "She did a lot of different things," said Venning, "mind you, she kept to the outline." The dance floor would clear and Tallulah would shout to the customers, "Nooow, I'm going to do so-and-so," or grab a man and say, "Let's do . . . !" and stir up a great commotion.

Du Maurier played Tony, "a rather banished Englishman," Venning recalled. Some conduct of an unconventional nature had brought him out to the wilderness, thousands of miles away from a moneyed and disapproving family. Tony owned the nightclub where Maxine carried on, and he, too, took to the cabaret floor. Du Maurier himself had a penchant for impromptu entertainment at charity benefits and the like, and according to the script he was here in act 1 asked to perform a recitation as well as a burlesque of *Pagliacci*'s "È finito."

Tony called Maxine "Swan Face" and hints of their budding attraction punctuated the color and noise of the saloon and its carousel of amusements as they conversed in Tree's florid and allusive phrases. "I don't mix up with men, like these women here," Maxine tells him. "After all, we aren't helpless like animals—helpless like children. . . .

"All my theories go to pieces sometimes," Maxine continues. "But I want, how I want, everything else to come first, then contact, contact, and you haven't a little bit of love for me yet."

"Contact" is a derivation from Emerson, although when Tony asks about it Maxine tells him it is courtesy of Henry James, whose injunction to "just connect" comes in *The Ambassadors*. James, it turns out, is a favorite of Maxine's. "Don't you read him? A man once told me never to leave off reading Henry James and Bret Harte. I was a kid then and it seemed pretty stiff at first."

Tallulah's Maxine was now out of her cabaret costume and wearing a simple skirt and blouse. Her hair was down. Du Maurier responded to her with the tender irony that he'd made all his own in this unforgettable not-

quite-love scene. "Gerald never went in for a lot of dramatics," Venning recalled. Du Maurier's way was to shadowbox his affections so that his endearments came wrapped with a little mockery or casual chaffing. He gently took Tallulah's hands while he smoothed her down, telling her about his long-pledged affections to a British girl waiting at home. "Give all that love, all that splendid beauty, to some fellow who's worthy of it—and forget me."

"Never in any world!" Tallulah's Maxine insisted. Later came word that an accident had eliminated all of the relatives ahead of Tony in the line of succession. He would have to say good-bye to Maxine and return to England to claim his inheritance. "The parting was very moving," Venning said. "The audience had taken to Tallu. They were desperately sorry for her." But the class consciousness with which those in the audience had been brought up made them wary: "Gerald was playing a titled man so they felt, 'Well, it wouldn't do; it *wouldn't* do. . . . '"

"London audiences are much more demonstrative than New York's," Tallulah writes in *Tallulah.* "In New York spectators either clap their approval or remain silent. In London they grow vociferous in their appreciation, as they do in their dissents." She remembered a shower of "screams and roars" greeting the fall of the first-act curtain, a squall so ferocious that it blew her, terrified, back to her dressing room. Sobbing throughout the next two acts, she was convinced they had hated her.

"I have to work on my part, and go on and on," Tallulah had said to Audry during rehearsals. "You come on, and in one act have grabbed them by the throat!" It was, Venning said with a chuckle, "only too true." For in *The Dancers* Audry was playing a favorite melodrama perennial: the woman who erred. A single transgression could cost her everything: spouse, children, community. The fallen woman spent the rest of her life scouring her blemished virtue, struggling to "get back" to polite society . . . or taking the easy way out. It was a plotline beloved by the Victorians, a cautionary reminder. Society's laws were inviolable; woe to those women who felt immune. While the unfortunate woman paid and paid and paid, the audience wept even as it ordained her punishment. In those days, violin tremolos sounded the curtain's rise, signaling heartbreak and catharsis to come. In the twenties, pit orchestras still played ditties before showtime and entertained during intermissions. And onstage in *The Dancers,* the desperate one consoled herself by spinning a violin lament on the gramophone.

At the fall of the first-act curtain, Una Venning scrambled up the backstage stairs, wriggling out of the street wear she had worn sitting in the sa-

loon. Full stage makeup went on as well as clothes suitable for a personal secretary to a society leader: Act 2 opened in the home of "Mrs. Mayne," guardian to Audry Carten's "Una Lowry." Mrs. Mayne was played by Lillian Braithwaite, a distinguished and formidable actress, who went from *The Dancers* to the lead in Noël Coward's *The Vortex,* the play that began his playwriting success.

Tony, now the Duke of Chievely, thought Carten's Una Lowry had remained the same young woman he'd left in England. But she had become, in the words of London's weekly *The Sketch,* "an erratic and neurotic nightbird" who was an easy mark for the temptations of the dancing life. Discovering herself pregnant by a dancing partner, she takes her own life rather than confront the duke with her secret. "Delicate, eerie, sensitive, nervous," Carten's acting "touched us all to tears in her desperate agony," *The Sketch* reported.

Reading the program, the spectator knew that the Tallulah Bankhead of act 1 was going to be back again in act 4. Now she was playing one "Tawara," although actually she was still Maxine, but had become famous for those same Indian dances she had used to entertain in Canada. Tawara had outgrown the pinwheel flares of emotion to which she'd been prey in her early youth. The last act, Venning said, "was to show the years had gone by and she was now a stable person. And, aah, what a difference! Tallulah was so controlled, where before you'd seen her as a wildly fantastic thing with emotions of every description."

The duke appears in her dressing room. He is still haunted by the loss of his intended, but the passing years haven't banked the fires of his and Maxine's mutual attraction. With maturity's new wisdom, Maxine understands all. With the old forthrightness, she doesn't mind telling the duke that her ardor is still consuming.

Sprung to continental glory, Maxine "Swan Face" Tawara has not mutated beyond recognition. She is just as forthright and unguarded as she'd been on the Canadian frontier. In this highly effective scene of acceptance, reconciliation, and new beginning, Tallulah was "very subdued and sincere," Venning remembered. "Don't let's talk of how we've arrived to where we have arrived," Tallulah as Tawara told du Maurier, "We can give each other our press notices to read and that will save time." Instead she'd like them to measure "how much we have loved people," and if they had been true to themselves: "whether as we grew we struck the right shoots of ourselves."

When the last-act curtain came down, dulcet chords of tragedy, ro-

mance, and sex had been expertly sounded. *The Dancers* showcased a triumvirate of star performances: the acting was praised even by critics who felt tears should be milked a bit less shamelessly. *The Stage* reported that "Miss Tallulah Bankhead, an American actress, made a palpable hit by reason of the sincerity and tenderness she showed as that unshaken follower of an ideal. . . ."

"Miss Bankhead is the most natural thing that has 'ever happened,'" *The Era* declared. "In Canada she is alive to the dangers of circumstances, able to take care of herself, and yet sweet and joyous; not a babe in Bohemia, but a babe of Bohemia—the healthiest and happiest product of professional life. She is just as good as the successful favorite of the Parisian stage.

"The part is one which would lend itself so easily to exaggeration, to over-acting, to artificiality. These pitfalls Miss Bankhead avoids. Her performance was delightful." The *Illustrated Sporting and Dramatic News* called Tallulah's performance "really beautiful . . . reconciling us wholly to the Indian summer ending in which Tony Chievely swears with uplifted head to love and cherish her all his life (and do we not know how firmly he keeps his word?)."

London cheered Carten and du Maurier's performances, but the city was aflame over Tallulah. "There had been nothing like this since the days of Mrs. Langtry," recalled theater historian W. Macqueen Pope. Doubtless at Tallulah's urging, du Maurier wrote her father soon after the play opened. "A very beautiful and charming young lady who brags about being your daughter has made a great success at my theatre—deservedly—and everybody is very fond of her—rightly—even the King and Queen of England. Thank you for allowing her to come here. She is most welcome."

Tallulah wrote Will to report her triumphs and enumerate her celebrated admirers. Edwina and Louis Mountbatten had asked to be introduced to her. "Do you remember when they came to America and were made such a fuss of? It was rather nice their coming back to see me without knowing me, wasn't it, Daddy? Ha, ha. I have not become a snob, darling, but being my precious daddy I know you want to hear everything that's happening to me. . . . I am terribly happy but miss you all so. . . ."

American readers were informed of her triumph. "Tallulah Bankhead has made a *succès fou* in London," a columnist reported in the May issue of

Tallulah, wearing Chanel, with Leonard Upton in *The Green Hat*.

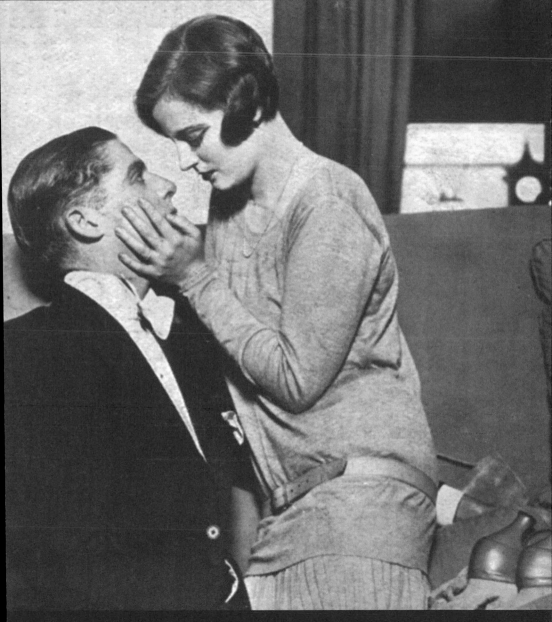

Theatre magazine. "I rather thought that Tallulah would be a great success on the other side. She has a quality of Yankee audacity and beauty combined with a smartness and breeding that would make her especially desirable in belted Earl circles." American readers were kept informed as well that the seeds of a rapport between Tallulah and the Prince of Wales envisioned by Mrs. Bankhead had now possibly come to fruition. In New York, *Zit's* printed a June dispatch from London: "According to theatrical gossip, the heir to Britain's throne is now paying marked attention to Tallulah Bankhead, beauteous young American actress now playing here."

Breathing a heady ether of success, Tallulah "went haywire," as she admits in her autobiography. That solo dressing room came in handy as a makeshift salon: "We made so much noise Sir Gerald had a door built on the stairway sealing off my room." Sometimes Tallulah's new friends had no compunction about having drinks sent into her dressing room, although Tallulah herself didn't drink during performances. Sometimes they even took her to supper during the ninety minutes she was offstage. "This was very irregular, very unprofessional," Tallulah later confessed. "I should have been ironed. I marvel Sir Gerald tolerated such nonsense."

But Tallulah and Audry must have both flattered the master and tried his patience. "Gerald adored her," Tallulah's friend Gladys Henson would recall, "in the nicest possible way." Du Maurier himself was a master pranksman. Playing bait and switch with stage props, assaulting the unwitting with novelty toys—these were capers that kept depression at bay, daughter Daphne speculates. He had inherited a chronic melancholy from his father. Du Maurier was undoubtedly called upon to assuage the feelings of paternal neglect that Tallulah could never redress. In her autobiography, Tallulah flirted as intimately with her own emotional truth as she ever dared when she talked about the demands with which she straitened him. Six weeks into the run, du Maurier had decided he needed a two-week vacation; Tallulah and Audry would have to fall in love with his understudy. Tallulah upbraided him for abandoning her. "I fumed and fussed and made a nuisance of myself," she writes, suffering "a recurrence of the pangs" she had experienced years earlier when Will had taken Eugenia for a private picnic one afternoon and left Tallulah at home.

Tallulah moved from the Ritz to a service flat—an apartment with cooking and cleaning included—at 23 Weymouth Street in Mayfair. But soon afterward she wrote Will that she had decided to sublet it for several months. She was going to live with society singing teacher Olga Lynn, "who is the most divine woman and has been a great friend to me." Lynn

customarily rented a house for the spring social season and this year she was living on Catherine Street near Covent Garden. "She is much older," Tallulah wrote, "but everyone worships her here and she has a lot of influence in every direction."

"Oggie knew everybody," Venning recalled. "It was the right place for Tallulah." Also living at Lynn's for some reason was Gladys Cooper, who was at the height of her West End popularity. Years later Tallulah related that she had been in bed one night when Cooper knocked on the door and came in to say good night; Tallulah looked up and beheld a vision, the most beautiful woman she'd ever seen. She was fascinated by the way Cooper had started as a chorus girl, graduating to her first dramatic role as du Maurier's leading lady. Over the years Cooper and du Maurier acted several more times together and she was his regular partner for lunch on matinee days.

Hair bobbing had hit London in a big way. M. La Barbe, a famous Parisian hairdresser, came over every two weeks to London, where actresses met in the afternoons for tea and shingling. Tallulah was present when Gladys Cooper shed her wavy blond mane, and was "terribly upset to watch the parting, but she looked so nice afterwards that I felt just a little intrigued." Du Maurier was one of many men who did not approve. He was chagrined when his wife, Muriel, submitted to the shears, and he "nearly went mad," Venning recalled, when Tallulah decided to follow Cooper's example. She ran to his dressing room, tossing her shingled hair back and forth. "Look, Sir Gerald!" Du Maurier, Tallulah claimed, drew a blank for a full minute before bursting into tears. He insisted that the play was now ruined. That was hardly true. But a scene in act 1, in which Tallulah let down her hair, combed it, and pinned it back up to the admiring murmurs of the audiences, was undoubtedly now modified.

When summer came Tallulah demanded time off for her own vacation, although her contract contained no such stipulation. Du Maurier agreed, and Tallulah went off to Venice to share a small palazzo with Viola Tree and a band of friends, including Lynn and Sir Francis Laking, an indolent young man who became Tallulah's court jester. Cole and Linda Porter and a tribe of international sybarites were all there to welcome her.

Tallulah had never set foot on the Continent and "I was agog." She went with her friends on a sailing jaunt her first day. Wary of the Adriatic sun, her friends pleaded to return quickly, but she was mesmerized by the flame-colored spinnakers of distant ships and kept begging for a few more minutes at sea. When they eventually headed for shore, the tide was

against them, further delaying their return. Finally, they pulled up to the beach; Tallulah stepped out of the boat and collapsed on the sand. She was carried to her cabana with a 106-degree temperature and a bad case of sunstroke. Her first day in the sun was her last for the entire vacation. "Belatedly it dawned on me that this was the fruit of my rebellion."

Surely the universe, having just presented her with stardom, had more good things to bestow. "I think she did honestly believe that things came her way if she asked properly." She was quite game to fall to her knees and pray, anywhere and anytime, Una recalled, having witnessed supplications even in the living room of a friend's house. Venning assessed Tallulah as "hyper intelligent," but her intelligence could feed her megalomania, could make her a menace to life and limb, hers as well as bystanders—innocent or otherwise.

In *Tallulah,* she recalls buying a pearl necklace "to prove to the toffs and my fellow players that I knew the score. What I proved was that I didn't know the score. Eager to drive my own car, I hocked the pearls to buy a Talbot coupe." Venning remembered a call from Audry: "Tallu is going to buy a car!" Una declined to accompany them, but soon they were regaling her about their jaunt. Audry and Tallulah had descended on a Mayfair shop that stocked show cars. "Tallu bought one, and drove it out *then and there.* She'd never driven a car before! She didn't tell them, and laws were a lot more relaxed. She knew more or less what she had to do. And they got back to her place and after that she did take some lessons." Six months later, however, Tallulah sold the Talbot so that she could redeem her pearls.

Now that she had established herself, Tallulah was perfectly prepared to accept a marriage proposal from Alington; Venning recalled that throughout the run of *The Dancers,* Tallulah was convinced that one would be forthcoming. Marriage to Alington would have fulfilled a long-range scenario running parallel to Tallulah's theatrical designs. "When I was twenty-one," she told Denis Brian two years before she died, "I dreamed of being a star, and then marrying a rich man I was in love with, and having three sons, and racehorses, and gambling all night, and being a good wife and mother." Yet, as a prospective husband, Alington certainly presented difficulties.

Her affair with him in no way precluded her virtual adoption by some of the most prominent gay women in London. Among them was Barbara Bach, a close friend of Somerset Maugham's and a leading hostess married to a successful doctor with whom she shared an enormous house in Re-

gent's Park. Tallulah was also frequently in the company of novelist Rad-clyffe Hall, whose lesbian romance *The Well of Loneliness* incited a furor in 1928, and her lover, sculptress Una Troubridge. Another close friend was Gwen Farrar, whose music and patter act with Norah Blaney enlivened re-vues and music hall bills. Farrar played cello; Blaney noodled the key-board. "Of course nobody sang really bawdy songs in those days," Quentin Crisp recalled in 1993, "but Gwen did sing songs which included such couplets as 'Last night my Ma got plastered / She said that I'm a bastard.' Norah sang sad songs: like 'How About Me?'" Their appearance together provided as faithful a replication of a heterosexual dyad as their audiences would accept from a same-sex couple. Blaney was quite conventionally feminine, while Farrar shone with an androgynous and unmistakable glamour, her hair trimmed to a lank point across one cheek.

On nights when she wasn't working, Farrar often hosted musicales in her home on the King's Road, and Tallulah frequently attended. Farrar's evenings at home were intimate and mellow, Tallulah being usually one of not more than a half-dozen guests. Ballets Russes star Anton Dolin was present for a midnight serenade Farrar performed in the street outside Tal-lulah's apartment. Tallulah and several friends were chatting casually when a cello's mournful strains rose to her windows. Then came Farrar's voice, and her mournful strain: "I want my Tallulah baby!"

Risky Behavior

"When I first saw my name in lights, I thought it was the most *obscene* thing I'd ever seen in my life."

F rom a triumph unprecedented in her career, Tallulah found herself in the worst professional disaster she had yet experienced. During the ten-month run of *The Dancers,* she believed that her future was assured. Once the play was over, however, she was convinced that she had exhausted her prospects. "I consoled myself with the fantastic idea that I had been especially cast for the part," she wrote in 1928, "and that some one would be sure to cast me for another equally 'special' part. But the months passed and I was forgotten." Actually, Tallulah was out of work for only two months, but her words portend the insecurity that would lead her to make many career mistakes born of haste.

She did, however, turn down an offer she did not like from a management that she didn't trust. Shrewdly, she asked more than she knew they would be willing to pay her, since she "did not want it said I refused a part." Tallulah then "wondered fearfully whether Fate would punish me for that, and never give me another part!"

The play that she did choose was *Conchita,* a florid melodrama set in Cuba during the final days of Spanish rule. Though *Conchita*'s auspices had been favorable, it was probably the worst play she ever appeared in. It

was written by Edward Knoblock, one of London's best-established playwrights. Knoblock had been born in New York in 1875, but had become a British citizen in 1916. Knoblock's *Milestones,* written with novelist Arnold Bennett, tracing the fortunes and travails of one family through the ages, had been performed in every nook and cranny of the British Empire. A year before *Conchita,* Knoblock received an "adaptation" credit on Ernst Lubitsch's *Rosita,* the director's first American film, in which Mary Pickford's Spanish dancer bears every bit as much resemblance to Tallulah's as the two titles would suggest.

Conchita was directed by Basil Dean, one of the most important figures in London theater, who was destined to play a significant role in Tallulah's career. He and Alex Rea were partners, renting the adjoining Ambassadors and St. Martin's Theatres. Tallulah had carried a letter of introduction to Dean with her to London. Perhaps by way of atonement for *Heartbreak House,* the Theatre Guild's Lawrence Langner had described her as "a serious young actress, not at all satisfied with playing so-called 'type' parts."

Conchita was to begin a coproducing venture between Dean and impresario Sir Alfred Butt, who were intending to present a "series of romantic plays" at the Queen's Theatre. *Conchita* plied themes that could well have attracted Tallulah on the deepest levels: a sixteen-year-old serving girl in a rough inn at a small seaport in Cuba, Conchita was destined to enjoy the triumph of a Cinderella-like transformation, and to do so by claiming the legacy of her dead mother's glory.

Knoblock understood the surprise value in having the audience discover that the most humble figure onstage is actually the star. Tallulah was first seen as a silent figure scrubbing floors, dressed in sandals and a tatty dress. Ben, an American sailor, strikes up a conversation with her. She is an orphan, and can neither read nor write. Her mother, a great dancer in Spain before moving to Cuba, had died ten years before, depositing her in the care of Tío Miguel, the innkeeper. Her closest friend is her monkey, Ching Chong, named for a jujitsu move that a Chinese acrobat had once taught her. Dancing is Conchita's one pleasure; Tallulah danced in each of *Conchita*'s three acts.

Conchita attracts the eye of corrupt police captain, Don Pablo, who has just been ditched by La Rubia, a blowsy young temptress. Don Pablo demands that Conchita be scrubbed and adorned and made ready for his conquest that night. Naive as she is, it is not until well into the second act that Conchita gets wise to the trick. When Ben returns, he spars with Miguel and kills him. Just as Ben and Conchita are about to flee, Don Pablo

arrives and the curtain falls. Throughout the third act, Don Pablo and Conchita play cat and mouse, until Conchita uses the Ching Chong maneuver to pin Don Pablo to the ground, then dances a fandango of triumph over his hog-tied body, before she and Ben escape together.

At the dress rehearsal, Conchita's beloved pet seized her black wig and pulled it off Tallulah's blond head. "I always thought that the monkey scored his success a day too soon," she recalled in 1928. "If he had only repeated his performance on the opening night, the play might have been saved."

Tallulah was far from the only first-rate talent to be trapped in *Conchita*. Especially considering the fact that she did not attend drama school, it is important to mention how many illustrious actors she worked with as a young performer, from whom she undoubtedly learned a great deal. Lyn Harding, who played the wicked Don Pablo, enjoyed a vogue for his portrayals of rakes and reprobates, while Knoblock had taken care to stock his play with a rogues' gallery of supporting characters played by some of the best character actors of the day. There was Miles Malleson, as Lorenzo, a barber haggling with Tío Miguel over fees. Mary Clare was La Rubia, and Clifford Mollison was Pepito, a comically timid swain dumbfounded by his amorous success with La Rubia and completely dominated by her. Clare and Mollison had two short scenes together, one in the first act and one in the third, "and we stole the play," Mollison claimed in 1982, "because we came on, did our stuff, like a music hall act in a way, and off we went."

Onstage during the opening on March 22, 1923, Mollison could hear audience members making plans to meet the next day. The curtain fell "to the accompaniment of almost hysterical laughter," reported James Agate in the Sunday *Times*. *Conchita* was booed, and for the first time in her career, so was Tallulah.

In a kind of euphoria at having survived the debacle, Tallulah went out with friends to Ciro's, but this would be the last time she frequented that chic bastion. She was thereafter banned from the premises for allegedly having splashed a glass of champagne in Gladys Cooper's face. Tallulah swore that it was Francis Laking and not she who had splashed Cooper. Indeed, Hannen Swaffer, in a report for the *New York Post,* implicated "a young baronet, who basks in the light of the footlights and who has conceived a great admiration for Tallulah Bankhead." He had been "almost in tears over the groans and moans of the audience" during the opening night performance. At Ciro's he saw Cooper laughing with a friend, and imagining her jeering over Tallulah's debacle, he doused her. The next

morning, Laking sent Cooper a note begging her forgiveness. She sent back word that she preferred being splashed on a nightly basis to continuing a friendship with him.

Conchita's reviews were scathing. The Sunday *Express* wrote that the character of Conchita was "so simple as to be absolutely unreal." *The Stage* accused Tallulah of making matters worse by acting "with too obvious an assumption of childish naiveté, ingenuousness and the 'artless thing' pose."

"It is hardly fair to criticize the acting," wrote the Sunday *Express*. Given the audience's hilarity, "the actors must have seen how hopeless was their task. Even so, Tallulah Bankhead was not capable of playing Conchita or of suggesting the type."

She also received some praise. *The Era* declared that "The producer and the actors worked hard in their attempt to infuse life into the play. Miss Tallulah Bankhead took advantage of the occasional opportunities afforded her as Conchita, and was all the time appealing and charming." The *Times* described her "a lithe and lovely Conchita, a good dancer, and what her compatriots call a 'good-looker' into the bargain." Hubert Griffith wrote in *The Observer* that as "the delightful Cuban barmaid ingénue," she had exhibited her "talent for acting, her soft, hoarse attractive voice, and her obvious talent for dancing." But the *Evening Standard* objected that she "hardly dances quite in the Spanish manner."

In the cast of *Conchita* was also Barbara Gott, whose acting career was largely devoted to grotesques. Barefoot, in large brass earrings and smoking a cigar, Gott played Afrodita, "a shriveled old Negro hag of indefinite age." *The Era* commented, "In many ways, it was the best part in the play."

Tallulah was so ashamed of her own performance that she was willing to do whatever it took to make sure the play closed as soon as possible. Every evening, she and her maid walked past a threadbare line at the box office and condemned the play in voices as loud as possible—presumably Tallulah disguised herself in some way. "I felt rewarded when I saw several people depart at the end of the queue, apparently considering the play not worth the wait. The fewer the audience the better I was pleased because I did not want people to see how bad I was. . . ."

Her colleague Clifford Mollison agreed, describing both Tallulah's performance and the play itself as "insufferably bad." He found Tallulah "horrifying. I hated her. She was all in all a woman I don't like. You couldn't really hold a conversation with her much—because she never listened. She was always thinking of somebody else. To be fair to Tallulah, I was just another young actor coming up, another member of the company." He recalled, too,

her complimenting him on his "Nice notices, Skiffy!" as he was called by friends, when she saw him at the theater before the second performance.

Mollison repeated a rumor then current in London that Tallulah was having an affair with Florence Mills, one of the stars of the revue *Dover Street to Broadway,* which came to London in 1923. This had actually been insinuated by *Broadway Brevities* in December 1922, when Tallulah was still in New York: "Was ever anything more in the line of sisterliness recorded than Tallulah Bankhead reported to have purchased six pairs of chocolate hose as a gift for Florence Mills?" Mills may have been the first in a series of female black entertainers with whom Tallulah was infatuated. Long after Mills died from appendicitis in 1927, Bankhead spoke glowingly of her artistry, as did, it seems, everyone who ever saw Mills perform.

Conchita lasted only a week. Swaffer dispatched to the *New York Post* that it "was the only play which was unaffected by the omnibus strike, for it would have died anyway. 'We cannot even give the seats away,' moaned one of the management." Experienced though he was, Knoblock himself was bewildered at the utter rejection suffered by his play. "Funny," he mused to Mollison, "I thought it had color." In his 1939 autobiography, Knoblock was still stung by the play's failure, protesting that what he had really intended was "a melodramatic comedy," a hybrid genre requiring defter handling than Knoblock claimed Dean was able to give. He regrets agreeing to Dean's request that he not come to rehearsals until a week before the opening and alleges that the leading players were wrong for their roles. But the experience remained so painful (or Knoblock was so reluctant to provoke offense) that he neither mentions their names nor even the name of the play.

If nothing else, *Conchita* allowed Tallulah the thrill of seeing her name in klieg lights for the very first time. In her autobiography she talks of walking Audry Carten round and round Shaftesbury Avenue to view the marquee of the Queen's Theatre when the lights were first turned on, a week before the play opened. But with the rush of gratification came the lash of something more conflicted. Decades later, during a pre-Broadway tryout in Baltimore, Tallulah would glance at a theater marquee similarly emblazoned with her name and spit out with bitter bravado, "When I first saw my name in lights, I thought it was the most *obscene* thing I'd ever seen in my life." In 1962, she again recalled the incident, saying she had burst into tears of shame, thinking of her grandmother's oft-repeated dollop of Victoriana: "Fools' names are like their faces / Always seen in public places."

The Bankheads only heard about *Conchita* one week after it opened,

which meant just as it was closing. On April 1, Marie wrote an inquiring letter after seeing an item in a week-old issue of a London paper. Marie was the family's delegated correspondent to Tallulah, although she received little for her pains except Will's undoubted gratitude. Tallulah did not like writing letters as a rule, much preferring telegram or telephone. "Of course it hurts us very much," Marie wrote in this letter, "that you are so disinclined to keep in touch with the members of your family in Alabama."

Five weeks after *Conchita*'s closing, Tallulah was starring opposite two of London's greatest stage favorites, Herbert Marshall and Cathleen Nesbitt, in *This Marriage,* a comedy by Eliot Crawshay Williams. A former politician, Williams had revised and expanded a one-act play of his entitled *Rounding the Triangle,* which had first been produced in London in 1921. In *Rounding the Triangle,* a young man is finding it impossible to break up with his mistress of five years, whom he first met when she was walking the streets. His fiancée, a progressive young woman, is not upset but calmly suggests that he continue to see her after they are married. Her tolerance offends his conventional sensibilities, and he tells her their engagement is off. His ex-streetwalker mistress, too, has absorbed his bourgeois prissiness and is equally outraged at the idea. Seeing him for the prig he is, his betrothed is happy now to give him up. But she has bonded with her rival, and announces her intention to mentor the young woman so that she does not go back to the streets.

In *This Marriage,* the fiancée was now Vera Farrington, similarly a representation of the modern woman who, reported the *Christian Science Monitor,* "has outspoken views upon subjects upon which the Victorian girl was presumed to be ignorant." After four years, Vera's marriage to Christopher Maitland has settled into routine when Yvonne, played by Tallulah, sets out to seduce Chris and succeeds. *The Stage* described the character of Yvonne as "ably and not offensively drawn by the author . . . not exactly the ordinary adventuress of melodrama or night-club." Vera discovers the affair and summons Yvonne by sending a telegram signed with her husband's name. Vera assures Yvonne that she recognizes Yvonne's importance to her husband, and in fact has no objection to his continued relationship with her provided that Vera is allowed to retain the major claim on his affection. Yvonne is overcome at Vera's selflessness and tells her that instead she will give him up. Chris returns home unexpectedly, and Yvonne hides behind a curtain, overhearing his confession to Vera. When it is over, she steps out of her hiding place and tells him what a good wife he has and walks out of their lives forever.

In 1978, Nesbitt recalled how impressed she had been during rehearsals with the accuracy of Tallulah's reaction of surprise to Nesbitt's proposal that they share her husband. "I remember thinking, 'How clever she is.'" Nesbitt was nursing her newborn son, and when she offered Tallulah the stage-level dressing room, Tallulah refused, saying that she would not think of allowing Nesbitt's son to traipse upstairs. Nesbitt laughed at the way Tallulah seemed to presume that the infant would need to walk up the stairs himself every night. She found Tallulah "wonderful to play with, because she played *to* you, *with* you. A lot of people don't mean to be bad, but you're here and they're there. With Tallulah you were playing with another human being. It was person to person."

This Marriage enjoyed "a wonderful reception on the first night," Tallulah recalled in 1928. But critical voices were decidedly mixed. It was felt that expanding the play from one to four acts had not improved it. Tallulah's own reviews were good. The *Telegraph* wrote that "she plays magnificently in the sofa scene, making you realize that the unfortunate Chris had as little chance of escaping her fascinations as the rabbit has from those of the snake." The Sunday *Express* praised Tallulah for "the discretion shown in the handling of the sofa and confession scenes." Despite the names and talents of the three stars, however, three weeks later the play was shuttered. "I really did think then that I was a failure," Tallulah recalled, "the worst actress in London."

Soon after, she heard that Will would be visiting London as part of a delegation from the U.S. Shipping Board. Determined to shine for him, she jumped into rehearsals for *The Creaking Chair,* a murder mystery written by Allene Tupper Wilkes and "revised" by Roland Pertwee. Tallulah said that she did not like mystery plays, but *The Creaking Chair* exemplified the comedy thriller, an emerging genre of the 1920s. "We saw a great deal of Tallulah," Will wrote Marie. "She was precious and so attractive and looked superb. She certainly has made wonderful friends who seem devoted to her."

Will and Florence were invited with Tallulah to a dinner given at the Savoy Hotel by Sir James Cook. In attendance were other theatrical notables as well as "all sorts of dukes and earls and things," Will reported. "I was called upon for a speech at dinner, and drank to the health of the British Empire." Will began by proclaiming American women the most beautiful in the world, expanding on the boast until Tallulah was cringing in embarrassment at his chauvinism. However, he concluded with a deferential flourish that excused all that had come before. "American women

are the most beautiful in the world," he repeated, then paused and said, "And now I can see why, because they're descended from the English and the Irish."

In *The Creaking Chair,* Tallulah was Anita, the wife of Egyptologist Edwin Latter. Unbeknown to him, his archaeological partner, Carruthers, had arranged for him to be stabbed in Egypt. Thus he is confined to a wheelchair that creaks because his daughter has tinkered with it. She has been pilfering his money to pay her gambling debts and doesn't want him surprising her in the act. Carruthers and his wife live next door to the Latters, and it is revealed that Mrs. Carruthers had actually been in love with Latter. However, she is now colluding with her husband to fleece Latter of a priceless necklace sent from Egypt.

Anita was one of the most flamboyant roles Tallulah ever acted. Born English in Egypt, she had been kidnapped as a girl by a half-caste couple from the slums of Port Said, who were about to sell her into prostitution when she was rescued by Latter. Seeing the color blue, she is sent into a tizzy, reminded of the blue doors of the Port Said brothels. Tallulah spent the play cowering before blue items of varied description, sprinting up and down stairs, speaking broken French and English, being shot at, biting her husband's hand in sudden spasms of fury or jealousy: "It is the superabundance of excitement that prevents 'The Creaking Chair' being one of the best 'mystery' plays seen for a long time," declared *The Era.*

After Mrs. Carruthers is found murdered, each of the many residents and guests of the Latter household is suspected in turn. But the villain turns out to be Philip Speed, an ersatz journalist who is really a member of the Ulema, a secret society dedicated to driving the archaeological grave robbers out of Egypt. The authors allow him an eloquent defense of his cause. He wonders whether the British government would allow him to pillage Poets' Corner in Westminster Abbey in the same way that the treasures of his native country are picked clean by the British.

The Creaking Chair boasted a superlative cast. Latter was played by beetle-browed C. Aubrey Smith, who was a decade away from his long career as a retaining wall of Hollywood character acting. Once again Tallulah was working with Nigel Bruce, who now played the comic role of Holly, the Latters' devoted but irreverent Scottish butler. Eric Maturin was John Cutting, reporter boyfriend of Latter's daughter Sylvia. Sam Livesey played the inept detective Oliver Hart. Although it was Smith who was officially credited with the direction, *The Stage* noted that Gerald du Maurier had also put his directorial oar in.

The Creaking Chair tried out in Wales before opening on July 22, 1924, in London, where *The Observer* called it a "well-known box of tricks, very well handled, brought in with a more than an ordinary amount of inventiveness and surprise . . . a real sense of comedy and character. . . ." *The Era* averred that "It is all thrilling while it lasts, even if the story does not bear much investigation." The *Illustrated Sporting and Dramatic News* called it "an entertainment as good as any of its kind, and perhaps the best we have had in London."

"Miss Tallulah Bankhead makes a hit as Mrs. Latter," reported *The Era*. The Sunday *Express* commended Tallulah's ability to make the part of Anita "attractive and almost interesting." *The Stage* declared that Anita's "moodiness and semi-savagery" were "brought out capitally" by Tallulah, while *The Observer* wrote that "The beautiful Miss Tallulah Bankhead, who can give empty and meaningless performances when she likes, is very good this time."

The play was launched on a long run. C. Aubrey Smith persuaded her to let him deduct ten pounds a week from her salary to be held in trust. By the time the play closed she had saved three hundred pounds. A steady salary allowed for myriad adventures around London and its environs. But by now Tallulah had realized that Alington was eluding her. One night, Alington was hosting a large and very dressy affair in a friend's house on Cheyne Walk, by the Thames in Chelsea. Una Venning drove Tallulah and Audry dressed as servants in caps and aprons. They scooted down to the basement. "We've come from Carter & Coser, extra staff." Venning idled in the getaway car, as always. "They took some trays up," Venning recalled, "and it was Tallu who gave the show away. Audry was being dumb and stupid; whereas Tallu was sparkling"—and perhaps serving the food with too careless a flourish. Alington spotted them very quickly. He took Tallulah by the scruff of the neck, led her to the door, and dumped her down the front steps. As they fled the scene, Tallulah's bravado was at its most defiant: Ha, ha, it hadn't come off! On to the next.

Joe O'Donohue, an American socialite visiting London in the early 1930s, asked the elderly Duchess of Rutland if it was true that Tallulah had once been engaged to Alington. "Only she thought so, my dear, and Napier was far too well informed of what he had to do for the Empire to even consider it."

Instead, Tallulah's life was taking a very different turn. Her need to affirm her own desirability was emerging as perhaps the strongest motivation

in her life—one might say even stronger than her own libido. It led to her seemingly rampant promiscuity, which can be traced to her first years in London. No longer subject to her family's surveillance, Tallulah ran wild. Fabia Drake was two years younger than Tallulah, and was cast in *The Creaking Chair* as Tallulah's stepdaughter. In her memoir, *Blind Fortune,* Drake writes that Tallulah was "curiously weak where sex was concerned." One night, Tallulah asked Drake to join her at dinner with a newspaper columnist "because I know he'll want to sleep with me," Tallulah said, "and I can never say 'No.'"

With a defiant bravado, Tallulah seemed to proclaim her behavior the proper template for modern young women. She "could not make me out at all," Drake writes. "She found my virginity an absurdity: 'Such a shocking waste, darling, with your figure.'" Tallulah accepted Drake's "condition" in the end and gave up trying to proselytize her into affairs. "We became genuine, if unlikely, friends; her humor was irresistible . . . and her warmth and generosity."

The economically self-sufficient woman could avail herself of new opportunities for sexual activity outside marriage, but she often remained as badly uninformed as her mother had been, with results that could be catastrophic. Tallulah needed to look no further than her fellow actress Meggie Albanesi. Albanesi was extraordinarily gifted. "In the theater, impeccable," Clifford Mollison recalled. "Out of the theater, all over the place." Basil Dean, who had guided Albanesi's career, attributes to her Catholic upbringing her refusal to take any precautions against pregnancy. Abortion was illegal and even the wealthy were forced to seek out whomever they could; in Ann Andrews's words, "You had to have some weird nurse with a shoehanger or something. . . ." In December 1923, Albanesi died at age twenty-three from a mishandled abortion.

Tallulah may have been prey to the same conflict that Albanesi apparently experienced. No matter how defiantly and how speedily she had shed the strictures of her grandmother and of her early religious training, they could not be discarded lightly.

Andrews related a story that Tallulah had told her about her first pregnancy and subsequent abortion. Lesbian playgirl Jill Carstairs was sailing her yacht down the Thames on an overnight trip. On board she was hosting a party that included Audry Carten's sister Waveney, who Andrews said was affectionately called "George." Tallulah was not asked, nor was Waveney's husband. Tallulah and he were somehow left together, and out of spite, Tallulah flirted with Waveney's husband and became pregnant for

the first time. The story is sketchy, and according to David Herbert, who knew all the parties involved, Waveney Carten was not called George. But it has an unmistakable ring of truth. Rejection of any kind unleashed from Tallulah the fury of a wounded animal. Her need for professional, emotional, and sexual affirmation was unrelenting. "On the surface all confidence, all swagger and strut, inside I churned with doubt," she writes in *Tallulah*. "Any minute the clock might strike twelve and I'd be back in a hall bedroom at the Algonquin, or, worse yet, in Grandfather's yard at Jasper."

Tallulah had doted on Cathleen Nesbitt's infant son and she developed a quasi-maternal relationship with Audry Carten's brother Kenneth, who was eight years younger than Tallulah. In Tallulah's mind there was no question that she would have children one day, but also no question of delivering an illegitimate child. She was convinced such an indiscretion would end her career—and she was probably right.

The emotional resonance of the story Andrews told is enhanced by the way that Tallulah described a gruesome punishment for her misbehavior. She was three months pregnant by the time an abortionist was located; he apparently administered some kind of saline solution. Her friend Oggie Lynn had solicited an invitation to a noblewoman's estate, where Tallulah would have presumably been able to undergo the induced delivery incognito. Soon after they arrived, however, Tallulah was writhing on the floor in agony. There was no choice but to call a doctor. The fetus was delivered, and Tallulah remained ill in bed for the next few days, then returned to London, where she was confined to bed for two weeks. And yet Tallulah continued to be as reckless as Albanesi: she would have four abortions before she was thirty. It may have been only luck that enabled her to survive.

Modern Wives

"Yes, we're still speaking. Aren't you all surprised?"

In November 1922, Tallulah had been present at one of the greatest Broadway openings of the century: *Rain*, starring Jeanne Eagels. "It's the first time I ever heard cheering in an audience," Tallulah recalled in 1964. "She was so magnificent." John Colton and Clemence Randolph had adapted a short story by Somerset Maugham, featuring as heroine Sadie Thompson, a prostitute deported to a South Seas island. Persuaded to accept salvation by a zealous reverend who does not realize his own lasciviousness, Sadie returns with a vengeance to her old life when she comprehends the truth.

Despite the newly frank postwar climate, *Rain* might not have been palatable but for the casting of Eagels, whose turned-up nose and air of fragility might as easily have suited her to playing Pollyanna. Six years before *Rain*, Eagels made a silent, *The World and the Woman*, that survives today and anticipates *Rain*'s depiction of a fallen woman's attempted rise. Sullen and metallic as she walks Manhattan streets, beatific after finding religion as a maid in the countryside, Eagels's performance in the film demonstrates how in *Rain* she would have artfully fused the polarized archetypes of woman. She was virgin and whore at one and the same time.

Tallulah's persona was equally able to seamlessly fuse the two polarities, and when Charles Cochran first saw her in New York in 1922, he tried

unsuccessfully to option the play for her. It was instead Basil Dean who was able to option *Rain* for production in London. Once Dean learned that Eagels had decided not to come to London, he immediately offered the role to Tallulah and was willing to wait until *The Creaking Chair* had creaked its last. As the months went on, the humor in the script was broadened and heightened, spilling over into antics among the cast. In 1928, Tallulah described one incident: in act 2, Nigel Bruce as the butler was to hand her a pair of mud-stained slippers, implicating her in a late night visit to the murder victim. At one performance Bruce approached her, she turned to take them, but in the palm of his hand lay a pair of patent-leather doll's shoes. "I could not help it," Tallulah recalled. "I simply broke down and laughed. So did the audience."

This hilarity onstage and in the audience finally came to an end in February 1925, and Tallulah turned her attentions to pursuing the part in *Rain* that she wanted desperately but that was not yet definitely hers. Maugham, who of course had written many successful plays, retained casting approval over this adaptation of his fiction. Dean writes in his memoir, *Seven Ages,* that where casting was concerned, Maugham "had a habit of pretending indifference until the last moment when he would suddenly pounce, with a decisive yea or nea that was usually an expression of personal like or dislike." Maugham had actually already declared a preference for Fay Compton, who had successfully starred in other plays of his. Perhaps Maugham thought that the ladylike Compton would provide an intriguing casting against type in the Eagels manner, but Compton's persona was really too genteel to be seriously considered.

Tallulah wanted the part so badly that she was willing to sign a decidedly unorthodox contract with Dean:

> I agree to play the part of Sadie Thompson at a salary of forty pounds
> per week. I note that the management is to commence the production
> of the play not later than 30th June, 1925. I agree that if Mr. Somerset
> Maugham should definitely disapprove of my engagement, I will cancel
> it and your company will not be under liability to me in respect to it.

Tallulah was also willing to accept Dean's suggestion that she return to the U.S. to see Eagels perform *Rain* once again. As it happened, Dean was also going to New York to consult with Maugham. Tallulah arrived in New York on February 24, 1923, on the S.S. *Berengeria.* Her sister was at the pier to greet her.

Eugenia and Tallulah were never as close as adults as they had been as children. They no longer needed each other to face the traumas of their childhood situation, and the rivalries that had plagued them even as girls could still flare up just as violently. But they also enjoyed each other's company for short spells, and tried to the very end of Tallulah's life to act as sisterly as their temperaments permitted.

In New York, Dean told Tallulah that Maugham had gone to Washington, and Tallulah resolved to follow him and plead her case. Dean felt that she was making a mistake since Maugham "did not like aggressive women." Maugham, in fact, did not like women at all as a rule. Most particularly he did not like his wife, Syrie, who was one of the leading interior decorators of the day, and an active hostess and good friend of Tallulah's.

But Tallulah made the mistake of not heeding Dean's warning. She saw both Maugham and her father in Washington, and then revisited Eagels's Sadie Thompson in Pittsburgh. Tallulah intended to return to England on the same ship as Dean and Maugham, but on Dean's advice, on March 22 she left New York on the S.S. *Caronia*. "Frustrated and miserable," Tallulah didn't leave her cabin once during the crossing, but saturated herself in Sadie by playing jazz records from the second act of *Rain,* spinning them unceasingly while she worked on her part.

Her sights set on *Rain,* Tallulah had turned down two leading roles in the London production of Frederick Lonsdale's Broadway hit comedy *Spring Cleaning.* She could have played either the straying bourgeois wife or the prostitute her husband brings home to shame her out of her infidelity. Tallulah was also offered the chance to play either wife or mistress in *Tarnish,* another proven import from Broadway. But she "wanted Sadie to be my first all-out hussy."

In London, Maugham watched two days of rehearsals and then pounced. Dean summoned Tallulah to his office and told her that Maugham did, in fact, definitely disapprove of her Sadie Thompson. Tallulah's dismissal was both disappointment and embarrassment, for it was and is almost unheard of to fire a star two days into rehearsals. Tallulah later surmised that she had put everything into her first days' rehearsal and given a performance that reflected her idolatry of Eagels, reproducing too slavishly what Sadie's originator had done. She also wondered if at some point she had personally offended Maugham by imitating his stutter, unwitting mimicry being a reflexive habit of hers.

"I had the bother of getting rid of [Tallulah]," Maugham wrote a close

friend. "It was more bother than you would imagine since she used every scrap of influence she had to sway me and when I finally put my foot down I was the object of the obloquy of all her friends."

On the sidewalk, "sobbing as I had not sobbed since foiled as a child," Tallulah encountered Mary Clare, with whom she had acted in *Conchita.* Clare took her to a tea room and tried to console her. That night, in the apartment at 44 Curzon Street to which she had moved in February, Tallulah gave "one of my phoniest performances," her only formal suicide attempt. Tallulah changed into her Sadie Thompson costume and put one of Sadie's 78s on the gramophone. She swallowed twenty aspirins, scribbled a suicide note—"It ain't goin' to rain no moh"—and lay down on her intended bier. Her farewell message contained an additional irony since London had been subject to a monthlong deluge. As she waited for the end, Tallulah envisioned crowds, "curious and muted," at her door, restrained by impassive policemen. She saw a path cleared for the coroner to enter . . . headlines in all the papers . . . transatlantic cables pulsing with the tragic news . . . and, of course, "Maugham stoned in the streets!"

The next morning, a phone call awakened her. Tallulah felt perfectly fine and even better when she'd gotten off the phone. Producer Tony Prinsep relayed an invitation from Noël Coward to star opposite Edna Best in his play *Fallen Angels,* due to open in less than a week. Best's costar, Margaret Bannerman, had had a nervous breakdown. When Coward himself called to talk to her, Tallulah demanded one hundred pounds a week, sixty more than she'd agreed to for *Rain;* Coward agreed if she could learn the part so that no delay in the opening was necessary. (In 1928, however, Tallulah would admit that Coward had offered to delay the curtain if she needed more time.)

"I don't give a good goddam if I play this or not," Tallulah had announced to Coward when he balked at her salary request. But in truth, she would have cared very much about *Fallen Angels.* Four years after she had met him in Manhattan, Coward's name was now on everyone's lips in theatrical London. And the part was perfect for her: Julia Sterroll, a bourgeois London wife who receives a note from an old flame that he is arriving from Paris for a visit. Jane Banbury, Julia's best friend since childhood, has also shared Maurice's affections, as Julia well knows. But the two women have consigned the affair to the past and believe that their lives will never again be turned upside down by passion. When Jane appears half hysterical on

her doorstep, Julia learns that Jane has received an identical note from Maurice. Jane insists that she and Julia should flee rather than succumb to temptation. But with their husbands conveniently planning a golf trip, the two women cannot resist. Julia orders a lavish meal. Dressed to the nines, she and Jane become besotted on food and drink, increasingly frustrated and quarrelsome as they wait in vain for Maurice to appear. Finally Jane storms out, claiming that she is leaving to fulfill a private audience with none other than Maurice.

When the act 3 curtain rises, Julia is discovered morosely eating breakfast alone. Jane's husband, Willy, arrives and Julia tells him all. They go out looking for Jane, who in the meantime returns to Julia's apartment and tells Julia's husband, Fred. Finally Maurice appears, mitigating his belated arrival with the news that he has rented an apartment in the same building. The women make up a yarn that Maurice is simply an old friend and confidant and the confession they have made to each other's husband was really a ruse devised to make the men more attentive. Maurice invites the women over for lunch. The husbands reluctantly agree, until they hear their wives harmonizing with Maurice on a French love song that the audience knows Maurice used to woo the two wives. Alarmed, Fred and Willy dash out the door as the curtain falls.

Tallulah "came flying into rehearsals," Coward recalled in his 1937 autobiography, *Present Indicative*. "Her vitality has always been remarkable, but on that occasion it was little short of fantastic. She took that exceedingly long part at a run. She tore off her hat, flipped her furs into a corner, kissed Edna, Stanley [Bell, Coward's nominal director], me and anyone else who happened to be within reach, and, talking incessantly about 'Rain,' embarked on the first act."

When they opened on April 21, 1925, Tallulah's crash preparation was in no way evident. She gave "a completely and brilliantly assured performance," Coward recalled. The critics agreed. The *Evening Standard* found Tallulah "exceptionally beautiful and exceptionally amusing." Hubert Farjeon in *The Sphere* said that she and Best had behaved "as amusingly as any women have behaved on the stage for a long time."

But the play was excoriated on the grounds that its depiction of women's adultery and drunkenness was indecent and unsavory. Coward said that he received hate mail from all over England. Some critics made a show of seeming to praise the acting against their better instincts. To the Sunday *Express*, Best and Bankhead were "excellent actresses doing an ig-

noble job nobly." Comparable ambivalence came from *The Tatler*'s correspondent, who declared that:

> The two people who came best out of the whole affair are Miss Margaret Bannerman, who retired from the cast, and Miss Tallulah Bankhead, who took her place, and gives a brilliantly amusing performance. The second act, when they have to portray all the various stages of becoming completely "sossled" is never once offensive, and it is often ridiculously funny. It was a triumph for both of them, more especially for Miss Bankhead. One slight exaggeration, and the whole act would have been thoroughly beastly. But I shall always remember Miss Bankhead's smile of triumph when she suddenly and most unexpectantly [sic] uttered the word psychology without the word staggering all over the place, as it were, and she having to sit down, give it up, and say "brain" instead; as well as Miss Best struggling to be a "perfect lady" before the parlourmaid.

G. F. H. in *The Sketch* concurred that the "subtleties of the drinking scene cannot be adequately described. All I can say is that the disquieting incident is realized with a delicacy and point that deserved the unstinting applause they won from an appreciative audience."

Coward had written a highly accomplished comedy, but the *Observer*'s Hubert Griffith was almost alone in considering the text to be equal to the comedic tropes of the two stars: "When Tallulah Bankhead's acts began so subtly to fail to synchronize with her speech, and tipsy dignity to freeze her thought and gestures, I wondered if Mr. Coward's material could possibly continue to support her amazing technique. It could. . . ."

As so often throughout his career, Coward's characters were condemned for their shallowness and frivolity, for not being characters at all but rather pegs on which to hang quips. *The Era* called Julia's maid the best-drawn character in the entire play. Yet flippancy is not necessarily a drawback in comedy or farce, where characters do function as levers of hilarity. It is not depth or specificity but instead clearly delineated types that often serve the comic muse most effectively.

Julia and Jane were not identical; Tallulah's Julia was the dominant partner. Taken as a duo, however, Coward's heroines provide a new and distinctive comic type that spoke to the wider awareness women gained after World War I. They are not exceptionally creative or brilliant, but sharp and eager to understand the world and themselves. Julia's husband, Fred,

balks when she tells him in act 1 that the first fine rapture of their marriage has gone and they have settled into something more companionable. She's discussed it with Jane, she tells him, and in response Fred calls them "psycho-analytic neurotics." He asks if she discusses everything with Jane, "even the most intimate relationships—us?"

"Yes, you know I do, I always have."

"I think that's dreadful—it shocks me." But he admits that he does exactly the same with Willy. "I'm sure married life was much easier in the Victorian days," Fred says.

Julia tells him, "If you think women didn't discuss everything minutely in the Victorian days just as much as they do now, you're very much mistaken."

"But it was all so much simpler," he says.

"For the men."

"For the women too; they didn't know so much."

Julia corrects him: "They didn't give themselves away so much, poor dears, they were too frightened."

Fallen Angels is about Julia and Jane's marriages, their shared love interest, the friendship between their husbands, but most of all about the volatile yet enduring friendship between two women. The play established them as conspirators in a way that could have made the male psyche of the time very uneasy. *Fallen Angels* acknowledged the possibility that respectable married women could lead secret lives, that they may have had sexual relations before marriage that were not reported to their husbands, that the prospect of extramarital relations is real even on the part of devoted wives. There were almost no female drama critics in London at the time. Had there been, they might have better appreciated the play's subversive message and done less quibbling.

On opening night, Tallulah could not resist putting paid to the *Rain* ordeal by tinkering with one of Coward's lines. "Oh, dear, rain," she was to remark. Instead she spat out disdainfully, "My God, RAIN!" She was met with a wave of laughter by the knowing first-night audience. Talllulah was discovering her own voice, refining the comic possibilities of her delivery, a process that must have begun with Crothers's *Nice People*. Indeed, her single greatest gift as an actress may have been her ability to imbue the most innocuous lines with subtle and ambivalent inflections, often tuning her gift to heightening comic response.

Fallen Angels provides ready material to experiment with overtone and insinuation. "No one could have got more value out of the impudently

witty lines," actor/director Sir Seymour Hicks recalled in 1938. He cited an exchange in act 3 when Julia tells Willy that Jane has run off with Maurice. "I don't believe it—you're unhinged," he tells her. "I'm perfectly hinged," Tallulah as Julia replies. "It's true."

"These lines may not in cold print seem masterpieces of humor," Hicks wrote, "but their effect on the audience, for a large part of which the actress herself must be given credit, was electrical. In the jargon of the profession, they 'stopped the show.'"

In 1978, Anton Dolin acted his recollection of these same lines, spitting out "I'm perfectly—" with affronted dignity, continuing with a pause before "hinged" that prepared the audience for an ambiguous edge on the word itself. It sounded as if Julia's outrage were justified by the borderless world of depravity contained within the word *hinged*.

"I've had much too much to eat already," Jane tells Julia's maid Saunders during the act 2 bacchanalia. "So have I, but we must go on, it will keep up our strength," Julia replies. In 1992, Quentin Crisp recalled attending the performance as a teenager. Tallulah read the line in a tone of stoic resignation that underscored "must." The audience fell apart with laughter.

Coward writes that "there was no sense of struggle" between Best and Tallulah, and said that the fact that they remained amicable during the run was "definitely a strategic triumph," given that "their parts were about equal and that they had to play the whole second act alone together." "Neither of us felt jealous of the other," Tallulah claimed. She and Best took to attending parties together, entering hand in hand and announcing, "Yes, we're still speaking. Aren't you all surprised?"

Best was marvelously attractive and a superb actress, equally definitive in her renderings of commonsense British self-sufficiency and of tremulous, gaminelike poignancy. She was then married to Herbert Marshall, with whom she sometimes acted. Tallulah considered Best "one of the sweetest and nicest people I have ever known on or off the stage." Yet according to Best's daughter Sarah Marshall that did not prevent Tallulah from laying down a gauntlet to Best early in the run. Tallulah was to supply a "feed" line to Best, and thus elicit from Best a punch line. But at one performance Tallulah mumbled the feed line that Best was waiting for. Best was rather awed by Tallulah, but she wanted her laugh and so she mustered her courage. "Excuse me, darling," Best improvised, "I didn't quite hear what you said." Tallulah dealt her a look and then mumbled the line once more. Best thought it would go on forever. "I'm sorry, dear," she insisted, "I still can't understand a word you're saying." Tallulah took the

olive pit out of her mouth, very pointedly put it down on the plate, fixed Best with a stare, and enunciated the line with punctilious clarity. Best said her line and got her laugh. "And they were best friends for the rest of their lives," Marshall recalled.

"I enjoyed every performance," Tallulah would write about the run of *Fallen Angels,* but perhaps she enjoyed them more than Coward felt was necessary. "She was totally undisciplined," Coward's ex-lover Jeffrey Amherst complained in 1982.

Almost every item in the five-course meal Tallulah and Best consumed onstage was made from bananas. The cocktails they drank were really ginger ale; however, one night Tallulah decided to substitute champagne. Best took one sip and looked at Tallulah, horrified. Suddenly Tallulah realized the peril she'd put them both in: the dialogue and stage business required that they drink refill after refill during the next thirty minutes. It was difficult enough to speak clearly when her mouth was constantly chewing, let alone trying to do so with a thickening tongue. "I never drank so much so fast in my life," Tallulah said in 1962, and yet she claimed that both she and Best stayed cold sober—"out of sheer terror, I guess." Nevertheless their acting was so constrained that "we didn't get one single laugh in a scene that was foolproof for laughs."

"Tuesday she might give a performance that would knock your eyes out," Amherst said. "Frightfully good. And then Wednesday night go off, and Christ knows what might happen. Noël got very cross with her, but she wouldn't listen to anyone if she didn't want to." Coward later claimed that the "well-marked restraint" with which *The Era* said that the dinner scene had been handled gradually eroded. He was constantly taking offense on behalf of his scripts. In his opinion the pristine perfection of his dialogue could only be diminished by the embellished shtick introduced by actors. He had similar arguments with nearly every star who acted in one of his plays. With Tallulah, matters came to a head when Coward confronted her and tore her performance to shreds. They did not exchange words at all for three years, Coward later recalled. Visiting London in 1928, playwright S. N. Behrman witnessed "a minor, controlled spat" between them in Coward's dressing room. Una Venning, who acted in several of Coward's plays, said that "Noël admired her very much: her determination, her enjoying life her way," yet his relationship with Tallulah would always be a little equivocal.

Tallulah told John Kobal in 1964 that of all the plays she had done in London, *Fallen Angels* was the one she most enjoyed, and perhaps there was a slight defensiveness in her caveat: "And I thank Noël for that. Always."

Femme Fatale

"There were some God-awful lines in *The Green Hat*. . . . I couldn't bring myself to speak the stuff. So I just mumbled the unbearable lines when the time came. The audience didn't seem to mind."

Tallulah was involved with innumerable men all through her London years. "I sometimes think that I was born in love," she wrote in 1928. "But I am always changing the object of my objections," she admitted, but perhaps thinking particularly of Alington, wrote that "more frequently it is the object that falls out of love with me." Her lovers ranged from French tennis champion Jean Borotra to American tennis champion Frank Hunter to British peer Lord Birkenhead. Next to no information survives about most of these affairs and how seriously she took them, but they seem to have been short and/or protracted but casual. What is apparent, too, is that Tallulah's need to incarnate herself as a sexual adventuress was as strong as her need to have sexual adventures. "She wanted to be thought a very go-getting woman," Gladys Henson said. What had begun in New York was now amplifying in London. She painted herself as a reprobate, broadcast her own wickedness. Her flaws became the butt of her own ironic badinage. "If anybody had something bad to say about her, she'd have said worse," Henson recalled. "She was a very maligned lady, but she maligned herself more than anybody else did."

Henson was a few years older than Tallulah, and had been on the stage since she was a child, before retiring in 1926 when she married Leslie Henson, one of the foremost comedians of the day. Henson returned to the stage in 1933 after they divorced.

Offstage and on, Gladys Henson was "a wit if ever there was one," as Clifford Mollison recalled. Yet initially she was "terrified" at the idea of meeting Tallulah because of Tallulah's own sharp and occasionally deadly sallies. Nevertheless they became close friends. "She was a darling," said Henson. "I loved her." Henson had her own pet name, "Lu," that she alone employed. "She was kind-hearted—her heart was in the right place. She put on the hard boiled stuff all right, but she wasn't really."

Henson noted and accepted the disjunction between Tallulah's intellect and her emotions. "She was clever as paint. You'd have thought she was a lot older than she was. She read a lot, you see. She was quite literary minded." Tallulah was also "very self-centered," Henson said. "She'd want to know everything that happened the night before, that kind of thing. But if you bored her she'd say, 'Go away, you're giving me claustrophobia!' And we'd say it right back to her." When Tallulah boasted excessively of her father's achievements, "I'd yawn and say, 'You're at it, again, Tallulah.' She was really just an ordinary human being," Henson said, "in an extraordinary way!"

David Herbert found her less self-centered. Herbert was the second son of the Earl of Pembroke, who was an acquaintance of Will Bankhead. Herbert got to know Tallulah after Will alerted Herbert's father to her arrival in England. "A lot of actors and actresses are rather bores if I may say so, going on about themselves all the time," Herbert said in 1993. "Tallulah didn't, you know. She would be full of life in general, what was going on, general conversation—it didn't always come back to Tallulah." He found her "extraordinarily thoughtful," interested in him, always asking, " 'How are you getting on? How's life?' "

Irish dancer Patrick Healy-Kay became a star of Diaghilev's Ballets Russes under the name Anton Dolin. After a feud with Diaghilev, Dolin left the company, and in 1925 was dancing on a variety bill at London's Coliseum. From the stage he noticed a very beautiful young woman sitting in the first row of the orchestra every week on a certain matinee day. But he didn't meet Tallulah until one week when she went backstage to visit Norah Blaney and Gwen Farrar, who were performing on the same bill. "Oh, you're not tall!" she greeted him. "I only like tall men!" Her assaulting bravado did not faze him, and indeed Dolin was a firebrand who could

give as good as he got. They became fast friends. "Despite all her flamboyant 'I am, I am!' she listened, too," he recalled in 1978.

In her next play, Michael Arlen's *The Green Hat,* Tallulah again impersonated a woman after whom she might have patterned herself: Iris March, a notorious adventuress who was one of the great literary heroines of the decade. The play was a dramatic adaptation of Arlen's enormously popular novel of the same name. The son of Armenian immigrants, Arlen was fascinated by the British aristocracy and wrote novels about the romantic peccadilloes of the Mayfair set. His enraptured lyricism was comparable to Fitzgerald's, but quite a bit more engorged. Arlen enjoyed a tremendous vogue before his literary gifts seemed to sink under the weight of their own excess.

In *The Green Hat,* Iris March is secretly engaged to Napier Harpendon, scion of a landed-gentry family. Secretly, because the Marches and the Harpendons are enmeshed in a Capulet–Montague enmity. Napier's father considers the Marches immoral and forbids the marriage. Instead, Iris marries sports hero Boy Fenwick, who kills himself on their wedding night. "Boy died for purity," Iris announces, encouraging the belief that he killed himself when he discovered that her purity fell short of his ideal. In actuality he killed himself at the shame of having to disclose that he had venereal disease. For her pains, Iris must endure the denunciation of her dissipated younger brother, Gerald, whose worshipful attention to Boy is never quite explained.

Iris decamps to the Continent, from which scandalous reports of her behavior drift back to London. She returns several days before Napier's wedding to a conventional young woman is to take place. She asks his help in contacting her brother, who is dying of pneumonia. The inevitable transpires.

Napier's wedding proceeds, but Iris secretly gives birth to a stillborn child she had conceived with Napier. When Napier learns that Iris was blameless in her husband's suicide, he tells his wife. She insists that he reunite with the woman he has really loved for so many years. This leads, however, not to Iris's triumph but to her destruction; she believes Napier has betrayed her, robbing her of the one unselfish act she has committed. His need to protect her reputation reduces her estimation of him. She lies to him that his wife, Venice, is pregnant and sends him back to her, then drives her yellow Hispano-Suiza into an ancestral elm on the Harpenden estate.

Overwrought as it was, *The Green Hat* hit the 1920s in the solar plexus

by positing the thesis that coexisting with, and indeed exonerating, Iris's ostensible immorality was a spiritual nobility that put to shame the condemnation of her upstanding accusers. Iris's contempt for the British status quo is probably one reason why the play turned out to be a bigger hit in the U.S. than in Britain. "I despise our England," Iris tells Napier's father in a final confrontation in act 4. "I despise us. We are shams, with patrician faces and peasant minds. You want to bully me with our traditions. May God forgive you the sins committed in their name and me for ever having believed in them."

Tallulah and Arlen were friends well before *The Green Hat* became a bestseller. Tallulah claimed that an incident in the novel was based on a night when she and a group of friends motored down to Maidenhead and swam in the Thames. It was noted by the *New York World* in December 1924 that she was "spending considerable of her spare London moments" with the novelist and was already signed to play the part, although at that very moment she was pining for *Rain* while still starring in *The Creaking Chair*. As it turned out, Gladys Cooper had already been extended the right of first refusal on *The Green Hat* and decided to accept. It was racier than anything Cooper had done before, however, and she had second thoughts and withdrew. By then, *Rain* had eluded Tallulah, and she was thrilled to finally get the part of Iris March.

Barbara Dillon played Napier's fiancée, Venice Pollon. Dillon had been studying at London's Royal Academy of Dramatic Art, but was forced to leave before graduating because she needed to earn her living. She was as close to the sheltered Venice as Tallulah was to Iris. She had been on several tours of West End hits around the U.K., but *The Green Hat* was going to be her West End debut. "I was very shy, very nervous with everybody," she said in 1982. Yet Arlen himself was short and visibly foreign and that made him less formidable. He would always be something of an outsider in England. "When I saw Michael Arlen I thought, 'Hell, I'm not afraid of you.'"

The production was directed by Nigel Playfair. Playfair was one of the preeminent, yet most elusive theatrical figures of the time. He worked in West End commercial theater and also ran the Lyric Theatre in London's Hammersmith district, where he staged many classic revivals. "Nigel was very clever, but he got there very slowly," said Dillon. Playfair didn't come onstage and direct traffic, as directors were wont to do in those days. His direction was mild and Dillon approved. "He waited to see what you had to give and then he'd put something on top, whereas some of them just put something over you like a hood." During rehearsals the term *death wish* was

bandied about quite a bit. Iris's downfall was discussed as the inevitable re-sult not just of circumstance but an irresistible hunger for destruction that doomed generations of Marches.

Dillon snuck to the back of the theater whenever she could to watch rehearsals of scenes she wasn't in. She found that Tallulah was very intent on getting things "exactly right" and accepted Playfair's direction without dispute most of the time. Dillon retained a vague memory of Playfair in the first row of the orchestra and Tallulah at the edge of the stage arguing about a point of stage business. "He was so quiet and obstinate. It annoyed her. I think he won," she recalled, but Tallulah "would easily fly off if things didn't go her way—if her dresser forgot something. It would blow over in a minute. It wasn't simply a temper tantrum. She was a perfection-ist. She wanted what she wanted and she knew what she wanted."

Tallulah accompanied Dillon to the fashionable Handley-Seymour dress salon on New Bond Street, where Dillon was going to choose her clothes for the play. Several of the other women in the cast were also being outfitted there, while Tallulah's own costumes were designed by Chanel. One dress Tallulah advised Dillon to choose was a shade of midnight blue. At the dress rehearsal, Dillon looked down and saw that stage lights turned the blue to a less alluring dark gray, which she hated. Dillon had been in awe of Tallulah since the first rehearsal—"she had such a glamour about her you felt she could do anything." Although Tallulah "was always per-fectly pleasant to me," Dillon could never escape the feeling that she had been set up. "After that I felt I must be very careful not to step in her light."

During the final weeks of *Fallen Angels,* Tallulah was performing at night and rehearsing *The Green Hat* during the day. It was not unusual, in those prolific days of live West End theater, for popular performers to pig-gyback performances and rehearsals. *Fallen Angels* closed on August 29, and *The Green Hat* opened on September 2, 1925. As had *Fallen Angels,* the play outraged the critics on moral grounds. The *Times*'s James Agate lived a furtively homosexual life, but he was still conventional enough to take offense that *The Green Hat*'s tribe had "no occupation save making love, if love be the word; and one would say that their world is like a deer forest in the rutting season, if it were not that the stag is a noble animal."

Tallulah's performance was praised avidly in some quarters. Noel Har-ris in *Theatre World* admired her "dignity and air of tragedy" in the first act, although he felt she had brought "the character down to a lower level" in the torrid scene of act 2. The *Mail* praised Tallulah for her restraint, assess-ing that she "played quietly, and at times pathetically and always pic-

turesquely," and even contrasted her restraint to overacting in some other quarters: "She, at least, did not find it necessary to play upon the top note."

Leonard Upton played Napier. Upton had made his debut in 1919 at Playfair's Lyric Hammersmith. Dillon found him "a bit of a stick. I don't know what [Tallulah] thought, but I didn't think he was a very good actor. He was a pretty face most of all." Harris in *Theatre World* agreed, finding that Upton seemed "rather youthful to be caught in the maelstrom of great tragedy." Dillon avidly watched Tallulah's love scene with Upton, when Iris March visits Napier on the eve of his wedding; she wondered if Tallulah was able to elicit more than she had been able to. "She did, and it was quite powerful, but even so, he wasn't up to her par."

Along with Iris's final face-off with Napier's father, this love scene is perhaps the most memorable episode in the play. Napier and Iris pass through various stages of awkwardness and recrimination before they finally surrender to each other. They are now thirty but seem to be reliving their childhood companionship and adolescent romance. Iris's sexual rapacity is presented as a form of compulsion. "Shall I scratch my face—and make myself ugly? Shall I, Napier? I've had no fun for my beauty—only hell." Arlen titillated his audience with this vision of debauchery as a form of masochistic servitude, which at the same time vitiated Iris's transgressions, giving her more depth than a remorseless temptress would have. The *Evening Standard* said that the scene was "undeniably moving, and reveals the beauty that slumbers even in the lady who has been described as a beast. Here we had Iris and her portrayer both at their best."

It was in *The Green Hat* that Tallulah first reaped a consensus of criticism for careless diction. Alongside its praise, the *Evening Standard* nonetheless noted "considerable difficulties for the audience in the way of inaudibility." *The Stage* attributed her enunciatory irregularities to her five months in the Coward play, which it felt had left her "unable to get rid of the modern drawl, with slurred vowels and softened consonants" that she evinced in her long drunk scene with Edna Best. St. John Ervine in *The Observer* was of the opinion that the more Arlen's "appalling dialogue" was muffled the better the writer's interests were served: "Even so fine an actor as Mr. Norman McKinnel [who played Napier's father] had difficulty in keeping his head above the sea of silly words in which he and the rest of the company had to flounder. Some of them went under. Others helped the author by being inaudible at times. But none of them . . . were able to hold up all the time."

Critics would fitfully take Tallulah to task for a Dixie-style elision of consonants throughout her career. Since this was one component of her very personal and distinctive style, she may have not cared. On the other hand, Tallulah later recalled that she had gotten very alarmed when "some idiot in the gallery" called out "Speak up!" at her. These were fighting words, for any difficulties in following a play made the gallery fans furious. "I was terrified that I wasn't projecting," Tallulah said, and she stopped smoking for a while because she thought it was impairing her diction.

But what had likely taken place on the opening night of *The Green Hat* was something else. "There were some God-awful lines in 'The Green Hat,'" Tallulah recalled in 1938. "Boy died for purity" was an utterance that, in her opinion, "human beings simply don't say. I couldn't bring myself to speak the stuff . . . so I just mumbled the unbearable lines when the time came. The audience didn't seem to mind."

But Arlen certainly may have. In 1927, he published his novel *Young Men in Love,* in which an American actress named Ysabel Fuller bears a distinct resemblance to Tallulah. Ysabel goes to London, where she is taken under the wing of the middle-aged Miss Estelle Van Herben, "one of a considerable body of women who in our time have disdained marriage." In London, Ysabel becomes a musical comedy star. Passionate but shallow, she exerts a corruptive influence on the novel's hero.

One year after *Young Men in Love,* Tallulah delivered a postmortem on *The Green Hat.* "Although the book was so delightful, the play was undoubtedly bad—just full of lyrical lines that sounded out of place when spoken in modern dress." Her verdict was shared by many, yet it may have been a shortcoming of her sensibility that she could not suspend her own disbelief in Arlen's heightened rhetoric.

In 1923, Tallulah had seen Eleanora Duse's final appearance in London, when Cochran presented her in a special series of matinees. "She was magnificent," Tallulah recalled in 1966, lavishing what was for Tallulah the ultimate accolade, that Duse was "as realistic and as natural as one would be today." But the yardstick of reality that Tallulah treasured could conceivably also be located on the lofty plane of lyricism established by Arlen, even in the unlikely garb of contemporary dress.

Perry Brownlow was a member of the Grenadier guards and an avid theatergoer; eventually he became equerry to King Edward. He was also Barbara Dillon's cousin. Brownlow and Tallulah were having an affair

and "my family very much disapproved of this infatuation," Dillon recalled. When Brownlow squired Tallulah, Dillon and newspaper executive Richard Norton frequently went along as makeweight. One night Dillon went into Tallulah's dressing room to borrow an evening gown for that night's club hopping. Her dressing room was immaculate, a testament to the skills of Elizabeth Locke, who worked for Tallulah in her apartment and at the theater, "one of those marvelous dressing women," Dillon recalled, indispensable to theater stars for their silently omnipotent maintenance. "There was nothing she didn't know," Tallulah's friend and colleague Glenn Anders would say about Locke's presence in Tallulah's life.

The theater business was still reeling from the economic catastrophe of World War I, and any run over a hundred performances was respectable. *The Green Hat* managed 128 performances, and Dillon remembered full houses up to the end of the run. She seemed to recall that Tallulah had announced she was leaving. "I think she'd had enough of it." Dillon was not surprised, for "it was an awfully stupid play, such a silly story." For her, too, the lyricism and the symbolic weight of the novel had been lessened by dramatization.

Tallulah went so far as to say that she "grew to hate" *The Green Hat.* "I had to interpret the part of a morbid woman in a depressing atmosphere all the time," she wrote in 1928. "I do not personally think that any woman can appear attractive if she is devoid of a sense of humor, as that woman was. . . . I did not enjoy acting in that play half as much as I enjoyed my part in 'Fallen Angels.' The one was as morbid as the other was gay."

Offstage and on, comedy was then and would remain her preferred métier, perhaps her favorite way to deflect emotional exposure. "It was very difficult to pin her down about anything," Tallulah's friend Stephan Cole said, "because Tallulah would say anything that fitted the moment and would be funny. She couldn't resist it." Cole asked her once why she'd gone into the theater, and she told him, "To meet men."

Humor was a buffer against life's vicissitudes. "If she had a failure, she'd rise above it by making a joke of it," Gladys Henson recalled. Onstage she found the audience's enjoyment of what she did so intoxicating that she could often up the ante with as many embellishments as they would tolerate, even if it meant overriding the objections of an author like Coward. Just as much as drama, humor of course acknowledges life's trials even as it turns them on their ear. Tallulah resented that comedy took sec-

ond place in prestige and academic approbation. "I think comedy is the most creative and original thing," Tallulah told John Kobal in 1964. "It isn't just the author. You must create something out of yourself. And it makes me sick when nobody ever gets any award for a great comedy performance. Chaplin never got any award, although I cry more at his films than laugh, because they break your heart."

Something Different

"Good thing I had me drawers on, wasn't it?"

T he gallery, the highest tier of the theater, had been for much of the nineteenth century a refuge for prostitutes. By the 1920s the spectators who crowded into the unreserved bench seating were socially infra dig only because of their poverty. But they were nonetheless an established pillar of the theatrical community, even an elite of sorts. Raucous in their approval or disapproval, their opinions were consulted, or at least taken into account, by producers and stars. They were exceptionally loyal to their favorite stars, with whom it was not unusual for them to become personally acquainted. Bernard Bashwitz, a teenage gallery regular during the late 1920s, recalled two sisters who adored musical comedy star Jack Buchannan. "Jack was very good to them," Bashwitz said in 1982, and at one Buchannan opening night, the sisters happened to be sitting next to people who hated the show. A skirmish nearly developed because the sisters "just couldn't tolerate anybody saying anything against Jack."

Tallulah was acquiring a gallery following that was, according to *Theatre World*, "unlike that enjoyed by any other actress." It was for one thing largely female; the gallery was sometimes called the "Gods," and Tallulah's fans became "goddesses." Even by the norms of the gallery, its adulation bordered on the hysterical. Tallulah had become "almost overnight, the idol

of all the up-and-coming generation of working girls," Basil Dean writes in *Seven Ages,* "who saw in her the embodiment of their dreams of a free life."

Even the cheapest theater tickets made a sizable bite in the budget of the untrained working woman. Many of Tallulah's fans were making no more than a pound a week, whereas Tallulah's salary climbed by the end of the decade to hundreds of times that amount. Tallulah rewarded her zealous admirers with special acknowledgment, taking her curtain calls by lifting her gaze first to the gallery, then slowly lowering it until she eventually reached down to the stalls, the high-priced tiers at the back of the orchestra. "To me the attendance of the galleryites was a greater tribute," Tallulah writes in *Tallulah,* "since it involved greater sacrifice, than the presence of the loafers in the lower regions."

As *The Green Hat* reached its closing, Tallulah was returning to Dean's aegis. Dean had replaced Tallulah in *Rain* with Olga Lindo, an excellent young actress, and the play ran for five months, but Dean regretted not challenging Maugham's decision, for he believed that *Rain* would have run a lot longer if Tallulah had starred. Dean offered Tallulah the lead in *Scotch Mist,* a new play by Sir Patrick Hastings, hoping that she and the very popular Godfrey Tearle would be able to rescue a script that Dean considered poor. Hastings was a prominent attorney and had been attorney general in Ramsay MacDonald's government. Dean calls him the most prominent cross-examiner of the day, whose performances at the bar "possessed an acute sense of dramatic values." Playwrighting was a sideline that Hastings plied with imperfect success. "Although his dialogue was terse and sharpened with caustic humour," Dean writes, "none of his characters ever seemed to come alive."

Tallulah was Mary Denvers, the indiscreet wife of cabinet minister Sir Lawson Denvers. Tearle was equally well cast as David Campbell, a rugged, taciturn Scotsman. Mary proclaims at the beginning of the play that morally she is as spotted as a leopard. Her husband copes with her apparent infidelities by raining down upon her Hastings's much-praised epigrams. Mary is about to go to Deauville with Freddy Lansing, her latest admirer, when David, a friend of her husband and old flame of hers, suddenly returns to London from an African expedition. Sir Lawson and David have planned to go fishing at the ancestral home of the Campbells, situated in the wildest part of the Highlands. Mary is riveted and invites herself along. Adding to the mix, Freddy decides to tag along, too. In Scotland, while Denvers and Freddy are out on a long fishing expedition, David and Mary are left alone. He professes his love and tells her: "Every one of

those men who you cheated is in this room, watching you now. You are going to pay us all." Mary struggles, smashes a lamp, the stage goes dark, and the curtain falls.

The next morning Mary is discovered alone and traumatized. Her husband tells her, "I remember a short time ago you envied the position of a prostitute. That hardly seems necessary now." But it is now revealed that where there had been smoke there was not fire, another example of the requisite obfuscation of the time where the sexual behavior of a stage heroine was concerned. Mary is not really a bad woman; she has merely been living up to the pose invented for her by her husband. But though she is furious at David, he defends his aggression by telling her that she is being stifled by her loveless marriage and he is determined to revitalize her. She cannot deny that she has fallen in love with David, and Mary's husband and Freddy disappear conveniently as the third act curtain falls.

"I always found Tallulah extremely charming," Hastings writes in his 1948 *Autobiography,* "and both my wife and I liked her enormously. Not only was she a delightful actress, but she was free from those exhibitions of the artistic temperament which are not wholly unknown in the theatre and can on occasions become a perfect nuisance." An inducement to refrain from exhibitions of the artistic temperament may have been Hastings's repeated effusions to the cast about how their acting abilities far outshone his script. "Her kindness to everybody connected with the theatre was remarkable," Hasting writes, "and she was the most popular leading lady I have ever met." Hastings recounts that at a dress rehearsal, her costumes arrived late from the costumier: Tallulah disappeared, but was soon found in the Ivy restaurant next door, ordering dinner for the three seamstresses who had worked overtime.

Godfrey Tearle was married to Mary Malone, a beautiful Irish actress. Malone was intensely jealous despite the fact that Tallulah evinced no sexual interest in Tearle. Nevertheless, Malone attended every rehearsal, "making her feelings so obvious," Dean recalls, "that everyone in the theater viewed the progress of this tea-cup comedy with secret amusement." When the time came to allot the dressing rooms, Malone told the stage manager that Godfrey would prefer to dress at the top of the theater, next door to the wardrobe room, where he would get more fresh air, and conveniently be well out of Tallulah's way, since she was, naturally, dressing on stage level.

At the final dress rehearsal, both Tallulah and Dean were astonished to

find Malone seated in the middle of the front row of the orchestra. When they came to the second-act climax, Tallulah emoted with such abandon that Malone was reduced to tears. It was, Dean writes, "as if her Godfrey were being raped before her eyes." After the curtain came down, Dean was walking backstage to give the cast notes. Tallulah popped out of the door connecting backstage and auditorium, shot a look at Malone, and then said to Dean, "Good thing I had me drawers on, wasn't it?"

On the opening night, Tallulah played with the same intensity, nearly breaking her arm in the second-act finale. "The part of the wife is the most exacting I can remember," she told a reporter, "and I went on to the stage very anxiously. It is such a varied role, and in the second act a little realistic violence is necessary. I missed a step, and I can only blame that first-night feeling."

"In my endeavors to be modern perhaps I had gone a little too far," Hastings writes. "At the end of the second act there was considerable doubt as to whether or not Tallulah had saved her honor by the skin of her teeth. In fact she had not. That may be the reason why her many admirers were a trifle shocked."

Newspaper magnate Max Beaverbrook hosted an opening-night party and let Tallulah write out the guest list herself. By her account, a large and eclectic turnout enjoyed a champagne-in-the-scuppers shivaree; it was not dampened by the derisive reviews that started to appear early in the morning. Read today, *Scotch Mist* seems equal parts meretricious romantic melodrama, bright comedy of manners, and one of the most mordant portraits of marriage on the rocks to be written between Strindberg's *The Dance of Death* and Albee's *Who's Afraid of Virginia Woolf?* But London's critics had no time for it at all. "You should have heard the comments of the pit and gallery when they left 'Scotch Mist,'" Hannen Swaffer wrote in the Sunday *Express*. "But for the general popularity of Mr. Tearle and Miss Bankhead there would have been booing."

"Tallulah was really good," Swaffer declared. "She gets better in every part she plays. She is of-the-moment and she looked really beautiful but only her good acting, and that of Godfrey Tearle saved the first night from absolute disaster. It was, at first cheaply cynical and afterwards, so brutal." *The Era* called her part "long and exacting . . . it is greatly to her credit that she extracted from it every spark of interest." *The Sketch* reported cryptically that she was "somewhat undistinguished in manner, but she has had good training." The *Evening Standard* said that she had "acted so extremely well as to minimize the slight exaggeration of Sir Patrick's compliment,"

given in his curtain speech, that Tallulah was "'the first actress in England.' In the first act, where she had some comedy, she was delicious."

The day after the opening, Hastings came to the theater to commiserate with Dean and his partner Alec Rea. They were engaged in a frantic search to find a new attraction for the St. Martin's Theatre. The box-office manager came into the room, a little dazed as he explained to them that his telephones were working overtime: everybody in London seemed to be wanting seats, and he had to suppress his initial suspicion that they were calling the wrong theater by mistake. That night and for a number of weeks they were sold out, but the run sputtered after a number of prominent moral arbiters, including the Bishop of London, issued stinging denouncements. Dean, however, writes that the public condemnations were what enabled *Scotch Mist* to last as long as it did.

In any case, after a couple of months Dean was offering Tallulah a prime opportunity in the role of Amy, a poor waitress in Sidney Howard's *They Knew What They Wanted*. Howard's third play had garnered the thirty-three-year-old playwright his first hit and a Pulitzer Prize after it opened on Broadway in November 1924. In New York, Amy had been created by Pauline Lord. Nearly forgotten today, Lord was one of the most revered stage stars of the century. A rather bovine, dowdy figure, she specialized in portraying waifs, strays, lost souls: in 1921 she had created O'Neill's *Anna Christie*. She was just as expert in comedy, as she demonstrates in her one film, *Mrs. Wiggs of the Cabbage Patch,* in which she stars opposite W. C. Fields.

Lord had decided not to repeat her triumph in London, and Dean welcomed her decision because "I was thinking all the time" of Tallulah. That was a bold decision on his part because the part was unlike anything she had ever done. He had to convince both Howard and the Theatre Guild, which owned the play; they were at first "violently opposed" to his choice.

Howard's most lasting fame accrues as the author of the screenplay for *Gone with the Wind,* but he was one of the most versatile and prolific playwrights of the twenties and thirties. Many of his best works were adaptations of foreign scripts or historic themes: *They Knew What They Wanted* transposed elements from *Cyrano de Bergerac* and *Tristan und Isolde* to the Italian winegrowers of California's Napa Valley. The plot tells of a sixty-year old vineyard owner, Tony, who has wooed Amy, a bedraggled "Frisco" spaghetti slinger, by mail with pictures of his handsome young foreman, Joe. Amy has accepted Tony's marriage proposal and, as the first act begins, is about to arrive by train at the ranch. Tony is so apprehensive about con-

fronting her with his true appearance that he crashes his car and breaks both legs on the way to meet her. Amy decides to go ahead with the marriage because it offers undreamed-of security. But on her wedding night she falls into Joe's arms. By the third act she is settled in her new life and genuinely attached to her husband, but discovering herself pregnant by Joe, she is about to flee with him. Tony, however, is willing to accept their child as his. Amy is content to stay with him, while the restless Joe moves on to another itinerant berth.

In London, Tony was played by Sam Livesey, with whom Tallulah had worked in *The Creaking Chair*. Glenn Anders had played Joe in New York, and although a decade older than Tallulah, he had never visited Europe and was eager to make his debut in London. Tallulah had seen him act in New York, and his presence, his knowledge of the play, buttressed her decision to try something so different.

Anders's first day of work in London was unforgettable for him. Alone with Dean, Tallulah and Anders began rehearsing their initial meeting in the first act, but before long Tallulah was giggling at what Anders was saying to her. She'd never heard the lines ladled out with the folksy drawl he used. From the front row, Dean issued a stern "Stop giggling, Tallulah," and continued to deliver his customarily precise line readings and instructions. As John Gielgud has recalled, Dean "would not allow people to think for themselves or develop their characters freely and his meticulous method of giving them every inflection and tone, before they had experimented themselves, made them feel helpless and inefficient." Dean continued "picking on her," Anders related, until after about twenty minutes Tallulah rose out of her chair and to Anders's shock "just broke it up." He didn't recall "whether she said something vindictive or something angry, or nothing. But it would be like Tallulah to say, 'Oh, shut up, Basil.'"

Tallulah led Anders away to lunch at the Ivy across St. Martin's Lane. Dean sat on the other side of the restaurant. Tallulah ignored him, but plied Anders with question upon question about the New York she hadn't seen in three years. Around the dining room a ledge ran behind the banquettes. It was an off hour, thirty minutes after the lunch crush had begun to thin. Anders was taken aback at the cavalier way that Tallulah let Napoleon, a Pekingese that Alington had given her, scamper around the ledge. Suddenly another diner felt something warm and frisky licking her ears. "Oh, darling Naps," Tallulah scolded, "come back here, you naughty little boy!"

After they went back to rehearsal, the afternoon passed without fur-

ther incident. Tallulah invited Anders over to her apartment on Curzon Street, charging into the suite of tiny rooms. "Tallulah: talk, talk, talk, talk, grabs the hat, throws the hat down, and goes into the drawing room. Talk, talk, talk, talk—then another room." By the time they got to the bathroom, Tallulah was stark naked and ready to plunge into the bath that had already been drawn for her by the meticulous Mrs. Locke.

Tallulah found Dean cold and flinty, as did most of the actors he directed, but "she accepted the fact that he was a good director," Gladys Henson would recall. Surviving photos show a Tallulah integrated into the rural ensemble Howard had devised, and scaled down into the prosaic dimensions of his heroine. "Tallulah was trying her damndest," Anders recalled. "She would do anything. Oh, *God*, how she tried!" Dean found Tallulah's approach was "intelligent—no surprise that—and conscientious even to the dressing of the part":

> Her appearance in a wedding dress . . . was an obvious opportunity for display by anyone as fashion conscious as Tallulah, but she did not fall into the trap. She went off to buy the cheapest clothes she could find, but she wore them with such distinction that one of our women's papers accused of her over-dressing the part.

Dean's publicity chief immediately announced that her wedding dress and two cotton dresses with accessories cost six pounds in all.

Scotch Mist closed on May 3, 1926, a watershed day in British history: the first day of the general strike that paralyzed England. Workers in all industries walked off their jobs, but Tallulah continued to rehearse *They Knew What They Wanted*. With no cabs available, she took to standing in Piccadilly, flagging any passing car and announcing, "I'm Tallulah Bankhead. Will you take me to my rehearsal?"

"We didn't have any trouble getting down to St. Martin's," Anders recalled drily. Nonetheless, the nine-day strike necessitated a postponement of the opening night, and Tallulah crossed the Channel for a brief rendezvous with the gaming tables of Le Touquet. When they finally opened in London on May 20, their reception was all Anders and Tallulah could have wished for. Anders never forgot Tallulah walking to the wings and bringing him center stage to "a *hell* of a hand: there were too many Americans in the house."

MARVELOUS SUCCESS IN NEW PLAY, Tallulah cabled Will the next day. SENDING NOTICES WRITING LOTS OF GOOD NEWS AM WELL AND HAPPY LOVE TO ALL TALLULAH.

Hubert Griffith in the *Evening Standard* wrote that while London had seen Tallulah "play many different parts, from very well to very badly," she had never before "touched anything like last night's performance in its strong, considered 'drive,' its strength and its subtlety."

"She has got into the skin of this slangy, self-respecting, decent-minded waitress," *The Era* declared. Tallulah had "exhibited the girl's mind—her misery, her courage, her loyal acceptance of the consequence, with revealing skill," reported the *Times*. The *Telegraph* wrote that "she shows us, as Amy, that she is a better and more versatile actress than we had been allowed to suspect hitherto."

Despite Amy's infidelity, this play did not provoke the squeamishness elicited by Tallulah's earlier London vehicles. The *Telegraph* expressed its relief that she had been "for once allowed to get away from her studies in decadence." Her transgression was extenuated by the Latin flavor and the American locale. For *The Sketch,* Amy "was the strong, matter-of-fact girl who had struck a bargain and meant to stick to it beyond one moment's yielding to the call of youth—so natural in a sultry clime where the sun and blood radiate in intensity." Furthermore, Amy was a monogamous woman who elected to stay with the husband she had grown to love. The *Times* was grateful that the passion of the second act was handled with discretion. "A little too much wildness, the least concession to pseudo-Orientalism would have made of Amy a trivial good-for-nothing."

Anders recalled that onstage Tallulah worked in "complete sympathy" with him, and this sympathy was essential for their scenes together. A long duet in the first act counterpointed her tentative attempts at intimacy with the silence of the bewildered Joe, who is in the dark about Tony's deception. The *Times* described how Tallulah "nervously twisted her handkerchief and made little advances to him, half-bold, half-naïve," while Anders "stared and hesitated and swaggered in his shyness." The scene was "extremely moving," recorded Griffith in the *Standard,* and "magnificently acted."

Their romantic encounter came at the end of the second act, a thunderclap in an appropriately volatile setting. Oil lamps burn low in the living room of Tony's ranch. Outside the grounds are hung with lanterns, while raucous and festive voices echo offstage from the nuptial celebration. Tony has been put to bed and Joe plans to sleep outside; he talks to Amy as he puts together his bedding. "Joe doesn't know," Anders said about his stage character, "it doesn't dawn on him that the scene is getting hotter. But the audience knows; they can feel it." Joe points out many endearing traits

of Tony's, trying to encourage Amy toward her rightful place with Tony in their wedding bed. From time to time he lays a reassuring arm on hers, until finally she bristles—"Leave me alone, can't you?"—and Joe instantly understands what her agitation is all about.

"Tallulah had a marvelous ability to make the audience feel what she was," Cathleen Nesbitt recalled. When Anders put his hands on Tallulah, a little shiver went through her and "the entire audience shivered too." Tallulah bolted into the garden and Anders ran after her. A man sitting behind Nesbitt remarked to his friend, "That curtain went down just in time, or we *would* have seen something!" Fifty-two years later, Nesbitt's eyes lit up as she said, "I've never seen anyone able to create such erotic tensions, without any words! Tallulah left you breathless."

During the play's run, "we were together much more than we were apart," Anders recalled. After the show he was invariably in white tie in case they decided to go dancing, Tallulah on his arm in short flapper chemises. Tallulah "knew every inch of London" but preferred "odd places: not pretty, but good music, and you had to be somebody pretty special to get in." But they also frequented the ultraswank Embassy Club on Bond Street, the Prince of Wales's favorite haunt, as well as formal balls in which they were announced by liveried footman.

"I never saw her take dope," Anders insisted, but he mentioned glancingly their visit to an opium den in London. In her autobiography, Tallulah describes the same establishment, which occupied the top floor of a house in Chelsea. She recounts her initiation there into opium smoking, referring to this drug use as a onetime experiment. But given Napier Alington's involvement with opium at one point, the drug would have had a particular fascination for Tallulah.

Nadezda, Marchioness of Milford Haven, was the daughter of a Russian grand duke and a descendant of the great Russian poet Aleksandr Pushkin. She was married to Philip Mountbatten's brother George. The Milford Havens were known for their sexual gamesmanship; eventually, the marchioness endured a terrible scandal when the custody suit brought by Gloria Morgan Vanderbilt over her daughter Gloria made public the elder Gloria's affair with "Nada" Milford Haven.

One afternoon Tallulah and Anders returned to Tallulah's apartment to find Nada waiting. Tallulah inquired about seven-year-old David Mountbatten. "He's just as cute as ever," Nada said. "He came home the other day and said another boy was trying to take his pecker and masturbate him."

"What'd you say?" Tallulah asked.

"I told him if he liked it to let his friend do it."

Anders thought it had been Nada who sent a gift backstage to Tallulah during one performance: a brooch studded with diamonds, but wrapped without fanfare, in plain tissue paper. Once he asked Tallulah about plans to spend the weekend at the Milford Havens'. "Oh, Glenn, I feel too tired to sleep four in a bed."

"What? What did you say, Tallu?"

"Glenn," she said, "don't you know that he's in love with *you* and she's in love with *me*?"

Anders claimed that these and similar revelations caught him unawares. "It would all add up," he summarized, to Tallulah sighing with mischievous stoicism, "Oh, Glenn, you are so middle class!"

As in her two previous plays, Tallulah's understudy in *They Knew What They Wanted* was Beatrix Lehmann, who was a recent graduate of the Royal Academy of Dramatic Arts. Lehmann was a lesbian; she was lean and boyish, with a dark, rather ratlike face: a *jolie laide* if ever there was one. Her strange aura of frustration found fruition in a long and notable career. Lehmann was "very, very much in the picture," Anders recalled. "Tallulah must have been in love with her. We were together all the time." Tallulah, Anders, and Beatrix Lehmann went several times to stay with Beatrix's sister Rosamund and her husband, Leslie Runciman, at their country estate. Rosamund was then writing her first novel, *Dusty Answer,* which began her distinguished career in British letters. Her brother John also became a noted writer, and Beatrix herself had two novels published.

"Was I good tonight?" Tallulah sometimes asked Anders meekly after the third-act curtain had fallen. Anders never knew quite what to say; for him Tallulah was too alluring for the part. In the published script, Howard describes an Amy whose "loveliness is quite beyond belief. She is small and plump and vivid and her golden hair shines about her face like morning sunshine." But it was Pauline Lord who had stamped the part in her own image when she created the role on Broadway. Lord "wasn't ugly but she wasn't barely pretty," recalled Anders. His second-act encounter with Lord was a case of Joe capitulating to Amy's irrepressible desire. "With Tallulah you always wondered why it wasn't the other way. I could have been in love with her from the time I laid eyes on her in the first act."

Anders's sentiments were echoed by Herbert Farjeon, who voiced in the *Sphere* a dissenting opinion on Tallulah's performance. "For the first time since *Conchita,* I was disappointed in the performance given by Miss

Tallulah Bankhead. . . . She does not invest the part with character of its own but rather absorbs it into her own personality, and so does anything but suggest a girl who would *need* to arrange a marriage by correspondence. She could find twenty husbands a day."

Anders remembered Lord in the Broadway production, delivering a resigned resolution in her soft, winsome voice. "No. I ain't going. Why should I go? I like the country. This place suits me all right. I'm here and I might as well stick." Hopeless and helpless, she sank into a chair as the first-act curtain fell. "Now Tallulah standing there, exactly as Polly did, still her body was too lovely, too healthy—no matter what she was feeling inside—for it to be the same."

Skylarking

"Over here they like me to 'Tallulah,' you know—dance and sing and romp and fluff my hair and play reckless parts . . ."

They Knew What They Wanted was the critical peak of Tallulah's eight years in London, but it was not one of her longest runs. The houses were jammed in the opening weeks and then, to both Anders's and Tallulah's disappointment, audiences dwindled. Nevertheless, its three-month run could still have allowed Basil Dean to reap a profit: "Tallulah had now scored two box-office hits," he writes in Seven Ages. Dean wanted Tallulah for his next, and as it turned out much more popular production, a dramatization of Margaret Kennedy's shamelessly sentimental best seller The Constant Nymph. Dean writes, however, that Tallulah and he could not agree on salary. Tallulah may really have felt she could get more money, or the money may have been a ploy. For she must have realized how wrong she was for the part of Tessa, a seventeen-year-old waif who dies just as she is about to consummate her nearly lifelong infatuation with a married composer. Calling people's bluff where money was concerned was a ruse of Tallulah's. She had done it before accepting Conchita in 1924, and was still trying it decades later, when offered a part in a Frank Sinatra film. "Well, it wasn't me," she told her friend Cal Schuman, "and I said, 'I'll do it for $100,000.' It was only about five days work. They said, 'We'll pay you

$100,000.' 'Oh,' I said, 'Darling, I was only kidding. The reason I can't do it is I'm not right for it.'"

Tallulah as Tessa "would have been the quaintest casting," jeers theater historian J. T. Trewin in *The Footlights Flickered*. Tallulah's rejection was the best thing that could have happened to Dean's production, for in her place he secured a dream embodiment in the person of Edna Best. Dean may actually have been urging Tallulah to join the roster of performers that he engaged under long-term contract; however, she stayed freelance, although she acted again for him in 1928. Dean's final words on the subject of Tallulah Bankhead are harsh, more so than one would imagine her obstinacy over that particular part or salary should have engendered:

> It seemed that my judgment was correct and that she might yet prove to be the star to guide me into financial haven. But I made no allowance for the rifts in her character . . . she lacked a sense of dedication that alone could overcome her lack of basic training. She was always an amateur—in the better sense of that term—approaching the theater, and indeed each aspect of her life, as an experiment, quickly to be dropped when unsuccessful. She told me once how as a child she used to rehearse gestures and facial expressions by herself in a long mirror, a form of narcissism fatal to integrity.

Writing after Tallulah's death, Dean was on target about some of the vagaries that ultimately eroded Tallulah's career, but his linking of mirror gazing and artistic shortcomings is nonsense. The motivations of exhibitionism and narcissism are integral components to a performer, and they need not preclude more sophisticated artistic strivings. What would Dean have made of Vivien Leigh, one of the most intensely dedicated of actresses, who was in the habit of reciting her part to her dressing-room-mirrored reflection? Nor does Dean acknowledge the rifts in his own character—he was not just disliked but hated by many for his brusque and sometimes sadistic behavior.

Dean's sentiments, however, have been echoed by biographers and historians, revealing the same moralistic skew with which her life and career would come to be analyzed—often not overtly moralistic about Tallulah's private life, but instead about her career choices. She has so often been accused of betraying her talent by selling out for commercial success, and while there is truth to the accusation, too often these chroniclers give the impression of being strangers to the realities of every actor's life.

"Because of my spendthrift ways, my scorn for tomorrow, I was never in a position to sit back and wait for a good play," Tallulah writes in *Tallulah*. "Who in the theater can afford that luxury? Pressed for money, I had to take the first thing offered me. Always in debt, I was nagged by necessity. I couldn't take time out to pause and reflect." And yet, while all that is true, Tallulah is perhaps disingenuous in attributing solely to necessity the fact that she never again appeared in London in a play as good as Howard's.

It has been said that Tallulah deliberately picked poor plays, which is unlikely, since the more feeble the play, the more difficult becomes the actor's task. But certainly she picked commercial plays, as well she needed to, since her father was no longer sending her money, and she was not only paying for herself but for a small staff. She was also perfectly willing to assist friends and lovers who needed money. She was subject to spontaneous rushes of generosity, prone to pressing large sums onto passing flower girls in the street.

But lapses in Tallulah's own taste must also be considered. She had said in 1921 that the 1890s pyrotechnics of Berton and Simon's *Zaza* constituted the finest role ever written. (That absurd statement was attributed to her in an interview shortly after verismo composer Leoncavallo turned *Zaza* into an opera sung first at the Met by soprano Geraldine Farrar, who was an idol of Tallulah's during her early years in New York.) Two years later, Tallulah could still "wipe out things absolutely and not see their value at all," Una Venning complained. "If a thing wasn't rip roaring drama, somebody wasn't murdering somebody or going to bed with somebody, or doing something fantastic: 'Oh, dull as a ditch.'

" 'But Tallu, didn't you see how subtle it was, when they'd come to the conclusion that it was the parting of the ways, and what were they going to do about it?"

" 'Oh, balls!' "

Tallulah's comprehension of the theater undoubtedly continued to evolve. But although she gladly read works of philosophy and mysticism, when it came to theater, she always looked above all for the visceral response. Silvio Narizzano, who directed her in her last film in 1964, recalled discussing Britain's Angry Young Men playwrights. Tallulah liked the emotion in John Osborne's work but didn't care as much for Harold Pinter; he was "too laid back," Narizzano recalled, "too cool."

"Over here they like me to 'Tallulah,'" she told New York reporter Milton Bronner, who interviewed her just as *They Knew What They Wanted*

Tallulah and a friend at a movie premiere in England, 1934.

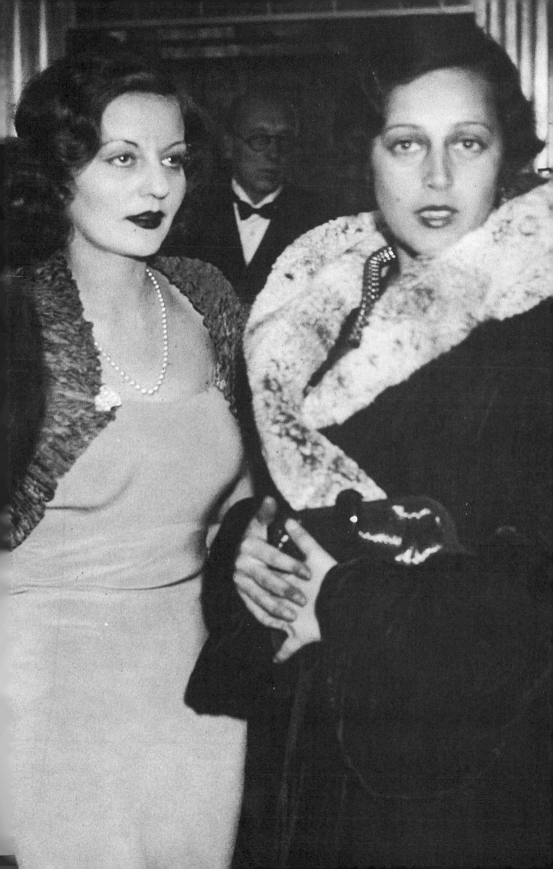

was about to close. "You know—dance and sing and romp and fluff my hair and play reckless parts. . . ." Of course she was not obligated to comply. Had Tallulah wanted to, she could have played Chekhov or Euripides with a number of theater societies that operated around London. She could have acted Restoration comedy at Playfair's Lyric; it was there in 1924 that Edith Evans scored an epochal success in Congreve's *The Way of the World*. If Tallulah had been determined to play Shakespeare, she could have gone to the Old Vic in the unfashionable Waterloo neighborhood, which had begun to attract talent of the caliber of Evans for limited-run repertory seasons. But "Shakespeare just was not popular in the commercial theatre," Richard Huggett writes in his biography of producer Binkie Beaumont, the Bard becoming "unfashionable for the first time in 300 years." What distinguished du Maurier's career from previous actor-managers was his avoidance of classic drama. "There are few of us who do not prefer a single 'Oh-but-my-dear' from Sir Gerald to all the music in Romeo and Juliet," Hubert Farjeon declared semifacetiously in *The Graphic* in 1928. The great majority of the leading stars of the twenties were more eager to venture into the fashionably shocking realm of jaded morals and manners than in work that was experimental, obscure, or archaic.

Gladys Henson didn't believe that Tallulah was deliberately harping only on one gallery-pandering string. "Nothing she would have done could have surprised me. If I'd read Tallulah was going to play the Virgin Mary I wouldn't have thought it odd. She'd have attacked it like a mad thing, but she'd be saying all the time, 'I should really be playing Mary Magdalene.'"

"New York audiences . . . are quicker and keener," Tallulah had told Bronner. "They are more ready for the new things. If life and logic demand tragedy, they are ready for tragedy. . . . Londoners are more old-fashioned and sentimental. They hate to have the curtain rung down on pain and sorrow. . . ."

Looking at the plays scoring the longest runs in New York during the 1920s, one may be skeptical at claims made for the relative progressivism of Broadway audiences. A case in point is *The Gold Diggers*, which was given its London premiere by Tallulah four months after *They Knew What They Wanted* had closed. Directed by the legendary David Belasco, *The Gold Diggers* opened on Broadway in September 1919 and ran well over a year in New York starring Ina Claire. Written by farce carpenter Avery Hopwood, it was fast and funny and cynical, but constantly equivocating about the nature of its man-fleecing heroines. Hopwood wrote to a friend describing the difficulties he'd faced. "No cinch to put a girl into that cir-

cle, keep sympathy for her, keep her clean, get her 'a good man in marriage' at the end and still let the thing be a fairly true picture of that life. I worked myself woozy over that scenario."

The four-month interval between the London closing of Howard's play and the opening of Hopwood's was the longest hiatus in Tallulah's London career. Perhaps she had again put some money away and could afford an extended wrangle with Dean over *The Constant Nymph*. Or perhaps this was an extended period of career indecision.

In early October, "a question of throbbing interest in London today" became the possibility that Tallulah might marry Prince Nicholas of Romania. In London to patronize the made-to-measure tailors of Bond Street, he was seen at a nightclub with Tallulah, with whom it was rumored he had been infatuated for several years. In her autobiography, all she discloses is that they walked home on Piccadilly at 3:00 A.M, when she decided to impress him by cartwheeling down the street. But when a reporter from New York's *American* called to inquire, she stonewalled until cornered. The prince was only a slight acquaintance and not even, to her knowledge, in London. "But you were seen with him early this morning at a night club," the reporter explained. "Well, he is only here for a couple of days," Tallulah relented.

In November she went into rehearsals for *The Gold Diggers* without illusion, describing it to cast member John Perry as "bloody awful." But she had seen Ina Claire play it in New York and had realized its lucrative potential to provide a mightily entertaining diversion. In spite of its shortcomings, Hopwood's *The Gold Diggers* is in retrospect one of the most important American comedies of the century, launching the long series of gold-diggers comedies on stage and screen.

Tallulah was to play Jerry Lamar, ringleader of a group of Manhattan chorus girls. Jerry's sheltered roommate, Violet, is in love with Wally Saunders, a socially prominent young man whose uncle and guardian opposes the match. Jerry tries to break down the opposition of Wally's Uncle Stephen Lee by inviting him to supper and painting her own character in the blackest of colors. Sweet little Violet will look like an angel by comparison.

Hopwood makes the character of Jerry very appealing. She has ambitions well beyond parading in production numbers. When one of Jerry's friends asks her why she didn't come to a recent party, Jerry announces, "If I'm going to be a Galli-Curci or a Mary Garden I can't stay up all night."

Jerry is independent: "I've had measles and whooping cough and the mumps—but, thank goodness, I escaped love!" She is chaste. One of her

fellow gold diggers describes how "Jerry always makes the men come across—and she never comes across herself!" Jerry is irreverent. Wally blurts out that his uncle "said you smoked—he said you drank—he said you sat up all night!"

"What could be more ladylike?" Jerry asks.

"You know, I've got it all thought out—this whole men and women business—so far as it concerns us!" Jerry tells her girlfriends. And in her banter with them, Jerry's philosophy unfolds: "For it's one of two things— either you work the men, or the men work you! . . . men will do a good deal for us now—but, oh, girls—lose your figures or your complexion— get a few lines in your face—get tired out and faded looking, and a little passé—and the fellows that are ready to give you pearls and sables now— well—they'd turn the other way when they saw you coming."

Couturier Edward Molyneux was providing Tallulah's clothes for *The Gold Diggers*. In Paris for fittings, Tallulah ran into Napier Alington, who had never disappeared entirely out of her life. They dined at Jean Cocteau's nightclub, Le Boeuf sur le Toit. Alington was going to take the midnight train for Geneva, where he was to be treated for his tuberculosis at a sanitarium in Évian-les-Bains on Lake Geneva. "Charged with both anxiety and affection I was my gayest," so much so that Alington missed his train that night, and then for the next five nights. On the sixth attempt, they managed to deposit him on the train, but he hopped off with his bags as it was leaving the station.

The following night they reported to a train, but the wrong train; it was leaving for Genoa. Instead they spent the balance of the night at Bricktop's nightclub, before he took her back to the Hotel Chambord, and they arranged to meet in Switzerland. After she was finished with her fittings, she left for Switzerland.

Tallulah's sister was now living in Paris with her husband, Morton Hoyt. Eugenia loaned Tallulah her French-speaking maid for her trip to Switzerland. They checked into a suite at the same hotel where Alington was expected, but Alington was nowhere to be found. Tallulah spent the next two days frantically calling his suite, or standing on her terrace watching jitneys arrive from Montreux, hoping he might step off one. Then a Belgian whom Tallulah recalled only as "The Fox," called and said he had been sent by Alington. The Fox "offered a lot of fantastic excuses which added up to the suspicion the fugitive was on a monumental spree." Nonetheless, Alington's return was promised for the next day. The Fox in-

vited her to accompany him to the hotel's casino, where she found Alington planted at the chemin de fer table.

"Hello, Lulas," he said blandly, and went on riffling his chips. "I decided to blast him then and there," Tallulah writes, "but when he approached my rage vanished." They spent "two magic weeks" together, then Tallulah returned to Paris, leaving Naps to "God knows what adventure." Tallulah and her maid spent the night sobbing, the maid for a chevalier killed in the Great War, Tallulah because she surmised in Alington forces that she could not stem. "I knew he was doomed. I had a feeling he welcomed that doom."

The Gold Diggers was produced by Herbert Clayton and Jack Waller, two American partners who used Hopwood's plays as a wedge to penetrate the London market. William Mollison, who was the brother of Tallulah's Conchita colleague Clifford Mollison, had directed Hopwood's The Best People earlier in the year and now directed The Gold Diggers. The play reunited Tallulah with Jobyna Howland, who came to London to repeat the role of salty divorcée Mabel Monroe, a part she had created on Broadway seven years earlier. Howland was a heavy drinker who "used to weave about like the Eiffel Tower in a high wind," Clifford Mollison recalled. Now that Tallulah was almost twenty-five, Howland had probably stopped assuming her maternal pose, which must often have been a matter of do-what-I-say, not-what-I-do.

Before opening in London, The Gold Diggers tried out in the seaside resort town of Blackpool. William Mollison was awakened in the wee hours by a Blackpool hotel official asking if he could kindly restrain Howland and Tallulah, who were walking about the halls, stark naked, blind to the world, and turning the air blue with curses.

Opening in London two weeks later at the Lyric, The Gold Diggers aroused condescension, shock, and exasperation from the critics. "A very ugly picture of one phase of theatrical life in New York City has been painted," said The Stage. The Times felt that the effort of Hopwood's compromises between realism and palatability were all too apparent, citing the presence of "for sentiment's sake an obviously respectable mother to banish any misgivings about the birth and breeding of our heroine." Yet most of the reviewers were entranced by Tallulah's performance. "Miss Bankhead does it amazingly," offered The Observer. The Sketch averred that she had "displayed infinite resource and savoir-faire." The Times complimented her "unflagging energy, and in the circumstances, surprising

charm." *The Era* found Tallulah's acting "so good that almost one believed in the part, and that was no mean achievement."

Jerry climaxed her second-act's vamping of Stephen Lee with a giddy Charleston and cartwheel, and once again Tallulah's dancing was a sensation. *The Sphere* called her solo "so expert that Mr. Cochran, who was in the stalls, might well have contemplated engaging her as a dancer for his next revue." In *The Observer,* Hubert Griffith said it combined "all the scandalousnes of the worst can-can with all the grace of the best Charleston." *The Tatler* reported the decorous patrons downstairs emitting "envious murmurs of half-suppressed admiration" while the proletariat in the gallery let out "unstinted cheers."

According to *Tallulah,* Adele Astaire told her that she had never seen a better dance, was ecstatic about the cartwheel, and was going to take up dramatic acting, "by way of reprisal." But she thought that Adele was pulling her leg. "When a dramatic actress breaks into a dance, surprise has considerable to do with the resulting applause. . . . The unexpected always created a commotion in the theater. Think of the sensation Katharine Cornell would cause did she do bird calls or a turn on the trapeze!"

John Perry played a bit part in *The Gold Diggers.* A young man drunk on the theater, he made a point of watching Tallulah's performance every chance he had. Since Tallulah and he both arrived at the theater quite early, they frequently talked before the performance. Once Tallulah complained that she was losing a laugh because Frederick Kerr, who played Wally Saunders's family attorney, turned upstage as he said her "feed" line and the audience didn't hear him. She probably said something to William Mollison rather than to Kerr himself, who was a star in his own right and "rather grumpy," Perry recalled.

Perry had a talent for dancing, and Tallulah advised him to develop his gift by enrolling in a class at the Espinosa School, one of London's most prominent dance schools. Perry got the opportunity to play a better part, but the producers insisted on holding him to his commitment to *The Gold Diggers.* Tallulah, however, intervened with the management and Perry was able to avail himself of that opportunity.

From London's Ritz, Hopwood wrote to actress Fania Marinoff in New York: "I've been very busy with 'The Gold Diggers,' which is an emphatic success—with Tallulah scoring over Jobyna, which I think is rather remarkable." In his late forties and at the peak of his success, Hopwood was

burning himself out in a hedonistic frenzy, perhaps inspired by despair over his homosexuality and over his capitulation to the dictates of commercial success. A heavy cocaine user, he had less than two years to live. "Oh, darling," he wrote Marinoff, "Tallu & I have had a *grrrand* time—& are still doing so."

Sex Plays

"Sometimes when the audience thinks that I am weeping because a villain has betrayed me, I am really indulging in a good cry over my personal affairs . . ."

During *The Gold Diggers,* Tallulah was having an affair with cast member Hugh "Tam" Williams, who played Wally Saunders, Violet's betrothed. Williams was an excellent actor and a powerfully erotic presence, as his many films testify. He was a couple of years younger than she and married to a young actress, Gwynne Whitby. Actor Robert Flemyng said that Williams had had other affairs and would continue conducting them throughout his life, although at the time of his dalliance with Tallulah he had no intention of leaving his wife. Nor did Tallulah expect him to. But in time not only did Whitby know about her husband's affair but, apparently so did the entire theatrical profession in Britain. Conventional wisdom placed all blame on Tallulah.

"The Tam thing was very bad," Una Venning recalled. "Everybody thought it was disgusting of Tallu, although I've no doubt he did his part, too." Although he remained friendly with Tallulah, Gerald du Maurier, for one, disapproved of her conduct on the grounds that by its brazenness she tainted the reputation of the theater. Motivated as always by conflicting forces, Tallulah could have enjoyed the way the visibility and exposure of

the affair validated her desirability even as it guaranteed that she would again ultimately reap punishment.

Amid so much that was tempestuous in her professional and personal life, Tallulah sought to establish a domestic bulwark. In March 1927 she'd moved from Curzon Street to an apartment at 20 Hertford Street, but in December she signed a standard ninety-nine year leasehold on a tiny house, a converted stable at 1 Farm Street. Tallulah was now one block away from the centuries-old trees of Berkeley Square; this was one of the beautiful and pristine eighteenth-century neighborhoods still intact in London. On the ground floor there was a garage, kitchen, and bedroom; upstairs, living room, dining room, and two bedrooms. The house allowed her room for her first live-in staff. In the downstairs bedroom Tallulah installed a married couple, John and Mary Underdown, as butler and cook. Catherine Matthews, a cousin of Marie Bankhead's who visited Tallulah in 1928, described 1 Farm Street to Marie: "Silver wood work, tarnish gold rug on the straight narrow stairway, a pleasant odor of onions—the kitchen and some servants & Tallie in her bedroom, colors there were pink and gold. Her dining room was small but nice—dark oak."

Edith Smith, a young fan of Tallulah's, moved into the spare bedroom upstairs as live-in secretary. Smith became an inseparable friend, confidante, and lady-in-waiting, who was almost as close to many of Tallulah's friends as Tallulah was. "Edie was absolutely marvelous," David Herbert recalled. "She worshipped Tallulah, but she used to give her hell sometimes: 'You can't behave like that. . . . Pull yourself together!'"

Smith had been working in the bakery department of a large department store when one day she saw Tallulah coming into the shop and quickly devised a plan to attract her attention. "Wedding cakes!" Smith called out as loud as she dared. "Wedding cakes, anyone?" Tallulah glanced her way and a long association began. ("Wedding cakes" remained Smith's pet name for a number of Tallulah's friends.) She was Tallulah's age and had been raised in England, but her parents were German. It is doubtful that Tallulah could have tolerated a sexual competitor in her employ; Smith was plump and she was exclusively gay. As an employee, she was sensible and good-humored and discreetly firm.

The Gold Diggers played five months, but weeks before it closed Clayton and Waller had brought Tallulah a new script by Hopwood. *The Garden of Eden* was adapted from a play by two popular German playwrights, Rudolph Bernauer and Rudolph Oesterreicher; it reaches us today as an

emanation from the same lurid nightclubs and leering predators preserved in the contemporary German silents directed by G. W. Pabst. The prior August, the *New York Herald Tribune* had reported that *The Garden of Eden* had "been a sensation in Berlin" and would soon be brought to Broadway with Jeanne Eagels as star. Although this never came to pass, Eagels's reputed interest was all the endorsement Tallulah would have needed, had she any qualms about playing in this frequently squalid melodrama, or she might, on the other hand, have relished the sensation that *The Garden of Eden* was sure to incite.

She was to play Toni LeBrun, a dancer in a Parisian clip joint, the Palais de Paris. After Toni repels the advances of a rake, Monsieur Glessing, she confronts Madame Grand about the nature of her business. Madame Grand throws her out on her ear. Toni is rescued by a fairy godmother in the person of Rosa, her dresser at the club, who reveals that she was once a baroness who fled some revolution-torn republic. Once a year she recaptures her lost grandeur with a vacation in Monte Carlo. Rosa takes Toni in tow and proceeds to adopt her after their arrival at the Hotel Eden. Toni falls in love with Richard Lamont, a young diplomat. On the morning of their wedding a snake appears at the Eden: it is Glessing, who, as it turns out, is something of a professional mentor to Richard. He tells Toni that he will be quiet about her past so long as she eventually agrees to come across. She refuses and jumps the gun by telling Richard who she really is; his relatives accuse her of snaring him under false pretenses. Richard turns out to be a hopeless prig and careerist. He won't confront Glessing because he needs to stay in his good graces for the sake of his career. Instead, he insists that it is Toni who must apologize to Glessing for calling him a scoundrel. Toni tears off the spectacular gown, veil, and jewels that Richard's family had presented her and stands defiantly clad only in her lingerie before storming out.

Act 3 finds Rosa and Toni back in a cheap hotel in Paris. Toni is dubious about lucrative offers of magazine serialization and a musical role in a revue exploiting the fiasco. Enter Prince Miguel de Santa Rocca, who had been a guest at the aborted wedding. The prince—"that eccentric old fossil," Glessing described him—has all the irony, generosity, and self-knowledge Richard lacks. Toni's behavior at the wedding enchants him. He proposes marriage and promises her that sex will not enter into the equation. He tells her, "In twenty minutes I'll be back for you with everything settled, if I haven't had a stroke in the meantime." Toni skips out to the altar telling Richard's uncle Herbert, who has come to offer money in return

for silence, that Richard need not worry about his career; she'll be happy to put in a good word for him with the prince.

The role of Lamont enabled Tallulah to keep Hugh Williams close at hand, to engage him now as love interest, and play a long, very romantic scene with him in act 2. Barbara Gott, Tallulah's colleague from *Conchita,* added to her gallery of grotesques the role of Madame Grand, proprietress of the Palais de Paris. Eva Moore was Toni's foster mother, Rosa. Moore is known to horror-movie buffs for her impersonation of a raving inhabitant of 1932's classic *The Old Dark House.*

The Garden of Eden's first performance was in Edinburgh on May 23, 1927. A week later, it came to London. "What a night it was for the gallery girls when Miss Tallulah Bankhead, the darling of the goddesses, the fashion craze of the moment in the stalls, stormed, raved, and ranted her emotional way through the theatrical absurdities of Mr. Avery Hopwood's latest comedy," the reviewer who called himself "Trinculo" reported in *The Tatler.* "It contains a 'fat' part for Miss Bankhead, in which that adored divinity, slim, shingled, and divinely fair, is given unbridled license to under-dress and over-act to the top of her bent. . . ."

Although Tallulah never needed much encouragement to overact, Hopwood's script encouraged or even demanded such displays, since Toni is frequently in a state bordering on apoplectic. *The Tatler* described Toni's flight from the cabaret: "Husky and huskier grew the throb of her voice, wilder and freer the confusion of her packing. Clothes flung here and there, upset, crammed back with feverish haste into a suitcase. What tears, what emotion! And what nonsense!"

"A preposterous conclusion," the *Evening Standard* called Tallulah's disrobing at the wedding, "but so much more original than anything else in the play that the gallery breaks into spontaneous cheers." It may have been preposterous or gratuitous on the score of logical plot motivation, but Tallulah's keen instinct for theatrical effect could have induced her to accept the script based on that one incident. Hopwood often liked to work stripteases into his comedies. Here he was paraphrasing a hallowed gesture of divestiture, the rejection of trappings and appurtenances as a sign of spiritual integrity—even though Tallulah retained her exquisite silk lingerie.

The censure of the theatrical community over her affair with Williams was paralleled by something of a harsher tone toward her among the critics. *Theatre World* wrote that "Her performance may save 'The Garden of Eden,' but the cost will be too great to make it worth her while." She was increasingly reprimanded for her theatrical mannerisms during the balance of her

stay in London, begging the question of whether Tallulah was relying on them excessively or whether the critics had just latched on to a convenient topic. Was there increasing discomfort with the phenomenon of Tallulah, including, of course, her controversial private life? During the nineteenth century, an actress's morality was considered a legitimate reason for censorship of her acting. By the 1920s that would no longer have been considered germane—at least officially—but the undercurrent remained.

Willful as Tallulah was, she "cared desperately about the critics," Gladys Henson said. In 1940, Tallulah recalled that while in England, she had been taken to task for "my slouch walk, the way I held my shoulders, the toss of my head. But even though I antagonized them, they [the critics] gave me good advice. 'Hold up your shoulders,' one of them told me"— Tallulah was prey to the concave posture that was fashionable at the time—" 'and breathe deeply.' "

"I used to have a habit of throwing back my head because my hair was shingled and so very thick and heavy," she wrote. "When I had to bend over, I immediately shook back my head without realizing I was doing it. To do it occasionally was all right, but to do it often was not so good, so I had to guard against the habit."

Yet, as Tallulah well knew, mannerisms are essential to the success and identity of a star. Actors without distinctive mannerisms do not become stars, and do not inspire the adoration on which Tallulah thrived. Once Tallulah complained to du Maurier that no matter what role she played, many critics complained that she remained distinctively herself. According to Tallulah, his response was, "See that they say nothing else."

The Garden of Eden was hokum, but Hopwood had done a better job than the critics acknowledged. *The Graphic*'s Hubert Farjeon was the rare critic to admit that "some of the dialogue is delicious." The contrasting environments of tawdry cabaret and balmy Riviera playground were well evoked. *The Garden of Eden* filled the Lyric Theatre for seven months. Tallulah's success inspired Archie Selwyn to bring the play to Broadway that fall starring Miriam Hopkins, after Jeanne Eagels had backed out of her original commitment. In 1928 Corinne Griffith starred in a Hollywood adaptation. If anything, the film is racier than the play script, since the Palais de Paris's proprietress is now meant to be a lesbian, and even gets to undress Toni when Toni refuses to wear a certain costume because she claims it is indecent.

In the fall of 1927, Tallulah signed a lucrative contract to make her first British film, *His House in Order,* an adaptation of Pinero's 1906 play.

Acting with her were Eric Maturin, her onstage ravisher in *The Garden of Eden,* and Ian Hunter, her adversary/admirer in *The Gold Diggers.* By day she stepped into an entirely different milieu than she occupied at night in *The Garden of Eden.* Here Tallulah prowled a stately country home as Nina Jesson, the second wife of a British politician. Nina is a free spirit, a child of nature, and her husband and his late wife's relatives compare every move she makes unfavorably to her predecessor. However, her brother-in-law rescues her when he reveals that the first Mrs. Jesson was an adulteress. Nina and her husband look at each other with renewed appreciation and decide to start their lives together anew. Nina was a very good role for Tallulah, and it is unfortunate that the film itself does not survive in any archive.

The director, Randle Ayrton, was an actor with almost no experience directing film. *Film Weekly* found his work inadequate, but said that Tallulah was "as good as might be expected; she is at least natural, in spite of the drawback of an atrocious make-up. . . . All the characters, with the exception of Tallulah and Ian Hunter, move about with a gloomy and unnatural manner which renders the picture almost destitute of entertainment."

Perhaps Tallulah had taken to heart the critics' outrage over *The Garden of Eden.* Doubtless she sought some damage control on the bad critical repute it had garnered her. By the time the play closed she had "decided I would never again play in any sex drama. I was sick of this type of play." Instead, as *The Garden of Eden* was drawing to a close, Tallulah signed a contract with Archie Selwyn to star in a new comedy by Frederick Lonsdale. Lonsdale's drawing-room comedies were the equal of Maugham's. The only problem was that his new play did not exist except in theory, and Lonsdale was notoriously slow to produce. While she waited for Lonsdale's script, Tallulah turned down Ann Harding's role in the London production of *The Trial of Mary Dugan,* which was selling out on Broadway. Lonsdale failed to deliver the manuscript as contracted on January 1, 1928. Tallulah resolved to blast him when she next ran into him, but when they came face-to-face at a party she found him so charming she was disarmed.

She said that she took *Blackmail* as a way to redress her mistake in not accepting *Dugan.* The author, Charles Bennett, was a young actor who had recently had his first play produced in London. He sold an option on *Blackmail* to producer A. H. Woods, who shuttled between London and New York, where he controlled the Eltinge Theatre on West Forty-second Street. Woods was walleyed: "You never knew whether he was talking to you or somebody else," Bennett recalled in 1992. Also you didn't know be-

cause he called everyone "sweetheart," man or woman; he sweetheart-ed the way Tallulah darling-ed, until the endearment bounced back and became his nickname.

Woods was at that very moment considering casting Tallulah in a film version of *The Green Hat,* to be made in England by the prominent American director Marshall Neilan. According to *Variety,* a trade showing of *His House in Order* discouraged them and they decided instead on Blanche Sweet. (That she was married to Neilan may have played a part in their decision.)

Woods took Bennett to Tallulah's home to read the play to her. She listened intently, as did "a maid," who was probably Edie Smith, who served as a regular adviser to Tallulah, Bennett claimed, on whether a proposed script would suit the tastes of Tallulah's gallery following. Tallulah said she would do it and Woods was so excited that he brought out two hundred pounds and threw them at her feet with a lordly gesture. Bennett was broke at the time and had to restrain himself from scooping up a handful of bills.

Bennett became a frequent guest at Farm Street, where Tallulah "plied me with a lot of very pleasant drink and a lot of very pleasant social life." He was a regular guest at cocktail parties that Tallulah hosted there. Having been "a rather unknown actor," Bennett was thrilled to "suddenly find myself mixed up with all the big stars, the most famous people in England." As many as fifty or sixty people spilled into the bedroom, down the stairs, into the kitchen on the ground floor. "As I was new to that form of top café society, she used to take great joy in presenting these people to me."

Bennett recalled going to Farm Street once and finding her alone and in seventh heaven. "Oh, Charles, I do want you to listen to this record." On the gramophone she spun Gertrude Lawrence singing Gershwin's "Someone to Watch over Me." She had spent the afternoon playing it over and over again.

Blackmail opens in the studio of artist Peter Hewitt with his penniless friend and fellow artist Ian Tracy helping himself to some food and drink before telling Hewitt's landlady that he will wait outside. Daphne Manning, an artist's model, has been picked up by Hewitt at a ball at the Chemil Galleries after a tiff with her fiancé, Detective David Webster. She comes back with Hewitt to his studio, where he drinks too much whiskey and forces himself on Daphne, who defends herself by stabbing him fatally with a bread knife. Ian has been watching Hewitt's apartment from downstairs and knows all. Daphne spends all night and most of the next day wandering around London; when she arrives at her parents' apartment, David is

there and she confesses all to him. To exonerate Daphne, David tries to suppress evidence of her guilt, going to the length of submitting to Ian's blackmail attempts. But then Ian is arrested by the police and charged with the murder. Daphne surrenders to the police rather than let him hang, but her prospects look good since David has forced Ian to swear in as witness for the defense.

Raymond Massey, who was acting by night in S. N. Behrman's *The Second Man,* was engaged to direct. Originally, Daphne was a shopgirl, but according to Bennett, Massey and Butt decided that *Blackmail* be boosted up the social scale from the slummy end of Chelsea up to the posh Sloane Square area. Tallulah had not shown any aversion to playing a shopgirl and indeed was one of the few actresses in London who regularly played working-class heroines. Rewriting was mandated, and Bennett thought that the upgrading ruined his play.

In his autobiography, Massey tells a different story: Tallulah's frequent suggestions about improving the script had irked Woods, and a few days before rehearsal started he told him to "get that Bankhead broad off my back." Woods instructed Massey to mollify Tallulah. Accordingly he arrived at Farm Street by appointment, armed with the script of *Blackmail.*

Upstairs, Tallulah awaited him in her bath, her head and shoulders obscured by a fog of steam and soapsuds. Massey sat on a stool and listened to a ten-minute aria by Tallulah on "the care and feeding of theatrical managers and dramatic authors." He left Tallulah's, his script "a mess of pulp, and dizzy with the heavy scent of bath salts," realizing that he hadn't been able to reassure her about the script because he had hardly gotten a word in.

The next day, he had some minor surgery on an infected toe. When rehearsals began the next week, the initial reading went without a hitch. Massey was apprehensive about spending all afternoon on his feet blocking the first act. He and Tallulah were sitting together in the orchestra when Woods appeared.

"Well Miss Bankhead, can we go ahead with the rehearsal?"

"Buzz off, Sweetheart, I'm talking to the director."

"That," writes Massey, "was more than Al could take." Partial to extravagant gestures, Woods now executed one far less magnanimous than the shower of pound notes. He grabbed Massey's cane, hanging on the seat in front of him, and made a violent gesture toward the script sitting in the director's lap. However, his thrust went too wide of the mark and he brought the weapon down on Massey's bad toe. Massey howled, Tallulah leaped at

Woods, stepping on Massey's toe in the process. "You walleyed old bastard," Tallulah shouted at Woods, "you've hurt him!"

Tallulah followed Woods up the aisle and they disappeared into the lobby. She returned shortly and handed Massey's cane back to him. "All right, darling," she said, "let's go. Sweetheart will be quite tame tomorrow." Massey asked Tallulah how she had silenced Woods. "I just said to the old pirate that I was young and inexperienced, that I couldn't stand violence, I just wanted peace and love and understanding, and would Sweetheart please for God's sake leave me alone and let me work it out with you, darling!"

Nevertheless, Tallulah was "impeccably professional throughout rehearsals," says Massey. But Bennett recalled friction. "Massey was in charge and determined to be so. He was tough and he was adamant and rather rude. Determined to get exactly what he thought he wanted in a person." A dispute between Massey and Tallulah climaxed with her tearing madly at her pearl necklace until it ripped and the pearls scattered. Clearly, there was no love lost between Massey and Bennett. The playwright recalled: "Raymond Massey never liked the play and he should never have directed a play he didn't like. Whenever a director takes on something he doesn't like it's wrong from the word Go."

When it opened on February 28 at the Globe, *Blackmail* provoked violent pro and con demonstrations following the final curtain. According to the *Mail*, "something like a vocal battle took place between the Bankheadites and those who put the merits of a play before the merits of a personality." Tallulah was held accountable by the audience. "In the end the Bankheadites won," the *Mail* declared, "but only by a narrow margin." In the Sunday *Express*, ever-loyal Hannen Swaffer recounted that "Tallulah was booed . . . but did her dazzling best in very trying circumstances." He casually reminded his readers that his was an insider's report. Swaffer not only reviewed but wrote theatrical columns. "Even two of Tallulah's persistent admirers, she tells me, booed the play. She got her revenge later on that evening when, hearing community singing at a late night cabaret, she and her party booed when the other half of the room was singing. Tallulah always takes her troubles with a bewitching humor."

Some critics felt that her heart really wasn't in *Blackmail*. "Good actress as she is," *The Era*'s critic offered, "her emotional crisis as Daphne failed to move me." She had been best in the seduction scene, which "would not, I imagine, have passed the Censor if he had seen the play rather than read

it." However, "after she had killed the man with remarkable dexterity, she never varied the tensity of anguish. There was little in the writing to help her, but her anguish, expressed in gasps and sobs, seemed very hollow to me." *The Sketch*'s reviewer laid principal blame on Tallulah. "Many of the scenes make for effect, but somehow we could not feel the inwardness of the characters; they all, more or less, bore the stamp of cliché. In saying this, I would not be unfair to the author; maybe, if the leading part had been differently expressed, we could have been more moved."

> But the truth is that Miss Tallulah Bankhead, skillful in the highest degree as she is, has neither the diction nor the power of an emotional actress. Often she slurs her words, and we only hear half she says; often she strikes the same strange attitude rather as if she were suffering from some troublesome physical pain; in outbursts she rarely strikes the heart-note, that peculiar accent that causes vibration in the hearer; we are always conscious of being in the theater, of the theatrical, of an idea that a producer may have tried to make an actress what is not in her, and so had made her sound artificial. As the play went on I tried to visualize other impersonators I could name in the part, and I felt the difference. The *cri de coeur* is one of the dowers of Nature; it is innate, and but rarely can be impelled. I doubt whether Miss Bankhead possesses it, however skillfully she may strike other chords of the human clavier.

Did Bennett agree that Tallulah had delivered his lines with undue speed or insufficient audibility? "No," he insisted, "she just talked in a perfectly normal way and what she said could be heard." He dismissed the critics' gibes as "nonsense. Critics are idiots, most of them."

The Sketch's critic felt that it was a fatal mistake for *Blackmail*'s curtain to come down "at the very portal of its climax," as Tallulah was marched to the police station, and he decried the lack of a trial scene to show "the heroine white-washed by the unwritten law." The audience was reported glancing at their programs to see if there was indeed another act yet to come. But we might ask, would the outcome of the trial have been a foregone conclusion? Given that Daphne had agreed to return with Hewitt to his studio, self-defense might have been considered a gray area of grounds for acquittal. Many British jurors of the day might have believed that Daphne had gotten just what she'd asked for—particularly so had she been a working-class heroine. Making her upper-class might have served

to ensure the audience's sympathy. Daphne actually fits quite well into the morally ambivalent archetype to which Tallulah's talents were so well suited.

Blackmail lasted only a few weeks. When the run was finished at the Globe, the rights reverted to Bennett, who claimed that no fewer than six tours of *Blackmail* at one time were wandering around the British Isles. "But I'd taken it back to its proper time and period." Hitchcock's film adaptation in 1929 began Bennett's long association with the director, for whom he later worked on the scripts of *The 39 Steps, The Man Who Knew Too Much,* and *Secret Agent.*

Soon after *Blackmail* closed at the Globe, Bennett gave an interview in which he voiced his resentment at the changes Butt had ordered. "I told the truth about it," he recalled. "I suppose I shouldn't have." Tallulah stopped speaking to him, but vented her dissatisfaction to the *Express:* she had been "roped into *Blackmail,*" and was sick of overwrought emotional plays. "Sometimes when the audience thinks that I am weeping because the villain has betrayed me, I am really indulging in a good cry over my personal affairs, and probably wishing things I would not tell you.

"I was tremendously glad when *Blackmail* came to an end. I always think a bad play is like a new dress that fits badly in part and has to be altered. At each trial a part has to be changed. When you alter something it automatically throws something else out of place. And so you can never forget that the dress has been practically remodeled. Consequently you never really like it and always wonder why you chose it at all. That is how I felt about *Blackmail.* Now I am hoping that my next play will be a real Paris model."

Surveillance

"Hello, everybody, Tallulah speaking. I give you due warning I'm going to sing . . ."

A month after *Blackmail* closed, Tallulah was opening in a new play. *Mud and Treacle* was shot through with talk of an intellectual nature that she could have imagined might silence critics of her previous plays. Basil Dean was directing her for the fourth and last time. The script was by Benn Levy, who at twenty-eight had already had a couple of West End successes and in years to come would have many more. The cast surrounding Tallulah was again superb. Nicholas Hannen played a middle-aged socialist, Solomon Jacks, who visits a house party in the country, where he falls in love with Tallulah's Polly Andrews. She is the daughter of a landed family and a distant cousin of his. Solomon has no objection to lust, but love is the one thing he cannot stand: "It is jumping into a river whose currents are compounded of mud on the one hand and treacle on the other." To extinguish his own ardor, he extinguishes her life.

Levy introduced an attempt at innovation by opening the play with a tableau showing Tallulah lying dead on a sofa. The rest of the play proceeded as a flashback that begins three weeks earlier. Polly is discovered strumming and singing "Frankie and Johnnie" as she awaits Solomon's arrival. Several competing bids are being made for her attention. One is by

Hector Wilson, the local Conservative candidate, played by Eric Maturin in his third appearance opposite Tallulah. Polly, however, is politically liberal. She's been helping a local Laborite, who is trying to establish a district Labor club. In addition, Polly is carrying on a flirtation with Archie Pretty, a man of leisure who is politically liberal and unhappily married. His wife, Pearl, a former barmaid, espouses the standard working-class prejudice against socialists as parasites. Pearl was played by Ursula Jeans, one of London's fastest-rising young actresses. Polly's mother, Daisy, was played by Mabel Terry Lewis, niece of the legendary actress Ellen Terry. Terry Lewis's hawklike profile and patrician manner suited her for this über–grande dame, who takes a seat "as only women of her generation can." Daisy is full of acerbic comments about her daughter. Daisy explains that she had to foxhunt to retain her late husband's affection. "Was it worth it, Cousin Daisy?" Solomon asks. "Why didn't you divorce him?" "I was afraid I might get custody of the child," Daisy replies. As in *The Garden of Eden,* however, the emotional core of the play resides in several intimate exchanges between mother and daughter. In 1993, Quentin Crisp still recalled a memory of Tallulah sitting quietly at the feet of Terry Lewis.

Also contributing their views on life and politics to *Mud and Treacle* are an agitating miner brought along by Solomon, as well as Archie's father, who is hosting the house party, and the estate's butler, who is revealed to be the anonymous voice behind a liberal political column in the local paper.

Levy's play was very much a young man's work, rather too clever for its own good. He aimed at a very ambitious hybrid; on the script's title page he introduces the play as "A Comedy or perhaps rather a Tragedy. A Murder Mystery and a Shameless Tract in Three Acts & A Post-Dated Prologue." In similar fashion the protagonists of the play keep underscoring its own artifice à la Pirandello. Polly, for example, is described by Solomon as "a kind of Noël Coward heroine; or at least moving in that direction."

During the third act, Solomon drinks a great deal late at night, then summons Polly from her room. They confess their mutual love. Solomon is agonized at the realization that "I don't care if I never do another jot of work again so long as I can love and be loved by you."

"Well, what are you going to do?" Polly asks.

"I thought—seduce you or perhaps kill you."

Robert Harris played Archie Pretty, Tallulah's liberal admirer. Harris was four years older than John Gielgud, and during the 1920s it looked as though he rather than Gielgud was destined to become the great classicist of his day. Harris already had an extensive history with Dean. He had been

under contract to him for several years after graduating from the Royal Academy of Dramatic Art. Harris had seen several of the leading actors of the day baited by Dean to the brink of tears. But Dean was never directly unpleasant to Harris, who sensed that the director knew it would crush rather than spark the young man's talents. Harris didn't think Tallulah would have been able to take direction easily from a man like Dean, for his fondness for "correcting people for the joy of correcting them" would have stuck in her craw. But "I'm sure they got along," he said in 1982 with a twinkle, however. "She'd have the better of him!"

Years after the play, Levy had talked to Harris about Tallulah's photographic mind: she had only to look at a page of script to commit it to memory. "He said that might be one of the reasons why sometimes she was difficult in rehearsals," Harris recalled, "because weeks rehearsing a part she already knew, practically before rehearsals started, she found very boring at times." But Harris had no specific recollections of difficulties during *Mud and Treacle*. "Rehearsals for that play were very happy ones."

An ugly incident loomed, however, as the play prepared to open. After starring for Dean in the New York production of Coward's *Easy Virtue*, Harris had left Dean's aegis for another production before returning for *Mud and Treacle*. Harris discovered that his name did not appear on the "bills," the posters announcing the production and cast outside the theater. He was convinced that Dean was issuing a belated punishment for his earlier defection. He confronted Dean, who responded with a smug admonition to "work, and in time these things will come." Tallulah asked Harris why his name had been omitted. Did he want her to speak to Dean about it? He was very impressed with her fealty but told her no. "That's good," she told him, "because I've got a bone to pick with him myself." Harris never knew what hers was about.

When *Mud and Treacle* opened at the Globe Theatre on May 9, 1928, it was dismissed by many critics. Even its dialogue, which makes the play well worth reading today, was given short shrift. In *The Era*, however, "G.W.B." said that it "may be an ill-balanced play with an ending that strikes one as anything but inevitable tragedy, but it does have the merit of keeping the mind excited all the time. Very few plays have succeeded in doing that. . . . Some of the dialogue is brilliant. Patches of talk between the mother and daughter were exceedingly witty. . . .

"In the quieter and less flamboyant part than she has had lately, [Tallulah] was excellent as the girl, although she must correct the tendency to slur her words." He suggested that she might profit from the example of

Mabel Terry-Lewis, "whose diction was perfect, and who gave delicious point to every one of the clever lines Mr. Levy had given to Mrs. Andrews."

In the *Evening News,* "J.G.B" reported that Tallulah "gave one of her best and most careful performances as Polly." The *Evening Standard,* however, said that her performance "revealed more effort than sincerity. Her technical brilliance is unchallengeable; she was effective in the quieter scenes; but her impassionate moments were the visible work of a craftsman; they lacked the spontaneous vibration of the 'art that conceals art.'"

Tallulah's alleged faults in diction are puzzling, since the zealots in the gallery used to get incensed over inaudibility. We will never know whether she simply felt some of Levy's dialogue did not bear enunciating, or whether she refused to surrender her typically Southern mushiness—although by now she had acquired a distinctly British tone. Certainly the times were changing and diction was becoming more colloquial. In a 1927 article for *Theatre World,* Kate Emil-Behnke, principal of a school of elocution and acting, wrote, "There is no denying that there is widespread criticism of the acting of the present day . . . not the least serious complaining is that it is impossible to hear what is said."

One must at least consider the possibility that Tallulah, as Brando did twenty years later, was employing a naturalistic style that was new and thus required acclimatizing. Our only audio evidence of Tallulah's London dialogue is a brief lead-in to her rendering of the song "What Do I Care?" that she recorded in 1930. "Hello, everybody, Tallulah speaking. I give you due warning I'm going to sing. When you've recovered from the shock, if ever, I propose to warble to you in my very best Galli-Curci manner a little song all about—well, I give you one guess as to what it's all about. . . ." She speaks in the clipped drawing-room tones of contemporary comedies of manners, making her words world-weary, insouciant, and suggestive. Her pace is quick but her words are distinct.

A few nights before *Mud and Treacle* opened, Tallulah had attended her sister's debut on the London stage. Eugenia's second marriage to Morton Hoyt had ended, and she decided to try her hand at acting, using the name Eugenia Hoyt. She later recalled wryly to David Herbert how unfair it was that Tallulah had inherited their mother's beauty and acting abilities, while "all I inherited was Daddy's love of fishing!" Witnesses to Eugenia's offstage conduct, however, were adamant that she possessed undeniable histrionic abilities. In *The Barker,* a carnival melodrama that had opened on Broadway a year earlier, Eugenia played a dancing girl named Cleo, an insignificant role that was little more than an extra part.

In London Eugenia's behavior was all too reminiscent of her sister's. Eugenia was "a terrible man-chaser. She had a lot of fun," remembered Ben Welden, who was in both the Broadway and the London productions of *The Barker*. Romantic leads Claudette Colbert and Norman Forster were also repeating their roles in London. Colbert and Forster told their colleagues that they had been married by the ship's captain on their way across the Atlantic. Colbert, however, continued to live with her mother, who had made the crossing as well. Eugenia considered that the coast was clear. "One day she made a play for Forster," Webster recounted, and "a hell of a scene" ensued between Colbert and her husband.

In London, Eugenia set her sights on Tallulah's own boyfriend, Tony Wilson, who told Tallulah that he was twenty-seven but was actually only nineteen when they began an affair. His older brother, Martin, was devoted to exotic pleasures. Decades later Eugenia recalled "his happy dust . . . Sister and I used to take it." Yet it was not Martin but rather Tallulah's spoken-for Tony with whom Eugenia began an affair. A terrible breach ensued between the sisters. For the rest of their lives, the simmering rivalry begun when they were children would inevitably rupture long periods of détente between them.

Between Colbert and her own sister, Eugenia felt that London was getting a little too warm. Without giving *The Barker*'s producers advance notice, she stole back to the Continent and then to the United States, where Hoyt caught up with her and they married for the third time. Less than a year after *The Barker*, Marie would be writing Tallulah that Eugenia and Hoyt were in Miami, "where they have an apartment and runabout car. This means they are having a good time I suppose. Of course, Eugenia is very flighty and Morton is unstable and no permanent happiness can reasonably be expected of their marriage." After her third marriage to Hoyt quickly collapsed, Eugenia returned to Europe, where she spent most of the 1930s. Glenn Anders said that the family considered Eugenia's behavior a potential liability to their political stability. "Eugenia was absolutely taboo at that time," Anders recalled. The Bankheads "kept Sister out of the country. They chased her out of America."

Eugenia and Tallulah did not speak for several years after their contest over Tony Wilson. But the matter didn't end with their eventual reconciliation. "Tallulah never forgave her," Stephan Cole claims. After Tallulah's death Eugenia grumbled that she had not left her more money. Cole told her the cause was to be found in the way she'd behaved in 1928 and perhaps on other occasions. "I think she was mean to mind my taking those

men," Eugenia complained in 1971. "They weren't worth a damn, really. I just thought they were attractive at the time—and I didn't know they were hers!"

Tallulah's reputation was by now so tainted that her slightest indiscretion might backfire alarmingly. While she and Tony Wilson were going out, they had driven to Eton to visit his younger brother, smuggling him out of the campus under a rug in their car so that he could eat with them at the Hotel de Paris, a popular establishment in Bray, a village on the Thames River. Before long it was alleged that Tallulah had been responsible for the expulsion of no fewer than five Eton students, "owing to indecent and unnatural practices with them," according to a Scotland Yard report that was opened to the public seventy years later.

An inspector was assigned to scope out the Hotel de Paris. He ascertained that Tallulah was "exceedingly well known" there, and he watched her arrive on Sunday, July 22, for lunch at the hotel. Joined by friends, she spent time on the water, and stayed until the evening before driving back to London. But no underage men were with her, and "the story that several Eton boys flew over by aeroplane to Bray from Eton must be accepted with the greatest reserve."

A review of Tallulah's professional and personal activities was nevertheless conducted. An inspector's report noted that Tallulah "has appeared in a 'sex' play. . . . Although it is rumored in theatrical circles that Miss Bankhead is regarded as a sexual pervert, it has not been possible to gather any information to confirm this."

First Lord of the Admiralty William Bridgeman went to Eton to discuss the matter with the headmaster, who knew that Tallulah, had visited the campus, and "it had been conveyed to her that she must not do so again." But Eton did not want to press any charges against Tallulah, and evidence of any legal breach on her part was nonexistent. The matter was then dropped, but Scotland Yard's disapproval of Tallulah's private life returned in 1934 to haunt her.

Tallulah's next play, *Her Cardboard Lover,* was certainly not going to dispel the aura of debauchery that was by now synonymous with her name. She was returning to the genre of "sex plays" she had resolved to forswear after *The Garden of Eden,* but to a less louche specimen. *Mud and Treacle* had been an ensemble piece—*Theatre World* was dubious that Tallulah's admirers would "relish seeing her relegated to the background for three-quarters of the evening." Perhaps that was why it closed within a month. By contrast, *Her Cardboard Lover* was dominated entirely by Tallu-

lah and her costar, Leslie Howard. It was an adaptation by Valerie Wyngate of a French farce written by Jacques Deval, who penned a string of hits in the 1920s and '30s.

In the U.S., *Her Cardboard Lover* had already been played by two actresses for whom Tallulah had the deepest admiration: Laurette Taylor and Jeanne Eagels. In 1926, Taylor tried it out of town but producer Gilbert Miller closed the play before it got to New York, feeling that Taylor, then in her early forties, was too old for the role of a capricious Parisian divorcée. P. G. Wodehouse was called in to tinker with Wyngate's adaptation, and reportedly succeeded in improving the male lead but not the female; in 1935 Tallulah would complain that the script was devoid of a single witty line. In the spring of 1927 it came to Broadway starring Eagels opposite Howard. Farce was not her métier, and Eagels was beginning the tailspin that led to her death two years later from a drug and alcohol overdose. Howard scored a personal triumph by carrying the play through to success.

In London Howard not only repeated his role but directed as well. Tallulah knew Howard from New York, where he had played a supporting role in *Danger* in 1922. He had the sensitive look that she appreciated in men, and was an inveterate womanizer. Unable to contain his philandering, his wife took to perching backstage, glaring furiously at young attractive women in the cast of any play he was in. According to Tallulah, Mrs. Howard's ubiquitous presence ensured that the furthest Tallulah got with Howard was the popular game of Sardines, during which bodies were stuffed into closets to provide an opportunity for furtive groping or kissing.

Her Cardboard Lover opens in a casino in St. Jean de Luz, where an impecunious young pup, André Sallicel, declares his love to Simone Lagorce, a rich young divorcée, and is rebuffed, before losing ten thousand francs to her at the gaming tables. She suggests that to make up the debt he will for the next five months be her "cardboard lover"—employed as her secretary, he will pretend to be her lover as well, and do whatever it takes to keep her from her returning to Tony, her caddish, yet irresistibly magnetic ex-husband. The imperious Simone insists that her agreement with André contain the proviso that their lovemaking shall be strictly for show. The play traces a gradual humanizing of Simone, who at one point is told by her maid that she is "too rich to understand," that André is impoverishing himself trying to keep up with her lifestyle.

The highlight of the play is act 2, which takes place in Simone's bedroom, dominated by an enormous, opulent bed. André keeps testing Simone's resolve not to make contact with Tony, and she keeps failing the

test. André disguises his voice and telephones Simone in the guise of her husband, telling her exactly which kimono he wants her to slip into. Simone erupts in paroxysms of emotional and sexual need, tearing off her dress and heeding his instructions. André walks into her room and chastises her for taking the bait. But finally Simone does actually succeed in luring Tony to her apartment. André strolls out of the bathroom in pajamas and Tony stalks out of Simone's apartment. In act 3, Simone realizes that she has completely worked Tony out of her system and she is able to reciprocate André's love. He is cardboard no more.

When the play opened in London on August 21, 1928, reactions ranged from amiable to dismissive, and frequently gratuitously so, but the acting was appreciated. *Theatre World* said that Tallulah had discarded "the mannerisms that have spoiled her work of late," although this would seem to have been a play that invited as many mannerisms as possible. In the Sunday *Times,* James Agate wrote: "It has been said of the grand amoreuse that she must take the spectator into a world where there is one loyalty— the loyalty to Venus—and notions not having to do with the goddess are rendered what the metaphysician calls unlawful concepts. This actress is mistress of that world. . . ."

The Stage's unsigned reviewer said he had become an admirer for the first time: "She brings out the conflicting emotions of the part with a great deal of sincerity, and makes quite a pleasant thing of the young lady's final surrender to her 'honest' admirer. . . . Miss Bankhead has certainly raised herself a step or two in the ladder."

Although it has been suggested that Tallulah targeted her choice of vehicles primarily to the gallery, this could not be entirely true, simply on economic grounds. The unreserved tickets in the gallery and in the pit— the orchestra section in front of the raised stalls—cost so little that even selling them out regularly could not be the major engine in a long-run success. *Her Cardboard Lover* settled down to a six-month run at the Lyric because all sections of the house were attracting patrons. (If Tallulah and Howard were even half as amusing as Marion Davies and Nils Asther are in the surviving silent film adaptation, *Her Cardboard Lover* must have been very diverting indeed.)

Nevertheless, the taste and behavior of Tallulah's gallery following were attracting new attention. News reporters on the daily papers reported that her fans had started lining up twenty-eight hours before the opening night curtain. (Although the wait did not demand constant attendance, for attendees could substitute a proxy of tiny stools hung with name tags.)

Throughout opening night their acclamations were a raucous distraction from the action onstage. London's drama critics now began to describe Tallulah as the prisoner of a cult that was foreclosing her professional options. *The Tatler* argued that Tallulah's fans would turn on her if she pursued a different line of theatrical fare. "Film-fed Flossie who is nerve-shucked into ecstasy at the sight of discarded stockings and diaphanous pajamas, and thrilled to the fibre of her being by a divan bed and a tray of cocktails is prepared to scream her disapproval if her goddess should dare mount another pedestal."

Other critics sought to clarify the issue by separating Tallulah and her impersonations. Hubert Griffith of the *Evening Standard* said he wished to portray her as craftswoman rather than an icon deified so long as she maintained an onstage pose that corroborated an enticing public persona. "Miss Bankhead, even as the maid that milks, must be a good workman if she is to do her job well . . . no actress can play in the same play for two or three hundred nights (and be the chief attraction of it), without an enormous expenditure of vitality, hard work, and strict attention to business. . . . Is this a step down or a step up from the heroine who moves the gallery to envy on the imaginary grounds of her unlikeliness to themselves?" Griffith was not prepared to issue judgment but was adamant that "It is, at least, a step in a quite different direction."

Betrayals

"Oh, darlings, I've been fucking all night!"

Nineteen twenty-eight was a year of betrayals. Not only did Eugenia appropriate Tony Wilson, but Tallulah's dream to become Lady Alington, which had remained fixed at the back of her mind, was squashed all but irrevocably: at the end of September, Napier's engagement to Lady Mary Ashley-Cooper was announced. Ashley-Cooper was twenty-six, exactly Tallulah's age, the eldest daughter of the Earl of Shaftesbury. Her beau ideal's decision to marry was motivated in part, David Herbert claimed, by his desire to have children. Alington must have long ago decided that Tallulah would not be the proper wife and mother. His own mother may have helped him to that decision. Lady Alington was determined that Napier and his sister Lois be brought to some accommodation with outward propriety.

It was seemingly on the rebound that Tallulah became engaged to Count Anthony de Bosdari, an Anglo-Italian venture capitalist. But her impulsive decision brought only more disappointment and frustration. Bosdari was "handsome, possessed of great charm, and the last word in confidence," Tallulah writes in her autobiography. "He was smart, crafty, and a bit twisted."

She met him while on a holiday in Brighton with a lover of hers named Monica Morrice. In *Tallulah,* Tallulah offers the interesting recollec-

tion that it was Morrice who was first attracted to Bosdari and asked Tallulah to send a note to his table. Back in London, he sent her a letter that "stated brazenly he was going to marry me." Three days later he showed up at Farm Street and told her butler that he wasn't going to leave until she agreed. After the rejections of that year, Tallulah was susceptible to being swept off her feet. "I didn't know how to cope with so rugged a Romeo!"

In late November, she wrote to "Daddy Darling: Now darling hold your breath and promise not to tell a soul except Florence because it's a great secret but I'm going to be married at Xmas." She inventoried Bosdari's social, educational, and financial accomplishments in the tone of hyperbole that informed all of her letters to her father. She was going into such detail "so you will see I'm marrying a man that you will appreciate and love." Bosdari loved music and he danced "better than any one in the world which is very important because you know what happened to the man who wouldn't dance with his wife and apart from this I love him so there. . . ." Bosdari had given her "the most beautiful diamond necklace and a Rolls Royce. . . . He also thinks it would be rather chic for me to pick him up at the office. Just a model wife you know. I don't have to give up the stage unless I want to but he thinks I will want to. He's usually right." She might genuinely have welcomed, at least temporarily, the prospect of an early retirement. Not only did Tallulah want children, but she found the insecurity and the routine of an actor's life sometimes all but unbearable. A few months earlier, she had written in the Sunday *Express*: "My greatest ambition always is to get a good play and then another good play and so on through the jolly years of life. The only other ambition I really have is to be free of ambition for to be ambitious is too exciting and harrowing for peaceful enjoyment."

She informed Will that she was marrying on December 22 at the Regent's Office "as you are not here to give me away." But she promised a visit to the U.S. as soon as *Cardboard Lover*'s run was over. "Won't it be fun. I can just see that precious Florence jumping all over the house with excitement."

The Bankheads seem to have had no idea what Tallulah's life in London was really like. Aunt Marie wrote to Will with evident sincerity: "I received your letter with the enclosure of Tallulah's exuberant young love story and am delighted that the child is so happy in her engagement. Tallulah has not spread her affections so broadly and for that reason her love may be deep and lasting."

Tallulah had written her father that Bosdari was "going in for politics next year. I think it best to keep it in the family." Nevertheless, Marie was

perturbed by statements Tallulah had given out suggesting that her retirement from the stage would not mean a spurning of public life. "My ambition is to reverse the performance of Lady Astor," Tallulah said. "She is an American woman who got elected to the House of Commons. I will shortly become an Englishwoman through my marriage to Count de Bosardi. Then I will try to capture a seat in the American Congress. This will be possible because I retain my American citizenship rights."

Tallulah would have to run against her own father in the House of Representatives, or against her uncle John for the Senate, since John was planning to run against the incumbent Senator Heflin in 1930. Marie wrote Will, "The newspapers seem to be pretty close on Tallulah's heels and have cabled some rather silly stuff purporting to be an interview with her. I think it's a good idea for all concerned for you to cable her and very gently admonish her against interviews." Marie had been able to keep most reports out of the pages of the *Montgomery Advertiser,* where she had previously been on staff, but other papers were having a field day.

During the run of *Her Cardboard Lover,* Tallulah was reunited with Sara Mayfield, a childhood playmate from Montgomery. Mayfield was in London pursuing a degree in art history and had been given a letter of introduction to Leslie Howard. After a Wednesday matinee of *Her Cardboard Lover,* Mayfield was having tea with Howard in his dressing room when she heard Tallulah's voice talking to Bertie Marr, Howard's manager. From the hallway, Tallulah heard the mellifluous tones of another well-bred Southerner. "Oh, darling, where did you get that marvelous voice?" Tallulah asked as she swept into the room. "The same place you did, Tallulah," Mayfield replied, turning around to face her.

"Therefore she being a politician's daughter embraced me and invited me to come to her house for cocktails next Sunday," Mayfield subsequently wrote H. L. Mencken's wife, Sara. "Tallu has wowed London," Mayfield wrote Sara. "She is the toast of Mayfair. . . . more glamorous and gorgeous than Garbo will ever be offstage and certainly more amusing—one of the few genuine wits I know." Mayfield and Tallulah went out together frequently. "The one adjective I know that describes Tallu best," Mayfield recalled in 1971, "is great-hearted."

Tallulah may already have had some second thoughts about Bosdari. Mayfield wrote Sara Mencken that Tallulah was "so tentative" about the engagement "that I suspect there's big game in the offing. . . . Even the PragoWager—as the English call the Prince of Wales—is carried away with her."

In 1971, Mayfield claimed to have known at first hand that Tallulah and the Prince of Wales did enjoy some type of relationship, just as *Zit's* magazine had reported back in 1923. "Much to the amazement of the Court, he would take her dancing, and to the Savoy Grill, which was one of Tallulah's favorite places. They were seen publicly not once, but often. I doubt that it went as far as an affair, but he was thoroughly infatuated with her and she was certainly ten times as charming as Wallis Warfield."

At Christmas, Tallulah sent Will a telegram from Paris telling him that the wedding had been pushed back to January 19. She ignored two cables from him asking for an update. Tallulah and Bosardi went for a trip to Berlin, where Bosardi was "up to some hanky panky with UFA," the German film company. During their stay Tallulah became convinced that "I was being used as a front, even a decoy," to further deals in the entertainment industry that Bosardi was attempting to broker. She did agree, however, to film for UFA a short sound excerpt from *Her Cardboard Lover* that was distributed as a trailer to movie theaters. She learned that Bosardi had been married before, in the United States; the legality of the divorce he received there was questionable under United Kingdom statute.

Aunt Marie heard rumors of the broken engagement from a friend well before Tallulah was ready to inform her family or make a public announcement. Marie wrote on March 1 that "I think it was the best thing you could have done. . . . You have done so splendidly for yourself that there is no reason why you should marry unless you have every reasonable expectation of a happy union. . . . I know how independent you have been of all of your family and perhaps you never feel the need of any affection from them but in case you are ever in real distress of mind I trust that you would call upon me if I could be of any service to you. . . ."

In the spring, Tallulah went to Scotland to begin a tour of *Her Cardboard Lover;* there, "I broke all previous records," she later wrote Will, "and surely have made for myself quite a new and large following." John Perry saw her in *Cardboard Lover* on tour and said that the farce was made richer because Tallulah made clear how desperately vulnerable Simone was to the charms of her ex-husband. "She could be very moving," he recalled.

Bosardi stayed in Germany. Tallulah finally phoned him from Scotland to tell him, "I can't marry you, Tony. I don't want to. Besides, it wouldn't be legal." Bosardi asked only that she not announce the news until he had clinched a certain deal. Tallulah agreed.

Her tour concluded, Tallulah went to the South of France to recuperate from the bewildering events of the past few months. She wrote her fa-

ther upon her return and was forced to admit that her ambitious plans had foundered. "My darling Daddy you must think me awfully mean but I've meant to write you every day for months now, but things kept crowding in until I had so much to tell you that I didn't know how to begin." As always, she allowed Will only the most threadbare information about topics large and small in her life. "About the engagement I can tell you that in a nutshell his American divorce is not legal in England." That was all the explanation she was prepared to supply, but she made vague allusions to travel plans: "You may be seeing the prodigal child sooner than you think. I hope so. . . ."

There was news, too, of her revised appearance; Tallulah was much more forthcoming on that score than she was about Bosdari. She seemed to cope with her humiliation by reverting to an intensified focus on her looks. After her holiday she was "very brown and sunburn and very much thinner. . . . I am letting my hair grow, am growing it off my face and behind my ears à la Greta Garbo." She had apparently had the second of two operations designed to improve her nose, which was superb in profile but less so straight on. She told Will: "I've had my nose operated on again and it is now perfect, but don't tell anyone as I don't want it to get in the papers. It's the same in profile but the bridge is narrower in front." Before and after pictures were enclosed.

The day after writing Will, Tallulah began rehearsals for a new play, *He's Mine*. This was an adaptation by Arthur Wimperis of *Tu m'épouseras*, a farce that had opened in Paris two years earlier, written by Louis Verneuil, a popular young playwright. (It had also been filmed in Hollywood in 1927 as *Get Your Man* starring Clara Bow.) A consortium of Americans, including Gilbert Miller, Herbert Clayton, and Jack Waller, was producing. The direction of the play, too, was very much a collaborative effort, involving the talents of Wimperis, as well as stage manager Arthur Hammond, but most importantly, Sir Seymour Hicks. Hicks was one of the great comedians of the day, veteran of a long run of transplanted French farces, some of which he had translated. In his 1938 memoir, *Night Lights*, Hicks recalls Tallulah's "hard work on the stage and her conscientiousness at rehearsals" during *He's Mine*. "To regard her, as some still do, as a sort of gifted amateur, forced into the limelight and big parts by a strong personality and an exciting off-stage existence, is nonsense; and unfair nonsense at that."

George Howe was summoned to read before Hicks and Tallulah for the juvenile lead, Étienne. When Howe appeared onstage at the St. James Theatre, "Oh, my God!" Tallulah gasped, finding him an unlikely juvenile be-

cause he was prematurely bald. There was no need to worry, he assured her, he donned a toupee onstage. Howe did get the job.

By this point, Tallulah's need to expose herself had already become almost chronic. As much as a standard mode of seduction, it was a kind of reflex to cope with the rigors of social interaction, in which Tallulah, despite her impeccable Dixie training, became less at ease as her fame grew. *Darling* was an endearment on everyone's lips during the 1920s, but in 1962, Tallulah explained that it had become a habit for her not as an insistence on intimacy but because it allayed social anxiety. Her nudity also gave her a foolproof lever of control, but it also frequently destroyed the possibility of ordinary social exchange. And it became less and less voluntary as the years went on. There was almost no one in Tallulah's vicinity, no acquaintance of any length, who did not see her naked or at least very loosely covered. Her boundaryless interaction with those around her frequently merged into what can only be called socially aberrational behavior.

About a year after Glenn Anders had acted with Tallulah in 1926 in *They Knew What They Wanted*, he dropped in on her unannounced, immediately after arriving in London with a Columbia University fraternity brother named Tommy. As it turned out, Tallulah was having a quiet night at home reading in bed. Overjoyed to see Anders, she ordered her butler to open a bottle of champagne as she settled back into bed, beckoning Anders and his friend to sit close to her. "I just can't wait to ask—oh, tell me about your mother?" Tallulah cried. "Is she still—For Christ sake I've got a piece of tissue paper in my ass! Throw that in the can, will you Tommy?"

Nothing so unnerving awaited Howe when, at the end of the first day's rehearsal for *He's Mine,* Tallulah invited him home for tea. They were alone and Tallulah was the perfect lady as she made tea, asked him about himself, and listened quietly. Howe was thus even more startled when Tallulah, whose chair was lower than his, put her leg up and allowed Howe untrammeled sight lines. He failed to evince any reaction, however, and Tallulah abandoned her jest, perhaps with relief. "I was shy of Tallulah," he explained. "I wasn't a very forthcoming, chatter-upper; I was a rather modest gentleman of the time. But Tallulah took you on your value, and because I didn't make a pass at her, she quite respected me for that."

Howe was born in South America and had various stories she wanted to hear. He would come to realize that Tallulah was interested in people who'd traveled and had a foreign, remote background. His father kept an apartment above Harrods department store in Knightsbridge, and Howe subsequently gave a party there for five or six members of the cast. Tallu-

lah came, very intrigued about a private apartment above a department store.

Howe recalled her admiration for established actresses like Madge Titheradge, Sybil Thorndike, and Gladys Cooper. Two years earlier, Howe himself had acted with one of the most formidable doyennes in theatrical London, Dame Marie Tempest. During rehearsals for *He's Mine,* he was thrilled to escort Tallulah to the opening night of *Devil in Bronze* at the Strand Theatre, starring Phyllis Neilson-Terry. Cheers went up from the gallery when Tallulah's fans saw her. Settling into her seat, Tallulah received more applause than did the popular Neilson-Terry when she made her entrance onstage.

In *He's Mine,* Tallulah played Wanda Myro, a secretary and the daughter of a Budapest shopkeeper. For two years she had been the mistress of a young nobleman, Maxim de la Bellencontre. Now he has dumped her because his family demands that he fulfill a long-arranged marriage contract. Wanda arranges a sham car crash outside the Bellencontres' Loire Valley château, where the family's friend and permanent house guest the Marquis de Chantalard praises them for maintaining the old standards. "In these days of Bolshevism and Jazz, you're the only man I know who stands like a rock for the old regime, and refuses to bow the knee to strange gods or to—er . . . er . . ." "Vulgarly speaking," the duchess interjects, "to show the white feather to the Black Bottom." But it soon becomes clear that hypocrisy is among the most hallowed "virtues" at the château. *He's Mine* honored the venerable practices of French farce and took aim at the aristocracy and the church. The duchess has been secretly having an affair with the marquis for years. The marquis's daughter, Simone, is Maxim's intended, but she wants to marry his brother Étienne, who is headed for a seminary. Étienne's piety is questionable, however; the moment he is alone with Victorine, the maid, he begins pawing her.

Wanda is a picaresque heroine, a working-class adventuress, but not a gold digger. She has never cashed the kiss-off check that the duke and duchess sent her. Carried into the château feigning unconsciousness, Wanda passes herself off as a Serbian princess. Within a few days she has utterly disarmed the household and is ready for Maxim, who is about to return home for his wedding. She bets him that in three days they will be engaged. He retorts that in three days she will have conceded defeat. "After my father, I shall become the head of the family," Maxim tells her. "Yes, and I shall be the brains." She knows she is best for him—"I am fighting for your happiness"—and so feels sanctioned to employ every possible ruse to

win him back. Needless to say, by the fall of the third-act curtain, she and Maxim are to be married, as are Simone and Étienne.

Nearly every night after rehearsal, Arthur Wimperis; Helen Haye, who played the adulterous duchess; and Howe played bridge at Farm Street—a passion for the game had flared in Tallulah and would continue for the rest of her life. One night, while Tallulah was dummy, she disappeared and returned stark naked, running around the table, to the amusement of all present, although Haye put up a barrage of good-natured admonitions. She was one of the most beautiful dowagers in the British theater and, although quite proper, had many lovers of her own.

Tallulah's successful tour of *Her Cardboard Lover* earlier that year must have influenced her producers' decision to break in *He's Mine* with stops across Scotland and northern England. Tallulah traveled with her lover, Monica Morrice, who was boyish, amusing, and campy, one of many stagestruck socialites of the day. She was officially Tallulah's understudy, but had neither aptitude for the stage nor any particular understanding of its customs. One night on tour, Tallulah was nowhere to be seen as curtain time approached. The management considered the possibility of putting Morrice onstage, but there was just one hitch: she had never bothered to learn the part. Fortunately, Tallulah arrived just minutes before the performance was to start. She apologized gaily to everyone present, and went to make herself up while the curtain was held for twenty minutes.

"She seemed to own the company," Howe recalled, as if Tallulah were an actor-manageress in the tradition of du Maurier. She liked dining with members of the cast and invariably footed the bill. Over dinner, she enjoyed discussions about politics or the state of the poverty-stricken they saw as they toured. Somewhere on tour Michael Wardell also showed up. Wardell was an executive in the Beaverbrook newspaper empire, and in her sporadic way, Tallulah had been involved with him for several years. She also took a maternal interest in his son Simon, who was an elementary-school student.

As she boarded a train one morning during the tour, Tallulah announced to her colleagues, "Oh, darlings, I've been fucking all night!" Tallulah alternated, leaving Morrice furious in her bed while she trotted off in her nightgown to visit Wardell on another floor of the hotel. "Now, Tallulah," Helen Haye chided once again, "you must remember to stay in your room; you can't go wandering about the passages!"

Touring was still something of a novelty for her. As the company traveled farther north, it may have been difficult sometimes for their audience,

steeped in burrs and brogues, to follow Tallulah's transatlantic accent. Howe somehow sensed that the audience of straitlaced burghers didn't quite approve of her; despite her success on tour earlier that year in *Her Cardboard Lover.* He watched her work extra-hard to woo the audience. She didn't miss a beat if a laugh didn't come, but then in the intermission, or after the final curtain, she frequently commented on what had worked or what hadn't, and why, and discussed what she could try differently at the next performance.

As Cathleen Nesbitt had, Howe compared acting with Tallulah to the difficulty of playing with an actor who's not really looking at you; by comparison, Tallulah "played completely *with* you." In act 2 of *He's Mine,* would-be seminarian Étienne's fascination for Wanda leads him to sneak into her bedroom and hide in the closet to wait for her. The closet had a sliding door in back so that Howe could slip out until he was due to be discovered by Wanda. One night in Wales, however, the door jammed, and Howe was obligated to spend the balance of the act nearly asphyxiated by Tallulah's beautiful costumes, steeped in the heavy floral perfume she used. In 1982 he could almost still smell them.

In Glasgow, Howe and several actors were visiting a golf club in the mornings. Tallulah would meet them for lunch, violating propriety by walking over the sacred green in high heels. At lunch in the club room, Haye would try fiercely to rein in Tallulah's language, which horrified the old Scottish gentleman sitting around them. "Tallulah, shut up," she'd whisper.

Howe could see that Tallulah had great respect for Haye's talent and experience and might easily have consulted her about issues in the play. Tallulah could also have benefited from the decades of wisdom and experience accumulated by Frederick Volpe, who played the marquis, and had acted with Tallulah in *The Garden of Eden* as Hugh Williams's fussbudget uncle Herbert. Playing Maxim's father in *He's Mine* was Allen Aynesworth, a walking piece of theater history whose experience dated all the way back to the opening night of *The Importance of Being Earnest* in 1895.

Lawrence Anderson had been cast as Maxim. Anderson was related to Laurence Barrett and Mary Anderson, eminent tragedians of the nineteenth century. According to Howe, Anderson himself was "a rather solemn and traditional actor" without much comedy in him. Before *He's Mine* opened in London on October 29, 1929, Anderson was replaced by Harry Kendal, a well-known young comedian with a touch of eccentricity that can be glimpsed pleasurably in Hitchcock's *Young and Strange.*

"This far-fetched piece should obviously be played as a hurly-burly of outrageous farce," James Agate wrote in the Sunday *Times*. Agate wanted the doors slammed with more force, pratfalls risked, the drawing-room floor scuffed with frantic footsteps. According to his critique, Aynesworth, Volpe, Howe, and Haye were "a quartet of players in the greatest reputation and accomplishment in pure comedy, none of whom, with the possible exception of Mr. Volpe, has ever had the faintest notion of making himself patently and fantastically ridiculous."

As for Miss Tallulah Bankhead, I am compelled to say that after the first few moments she appeared to give up acting entirely and resign herself to abounding and splashing out in her own temperament. She gabbled through her part at terrific speed, and indeed it was so absurdly wordy that if she had not done so she would still have been acting half an hour after the rest of the cast had gone home. But the multitude of words, and the speed with which they must be delivered, made the performance as breathless as a Continental express two days behind its time. Miss Bankhead has taught herself to be an extremely accomplished actress, and the most regrettable thing about the piece seemed to me that it tempted this good artist to forget all she has learned about her art.

But St. John Ervine reviewed the second night for the weekly *Observer* and felt that Tallulah had given "an uncommonly good performance," that she and Aynesworth, "by sheer acting and facial expression, provoked the audience to the laughter which the lines attempted, but too often failed to rouse."

Ervine had gone to the performance with the belief, derived from several reviews of the first night, "that Miss Bankhead would shout her way through the piece." He found her instead

displaying abilities for comic acting and quiet effects that I ought to have known she possessed from my recollections of her work in "Fallen Angels" and "They Knew What They Wanted." Miss Bankhead has not completely mastered herself. She has not learned the full value of repose, nor does she yet understand how to obtain the utmost effects from a line—I suggest to her that she should closely observe the work of Miss Helen Haye in this piece—but she has talents to develop, has, indeed, developed them considerably since her first appearance on the English stage.

Had Tallulah modified her performance after reading the opening night reviews, or is this just one more example of the divergent responses the same performance can evoke?

On the basis of its script, *He's Mine* was rather more diverting than *Her Cardboard Lover,* but it lasted less than a month at the Lyric. However, *He's Mine* was the occasion for a new candor.

Onstage, Tallulah expanded the boundaries of sexual equivocation as they were being expanded in society, at least in the fringes of a social and artistic elite. Amid this climate of ambiguity, it was now acceptable for *Theatre World* to hint at lesbian undercurrents in her audience:

> No criticism of Tallulah Bankhead's plays is complete without reference to her displays of lingerie. Personally, I find her more attractive in a jumper-suit than without one, and I am quite willing to take her underclothes for granted. I am told, however, that these rather feeble attempts at immodesty are for the benefit of the feminine element of the audience. Well, well girls will be boys!

Constrained by Crinolines

"Whenever Tallulah moved or breathed there was chemistry flowing."

—ACTRESS JOAN MATHESON

S he wanted to be a *great* actress," Tallulah's friend David Herbert recalled. "I think she *was*, myself. I felt it in my bones; she wanted to be even better than she was." But Tallulah was subject to an equally compelling hunger for money, luxury, and stardom. These were not irreconcilable goals, but nevertheless required a very delicate balancing act that was increasingly undermined by the public persona she had created. When Estelle Winwood made a short visit to London in the late twenties, Tallulah complained—as she would do throughout the rest of her career—about the dearth of good roles that she was offered. "My dear Tallulah," Winwood replied, "has it ever occurred to you that Cochran, Basil Dean and all the others are reluctant to engage you these days because of your reputation other than that of an actress?"

It's unlikely that British producers were actually reluctant to hire Tallulah, although it is true that after 1928 almost all of her London plays were produced by Americans. Indeed, in London she had come to symbolize an American invasion of sorts at a time when "the Americanisation of

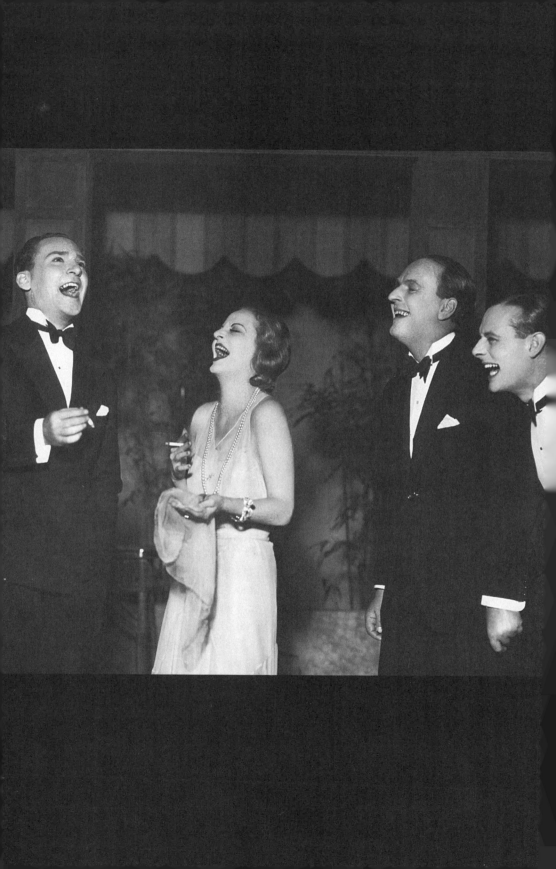

the London stage is almost the sole topic of conversation," *Theatre World* reported in 1928. But it is certainly likely that her private life had become too well known for her to be completely believable in a role that did not comport with her own notoriety.

It was probably financial considerations that brought Tallulah to the stage of London's Palladium a few days after *He's Mine* closed. Her appearance amid an assortment of magicians, song-and-dance teams, and tumblers was not as unusual as it seems today. Many dramatic stars of the day toured the music halls of England and the vaudeville theaters of the United States. For her music hall debut, Tallulah had selected a sketch by Edwin Burke, entitled *The Snob,* in which she was a young wife whose husband will not recognize his illiterate bootlegger brother, and "by means of a trick," *The Stage* explained, "exposes the snobbery of her husband." The unsigned review reported that *The Snob* "shows off her own particular art to advantage, if it does not exactly overtax her talents," and mentioned that "a funny little surprise at the finish gives an added touch to her performance." Tallulah's success earned a second-week holdover at the Palladium.

Tallulah may have preferred comedy, but "like all comedians," droll Gladys Henson remarked, Tallulah "longed to play Hamlet." If not so far as Shakespeare, she nonetheless determined to range very far afield in her next stage appearance, choosing a revival of Alexandre Dumas *fils's* 1849 *La Dame aux Camélias,* better known in English as *Camille.* Dumas's first play was written when he was twenty-five. It was a dramatization of his own novel, written two years before, and based in part on his love affair with the courtesan Marie Duplessis. Dumas's tale of Marguerite Gautier, the courtesan who tries to discard her past with a new life and younger lover, remained one of the great warhorses of the international repertory well into the twentieth century. Marguerite sacrifices her one chance at happiness at the urging of her lover Armand's bourgeois father. The fallen woman accepted just enough punishment to make her acceptable as a heroine. (The play was nonetheless considered scandalous by many in Britain and the U.S.)

The mystique of the role must have attracted Tallulah, in part because it had been indispensable to the repertory of so many international stage stars. She could have seen in the martyrdom of Marguerite a precedent for roles like Iris March in *The Green Hat.* But her principal motivation seems to have been rebuttal. After *Camille* opened, she told Ward Morehouse of the *New York Sun,* "It's been said that I only do plays in which I un-

Let Us Be Gay

dress. . . . As a matter of fact, I've undressed in but two plays out of fifteen—*The Garden of Eden* and *Her Cardboard Lover*. Anyway, I decided to give them *La Dame aux Camélias,* and let them say I undress in that!"

In *Camille* she was again directed by Nigel Playfair. A young actress named Joan Matheson, who had recently graduated from RADA, was making her West End debut playing Nichette, Marguerite's loyal and innocent young friend. Matheson found Playfair's stance as director extraordinary in its remoteness. "Looking like Queen Victoria," Matheson said in 1982, Playfair sat in the stalls or in the box, very seldom venturing onto the stage. "I think having got together what he thought was the right cast, he relied upon his little magic to work and blow it all together." If so, this was a strategy that had served him in good stead in many of his revivals at the Lyric Hammersmith.

Having directed Tallulah in *The Green Hat,* Playfair must have assumed he would be able to handle her again. Yet while she "never complained during rehearsals," Matheson said, "she went her own way. It's as simple as that. She said, 'Yes, yes, darling, of *course,* my love, of course dear,' and then went straight away and did exactly what she thought she would do in the first place." And in Matheson's opinion, Tallulah's whole approach and manner was too contemporary. "She had no sense of period," Matheson complained.

Yet Tallulah later recalled that she felt straitjacketed by her attempt to conform to what she interpreted as proper period decorum. In 1938 she said: "I had a ghastly time trying to maneuver the old-fashioned costumes and make all the old-fashioned attitudes. I was perfectly miserable because I couldn't cross my legs and slouch in a chair, and puff at a cigarette." Her experience of the play, and perhaps the audience's as well, suffered from her inability to suspend her own disbelief. "It just seemed phony to me."

Where Tallulah shone was in the scenes of gaiety, and those establishing her camaraderie with her demimonde cronies. "She used the bawdy side of the part, and she felt happy with that," Matheson recalled. "That was lovely. What she was lost in was this wonderful recovery, this return to days of refinement. I think she'd have been happier if the whole thing could have been coarser and more truthful. The way it's always done is that she suddenly becomes pure and lovely, not a courtesan anymore. There's this immense refinement."

Another source of frustration was her leading man. Tallulah's first choice for Armand had been Laurence Olivier. But he had just married ac-

tress Jill Esmond, whose mother, Eva Moore, had played in *The Garden of Eden,* and thereby been privy to Tallulah's affair with Hugh Williams. Moore as well as her daughter refused to let Olivier act opposite Tallulah.

Instead, Playfair hired Glen Byam Shaw, a good, honest actor who was just as handsome as Olivier. Between Shaw and Tallulah there was no special chemistry, Matheson said. Then she qualified that by adding, "Whenever Tallulah moved or breathed there was chemistry flowing. But Glen was holding out against it. She was way after him, and he was by no means interested." Shaw had recently married Angela Baddeley, a lovely and accomplished young actress. Tallulah and he were cordial, but she was put out about not getting anywhere with him. It was not what we would today call sexual harassment, "it just wasn't all the fun it could have been," Matheson observed. Tallulah must have known that Shaw was not a stranger to contingent arrangements, having before his marriage been a lover of poet Siegfried Sassoon. "They were not together on stage and certainly not off," Matheson said. Yet Tallulah remained surrounded by admirers: "There was always somebody, something for her. You never knew whether it was going to be heterosexual or homosexual, and it really didn't matter at all: she was full of warmth."

Tallulah's girlfriend Monica Morrice was still very much in the picture, playing a bit role in *Camille.* Although she and Tallulah ate supper in Tallulah's dressing room after each performance, Morrice was not extended special privileges in the theater. She shared a room several flights up with three or four other women in the cast. One of them was Ellen Pollock, who in 1982 described Morrice as "a tiny little thing, flat as a board, with a very short gamine hairdo. Looked more like a boy than a girl, and acted like a young boy, always naked in the dressing room flying about, didn't give a damn."

At one point Morrice decided that her wig was appalling. Pollock expected that Morrice would go circumspectly to the stage manager, confess that it didn't fit quite as it should, and ask if Playfair could possibly have a look at it. Instead, Morrice marched to the stage in her own customary trousers and strode to the footlights. Her wig perched on her head like a bird's nest, she stood arms akimbo and greeted Playfair with a cheeky, "Well, do I wear it?"

Morrice was informed that she would wear the wig and she obeyed. "But the cheek of it!" Pollock exclaimed. "I couldn't believe my eyes! Everybody held their breath, they thought Nigel would blow up." Pollock

was nevertheless fond of Morrice and ventured to ask her why it was that she swore so unceasingly. "It's my natural way of speaking. What do you mean?"

"I think it's awfully ugly."

"Is it?"

"Yes, to tell you the truth it gives me the shivers."

The next day Morrice came in the dressing room and said, "Listen, everybody, nobody is to use any swearwords, do you mind? Because it's jolly ugly, and Ellen doesn't like it." Morrice's torrent of swearwords dried up from that point. "I was awfully impressed by that," Pollock said. She found Tallulah's language equally shocking, of course, although she never dared reprimand her.

Matheson was bewildered when Playfair made her Tallulah's understudy, for in Matheson's own opinion she could no more have reproduced Tallulah's allure than the man in the moon. Tallulah came to an understudy rehearsal to watch Matheson go through the whole part. "Well done, darling!" Tallulah told her when it was over. "You *beast* to be here!" Matheson protested. "I could have killed her. She just laughed and went on."

Camille opened at London's Garrick Theatre on March 5. In the Sunday *Express,* the adoring Hannen Swaffer described Tallulah as "the most fascinating creature now acting on the London boards," but nevertheless declared that she "would be better advised to stick to modern plays. She is a modern of the moderns. She is essentially a product of this age, which she reflects in every mood and tense, and in the deep pools of her beautiful eyes."

Camille was performed in a new translation prepared by Playfair himself with Edith Reynolds. They had made some cuts in digressive discussions of Parisian topical events. But Playfair noted in an introduction to the published translation that "the words and directions of Dumas have been followed perhaps more faithfully than in any recent production, even in his own country." Probably this was a mistake. In 1936, *Camille* succeeded for Garbo on screen in part because it was entirely rewritten. If not brilliant, the screenplay is still a lot more fluid than Dumas's original, which was certainly not, for the tastes of 1930, a vital script. "Marguerite becomes human when she ceases to orate (which is seldom)," noted the *Times.* For the first time in her life, Tallulah was delivering what the *Times* called "set speeches." They were not rolling Elizabethan monologues, but rather long recitations that sometimes repeated, verbatim, the text of letters Marguerite has received. They discharged information rather than simulated conversation.

Tallulah altered her diction for *Camille,* dropping her colloquial delivery and adopting a more formal address. But she was certainly not at home in these recitations. The *Times* complained that these speeches were "marred by her tendency to begin each period loudly and instantly to lower her tone; the rhythm is wearisome and its regularity destructive of sense."

Sometimes Marguerite voices her private thoughts, delivering asides to the audience that were accepted dramaturgy for centuries but were by now superannuated. "In these days of sophistication the 'asides' and soliloquies with which the play abounds appear ludicrous in the extreme," D.C.F. reported in *Theatre World.* Ivor Brown in *The Observer* noticed that Tallulah was obviously frightened by them. They were certainly a drastic departure from the naturalistic dialogue she had delivered for most of her career. "Does he love me, I wonder?" Marguerite asks herself. "Am I even sure that I love him, I who have never loved?"

Playfair's concession to the tastes of a contemporary audience was his apparent interdiction of the emotional paroxysms with which earlier actresses had milked the play dry. Back in the 1890s, George Bernard Shaw had written that the emotional displays exploited in *Camille* were "not fundamentally distinguishable from that offered by a public execution or any other evil in which we still take a hideous delight." *The Era's* critic confessed his surprise at finding:

> in place of the high colored and feverish affair which we had expected, a play of half-tones and mild plaintiveness. Just a series of pretty pictures and dresses in Sir Nigel Playfair's well-known Hammersmith manner. . . . We left the theatre feeling that there is only one way to play "The Lady of the Camellias" and that is the old way. Bring anything savouring of the precious near it, and each shows up the absurdities of the other.

Instead of the flood of congratulations a success elicits, after the reviews appeared "we all kept away," Pollock recalled, "it was so embarrassing." Tallulah gave her reviews an offhand dismissal, but her behavior showed that she was demoralized. In the wings she was tense, sometimes shaky. "She wouldn't want anybody near her at all," Pollock recalled. Sometimes she was not in the wings when she should have been. Her cue would be sounded, and she wouldn't come immediately, so onstage there'd be a few seconds of panic until she arrived." "She could shatter you a little

bit," Matheson recalled. "In fact, you didn't quite know where you stood with her—ever."

Matheson felt sure that Tallulah herself was more aware than anyone of her own inadequacies in *Camille*. "She really didn't like herself in the play, and she was fighting against it. I felt this terrific vitality being crushed by the fact that she knew she'd made a mistake."

After one Saturday-night performance Tallulah headed for a weekend in Paris. But when Monday night rolled around, she was nowhere to be seen. The possibility of putting Matheson on could not even be broached because Matheson's own understudy for the part of Nichette had lost her voice. The performance was canceled and the audience's tickets refunded. Tallulah appeared Tuesday night and sent apologies to the cast via the call-boy. "We were all very shocked," Pollock recalled. "In all my long career I never remember anything at all like that."

Tallulah's *Camille* seemed to be beset by more than its share of mishaps. At one performance, she had finished her death scene and the curtain descended only to rise up again instantly. The audience saw Tallulah walking offstage breezily, her crinolines gathered around her waist. On another occasion, the fourth-act curtain did not fall as scheduled on the final crescendo of Tallulah as Camille, her current protector D'Varville and the scorned Armand at loggerheads with each other. The actors had no choice but to continue the scene as D'Varville's threatened slap across Marguerite's face became a reality. Tallulah responded with a retaliatory slap. The charade seemed to the cast to last an eternity, as it was forced to keep simulating appropriate reactions of shock and distress. When the curtain finally came down, Tallulah was livid. The stagehand responsible "was in terror of his life." Backstage echoed and reechoed with her expostulations. "Finally," recalled Matheson, "this was typical of Tallulah—having blasted him to hell, she finally sent for him, and got him stinking drunk to cheer him up, after having nearly finished him."

Pollock had given birth a few months before *Camille* opened, and she kept her infant son in a basket in her dressing room, breast feeding him during the intermissions. "Bring that baby down. I like that baby," Tallulah said, and sometimes asked if Pollock would let him stay with her alone while she made up. Tallulah asked Pollock and her baby to a cocktail party she was hosting for a few guests.

Camille lasted only two months in London, but Tallulah's popularity in the English provinces warranted a tour, where yet another onstage calamity occurred. A modernized set had been built for the tour, substituting levers

inside the stage for the system of ropes and pulleys that manipulated scenery. A veteran stagehand was still a bit baffled by the new apparatus and sat down accidentally on one of the levers. Tallulah and Matheson were seated in the garden for act 3. Tallulah was extolling the virtues of country life when, with a terrible clang, all the pillars shot up into the air and rocked backward and forward. Matheson was paralyzed, determined to continue with the play at all costs and behave as if nothing had happened. "But this is when Tallulah took charge. She knew what to do. She just fell about with laughter. The audience laughed, she laughed, I laughed." The pillars came back into place, "and she picked it up, got everybody back into the scene." This stagehand was more fortunate than the previous malefactor: Tallulah had laughed all her irritation out of her system.

London Farewell

"She does all the right things in the wrong way, or all the wrong things in the right way."

—PLAYWRIGHT ST. JOHN ERVINE

As she began rehearsing Rachel Crothers's *Let Us Be Gay* in July 1930, Tallulah had no idea that this would be the last time she would act on the London stage. Earlier in the year she had told Ward Morehouse of the *New York Sun* that she would love to act in New York again. "But I live here, you see. . . . London's my home. . . . I have servants. . . . It would be trouble, great trouble, to pick up and go to America for any lengthy stay. But I could go over and make a talkie and come right back. That I'd like to do."

Two seasons earlier, *Let Us Be Gay* had been a hit on Broadway starring Francine Larrimore; Tallulah was pleased to be succeeding the actress she had supported in *Nice People* nine years earlier. In her fourth and last appearance in a play by Crothers, Tallulah was on territory both familiar and unexplored. *Let Us Be Gay* returned her to the contemporary setting to which she was best suited. At the same time she acquired a new element of maturity, playing for the first time a mother and a divorcée.

In the prologue, we meet Kitty Brown, a young California matron, devastated by the discovery of her husband's infidelity and telling him tearfully that she is determined to divorce. Act 1 opens three years later, in the East

Coast country house of a grande dame, Mrs. Boucicault, who has met Kitty in Paris. Mrs. Boucicault has summoned her for an urgent mission. She wants Kitty to lure a houseguest away from her granddaughter, Dierdre, who has fallen for him despite being engaged to another, more suitable young man. Kitty's prey turns out to be her own ex-husband, Bob Brown. Bob spends the next two acts trying to persuade her to take him back.

Let Us Be Gay is a classic comédie à tiroir, in which drawers open and subplots spill out. At Mrs. Boucicault's, a constellation of available men is each fascinated by Kitty. One of them, writer Wallace Grainger, is there with his married mistress, Madge Livingston, who justifies their affair on the basis of the artistic inspiration she supplies him. But his talents are flagging and she is struggling to puzzle out her role in his decline.

It is the themes of Let Us Be Gay rather than its plot that provide a telling time capsule of cultural anthropology. We are confronted with women's changing roles in a world that has been radically remade. The Kitty Brown we meet in act 1 is a different woman from the injured innocent of the prologue. She has acquired seasoning and sophistication, and easily sports a charming and blasé facade. She is now working, designing clothes. Sexual freedom and economic independence go hand in hand. Mrs. Boucicault asks her when she will marry again and Kitty tells her never: "When I'm paying my own bills—men may come and men may go."

"Like you," Kitty tells Bob, "I've been amusing myself with anything and everything that came my way. I know how a man feels about that too."

Helen Haye was the perfect choice to play Mrs. Boucicault, who is in some ways the most interesting character in the play. "Women are getting everything they think they want now," she declares, "but are they any happier than when they used to stay at home—with their romantic illusions— and let men fool them?" She is not a voice of reaction; she is genuinely curious. "I always knew that my husband wasn't faithful to me, but I lived in hell with him for fifty years because divorce wasn't respectable." Her own daughter has been divorced three times, and Mrs. Boucicault approves. "I'd like to live another fifty years—without the bother of living— to see this thing through. . . . I'm seventy-six, and I don't know anything."

During Let Us Be Gay, we see both Kitty and her ex-husband, Bob, put on and discard various masks. Kitty insists that Bob conceal their former relationship. When the other guests are present they talk to each other with studied impersonality, their words freighted with coded meanings. But when they are alone they talk as intimates. In the final seconds of the play, Kitty's private mask seems to crack completely as she capitulates to

Bob's plea that they reunite. "I've been so gay," she confesses, "so—so full of—so empty."

Her turnaround is too abrupt; Crothers rings down the curtain too soon. We aren't given time to speculate on how their inevitable remarriage will compare to their first. We feel better for knowing that Kitty has finally, at least privately, dropped her defenses, thus revealing the soul behind the facade. But the identity she has developed since her divorce has improved her in many ways. Today's audiences would not want to see her sacrifice her hard-won autonomy. Crothers leaves unresolved the issue of whether Kitty's newly exposed vulnerability will preclude her independence. Most importantly: Will she keep her job?

Playing Dierdre, Joan Matheson was working again with Tallulah, this time in a far more difficult role. Nichette in *Camille* is, as Matheson said, "a lovely little part; the sympathy was there all the way." But plunged into Crothers's drawing room repartee, "I could do everything wrong." Dierdre, too, is masked: a young girl in over her head, pretending to be worldly. It was a wonderful part, but quite difficult, Matheson said, because "the young girl playing her had to more or less observe herself. She had to be adult enough to know how a childish person would appear trying to be more grown up than she was—and making a complete fool of herself." Act 2, scene 1 shows an increasingly drunken and distraught Dierdre railing against her grandmother's intrigues. In scene 2, she discovers that Kitty and Bob's rooms are adjacent and accuses them of cavorting under her grandmother's roof. In act 3, she is left in limbo when she learns the truth about Kitty and Bob's common past.

Before rehearsals began, Tallulah summoned Matheson several times to Farm Street to work on their scenes together. It was always around noon, and Tallulah was to be found in her bath, evidently recovering from a slight hangover. Matheson sat near the tub, and Tallulah gave her tips as they read the lines.

Kitty was a character with whom Tallulah could have almost instinctively identified. For Tallulah's facade, like Kitty's, protected and simplified her. "She was intelligently interested in all sorts of things," Matheson recalled. "She read all sorts of things: biographies, history. Only you wouldn't have known it from just talking to her. Her general conversation was tremendously light and bubbling. It was laughter. But you'd see books around and occasionally she would let something out."

As always, Crothers was directing her own script. Tallulah now finally explained to her that it was fear of offending Alington that had prevented

her from delivering her "kings and queens" line in *Everyday* in 1921. Crothers chided her for not confiding earlier. They were certainly on good terms, but Matheson claimed that "even Tallulah, like the rest of the cast, got fed to the teeth with Rachel because she was the kind of director that had to push and nag. She couldn't help, she couldn't ease it in—it had to be 'like that' or not at all."

Matheson found her booming interjections very trying. "C'mon, darling, give," Crothers urged her. "We want more out of you!" Matheson complained about "this terrible voice going '*aaawn*,' one of those awful"— Midwest American—"voices. It rang in my head all night."

Tallulah would whisper a reminder to Matheson to "wait for the laugh," or tell her, "Don't worry, darling. Just get a bit more speed on it. Don't hang around." ("Young people always tend to dwell very hard on it," said Matheson, "drag it out, make the most of it—milk it, in fact.")

During one rehearsal Matheson burst into tears and dashed blindly offstage. "If I could have gone into the street, I would have and never gone back." She found herself in the gallery being mopped up by Tallulah, who ordered her to "get back down there!"

"I went back, 'cause she made me," Matheson said. "I wouldn't have otherwise, not for anything in the world." "You've broken," Tallulah told her, "and now you'll be all right." Tallulah "totally forgot she was the star," Matheson recalled gratefully. "Anyone else might have said, 'Oh, for God's sake, call me when this stupid child has either come back or not.'"

Crothers never went at Matheson again. "Well, now we've busted it," the playwright announced. "Now we've got something; we've got something at *laaast*."

Let Us Be Gay opened in Birmingham on August 4, 1930, "The acting is capital throughout," reported *The Stage*'s correspondent. "Miss Tallulah Bankhead has a part which eminently suits her distinctive style, and her talents have full play. She acts with finish and understanding, always with sincerity in the graver moments and in other scenes with a fine touch of comedy."

When the play reached London's Lyric Theatre on August 18, Tallulah was "fighting a gallant battle against the silly Tallulah worship," Hannen Swaffer reported in the Sunday *Express*. The rise of the prologue curtain found Tallulah sitting on a bed, sobbing out Kitty Brown's betrayal. "The staggering novelty" of the bedroom setting, "which cannot have been seen since Tallulah's last play, caused a hurricane of applause from excited females in the gallery. I guessed why they were nearly paralyzed by their

frenzy. Tallulah was in no way undressed! Perhaps they could not believe it! They yelled and screamed. Meanwhile Tallulah hid her face, nervously waiting for a chance to speak. For nearly a minute the screams went on, while I heard the voices of men upstairs, imploring to throw somebody else out."

The Stage's London reviewer called the play an "essentially artificial and unreal comedy," but was pleased to discover that Tallulah revealed moods of "passion and emotion hitherto unexplored." In the *Evening Standard,* Edith Shackleton alluded to the need of Tallulah's fans to pretend that her stage persona did no more than replicate her own life: "It is held by a few of her most fervent admirers that Miss Tallulah Bankhead never acts, but last night she was doing something so like it that the difference does not matter."

As Shackleton suggested, the gallery had become an albatross, and by now Tallulah at least to some degree realized that. "She didn't give a hoot for them, really," said Gladys Henson. "She was flattered by their attentions but she was a bit bored with them, really, 'cause they *are* boring."

"It is not Tallulah's fault," Swaffer wrote. "She works hard and she really tries. She has more 'personality' than any other girl on the stage. . . . They do not give Tallulah a chance."

An unidentified clipping pasted in Matheson's scrapbook raised a battery of red flags: "Miss Bankhead romped through this boomerang romance with enough spirit for half a dozen plays," one reviewer wrote. "Her vitality, indeed, is her greatest asset. I've never seen an actress of Miss Bankhead's eminence with less technique." Her alleged lack of "technique" is one of the most common shibboleths leveled at Tallulah, and the accusation is often flung indiscriminately without clarifying what *technique* actually means.

Matheson felt that the reviewer was confusing technique with style. Tallulah's British colleagues were playing in a recognized and familiar style, employing ways of moving, of behaving, of reacting that Matheson regarded as already codified. Tallulah had her own ways. "There was certainly nothing accepted about her: she didn't make any of the accepted movements," Matheson said. "We had a way of coming to the door; well if Tallulah wanted to, she'd come through the door backstairs. She didn't use the sort of technique that we were expecting from Marie Tempest or Gladys Cooper."

For Matheson, *technique* refers to the craft of handling oneself onstage, "being able to present yourself so you're heard and seen and your

points come over." Here Tallulah showed undoubted adeptness. "She knew how to project; she knew how to control her audience. Of course she had technique."

For the British, *technique* may be synonymous with restraint. Compared with Americans, "I think the British thought they were pretty much better actors," *The Dancers*' Una Venning said, "mainly because they were so much more subtle and controlled." In the same vein, "Sir Topaz," the droll drama critic for the weekly pictorial *Eve,* wrote after *Blackmail* that Tallulah could be counted upon to "discharge more emotion and give more of herself in one undisciplined half-minute than almost any English actress can contrive in three acts of polite disturbance."

Playwright and sometime critic St. John Ervine invariably praised Tallulah in his reviews, yet in a profile for the *New York World* in September 1928, he wrote that she "contrives to make a show during performance, and she makes it by throwing technique to the winds and going all out for a wild-storm-at-sea effect." Unquestionably this itself is also a technique, simply not one perhaps that Ervine felt comfortable with. He wrote that "She reverses the established canon of acting, that an actor gains control of his audience by keeping control of himself, for she gains control of her audience by losing control of herself." But did she lose control of herself or did she simulate losing control? Not having acted onstage with Tallulah, Ervine might not have been in the best position to know. "She does all the right things in the wrong way, or does all the wrong things in the right way." No matter what he thought of the means, the effectiveness of the end could not be denied. "Whatever the way in which she does them may be, she seizes and holds and keeps her audience," which one could well argue is or should be the primary goal of any acting technique.

Technique is also defined as the ability to maintain consistency in a performance over the course of a play's run. Barbara Dillon from *The Green Hat* said she thought that Tallulah had "magnificent instinct. But I don't think she'd been on the stage long enough, then, to have developed a technique which could have been employed on its own. It takes years of experience for a great star to be able, even if they are right off color, to fall back on their perfect technique. I think she was more dependent on mood. She was very young, remember." And on this score, it may be said that Tallulah never reached technical perfection.

After performances of *Let Us Be Gay,* Tallulah entertained in her dressing room until the stage doorkeeper was begging to be allowed to go home. "And the drink would flow then," Matheson recalled. Tallulah, however,

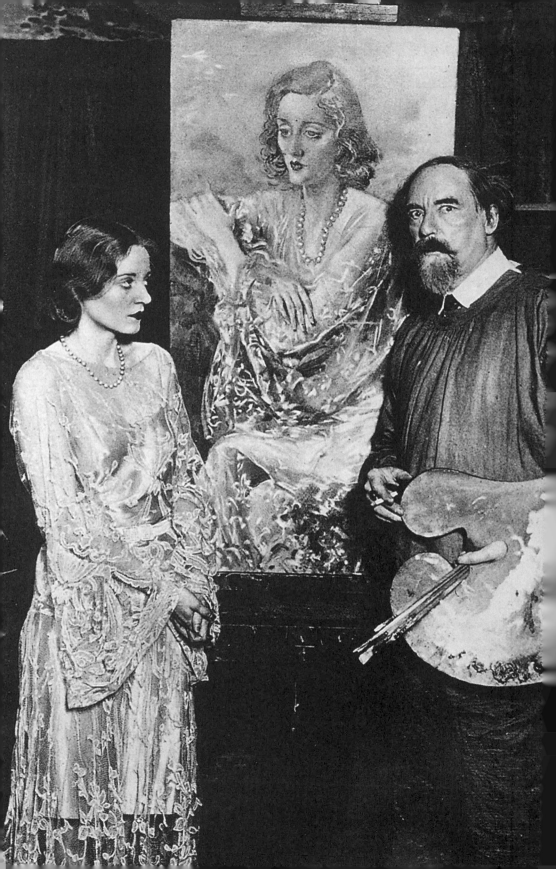

forbade drinking among the younger members of the cast, who frequently were invited with her to parties. Michael Wardell gave one at his house in Mayfair, where Tallulah and the Marx Brothers took turns reciting Shakespeare. The parties would still be at their peak when Tallulah would shoo out her junior colleagues: "Go on, darlings, you're all going home now, out you go." She instructed her chauffeur to drive each one of them home in her green-and-cream Bentley.

Passing through London was Walter Wanger, an independent producer at Paramount Pictures. Wanger was just the man to persuade Tallulah to commit herself to a future in films. He did not spend most of his time in Hollywood and he was not the prototypical Hollywood fast-talker, but "a very sophisticated man of the world and New York character," Douglas Fairbanks Jr. recalled in 1992. Wanger had been an ace aviator in World War I, then an aide to President Wilson at the Versailles Conference. He very quickly became one of the most powerful producers at Paramount, Valentino's *The Sheik* one of his first great successes. Wanger was "always a profligate spender of his own and the other fellow's fortune," screenwriter Frances Marion recalled in her 1972 autobiography. "His bravado either attracted or repelled those whose lives he touched."

Wanger was married to Justine Johnstone, a World War I *Ziegfeld Follies* beauty who had since begun medical school and eventually became a noted pathologist. But he was a ladies' man who "had beady eyes for all the various stars," recalled Sam Jaffe, who was then production manager at Paramount. Tallulah and Wanger were involved in London, and she was apt to be influenced by a bed partner. In any case, Wagner had a spectacular offer to make. Tallulah signed a multiple-option movie contract that would pay her an initial salary of $5,000 per week, rising to $8,000 should Paramount keep picking up her options. Neither Wanger nor Tallulah was evidently discouraged by the tepid response to *His House in Order* in 1928. Her unusual voice would, of course, be adding an entirely new dimension to her film possibilities.

Tallulah wrote to her father: "I'll have some interesting news for you in several weeks about my coming to America and talking films. Hollywood for me I'm afraid. I'll be a bit nearer to my favorite man, Mr. Bankhead anyway. . . ." Tallulah seemed to still regard films with the condescension of the stage star, but it was Will who had been urging her years before to concentrate on film work.

Tallulah and artist Augustus John pose before her portrait.

Her Paramount commitment made, Tallulah seemed to lose interest in *Let Us Be Gay*. Toward the end of the run, she became "a frightful giggler," Matheson recalled. "She would do terribly naughty things," say lewd things behind her hand, her shoulders shaking with laughter at her own joke, turning her back to the audience so that they didn't see. "The older actors were able to control themselves," Matheson recalled, "and I think I learned how to, but she was awful." Tallulah's misbehavior led to the management's posting calls for the entire cast to report for brushup rehearsals. She went under protest, grumbling about "too many calls, darling!" Crothers, who was in the best position to rein Tallulah in, had by this time returned to America. In Matheson's scrapbook was a limerick written by a cast member including words to the effect that "Miss Bankhead thought extra calls were so much balls!"

As she prepared to return to America, Tallulah was deriving great satisfaction from the furor caused by the Royal Academy of Art's decision to display a new portrait of her by Augustus John. He had painted her the previous fall in the pink lace peignoir she wore in act 2 of *He's Mine*. She had been painted before in London, notably by the renowned society portraitist Ambrose McEvoy. But John was different, a notorious bohemian with an altogether more intellectual cachet. Tallulah apparently could not resist the opportunity of becoming the great man's muse in life as well as on canvas. John had written to her on May 12, 1930. "I am frightfully well now after a course of treatment and want to return to you before long like a giant refreshed. Are you working terribly hard? With love and admiration and gratitude."

"Fresh from her bath and just a little bit rosy from hot water and indignation," Tallulah discussed the portrait and its reception with a reporter from the *Sunday Express*. "Like it?" she asked, laughing. "Why I adore it! Say I'm absolutely crazy about it. They think it's ugly, do they? Well it's me. Yes it is. The real me. Perhaps they think I'm ugly. Some people do. They're right. Some people think I'm beautiful. They're right too. It's a matter of taste."

She had purchased it at great expense and was going to hang it "where everybody can see it. Anyway thank God it's not like a bon-bon picture. It's not like a chocolate box. It's a great piece of art. . . . John is a great artist and when he paints he paints the essentials. He doesn't try to just make a pretty picture that will look nice and dull and be incredibly unimportant, and I think . . . he's put the essential *me* on the canvas and not just a little pink and white image of me like a lot of other things that are hanging around."

Tallulah told herself that if Hollywood did not pan out she could easily return to London, but she committed herself seriously to the prospect of a new life. To prepare for the camera's scrutiny, she intensified her dieting of the late 1920s. Her lifelong fight against the natural plumpness of the Bankhead women included potent laxatives and eventually amphetamines.

She sold the leasehold on 1 Farm Street and surrendered her Bentley. She owed money all around London, including an arrears to the Inland Revenue Service. This must have been why just days after *Let Us Be Gay* closed on December 13, only a few weeks before she was due to leave England, Tallulah was not resting but instead opening at London's Palladium music hall in a two-week run of a sketch called "Always Apologize." Audry Carten had written it with her sister Waveney, and Tallulah had first performed it at a benefit in 1927. "Always Apologize" depicted a young wife's hysteria when she believes her husband failed to place a bet on a Derby-winning horse. "It is all slight but noisy," wrote the *Times* (London), "and Miss Bankhead is amusing in tirades, screeches, and gesticulations which the audience finds sufficiently entertaining."

Tallulah wanted and expected that in Hollywood her star would graze Dietrich's and Garbo's. Hollywood stardom would represent the logical next phase in her relentless quest for acceptance and validation. In London a writer had told her that the adoration of Garbo issued from the lowest to the highest of social echelons. "That's a most divine thing to have said of you," Tallulah would later tell William H. McKegg of *Picture Play*. "If you can spread your appeal over so vast a range you have reached the top." Determined to conquer new worlds, Tallulah left for Paramount's studios in New York.

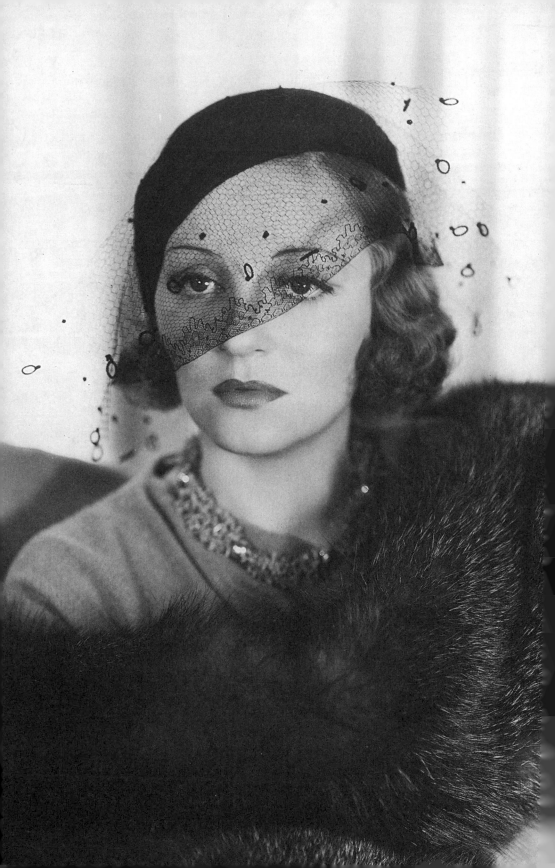

Part II
1931–1939

Paramount

"I was completely unaware that I'd gotten frightfully British."

On January 13, 1931, Tallulah disembarked in New York Harbor from the S.S. *Acquitania*. At the pier she was reunited with Will and her stepmother, Florence; she hadn't seen either since her visit to the U.S. in 1925. Will's love of politics consumed him— "Don't let ambition kill you as it did Billy," Florence warned Tallulah years later. Now he had aged considerably. Florence, who had a habit of getting carried away with herself, told Tallulah at the pier that she was too thin, and she was "a little hurt," Tallulah recalled, when Tallulah declined her stepmother's request that she then and there recite a speech from *Camille*.

Tallulah checked into a suite at the Élysée Hotel on East Fifty-fourth Street, large enough to accommodate herself, secretary Edie Smith, and dresser Elizabeth Locke, whom she had brought from London. The press corps descended, and Tallulah was subjected to droves of interviews in which she dispensed refreshingly uninhibited patter. "Let's be frank," she told Frances Denton of *Photoplay*. "We're all working for money. The legitimate stage is too uncertain." She wanted a change from the nightly repetition of the theater. She was open to what the movies might do for her persona; asked about her preference in roles, she said she would "play anything."

One week after her arrival, Tallulah was in harness at Paramount's studios in Astoria, Queens. Closed since 1926, they had been reopened with the advent of talkies so that the mellifluous tones of Broadway actors could be more easily snared. "I was full of inhibitions and uncertainties," she later recalled. "I knew nothing about making movies." She had of course made half a dozen silent films, but she had never felt completely comfortable: "The camera coming up on me made me so nervous." And 1928's *His House in Order* had been the only feature film she'd made in a decade. Moreover, the camera technique of early sound film was very different from what silents employed, and demanded far more restricted, static address to the camera.

She spent her first days making tests, and when she saw them she was appalled. "I sounded so affected," she recalled in 1966. "I was completely unaware that I had gotten frightfully British." She felt that she was too frenetic. "On stage my whole point was my vitality, which if I showed it in pictures, looked as if I had St. Vitus's dance."

Now that Tallulah was stateside, Aunt Marie became something of a self-appointed surrogate mother to her. Marie also had her own son, Thomas Jr., who was a few years older than Tallulah. Marie's husband had died suddenly in 1920, after thirty years of marriage, and in 1938, she said that she was still adjusting to his death. Marie had been writing editorials and features for the women's page of the *Montgomery Advertiser*. She took over her husband's job as archivist of the state of Alabama, but she was under great stress because B. M. Miller, the new governor, was cutting the department's financing.

"The whole of Alabama is watching your career with personal interest," Marie wrote Tallulah on January 22. She told Tallulah that at a reception to honor the governor's wife, each guest had been asked to give a brief talk about a prominent world figure. Four had chosen to speak of Tallulah: "'Our Tallulah' as they called you."

As any mother might have done, Marie made demands of her own. She began angling for some type of position in Tallulah's entourage, as secretary or publicist. "I am sure you need no help as you have done everything for yourself alone but if you and your producers feel that I could be employed in any connection, I am at your service. . . ." That same day, Marie was writing Will about her proposal. "I would love very much to have a chance as I have been sitting here on this desk for eleven years and feel that I have only a little while left in this world and I have always wanted to be connected with the theatrical movement in some way." Will

seems to have purposely stayed out of it entirely. Tallulah returned Marie's affection, but was careful to limit how much access or encouragement she gave her. Considering Tallulah's lifestyle, it would have been intolerable to have any of her elders living with her permanently.

Marie also began a correspondence with a Mr. McCarthy, head of Paramount's East Coast public relations. She sent him publicity ideas, and later that spring, he, too, received her request for a job. Marie certainly could have fulfilled a publicity position competently, since she was an able journalist who had also had a historical novel published in 1927. Paramount had nothing to offer her, however, but its representatives were unfailingly polite to her on Tallulah's behalf.

Early in March, Marie conveyed to Will encouraging evidence that Tallulah was behaving herself. She wrote that McCarthy had informed her that Tallulah had "made a hit with all of those with whom she is working as she had tried to co-operate in every way possible. I thought this would gratify you."

Dietrich was Paramount's greatest star at the moment, and much of the studio's prepremiere buildup hailed Tallulah as a second Dietrich. But *Tarnished Lady* actually bore little resemblance to the films that Dietrich was making. The setting was Park Avenue, which was hardly Dietrich's turf. But it could just as well have been Mayfair—it is a drawing-room melodrama, a lot closer to *Let Us Be Gay* than to Dietrich's *Morocco*.

Tarnished Lady was written by Donald Ogden Stewart, who had already distinguished himself both as playwright and screenwriter. The screenplay was based on Stewart's short story "New York Lady," an exploration of one of literature's great themes: the maturation of a proud and privileged woman, whose character is immeasurably deepened by adversity. The milieu was genteel poverty on the lower tiers of high society. Tallulah played socialite Nancy Courtnay, forced to marry self-made tycoon Norman Cravath, redoubtably lockjawed Clive Brook, so that she can settle her family's debts. She must give up DeWitt Taylor, the young artist she's in love with. When her mother's financial support is ensured by an inheritance, Nancy feels free to leave her husband, who is too proud to tell her that he has just suffered financial wipeout. To her chagrin, Nancy finds that her old flame is at that very moment entertaining her nemesis, Germaine, who earlier had her sights set on Norman. Nancy realizes her error, but even after discovering she's pregnant by her husband, cannot bring herself to beg his forgiveness. Nancy supports herself and her baby son as a dress saleswoman. Germaine comes into her shop one day and tells her

she is going to marry Norman when he has gotten his divorce. Later, realizing Norman still loves Nancy, Germaine bows out, and Norman and Nancy are reunited.

Tarnished Lady was released at the end of April. Tallulah watched the New York premiere from the executive offices on the balcony of the Rivoli Theater on Broadway. Publicist Louis Sobol walked in on her during the screening. "I can't bear to watch it," Tallulah whimpered. "I just can't. I wish I could stop them. I should have stayed in London." She recalled later that "I managed to get out of the theatre, blind with tears as I was." She made her friends swear not to see the film, although she confessed she was pleased when Noël Coward said he liked her in it.

"A fine actress made her screen debut in a poor picture," Regina Crewe reported in the *New York American,* sounding one of the critical notes that would recur for the balance of Tallulah's stay at Paramount. Crewe described Tallulah as "an excellent technician, well poised, and possessing a certain glittering fascination. There is a tenseness in her acting and a power in her personality that succeed in gripping an audience and holding its undivided attention."

Tarnished Lady was George Cukor's first solo directing assignment. There are moments that are distinctively his, such as the prolonged two-figure shot capturing the barely veiled hostility between saleswoman Nancy and customer Germaine. The talkies were fast becoming more fluid, more mobile, and less stage bound. But as a whole, *Tarnished Lady* is flat, especially in its final segments. We don't understand Nancy's sudden realization that she's really in love with Norman, since they've never really had anything in common.

Tarnished Lady is no worse, however, than most of the productions in which Garbo, Joan Crawford, or Norma Shearer were starring, nor worse than most of what Paramount's own Clara Bow, Claudette Colbert, Kay Francis, or Miriam Hopkins were making at the same time. This must be stressed, in light of the harsh dismissal Tallulah's Paramount films have since received, often by writers who have obviously never seen them.

Dietrich's films for von Sternberg at Paramount are of course in a class by themselves. They are frequently cumbersome and badly paced, flouting theatrical norms of logical narrative and characterization. What their endlessly shifting tableaux do provide is a spectacular excursion into a realm of uniquely cinematic possibilities. This was probably why they became among the first popular oeuvres to be canonized by academia with the rise of cinema studies in the late 1950s.

Watching *Tarnished Lady* today, the biggest surprise may be the discovery that weeks after leaving London, Tallulah's acting skills were much more developed than what many of her London reviews suggest. She doesn't overact either; in fact, Tallulah felt her attempt to modify herself had backfired. "In calming myself down I lost a certain naturalness," she said in 1964, "part of my own personality which I had on the stage and which you either liked or disliked, but there it is, that is me." But it is easy to disagree. There is no question that her theatrical allure never fully registered on film, but her ability to recognize the requirements of the medium is why her films are able today to refute the critical barbs she received.

But American audiences had a right to expect much more than what *Tarnished Lady* delivered. The public had been promised a breathtaking new star and subjected to an aggressive advance publicity campaign anticipating Tallulah's debut. The juggernaut was so intense that the public's skepticism could well have been aroused. A year later, Tallulah talked about the affront her arrival was said to have delivered to another screen goddess. "I was said to be trying to 'do a Garbo.' A fatal thing to say about anyone. Words perfectly calculated to arouse the defensiveness and rage of thousands of Garbo fans."

Reviewing *Tarnished Lady*, *The New Yorker*'s critic displayed what seemed like resentment at being coerced. "She proves to be an ordinary young actress, suggesting mostly a feeble resemblance to the more beautiful and able ones, especially to Miss Dietrich. She fails in the end to establish any sort of identity of her own."

Paramount was not discouraged. In 1931 the studio was riding high on Dietrich, the comedies of the Marx Brothers, and the potboilers of DeMille. Tallulah's option was picked up, and preparations began for her second movie.

Tallulah had invited Marie to visit her sometime in the fall if she was still in New York. Paramount was again shutting its Astoria studios to consolidate its production facilities in California. She apparently gave Marie some vague words of comfort about the prospect of employment. "You will never know how happy it made your old Aunt to realize that you had not entirely ignored her," Marie wrote, "and the fact that you held out hope that you may be able to arrange something for me later on has given me new life."

Marie's aspirations extended to front as well as backstage. She informed Tallulah that she was acting the "heavy comedian" roles at Montgomery's Little Theatre. "I would make Marie Dressler look to her laurels if

they put me on the screen but I am not seeking that type of a job as it would be too ambitious an expectation."

Tallulah followed that up with what Marie described in a letter of May 13, 1931, as "a generous check" that had rescued her from "my emergencies." On June 19, Marie wrote an almost painfully honest and humble letter, apologizing for seeming "terribly unresponsive" during another phone call from Tallulah. Members of the family had been in the room and she could not speak freely because she hadn't told them about her aspirations. She also detected an unspoken message from Tallulah that "there was nothing doing" as far as a job with her was concerned. "This conviction sort of froze me over in addition to the situation of the audience."

Tallulah had told her she did not want to leave New York. "But with your whole hearted devotion to your business," Marie assured her, "you will be too occupied to grieve for absent friends. It will be an interesting and novel experience for you and this will compensate for other things."

But Marie was going to visit Tallulah in New York before she left for Hollywood. She also had a new idea about how Tallulah could help her, a way perhaps of covering her pride. "I feel that you are the life line that can be thrown out to me in the way of getting someone interested in the two moving pictures ideas which I have. . . ." Marie did come to New York that July. "I miss your motherly presence in the apartment," Edie wrote her after Marie had returned home. Tallulah must have made some inquiries on her behalf, for Marie would continue to send her scripts over the next decade.

Discussing *Tarnished Lady* a month after the premiere, Tallulah had told the *Herald Tribune,* "I think perhaps our trouble was that all of us connected with it were stage people, instead of picture people. . . . Next time it may be better if I have some old veteran to show me the tricks." But George Abbott, who directed her next two films, was a theatrical polymath—actor, writer, and director—who was relatively inexperienced in film. He signed to direct for Paramount in 1929, but film was not his medium and not one for which he had great enthusiasm or aptitude.

Tallulah "was self-consciously eccentric," Abbott said in 1982. She would sit on his lap and confide, "I want 'em all to think I'm your lover." But on another occasion she said to him, "I never could fall in love with you. You're too reliable. I have to have a cad, so I don't know where he is at night." Nevertheless, "we got along perfectly," Abbott said. "I can't remember any trouble."

My Sin, Tallulah's second film, was written by two successful and ex-

perienced drama smiths, Adelaide Heilbron and Owen Davis. In the opening scenes, Tallulah appears deeply entrenched in classic Dietrich territory. She is a cabaret singer in Panama, whose no-account husband had married her in the United States, brought her to the tropics, and "then drove her down and down and down." We see her first in the cabaret, singing, carousing, but spooked by persistent peripheral visions of her husband. What she thinks is a phantom becomes real back in her digs, where he appears intent on stealing the savings she's stashed to return home. Their struggle over a pistol leaves him dead.

Fredric March is Dick Grady, a lawyer on the skids who dries out so that he can defend her. She is acquitted but nonetheless attempts suicide. Grady stops her, and encourages her to go back to the U.S. and construct an entirely new identity. The next time we see her, she's a successful New York interior decorator going by the name of Ann Trevor, and is soon to be engaged to one of her clients. When Grady appears in New York she doesn't realize at first that he's really the man for her. But when a government official recognizes her and tricks her into confessing her past, society marriage becomes, of course, out of the question. She is left free to settle down with Grady.

During the filming of *My Sin,* Mrs. Locke left for a visit to England that she imagined would take no more than a few weeks. She had recently undergone an operation and her health was still poor. Moreover, her daughter had remained in England and she had family matters to take care of. Before she left she wrote Will thanking him for helping to secure her reentry permit: "I want to take this opportunity to tell you what a joy it has been to me all these years to be with your dear daughter, who has been almost like a child to me. . . ." Will fretted that Tallulah would die a pauper, and Mrs. Locke was eager to reassure him about the state of her finances. "I thought you would be interested to know that she is saving her money and already has invested in a Trust Fund for $30,000. She owes no bills anywhere and everything is straightforward for her to go ahead now to make a lot of money."

Tallulah's family very much wanted her to visit home, but instead she used her vacation to take a trip out west with a new girlfriend, actress and socialite Hope Williams. Williams boasted a mannish beauty and a tomboyish charm, a lovely voice, and a sufficient amount of acting ability. In Philip Barry's *Paris Bound* in 1927, she clumped across the stage incongruously clothed in a frilly white dress. Tallulah's friend Ruth Hammond

was in the audience, and she recalled in 1991 that she as well as the rest of the audience wasn't quite sure what had hit them, but they were entranced by the certain prospect that here was a novel type. Williams's success announced a new rapprochement between New York high society and the entertainment business.

Upon her arrival from London, "Tallulah found that all the top-drawer lesbians—social ones—were making a play for Hope," Ann Andrews recalled. "Well, that's all Tallulah needed, 'cause she had a great sense of 'I want to be the boss of everything!' And so, my dear, all she had to do was be charming and that led to quite a long affair."

But more than conquest probably motivated Tallulah. Williams was "sharp as a tack," socialite Joseph O'Donohue recalled in 1993, "well-read, beautifully brought up, came from a good family, very good looking: everything a high-class lesbian would want to have." Williams was also a shrewd businesswoman who owned a commercial dude ranch in Wyoming. In between finishing *My Sin* and beginning her next film, Tallulah and Williams spent a couple of weeks in Wyoming.

Tallulah was back in New York by the time *My Sin* opened in New York on September 11, 1931. *Film Daily* said it "offers additional evidence to the effect that Miss Bankhead is first class starring material." But again she failed to ignite the box office. Yet she distinguished herself in a role that was notably second-rate. In the Panama scenes she demonstrates a neurotic edge that is entirely different from Dietrich's behavior in similar stories and locale. Tallulah and March are a magnetic couple. Next to him she looks even smaller than she was, and thus particularly vulnerable. With Lily Cahil, who plays Tallulah's boss in the interior decorating business, Tallulah demonstrates an appealing female camaraderie. The cinematography is better than it was in *Tarnished Lady*. Photographer George Folsey had more experience with talkies than did Larry Williams, who had worked for Cukor. (Folsey was eventually to reap thirteen Oscar nominations.)

A month after *My Sin* opened, Will made the mistake of letting Marie know that Mrs. Locke had decided not to come back to the U.S. after all. Marie proposed herself as Mrs. Locke's replacement, adding that a position with Tallulah would also give her opportunity to study the technique of screenplay writing. Tallulah telegrammed Marie her regrets that she couldn't "MAKE ANY ARRANGEMENTS ABOUT YOU. . . . PARAMOUNT HAVE ENGAGED A MANAGER FOR ME THAT IS WHY MRS LOCKE IS NOT COMING BACK." In Hollywood, Tallulah herself did engage an agent to negotiate with Paramount on

her behalf, but he was surely not performing the same duties that Mrs. Locke had. Marie immediately telegrammed her regrets and then changed the subject.

Customarily distant yet cordial with her family, Tallulah did genuinely enjoy spending short periods of time with them. Eugenia Bankhead was in New York that fall, and the two sisters, now reconciled after their breach in 1928, got along famously. Two factors ensured harmony: they lived separately, and Tallulah picked up all the tabs. "Perhaps I shouldn't say that," Edie reported to Marie, "but Miss Tallulah loves doing it anyway."

Eugenia was a voracious reader who spoke several languages, but could not or would not work. She spent a great deal of her life in mad pursuit of love, sex, and funding. Her greatest torment was not being able to have children. A minor operation when she was twenty had resulted in septicemia, which rendered her infertile.

After New York, Eugenia returned to Europe, where a friend of Marie's ran into her at the Paris Ritz. Marie suggested that Eugenia might be pursuing yet another reunion with her ex-husband Milton Hoyt. Eugenia had told Marie's friend that Hoyt had been in Paris but had left the day she arrived. "Of course I do not know how true this may have been as Eugenia has a good imagination. She also told a party who she met on the ship that she had lost three beautiful children. Dear child, I think all of her unnatural behavior is due to her mother frustration."

George Abbott again directed Tallulah in her next film, *The Cheat,* which had first been filmed by Cecil B. DeMille as a silent in 1915 starring Sessue Hayakawa, then in 1923 as a silent vehicle for Pola Negri. Tallulah was Elsa Carlyle, a Long Island matron with an uncontrollable urge to live on the razor's edge. Elsa tries to recoup her gambling losses by investing the takings from a charity bazaar. When her investment tanks she accepts money from a mysterious playboy, Handy Livingston, just returned from the East, played by Irving Pichel. Elsa's husband suddenly announces that a deal he's been brokering has succeeded, and Elsa is able to return the money to Livingston. But that's not the payback he was envisioning. When she balks, he brands her shoulder with an iron imprinted with an Asian symbol for *I Possess.* (Earlier he had shown her a collection of dolls, each representing women in his past and each similarly stamped.) Elsa retaliates with a gunshot that only hits Livingston's shoulder. Her husband insists that she let him take the rap, but during the subsequent trial Elsa leaps to her feet and denounces Livingston. The court finds branding sufficient ex-

oneration for attempted murder, and by the final fade-out we believe that Elsa has learned her lesson.

Abbott relinquished directorial duties midway during the production after his wife became ill, and so we do not know how much he contributed to *The Cheat*. It is not a bad film, although the postbranding sequences feel anticlimactic. Like so many of the early talkies, it is very short, but unlike so many of them its sixty-five minutes don't seem overly crowded with incident.

Folsey was again behind the camera, and cinematographically, *The Cheat* is more elaborate than either *Tarnished Lady* or *My Sin*. Tallulah takes to the dunes to brood over her gambling flameout, her lamé gown aglow against the night. Livingston catches up to her and she accepts his invitation to motor over to his mansion for a tour. When they return to the yacht club, they meet her husband. Tallulah's hair blowing in the ocean breeze supplies a humanizing contrast to her usually immaculate coif. "You know, darling, I *am* mad!" she tells her husband. "Mad about living, things going round, I love them. Ferris wheels. Train wheels. Roulette wheels!"

Tallulah's husband is played by Harvey Stephens, an unexceptional actor who nonetheless radiates a boyish, almost gauche sincerity; he is a convincing foil for Tallulah's combination of nervous intensity, swagger, melancholy, and languor. Theirs is a convincing marriage of opposites.

Unlike her first two Paramount projects, *The Cheat*'s production values are deluxe. Pichel lives in a mansion that is a veritable cornucopia of Eastern delights, replete with gamelan players in residence. He loans his house to the Milk Fund for its annual ball, where Balinese dancers snake through the house as Elsa learns that she has lost her money. *The Cheat*'s visual gloss is not quite in the MGM class, but it is strongly reminiscent of Garbo's 1929 *Wild Orchids,* in which Garbo's Western wife is also lured into an Eastern playground. In both films, the married heroine risks compromising her moral integrity when she accepts the gift of a jeweled gown from an Eastern admirer. In *The Cheat,* Pichel insists Tallulah wear a resplendent jeweled gown, which he's brought back from the East, to the Milk Fund ball.

Tallulah was just arriving in Hollywood when *The Cheat* opened on December 11, 1931. The *New York Times* said that "Miss Bankhead, who has been somewhat unfortunate with her previous screen vehicles, at last appears in one that really merits attention," and noticed the improvement in the way she was photographed. But *The Cheat* fared no better than Tallulah's first two vehicles, although it is likely that Paramount recouped

money in England. Each of her movies was seen there as soon as it opened in the U.S.

Edie wrote Marie: "It's a great pity 'The Cheat' didn't come up to expectation but Paramount realize [sic] what a star they have in Miss Tallulah and say they are determined to get her a good story next time."

Hollywood

"I think I am simply awful-looking . . . on the screen, unnatural, awkward, graceless. I never get used to myself. . . ."

Tallulah arrived in Hollywood in the late fall of 1931 not quite at the pinnacle of her profession, in a town where you were only as good as the grosses on your last movie. Nevertheless, she made sure that she was a presence to be reckoned with. "We knew she was outspoken; we'd heard about her," Paramount production manager Sam Jaffe recalled in 1992, seventy years after he had moved to Los Angeles in 1922, when Sunset Boulevard was a dirt road all the way to the Santa Monica beach. "We knew she was a person that—either she did it unconsciously or consciously— but she did things to shock you."

She found some willing conspirators in outrageousness, including her alleged rival Marlene Dietrich. At Paramount's Culver City studios their dressing rooms were adjacent to each other. They took pleasure in raising eyebrows with fortissimo boasts of lesbian seductions and they decided to start rumors of an affair between them. Dietrich was known to powder her hair with gold for the camera. Tallulah reportedly appeared on the set one day and, in front of dozens of assembled crew, held up her dress to reveal pubic hair powdered in gold.

As Jaffe got to know her, however, he discovered other facets, includ-

ing "an interesting side; a warmth about family." She was interested in his home life, his three daughters, his upbringing on the Lower East Side of Manhattan, the son of Russian-Jewish immigrants. "You could assume that she had no interest in human beings as a rule, but that's not true."

She rented a home at 1712 North Stanley Avenue from silent screen star William Haines, who was starting a new career as an interior decorator. On December 30, 1931, Edie wrote Marie that they were now comfortably settled in, with three servants in residence. Edie was enclosing a check for fifty dollars from Tallulah, "who says she would so much like to have made it larger but she has had so many heavy expenses during the last month. . . ." Tallulah's expenses were not exactly ones Marie could have sympathized with: she had bought a Rolls-Royce, a complete new wardrobe, and another Augustus John painting. "However she says she is not going to spend any more money for weeks and weeks. . . ."

Audry and Kenneth Carten came from London for a long visit; when they left, actor Alan Vincent moved in. Vincent played minor roles in films and when he was out of work did secretarial work for some of the major stars. He was a perfect companion and escort for Tallulah: slim, good-looking, "very funny, very witty, a highbrow," Douglas Fairbanks Jr. recalled. He was also gay, and thus more likely to be accepted by Tallulah as friend rather than sexual quarry.

Although Tallulah was fast discovering that film was not her optimal medium, Hollywood was in one way the perfect place for her. Back in 1928, the London *Graphic*'s Hubert Farjeon, in a state of high irritation over her performance in the play *Blackmail,* had written: "The surprising thing about Miss Bankhead is that she should be on the stage, for she looks like a film star, she acts like a film star, she tosses her hair back like a film star, and the plays in which she appears are essentially film-star plays."

In Hollywood there was no stigma attached to "personality" acting. The glamorizing that movie stars received was sufficient transformation for any role they were called upon to assume. They were loved for their mannerisms and because they projected a specific and consistent persona. And they rarely risked ruffling their audience's expectations by playing a role against type. This was actually standard practice as well for most of the great Broadway and West End stage stars. But the critics liked to pretend that it wasn't, as though by pretending, they could make the theater conform to an academic ideal rather than continue to function as a marketplace, in which stars were the choicest commodity.

Detractors who decry Tallulah's "playing herself" measure her work

against a criterion that in actuality does not exist and never has. Most theatrical impersonation has been about an actor's repetition and development of a key persona. This was as true during the Renaissance heyday of the Italian commedia dell'arte mime shows, in which actors performed the same types during their entire careers, as it was in the repertory companies of the nineteenth century, when representation was broken down into specific "lines of business" on which actors based their careers. More frankly than anywhere else in the entertainment world of this century, Hollywood accepted typecasting as a given, and this assumption powered the industry's fortunes.

Although Tallulah said that the camera stifled her, actually she learned valuable lessons as she studied the craft of film acting. On January 28, 1932, Marie wrote that she had just received a letter from Samuel M. Peck, poet laureate of Alabama. He had seen *The Cheat* and wrote: "What pleased me from the first about her acting is that every look, gesture and accent means something essential to the drama given." He ranked her economy with the French actors of the Comédie Française, whom he considered the finest in the world.

But as she began working on *Thunder Below,* her fourth film for Paramount, Tallulah was forced to heed the consensus that her career was foundering. *Silver Screen* published a eulogy in its February issue: "She won her spurs in England but we seem to want to give her the boot." In Britain, *Picturegoer Weekly* was protesting: "Far better would it have been if Tallulah had stayed in London."

For a woman whose beauty was integral to her sense of personal and professional worth, the most disorienting realization must have been the discovery that she was not considered ideally photogenic. This may not have been the first time she had heard this, however. "Some of the angles used from which to photograph her ought to be avoided," *Variety*'s "Frat." had written about *His House in Order* when it was shown at New York's Palace early in 1928.

After Tallulah's death, George Cukor insisted a number of times that her face was not suited to the screen. "On the stage she had beautiful coloring," he told Gavin Lambert, "and on the screen she had beautiful bones, but her eyes were not eyes for movies. They looked somehow hooded and dead. . . . Her smile didn't illuminate, when she spoke her mouth didn't look graceful, and her eyes never really lighted up."

Although Tallulah certainly did not mate with the camera the way

Garbo did, Cukor's remarks demonstrate a lack of insight that is surprising in a director of his caliber. "I don't know what in the world he's talking about," said Artie Jacobson, who was assistant director on the two films that Tallulah made for Paramount in Hollywood. "There may have been certain scenes where he felt that way, but I never found it. We never had any photographic problems with her at all."

Perhaps Cukor was rationalizing the undoubted fact that Tallulah was better photographed in all the pictures that followed his own *Tarnished Lady*. Cukor was relatively inexperienced and would have been apt to leave photographic issues to the cameraman. But Tallulah herself internalized the criticism. "I think I am simply awful-looking . . . on the screen," she told Hollywood reporter Dorothy Spensley, "unnatural, awkward, graceless. I never get used to myself. . . . Until I went into pictures, I thought I had a face, but now I know I haven't. Oh, I have good eyes, but my nose . . ."

In Britain, *Picturegoer Weekly* had even published news of the plastic surgery she had undergone in London. What has not been said as frequently is that Dietrich herself had a broad and inelegant nose, and so did Claudette Colbert, Ginger Rogers, and Carole Lombard. And, of course, each of these women had a glorious film career.

More relevant is the question of Tallulah's persona. In her review of *Tarnished Lady*, Regina Crewe wrote in the *New York American*, "She brings a distinct new type to the screen," which was very true, and it may be that hers was a problematic type for that place and time. In 1972's *From Reverence to Rape*, Molly Haskell writes that in American movies, "we rarely see a morally ambiguous heroine, who doesn't fit into the dramatic dialectics of an either/or, virgin/whore polarity." This is just what Tallulah did: her randy yet socially impeccable heroines transgressed that dichotomy. Tallulah's behavior on-screen could almost be as reprobate as Dietrich's, but unlike Dietrich or Garbo, Tallulah was never exotic enough to represent the "Other." Thus she was perhaps more insidious than her foreign rivals. Perhaps she made Americans uncomfortable: the mass American audience did not want to see itself as morally ambiguous. Surely that was at least as much a factor in Tallulah's disappointing box-office performance as the somewhat bulbous tip of her nose.

Thunder Below was an adaptation of the book by Thomas Rourke. After Marie heard that Tallulah was going to star in the film adaptation, she read the novel and offered the sort of unsolicited opinion that could only have made Tallulah doubly glad that she had not signed Marie on to her staff.

It is very fortunate that the moving picture playwrights so reconstruct a book that the author himself cannot recognize it. How an appealing screen play can be made from such an obscene story is more than I can comprehend. I was in hopes that your producers would select for you something of a nobler character for your next production.

Marie did have a point. *Thunder Below* was a dismal tale of adultery in the oil fields of Central America. Tallulah was Susan, a stir-crazy tropical wife à la Maugham's Leslie Crosby in *The Letter*. Her husband Walt was Charles Bickford; Paul Lukas was her lover as well as her husband's best friend. When Susan and Ken learn that Walt is going blind, they don't have the heart to go through with their plan to run off together. She latches onto another man, a temporary visitor to the tropics, and considers using him as her escape hatch out, but is then briefly reunited with Ken before he becomes once more overwhelmed by remorse. She, too, understands the futility of their relationship and gallantly forgives him for failing her once more, then leaps to her death.

The film was directed by Richard Wallace. He was not a particularly distinguished director, but Tallulah found him "a divine man." He had once operated a merry-go-round in a carnival; before that he had been a medical student, later an undertaker's assistant. He was fascinated by cadavers. Once, after a trying day at the studio, he took her to a morgue. "Tallulah, this should cheer you up. See how peaceful they are."

On March 24, Edie wrote Marie conveying Tallulah's regrets at not being able to send $500 that Marie had requested. Tallulah was again in financial distress, having had to pay $15,000 in IRS arrears. Her checking account was overdrawn, and her trust fund was off-limits. "She is miserable at not being able to help you out, but when financial conditions are better, she promises to send you a check."

Rather than the hoped-for improvement, *Thunder Below* turned out to be slow, heavy, ponderous, enlivened by some comic relief from Eugene Pallette. The *Times* (London) called Tallulah's performance in it "steady and unextravagant," which was perhaps high praise given the criticism her alleged onstage excesses there had reaped. "It is not her fault that we are given scarcely more than a glimpse of the mind of the woman she represents." Tallulah was "too good an actress" to let *Thunder Below* "curdle entirely," Gerald Breitigam wrote in the *New York World Telegram*. "Despite the blueprint which the screen play follows there is room for loveliness and

splendid tragedy and glamour in the characterization of Susan, and Miss Bankhead does have her moments. There is one high point, indeed, in which her voice plucks at the heartstrings. But in the main her characterization lacks the changing colors to make it really stand out."

While Tallulah is at all times challenged by *Thunder Below*'s banality, she usually fights it to no less than a draw. She achieves something almost unheard of in films at that time: convincingly portraying a woman nearly eaten alive with frustrated sexual desire who is not working class, not a native tribeswoman, not a prostitute. She is a well-bred white woman, and Tallulah supplies one of her most provocative floutings of conventional screen morality, which preferred to confine adultery to the socially marginal. Tallulah's Susan is at all times sympathetic, yet her frustration and restlessness make her a potential menace to herself and others. Too guilty to leave her husband when she finds out he is going blind, eventually she is furious at her lover for being just as paralyzed by guilt. "I'm what any woman would be living like this, only I'm being honest about it!" she tells Lukas in a scene where—in the couched language of the era—she demands that he sleep with her or repudiate her entirely.

Paramount had put Tallulah again and again into lugubrious melodrama. Reviewing *Thunder Below*, Marguerite Tazelaar in the *New York Herald Tribune* bemoaned the fact that "It has been Miss Bankhead's ill fortune to be cast in another role where sustained moping and sad-eyed histrionics are demanded of her instead of the high comedy and ironic characterization she does so brilliantly." Tallulah could surely have become one of the screen's most illustrious comediennes, but Paramount was churning out vehicles for many of its stars without ensuring their quality. In its January 5, 1932, issue, *Variety* had written that while "heavily ballyhooed," Tallulah's films of 1931 had "registered only mildly, due, no doubt, as in the case of Miss [Ruth] Chatterton and other Paramount personalities, to unfortunate choice of material." Von Sternberg wisely restricted the number of movies in which he directed Dietrich. *Dishonored* was the only film in which she starred in 1931. But Tallulah had cranked out three, Chatterton four.

Nineteen thirty-two was turning into a disastrous year for Paramount, after a decade-long run of spectacular success. Employees had been paid in stock options, which had now plummeted in value. Hundreds of Paramount employees were fired, and the remainder, including Tallulah, were forced to accept salary cuts. Studio head B. P. Schulberg was about to lose his job. Production manager Sam Jaffe's sister Adeleine had married Schulberg, when she was a secretary and he was a newspaper reporter. "Schul-

berg couldn't handle it all," said Jaffe. "He made too much money, and he destroyed himself fucking and drinking." Wanger and Schulberg had a falling-out and Wanger departed. Schulberg began a long affair with Sylvia Sidney, which preoccupied him. Jaffe would walk into Schulberg's office and be told that he was at the tailor, the dentist—"And I knew what that meant."

Gary Cooper and Others

"I'm only one of the million gals who'd love to hear their most personal question answered, 'Yup.'"

Director Marion Gering's success at Paramount could be seen to typify the studio-wide malaise that had struck Paramount. Gering had come to the U.S. as part of a Soviet trade delegation in 1924. Sylvia Sidney brought Gering with her to Hollywood after he directed her on Broadway in *Bad Girl,* the play that brought her to Hollywood's attention. He directed Sidney's first film and several of her subsequent vehicles at Paramount.

"He was the kind of a guy that looked over his shoulder," Artie Jacobson said. "Nervous. Very dependent." "I thought he was lousy," Jaffe agreed, "but Schulberg was taken with him. He seemed to get along with Sylvia Sidney and he played up to Schulberg."

Gering was assigned to direct Tallulah's next film, *The Devil and the Deep,* although when recalling the production, Jacobson insinuated that he was forced to shoulder much of the directorial burden. It was written by Benn Levy, in whose *Mud and Treacle* Tallulah had starred four years earlier in London. He was in the middle of a brief but distinguished stint in Hollywood, where his wife, actress Constance Cummings, was also under contract.

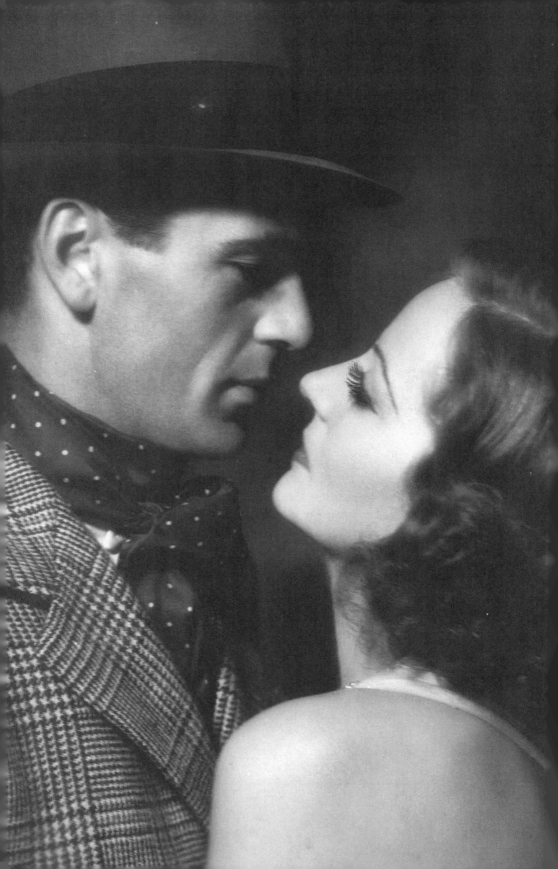

Tallulah plays Diana Storm, the wife of a psychotically jealous marine commander, Charles Storm, played by Charles Laughton in his Hollywood debut. They are stationed together in a desert port in the Middle East, amid a British community that doesn't question Storm's jovial hail-fellow-well-met manner. They commiserate about his marital unhappiness, but behind closed doors he brutalizes his wife. He has dismissed and thus disgraced young Lieutenant Jaeckel—Cary Grant—because he suspects him of having an affair with Diana. She tries to save Jaeckel's career and exonerate herself by letting her husband eavesdrop on a meeting between them. What follows is a beautifully acted scene riddled with unspoken tension. Tallulah must not let her husband think she is deliberately deflecting a confession of love from Grant, all the while hoping desperately that none will be forthcoming.

Laughton is unconvinced, and after he turns violent, Tallulah stumbles out of their house. Swept along by a tide of native feast-day celebrants, she is all but trampled until she is rescued by a handsome stranger, played by Gary Cooper. "I want never to have been born," she tells him, but is consoled by their night of love on the sands—consoled and newly empowered. When Laughton asks her the next morning where she has been, she informs him, "You've lost the right to ask that question."

Later that very same day, Cooper comes to their house and she realizes that he is the Lieutenant Sempter her husband has hired to replace Jaeckel. Cooper is captivated by Laughton's hearty bonhomie and appears disgusted by Tallulah's infidelity. After Laughton manages to discover all, Tallulah sneaks on board his submarine the night it is scheduled to sail, suspicious that Laughton is plotting a catastrophic revenge. He does engineer a collision between his submarine and a freighter, relieving Cooper of his duties when he tries to rescue their vessel. Laughton wants them all to die together. Only now does Cooper see Laughton's true colors. The crew mutinies after Tallulah steps forward to implicate her husband. She and Cooper escape with the crew, while Laughton chooses to die, opening the sluices and laughing maniacally as his cabin floods.

Tallulah found Cooper very compelling indeed. In New York a year earlier, Walter Wanger had sent Cooper to replace him when he couldn't take Tallulah to a Beatrice Lillie opening as planned. Tallulah proceeded to chatter nervously all evening and the abashed Cooper didn't utter a single word. In Hollywood she told Jaffe, "I like him very much. I'm going to fuck him." "I said, 'I'm sure you will,'" Jaffe remembered. Weeks later he walked

Tallulah with Gary Cooper, her co-star in *The Devil and the Deep.*

on the set where Cooper and Tallulah were working. "She looked at me and winked and nodded her head, as if to say, 'Yes, it's been done.'" But things had actually not turned out as Tallulah intended.

The long climactic sequence on board Laughton's sub was filmed at night, and their meal break was at midnight rather than midday. One midnight, Jacobson didn't see Tallulah in the studio commissary. He went back to the set to look for her. She wasn't there either, but Cooper was returning from his meal. Jacobson watched as he walked into his dressing room and came bounding out with lipstick printed from forehead to chin. Cooper started to run out to his car, Tallulah in hot pursuit, her evening gown hiked over her knees. Jacobson caught up with Cooper in Beverly Hills and brought him back to the studio in Hollywood.

Cooper's rejection did not diminish Tallulah's admiration. In 1935, screenwriter Frances Marion joined Tallulah's table at the Stork Club, where an argument was in progress.

"You call that acting?" a Cooper detractor was saying, sniggering. "All he can say is 'Yup.'"

"His casual charm appeals to me," Tallulah retorted. "It's more effective than watching you hams emote."

"Dry up, Tallu, you're not thinking about his acting."

"You're damned right! I'm only one of the million gals who'd love to hear their most personal question answered, 'Yup.'"

"I enjoyed her," Jacobson recalled. "Very down-to-earth, never said, 'I'm Tallulah Bankhead, who the hell are you?' A nice gal to work with, great sense of humor." But Jacobson was aware of some prior history between Tallulah and Laughton that perhaps explained the friction on the set of *The Devil and the Deep*.

Laughton was Stanislavsky-influenced and could not just walk in and do a close-up cold. He had to go through the entire scene first, and his shoulders would start heaving as he worked himself into the climactic declarations that were going to receive close-up scrutiny.

One day they were filming and Laughton's shoulders were heaving when onto the set drifted the syncopated strains of "Darktown Strutters' Ball." Laughton stopped heaving. "What the hell is that? How can I do a scene? Oh, I think I know what it is." He demanded that Jacobson "go in there and tell that bitch I'm rehearsing. Break the record if you have to."

"What does that ass want?" Tallulah asked Jacobson in her dressing room.

"He's trying to do a scene, and you're playing a record."

"I want to play my record. If he's the actor he claims he is. . . ." She chewed Jacobson's ear with a tirade but did turn off her gramophone—for a while. When her musicale resumed, Jacobson went back to Tallulah with a cease-and-desist order; otherwise she'd be held responsible for interfering with production.

"Oh, I got to him, eh?"

Laughton exacted his revenge. When they filmed a scene where Laughton slaps her, he delivered a blow that knocked her out of camera range. "She went right across the set," Jacobson recalled. "We had to fix the makeup each time. You'd see his fingerprints on her cheek. We did four takes and each time the same thing happened." Assaulting Tallulah with accusations about her fidelity, Laughton made sure his sibilant consonants sprayed spittle across Tallulah's face.

The Devil and the Deep has its own twist of originality and it benefits from the superb photography of Charles Lang. The production is very handsome, simulating the North African desert as evocatively as Morocco or The Garden of Allah. Levy took any number of critical hits for his screenplay. Of course we know no more about how much of it is actually his than we do about most films' credited authors. High colored as the genre and story required, but enhanced by drawing-room literacy, it is certainly better than most of the hack scripts that Hollywood was filming. Laughton is allowed to be sympathetic as well as repugnant. Tallulah's role allows her varied dimensions to exploit. She displays a dignity and distinction that is a little different from what we've seen in her previous films. Diana is the most polite and mature of her Paramount heroines. At the same time this is the most neurotic of Tallulah's screen characterizations, limning in no uncertain terms a woman battered by psychic and physical abuse. Indeed, she is almost too jumpy and tortured to be classed as a conventional screen heroine. Dietrich or Garbo would never have allowed their beauty to be mussed by as many twitches, fumbles, and hesitations. Tallulah is on edge for almost every one of The Devil and the Deep's seventy-six minutes.

After it was released mid-August, Mordaunt Hall wrote in the New York Times that "this melodrama, owing to the excellent work of Mr. Laughton and Tallulah Bankhead, succeeds in being something out of the ordinary and a picture that always holds one's attention." In the Daily News, Richard Watts Jr. complained about Levy's dialogue and wrote, "It does, however, serve to indicate how fine an actress Miss Bankhead really is. The synthetic speech and emotions of her role, under her skillful handling, take on a surprising quality of reality and poignancy."

One of the very few contemporary critics to see Tallulah's screen performances unclouded by current critical dogma is actor and author Simon Callow. In his 1988 book *Charles Laughton: A Difficult Actor,* he writes that Tallulah's performance "now seems an extraordinarily original portrait of an unfulfilled and oppressed woman, bored and unhappy, oddly attached to the paranoically jealous husband that Laughton plays. . . ."

Almost inexplicably this time, Tallulah's film failed to elicit more than a tepid response from the public. Several weeks before the film's release, Paramount had already decided to loan Tallulah to MGM for her next project. Edie wrote Marie that she and Tallulah were looking forward to the change. They sensed that the studio was imploding. "There have been so many changes made in the Paramount staff during the last two months, and no one seems to know what they are doing."

Edie enclosed a check for $100 and expressed Tallulah's regrets that she could not send more. Tallulah's aunt on her mother's side, Clara Mae Floyd, whom Tallulah had likely met as a child but had not seen for many years, had written to Tallulah "three pathetic letters," and Tallulah felt obliged to help her out with her taxes. Tallulah was also contributing to Eugenia's financial upkeep. "Incidentally I have to write to her and inform her that Miss Tallulah will have to cut her allowance too, as times really are bad and according to all accounts this time next year all film stars will only be getting a quarter of what they are getting now, and the income tax as you know will be much heavier." Edie did not add the conviction she and Tallulah must have shared, that their stint in Hollywood was fast outlasting its usefulness to either Tallulah or the movie industry.

"I Want a Man!"

"I might lay my eyes on a man and have an *affaire* with him the next hour."

Tallulah did not go out all that often while she was in Hollywood. Social life was nothing like what she'd known in New York or London. When working, screen actors were required to rise just about the time that Tallulah was used to falling asleep. When she did go out, however, she was sure to make a stir. "If a party is dull, it is always Tallulah who animates the crowd," Marcella Burke wrote in *Screen Book* magazine. "I have seen her jump on a table in one of the Biltmore bungalows at a supper party given for Ina Claire and dance divinely." A little while later, the guests were "silenced by the sheer beauty of Tallulah standing against a wall giving a swift impersonation of Sarah Bernhardt." She wrapped a scarf around her throat, pushed her hair over the forehead, lifted her face "tip-tilted against eternity," and declaimed a few words in French. "Tallulah had transmitted the spirit of The Divine Sarah. . . ."

Burke does not recall Claire's reaction to Tallulah's hijinks. Perhaps she found them as entertaining as Burke did. Perhaps Claire's supper did need some enlivening. But surrounded by peers and competitors as she was, Tallulah's need to make a stir rarely brooked recognition that a party was supposed to revolve around anyone else. Hollywood placed a greater

store on toeing the line than did London or New York, but Tallulah had little respect for the rules of Hollywood's game. "People were frightened of her, a little on edge," Douglas Fairbanks Jr. recalled. "You never knew what she was going to do or say. She was impulsive and a law unto herself."

Tallulah's irreverence was only sharpened by the pretensions of this most vainglorious of company towns. Sam Jaffe said that at one party a woman walked up to her and introduced herself, "Miss Bankhead, I'm Mrs. Joe E. Brown," to which Tallulah replied, "That's the way you cheapen yourself."

Given the chance to be introduced to her adored Greta Garbo by screenwriters Salka and Berthold Viertel, Tallulah was "a little awed in her presence," she recalls in *Tallulah*. Over dinner, Tallulah clowned excessively before Garbo. Nevertheless, Garbo accepted when Tallulah subsequently invited her to dinner. Tallulah recalls, "When at ease with people who do not look upon her as something begat by the Sphinx and Frigga, Norse goddess of the sky, she can be as much fun as the next gal."

Fairbanks's then-wife, Joan Crawford, asked Tallulah to a small dinner party and assured her that dress would be casual. When Tallulah arrived in slacks, she was greeted by Crawford decked out as if she were going to opening night at the Metropolitan Opera. Fairbanks thought that Crawford was very likely intimidated; such elaborate dress was not customary when they entertained. Nevertheless, Tallulah and Crawford enjoyed each other very much. "Whatever Joan's notions of informality, she could be prankish," Tallulah writes. Crawford had told her not to bring an escort; she was inviting someone she thought that Tallulah might like. The blind date turned out to be eight-year-old Jackie Cooper, accompanied by his mother. Tallulah had indeed adored his performance in *Skippy*, going back four times to see it.

Fairbanks said that Tallulah was "housebroken" whenever he saw her; indeed she parlayed her "exquisite" manners into a mark of distinction. "She was very consciously upper class in a world that was drawn mostly from either lower or middle," he said. "She knew that she was Southern aristo and never let you forget it, either. She didn't say it in so many words; it was just her attitude.

"The feeling people had about her: she was born of a privileged class," he said with a chuckle, "and just took advantage of those privileges—which were not those shared with other lesser mortals."

Tallulah and child star Dickie Moore enjoy an ice cream
on the Paramount lot.

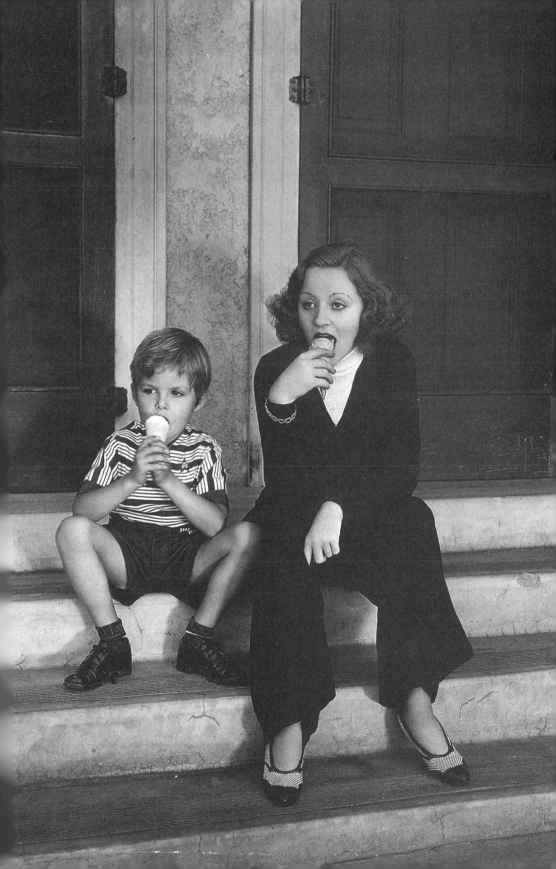

It was her relationships with her fellow stars that *Motion Picture Story* magazine's Gladys Hall wanted to discuss when she interviewed Tallulah in the summer of 1932. The subsequent article caused such a furor that some serious ostracism undoubtedly set in as a result. Hall asked Tallulah if Hollywood was giving her the cold shoulder. Tallulah said if it was, "I haven't felt the chill. It is news to me. It may be that *I* am suspected of giving *Hollywood* the cold shoulder—because I accept so few invitations. Because I have never given parties. Because such hospitality as I have accepted I haven't returned. It has reached a point now where, if I gave a party at all, I would have to invite about five hundred people."

Tallulah didn't really want to talk about Hollywood, but she had a lot she wanted to get off her chest. She wanted to defend herself against the canard that she was frivolous. She wanted to explain herself.

> I have an inferiority complex. It is my defense mechanism working. So that, if I take a fall, if I fail here or there, if the movies or a man chuck me out on my ear, people will laugh it off and say, "Oh, well, Tallulah doesn't care!" But I would care. I'd care all right, but not so much as if people knew that I cared. I can't bear pity. I can't endure sympathy. A kindly pat on my bowed shoulder would drive me nuts.

She said that she might "lay my eyes on a man and have an *affaire* with him the next hour." But she insisted that her behavior was not compulsive: "Promiscuity implies that attraction is not necessary." Nevertheless, Tallulah had been living quietly for some time. "I haven't had an *affaire* for six months," she said to Hall. "Six months! Too long. If there's anything the matter with me now, it's certainly not Hollywood or Hollywood's state of mind. The matter with me is, I WANT A MAN! . . . six months is a long, long time. I want a man!"

Tallulah had committed what was in Hollywood an unpardonable sin: underscoring the obvious truth that stars enjoyed sexual license denied most of their fans. Morality clauses in most stars' contracts meant that they could be disciplined or dismissed for conduct unbecoming a public icon. In 1993, ex-*Follies* girl and actress Lina Basquette recalled her friend Clara Bow tooling around Hollywood at night during the late 1920s to pick up men. Basquette chastised her for risking the rupture of a hugely lucrative Paramount contract. Many stars were similarly one step away from disgrace.

After the article-induced backlash began, Tallulah issued the requisite denial that she had said what Hall said she had said. *Time* reported that

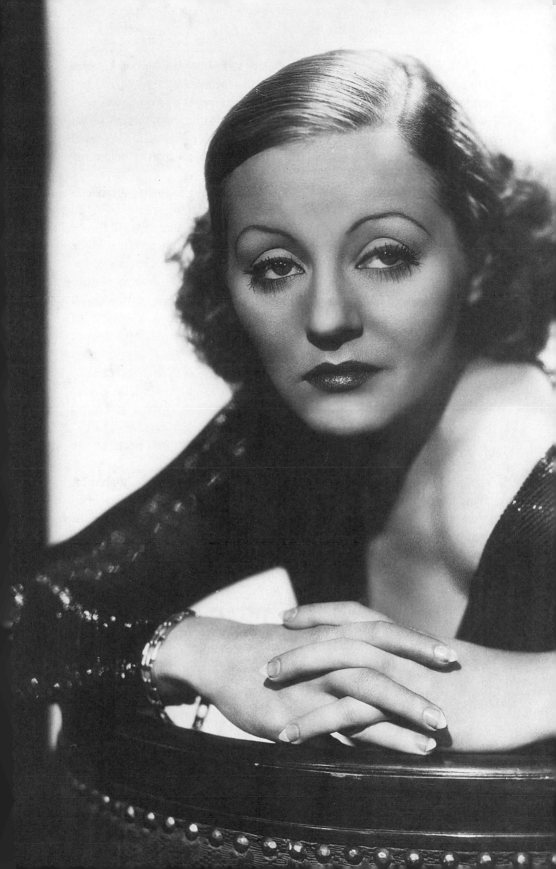

Will Hays, moral watchdog for the industry as head of the Motion Pictures Producers and Distributors Association, had reprimanded Hall, *Motion Picture* magazine, and the Paramount publicity bureau. Hays's office was considering adding to its onerous code a regulation against "verbal moral turpitude" on the part of cinema celebrities. A plan was also considered that would have imposed censorship strictures on journalists before the studios permitted their stars to receive the press.

Aunt Marie cannot have still been as naive about Tallulah's lifestyle as she had been in 1928, when she vented to Will her fantasy about Tallulah's closely harbored affections. Indeed, in 1931 she had written to Tallulah: "You have made your own reputation and it would be very unfitting of me to attempt to impose any old fashioned ideals upon you. The fact of the business is I am not as old fashioned a person in my own ideals as most of my generation." But the *Motion Picture Story* interview was too much for her. On August 6, she wrote Tallulah a blistering letter that concluded with: "I suppose you will never want to see or hear of me again. I don't know how you will take this letter. I mean it for your good, just as I used to spank you when you were a kid." Marie signed, "With love and grief."

Tallulah responded with a contrite telegram, asking her to send it on to Will if he had read the article, but if he had not, "DON'T WORRY ABOUT HIM AND ABOUT IT HEREAFTER I SHALL REFUSE ALL MAGAZINE INTERVIEWERS. . . . PLEASE BELIEVE ME I COULD NOT AND WOULD NOT SAY OR DO ONE TENTH OF THE THINGS THAT ARE ACCREDITED TO ME."

Marie was relieved, but she had a new admonition that Tallulah must have found devastating. Will had been in Montgomery and he, too, had read the article, telling Marie that "he was going to write to you but that he had been too hurt to do so as he did not wish to be unkind." Marie was astonished when Will told her that he had not had a single letter from Tallulah since she'd moved west nine months earlier.

> I do not see, Tallulah, my child, how you can wound as loving and devoted a father as Will has been to you by neglecting him in this manner. It would take you only a few minutes to drop him a few lines each week and in the years to come when he has left us you will be happy to think you gave him that much pleasure.

It was not until Will's death in 1940 that Tallulah began to construct a revisionist fable about their relationship, positioning him as the veritable center of her world and her affections. But the surviving paper trail records

her attempts to put definite boundaries around their relationship during his lifetime. She knew that he would have disapproved of much in her life, but her insistence on divulging nothing at all to him for long stretches was obviously motivated by more than her need to shield herself from unwelcome disapproval. After the disappointments of the past, she must have found it safer to keep him at a distance. Unable as she was, perhaps, to discuss her lingering resentments, her distancing sent a continuous message of reproach. Yet when she did write, her invariable recitation of only good news also tells us how much she sought his approval, and of late Tallulah had not had that much good news to share with him.

The film MGM chose for Tallulah was called *Faithless*, which was based on *Tinfoil*, a novel by Mildred Cram. It was perhaps the most pronounced expression of the theme Tallulah plied in all her films from 1931 to 1932. She was once again a well-bred woman struggling to retain her integrity, autonomy, and identity when toppled from her high perch, or in eminent danger of being so. But in *Faithless* she played a much more spoiled and reckless playgirl, whose comedown was therefore that much more excruciating. Carol Morgan's extravagance strips her completely of her erstwhile insulation from life's miseries. Like Dietrich's *Blonde Venus* and Bow's *Call Her Savage*, both made the same year as *Faithless*, the film pulls out all the stops and is packed with incident. Vignette after vignette shows us Tallulah—magnificently dressed by Adrian—as heiress, society parasite, kept woman, impoverished wife, and prostitute.

Faithless was directed by journeyman Harry Beaumont, who fourteen years earlier had directed Tallulah in the silent *Thirty a Week*. In *Faithless* he elicited from her the finest acting she had yet done in films. Tallulah imbues frivolous Carol Morgan with the pluck and grit and, eventually, the moral integrity of heroines penned by Charlotte Brontë or Edith Wharton.

More than in Tallulah's preceding films, in *Faithless* the spiral down is preceded by and interwoven with episodes of comic relief and madcap exuberance. We sense an all but palpable delight on Tallulah's part at finally being given enough comedy to allow her to show her skills. With dazzling élan, she bites into a series of battle-of-the-sexes exchanges with equally expert Robert Montgomery. After Tallulah's death, Montgomery told Brendan Gill that he had fallen ill shortly before *Faithless* was due to go into production. MGM offered to find Tallulah a replacement, but she elected to wait for Montgomery. Doubtless she knew that he was a better comedian than any of her preceding leading men on screen.

Montgomery plays Bill Wade, a young advertising executive who

wants to marry Tallulah but insists they will live on his income rather than her fortune. After the stock market wipes out her fortune, she decides to accept his offer, until he tells her that he, too, is now penniless because he has just been fired. She is not yet willing to endure poverty and instead embarks on a series of stints freeloading on acquaintances in the gilded set. Eventually she is driven bag and baggage out of a nouveau riche's mansion by her hostess when she discovers that Tallulah is borrowing money from her friends.

As Tallulah is exiting furtively, the husband, played by Hugh Herbert, buttonholes her and lets her know that he is willing to stake his own interest in her welfare. Mordant irony suffuses her responses throughout their scene. Herbert's inimitable comic eccentricity again gives Tallulah a delicious foil. As in so much of the best high comedy, words become weapons to parry, to cloak, and to disguise.

"Why, if it weren't for this depression I wouldn't have a chance with a high-class dame like you," Herbert tells her.

"It's an ill wind—" Tallulah responds. "But the depression is over, Mr. Blaney. The panic is now on. And so I don't believe I care to buy your violets." Uttering the word *panic,* Tallulah with the lightest of touches tells us that the nation's panic is hers as well, and tells us what she thinks of the disingenuous euphemism. But she is still proud enough to wriggle out of his entreaties no matter what abyss is her alternative. She accepts money from him only after he has convinced her that there are no strings attached. When next we see her, however, she has rather abruptly become his mistress. (It is possible that intervening scenes were filmed and then cut.)

When Montgomery tracks her down, Tallulah is now glad to throw over her gilded imprisonment and settle down to blissful connubial poverty. A whole new series of setbacks results in her being forced to walk the streets to pay for medicine for her husband. The inescapable desperation of America at that moment allowed Hollywood to speak bluntly about economic conditions. "Nothing matters when you haven't eaten for two days," Tallulah had muttered during one of the film's earlier crises.

Faithless is one of the most honest films about the reasons why women go into prostitution. It is impossible for Tallulah's Carol Morgan to find any other job. In an exquisitely lit and photographed scene amid the gloom of their tenement apartment, Tallulah exhibits some sublime pathos as she prepares to undergo her first foray into prostitution, and does so again as she returns, numb with humiliation. Her eyes certainly do not appear "dead," but rather large, luminous, and communicative. It must be noted,

too, that Tallulah in all her films uses her eyelids as expertly as her eyes. Few actresses have evinced such skill at using them to flash a fast and curt rebuke, or slowly lowering them to denote thought or comprehension. "The reason I use my lids as I do," she told a reporter, "is that when I was a girl I had a habit of nervously blinking my eyes, and I determined to end it. For a long time when I'd start to talk, I would keep my lids lowered." In reality, this tic actually continued to plague her throughout her life.

Tallulah told *Screen Book*'s Marcella Burke that she wanted to leave Hollywood. "But I don't want to leave until I've made one good picture." She hoped that *Faithless* "will be better than the others. I honestly feel it is good, but then—I may be all wrong," she said with a shrug.

Tallulah's current option was due to expire on September 20, 1932. *Variety* reported that the fate of *Faithless* would influence Paramount's decision about renewing. MGM was sufficiently impressed by the rushes to offer Tallulah Jean Harlow's role in *Red Dust* after Harlow's husband Paul Bern killed himself on Labor Day. Louis B. Mayer was worried that the publicity would repel the public. Tallulah reports that she was offended by Mayer's offer to gain from Harlow's tragedy and turned it down.

Faithless was seen in some Midwestern cities at the end of October, but not released nationwide until Thanksgiving. Reviews were bad, even severe. The *New York Evening Post* complained that "The smart-aleck dialogue, the utter lack of distinction in the handling of the theme, works continuously and fatally against the efforts of Miss Bankhead and Mr. Montgomery to bring their roles to life. What they are dealing with is trash, and neither is capable of disguising it."

Tallulah claimed that both Paramount and MGM had asked her to remain at a lower salary. But shortly after *Faithless* opened nationwide to lukewarm business, she was on a train back to New York with Edie Smith. By her own accounting she had saved $200,000 and thus could easily afford the vagaries of live theater. The stage offered a visceral satisfaction that films could not give her. "Put me on a lighted stage before a crowded house," she told *Silver Screen,* "and I'm myself."

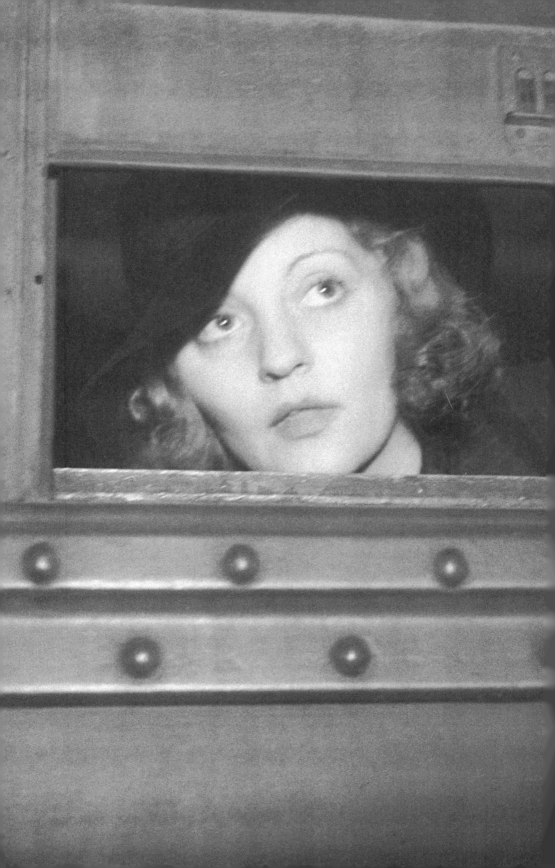

Back on Broadway

"I'm still an optimist in spite of everything."

Tallulah arrived at Grand Central on December 4, 1932, accompanied by Edie Smith, eight trunks, sixteen small packages, three portable phonographs, five hat boxes, and forty-eight pairs of shoes. Such was the inventory tallied by the *New York Sun*'s Ward Morehouse, who interviewed her a few days later in her suite at the Pierre. She told him that she wanted to do a play on Broadway, "but not *any* play. I'm still an optimist in spite of everything. I hope to find a play, a good one. If I do I'll stay. I'd like to stay. If I don't I'm off to London."

After two years of celluloid melodramas, tragedies, and weepies, Tallulah wanted to do a comedy; laughter was the logical refuge for Depression audiences. In Hollywood, Tallulah had told a reporter that Zoë Akins, who was now writing for the movies, was working on a play for her. But in New York she heard about *Forsaking All Others,* a drawing-room comedy that she had first read while still in Hollywood. It was written by two beginners, Fred Cavett, who had worked as assistant cameraman at Paramount, and Edward Roberts, a graduate of Professor George Pierce Baker's famous

Bidding Hollywood adieu, Tallulah peers out the window of a Manhattan-bound train.

playwriting workshop at Yale. Tallulah thought it would be perfect for Hope Williams and forwarded it on to her. In New York, producer Arthur Hopkins optioned it for Williams, but it turned out she had now chosen to do something else. Tallulah heard that Hopkins was relinquishing his option and bought the play.

Forsaking All Others wasn't just any play, but it was not exceptional either. "I was aware it was not a masterpiece," she writes in *Tallulah,* "but it was better than many of the seances in which I flourished in London." The play treated the romantic upheavals of one Mary Clay, a young member of the Park Avenue set. After being ditched at the altar by her fiancé since childhood, she mourns her rejection and then realizes that she's actually in love with a dark-horse suitor of hers.

Tallulah tried to find a producer to back the script, but even more than the movie business, the theater was smarting from the Depression. During the 1920s, producers thought nothing of investing their own money in shows, routinely risking and often suffering grave reversals. The collapse of the stock market had wiped out a number of major producers irrevocably.

Tallulah decided to produce the play herself, with the encouragement of Leland Hayward, a leading agent who later became a major Broadway producer. Hayward was an informal adviser to her at the time. It was reported in the press only that she had a financial interest in the play, which was not uncommon for Broadway stars. According to Tallulah, Hayward assured her that additional backers would materialize, but all the money that was staked turned out to be hers alone. And Tallulah insisted on the finest of everything: *Time* would describe one of Donald Oenslager's settings for *Forsaking All Others* as "the best-looking stage drawing room on Broadway."

Before she started work, Tallulah visited Washington to finally touch base with Will and Florence again. On January 10, 1933, Will wrote Marie: "Tallulah spent two days with us here and we had a big time together. She is certainly a most delightful child and inasmuch as I had not seen her for two years I enjoyed every minute of her visit." Her father would have been alarmed at her sinking her own money into as risky an undertaking as a Broadway play. As always, she did not tell him the whole truth. He informed Marie that Tallulah was "not financing the play which she is proposing to put on," but informed her that Tallulah had purchased the play itself "and will have all moving picture rights in the event the play is a success and will also participate in the profits of the stage play in the event there are any."

Producing a play "involves a lot of dickering with scene designers, directors, actors, theater managers and booking agents," Tallulah writes. "I wasn't

up to it." She recruited Archie Selwyn as her producing deputy, but he was only one of a gaggle of advisers. It was "a department of utter confusion and chaos," Jean Dalrymple recalled in 1982. "Everybody had something to say."

Dalrymple was handling press for the show. She had until recently been press agent for producer John Golden, and later enjoyed a long career as a producer. At the time, she was married to Ward Morehouse, who recommended her to Hayward as a staunch Tallulah booster. Dalrymple had been informally issuing around town a vehement rebuttal to the consensus that Tallulah had flopped in Hollywood. Dalrymple believed instead that the hyperbole with which Tallulah's film career had been launched had unfairly aroused expectations that she outstrip Dietrich or Garbo. "Who could? It made me very angry."

Selwyn suggested Harry Wagstaff Gribble as the show's director. He was an experienced Broadway director who had also done some writing. His play *March Hares* had come to London while Tallulah was living there. Tallulah liked him, but he hadn't been feeling well when he started work and after two weeks he withdrew. Cavett replaced him until the arrival of Arthur Beckhard, who began work on January 25. Beckhard was riding high at that moment. A former concert promoter, he had produced and directed two Broadway hits in the last year.

Forsaking All Others opened in Wilmington, Delaware, on February 3, 1933, and then in Washington, D.C., on February 6 for a week's run. At the end of the week, Beckhard left the show. He would later claim to the *Herald Tribune* that his suggestions for changes in stage business had been met with verbose resistance from Tallulah. The final breach came over a scene that Beckhard wanted her to play with her back to the audience. Tallulah rehearsed the scene the way he wanted her to, but at night she did it her way. She must have been aware that dismissing Beckhard's suggestion could make her seem like an old-fashioned ham, who wouldn't let the audience see her in any position except full-front address. She told the same paper that "I'm not at all averse to playing with my back to the audience, as long as I believe that it's putting the emphasis where it belongs. But in a light comedy a lot of the laughs come from facial expressions, and I believed that in the scene in question I should have played to the audience, and I did."

Dalrymple had written vaudeville scripts during the 1920s, and she recalled that Tallulah asked her frequently about how the script could be improved. She made notes about Tallulah's performance and gave these to her as well, and in her telling was able to salve Tallulah's anxieties about her return to the Broadway stage. "I feel *safe* when you're around," Tallulah

said to her. Morehouse was also brought in to do some rewriting. It was Morehouse who suggested the show's next and final director, Thomas Mitchell, who had not yet begun his thirty-year career as one of Hollywood's foremost character actors.

From Washington, *Forsaking All Others* moved to Boston, where it was greeted by most reviewers with genial tolerance. H.T.P. in the *Boston Transcript* didn't think the play gave Tallulah much to work with, but he appreciated her mining it for as much substance as she could. "Only the fashion in which Mary Clay 'left at the altar' pulls her hurt pride together, only her turning upon herself as well as upon the returning Todd, give proof of her mettle as maturing actress. . . . Miss Bankhead is trying to compose and project a character." The reviewer claimed that "The mannerisms that marred her later days in London have fallen away," and cited as an example the fact that "only once did the audience hear the husky Tallulah voice."

It is interesting to note Tallulah's sparing use of her deepest and throatiest register. The raspy baritone that is today synonymous with her name actually became chronic only in her final years, when her voice had become coarsened by smoking and drinking. She even told Anton Dolin that professionally she preferred her higher register and always tried to keep her voice higher onstage that it was normally.

The New York opening was postponed first to February 27, then March 1, as *Forsaking All Others* added a stop in Providence. Since the Delaware opening a month earlier, there had been many cast changes in roles large and small. Anderson Lawlor, who had been playing a small role, now replaced Douglas Gilmore as Tallulah's errant fiancé. Lawlor was a fellow Southerner, one of the gay men in Hollywood who congregated on Sundays at George Cukor's home, and "very funny and very dirty," Sam Jaffe recalled. "He and Bankhead were marvelous friends." Lawlor was good at playing wastrels and weaklings, as displayed in his best film role, Kay Francis's chiseling husband in Cukor's *Girls About Town*.

Tallulah's love rival Constance Barnes was originally cast with Mary Duncan, a film actress of some repute at the time. On tour, however, Duncan left the show and was replaced by Millicent Hanley. Perhaps *Forsaking All Others* was not big enough to contain both Tallulah and Duncan— particularly since Duncan's character was described in the script as "taller and slimmer" than any other character in the play. Or perhaps Duncan's return to the stage after years of films was not well advised. Soon after, she married and retired altogether.

But Tallulah had recruited marvelous talents to support her. Shep, the

Yale-graduate-turned-dairy-farmer with whom Mary Clay winds up, was played by ace comedian Donald McDonald. Acidic Ilka Chase played Tallulah's frequently tipsy maid of honor. Cora Witherspoon, like Chase, was a mainstay in Hollywood character parts and played Paula La Salle, a dowager of Gibson girl vintage who functioned as a surrogate mother to Mary Clay.

The Stage reported days of rehearsals lasting until three and four in the morning as everyone made the final push to pull the show together. Mitchell returned the play to the lighthearted mood established by Gribble, after Beckhard's apparent attempt to emphasize its dramatic conflicts. Poignancy remained in Tallulah's performance, however. "It is not a flash act that she puts on, or one bristling with personality alone," Tallulah's friend Robert Benchley reported in *The New Yorker*, "but a quiet, almost tender characterization in which even a sudden cartwheel has moments of pathos." This was her first cartwheel onstage since *The Gold Diggers* in 1926, evidence of the author's attempt to tailor the role to Tallulah and integrate her personal idiosyncrasies into a dramatic rationale. Her cartwheel capped a series of somber ruminations by Tallulah on her fiancé's desertion, an expression of her bewilderment as well as of her gumption. "Maybe I'll join the circus!" she concludes.

Tallulah had apparently decided that she would do her best not to be accused of overdoing her star-amplitude personal projection to the detriment of the ensemble. "Right now she has to hold herself back," John Plant reported in *The Stage*. "She refuses to be as electric as she can be. That is, except on opening nights, when the excitement always makes her fizz for the public." Tallulah sometimes referred to the fact that it was for this very reason that she did not give her best performances on opening nights.

Forsaking All Others could not have opened at a less opportune moment, for the country was panicked at the collapse of its banking system. Nevertheless, the first night at the Times Square Theatre went very well. "Rush." in *Variety* reported that "A cast that somehow conveyed an exhilarating sense of jaunty comedy and an audience palpitating with interest in Tallulah Bankhead's return to the stage, carried a frothy, superficial trifle of a play to a minor triumph in the theater."

Three days after the opening, Franklin D. Roosevelt was inaugurated and the country's banks began to close in the euphemistically named "bank holiday." Every show on Broadway was hit hard. Business was poor during the first week of *Forsaking All Others*, and those who did attend were undoubtedly anxious. The ovation Tallulah had received on opening night was a dismal smattering during the next few performances, dampening her spir-

its and those of her fellow actors. But banks began reopening on March 13, and the show began to rally; Tallulah was sufficiently encouraged to decide that she would remain in the States. On March 24 Will wrote her about his efforts to have her furniture from 1 Farm Street (which she had put in storage in London) shipped down to Jasper, where it would be kept at Sunset.

Acting on Broadway allowed Tallulah to return to the nocturnal existence that was impossible in Hollywood. She had begun visiting late-night spots in Harlem a decade earlier, and it remained in the early thirties a mecca for white sojourners. Titillation and entertainment that could not be found easily downtown were readily available. One favorite local character, Gladys Bentley, frequently dressed in pants and a derby hat, "and she would sing these *filthy* songs," Ann Andrews recalled fondly. "But such *amusing* songs you never heard!" Sometimes Bentley donned a skirt, which made possible her trick of picking up paper currency with her vagina, socialite Joe O'Donohue recalled. Watching that stunt "was one of Tallulah's great entertainments."

Harlem was more than a colonial playground for white Manhattanites; it also offered camaraderie between the races that was much less subject to the divisions enforced downtown. On Sunday nights, impresario Jimmy Daniels opened a room sprinkled with chairs and a piano where a cover charge allowed a drink of bathtub gin. Another impresario, Clinton Moore, convened a similar klatch on Saturday nights in a railroad apartment. Tallulah's friend Stephan Cole boasted that what prevailed at both Daniels's and Moore's was "a true mixture of black and white, mostly artists."

But at the Cotton Club, at the time the slickest, largest, and most renowned Harlem nightclub, blacks were allowed to enter only through the performers' entrance. Occasionally black performers at the club did, however, sit in the audience between shows. Fayard Nicholas, younger of the two dancing Nicholas Brothers, recalled in 1993 a night sixty years earlier when Tallulah requested that the two boys join her at her table after they had performed. She found out that the next day was Harold Nicholas's birthday. She congratulated him and asked if he would like a signed photo of her. He agreed happily. "Well, what about a bicycle?" she asked. He was at least as enthusiastic about that. "Now which one do you want?" Couldn't he have both? he asked her. She invited them to come to see *Forsaking All Others* the following night. They were free to go because they didn't appear at the club until midnight. After the third-act curtain, they went backstage to see Tallulah and found her waiting with hugs and kisses and both photo and bicycle.

As she had done in London, Tallulah again attracted stagestruck so-

cialites. It was at the crossroads of entertainment and society that Tallulah became romantically involved with John Hay Whitney, a fabulously wealthy venture capitalist, theater fan, and "angel" who had contributed to the funding of any number of Broadway shows. Two years younger than Tallulah, Whitney had been married since 1930 to socialite Liz Altemus. But their marriage was a failure and Whitney "was quite a well-known lover," Douglas Fairbanks Jr. recalled.

Despite Whitney's extensive traffic with the theater, some in his set clung to the old prejudices—or drew the line at Tallulah. Glenn Anders described a conversation with a woman he knew—"rich and then married rich, and very important socially, lived up at the Dakota." She said to him, "Glenn, you've got to get in and stop this affair between Tallulah and Jock!" Anders pretended not to know what she was talking about.

"I have not been at all well for a week," Will had written Tallulah in March, and on April 11 he collapsed while leaving the House floor, having just delivered a heated speech. The Capitol doctor first announced that Will had suffered a heart attack, but soon changed his diagnosis to "acute indigestion." This was, however, a dodge that Will, enormously invested in his political career, probably requested. Will never fully recovered from what was eventually acknowledged by all concerned as a serious cardiac incident. Tallulah would spend the next seven years knowing that there was a good chance that Will might die suddenly at any moment. But during this and subsequent crises she responded stoically, calmly describing to a reporter in her dressing room the risks of his current situation.

She was trying to keep *Forsaking All Others* open despite the fact that the grosses had started to slip. By the time the play closed in June, Tallulah had lost $40,000, so she later claimed. She presumably made back some of her money when Margalo Gillmore took the play on tour and more still when MGM bought the film rights. The studio turned *Forsaking All Others* into a mediocre film that was released in 1934. The great screenwriter Joseph Mankiewicz completely rewrote the play and somehow managed to further diminish a property devised by two neophytes. Tallulah believed that Leland Hayward had taken advantage of her inexperience and should not have let her put her own money into the show. In her autobiography she calls him "one of the most elastic reeds I was ever to lean on." Fifteen years later, Tallulah considered producing a play by Patricia Coleman, but ultimately backed out. *Forsaking All Others* was a sufficiently cautionary lesson; it remained her sole venture into production.

Disaster

"Don't think this taught me a lesson!"

H er notion is that she will not play simple women," *The Stage* had reported during *Forsaking All Others*. "She wants to do only those extremes who have great vitality: ladies of the town and ladies of the court." Tallulah's next role was not exactly either, but she was certainly exceptional: an almost neurotically headstrong Confederate belle in *Jezebel,* a new play by Owen Davis, who had coauthored *My Sin.* She was offered the part by Guthrie McClintic, one of the leading producer/directors of the time, who was married to Broadway star Katharine Cornell. He guided Cornell's career brilliantly, as well as steering numerous productions starring others. Twenty years earlier, he had been briefly married to Estelle Winwood, and was one of the Broadway power brokers Tallulah most liked and respected.

On July 10, 1933, she signed a contract with McClintic and then soon after skipped off to Los Angeles, for what was both a vacation and a chance to test her prospects anew in Hollywood. She lived for several weeks in a bungalow at the Garden of Allah complex in Beverly Hills, owned by her childhood idol, Russian actress Alla Nazimova.

In Hollywood, Tallulah made the social rounds with Alan Vincent, her ex-roommate, and made merry with the guests in adjoining bungalows at

the Garden of Allah. Laurence Olivier and his then-wife, actress Jill Esmond, were living there, as well as the great humorist, comic actor, and drama critic Robert Benchley. It's very possible that Tallulah and Benchley were involved and that her Hollywood trip was a chance to rendezvous with him away from his wife. Composer Vincent Youmans was also installed in a bungalow and Tallulah spent hours listening to him play his songbook of classic show tunes.

Hollywood remained interested in Tallulah. Tallulah said in 1951 that she had—to her later regret—turned down Bette Davis's waitress role in *Of Human Bondage* because she was afraid that her attempt at a Cockney accent would sound ridiculous to friends back in England. MGM was interested in her starring in a film of Ivor Novello's play *Party,* in which the role of wayward actress Miranda Clayfoot was both suspiciously similar to Tallulah, as well as written by Novello for her. It had been performed in London a year earlier and was being prepared for a Broadway opening as well.

Party describes the saturnalia in Miranda's apartment as she presides over a party commemorating her latest opening night. It offers an interesting portrait of the bluff in Tallulah's facade and the process by which a persona is constructed. Tallulah's vices were all real, but equally all exaggerated by her in her pursuit of notoriety. But some of Miranda's purported vices are simply for show—carrying a box of cocaine that she never actually sniffs. At the close of the third act, she submits to the tutelage of grande dame Mrs. MacDonald, patterned after and then played by Mrs. Patrick Campbell.

But *Party* was not going to fly with Tallulah—it was never filmed—because MGM was said to insist that Tallulah perform it in Los Angeles before they would film it. Tallulah returned to New York, attended the premiere of George Cukor's *Dinner at Eight,* and started rehearsing *Jezebel* on August 11. Frances Creel, daughter of the great Belasco star Blanche Bates, was making her stage debut in *Jezebel.* "She's such a sport," Creel told the *Evening Post* about Tallulah, "she's grand, she keeps the whole company amused." Tallulah and Creel were photographed together. Tallulah was tan and gorgeous. No one could have suspected that she was gravely ill.

Complaining of violent abdominal pains, Tallulah checked into Doctors' Hospital on August 26. Her stomach had started to swell. An initial bulletin stated that she had kidney stones, but Tallulah recalls in her autobiography that she was suspected of having an intestinal flu brought on by sleeping with a fan close to her bed. Her fellow actors came to her hospital room and rehearsed with her. She was then allowed to leave the hospital

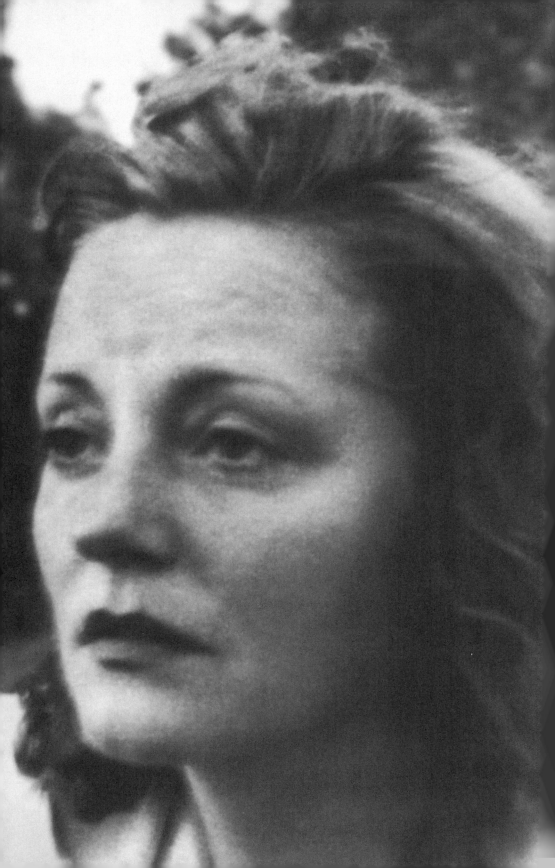

during the day, dosed with painkillers, to attend rehearsals at the Martin Beck, but her condition did not improve. The Philadelphia opening was canceled. Tallulah sent a telegram of profuse apology to the local producing group that was to present *Jezebel* there. McClintic was still trying to go ahead with the Broadway opening, scheduled for September 25. He announced that the play would open cold in New York, without any preliminary tryouts on the road. When that, too, began to seem unlikely, Tallulah begged McClintic to find another actress and continue with the production. Margaret Sullavan, who had not yet hit it big in Hollywood, was approached by McClintic and accepted, but he soon reconsidered and decided to stake his hopes on Tallulah's recovery, even though it meant great financial hardship for him.

The production was intended to be sumptuous, including a full complement of choir-singing plantation slaves. On September 18, all twenty-eight actors and singers were given two weeks' pay in lieu of the four weeks' half pay customarily paid for the rehearsal period. But the cast did not want to look for new jobs; they still hoped to begin work again soon. "There is something ferocious about the loyalty of the ill-starred 'Jezebel' company to its ill star," Leo Fontaine commented in the *Telegraph*.

A day later, Tallulah called Ward Morehouse from her hospital room and told him:

All I want in this world is to get well and get out of here. I'll start rehearsing the day I crawl out of this hospital, and I hope to open in 'Jezebel' in five weeks. It's a fine play, a swell play, different from anything I've ever done, and I hope to do justice to the play and the part. The doctors tell me that I'll surely be able to start playing within a month or so. I'm getting rested, and this is good for me whether I like it or not. Guthrie McClintic is a saint and an angel and the best director in the world, and it'll be heaven to start working for him.

On September 22, newspapers reported that Tallulah would leave Doctors' Hospital in about a week's time. She would rest for two more weeks, and then pick up where she'd left off with *Jezebel*. They would still be able to open on Broadway at the end of October. But as it turned out, Tallulah's condition once more prevented the play from resuming. "During all this time the doctors promised she will be out by next Tuesday, etc.," Edie Smith wrote Will weeks later, "till it all seemed endless and the poor child was suffering terribly. . . ."

The last thing Tallulah would have ever allowed Will to share with her was a personal crisis; her customary evasiveness was now exacerbated by her awareness that his health was fragile. On September 29, Will wired Tallulah at the hospital:

I CONTINUE TO BE EXTREMELY ANXIOUS ABOUT YOUR CONDITION I HAD HEARD NOTHING FROM EDIE AS PROMISED PLEASE URGE HER TO WRITE ME IMMEDIATELY RELIEVING MY ANXIETY STOP PLEASE SEND ME BRIEF TELEGRAM AT ONCE GIVING ME YOUR CONDITION AND IF STILL IN HOSPITAL STOP WITH ALL LOVE AND DEVOTION IN WHICH FLORENCE JOINS

On October 16, Tallulah was finally allowed to leave Doctors' Hospital. The press reported that she was "said to be recovering rapidly." Before long, however, she began running a dangerously high fever and losing weight rapidly. She checked into Lenox Hill Hospital, where she was attended by three doctors including her gynecologist, Dr. Mortimer Rodgers. Rodgers was the brother of composer Richard Rodgers and the head of OB-GYN at Lenox Hill. Exploratory surgery finally supplied the answer her doctors had been searching for: Tallulah was suffering from gonorrhea that had so completely assailed her reproductive system that her life was now threatened.

On November 3, Tallulah underwent a five-hour radical hysterectomy. News reports stating that she had undergone a "slight operation" were then amended, confirming surgery described as needed to remove "an abdominal tumor." Tallulah was so ill that she read her own obituary in one newspaper. She was released from Lenox Hill at the end of November, having been hospitalized for nine weeks out of the previous twelve. Her weight was down to seventy-five pounds, but her wit remained robust. "Don't think this has taught me a lesson!" she said to Dr. Rodgers as she left the hospital.

A nurse attended her in her suite at the Élysée. On December 1, Edie Smith wrote Will telling him about the operation but fogging over all details:

I sincerely hope you will pardon me for not having written you all about Miss Tallulah's illness earlier, her condition was so uncertain each time I intended writing you therefore I thought you would gain more news by wire and also she instructed me not to worry you especially as all the doctors agreed she was not in a serious condition, however it seems her condition was much more serious than they thought.

McClintic had no choice now but to replace Tallulah; Miriam Hopkins opened in *Jezebel* on December 19, but the play lasted only four weeks.

The physical and emotional trauma of Tallulah's hysterectomy cannot be underestimated. The subsequent course of her life would indicate that she was in some ways irrevocably altered by it. A hysterectomy shocks a woman's body into an instant menopause; any remedial hormonal treatment would have been perfunctory by today's standards—if it existed at all. We will probably never know whether the hysterectomy could have been avoided had her condition been correctly diagnosed earlier.

It was during her recuperation that Tallulah renewed her acquaintance with Stephan Cole, an aspiring actor whom she had met a year earlier at a party. He was a friend of Edie Smith and Smith now brought him over to Tallulah's suite at the Élysée to play bridge. A genial and well-informed man, Cole became one of the most important people in Tallulah's life. From 1937 to 1948 he was stage manager or assistant stage manager on ten of her productions. Shrewd and efficient, he possessed an obstinacy that in its heyday must have rivaled Tallulah's. He earned Tallulah's respect and confidence; she trusted him with information that most people around her didn't have. Tallulah told Cole that it was Hollywood's George Raft who had given her gonorrhea.

Her doctors had told Tallulah to spend two weeks in a tropical climate recuperating, but for once she actively wanted to be home with her family, and she decided to spend Christmas in Jasper. She says in her autobiography that she arrived "haggard and pale as the ghost of Hamlet's father," but with an enormous appetite. Her trip was shadowed by mutual anxiety between Tallulah and her father, who had recently suffered another cardiac incident. Each wanted to allay the other's worries and bluffed about how rapidly each was recuperating. Will wanted to show off Tallulah and asked her to appear with him at a movie theater in town. Tallulah put on her best little black dress and pearls to ascend the ramshackle stairway behind a feed store that led to the theater. She planned on collecting her thoughts while her father introduced her; instead, words failed the normally eloquent congressman. "Ladies and gentleman," Will announced, "my little girl" and disappeared into his seat. Tallulah explained to the audience what had just happened and all was smooth sailing for the rest of the evening. But these and similar social exertions took their toll, and she later complained that she'd suffered a relapse "from all the bloody handshaking" she'd done during her intended recuperation.

She returned to New York and went back to bed. "Normal women go

into melancholia after a hysterectomy," Tallulah told a friend in her final years, "and I'm pretty normal for an abnormal woman!" Her despair and depression are visible in some of the series of photographs taken by Carl Van Vechten at the end of January 1934, as is her drastic weight loss, which in some pictures makes her bone structure even more strikingly delineated. But within a couple of months, Tallulah was physically much improved; she now weighed 125 pounds and was starting to diet again. She decided that a visit to England would cheer her. Together with Edie, Tallulah set sail on March 31 and arrived in Southampton a week later. In London they checked into the Hotel Splendide on Piccadilly.

In May she began an affair with Rex Whistler, a noted artist, illustrator, and muralist. "I have been having an affair with Tallulah Bankhead," Whistler told his brother Laurence, who recalls in his biography of Rex that he remarked, "not without the twinge of venial envy that was requisite, and looked for, 'Wasn't that rather alarming?'"

"It might have been," Rex replied, "but, do you know, the curious thing is, *she* was shy of *me!*" After her recent ordeal, Tallulah was rather sobered about sex, Whistler told his brother, describing an erection as "the dreary conjuring trick men produce." "Not very romantic!" Whistler complained to Laurence.

An odd paradox of Tallulah was that despite her erratic behavior, she was usually meticulously punctual and expected others to be as well. One evening Whistler arrived two hours late for dinner. He carried bouquets of white and yellow tulips but explained that he had found them too prosaic and had touched them up with black stripes on the white and black dots on the yellow. The paint had taken a long time to dry. He was forgiven.

"Rex was gentle," David Herbert recalled, unlike so many of the brash bons vivants Tallulah knew. "I think she was very, very touched that this wonderful young artist was in love with her." His ardor was reciprocated— "as far as darling Tallulah could be in love with anybody!" In any case, he saw great tenderness between them. "Tallulah-hula," Rex Whistler called her, and told his brother that she was witty and warm, "not intimidating . . . just fun."

London was a glorious reaffirmation for Tallulah. Her hotel suite overflowed with floral tributes. Herbert said that going out with her was "like being out with Garbo," with people standing up in restaurants to get a better look. She was feeling strong enough to go back to work and, elated by her reception in England, decided to take a job there. In accordance with her status as an alien and a visitor, she requested permission from the Home

Office to perform at a benefit organized by Lady Pembroke, David Herbert's mother, and the annual garden party given by the Actors' Benevolent Fund. Her request touched off a minor debate in the Home Office. Surviving documents reveal that several on its staff were bitter that the surveillance she'd been under in 1928 had not been sufficient to push through a deportation. On May 31, the Home Office informed her that the secretary of state "does not wish to raise objection" to her appearance at the two charity functions, but was "unable to agree to her taking other engagements."

But she had already accepted an offer to tour Britain's music halls for five weeks in the same one-act play, *The Snob,* in which she'd made her variety debut at the Palladium back in 1929. On June 8, producer Daniel Mayer made formal petition to the Home Office to allow her to fulfill these tour engagements. Within the office, opinion was divided. "Knowing what we do of this woman," one officer wrote, "I think it is undesirable that she should be allowed to remain here & take engagements. We have already told her that she cannot take employment here." A colleague disagreed, stating that "if we object there is sure to be a fuss. . . . I do not think we could justify refusal, having admitted her to the country."

Reluctantly, permission was granted, and Tallulah opened in Liverpool in *The Snob* on June 18, 1934. *The Stage*'s Liverpool correspondent described her role as "much too slender for her to do herself anything like justice. She acts, needless to say, with accomplished ease and grace, but even so talented an actress as Miss Bankhead cannot put life into a part which scarcely exists."

Tallulah renewed contact with producer/director Basil Dean, who had been so important to her earlier London career. On July 2 and again on July 19, Dean's office wrote the Home Office, telling them that Dean was considering Tallulah for the lead in a new J. B. Priestley play and his plans would be ruptured should she be forced to leave the country. From the Queen's Hotel in Birmingham, Tallulah wrote on July 7 requesting permission to remain through the summer to discuss pending engagements, but not dependent on her accepting them, "as my Doctor strongly urges me not to return to New York during the terrific heat."

Performers were not generally granted residency extensions simply to look for work, yet an internal Home Office report dated July 12 stated: "However unsavory her personal reputation may be Tallulah Bankhead is a 'star artist' . . . and until we are prepared to refuse her admission to U.K. . . . we shall only make ourselves look foolish if we attempt to bring her stay to an end on a frivolous pretext. . . ." On July 17, Tallulah received permission to remain until September 30.

Will was not aware that Tallulah was again working, for on June 23 he had written her at the Splendide that "I've been very anxious to hear something from you about your plans and how you are getting along. I hope that as soon as you see this you will have Edie write to me at once as I am tremendously concerned about your future."

Tallulah's sister had also been in London the previous fall, where she had announced her engagement to Kennedy McConnell, son of a retired Scottish coal magnate. Soon afterward they called off the engagement; this happened more than once during the early 1930s, as Eugenia, now realizing that she could not live with Morton Hoyt, lunged impulsively at those whom she mistook for potentially permanent partners. In the spring of 1934, she was visiting Will and Florence in Washington. Perhaps Tallulah had turned off her cash spigot to her sister, for Will wrote that he had now started giving her an allowance again, which he claimed was "a great burden on me . . . but under the circumstances I feel that I ought to do so as long as possible."

Theatre World reported that Tallulah would return to the London stage that fall in a new comedy, a reference perhaps to the Priestley play, or to S. N. Behrman's *Serena Blandish*, in which Tallulah was apparently interested in starring. An exquisitely ironic comedy of manners, *Serena Blandish* had played on Broadway in 1929. Tallulah would essay the role originated by Ruth Gordon, a young woman whose straight-shooting ways founder her amid the corruption of British high society.

But a transatlantic call from Jock Whitney, Tallulah's favorite New York beau, was enough for her to reverse course entirely. He was sending her the script of *Dark Victory*, a new play by Bertram Block and George Brewer Jr., that he wanted to produce on Broadway in the fall. He cabled:

THIS REALLY IS WORTH YOUR WHILE AND JUST YOUR DISH SO TAKE A LONG BREATH READ IT AND CABLE SOON STOP BY THE WAY YOU'VE BEEN GONE LONG ENOUGH LOVE.

Dark Victory was the story of a Long Island socialite whose life is spent in frivolous pastimes when she discovers she has a brain tumor. She falls in love with the idealistic doctor who treats her. In the Vermont countryside, they enjoy a brief respite before she faces imminent death with the realization that their relationship has redeemed the meaningless life she had been leading.

New is perhaps not the right word for *Dark Victory*: the property had

been floating around the entertainment capitals of both American coasts. Tallulah had read it and rejected it while she was still in Hollywood. Earlier in 1934, Katharine Hepburn had agreed to try it out in summer stock and then changed her mind. But Tallulah left London in late September, soon after the script reached her. Whitney assured her that no less a playwright than Maxwell Anderson had spent time revising it. More attractive was the flattery of Whitney's wishing to invest in her, and the possibility it may have suggested that he would consider divorcing his wife and marrying Tallulah.

Recovery

"I choose to believe what I choose to believe."

Well-schooled as Tallulah was in the art of glossing over holes in a script, and still nervous about the quality of *Dark Victory,* she determined that it would receive the very finest in the way of production values. Robert Edmond Jones was recruited to design the sets. Jones was the elder statesman of Broadway set designers, very much influenced by European experiments in stagecraft. He had designed the settings for John Barrymore's *Richard III* and *Hamlet* a decade earlier. Tallulah's costumes were by Elsa Schiaparelli, whose strapless satin gown she had recently modeled for British *Vogue.*

Tallulah negotiated her contract with John F. Wharton, the attorney who handled all of Whitney's theatrical investments. David O. Selznick was already considering filming *Dark Victory* with Garbo, and Tallulah was hardly interested in serving as a dry run for another actress. She won a contract stipulation that if she did not play Judith Traherne on screen she would receive a percentage of the film sale.

Her leading man was Earl Larrimore, a good and popular actor. The director was Russian-born Robert Milton, one of the busiest on Broadway. "We get along splendidly," Milton told the *Herald Tribune.* "Tallulah is delightful for a director to work with because, like Nazimova and Mrs. Fiske,

she is willing to trust the judgment of the people concerned for her technique and business." (Milton was undoubtedly using *technique* here not to mean acumen but rather approach, style, attack.)

Robert Henderson, a young actor who later married Estelle Winwood, attended the November 9 opening at the Plymouth Theatre. He was thrilled by the "doomed quality" that hovered around Tallulah's Judith Traherne from her first appearance. She was "a woman who the gods were going to catch. She was fighting against an invisible web." Tallulah interjected her own recklessness, making the character "the kind of woman who will dare anything and doesn't care, even though she knows she's going to destroy herself." Henderson recalled with pleasure her singular neurotic/erotic tone established in the early scene when her doctor's probing flashlight reveals that her eyes are failing, and found her extraordinarily convincing in the final scene of enveloping blindness. Stephan Cole, too, said that she was heartbreaking.

Robert Garland in the *Telegram* wrote that she had acted with "unflagging skill." In the *Sun*, Richard Lockridge wrote: "Miss Bankhead gives an altogether admirable performance for the first sane act and a half. At odd moments even in the later difficult moments she brings into her playing a note of tense feeling which cuts through the theatricalism."

At her lowest ebb, Judith Traherne thinks of giving herself to the groom at her estate stables. Waggish Percy Hammond of the *Herald Tribune* was intrigued by this scene in which "Miss Bankhead was gorgeously tempting and tempted, and for a moment or two many of us feared that she would request him to visit her in the middle of the night."

Business was lukewarm. *Variety* speculated that *Dark Victory* was the right play at the wrong time. "Tragedy has a place in the theatre, but it seems so much vexation has plagued the people that they prefer to be amused instead of going through an ordeal." The paper's "Ibee." reported that several of the first-night audience had passed out in response to the tensely realistic medical examination Tallulah received in the opening scene; now the script was said to be in the process of being "lightened," as Whitney was committed to giving *Dark Victory* a fighting chance.

Joe O'Donohue spoke with all the unwitting condescension of his class and his time when he said, "I think he liked her very much and even when you're Jock Whitney, Tallulah Bankhead—an actress, and with *that* personality—had a great allure." For her part, Tallulah was "crazy about Jock," Cole recalled. She expected her beaux to meet high and critical standards. Whitney was an accomplished businessman, sportsman, and a man

of some aesthetic discernment, yet his manner was charmingly self-effacing. He was "everything she wanted," Cole said.

Tallulah said to Glenn Anders that she didn't think she was beautiful, but she knew that she needn't take great pains to look wonderful. "I saw her so many times get out of the tub, climb into a slip, run a comb through her hair, smear with the lipstick, into the dress and out the door." But when she was going to see Whitney she took extensive care about her appearance. She was happy to go out with him alone, which was rare for Tallulah, who usually traveled with a party.

Their relationship was not without great frustrations. As attractive as she found him, Tallulah could not experience an orgasm with him. He was aware of this and it bothered both of them. When she recalled this to actor Sandy Campbell in 1956, she attributed it to her not being able to reach a climax with any man with whom she was in love, a polarization between emotional and physical intimacy that may have prompted Tallulah's restless exchange of partner after partner. It's also possible that her hysterectomy had affected her sexual response.

Nor could she have a child by Whitney, which would have been her ace card in cementing their relationship. After four years of marriage, Whitney had no children, which was attributed around town to his wife's not wanting them. Animals were Liz Whitney's great passion. She owned an enormous menagerie, and bred horses and dogs. Helen Hay Whitney, however, desperately wanted an heir for her only son. She offered a million dollars to any woman who could produce one, and Cole said that she didn't care "whether it was Tallulah or the laundry woman."

"I choose to believe what I choose to believe," Tallulah would tell Cole. For a while, what Tallulah chose to believe was that her hysterectomy had somehow not been absolute.

"It's a miracle; I'm bloated," Tallulah told Cole. "Then stop eating," he said. "Tallulah," Cole reminded her, "they took everything out. *Everything.*" No pregnancy of course materialized, and Tallulah's sterility became a continued source of anger and sorrow. Her drinking seemed to increase, and her drug use was also considerable.

Insomnia had dogged Tallulah since, at the latest, her Paramount days, when *Screen Book* magazine reported her reading through the night because of persistent difficult falling asleep. By the time she returned to New York, Tallulah had turned for remedy to barbiturates that soon hooked her into a psychotropic treadmill, which did not stop her from indulging in recreational drug use as well. O'Donohue remembered Tallulah sending

Cole to Harlem with twenty dollars, enough for cab rides both ways as well as for a purchase of cocaine. "I went to Harlem once to buy cocaine for her," Eugenia Bankhead recalled in 1971. Over supper one night at the Algonquin, Tallulah asked Gladys Henson, "Am I tidy?" after returning from the women's room. "She was covered in cocaine, all down a beautiful black dress," Henson recalled. "No," I told her, "you look like a Southern colonel with a little white mustache and some powder all down your front." Tallulah laughed herself silly and repeated the story to all and sundry.

That fall, Henson and Sybil Thorndike arrived from London to recreate their roles in John van Druten's *The Distaff Side,* in which Estelle Winwood was also starring. Tallulah and Thorndike were both staying at the Gotham Hotel at Fifty-fifth Street and Fifth Avenue. At three o'clock one morning, Tallulah rang Thorndike's room. "This is Tallulah speaking. I'm having a few friends in from London. You *must* come, must come along." After Thorndike arrived in a nightgown, Tallulah delivered an encomium to her brilliance, concluding by telling her, "You're a fucking dear old darling, and I love you," and giving her a kiss. Later in the evening, Thorndike announced that she would have to buy a dressier nightgown. She became a frequent guest at Tallulah's.

"She almost had a salon at the Gotham," Gladys Henson said. If she was working, Tallulah used to take a nap after getting home from the theater and then she'd get up at 2:00 A.M. and preside over open house. Marijuana was very prominent in her vicinity during the 1930s. Hugh Williams, Tallulah's lover and colleague from London, was visiting Manhattan. Early one morning, he walked into Tallulah's suite and with a show of comic disbelief quipped, "I think I smell a Chesterfield!"

For Tallulah, doctors were increasingly both caregivers and drug suppliers. In London she had been used to spraying her throat with a cocaine-laced solution that was prescribed for laryngitis. In New York, Dr. Milton Reder, Tallulah's eye, ear, nose, and throat physician, liberally prescribed a similar solution. In 1983, he recalled frequent summonses to her dressing room to administer his elixir. Tallulah's stage fright resulted in frequent attacks of laryngitis, which her smoking of course exacerbated. But Stephan Cole described, too, a little game, in which Reder, making a house call to Tallulah's suite, would conveniently disappear to the bathroom, giving Tallulah the chance to rummage through his bag and pilfer several vials of his solution. Both doctor and patient played dumb, but, Cole believed, the cost of the drugs found their way onto Tallulah's bills.

On December 20, 1934, Tallulah went to sleep around 3:00 A.M. looking

forward to the next day's matinee. The company manager had told her it was the first sold-out performance since the opening night. She awoke to find that her voice was gone. Estelle Winwood, who'd spent the night at Tallulah's, called Dr. Reder. He instructed Tallulah to proceed to the theater and he would see her there. By the time Tallulah reached the Plymouth, her face was swelling rapidly. Dr. Reder sent her home and the matinee was canceled. Tallulah had contracted an infection that was then potentially deadly, but could today have been cured immediately with a dose of penicillin, Reder recalled.

Without Tallulah, Whitney was not interested in prolonging *Dark Victory*. It closed immediately. But in 1939 it became one of Bette Davis's most memorable vehicles, as did *Jezebel* in 1938. Davis's performance in the former was perhaps influenced by Tallulah's, for *Dark Victory*'s company manager later told Cole that Davis was in the audience for one of Tallulah's performances in New York.

Tallulah spent several weeks in bed, wrapping a veil around her face to receive visitors and savoring the air of mystery it provided. But no sooner was she on the way to recovery than her father was again in the throes of a health crisis. On New Year's Day, 1935, he was hospitalized in Washington, D.C., for "a medical examination and rest," due to what was described as a "cold and indigestion." He had just been nominated to the position of floor leader in the House of Representatives. The *New York Times* reported the family's fears that this was actually a reprise of his "severe heart ailment" of two years earlier, which had also been publicly diagnosed as indigestion. This is exactly what it turned out to be, and it was months before he regained full mobility. By January 6, Tallulah was well enough to fly to Washington to visit him, but returned to New York immediately to start work on her next play.

Producer Sam H. Harris, who had presented her in *Nice People* in 1921, had approached her with an offer to star in a revival of *Rain*. He had been the producer of the original production in 1922. From the moment she had been dismissed by Maugham in London in 1925, Tallulah had vowed that she would someday play Sadie Thompson successfully. And now Maugham was apparently no longer an obstacle.

Yet *Rain* as a theatrical property had become somewhat shopworn. Gloria Swanson and Joan Crawford had starred in film versions. After Broadway, Eagels had toured it extensively across the United States. It had also been performed by great Broadway stars in summer stock and the "subway circuit," which comprised a separate itinerary of theaters, clustered as near

As the repentant Sadie Thompson in *Rain*.

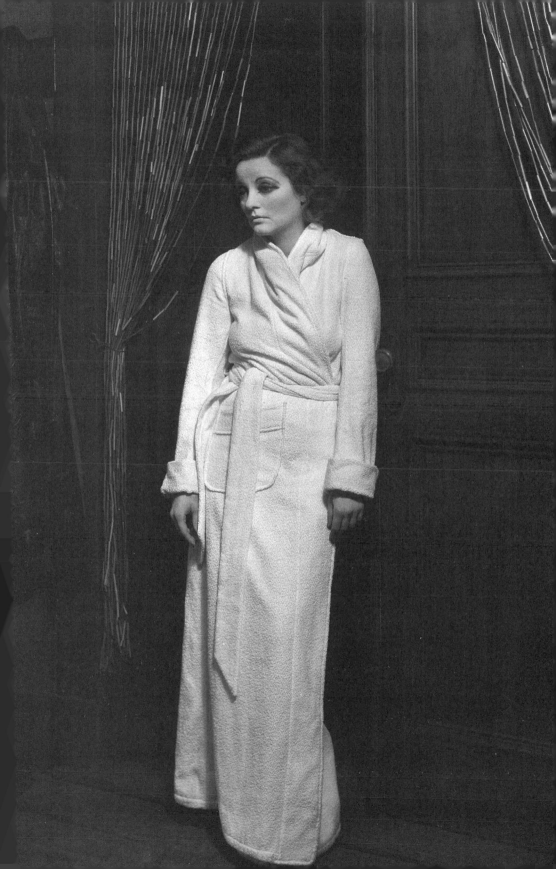

as the Shubert-Riviera on Ninety-sixth Street and Broadway and continuing north and east throughout the boroughs of New York City. However, Tallulah said that "nearly all of my friends—managers, directors, actors, and just plain, non-theatrical people"—advised her to accept his offer.

A well-built and gripping drama, *Rain* continues to reward reading to this day. Although the character of Sadie has become something of a cliché, she is one of the greatest in theatrical literature of the period. Sadie's tough rowdiness conjoined with intermittent self-doubt and chinks of vulnerability fit the layering of Tallulah's on- and offstage personas.

"I'm in quite a spot," Tallulah confided to a reporter. "One minute I'm thrilled to death and the next I wake up in a cold sweat. It's a bit different from anything I've ever done. . . . I've played bad girls before, but they were always ladies, more or less. But now . . . I'm a nice little common bad girl—a cheap little floozie."

Tallulah always believed that Maugham had turned thumbs down on her in 1925 because her performance in rehearsals mimicked Jeanne Eagels's. To Howard Barnes of the *Tribune,* Tallulah now described her "fear of seeming to borrow anything from that memorable performance. . . . If I appeared in 'Rain,' I wanted to make Sadie Thompson my own interpretation of the part. . . ." Cole recalled her capacity to discern true and appropriate details of character and costuming. "If she were this kind of a person, she would do this or that; Sadie Thompson would use this kind of a handkerchief, carry *this* kind of a bag, not that."

At the out-of-town opening in Philadelphia, Tallulah's eyes were teary as she gave a curtain speech. "From the fact that I am playing this part, where 'Rain' was first given, with Jeanne Eagels, people must think I am either the bravest or the most conceited woman in the world. Neither of these things is true. Nobody has more respect for Jeanne Eagels than I, God bless her."

Tallulah's *Rain* arrived at Broadway's Music Box Theater on February 12, 1935. Years later Tallulah said that, daunted by the memory of Eagels, she once again hadn't given as good an opening night performance as she could have. When Barnes interviewed her the afternoon following the opening, he found her going over every moment of the performance. "I think I'll do a better job tonight," she told Barnes, "when there aren't so many in the house overanxious to have my performance a success, rooting for me and holding their collective breaths every time I come to a bit of business."

In the *Times,* Brooks Atkinson described her as "an actress of extraor-

dinary range," who was well equipped "for every situation the play invents—fear, remorse, pathos, contempt and pity for the misery of the world." But he thought that Eagels had dissolved more naturally into the part, and synthesized its many facets more coherently.

Harris had assigned Sam Forrest, one of his oldest and closest associates, to direct *Rain*. Tallulah praised his work, but it is likely that the ideas about interpretation were hers. In 1922, the public was still asking that theatrical prostitutes nurture hearts of gold beating within their bespangled breasts. Tallulah could well have surmised that the times were ready for a rougher, franker interpretation. She may have gone overboard in making Sadie too salty, too rowdy. Richard Lockridge in the *Sun* found her too raucous in her initial scenes but said that when she unbuckled her defensive armor she was even more vulnerable than Eagels had been.

Tallulah believed that she had worked on and improved her performance over the run. This is certainly possible; Cole described her as "a severe critic of her own work." He saw her admit mistakes she'd made with a part, "not audibly but mentally. She'd go to work on it after reading the notices—in the theater, without saying a word." Tallulah also was willing to call up critics and ask them for additional response beyond what they had written. Elliot Norton, who became the dean of Boston critics, recalled that this was how she struck up a long friendship with him during these years. Tallulah was "willing to accept negative criticism if you could back it up," Norton recalled in 1995.

Will remained in the hospital, where he had been sworn in as house floor leader at the end of January. Tallulah was flying to Washington once a week to visit him. Florence Bankhead vigilantly attended Will's bedside at Johns Hopkins in Baltimore. Tallulah thought that *Rain* might be a good diversion and invited Florence to come to New York for a matinee. As soon as Florence accepted, however, Tallulah started to panic, seized with the conviction that Florence would be offended by Sadie's profanity. Tallulah decided she couldn't wait to hear the worst and summoned Florence backstage during the first intermission. But Florence was delighted: "Tallulah, honey, you're just precious, Sugar. You're just like you were when you were a child. Remember your tantrums?"

Tallulah told the *Tribune*'s Barnes that she hoped *Rain* would run but confided that she was already scouting for her next play, preferably a high comedy. She complained that most of the finest comedy writers were either working on motion picture adaptations, or, like Maugham himself, had given up writing plays. She had beseeched S. N. Behrman to write a

play for her. She'd wanted to star in his *Serena Blandish* during her recent stay in England. He wrote the most sophisticated drawing-room comedies of the day, gracefully incorporating liberal social and political comment. It's not clear what happened with this project, but the idea appears to have been what materialized in 1939 as *No Time for Comedy,* by which time Tallulah was starring in *The Little Foxes.* It was Katharine Cornell, making one of her rare stabs at comedy, who starred in the role Behrman had once envisioned for Tallulah.

Tallulah was going to need a script sooner rather than later, because *Rain* lasted only forty-seven performances. Ward Morehouse, who had been one of the boosters urging Tallulah to take the part, revisited the revival in its last week. In the *Sun,* he wrote that while Tallulah's colleagues were excellent, because of *Rain*'s familiarity, another star should have been cast opposite Tallulah. He thought that Tallulah's work had improved since the opening night. Marlene Dietrich sat three seats away from Morehouse, and he watched her at the final curtain stand up and clap her hands "with all her strength."

Tallulah thought about bringing *Rain* to London, but then developed cold feet. After her disappointing showing in films, her illnesses, and yet another Broadway flop, she had come to believe that she was jinxed. Desperation attended everything to do with her next play, *Something Gay,* which she began rehearsing for the Shuberts on March 25, 1935, days after *Rain* had closed. *Something Gay* was written by Adelaide Heilbron, a successful screenwriter who had worked on *My Sin.* It was a story of marital dare and double dare, in which Tallulah as Monica Grey suspects her husband of cavorting with an apartment-house neighbor. She resolves to flirt with an old flame of hers. But her husband calls her bluff by encouraging her and her old swain, with predictable results: she and her ex-lover decide to revive their old affection for real.

Walter Pidgeon, whose Hollywood career had temporarily run aground, played Tallulah's husband. Silky-smooth British actor Hugh Sinclair, then at the peak of his considerable popularity, enacted Tallulah's lover. Thomas Mitchell again directed her. "She would completely be guided by him," recalled John Kenley, a member of the Shuberts' production staff at the time.

On April 2, Will wrote Tallulah that he was improving slowly but was still homebound except for the occasional spins his driver took him on when the weather was good. He was afraid that he wouldn't be able to return to Congress before the end of the session. "I was pretty hard hit and

am still off a great deal in weight but am picking up a little." Tallulah had engaged a heart specialist in Baltimore, a certain Dr. Thomas, to treat her father and had apparently promised to pay his bill. "I regret very much to have to remind you of it," but the doctor was sending Will his bill and he had no choice but to send it on to her. "I hope that you can find it convenient to send him the money now."

Something Gay opened in Boston on April 19. "Libbey." in *Variety* said that Tallulah had delivered "a splendid performance ranging from cutting satire to downright mugging in a desperate effort to save the show." Two weeks later the show opened on Broadway at the Morosco. Given Tallulah's frame of mind, it is not surprising that John Mason Brown in the *New York Evening Post* described her as "unusually fretful at the start" of the opening-night performance. "But she soon stopped her needless pacings, controlled her energies and settled down to a performance that was commanding and varied and skillful." George Jean Nathan in *Life* wrote that the play had brought her "back to the plate for the third time in the season, but once again failed to provide her with a bat."

Something Gay limped along for two months before succumbing to the summer doldrums. Cole remembered how beautifully Tallulah and the languid Sinclair played opposite each other. But he said that comic business that had been in the production on opening night began to fall by the wayside. This may have been in response to the criticism that she had done too much: Arthur Pollock in the *Brooklyn Daily Eagle* had complained, "Not content ever with getting her effect once, she bores ahead and underlines it heavily three or four times." But according to Cole, what expanded in direct proportion to the stage business that fell away were covert gags between her and Sinclair, both doubtless bored to distraction by the script itself

When Michael Mok of the *Post* proposed that Tallulah discuss why "you appear in one poor play after another," she responded testily, "Do you think I pick poor plays for fun?" She ranted at him about her need to make a living, complaining that "I've been on the stage fifteen years and I've been in only one good play, Sidney Howard's *They Knew What They Wanted*. . . ." With restored composure she lobbed a challenge back to him. "I'll make you a proposition. . . . You write a brilliant comedy and I'll buy it."

Jock

"Parental restraint prevents me from gushing, but I think she did it very artistically."

—Will Bankhead

I n her autobiography, Tallulah writes, "In my time I've scrambled many a commandment, upended many a statute, but I've never been a kept woman!" It's not clear whether she is looking down her nose at all women supported by men or simply observing the conventional prejudice against women who did so without benefit of wedlock. Perhaps she is simply jesting. Although she prided herself on her self-sufficiency, Tallulah had been raised with the assumption that there would be a man footing her bills. Part of her may have longed for what her intellect would have condemned; one of Whitney's allures was the financial security he could provide.

But however seriously Tallulah took her affair with Whitney, and hoped that he would, neither she nor he was monogamous during their three- or four-year affair. In the spring of 1935 playwright Clifford Odets was making a big splash on Broadway. She saw in Odets not only a lover but a potential dramaturge. In June 1935, Odets had gone to Cuba with a delegation organized by the League of American Writers to investigate conditions under the Mendieta-Batista regime. The entire delegation was

briefly imprisoned and then sent back to New York. Tallulah cabled him at the naval prison in Havana as soon as word reached her in New York:

DARLING I REGRET HAVING TO QUOTE THE SCRIPTURES BUT CHARLES MACARTHUR TOLD YOU SO STOP GOODY GOODY I HOPE YOU STAY IN THE DAINTY PLACE UNTIL YOU HAVE WRITTEN MY PLAY OR SHALL I BE BIG AND SAY OUR PLAY STOP NO BUT REALLY ITS TOO FANTASTIC AND RIDICULOUS BUT YOU CAN'T BE A GE-NIUS AND HAVE EVERYTHING STOP DON'T FORGET MY POSTCARD AND BE HAPPY. LOVE, TALLULAH.

Odets himself slept with hundreds of women and, says his son, some men as well. He was a misogynist, and for a man like him, Tallulah violated the last taboo by behaving with the same casualness as he did. He wrote about her without sympathy but with great insight when, in September 1935, as their affair was cooling, he confided to his diary:

I can't quite make out what is wrong with her. To say she is in flight from something is to say an obvious thing. She suffers from an awful and big sense of "insufficiency." She feels all people are aware of that lack and she compensates for it by giving you her sex instruments for your use and possible pleasure. That is her way of binding you to her.

That year Tallulah was also involved with another quirky, intense-looking young darling of Broadway, actor Burgess Meredith, who at twenty-four was starring in Maxwell Anderson's *Winterset*. In his autobiography, he recounts that Tallulah wired him to invite him to a party in her suite. She answered the door stark naked, cocktail glass in hand, threw her arms around Meredith, and thrust her tongue into his mouth. She insisted on introducing him to every one of her guests, who were talking, drinking, and playing cards, but all seemingly oblivious to Tallulah's nudity. Not long after, she pulled Meredith into her bedroom and demonstrated the way she honored her commitment to Whitney by demanding, at the height of their lovemaking, "For God's sake, don't come inside me. I'm engaged to Jock Whitney!" A formal engagement, however, was only a matter of wishful thinking on her part.

She must have known, too, that Whitney had his own stable of mistresses. But Tallulah did not like being superseded by any other woman in

her professional or personal sphere. She was miffed to find herself at a party hosted by a former mistress of Whitney's in an apartment that he had purchased for her. After downing a toast, Tallulah smashed one of the woman's Baccarat glasses into her fireplace. When Tallulah was drunk she did often start smashing glasses, but she hadn't been drunk, and Stephan Cole, who had gone with her, was convinced that she had done it not out of exhilaration but hostility. He told her that such a show of jealous pique was beneath her. "You're not Russian and you don't throw your own glasses into the fireplace, so I don't see any reason for you to throw hers." Edie Smith issued a similar admonishment. "We shamed her into sending the woman some more glasses," Cole recalled.

Cole could laugh at his own foibles, but looking back on his relationship with Tallulah, he never conceded that he might have been wrong in any dispute with her. This rigidity may have attracted her to him. One of Cole's appointed functions was to apply what would today be called tough love, to answer her demands for attention with firmness and, if necessary, ridicule. In his telling, Tallulah had been maternal with him during the early years of their relationship—he was twelve years younger—and then he had settled into a role that encompassed companion, lover, and quasi-parent. Nominating him to the caretaker role that Tallulah felt she'd been most crucially shortchanged of, she acceded to his authority and fought it at the same time.

No matter how aggressively Tallulah behaved, she had been born and bred a belle for whom sexual coquetry was de rigueur but sexual aggression just as strictly forbidden. Despite her brazen behavior, she also wanted to be seen as a hapless victim of sexual aggression. To Cole she made a bizarre simulation of passivity, telling him that Napier Alington had "raped me." It was and is not uncommon for Southern women to use the term loosely and colloquially to indicate intent or desire, as in "he raped me with his eyes." But Tallulah clung to the literal meaning and repeated it about other important men in her life, so much so that Cole later said facetiously, "As far as I can make out, the first time a man ever set eyes on her, he raped her."

"Tallulah, how many times can a woman be raped?" Cole asked her.

"Why, any number of times!" was Tallulah's perfectly accurate but nevertheless disingenuous response.

Tallulah did not work for an entire year after *Something Gay* closed at the end of June 1935. She had resolved to wait for a good play no matter how long she had to cool her heels. After finally accepting *Reflected Glory,* by Pulitzer Prize–winner George Kelly, she continued to wait while Kelly

fenced with the Shuberts about whether he would receive 60 or 50 percent of the motion picture rights. Eventually he prevailed.

Tallulah called the months-long wait "interminable." Cole recalled a night at the Gotham when Tallulah was drinking, depressed, melodramatic, and full of self-pity. "I'm going to jump out of the window!" she declared. "I'm going to kill myself." "Well here, let me open the window for you," he said. It was snowing outside. "Now be careful you don't slip," he cautioned. She whipped around and hissed, "You son of a bitch!" before walking away and quieting down.

Kelly's earlier plays had satirized the foibles and pretensions of middle- and lowbrow bourgeois America. Now, in *Reflected Glory*, he portrayed an actress, Muriel Flood, who dreams she wants home and children. She turns down one man because he insists that she give up the theater if they marry, but then succumbs to the blandishments of a con man who is already married. By the end of the play she has wised up to the fact that her real satisfaction will always come from the stage.

Although Tallulah symbolized to the public the flamboyance of the theater star, this was the first time she had actually impersonated a dramatic actress. *Reflected Glory* was an excellent vehicle, filled with cynical expert and sparkling observation. Kelly was an expert director and "a consummate comedian," recalled Anne Meacham, who supported Ina Claire in his play *The Fatal Weakness* in the late 1940s. Kelly had been born into a Main Line Philadelphia family but made a career as an actor in vaudeville. (His niece Grace later became a star, and then royalty, in her own right.) His first compositions were vaudeville sketches he acted himself. "He knew exactly what would work," said Meacham. "Every instruction he gave—'you pick up the cigarette case in this hand, you open it on this word, you take out the cigarette on this, you close the case on this word, you put it down on this, you strike the match on this—seemingly fanatical, but not at all. If you did it any other way the laughs would not come accurately."

Tallulah, too, trusted him implicitly. "No one had the same influence over Tallulah," said Cole. "It was the way he went about it, his attitude. He never raised his voice, never lost his temper. He was more like a priest in the theater."

Estelle Winwood was cast as Muriel Flood's colleague and confidante, Stella Sloane, whose acerbity is perhaps a mouthpiece for Kelly's own sentiments. She dismisses Muriel Flood's evocations of idyllic domesticity as a theatrical pose less truthful than her onstage acting: "As soon as you begin drawing that armchair up to the fire—the sequins come out."

Winwood was a delicious comedienne and she undoubtedly played Miss Sloane brilliantly. But Tallulah wanted Winwood in *Reflected Glory* above all because she found her a calming influence and she was agitated about her return to the stage. Playing second fiddle to Tallulah was an onus that Winwood took great pains to avoid. It cannot have entirely pleased her that the unfledged Southern girl she'd befriended was now the more famous star.

"Winwood was a fine actress," Ann Andrews said, "but she missed hers because she was oversexed. She was always living with somebody or marrying somebody instead of keeping her vitality for the theater." During the 1920s, Winwood had renounced her Broadway stardom to marry and retire to New Zealand, where she lived happily on a remote ranch. When her husband died suddenly after several years, she immediately booked passage back to the U.S. His family had opposed the marriage and so Winwood did not wait to press any claims against his estate. But on her return, she was seen by Broadway producers as a character actress. Only on tour or with regional theaters did she again play star roles.

Winwood's last husband, Robert Henderson, who knew her from the mid-1930s, described her attitude toward Tallulah as "always from the teacher to the student." Winwood was nineteen years older, for one, and her relations with Tallulah hinged on the unquestioned assumption that Winwood was a better and more versatile actress. Stephan Cole was very deferential toward Winwood, who was thirty years his senior. Though she could be caustic, he described her as unfailingly polite and soft-spoken—in his words "a gentlewoman."

Asked about Winwood's range in character parts, Cole said, "She played a Gullah Negress!" as if the issue were settled by Winwood's casting as a resident of the sea islands off the South Carolina coast in 1930's *Scarlet Sister Mary*. Tallulah, on the other hand, was more skeptical about the limits of Winwood's versatility—as evidenced by exactly that Gullah impersonation. In her 1966 interview with Richard Lamparski, she brought up that very play, in which Winwood had supported Ethel Barrymore on Broadway. "They couldn't have been more miscast," Tallulah said about Barrymore and Winwood. Gullahs speak a unique patois, "almost like a foreign language," Tallulah noted, and Winwood "playing with a Southern accent" seemed to her preposterous. "I didn't see it, but George Cukor said it was the biggest camp he'd ever seen." Yet Tallulah trusted Winwood's professional judgment and would accept criticism from her. "Tell me the truth, Estelle," Tallulah would implore, "how was I?"

Tallulah decided that *Reflected Glory*'s out-of-town tryouts would be as far out of town as San Francisco, her favorite city in America. Much of the production was put together on the West Coast. Howard Greer, who had been Paramount's principal costume designer, designed Tallulah's costumes; the screen's Phillip Reed played the would-be bigamist who almost ensnares Muriel Flood.

The San Francisco opening on July 20, 1936, turned out to be one of the great nights of Tallulah's career, earning her sixteen curtain calls. From there they moved to Los Angeles, where Tallulah's August 10 opening was again triumphant, a vindication of the frustrating time she'd had in Hollywood four years earlier. "*Reflected Glory* made Hollywood take another look at her," Cole recalled. Edwin Schallert wrote in the *Los Angeles Times* that "She is the most interesting actress seen here in the footlight world in ages."

Among the motion picture elite present at her Los Angeles opening was David O. Selznick. The day after the opening, George Cukor called Tallulah. Cukor was then slated to direct *Gone with the Wind*, although he was later replaced by Victor Fleming. "I've got our Scarlett," Selznick had told Cukor. As it turned out, Tallulah had read the book while in San Francisco and had already decided that she would make the perfect Scarlett. She believed that her age was her only drawback, since Scarlett is a teenager in the opening scenes and Tallulah was now thirty-four. "But through dieting, self-denial and discipline, I was sure I could come up to the pictorial mark," she writes in *Tallulah*.

Jock Whitney was Selznick's principal backer, but despite the fact that he and Tallulah were still involved, he did not interfere in Selznick's artistic decisions. Aunt Marie, however, went to work organizing a letter-writing campaign to ensure that Tallulah was given the role. "Most of the letters that came in were for Tallulah," Selznick's assistant Marcella Rabwin recalled in 1994.

On *Reflected Glory*'s opening night in Los Angeles, Tallulah had gone with a great flourish to the wings and brought Winwood out to take a special call together with her. The audience cheered. Henderson later said to Winwood, "Wasn't that nice of Tallulah to bring you out for a call?" Estelle said, "I could have walked out myself."

Winwood grew increasingly resentful. She felt Tallulah encroaching on their tacit agreement about who was mentor and who was apprentice. Winwood found Tallulah's acting suggestions—"Don't come in so quickly there"—offensive, and felt that only Kelly had the right to direct her. She let all concerned know that she was handing in her notice, and stayed firm

about her departure although Tallulah tried everything she could to persuade her to stay. Winwood told Cole that she "would rather remain friends with Tallulah than work with her."

Replacing Winwood was another friend of Tallulah's, Ann Andrews. Andrews played the role all through the New York run and during a subsequent tour. But Tallulah was affronted on Kelly's behalf when Andrews arrived at her first rehearsal and announced that she'd done some pruning of excess verbiage in her part.

Reflected Glory played for several days in New Haven before opening on Broadway at the Morosco on September 21. The critics found the play trite, although as Tallulah says, "Had it been written by a lesser playwright, I think they would have cheered it." It suffered comparison with Kelly's best work. Her reviews were generally very good, although as usual some critics carped that she was again playing a role too close to her persona to be challenging. Arthur Pollock of the *Brooklyn Daily Eagle* noticed a vast improvement since her last Broadway appearance in *Something Gay*. "Miss Bankhead has converted all her recklessness, all her careless, scattered talents, all her undeveloped aptitudes into something that appears very simple, something that has an uncommon naturalness and a high polish. This is the play she needed."

Reflected Glory was "a hurdle race," she told Michael Mok of the *New York Post*. "Can't get my breath except for eight minutes, when I lie down, panting like a little old lady." She was onstage almost continuously during all three acts. The role ran the gamut of emotion, containing vignettes of every description, including extended pantomime alone, in which Tallulah put on airs as she contemplated her own greatness, or reenacted an encounter, reprising it into a theatrical exercise.

But it was not so much the physical exertion that made Cole describe Muriel Flood as the most exacting role he saw Tallulah play. Rather it was Kelly's insistence that she give the same performance every night. He stood in the wings at each performance. If she changed any movement or timing, he would speak to her and she would accept his corrections. According to Cole, Tallulah "learned more about consistency from him than from anyone else."

She wasn't going out a lot and was on the wagon during the ten months that she was involved with *Reflected Glory*. Perhaps *Gone with the Wind* was her motivation, but perhaps she was alarmed at the steady increase in her own drinking. As so often was the case with Tallulah, concern

about her appearance may have been paramount. She told a reporter that she'd run into an old friend whose looks had so radically improved since he'd gone on the wagon that she was inspired. Perhaps sobriety brought the self-reflection that alcohol dampened. "I had everything I wanted in London for years," she told a reporter. "All the parties, all the smartness. Maybe too much. But I wanted it so much when I was a little girl." She took up the quiet pleasures of needlepoint, which she later told Will by mail that she found "fascinating and restful."

Reflected Glory was looking as though it would have a good run, but Tallulah's financial situation was anything but secure. The money she'd saved from Hollywood was almost gone. She was being dunned by the IRS for over $3,000 in arrears on the tax bill she had begun to pay off in 1932. She wrote Will that she had "many excellent movie offers, but as you have probably heard I may do 'Gone With The Wind.' . . . When I start filming again I want to take all Sister's responsibility over again. But I am not ready yet darling. However I will send her something from time to time."

Where *Gone with the Wind* was concerned, Tallulah was jumping the gun because it wasn't until a month later, over the Christmas holiday, that she flew to Los Angeles for two days to make tests for the film. The morning of her arrival, Louella Parsons in her nationally syndicated column issued an irate thumbs-down on Tallulah, but predicted that, because her friends Cukor and Whitney were involved, a fix was in and Tallulah would bag the coveted role.

Parsons's sourness may have had something to do with an interview Tallulah had given her the previous August in her suite at the Biltmore Hotel in Los Angeles. Dorothy Manners worked for Parsons for thirty years, beginning in 1935. Manners went along to the interview, where Tallulah greeted them cordially, but seemed preoccupied with a pet bird the size of a large canary. Parsons would ask Tallulah questions and Tallulah's response was to consult the bird in its cage. "Did you hear that? She wants me to tell her about my love life?" After waiting for the bird—"it seemed like a lifetime companion"—to chirp a response, Tallulah would turn back to Parsons and reply.

"Louella was amused by the bird," Manners recalled in 1994, "but she thought Tallulah was a little wispy-poo." Manners herself wasn't always sure whether Tallulah was talking to the bird or to Parsons, and asked herself whether Tallulah was slightly disturbed or slightly drunk. Once again, Tallulah's uncontrollable need to shock came at the cost of her re-

lations to the world. "Louella did admire her as an actress," Manners said, "but I think that interview sort of got Louella off Tallulah for almost any role!"

Tallulah looks ravishing in the surviving test footage for *Gone with the Wind,* but the camera's cold scrutiny revealed what Selznick wouldn't have seen from his seat at the Belasco the previous August. "The tests are very promising indeed," Selznick wrote Tallulah. "Am still worried about the first part of the story, and frankly if I had to give you an answer now it would be no, but if we can leave it open I can say to you very honestly that I think there is a strong possibility."

As Tallulah waited for more news of the role, attendance for *Reflected Glory* began to flag, and a tour was arranged. They opened in mid-January in Boston, where Mordaunt Hall in the *Boston Transcript* saluted the precision of her performance. "There is never a line that comes too soon or too late, or a pause that does not suit the situation. Her silence is eloquent in some passages and rapidly as she at times delivers her lines, her every word is distinct."

Will had become Speaker of the House in June 1936, after the death of Speaker Joseph S. Byrns. On the night of *Reflected Glory*'s Washington opening, February 9, 1937, he left a late House session to get to the theater in time. Before the performance he visited Tallulah and gave her a rabbit's-foot good-luck charm. She cherished it all her life, and it was eventually buried with her. Will signed a $950 million relief-deficiency bill in his theater box before the curtain rose.

"I hate to step out of character," Tallulah said as she began her curtain speech. "It's disillusioning, I know. But you have been so very gracious. I imagine you all understand"—she gestured to her father's box—"that I've been terribly nervous. . . ." She tossed a kiss to Will, who removed his spectacles and brushed away a tear. "Parental restraint prevents my gushing," he said later, "but I think she did it very artistically."

Will must have wished Adelaide could have been present that night, and Tallulah must have thought of her as well. Ann Andrews recalled the billfold with pictures of her mother that Tallulah kept on her dressing-room table. "Tallulah had this funny feeling that she had to protect her mother, that her mother was younger than she—that that was a young beautiful child over there."

In Washington, a former druggist from Huntsville found his way backstage and cried as he told Tallulah, "I'll never forget the night you were

born. I kept open all night for your mother, but it didn't help." Another former neighbor of Will and Adelaide's scrutinized Tallulah carefully, then concluded, "Well, you're beautiful all right. But you're not a patch on your mother." Tallulah kissed him.

On February 10, the *Washington Post*'s editorial page contained a tribute that must have greatly pleased both Tallulah and Will, highlighting as it did the most satisfying part of their relationship:

> Those who witnessed Speaker Bankhead's very legitimate pride in his daughter's acting . . . must have derived from that little drama of human nature as much pure enjoyment as from the play itself. Probably there is no relationship more ideal, and therefore more pleasurable, than that which exists between a father and daughter whose respective talents, while widely different, each is able to appreciate and respect. And in the case of Representative Bankhead and Tallulah there is no need for any reservation in the honors due and reciprocally accorded.

Reflected Glory was scheduled to tour the South, and its scheduled appearance in Alabama had left the Bankheads aquiver with excitement. On February 27, however, Tallulah wrote Will from the Netherland-Plaza in Cincinnati to tell him that her plans had changed. After a week in Detroit, then a split week in Indianapolis and Columbus, they were headed not for the South but to Chicago, which was the one city outside New York where Broadway shows might settle into an indefinite run. There were only two major legitimate theaters in Chicago and it was the only time that one would be available.

Tallulah let Will know that what was best for her career was at least as important to her as what would please the Bankheads. "In a way I'm disappointed about the southern tour being postponed but after all Chicago is the most important theatre town in the country next to New York and it's wise to get in there before the hot weather sets in." Nevertheless, she assumed that there would be a visit to the South in due time. Will, however, was anxious, writing to Marie on March 4: "I somehow very deeply fear that this will mean that she will not be able to make the southern tour at all and if it develops that way it will be a most grievous disappointment personally and I know to you and all of our relatives and warm friends in Alabama."

On April 1, Eugenia wrote from Italy, where she was slowly recuperating from an almost fatal bout of pneumonia. She thanked Tallulah for a shipment of books that included *Gone with the Wind.* "There is only one person to play Scarlett in America. Who but you were born and bred in that briar patch? Is it to be done in the films. Make them let you do it. I shall pray you get the part, cable me the minute it is settled." Ten days later, Will wrote Tallulah that a few nights earlier he had tuned in to a radio interview with Cukor. "Just as he was asked about Tallulah Bankhead the radio failed on me. I was so disappointed I wanted to shoot a hole through it."

Very Scarlett-like was a letter she wrote to Will from Detroit on March 6, 1937, concerning her acquaintance with a Mrs. Pinckney Bankhead, matriarch of a black Bankhead clan that had migrated from the South. Mrs. Bankhead had visited Tallulah backstage and invited her to her home, where she was served a Southern tea with fried chicken, biscuits, cakes, and ice cream. Present as well were a Barbara Bankhead and her son John Quincy Bankhead, who was several years older than Tallulah and remembered piloting her in a wheelbarrow back in Jasper. "The whole thing was very touching, simple and real," Tallulah wrote to Will, making an explicit link to Margaret Mitchell's steadfast restoration of Southern mythology. It was like "something out of Gone With The Wind . . . it didn't seem like the Civil War had been fought at all. . . ."

Tallulah also broached the subject of a widespread though officially taboo phenomenon of the Old South: miscegenation between white masters and black slaves or servants. Both Barbara Bankhead and her son John looked "more like Indians than colored," Tallulah appraised, and one of the Detroit relatives had told Tallulah, "All of the Bankhead men, both colored and white, were always tall."

Perhaps Tallulah was giving Will a little nudge, reminding him that she was privy to family skeletons; miscegenation and illegitimacy were not going to be overlooked by her. She also reminded him that it was this same Barbara Bankhead who had tended the infant Eugenia and Tallulah when another nurse was hitting the bottle. Yet at the same time she was reassuring: the black branch of the family tree professed undying loyalty to their white relatives. "They said the Bankheads were always good to their people and they told many humorous stories about how the Bankheads were always getting them out of trouble." Mrs. Pinckney Bankhead treasured a letter that Will had sent her. Nor did the Detroit Bankheads display any

desire to rise above their station. Tallulah wrote that "I thought you'd like to hear about it because they were really old fashioned respectful Negroes, religious, proud and dignified."

On April 12, Will's sixty-third birthday, he wrote thanking Tallulah for the birthday telegram she had sent. "You know of course how it touched me. . . . I thank God that I have been spared this long, and that my health is still excellent and that I am able to carry on." His health was not excellent, but he had had no heart incident in two years. He was enclosing a "gracious and interesting" letter sent him by a Mrs. Miles Ambercrombie, a Huntsville native who had been one of Adelaide's bridesmaids thirty-seven years earlier. She now lived in Greensboro, North Carolina. He had told Mrs. Ambercrombie that Tallulah would be performing in North Carolina despite not being sure whether this would happen. "I want you without fail to have Edie acknowledge this letter at once, and tell Mrs. Ambercrombie what she may expect from you."

The ever-vigilant George Kelly was along on the tour. After many of the performances, he, Cole, and Tallulah went back to Tallulah's suite and talked. Tallulah gladly ceded him the floor. Kelly was a man of great intellectual curiosity—a riveting raconteur whose vaudeville training enabled him to reenact any situation with élan. Despite her professional and personal infatuation, however, their intimacy stopped short of anything romantic: Kelly was gay. But his brother John was not. Tallulah happened to meet John Kelly in the elevator of her hotel, which led to an assignation in her suite. Only later did Tallulah learn who he really was, and once she did, she turned the situation to her humorous advantage. The tryst with John Kelly, she told Ann Andrews, was done "to *spite* George!"

Chicago had its fill of *Reflected Glory* after several weeks, which was nonetheless a perfectly respectable run in that city. *Reflected Glory* reached Birmingham, Alabama, at the beginning of May. From the Hotel Mayfair in St. Louis, Edie had written Marie on April 13 conveying Tallulah's message of welcome and wariness. "She is looking forward to seeing you all and would like you to wire immediately the number of seats you will require for the opening night. If possible, they should be restricted to members of the family only, as she is on a percentage and has to pay for each ticket. Naturally she doesn't want anyone left out, so she is leaving the tickets to your discretion." Edie added a little catnip for Marie: "If she gets the part of Scarlett O'Hara she is going to take you to California to help her with her Southern accent."

In Birmingham, an after-theater party was thrown for Tallulah by social doyenne Mrs. Melville Davis. The next day in Montgomery, two hundred of the city's social cream of the crop met Tallulah at a garden party given by a friend of Will's, Mrs. William Calvert Oates. The next day Will drove Tallulah to Wetumpka to see the small church where his parents had been married seventy years earlier. Soon after, Tallulah returned to New York with one thought uppermost in her mind: it was now time that she, too, finally marry.

Getting Married

"I've found that the longer you take a man seriously the more your independence is threatened."

One evening during the early 1940s, Tallulah, Ann Andrews, and Guthrie McClintic were sitting around her suite at the Élysée Hotel. They began talking about Tallulah's love life, and she started counting up her affairs, retrieving name after name, numbering among her partners some as unlikely as Cecil Beaton. Most of these relations were, in Andrews's telling, "quickies," and by her count, Tallulah's scorecard ultimately reached 185, before her doorbell rang, more guests arrived, and the tally came to a halt.

It is hardly wise to try to neatly parse anyone's sexuality, but libido may have been among the least pressing urges behind Tallulah's constant pursuit of sex. Sex satisfied her raging need for attention and reassurance. It was an attempt to solace an overwhelming loneliness that never left Tallulah and sometimes threatened to engulf her. When she felt lonely, Cole knew her to walk up and down for hours, chewing the inside of her mouth, not talking.

Yet Tallulah felt that emotional passion was dangerous. "I've found that the longer you take a man seriously the more your independence is threatened," she told a reporter in the fall of 1936. "It would be hard to give up

something I have regulated." But Tallulah's obsessive sexual adventures could prove as debilitating as the most fatal passion, as she had found out in 1933.

Tallulah had toyed with marriage most of her adult life, alternatively seeking it out with a certain ferocity and shunning it in favor of an active career and sex life. Marriage would have pleased her family and particularly her father. By 1937, marriage would also have given her public reputation some needed scouring. Although as a young woman, Tallulah had done everything she could to broadcast her bisexuality, she knew by now that if it became too widely known and accepted as fact, her career could be jeopardized. Acceptance among the sophisticates who condoned unconventional behavior did not mean any degree of public ratification, and performers were slaves to their public's favor. During the late 1920s, Ethel Barrymore and her two children had stayed for a week with Tallulah at 1 Farm Street. In 1930, when Estelle Winwood and Barrymore shared the stage in *Scarlet Sister Mary* on Broadway, Winwood told Barrymore that Tallulah would soon be returning to the U.S. "I don't know her," Barrymore told Winwood. "I nearly dropped dead," Winwood recalled. "She was so frightened that if people thought that she was a friend of Tallulah they'd call her a lesbian."

Richard Schanke's biography of Eva Le Gallienne claims that Le Gallienne's career suffered considerably because she did not make any attempt to hide her homosexuality. As far as their acceptance of sexual mores went, most producers, directors, and critics were conventional men of their time. Columnist Walter Winchell, for one, was a rabid homophobe. "Less-bian said about them, the better" he once referred to Tallulah and another star in his column. "She never said a word, never answered him," Cole remembered, "because you could have a fight and he could get very vicious. But the next time we were in the Stork Club, she flirted with him, took him home and put him to bed." Winchell, married and publicly sanctimonious, never dared cross her again after their one-night affair.

Tallulah's willingness to use her own sexuality to quash rumors about that very sexuality somehow seems of a piece with her ability as an actress to objectify and utilize every aspect of her allure. Onstage, there was no part of Tallulah that she would not expose if she felt the audience would react positively, even if it meant censure for "playing herself." Offstage, nothing about Tallulah's physical intimacies was sacred. What she would share only fitfully was emotional honesty.

Immediately after the *Reflected Glory* tour finished, Tallulah went to

London for a short holiday, seemingly determined to make one last attempt to persuade Alington to marry her. His young wife had died suddenly of pneumonia a year earlier, and although the marriage had produced a daughter, now eight, according to David Herbert, Alington and his wife were estranged when she died.

In his *Diaries*, Cecil Beaton described a Tallulah "Walpurgisnacht" during this visit in May 1937. At a small private party, "Tallulah danced frenziedly, throwing herself about in a mad apache dance with Napier Alington. After he left, she wept and bemoaned the fact that he had never married her," but then changed course and in front of the guests "threw off all her clothes, performing what she called 'Chinese classical dances.'"

In London, Joan Matheson, Tallulah's former West End colleague, received a call from Tallulah's ex-employee Mrs. Locke. "Come and see Tallu; she's miserable." Tallulah was staying at the Green Park Hotel. "I went and she *was*," Matheson recalled, something of a note of disbelief in her voice, because she had never seen this side of Tallulah before. Nevertheless, Tallulah received her very cordially. Now that Matheson was a big girl of twenty-seven, Tallulah even offered her a drink, which she had declared taboo when they had acted together seven years earlier. Tallulah herself was by now no longer on the wagon.

Deciding that Alington was a lost cause, Tallulah returned to New York, and to the fact that her runner-up choice, Jock Whitney, was also unavailable. Whitney was by now principally involved with British film star Madeleine Carroll. Whitney's kiss-off to Tallulah was a home he rented for the summer of 1937 on Langdon Island, located in the Long Island Sound off the Connecticut shore. It seems that Tallulah was perfectly willing to be just a bit of a kept woman. Had she not, she would not have been able to enjoy such a cushy vacation in a rambling home on this private island. Despite full employment over the past year, she had been able to do no more than pay her expenses and address her arrears.

On Langdon Island, Tallulah could prepare for her next major undertaking: at the end of May, she had accepted the offer of producer Rowland Stebbins to star that fall on Broadway in Shakespeare's *Antony and Cleopatra*. She had presumably heard good things about Stebbins from George Kelly, as Stebbins had produced two of his plays.

Tallulah told Whitney that on Langdon Island she had to have a little car with which to go shopping or to send the servants into Norwalk. Whitney sent along nothing more than a Ford, and "ohhh, that made her angry!" Cole remembered. At the end of the summer she presented it to the servants.

She loved the country and was genuinely proud of her rural roots, even as she sometimes exploited them for publicity purposes. Her curtain speech at the Temple Theater in Birmingham the previous May had been an effusion of populist sentiment. She claimed that "No matter where I've been—in New York, London or Hollywood, in every letter [my father] writes he tells me to remember that I am just an Alabama hillbilly—just one of the Bankheads who owe a debt to the State we can never repay." Will, however, never in any surviving letter to Tallulah said anything remotely like that. Although they enjoyed rustic retreats, the Bankheads cherished their professional status as lawyers and doctors. Years later, Tallulah made a reference in print to her "country cousins." "That did not go over well," Kay Crow, the wife of Tallulah's cousin, recalled. "It was not appreciated."

On Langdon Island, in a controlled and loving environment consisting primarily of Smith and Cole, Tallulah blossomed "into the healthiest thing you've ever seen," Cole recalled. She swam regularly, played badminton well and table tennis very well. "In spite of all the terrible things she could do, there were weeks and months when Tallulah was nothing but fun," Cole said. "She was more fun than anyone I've ever known." She was good company and a good sport. But Cole recalled that if too many guests were present, she would slip easily into her reflexive habit of making a group of people into an audience.

On July 6, she wired George Cukor in Hollywood:

DARLING DARLING GEORGE I HAVE BEEN WANTING TO WIRE YOU MANY TIMES AND TELL YOU ABOUT MY VERY WISE AND LOVELY SUMMER I HAVE A DELIGHTFUL HOUSE ON THE SOUND COMPLETELY ISOLATED BY TREES AND A DIVINE SWIMMING POOL AND AM HAVING THE ONLY SENSIBLE HOLIDAY OF MY LIFE I KNOW THIS WILL PLEASE MY VARY [sic] VARY GOOD FRAND [sic] GEORGE I WISH YOU WERE HERE. . . .

Tallulah included her address, as well as her phone number, "in case you should have an overwhelming urge to hear my voice." Whitney showed no such urge. He was supposed to appear on Langdon Island but he never did. Toward the end of July, however, Tallulah found a man she could believe was the mate for whom she'd been searching. She went to see a play based on Dorothy Sayers's comic whodunit *Busman's Honeymoon* at the Westport Country Playhouse. Actor John Emery walked onstage as de-

tective hero Lord Peter Wimsey, and Tallulah declared herself infatuated. Two years younger than Tallulah, Emery was very handsome in a somewhat cardboard, profile-dominated style. He was descended from a distinguished theatrical family. Tallulah had met him backstage in Los Angeles a year earlier, when she was trying out *Reflected Glory* and he was acting in Katharine Cornell's revival of *Saint Joan*.

After the Westport performance, Tallulah invited him to come visit her on Langdon Island, and after the week's run of his play he continued to stay. "I found him intelligent, amusing and exceptionally good-looking," she writes in *Tallulah*. He was also destined to be a lifelong pawn in the designs of dominating and glamorous women. It was not long before Tallulah told Stephan Cole and Edie Smith that she and Emery would soon be traveling to Jasper to be married.

Cole imagined that Tallulah told herself that she and Emery could somehow make the marriage become what she wanted it to be. But he thought that at least some part of her knew that it was all a mistake even before they married—a mistake born of expediency and fury at the rejections she'd experienced.

Originally she planned to marry in Washington at Christmas, then Tallulah decided that she didn't like "long engagements." *Long* at this point meant anything more than the month that she and Emery had been lovers. They decided instead to marry at the end of August. After her rejections by Alington and Whitney, Tallulah was determined that there would be no recalcitrance on the part of her intended. Even a brief separation seemed to make her anxious. One day Cole and Emery were planning to drive into Norwalk to buy outdoor things, badminton nets and the like, with which to surprise her. She came running out of the house, crying, "Take me! Take me!" They were not going to take her to buy her own surprise gifts, however. In the car, Emery asked Cole, "I wonder if she'll be mad when we get back?" "She won't be speaking to us," Cole predicted, "and she'll be in bed," which is where Tallulah retreated when she felt completely defeated. "And there she was, pouting," Cole recalled. "But we spread everything we bought around the bed and that got her right up again."

"John felt he was in love with Tallulah," said Cole. "She was certainly the most novel thing he'd ever seen." On another occasion, Cole clarified that Emery "felt he ought to be" in love with her, by virtue of the wag-the-dog reasoning that he had, after all, married her. During yet another discussion, Cole hinted that a dash of professional opportunism had motivated Emery, who had been dating Rosalind Russell. If so, however, his

plans surely backfired, since after he married Tallulah, Russell reportedly tried to put the kibosh on any Hollywood interest in him.

Tallulah's frequent attraction to men who served as father figures accommodated her need to test the boundaries of authority. Emery was physically overpowering, a foot taller than she and, although reticent and seemingly mild-mannered, perfectly capable of rising to her bait. According to Ann Andrews, one night an argument arose between them, Tallulah getting the better of it until Emery bounced her to the ground. Edie Smith told Andrews, "The minute I heard he'd knocked her down, I knew it was all over; she was going to marry him." He later slapped her at the Stork Club, which Cole said she was furious about only because it was a public arena. Orson Welles recalled to author Denis Brian that "Emery kept belting Tallulah and she loved it. He could be pretty rough." For his part, Emery told *Time* magazine a decade later that Tallulah had once struck him in the eye in a rage.

For Tallulah, one of the most attractive prospects of the marriage was that she and Emery could replicate the success of husband-and-wife stars Alfred Lunt and Lynn Fontanne. She determined that Emery would join her in *Antony and Cleopatra.* At thirty-two, he was on the young side for Cleopatra's love interest Antony, and so would instead play Cleopatra's "love-menace," Octavius Caesar.

A tenet of nineteenth-century middle-class American culture was that the Bible and the plays of Shakespeare represented the world's peak of literature. Will Bankhead shared that commonplace belief and passed it along to Tallulah as she was growing up. During the late 1920s, a rumor had circulated in London that Tallulah was thinking of playing Ophelia. She confirmed the rumor to a reporter and solicited his advice with a quip: "And who would you suggest for the role of the First Gold Digger?" But Ophelia, Tallulah later insisted, was "a lousy part"—in her eyes, a pawn manipulated by Polonius, Laertes, Hamlet, and Gertrude in turn.

While Shakespeare had been in something of an eclipse during the 1920s, he was fast becoming fashionable all over again during the 1930s. On Broadway, Katharine Cornell had played Juliet in 1935 to acclaim. In 1936, Leslie Howard and John Gielgud had challenged each other as Hamlet, playing the role concurrently in two different Broadway productions.

On August 30, Tallulah played Viola in an all-star radio broadcast of *Twelfth Night.* In the surviving air check, we hear her apply a Noël Coward

Tallulah with her husband John Emery on their honeymoon.

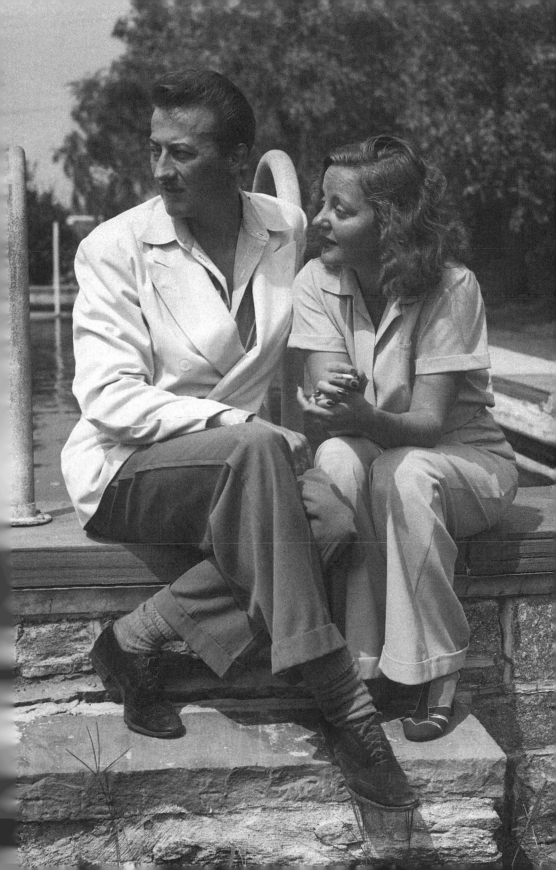

gloss to her readings, as she brilliantly overlays one stylization on top of another: contemporary drawing room repartee over the elaborately metaphoric rhetoric of Elizabethan verse. It is hard to imagine any actress answering Olivia's "I prithee tell me what thou think'st of me" with a "That you do think you are not what you are" of equal brio and insinuation. Viola's response to Olivia's asking "Why, what would you?," which begins with "Make me a willow cabin" and concludes eight lines later, is tossed off with impeccable breath control that allows her a comfortable pause before the final "and cry out Olivia!" There is a swelling gallantry to the way she reads "It gives a very echo to the seat/where Love is throned" in response to Orsini's "How does thou like this tune?" And in the private reflections, such as "A little thing would make me tell them how much I lack of a man," she exhibits a disarming earnestness. The entire cast is superb: Cedric Hardwicke as Malvolio, Helen Menken as Olivia, Winwood as Maria, and Orson Welles as Orsini. They each approach Shakespeare somewhat differently, which does not make for incoherence but for richness.

The next day, Tallulah, Emery, Cole, and Smith took off for Alabama. Louisa Carpenter, a du Pont heiress and crack aviatrix, loaned Tallulah her private plane and her champion Danish pilot. The plane experienced some trouble and they were forced to touch down en route for repairs. Tallulah and Emery got their hands on champagne and brandy and proceeded to get drunk, Tallulah rather more so than Emery. Forty-five years later, Cole retrieved a blurry snapshot he'd taken that captured Tallulah rolling around the airstrip in a pair of silk lounging pajamas. Tallulah could have been experiencing some panic. Committing that much of herself to any man would have been terrifying, and she would have been a far less intelligent woman not to have realized that after her many affairs with prominent and powerful men, Emery was definitely a comedown.

Her hands ranged freely over Emery as they resumed their flight south. Cole and Smith were squeamish and fretted about how Tallulah could possibly sober up in time for their arrival in Birmingham. Yet Tallulah somehow managed to pull herself together before they descended into a sea of reporters. They changed clothes at Birmingham's Tutweiler Hotel and then drove on to Jasper forty-five miles away. Tallulah's arrival had been trumpeted on radio and the local papers, and several thousand Alabamians had motored to Jasper to greet her.

The wedding took place at Sunset, the Bankheads' home in Jasper. During a talk with the family, a question came up about Emery's blood test, which was at that time mandatory to secure the wedding license. "Oh,

there's nothing to worry about," Will let out heartily, "John's been exam-ined on the way down!" Will was joking, but nevertheless "Daddy knew he *had* been," as it were, examined, already, by Tallulah, Cole said. He did not believe that Will was at all shocked by it. "He was a pretty racy guy him-self." Indeed, Jean Dalrymple said that Will had pursued her throughout the opening-night party following the Washington premiere of *Forsaking All Others* in 1933. In the face of Dalrymple's apathy, Tallulah had urged her, "Oh, Jean, why don't you give him a little feel?"

And this paradox in Will between gentlemanly decorum and raunchi-ness made it difficult for him to condemn Tallulah or her sister's adult be-havior, even though it seemed a direct refutation of the ideal of feminine behavior in which he had consciously tried to school them. According to Tallulah, Will never swore, and yet she did constantly. "His notion of an epithet was jackass," she writes in *Tallulah*. "'Never take the name of the Lord in vain,' he would say when I would rip out a goddam. I might reply, 'I'm sorry, Daddy, but goddam it'—Then he'd laugh."

Perhaps he was able to see the role he had played in molding his daughters, and perhaps he enjoyed Tallulah's irreverence. Tallulah herself knew that however much Will believed in his tenets of propriety, behind his facade there were other less refined strains. She had known it on some level as early as the age of five, when he had applauded her risqué imper-sonations. Perhaps it was the desire to appease or please these covert facets of his personality out of which Tallulah's outrageous bawdiness was born. She had found a way to connect with this secret side of him, to establish an emotional lifeline. His sometime disapproval was nonetheless an active re-sponse, and it was leavened by his own amusement at her antics.

Others among the Bankheads may have been less forgiving. "I think the family was always sort of embarrassed by Tallulah," said a neighbor who had moved to Jasper during the Depression. "She turned a lot of peo-ple off," said Barbara Bankhead Oliver, the daughter of Will's brother John's son Walter Will. "They just didn't approve of her too much." John Bankhead and his wife, Musa, "were very good" to both Eugenia and Tallu-lah, but their son, Barbara's father, "didn't much like her. He was pretty strait-laced about most things," recalled Charlotte Taggart, a Jasper resi-dent who worked for a time as his secretary.

Will and Tallulah together were "formidable," recalled Dr. Charles Crow, the son of Tallulah's cousin Marion, John Bankhead's daughter. "They were both gorgeous to look at and very effusive in their language and talked beautifully. It was fascinating to listen to them." Oliver and

Crow had once watched Tallulah and her father enliven the twilight with Shakespearean duets on the porch at Sunset. This younger generation accepted the eccentricities that may have disturbed Tallulah's contemporaries and elders. "Of course she didn't do all these wild and crazy things *here*," said Oliver; nonetheless, Tallulah's habits remained her own. During one of Tallulah's visits to Jasper, Oliver wandered into Sunset to hear her relatives asking where Tallulah was. "She's out there in the sunken garden taking a sunbath." Oliver walked outside and found Tallulah lounging nude, and although she was quite shy, she stayed to talk to her and was glad she did; Tallulah was very friendly. Dr. Crow found her "absolutely delightful." He was in his late teens at the time; Tallulah's responses to his questions about the theater "exuded the attitude that everybody was full of bull and trying to compete and win and beat the hell out of everybody else."

Smith was bridesmaid; Cole was best man at the wedding ceremony. Will's brother John and his wife were present along with Will and Florence; Eugenia was still living in Europe. A judge conducted the ceremony after a local minister begged off because Emery's first marriage had ended in divorce. Will asked if he himself could then read through the traditional wedding service "as my mother would have liked it," Tallulah recalls in *Tallulah*. Marie could not leave Montgomery, promising instead to drive to Birmingham the next day to meet them. Marie had given Tallulah permission to present Emery with the wedding ring that Tallulah's grandmother had given Captain John.

After the ceremony, Will asked Tallulah to address a few words to the crowds clamoring outside their gates. Tallulah went upstairs to change, and when she came downstairs, she saw that on the front lawn Will and Emery had launched impromptu into a scene from *Julius Caesar*. Then Tallulah convened open house for the entire Bankhead clan. Cole said that she found these family gatherings overwhelming: "all the Bankheads in a room together talking at the top of their lungs at the same time."

Tallulah and her party spent the next day with Marie in Birmingham. At ten-thirty on the morning of September 2, with Louisa Carpenter's pilot at her side, Tallulah herself piloted the plane out of the Birmingham Municipal Airport. She claimed in an interview conducted in flight that she was sharing the flying duties. "You know he's a bit mad," Tallulah told the radio listeners about Emery, "as mad as I am—or he'd never have married me." Tallulah and Emery were going to honeymoon for two weeks on Langdon Island before starting rehearsals. They wanted to bring *Antony*

and *Cleopatra* south before they were "worn out by a long run," and then take it to London.

On September 7, Marie addressed her letter to "My Darling Children" and targeted her words of connubial advice to John:

> I want you to guide that tempest of energy and exuberance you have for a wife, with a steady hand. She is one of the great women of her day—you know this, and our pride in her is boundless. But don't mind spanking her when she needs it, and you take your own spanking when you need it, and that's the way to weather the storm we call life.

"Believe me please," Emery wrote Marie, "that I shall do all in my power to live up to what the ring and that moment must have meant to you, and does mean to me." He and Tallulah could not enjoy their swims anymore "as we constantly worry when the rings are not on our fingers. Tallulah has decided that she prefers the ring on my little finger where you placed it, so that settles that." He felt that "things are going very well except for the few odd moments which occur now and then when I am made the recipient of that Imperious Bankhead Glare. But I am learning not to flinch TOO much."

Cleopatra Pissed

"Well, there's *one* note of reality in your fucking play: Cleopatra pissed!"

By now, *Variety* was reporting that Tallulah had been chosen for Scarlett O'Hara, but Tallulah herself knew better. "I'm NOT going to play Scarlett," she told the *New York Post*'s Michael Mok by phone from the Tutweiler in Birmingham, "and I'm tired of hearing about it. I'm thinking only of Cleopatra. Of course, Scarlett is divine, but Cleopatra is much diviner, don't you think?" Tallulah did not take her rejection as lightly as her prattle would indicate: losing Scarlett O'Hara "broke her heart," Gladys Henson said.

"She could not have played Scarlett," insisted Marcella Rabwin, perhaps echoing the sentiments of her boss, David O. Selznick. "Can you imagine Tallulah Bankhead being that young and innocent?" Selznick instead offered Tallulah the small but significant role of Belle Watling. Tallulah refused to "consider the part she was right for," Rabwin claimed.

An entire year elapsed before Vivien Leigh began her successful campaign to win the role of Scarlett. Whether Scarlett is ever innocent is open to debate, but Leigh in her midtwenties was exactly the right age: it is always easier to age forward rather than back. Rabwin believed that choosing an Englishwoman salved the South's fury that a native daughter was

not chosen. A Northerner might have alienated that constituency altogether.

Tallulah threw herself into interpreting Cleopatra, intending to take the same approach she had tried with *Twelfth Night*. "There's never been a modern *Antony and Cleopatra*," she told Cole, for whom she found a job in the production as assistant stage manager. "I'm going to do it."

Modern to Tallulah meant a more conversational delivery than the melodic cadences of an actor like Maurice Evans, with whom actors used to hum backstage under their breath. Modern was Orson Welles's rethinking of Shakespeare at the tiny Mercury Theatre on West Forty-first Street. Tallulah advised her friends to see anything Welles did. When he revised the world's classics, there'd always be some staging concept, some novel interpretation that was superior to any other version you'd seen.

Modern meant a "natural" response to the booming declamatory style of much nineteenth-century acting (which nevertheless saw itself as the avatar of unprecedented realism). During their lives, both Winwood and Tallulah issued manifestos in favor of naturalness. "My forte has always been natural," Winwood said in 1982. "That's why, when I did Shakespeare, I played it like a human being, and not as Shakespeare." Excessive stylization, Tallulah implied, came at the cost of the emotional truth. "Personally, I believe you must be natural even when playing the classics," Tallulah would write in 1940. "I don't mean that you should neglect the rhythm and the beauty and certain technical points that are peculiar to them, but when you read the lines you should give the impression of believing what you say."

But one generation's natural is another's stylized, and there is also no reason that stylized and truthful must be mutually exclusive. Seen on film today, the acting of both Tallulah and the somewhat more understated Winwood seems stylized as well as convincing. It was really only after World War II that many such false dichotomies became orthodox. Tallulah's delivery in *Twelfth Night* comes as a stylish and stylized contrast to the dogged conversational vernacular to which so many contemporary American interpreters of Shakespeare subscribe.

"Tallulah was always on the ball," Cole said. "If she was playing a part that was historical, or thinking of playing one, she would go into it. God knows she did go into Cleopatra to the nth degree." Tallulah's research would have clarified the many ways in which the historical queen was a different woman from Shakespeare's heroine, and probably much less of a coquette. Tallulah may have found the essential unreality of Shakespeare's

portrayal jarring—a daughter of politics, she knew exactly what the parameters of power brokering were. But it's not until the fifth act of *Antony and Cleopatra* that the queen begins to behave with the the full and expected majesty of a monarch.

Cole also saw her reading some volume of Shakespeare interpretation. It wouldn't have been extraordinary for a Broadway star like Tallulah to also retain the services of a coach as she contemplated her first onstage foray into Shakespeare. Constance Collier had indeed offered to coach her as Cleopatra, but Tallulah declined. A quarter of a century past her Edwardian heyday, Collier was now a successful coach in addition to a supporting actress in films. In 1912, Collier had played Cleopatra opposite Herbert Tree at His Majesty's Theatre in London. Her stentorian oratorical deliveries were marvelously apt for the grandes dames she played in Hollywood, but it is hard to see anything in Collier's work that would have resonated with Tallulah's approach.

Ethel Barrymore also offered to coach her, and unlike Collier, Barrymore would not have charged. Tallulah must have seen her play Juliet on Broadway in 1922. Ethel's forays into Shakespeare had been much less successful than her brother John's, but nonetheless, as Cole said, "Ethel knew her Shakespeare." Tallulah turned Barrymore down, too, telling her as she told Cole that "I'm going to play it quite differently than anybody else has ever played it."

Doing Shakespeare her own way, Tallulah envisioned capitalizing on her strengths in comedy. Cleopatra "must have had a lively sense of humor," Tallulah told a reporter, "for she played pranks . . . in other days it was the noted tragediennes who played the role, and the humor in the play didn't get much of a chance usually. We hope to give it a full effect."

Producer Rowland Stebbins had hired Professor William Strunk of Cornell University to prepare the adaptation. Strunk had adapted *Romeo and Juliet* for Cukor's film the previous year, and he is perhaps best known as the coauthor with E. B. White of *The Elements of Style,* the perennially popular writing handbook. At the first rehearsal Tallulah listened intently to Professor Strunk as he explained the play scene by scene, sharing his professorial insights into the play's meanings. But in his attempts to revamp Shakespeare's sprawling epic, the professor seemed to have gone astray. When Stebbins approached Margaret Webster, perhaps the most celebrated director of Shakespeare on Broadway during the thirties and forties, about directing this *Cleopatra,* she had no trouble refusing. Webster considered Strunk's adaptation to be of "blood-curdling ineptitude." Cole

related with irony that Professor Strunk had adapted *Cleopatra* "so well" that he decided to cut the renowned passages in act 2, scene 2, in which Antony's equerry Enobarbus describes Cleopatra riding a barge "like a burnished throne" on her first visit to Antony. "And that is the *one* scene the public wants to see," Cole said. "If you have nothing else but the barge and the snake, that's it, they're happy."

Tallulah apparently approved of one editing decision by Strunk. Fabia Drake, Tallulah's colleague in the *The Creaking Chair* thirteen years earlier, was visiting from London. At the Gotham, Tallulah told Drake they were cutting Iras's and Charmian's deaths from Cleopatra's magnificent farewell scene, "Because, of course, darling, we only want one death in that scene!"

"Strunk was a nice man," said Cole, "but I think he got a little mixed up." In addition to being assistant stage manager, Cole had also been assigned a bit part numbering only a few lines, "and I was saying them in the wrong country," he recalled. "I shouldn't have been in Rome. I was very shy about it, originally, because here was this great professor from Cornell, but I didn't want to do it, because it made no sense." Tallulah had also recognized the disparity. Cole posed a disingenuous query about how she thought he should read that particular line and she fobbed him off with, "Don't get me mixed up with that!" Finally Cole pointed it out to the professor, who to Cole's immense relief decided to simply cut the lines out altogether.

Cole believed that Orson Welles would have been the perfect director for Tallulah. "She would have taken it from him, no matter what he wanted her to do," said Cole. "It would have been absolutely unique and it would have worked." Instead, Stebbins hired Reginald Bach, a Welshman in his late forties who had acted for years in the West End. On Broadway a year earlier he had gotten good notices for directing and acting in *Love on the Dole* with Wendy Hiller. He was mild and gentle, with just the right theatrical flair to incite speculation about which part of Cockneyland he might originally have hailed from.

Charles Bowden said that there was "never any communication" between Tallulah and Bach. Bowden was among the bit players who did not come in at the beginning of rehearsals, so he didn't know how the relationship began between the star and the director. But by the time Bowden arrived the second or third week, there was an impasse. "He couldn't cope with her at all. Tallulah was pretty stubborn by that time. I think she knew it wasn't going to work." Bach had better communication with the younger people, with a college background, who were spear carriers and

played bit parts, and with the older, mature character actors playing roles like Enobarbus.

Had Tallulah solicited Emery's help with her interpretation? *"Noooo,"* Cole replied, in line with his feeling that Emery was a lightweight. Nevertheless, on Broadway Emery had played Laertes in *Hamlet* with Gielgud, and Benvolio in *Romeo and Juliet* with Cornell. But in the onstage action of *Antony and Cleopatra,* Tallulah and Emery had little to do with each other: Octavius Caesar and Cleopatra are kept apart for most of the play.

Tallulah's Antony was Conway Tearle, a good leading man on stage and screen with a Barrymore-ish flourish; indeed in *Dinner at Eight* on Broadway his role was a parody of Barrymore. At sixty, however, Tearle was a rather desiccated leading man for thirty-five-year-old Tallulah. Charmian was played by veteran actress Fania Marinoff, wife of Carl Van Vechten, whom Tallulah had known for almost twenty years. "Tallulah adored Fania, that's why Fania was in the play," but Bowden was perplexed when Marinoff arrived for her first day of rehearsals sheathed in bracelets. "Tallulah was trying to speak and all you could hear was clatter-clatter-clatter-clatter."

"Take off those fucking bracelets," Tallulah finally enjoined. "I can't hear myself think!"

The production opened October 13, 1937, in Rochester, New York. The day before the opening, George L. David, drama critic of the *Rochester Democrat and Chronicle,* interviewed her. She told him that George Cukor was there; he had directed a distinguished summer stock company in Rochester during the twenties. "George told me Rochester was a very lucky town in which to open, and I certainly hope he's right." Perhaps that was why she had decided to begin there, for otherwise it would have been an odd choice, not having hosted the launching of a pre-Broadway tour in ten years. Cukor had just directed Norma Shearer and Leslie Howard in MGM's film adaptation of *Romeo and Juliet* in which Tearle had given a blustery performance as the Prince of Verona. British impresario Charles Cochran, who had helped Tallulah snare her role in *The Dancers,* was also in Rochester for the opening. Perhaps he was considering the production for London, as Tallulah and Emery had hoped.

The next day, George W. White in the *Rochester Times-Union* wrote that "Miss Bankhead grew in the role. From an uncertain beginning her portrayal swelled, scene by scene," but he found the ambivalence in the script defeating her. "Shakespeare's own inability quite to make up his mind just what he did think of Cleopatra was reflected in a wavering characterization. . . . The depth of Cleopatra's character, the sincerity of her love for

Antony were not conclusively stated in Miss Bankhead's portrayal." Shake-speare's text as emended by Strunk remained "a pretty sketchy and sprawl-ing thing," and White voiced his preference that Maxwell Anderson or Robert Sherwood fashion an entirely new drama or comedy in which Tal-lulah would star as Cleopatra. Both playwrights had frequently treated his-torical subjects.

George L. David was more enthusiastic. He wrote that "no living ac-tress whom the writer has seen in many years of theater-going" was more qualified than Tallulah to embody Cleopatra. "She was a wily seductive woman, languorous of mind and sinuous of movement on occasion. But this was only one side as Miss Bankhead portrayed her." It was with "marked fluency and delicacy in shading" that Tallulah had been able to limn all the varied facets of the queen.

Variety reported that Stebbins had reputedly invested "a golden mint in the production." But according to Bowden, Stebbins's office flew by the seat of its pants, for all the largesse they dispensed. "It was an amateur pro-duction," Bowden said. Engagements were still being booked as they began the tour, so that stage dimensions weren't known in advance. And it seems that Jo Mielziner, at thirty-six already one of the most esteemed Broadway designers, had gotten a little out of control in his designs. The production was so cluttered that they could never fit all the scenery into any theater on the itinerary. In Rochester they performed in the Masonic Auditorium, a gargantuan space that offered only a shallow stage, which wouldn't accom-modate more than two thirds of the scenery they'd brought. Reporting from their next stop in Buffalo, *Variety*'s "Burton." noted that Mielziner had been forced to improvise a stripped-down mise-en-scène that was nonetheless "highly credible chiefly because of its vivid costuming and brilliant lighting."

"Burton." had complained that he couldn't understand all Tallulah was saying and reported that it was Emery who "easily walks off with acting honors," He was of "regal appearance and reading with clarity and under-standing." This put him, the reviewer speculated, "in a tough spot person-ally and professionally."

The tour was originally announced as ten weeks, with the Broadway opening scheduled for December 27. In Buffalo it was clarified that "if business warranted," the show was going to swing through the South be-fore coming to New York. However, business was not very good. After re-ceiving more bad reviews in Pittsburgh, *Cleopatra*'s weeklong engagement there had reaped only $9,000 despite playing in the 2,100-seat Nixon.

Producer Stebbins decided to cut his losses by pushing up the Broadway opening to November 10 from December 27. Engagements in no less than nine Southern cities were now postponed until a prospective post-Broadway tour, which never did materialize.

The trouble with Tallulah's Cleopatra, Cole claimed, was that she was "so modern nobody recognized it. Tallulah could have gotten the rhythm of the lines and still given her own interpretation. She never absorbed the rhythms."

On tour she "was just doing her best to get in and out," Cole said. "Sometimes she'd rush through a scene so you couldn't understand a word." It was their first professional work together and he did not have enough influence to confront her. Cole did venture to suggest that, "There must be something wrong with the acoustics of the theater because so many people are complaining that they can't understand the actors; the words are all run together." She knew what he meant. The next night she tried harder but the improvement didn't last. "This will never work," she said to Cole.

But Tallulah believed she was carrying on for the sake of her marriage. "It's *disaster* for me," she told Bowden. "But it's so good for Ted [as Emery was called by intimates] that I'm going to stick with it." After the production's demise, Tallulah gave announcements to individual members of the press at the Stork Club, "Well, you know the only reason I brought it into town was because John got such good notices." Actually she was obligated by the terms of her contract to go the distance. Of course, as Stephan Cole said, "She could have gotten sick: 'Due to Miss Bankhead's illness . . . ' But that would have been cheating," he said.

What Cole never disclosed and what it was left to Bowden to relate was that medical as well as emotional and artistic problems had in fact assailed her throughout the production.

One night, Emery and Tallulah were coming from their dressing rooms to the stage. Emery was busy with something and lagged behind Tallulah, who was left to struggle with Cleopatra's jewel case. "Miss Bankhead, may I carry that for you?" Bowden asked, and then nearly fell on his sword at the tale of woe that came out of her mouth. "Oh, darling, would you? You know I really don't want to lift much. They've gotten in my cunt and taken everything out. Everything. *But*—there is some hope. They've left a little bit of something in there so that I can have a reaction. Anyway it makes Ted happy, now that something's happening to *me*."

Bowden and Tallulah became friends. "I don't feel anything when I'm

being fucked," she said to him during the tour, attributing to her hysterectomy a lifelong feeling of frustration during intercourse that she mentioned on any number of occasions. Tallulah seems to have been alluding to a second operation intended to remedy some unfortunate aftereffect from her hysterectomy.

What Bowden also understood to be a result of one of the operations was incontinence, which could have been caused by the slightest nick on her bladder. Tallulah was frequently in a frantic haste to relieve herself. Assisting Tallulah with a costume change, her theater maid Rose Riley was forced to grab any nearby vessel. Bowden was horrified at the sight of Tallulah squatting over an urn held in the wings for the next scene while she pulled off one wig and one suite of cumbersome jewelry, slapping at Rose in rage, discomfort, and frustration. The meager sets turned the stage into an echo chamber. Bach came back one night in the middle of one of her tragicomic costume changes.

"Darling, you have to be very careful. The audience can hear you urinate."

"Well," Tallulah snapped, "there's *one* note of reality in your fucking play: Cleopatra pissed!" Bach scurried away. By the time they got to New York they were hardly speaking.

Terribly nervous as he was about his own performance, enduring his bride's humiliation, Emery's drinking got worse, as did Tallulah's. Bowden felt that "he became a real alcoholic. Some nights he'd go quite mad after the performance."

"Jesus, I'm so tired," he confessed to Bowden. "The show is important to me. But we do it and then she's always dragging me out afterward to some party."

"Do you want this marriage to work?" Bowden asked.

"Well, yeah, it'd be good for both of us."

"Then give her a good kick in the ass." Bowden was among those who believed a relationship with Tallulah could only survive when the man established undoubted authority. "She's looking for a father. I swear, all she wants you to do is say, 'We're *not* going *anywhere;* you're going home. *We're* going home tonight quietly.' If she fights, tell her, 'Then *I'm* going home.'" Emery, however, brushed off Bowden's advice. "When he didn't do it, but kept tagging along behind her, I said the marriage is finished."

Stress turned Tallulah into a diva from hell who seemed to be most concerned with what she was going to wear to her opening night execution

in New York. "The slave girls used to be terrified of her," Bowden recalled. "She'd suddenly look at one of them, and they'd know, Oh, God, she wants this costume!"

"Take it off, darling," Cleopatra commanded her hapless attendants after they'd all exited offstage. "I'm going to try that on for the next scene." And in the wings the chosen girl stripped down and Tallulah swept out onstage for a shakedown cruise in her pirated finery. After a while, the girls used to carry their dressing gowns down to the stage with them.

Finally Tallulah called in Cecil Beaton to administer a last-minute overhaul. Beaton's new costumes arrived shortly before the New York opening. The night before Tallulah faced Broadway she was onstage trying on her new ensembles. There was a capelet in an avant-garde fabric at the time, woven with plastic. "Christ, he's laughing at me," Tallulah grumbled. "I look like a shower curtain!" Part of her midriff was bared: "Look at my stomach: every secret," she said with a pat, "I've ever had is exposed!" Then came a pair of coiling snake armlets that didn't quite fit. "I can't move my fucking arm, darling!"

From the start, she detested the helmets of tightly coiled plaits that she'd been given to wear on her head. In her research, Tallulah had discovered, or claimed to have discovered, that Cleopatra had a fondness for wigs of all shapes and colors. Why, then, Tallulah argued, couldn't she be a blonde? (In her autobiography, Tallulah asserts that in London she won a five-pound bet with Lord Birkenhead when he wagered that Cleopatra was brunette.) The wigs were banished. In New York, Tallulah wore a quasi-pageboy with bangs, which conveyed something of an Elizabethan flavor.

On November 10, 1937, they opened at the Mansfield Theatre (today the Brooks Atkinson) in New York. "In the clutter and noise and mumbled speeches of the production it sounds pretty much like a collision in the property room," John Anderson wrote in the *Journal American* the next day. "You can scarcely tell what's going on. Scenes scamper past, with the insisted alarums of Virgil Thomson's brassiest brass, in a chaos of sound. . . ." In the *New York Times,* Brooks Atkinson wrote that Strunk's adaptation "has managed to rob the play of a large part of its motivation, dispelled 'the golden haze of sensuous splendor' which is the source of the tragedy, and reduced the size of the characters." Preparing the text for Tallulah, Strunk would have been expected to put Cleopatra's scenes in higher relief by minimizing some of the subsidiary plot strands; yet *Variety* reported to the contrary that she was offstage more than she was on. A near consensus from the critics was that her acting in the remaining scenes did not make them want to see more.

Atkinson complained that, "There is no suggestion of majesty in this Cleopatra, and, curiously enough, not much sensuousness or passion. Miss Bankhead's restless modernism gives it more of the garishness of a night-club scene. Her voice has none of the music that blank verse requires; she misses the rhythm of poetic speaking, and a large part of what she says cannot be understood." Richard Watts Jr. in the *New York Herald Tribune* called her "more a serpent of the Swanee than of the Nile"; John Mason Brown in the *Post* recorded that "Tallulah Bankhead barged down the Nile last night as Cleopatra—and sank."

But as always, Tallulah's reviews were not homogeneous. Even though the majority of critics considered her Cleopatra a disaster, it is worth quoting the minority opinion. Burns Mantle of the *Daily News,* who was not a particular fan of Tallulah's, nevertheless declared himself thoroughly impressed and commended her restraint. "The death scene is modestly played, and with a becoming dignity."

Robert Francis of the *Brooklyn Daily Eagle* was the only reviewer to acknowledge the limits of the character as she is presented by Shakespeare:

> I took my seat with some misgivings, but Miss Bankhead can always be counted on for the unexpected and she proceeded to do a Cleopatra that not only at all times was warm, moving and human, but frequently brilliant. She lifts a rather doll-like character out of a well of sentiment and makes her a vital, passionate woman. She is intriguing and interesting every minute she is on stage.

In the *Sun,* Richard Lockridge accused Tearle of erring on the colloquial side more than Tallulah had. Emery received some good notices, but his performance did not generate enough enthusiasm to justify Tallulah's decision to come into New York on his behalf. Watts, however, called him "the one member of the cast to play with both authority and a knowledge of the beauty of the lines. And then they have deprived him of his great speech when he hears of the death of Antony. It is all very discouraging."

Antony and Cleopatra closed after five performances. Producer Stebbins took his prodigious losses gallantly: "I could have had a yacht or the play. I picked the play."

Serving Time in Drawing Rooms

"You know I can't be happy in a part if I don't feel that I could be—to a certain extent—that sort of person."

I t has been suggested that the failure of *Antony and Cleopatra* proved conclusively that Tallulah was not capable of acting Shakespeare. Her *Twelfth Night* broadcast refutes this, however. It has also been speciously argued that Tallulah's failure as Cleopatra resulted from the limitations of a second-rate actress. Estelle Winwood was on tour and sent Tallulah a very supportive wire after the disastrous reviews appeared. But her own ambivalence about Tallulah surfaced when she told Cole soon after that *Cleopatra* had failed "because she's never learned her job." Nevertheless, Winwood's withering comments in 1982 were startling. "Tallulah couldn't play Shakespeare," she insisted flatly. Why not? "Well, my dear, now there's a question," she said with a caustic little laugh. "*Why* not? It isn't easy to play Shakespeare. I've played a lot of it. And to put somebody like Tallulah, who is just a little Miss Nobody, really, into a part in Shakespeare is ridiculous. She was noted as a beauty—beautiful hair, things like that. Not as an actress. Ever."

It's unfortunate that Tallulah never excelled in a classic part in a way that allowed her to prove the real scope of her talent. Toward the end of her life she seemed to realize that she had needlessly foreclosed her artistic options. "I am a purely naturalistic actor," she told radio interviewer Michael Perlman in 1964. "I'm not a classical actress. I could have been, but I never had that kind of training."

Marie Bankhead, as always, was entirely uncritical of Tallulah's acting. Undoubtedly feeling the need of a reassuring presence, Tallulah and Emery had invited her to come up for the New York opening. Back home after seeing the play, Marie wrote Tallulah on November 18, 1937:

> What a glorious treat you gave me! I shall never forget the thrills I had when the play unrolled before my eyes. I don't care what the critics say I know it was *great*. And how fine it was to be with you and John and see you so happy together. John certainly made a hit with the family both male and female. I got the repercussion of opinion after you left and it was all favorable. They just loved him. And of course they worship you.

If Tallulah's health problems were as serious as Bowden has suggested, she may indeed have been in no position to think or act rationally. Her marriage and her Cleopatra seem to reflect the long-standing pattern of self-sabotage seen in her impulsive career decisions, her often disastrous behavior with men, and her reckless abuse of her health. It is impossible to disagree with the assessment of Tallulah's friend David Herbert that she was "her own worst enemy." She herself must have on some level realized this. "She was a wise woman about her own life and what she'd done with it," Cole commented. Some of the aggression she vented on the world was undoubtedly born of frustration at how much harder she tended to make things for herself.

Antony and Cleopatra's critical reception in New York could not have come as a surprise to Tallulah, but perhaps the full ramifications of the calamity were more than she had imagined. 'No use denying I was desolated," she writes in *Tallulah*. Nevertheless, she took Emery to Washington days after the closing to watch Will preside over the opening of Congress. On December 12, Edie Smith wrote Marie that Tallulah and Emery—"the children"—had been on the wagon for ten days "and are really so much better," but were nevertheless having great difficulty falling asleep. But Tal-

lulah could not decide what role would afford the best recovery from Cleopatra. Edie wrote Marie that:

> Plays keep coming in but it doesn't seem that there is anything worth while for Miss Tallulah—the plays that look like anything at all are usually full of sex and its perversions—which might be alright for some coming star—and as Miss Tallulah has set up a certain standard she feels it would be dangerous to attempt anything that is in the least risky.

Soon after, Tallulah and Emery moved with Edie out of the Gotham and into a furnished apartment on East Seventy-ninth Street. Tallulah's culinary skills were modest and Edie cooked for them. Tallulah was desperate for money and trying to borrow from whomever she could. She told Bowden about a likely prospect, "a strange Moroccan" man who was keeping Stephan Cole. "Oh, darling, he can take care of *me!*" Tallulah snorted. "There's nothing to worry about there." Cole's protector—"well, he's practically a prince!"

Early in the new year, the Emerys were given a brief respite when John began rehearsals for *Save Me the Waltz,* a romantic comedy in which he was the ruler of a mythical kingdom. It boasted a superb cast including Mady Christians, Leo G. Carroll, Laura Hope Crews, and none other than Reginald Bach. *Save Me the Waltz* opened on Broadway on February 28, 1938, and lasted only eight performances. But immediately after, work came for both Tallulah and Emery in a revival of Somerset Maugham's 1921 play *The Circle,* one of his finest comedies. Tallulah was to play Elizabeth Champion-Cheney, a role originated by two great actresses: Fay Compton in London and Estelle Winwood in New York. Emery would play her rakish love interest, Teddy Luton, a rubber-plantation executive. Teddy persuades Elizabeth to throw off status and security in exchange for the passion and impetuosity missing in Arnold, her somewhat priggish, if well-meaning, husband, a local politician with eyes on bigger prizes.

The recurring pattern suggested by the title is established by Lady Kitty, Elizabeth's mother-in-law. Thirty years earlier, she left five-year-old Arnold and her husband to run off with Lord Porteus, her husband's best friend and employer. Elizabeth has invited Kitty and Porteus to visit and meet Arnold for the first time since they bolted. The plot is thickened by the unexpected appearance of Arnold's father, who, together with Kitty and Porteus, exhume and dispute their mutual past.

The Circle came Tallulah's way at the instigation of playwright Edward

Sheldon. After enjoying a smashing success as a young man early in the century, Sheldon had fallen victim to a slowly advancing paralysis as the result of a mysterious, perhaps psychosomatic, illness. His Gramercy Park apartment was consecrated ground for many great actresses in the theater, who sought the bedridden playwright's counsel and advice. One of them was actress Grace George, who, at sixty, was one of Broadway's great ladies. In part to distract George from her son's recent death, Sheldon proposed that she undertake the role of Lady Kitty, and proposed that Tallulah, who had complained to him of the dearth of viable plays, star opposite her.

After the debacle of her Cleopatra, Tallulah was determined in *The Circle* to show a completely different side. When forced by circumstances, she was capable of this kind of sensible damage control. Back in 1933, for example, when Tallulah was staying at the Garden of Allah in Hollywood, she had dived into the hotel's pool in a sequined dress that took on water so alarmingly that she climbed out of it and hoisted herself out of the pool naked. The next day the incident was making the rounds of Hollywood gossip when Tallulah showed up at a party with Alan Vincent. Wearing a middy blouse, she looked all of sixteen, Hedda Hopper recalled in her syndicated column ten years later. The image was so unexpected and so incongruous that no one ribbed her about the night before.

So did Tallulah in *The Circle* pull off a stunning reversal. Elizabeth is described as being in her early twenties, and Tallulah gave the part its full value as a young romantic lead. "It was an ingenue part and she played it as ingenue," Cole recalled. "It was unlike anything I'd ever seen from her, she looked so young and so innocent." It was not a comment on innocence that Tallulah delivered but a convincing simulation of the genuine article. "It takes a woman of my experience to play a virgin," Sarah Bernhardt once said. "I know just what to leave out." By the same token, Tallulah never attempted, as a younger actress might have done, to milk the role of Elizabeth for sentiment.

Tallulah told a reporter that "at first I thought it wasn't my sort of thing. Of course I have done a very wide range of parts—almost every kind of emotion—and yet it's as a comedienne that I fancy myself. Here I am, though, in a play [. . .] other people have all the laughs." Nonetheless she realized that, "It will be good for me to learn to lean back, relax, and let the other characters carry the scenes. I have been so used to sailing in and doing the work myself."

Grace George was known to be an perfectionist whose demands were always met since she was invariably produced by her husband, William

Brady. "He gave her the best productions that anybody could want," said Cole. George's stepdaughter Alice Brady was also a great actress. George's range easily encompassed the full spectrum from tragedy to comedy that the role demands. Vain, absurdly painted, affected, and capricious, Lady Kitty is nevertheless wise enough to present herself as a cautionary figure to deter Elizabeth from making the same escape that she had thirty years earlier.

Tallulah was grateful to Brady for rescuing her and Emery. She also got along well with director Bretaigne Windust, one of the busiest young directors of the time. Before the opening, Tallulah told a reporter that George was going to be "magnificent" in the play. A mistress of understatement, George's work could have been studied profitably by Tallulah, and undoubtedly was. For in Cole's words she "always had her eyes open. Anyone who was supposed to be good, Tallulah wanted to see what they were all about." He didn't consider her a "shopper," sifting through other performers' work, "but if there was something unusual, some little thing worth looking into, she'd keep it in mind." She was singularly interested in visiting the work of experienced senior actresses, other women of George's generation: Alla Nazimova, Laurette Taylor, and Jane Cowl among them.

Shortly before the *The Circle* opened on Broadway, an agitated Tallulah came to visit the senior actress to whom she was closest. Elizabeth had been "one of my favorite parts," Winwood recalled in 1982. She quelled Tallulah's anxiety by advising her to "just lie back on the author." Maugham's elegant dialogue needed no embellishing, a somewhat novel situation after the many occasions on which Tallulah felt compelled to do anything she could to rescue a bad script.

The Circle's April 18, 1938, opening at the Playhouse was termed "the social high spot of the week," by Radie Harris in her nationwide radio broadcast. "One of the most glamorous actresses on the stage today, Tallulah always attracts a glittering first night audience, culled from the social, literary and theatrical worlds."

The ovation that greeted her entrance stopped the performance cold. The audience seemed to want to assure her that she had been forgiven for Cleopatra, and so did the critics. Grenville Vernon wrote in *Commonweal* that, "First honors go to Tallulah Bankhead for her Elizabeth, in which she gives the performance of her career. She has charm, simplicity, pathos, feeling; both emotionally and technically her performance is a masterpiece."

"After the nightmare of being an ebony night club enchantress in *Antony and Cleopatra* Miss Bankhead finds her true self in Maugham's

work," wrote Thomas R. Dash in *Women's Wear Daily*. "Eschewing tawdry and meretricious languishements [sic] and febrile, overwrought acting, this actress is matchless as the sensitive and well-bred young English matron of finer sensibilities."

She looked, Arthur Pollock wrote in the *Brooklyn Daily Eagle*, "like something you dreamed." Cole recalled her entrance with George at the beginning of act 3. Having strolled in the garden, they entered the drawing room of the Champion-Cheney home together, George first as befitted her seniority. Each woman dressed exquisitely, they presented a breathtaking portrait of the beauty of age and the beauty of youth, and the audience was moved to applause.

Tallulah did not, of course, receive unanimous praise. In *The Nation*, Joseph Wood Krutch wrote that: "Miss Bankhead does not even try to act except intermittently. Between her occasional big scenes she either does nothing at all or, what is perhaps worse from the standpoint of a performance, relies for attention upon the casual exploitation of her voice or gestures or general personality."

Although notices for *The Circle* were on the whole highly favorable, it lasted only seventy-eight performances. Business took a dive with the advent of summer weather. Grace George decided to tour the play in the fall, but Tallulah and Emery resolved instead to star together in *I Am Different*, a comedy of marital misadventure, adapted by Zoë Akins from a play by Hungarian playwright Lily Hatvany. Several years earlier, Akins had successfully adapted Hatvany's *The Love Duel* as a vehicle for Ethel Barrymore. *I Am Different* took place in Akins's preferred milieu of the high-toned European drawing room, amid the same sort of brandy snifters and humidors that had surrounded Tallulah in Akins's *Footloose* eighteen years earlier. Tallulah would play Dr. Judith Held, a noted European author of volumes of popular psychiatry as well as advice-dispensing newspaper columns. In her writings she frequently takes aim at the foolishness of female jealousy. But her clinical objectivity is thrown to the winds once her path crosses Emery's Alex Thoerson, a reckless young playboy. His lover, a leading actress, has shot and wounded him in a fit of jealous pique over his desire to meet none other than Judith Held. Thoerson sweeps Judith off her feet and almost immediately she discovers firsthand just how slippery the long slope of amorous jealousy can become.

Tallulah's old friend and London colleague Glenn Anders played her husband; and Thomas Mitchell was again directing her. But "that awful play," as Anders recalled *I Am Different* fifty years later, was a colossal waste of time

and energy for all concerned. The leads started rehearsing in New York before they traveled to the West Coast where some of the smaller roles were cast. On August 10, Tallulah and her father displayed professional and personal solidarity across the thousands of miles separating Alabama from Hollywood. On a national radio broadcast, he exercised his dramatic ambitions by reading a monologue, for which Tallulah supplied an introduction.

Tryouts were to begin in San Diego on August 18. A New York opening was planned for November. Yet Tallulah realized the play's shortcomings and signed a contract allowing her the option of not taking *I Am Different* into New York. Judith Held was a long and difficult role. Cole, who stage-managed, described Tallulah's performance as "all technique and personality"—not feeling that the two were necessarily mutually exclusive. Tallulah was able to illustrate Judith's identity as author and newspaper columnist with sufficient accuracy to make the character credible. But during an interview in San Francisco, she issued a spirited assertion of the legitimacy of "personality" acting.

> You know, I can't be happy in a part if I don't feel that I could be—to a certain extent—that sort of person. Unless it's a character part (and I've only played two in my life—Amy in *They Knew What They Wanted* and Sadie Thompson in *Rain*) I try to adapt the role to my own personality and act it as naturally as possible. If I've got a jealousy scene to do, I simply try to remember how I've behaved when I'm jealous.

At the Los Angeles opening on August 22, "celebrities were everywhere to be seen and a street crowd of surpassing size came to pay court," noted the *Los Angeles Times*. Backstage, a *Herald Express* reporter watched Tallulah nervously "pacing up and down, worrying about lighting, constantly calling for water to soothe her throat after arduous last minute rehearsals all the night before." But Tallulah told Cole that she didn't mind being seen in Los Angeles even in as flimsy a vehicle as *I Am Different*, since she felt she could act better than most movie stars anyway. ("What passes for acting in Hollywood, with some few exceptions . . . puzzles and embarrasses me," Tallulah would write in 1949.)

Hollywood accorded the play a polite but hardly vociferous reception, nothing like the success she'd had there two years earlier in *Reflected Glory*. More enjoyable for Tallulah was the chance to go horseback riding with Cole through the then largely unsettled San Fernando Valley. Tallulah had

ridden since she was a girl and enjoyed it. (Her riding skills had been captured on film in *Thunder Below*.)

Tallulah put the brightest face on her seemingly hopeless struggle to find a durable play, telling the *Los Angeles Examiner:* "What I like best about playing in the United States is that I can't rest on my laurels. Abroad they go to see the stars in any play, old or new. Over here you have to establish a reputation all over again with every role. I like it. It's stimulating. It keeps you on your toes."

Tallulah, as always, felt the obligation to entertain her audience by whatever means necessary. Featured in a small role in *I Am Different* was Fritzi Scheff, a star of opera and operetta at the turn of the century. Concerned that *I Am Different* wasn't enough to send an audience home satisfied, Tallulah after some performances would take Scheff in front of the curtain and prompt the audience, "Now if you all ask very nicely, maybe we can get Fritzi to sing a chorus of 'Kiss Me, Again.'" Scheff had introduced the song on Broadway in Victor Herbert's *Mlle. Modiste* thirty-three years earlier.

From Los Angeles the play moved to San Francisco, where it was running when the the *New York Times* reported on September 17 that Tallulah didn't want to bring it to Broadway because she thought that major revisions were necessary, but "Miss Akins does not want any lines changed." Akins cabled a response that was published in the *Times* on September 25.

> May I say that there are no lines in the play which have not already been changed or juggled about as it suited them by either Mr. Thomas Mitchell the director or Miss Bankhead herself. . . . May I also add that the climactic scene of the play was never rehearsed as written and that a letter prepared by my lawyer forbidding a second performance if the scene was not played as written was sent to Mr. Joseph Gaites the manager in San Diego before the opening there but because the first performance was a little closer to my intentions than the preceding rehearsals I let that opportunity of closing the play pass however I have [done] nothing since that time but urge the management to have important revisions properly rehearsed and incorporated or close the play.

But Cole says that Tallulah wasn't behaving badly, "it was just one of the worst plays that ever happened." In any case, some accord with Akins was reached, since after a week's hiatus, *I Am Different* continued on to Chicago,

where it did quite well, remaining for three weeks before spending the week of October 24 in St. Louis and the following week in Cincinnati. That was followed by two weeks of one-night stands throughout the South, a territory where Tallulah could do no wrong. She played two performances, a matinee and evening, at the Temple Theater in Birmingham, and after both, the audience "brought her out again and again with heavy applause," Vincent Townsend reported in the *Birmingham News*. "Birmingham likes to see Miss Bankhead stomp, rant and toss her head and when she does one of her famous frowns of perplexity, that makes the picture just about perfect." Townsend conceded affectionately that she "can do a lot for the timing of a line and the shading of a stage situation with one of her mannerisms," but he spoke as a conventional Southern gentleman as well as a critic when he added that "we would like to divorce her from so many of those deep throaty laughs that work their way into her presentations."

I Am Different reached Washington on November 22, which was as close to Broadway as it got. Producer/director Herman Shumlin had just sent Tallulah the script of Lillian Hellman's *The Little Foxes*. Hellman hadn't yet finished the third act, but Tallulah wired back her acceptance immediately. She was to play Regina Giddens, a cunning and restless Southern matron living at the turn of the century. "Regina fascinated me, as did Lillian Hellman's searing prose," she writes in *Tallulah*. "Regina had depth and stature and eloquence." Anders watched her drop to her knees and address a divinity with a plea that "I must have that part!"

The play was "a God-send," she told Shumlin, in that it allowed Tallulah to stop the tour of *I Am Different* to come back to New York to start rehearsals for her new show early in January. The following summer, Shubert announced that Constance Bennett would star in *I Am Different* on Broadway, but nothing came of this. "New York has had its share of indignities," Tallulah writes in her autobiography. "It could well be spared that one."

The Little Foxes

"Well I'm *acting*, do I have to always be gracious and a Southern lady?"

It has been claimed that in *The Little Foxes,* Tallulah finally—as never before and perhaps never again—really delivered; she "acted," created a character, and no longer "played herself." There is an unmistakable subtext here: that Tallulah was deserving of approval because she *behaved,* her ferocious, subversive energy was contained and harnessed. When society celebrates the taming of a lioness, a male ringmaster must also be crowned. In this instance the ringmaster was Herman Shumlin, who produced and directed Hellman's play. He has been represented as a paragon of rectitude, imposing integrity on his wayward star in a way that his predecessors could not do.

Certainly there is an amount of truth to the myth. In *The Little Foxes,* Tallulah *did* give an unforgettable performance that revealed new dimension to her talent. And by her own account, she received invaluable guidance from Shumlin, who *was* a great director and a stern taskmaster. Shumlin was not, however, what the Medusa-slaying mythology claims. He was not a paragon of virtue but a fallible man who warrants more than the cursory depiction he has so far received.

"He had tremendous drive, more drive than anyone I've ever met," says his cousin, screenwriter George Slavin. "Whatever he did he would

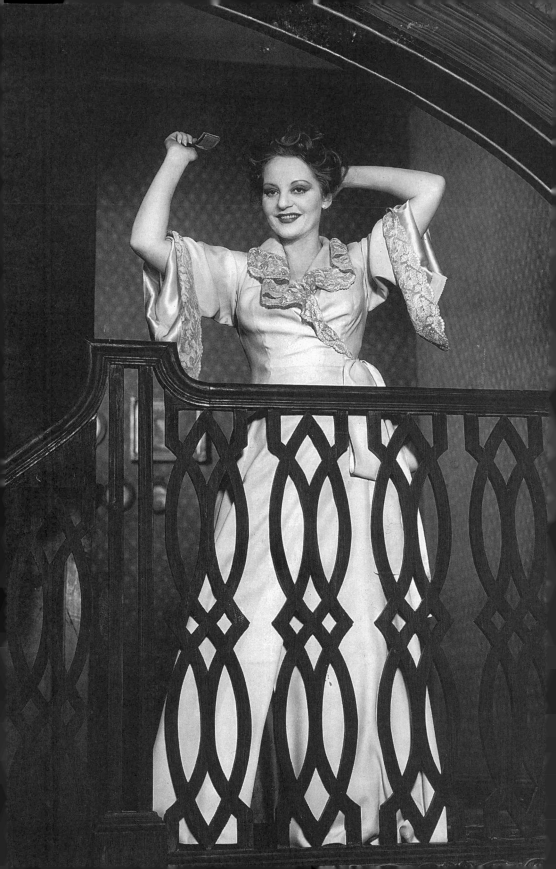

have been successful—and he would have made a lot of enemies. I never got personal with Herman," said Slavin, and few people did. "He was self-taught and he knew more than anyone I knew about what was going on politically and theatrically. That was his problem; he had no time for people who indulged in small talk. The human element was missing."

Shumlin subjected everyone around him to the relentless drive that had propelled his own rise. Eager to break into the theater, Shumlin had dropped out of high school, working for a time in his uncle Charlie Slavin's chain of moderate-priced women's clothing shops. Slavin sent him to producer/director Jed Harris, Broadway's crown prince during the twenties and thirties. Shumlin rose to become Harris's business manager and then struck out on his own. He had four flops before hitting the jackpot with *The Last Mile,* a prison melodrama written by an ex-con. George Slavin recalled a late-night call to his father from Shumlin. "Charlie, if I don't get twelve thousand dollars by tomorrow I'm going to commit suicide." Charlie Slavin not only contributed what he could but that night went hat in hand to friends to raise the balance. A huge hit, later sold to Hollywood, *The Last Mile* started Shumlin on three decades of prosperity and acclaim.

Shumlin hired Lillian Hellman as a play reader in his office and then accepted her first play, *The Children's Hour,* in 1934. *The Children's Hour* set the precedent for Hellman's work. It was an unflinching look at human malevolence and psychological brutality. It ran eighteen months and made Hellman a name to be reckoned with on Broadway and in Hollywood. But in 1936 Hellman's second effort, *Days to Come,* had lasted only five performances on Broadway. Flush from a Hollywood contract, she was able to nurse her wounds until summoning the courage to begin *The Little Foxes.* It "was the most difficult play I ever wrote," she recalls in her memoir *Pentimento.* Draft upon draft, nine in all, eventually produced a tightly—too tightly, some would complain—woven melodrama of social conscience.

The Hubbards are a family of capitalist spoilers in a small Southern town at the turn of the century. Brothers Ben and Oscar and their sister Regina are planning to spread their wings by building a cotton mill to adjoin the cotton fields outlying their town. They have joined forces with William Marshall, a Chicago industrialist who is attracted by their promise of cheap labor and strike-free conditions. Regina sends her seventeen-year-old daughter Alexandra to retrieve her estranged husband, Horace Gid-

Tallulah as a tempestuous Southern belle in *The Little Foxes.*

dens, from a Baltimore hospital, where he has learned that he does not have long to live. But when he returns he refuses to become part of the family scheme. With death approaching, he wants no more gambits to exploit and enrich, and Regina is left with no funds to get in on the deal.

Oscar's son Leo is employed at the local bank owned by Horace Giddens. Oscar and Ben prevail on Leo to lift a sheaf of bearer bonds in Giddens's safe-deposit box, which they will use as collateral in lieu of Horace's stake. Only too ready to cut their sister out of the deal, Ben and Oscar plan to replace the bonds when construction begins and outside investors can be recruited at favorable terms. Horace finds out, but tells Regina he will play along with her brothers' deceit, letting them use the bonds as the stopgap surety they need. He has made a new will, and these bonds, the instrument of her brothers' victory, are all she will get. The rest will go to their daughter, Alexandra. Defeated, Regina will not aid him when his heart gives way. She walks away from her husband's deathbed to confront her brothers, promising them silence about Leo's theft if they will cede her a three-quarters return for the one-third stake that her late husband's bonds supplied. She has gained the upper hand, the independence she craves, but Alexandra, appalled by what she has seen, leaves her for good.

Hellman brought Shumlin the play late in 1938; Dorothy Parker had suggested the title, a verse from the Song of Solomon: "Take us the foxes, the little foxes that spoil the vines; for our vines have tender grapes." Shumlin was committed to producing *Life with Father,* but Hellman demanded that he extricate himself or she would go elsewhere. Shumlin did and was not sorry. Although *Life with Father* ran ten years and would have set him up financially for life, *The Little Foxes'* success brought Hellman and him even closer; they became lovers during the run of the play. In an anthology of her work published in 1942, Hellman wrote, "He has done more than interpret these plays: he has wrung from them more than was in them, and hidden things in them which should not be seen."

Shumlin had originally talked to Hellman about Tallulah's playing Regina, but "we were both very nervous about her—Lillian in particular," Shumlin claimed. "Her reputation by that time was rather scarlet." And so before *The Little Foxes* found its way to Tallulah, Judith Anderson and Ina Claire had passed on it. "Each had a pleasant reason for refusing," Hellman said, "each meant that the part was unsympathetic, a popular fear for actresses before that concept became outmoded." Anderson, Shumlin recalled, had been less than pleasant, saying that *The Little Foxes* was "disgusting."

Shumlin again sounded out Hellman about Tallulah, but Hellman thought she might be too young. Tallulah was only thirty-six when she began rehearsals, but Shumlin had seen her frequently onstage, and "knew her power, her style, her authority . . . her wonderful vitality and a marvelous freedom . . . a daring and a boldness that I liked very much."

Shumlin's casting sense was remarkably acute and each role received as perfect a personification as could be imagined. Ben, point man in the family's operations until Regina trounces him, was Charles Dingle (whom Hellman could apparently forgive for his appearance in the ill-fated *Days to Come*). Carl Benton Reid was his hapless brother, Oscar, given the thin end of the wedge by both Regina and Ben. Lee Baker was William Marshall, and Horace Giddens was played by Frank Conroy. Dan Duryea played Oscar's wastrel son, Leo, before beginning a long career in Hollywood.

Patricia Collinge was Tallulah's virtual costar, this being the first play in which Tallulah had been so equally paired with a woman since *Fallen Angels* in 1925. Collinge played Oscar Giddens's wife, Birdie, the daughter of old Southern aristocracy, a pitiful figure of ravaged gentility. Birdie was just as great a part as Regina, and Tallulah knew it. Kenneth Carten said Tallulah told him she had even originally told Shumlin she would play either Birdie or Regina.

Collinge had been a leading Broadway actress for almost thirty years, but had been away from Broadway for four years, devoting herself to writing. Her play *Dame Nature* had recently been produced by the Theatre Guild.

To play Regina's daughter Alexandra, Shumlin hired Florence Williams, a twenty-eight-year-old native of St. Louis who had trained to be a concert pianist before falling in love with the theater in her teens. She had acted on Broadway with Lillian Gish, Judith Anderson, Helen Menken, Gladys Cooper, and Glenn Anders. "It was my very great pleasure," Shumlin wrote soon after her Broadway debut in 1933, "last night to see you in *Girls in Uniform*, and I wish to take this opportunity to tell you how beautiful a performance you gave and thank you for it." Earlier he had courted her unsuccessfully for a lead in *The Children's Hour*.

Shumlin's intensity was reflected in the preparations for the play. "Herman conducted as though he knew that he had a classic," Williams recalled. "We had *banquets* on the stage," laid out for breaks in rehearsal. "Ham, roast beef, every kind of bread you can think of."

Gathering material for her play, Hellman had raided the skeletons in her own family's closets. The painstaking efforts of Shumlin and his team

nearly caught her red-handed. During the second-act breakfast scene, a newspaper is casually perused by the Hubbards. Shumlin instructed stage manager Ben Krantz to find and reprint an authentic vintage issue. Hellman gave an approximate population, location, and year. But when Hellman saw the facsimiles Krantz had printed, she went through the roof: "Get all those destroyed immediately. I'll be sued! I'll be sued for libel. Get them out!" Krantz had found exactly the Alabama town from which her mother's relatives hailed. The lot of prop newspapers was destroyed and the gazette of an adjoining town substituted.

Tallulah brought to the rehearsals an intensity that matched Shumlin's. After Tallulah's death, Shumlin told Hellman's biographer Richard Moody that "no actress ever attacked a role with such fervor and such total commitment." Shumlin saw that the freedom he had admired in Tallulah was built on an armature of precision. "Her mind is tremendously alert and retentive," he averred. Tallulah wanted to know exactly what he was looking for at all times and would sometimes ask Shumlin to demonstrate things for her as Gerald du Maurier and George Kelly had once done.

"Regina was a challenge that I welcomed," Tallulah writes in *Tallulah*. For a woman who could not stand constriction, the most noxious of the role's requirements were period clothes laced in by corsets, which required a different movement protocol. Tallulah told Stephan Cole she had resolved to move only in period character from the first day of blocking, but she still missed being able to cross her legs or light a cigarette onstage. Her trademark red nail polish had to come off and clear lacquer was substituted: nail painting was hardly acceptable for the Alabama matron of 1900.

Shumlin "was a great director," she told Denis Brian in 1966. "He made me slow up." Tallulah modified what had been her characteristic diction: Regina's words issued with a measured gravity that suited the character's deliberation and didn't conform to Tallulah's own fizzy staccato—the repartee of drawing room comedy. But the difficulties that the role posed for Tallulah were not what Williams took away from those rehearsals. "I just felt it was so natural a thing for Tallulah. She knew the part so thoroughly; she knew *exactly* what she was doing."

Williams cites Shumlin's "structural sense of a play" as his great strength as director. "He was marvelous at putting it together: how to position people—where to put them. He did that beautifully, and oftentimes got a relationship between people because of the positioning." Nevertheless, there were definite limitations to Shumlin's vision, Williams believed. He worked the stage like a magnified chessboard, manipulating the pieces

brilliantly, but to him the pieces were hollow. "He just did not know how actors worked, how most actors worked," she says. "He felt they were puppets. Norma Chambers understudied Birdie; she worked for Herman as understudy quite a bit. One time Norma was explaining to him how one acts from within. He listened and said, 'If I believed that about actors, I'd never direct one again.'"

Shumlin would recall something charmed about the way the play coalesced: "We read it through the first day, then sat around and discussed the characters. The second day we read it again with interpolations and then began setting up the characters and scenes of the first act. . . . The whole play was set up in nine days. . . . I've never had a play come along like that."

The remaining weeks of rehearsals could therefore be dedicated to the process of perfecting, on which Shumlin concentrated mercilessly. Tallulah spoke admiringly of Shumlin's ability to rehearse the same scene twenty times in a row until the actors were able to produce the exact result he wanted. The director objected to any acting that did more than the text required. But it was just not possible for Tallulah to underplay as much as he wanted. "I did a couple of scenes the way I wanted to do them," she recalled ten years later. "I wanted to be Ethel Barrymore! And they said"—Tallulah shaking her finger primly—"No, no, that's overdoing it. You have to be the way a gracious Southern lady would.'"

"Well, I'm *acting*," Tallulah retorted, "do I have to always be gracious and a Southern lady?" Nevertheless, she followed to the best of her ability, and her performance was undoubtedly enhanced by Shumlin and Hellman's reprimands. Even when Regina was raging at floodtide, there was "never lack of control," says Williams. The plumb line of the characterization was self-possession. "She gave such stature to it, the way she played it. She was not a bit hysterical, ever," even when telling Horace, "I hope you die. I hope you die soon. I'll be waiting for you to die."

"I can still hear her saying it," Williams recalled. "Meaning every word. Cold as ice and just waiting."

"Here is a woman with whom everything is seething under the surface," Tallulah told a reporter. "I'm the kind of actress for whom it's always easy to let go, emotionally. This time, though, I must hold back, repress, especially in the early part of the play. The force behind the acting has to be mental."

Under Regina's subdued exterior prowled tensions and calculations that the audience felt as much as glimpsed. "I wouldn't say she was quiet in

that she just sat placidly, because she wouldn't be still in the mind—things were going on all the time," Williams said, thinking of the first-act party scene, when the Giddenses are entertaining Mr. Marshall of Chicago and the audience watched Regina begin to weave her web. "You saw her brain working; you got the whole thing, the wheels turning. But that always came across."

Without diluting Regina's virulence, Tallulah looked for and readily found in Hellman's text airs and graces in the character that would have been just as essential to Regina's success in the world as her single-minded determination. Tallulah's Regina was by no means an unalloyed fire-breather or stock villainess. Tallulah as Regina "was *beautifully* charming, when she wanted to be," Williams recalled. "But she let you know that it was turned on, Tallulah let you see just enough through her."

She "managed to get comedy out of *Foxes* nobody else would have," recalled Williams. She transformed ordinary exposition into merriment, not at the expense of the script, but often, it seems, without cueing from the lines as printed.

Early in the second act, after dispatching her daughter Alexandra to Baltimore, Regina is fielding a third degree from her brothers about why she and Horace have not arrived on schedule:

REGINA: Didn't I have a letter from Alexandra? What is so strange about people arriving late? He has that cousin in Savannah he's so fond of. He may have stopped to see him. They'll be along today some time, very flattered that you and Oscar are so worried about them. . . .

BEN: Regina, that cousin of Horace's has been dead for years, and in any case the train does not go through Savannah.

REGINA: Did he die? You're always remembering about people dying.

"Did he *daaaah?*" Tallulah asked, her voice swooping high on *did he,* then descending into how-dare-that-skunk-kick-the-bucket baritone effrontery on *daaaah?*

"It was priceless," remembered Williams, who enjoyed it just as much as the audience did. Shumlin would not have been Shumlin if he had not cast a wary eye on some of Tallulah's intonations; the director himself had "no sense of humor, poor man," said Williams. "If he did, it was so slight you couldn't notice it." But Williams felt that Tallulah's was a wise, tactical move. Fleeting interjections of humor gave the audience a breathing spell

from the foreboding, the strife that was always either being played out or just about to detonate. Tallulah made a very heavy play a bit easier for the audience, a strategy good actors have universally employed: "I always thought you must try to find the comedy even in parts like Lear and Hamlet," John Gielgud once said.

Tallulah's humor also established self-knowledge as a part of Regina's makeup, the impression that Regina knew herself well enough to laugh at her own machinations. "Did he daaah?" was poking fun at being cornered in her own deflective strategy. The relative on whom Hellman had patterned Regina "would speak with outrage of her betrayal by a man she had never liked," Hellman informs the reader of *Pentimento*, "and then would burst out laughing at what she said."

Tallulah's own hunger resonated with Regina's sexual frustration. Regina is a very desirable forty-year-old woman married to a man who has never excited her. They have not had relations in ten years—undoubtedly one reason why Regina keeps stating her determination to move to Chicago with the proceeds from the mills. Like every other character she played, Tallulah's Regina was a vessel of life force. Regina's story gained a regenerative potency beyond the confines of one woman's selfish struggle. Considerations of good woman and bad fall away when an audience encounters this type of mythic reverberation. Tallulah made the audience breathe along with her own rhythms—and with Regina's. She was "going to *get what she wanted,* some way," Williams said. "You felt that from the beginning, and it grew and grew, and swept you along with it."

Regina "was made for Tallulah, because of the insecurity and the ruthlessness she was able to bring into it." In Williams's recollection, Tallulah's performance had a rounding of character such that a strange kind of sympathy drifted in over the footlights. In her autobiography, Tallulah brands Regina "an unmitigated murderess." But perhaps this was an attempt to distance herself from the part, from qualities in herself that were reprehensible. "I was very close to that character," she would say to a friend in 1958. It's unclear whether she meant she knew the character intimately, or that she saw their common ground.

Hellman had wanted the audience to see themselves, at least some part of themselves, in the Hubbards; "I had not meant people to think of them as villains to whom they had no connection." She was disappointed, and felt she had failed, when the public stigmatized them as monsters.

Hellman biographer Carl Rollyson is not sure that the playwright didn't imagine Regina as a heroine. Hellman "saw the world as a tough

place that called for a hardness of character which often was not pretty to behold." One can see Regina's trajectory as that of an exceptional woman claiming her due, a woman thwarted by society of the opportunities she deserved. She is a paradigm of energy and intelligence in one of the most repressive societies in the world.

What she had endured explains, if not excuses, Regina's malevolence. "The fact is," William Wright declares in *Lillian Hellman: The Image, the Woman,* "we root for her, and if Hellman didn't want us to, she would be a clumsy playwright indeed." Where the audience is likely to retract its sympathy is in the fatal passage at arms between Regina and Horace. Hellman weighs the scale so that both antagonists are equivalent.

"For once in your life I am tying your hands," Horace tells her. "There is nothing you can do."

Her dream is gone. She will never get to Chicago. She will watch as her brothers grow rich with her money. Coolly she details the contempt she feels for Horace, has felt for most of their marriage. A cobra has been provoked. Horace crumbles under her brutality, and his heart failing, he clutches frantically at his medicine. When it shatters, he begs her to go for another bottle. As if instinctively, Regina rises to find it, then changes her mind. She looks straight out at the audience, not seeing, not hearing, determined not to know, as Horace stumbles toward the stairs.

Gasps went up in the audience, and yet they were still, perhaps unknowingly, willing Tallulah's Regina to victory.

The Little Foxes received its world premiere at the Ford's Theater in Baltimore on January 30, 1939. Tallulah had not acted in that city since leaving for London. A hairdresser was scheduled to come down from Elizabeth Arden in New York but fell ill at the last moment. Tallulah herself had to create the soufflé of waves and ringlets she wore in the first act. Two hours before the curtain, she sat in her dressing room, putting up her hair and taking it down again, until by the time she had it pinned to her satisfaction, her arms ached. Shumlin walked by and asked her how she was feeling.

"Oh, God, just awful," she said.

"Then you're all right," he told her, voicing a theatrical truism.

Hellman had given Regina an unforgettable entrance. Obliquely visible to the audience, she lingers in the dining room with Marshall, Alexandra, and Ben, while center stage in the living room, Oscar takes his tortured wife to task for chattering with their guest from Chicago. Decades later Hellman spoke of the "deep, thrilling" laugh that emanated from Tallulah at the dinner table. Hellman looked forward to it at every performance she

watched, sharing in the prickles of anticipation that it sent through the audience. It was eerie, like the call of a hyena, feral ambition flaring up behind a decorous facade. And then Tallulah would glide through the dining-room archway with her guests, wearing a sinuous black velvet evening gown that defied the sweet-pea shades worn by Alexandra and Birdie. A frothy lace border embroidered with paillettes snaked across her bare chest and arms. "She came out and all eyes turned to her," Glenn Anders recalled. "Who was going to look at anybody but Tallulah?"

Tallulah had asked Anders to come down to Baltimore and critique her performance. "I didn't have time to do more than tell her the good things," Anders said. But he advised her by letter that rather than batting coquettishly the black fan she held, she should do so languorously: "A queen has all the time in the world." Tallulah told Shumlin about it, and when the director next ran into Anders, he thanked him, saying if *he* had given her one more correction at that point, "she'd have jumped on me."

For all was not well in Baltimore, where Howard Bay, who had designed the sets, recalled to Carl Rollyson an intermittent cross fire between "Herman and Tallulah, Lillian and Herman, Tallulah and Lillian, and a little all around." They wondered if the play was too bleak for a world poised on the brink of real convulsion. Was it going to be the hit that Hellman and Tallulah needed so badly? There was a consensus that the third act was too long. Donald Kirkley in the *Sun* had complained that "the pace faltered, some threads of the plot came unraveled, and there were traces of uncertainty and confusion." Gilbert Kanour in the *Evening Sun* concluded that Hellman "let her fondness for phrases impede the rush of her drama to its crisis, and while talk, even for talk's sake, often has its advantages on the stage, there is far too much of it here."

Hellman undoubtedly did cut, for the complaints were not echoed in New York. Hellman had been doing some tinkering all along; Florence Williams had retained her original "sides," sheets of her own lines printed with a preceding cue line. Many new lines were penciled in over the printed dialogue. Williams explained that the major change—the substitution of a new ending—occurred before reaching New York. In Baltimore, the play had concluded with a tender exchange between Alexandra and Addie, one of the Giddenses' black servants, following a rather innocuous exit by Regina. Richard Moody was the single Hellman biographer to mention the revised ending. He attributed it to advice given Hellman by Sara and Gerald Murphy.

But Williams was sure that Tallulah was the catalyst. Lobbying for what she believed was required, Tallulah made the men's room of a Baltimore–

Pittsburgh train into an impromptu forum, calling a cast meeting en route to the troupe's engagement at Pittsburgh's Nixon Theater. Tallulah flounced in and hopped onto Carl Benton Reid's lap, sat there looking at him, and let out a gamy, "Verah strange that I don't feel your personali-*teh*." Benton Reid was not amused and she got down to business. "The play just isn't right," Tallulah argued. "It has to end differently. *Regina* should be on stage at the end. It's all wrong and we've got to convince Herman that it is."

"I think she rather thought that she had convinced everyone," Williams recalled. "I don't think they capitulated, really. She wanted confirmation from them and she hoped she would get it. She went to Herman and Lillian and told them what she wanted and I think she threatened to leave the show." That would have been professionally suicidal on Tallulah's part. She had, however, accepted the part before the third act was finished and so technically could have claimed veto power.

Williams recited the original scene, approximating the missing lines of Addie's dialogue that preceded the cues included on the "sides." She loved it and was unhappy about the change, as, she claimed, was Hellman. "I think Lillian was terribly upset," she said, "because she wanted the curtain to come down ready for the next play." Hellman envisioned *Little Foxes* as the opening of a trilogy tracing the rise and fall of the Hubbards. In 1946 came *Another Part of the Forest,* which showed the Hubbard siblings as young adults, twenty years before *Little Foxes.* Williams believed that the final play would chronicle Alexandra escaping her mother's domination.

However Hellman envisioned her future writing projects, they were of course of no interest to Tallulah. Hellman may have agreed with Tallulah's complaint, or it may have been echoed by the judgments of the Murphys or other friends. The revision strengthened Tallulah's dominance in the play. It also sharpened the focus of the work and gave it a more satisfying closure, "a wonderful plunk of the old log curtain," Williams said, laughing. (In melodrama's heyday, provincial theater curtains were built with a log on the bottom edge, and so the curtain fell with a thud.)

The new ending also made both Regina and Alexandra's characters richer. Carl Rollyson writes that Regina's realization "that her plans have cost her daughter's affection," which the revision established, is one of the things that "clearly mark her as a complex and vulnerable personality." Hellman and Tallulah were also shrewd enough to realize that audiences would be glad to see Regina receive some measure of retribution. Alexandra's revolt introduced a note of hope, however tenuous, that the little foxes of the world could be combated.

For Williams the insecurity that shadowed Tallulah's Regina through-out the play had become the fear that was the price of her victory. "She had to face the world alone, and she wasn't so sure after all if she could do it. She would have liked to have had Zan come along with her so she could play Big Mama and look after her dear little daughter and make all her con-quests along the way." Now Alexandra was privy to the insecurity that the audience had sensed all through the three acts.

Alexandra delivered the final line in the play: "Are you afraid, Mama?" "I read that line as if, You are afraid of something? *You?* It was the first time that Zan ever saw that, and she was delighted." Regina does not reply, but goes silently up the stairs. The look on Tallulah's face was chilling, her dawning realization of the isolation she might have to face.

On February 15, 1939, in New York the cast of *The Little Foxes* faced an opening-night audience that would not let them leave the stage before taking twenty curtain calls. Early the next morning, when Tallulah read the reviews at the party given by Clare and Henry Luce, she knew that her mo-ment had arrived.

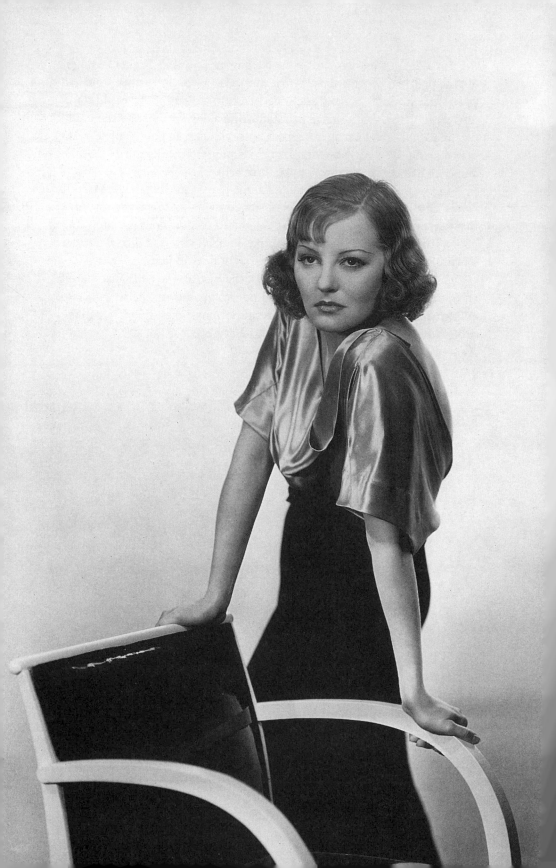

Part III
1939–1950

Triumph

"We are the talk of the town."

W hen they began calling for the author on opening night—not just our friends but the real public in the balcony—I felt like getting right down on that stage and praying," Tallulah told Mabel Greene of the *New York Sun*. Will had come to the Baltimore opening and sent her a long wire on the New York opening night. "He seems to be taking more interest than he usually does in my reviews," Tallulah confided to Greene. "Usually I have to send the notices to him, but this time he's getting them for himself. He says he thinks I look like my mother with my hair up in the play. Always before it was my sister who looked like mother and I who was supposed to take after the Bankheads."

The Little Foxes was an immediate sellout and was indeed Tallulah's first smash box-office hit in America. She won *Variety*'s citation as best actress of 1938–39 and received nearly unanimous critical acclaim. Grenville Vernon in the *Commonweal* extolled "the extraordinary variety" of her characterization; "in its combination of charm, common-sense, courage, avarice and utter unscrupulousness her Regina is a figure who might have stepped out of the pages of Balzac." George Ross in the *New York World*

Telegram called it "one of the best roles of Miss Bankhead's career"; while Pollock in the *Brooklyn Daily Eagle* described her as acting with "a simplicity which is not customary with her. . . . She has done nothing better."

Almost unanimously as well, the critics found *The Little Foxes* scorching and riveting. But many had reservations about its melodramatic emphaticness. Melodrama was at that point a discredited genre. Brooks Atkinson in the *New York Times* wrote:

> As compared with "The Children's Hour," which was [Hellman's] first notable play, "The Little Foxes" will have to take second rank. For it is a deliberate exercise in malice—melodramatic rather than tragic, none too fastidious in its manipulation of the stage and presided over by a Pinero frown of fustian morality.

John Anderson in the *New York Journal American* termed it "a drama so taut and absorbing that I couldn't take my eyes off the stage, not even to look at the First Nighters." But he responded more enthusiastically to Hellman's schematic illustration of pre– and post–Civil War Southern avatars than he did to the way she moved these symbols around. He wrote that Hellman "manipulates the values of the play so adroitly that the symbols are never obtrusive and never overshadow the powerful, if lurid, and occasionally over-plotted, events of the narrative. . . ."

Yet today *The Little Foxes* is generally considered one of the classics of twentieth-century American drama. Its flirtation with melodrama registers as a masterly acknowledgment of a hallowed tradition in the theater.

"Darling, how I wish you were here to see *Little Foxes*," Tallulah wrote George Cukor in Hollywood. "It has all been worth it. It's not only a good part in a good play but really the *best* play, and we are the talk of the town."

Despite the play's success, Tallulah's triumph seems to have done nothing to mitigate her growing malaise. If anything, she now became more aggressive, erratic, and destructive. Cole felt her vindication had come too late, that she was "like a hen that's been pecked too many times and turns on the whole coop." Tallulah's ego swung very high and very low. Hungry for approval as she was all the time, success could make her giddy, and after her many frustrations and disappointments, she certainly needed to mine *The Little Foxes* for all she could. But success also awakened additional anxiety. Kenneth Carten, who visited from London during the run, said she was afraid she'd never act as well again.

There was trouble in Tallulah's household as well. Emery and Tallulah were still trying to maintain a united front. He frequently dropped her off or picked her up at the theater. But the marriage had, at best, settled into a routine of convenience. "John didn't know what he was doing being Tallulah's husband," recalled Gladys Henson. "He was like an audience. She was a stranger to him, in a way. He was in awe of her."

"Why'd you marry John?" Henson once asked her. "He's the only one who ever asked me," she replied. This just may be true. Although Tallulah in her autobiography claims that Alington had sprung the question soon after meeting her, she herself seems skeptical about his sincerity. Certainly she had married Emery at a moment when her marital prospects looked very bleak indeed.

The weaknesses in the marriage were compounded by the fact that while Tallulah was enjoying her greatest triumph to date, Emery was having trouble finding a job. Early in 1939, Orson Welles had cast him in his Shakespearean amalgamation, *Five Kings*. But after the Philadelphia tryout, the Theatre Guild withdrew its financing. In the Emerys' suite at the Élysée, they discussed with Welles and a number of others how the production could be rescued. Tallulah got on the phone and began calling likely contributors, including playwright Marc Connelly, her neighbor at the Élysée and a friend from her Algonquin days. Connelly duly got out of bed and came over, but Welles didn't find the financing he needed. *Five Kings* never made it to New York.

Emery was next tapped to play Heathcliff in a dramatization of *Wuthering Heights* that was headed for Broadway. Edith Barrett, a former lover of his, was playing Cathy. Once Barrett knew that Emery was available, "she never stopped," recalled Robert Henderson, who was directing. She had the actor playing Heathcliff dismissed and replaced him with Emery.

Emery was generally considered more effective in costume parts than in contemporary ones, and Cole believed that Tallulah was coaching him throughout *The Circle* and *I Am Different,* "but on the QT." She was not on Quiet Time, however, when, at Emery's request, she arrived in Philadelphia to watch a dress rehearsal, accompanied by several friends and under the influence of alcohol. Without mincing words she told Emery what was wrong with his performance. Around ten-thirty the next morning, Henderson arrived to check on some details for the opening that night. He discovered the apparently demoralized Emery sleeping on one of the stage sofas.

Wuthering Heights came into New York early in May and closed after fourteen performances. Soon after, Tallulah's friend David Herbert docked in New York with a regiment of His Majesty's Merchant Navy. He bought a ticket for *The Little Foxes* and went around to see Tallulah after the performance. "Oh, darling, this is wonderful; we'll have a night out. We'll pick up my husband." The three went dancing at the Casino, a posh nightclub of that time in Central Park. "Now then, Tallulah," Emery urged, "we are going home," perhaps attempting to exert the authority that Charles Bowden had advised him to assert during *Antony and Cleopatra*. If so, it was by now too late in the marriage for Emery to be able to shift footing. "We are certainly *not* going home," she told him. "David's been fighting the war for us and it's his night out. We are going up to Harlem." They dropped Emery off at the Élysée and he slammed out of the car. Tallulah rolled down the window and shouted, "Darling, if I'm not home by five, start without me." "It's hopeless," Tallulah told Herbert about her marriage. "I don't know why I ever did it."

The Shuberts had a play they wanted Tallulah to consider, and John Kenley had been dispatched to deliver it to her. Edie greeted him at the door of their Élysée suite, to which they had moved from the furnished apartment they'd been driven to renting during their financial crunch of late 1937. "Come right in, come right in," Tallulah called from the bedroom, where Kenley found her and Emery in bed in medias res. She chattered on, praising his sexual prowess, while Emery ignored Kenley and continued apace. This was not the only time such a thing happened: in *Pentimento,* Hellman recalls that when Shumlin first went to talk to Tallulah about *The Little Foxes,* she conducted the parley while sitting next to Emery in bed. After hours of discussion, she pulled off the covers to display Emery's nudity and asked Shumlin what he thought. Perhaps she had ceased to see her husband as anything more than a display piece, a necessary escort and accessory.

For well over a decade, Edie Smith had not simply been Tallulah's secretary but her closest confidante, her anchor-to-windward, her bedrock. Now a parting of the ways seemed imminent. (Perhaps Tallulah's marriage had strained relations: "You lost respect for me when I married John because you knew I didn't love him," Tallulah told Smith repeatedly when she returned to work for her for a time during the 1950s.) In a letter, Tallulah tried to heal the tensions existing between them:

I realize that you have your life to live and the best part of it should be yet to come, with all my heart I hope so. Where you live or whom you

live it with is something for you to decide for yourself and I hope your decision will be the wise and right one for all concerned—I hope you will find a good job that you will enjoy and feel free in and know that is worthy of you . . . but great friendship like ours is not to be ignored—so what I want you to know is that no matter how high you soar if you would like to come back to the Cuckoo's Nest I would be very happy.

On my eyes I want your happiness and welfare as much as you do mine and I would not want you with me if it incurred any sacrifice on your part either physically, spiritually or mentally.

Well *that's that.*

Love,
Die Donner.

Die Donner was Smith's nickname for Tallulah, German for "thunder." Smith retreated to a significantly less thunderous job in the children's book department of Marshall Field in Chicago.

Waiting in the wings as Edie's replacement was a wealthy Canadian woman named Dola Cavendish. She took over some of Edie's functions, but Cavendish was neither a paid employee nor as intimate a friend of Tallulah's. Cavendish had known Tallulah in London; she was slavishly devoted, and believed to be in love with her, which Edie had never been. But Cavendish's encroachment may have been another factor in Edie's decision to leave Tallulah. Cavendish is recalled as charming, low-key, and lovable. She was also an alcoholic who was slightly tipsy many of her waking hours.

When Tallulah wasn't drunk she found drunkenness repulsive. Cole recalled late-night calls from her when they were on tour, asking if he would "get this goddamned woman out of my room." Cavendish would be sitting "with a cigarette sewn to her lip," Cole recalled, "trying to talk with a drink in her hand, drunk as a skunk."

But Tallulah's own drinking was heavy and steady all through the eleven-month Broadway run of *The Little Foxes.* Florence Williams recalled her coming in some Monday nights looking as if she'd had a sodden weekend. Tallulah was not under the influence during working hours, but she was perhaps cutting things a little close. Alabama native William Skipper, a young dancer in the Denishawn company, was working as a messenger for theater photographer Marcus Blechman. One day

he went around to the Élysée to deliver some proofs to Tallulah, who was eating before going to the theater. She gave him a drink and then another and another. "I don't know how many" Tallulah and Cavendish, who was in attendance, had already imbibed, he later recounted. She asked him all about himself and his experiences: Tallulah was a great admirer of Shawn and St. Denis. Twice a week Skipper posed nude at the Art Students League. "Oh!" Tallulah screamed. "I'm going to start art classes there next week."

In December 1939, Tallulah revisited two of her most traumatic rejections when she attended the Manhattan premiere of *Gone with the Wind* and the party given by Jock Whitney that followed. Whitney hosted the party at the Fifth Avenue mansion in which he'd been raised.

Glenn Anders escorted Tallulah. In the lobby banked with poinsettias, a footman took Tallulah's fur and she and Anders negotiated a marble stairway jammed with celebrities. They decided to battle the crowd no farther and sat at the nearest table overlooking the staircase they had just mounted. Every now and then Tallulah would wave a miniature Confederate flag she'd brought, but she was outflanked because the film's stars were all there in person. A footman walked up the stairs hauling a huge tin vat filled with bottles of champagne on ice. It looked very much like a bathtub, and Tallulah poked fun at its inelegance. "My God," she snorted, "is that the way the Whitneys live?"

It wasn't too long before they decided to leave. After jostling their way to the street, they faced a crowd that seemed to stretch for blocks. Held back by a squadron of police, eager faces leaned up close enough to coo greetings at Tallulah. Usually cordial with her fans, that night she was oblivious. The head of a long line of idling taxis drove up. Tallulah got in and Anders stepped in behind her in time to hear Tallulah's final deflationary gesture of the evening, directing the driver to proceed forthwith to "Childs, please!"

Tallulah's continued hunger for affirmation and approval, unsatisfied even by *The Little Foxes,* was demonstrated by her evolving relationship with Florence Williams. Williams had found herself the object of "much attentiveness" from Tallulah during the early rehearsals. They were talking during a break when Williams mentioned her husband. Tallulah looked at her and gasped, "My God! Are you *married?*"

"Yes," she said, "and very happily so."

"Oh," Tallulah replied with distaste.

Reflecting on the incident much later, Williams thought that Tallulah

had been attracted to her. Williams did have the slightly angular hand-someness that Tallulah's female lovers seemed to share. In Baltimore, shortly before *The Little Foxes* opened, Tallulah had been presented with the key to the city. She, in turn, gave the key to Williams, but the younger actress was bewildered more than flattered. Williams thought that Tallulah was "a little crazy and not my kind of person in the least."

At her opening-night party in Baltimore, Tallulah introduced Williams to her father. "This is my *baby,* Daddy," Tallulah had said with a suitable flourish, but Williams believed that it rankled Tallulah to be playing a woman with a grown child. Tallulah had last played a mother in *Tarnished Lady* eight years earlier, and in that film she was rearing a toddler. Perhaps Williams represented something particularly sobering: the advent of middle age. But if Williams had reciprocated Tallulah's interest, she would probably have stayed on good terms with her. Tallulah needed to be surrounded by colleagues who appreciated and responded to her offstage as well as on, even if her behavior sometimes made that difficult. "She never acted like, 'Don't come near me, I'm the star,'" Cole said. "Nothing pleased her more than another actor coming to her with a problem. That was one of the great things in the world."

Williams's indifference seemed to unnerve and enrage Tallulah. Onstage in New York she began to harass Williams with pigtail pulling, behind swatting, and pinching "upstage so nobody could see except the stagehands and the wardrobe woman." A tenet of Shumlin's direction was that the estrangement between Regina and Alexandra be signified by Tallulah never touching Williams. "And she violated it constantly!" Williams claimed. Shumlin knew that Tallulah was defying his staging decision, but watching from the audience, he couldn't see exactly what was going on. He regularly conducted brushup rehearsals of the play and took the opportunity to restage the offending passages, "but she didn't last more than one or two performances," Williams alleged. "She'd go back to doing what she felt like."

Earlier in her career, Williams had been the victim of an older actress's antagonism and was able not only to sail past it but to use it to fuel her own determination. But she was nonplussed by Tallulah's blend of venom and quasi-sexual provocation. "It was hell on wheels to concentrate and play that part," she said. "Now I'd handle it completely differently. I would say, "Tallulah, what the Samuel Thunder goes on?!' But I didn't know what to do then. I think back and I must have *infuriated* her—that I didn't re-

spond. That was probably the worst insult that I could have given that poor woman."

Williams wanted to leave when her six-month contact expired in August. Her agent told her that Shumlin wanted her to stay. Williams's understudy had been a very young actress, Joan Tetzel, who later made a career for herself in Hollywood. But when Tetzel left the show, Shumlin hired Eugenia Rawls as Williams's understudy. Rawls had played a small part in *The Children's Hour* five years earlier. She had admired Tallulah in *Rain* and *Reflected Glory,* and they shared significant experiences: Rawls had also been raised in Alabama by her grandmother.

When Hellman and Shumlin began to think about sending *The Little Foxes* on a tour to begin early in 1940, Tallulah apparently insisted that Williams be replaced by Rawls. "The interests of Lillian and the interests of the many involved in the production, and of my own were at stake," Shumlin wrote Williams thirty-five years later. "You were the victim."

The night after Williams was given her two weeks' notice, she walked past Tallulah's dressing room on her way to the stage. Tallulah dragged her into her dressing room, locked her in a mad embrace, and made the bizarre profession, "Oh, my darling, you're the bravest woman I've ever known since Robert E. Lee!" Williams pushed her away in disgust.

Rawls stepped into *The Little Foxes* at the end of October 1939. She was to become a very significant person in Tallulah's life. Perhaps her adoration was able to take the sting out of Tallulah's considerable resentment that she could not have children. Whether she would have decided to or not, Tallulah of course had wanted to be the one to choose. If Tallulah had to face middle age, she could do so with a loving daughter manqué. On December 2, she wrote Eugenia's grandmother:

> I can't wait for you to see her in this part. She has a scene where she is so touching that it almost breaks your heart; in fact, it is hard for me to keep in character when I watch her. (As you know, I am playing a very unsympathetic and cruel mother.) . . . My mother died when I was born and I was raised by my grandmother, so Eugenia and I have a great bond in common.

At a backstage party to celebrate the 500th performance of *The Little Foxes*, Tallulah cuts the cake for Katharine Hepburn, Eugenia Rawls, and Irene Castle.

In April 1941, eighteen months after Rawls joined the cast, Tallulah was matron of honor when Rawls married Donald Seawell, a young lawyer who became Tallulah's attorney. The Seawells had two children, a girl, Brook, and a boy, Brockman, who was given Tallulah's middle name, which was also the maiden name of her father's mother. Tallulah eventually bequeathed each of the two children one quarter of her estate.

Tilting Her Lance

"This is no time to be flippant or joking."

It was during *The Little Foxes* that Tallulah became for the first time active politically. Tallulah was well informed about world affairs, reading every one of the nine daily newspapers published in Manhattan during the 1930s. But now the increasingly dire European situation took on extra relevance because of her still-strong attachment to Britain. Domestically, her father had become one of FDR's most trusted lieutenants, and she could see how his efforts had helped remake America with the New Deal.

In June 1939, she went to Washington to lobby for continuation of the WPA's Federal Theatre Project. The Senate Appropriations Committee was opening hearings on a $1,735 billion relief bill passed by the House. An amendment to restore funding denied in the House bill had been attached to the Senate relief bill by Claude Pepper, a liberal Democrat from Florida.

Escorted by Emery, she took an early morning flight to Washington together with Shumlin and several other theatrical notables. Probably it was Shumlin who enlisted her; he was a lifelong supporter of left-wing causes. (Shumlin wrote in an official biography that, when working as a teenager in the office of a Newark manufacturing plant, he had been "dismissed as a 'Socialist'" for asking aloud why safety devices weren't installed on ma-

chines.) In her new role as activist, Tallulah conducted herself with the flair that audiences on two continents had come to expect.

She went first to Senator Pepper's office; Will and Uncle John were there to greet her. Will was noncommittal on the issue, but to the press, "His daughter seemed sure of his support." In any case his opinion as speaker of the House was much less important than John's, since the latter sat on the Senate committee. John was not disposed to support her, complaining that, "Those city fellows in Congress never vote to do anything for farmers. Sol Bloom [a Democrat representing New York in the House] and the whole crowd always vote against the farm bills." Tallulah insisted that Bloom "would do exactly as Daddy tells him to do," and told the reporters that John on her behalf would "filibuster for two years reading the life of Robert E. Lee." She asked him to confirm her assurance that he would filibuster, but he remained silent and she countered with a humorous threat to disown him. However, she quickly decided that the hilarity had gone far enough and told the reporters present that "this is no time to be flippant or joking."

Instead, her testimony to the committee contained a dash of coquetry, as she tossed off her blue slouch hat and sat not on a chair, but on the felt-covered committee table to read her prepared statement. She defended the project on philosophical as well as economic grounds, insisting that the theater was invaluable to the cultural life of the nation and that the Federal Theatre Project had played an unparalleled function in disseminating that culture, exposing the youth of America to great classics of drama. She claimed that its nationwide cultivation of new audiences for live theater had enhanced the viability of cross-country touring by Broadway shows. She noted the relatively small amount of money allotted to the project and pointed out that many of its initiatives had proved self-sustaining.

> To sum up, we ask that the theater project be continued because those now employed on it—95 per cent from the relief rolls—will be utterly destitute without it, or condemned to a form of work for which they are not fitted and in which the skills which they have spent their lives in attaining will deteriorate; because those skills are social assets which will be lost to the community; because the project's activities have contributed enormously to the cultural life of the nation, bringing education, cheer and a wholesome love of the stage as a civilized nation to millions of the least well-to-do of the nation; because the people of the stage by their generosity to others in distress deserve better than to be singled out for this discrimination.

"I beg you from the bottom of my heart," Tallulah concluded, "not to deprive these people of the chance to hold up their heads with the dignity and self-respect which is the badge of every American." With that she burst into tears that were probably sincere as well as histrionic. Tallulah had always replaced actors whose contribution she didn't think was adequate. But she was at the same time sentimental about the plight of unemployed actors and freely dispensed relief from her own pocketbook.

Tallulah stayed to hear several of the other witnesses, representatives of ten national arts and artists' organizations. She was still red-eyed when she left to fly back to New York for that evening's *Little Foxes*. Her Washington appearance was front-page news in the next day's New York dailies. The *New York Times* reported that she "mingled serious appeals for restoration of theatre projects with comic interludes involving the Bankhead family." Uncle John eventually voted in favor of the amendment, but it nevertheless failed to pass in the Senate, and the Federal Theatre Project was dissolved ten days later.

It was Tallulah's burgeoning political consciousness that precipitated the most contentious of her disputes during the embattled run of *The Little Foxes*. On November 30, 1939, the Soviet Union invaded Finland after weeks of fruitless negotiations about a territory swap that the Soviets insisted they needed in order to protect themselves against a possible Nazi invasion. The Soviet aggression was condemned by most of the global community. In the U.S., a Finnish relief fund was established with former president Herbert Hoover as national chairman and Mayor La Guardia as New York chairman. Most Broadway shows performed benefits to aid Finnish refugees. Tallulah announced that *The Little Foxes* would perform such a benefit. Hellman and Shumlin announced unequivocally that it would not.

Hellman enraged Tallulah by claiming that the Finland benefit was being vetoed because Tallulah had refused Hellman's earlier request that the company perform a benefit for Republican Spain. Hellman repeats the claim in her 1969 memoir, *Pentimento*. But while Florence Williams remembered Hellman asking the cast to wire their elected representatives concerning the Abraham Lincoln Brigade, the Americans who had gone to Spain to support the fight against Franco, "nobody ever asked me" about a benefit. (Had one been proposed, it would have been necessary to present the decision before the entire company.) In her autobiography, Tallulah says that Hellman's excuse was "a brazen invention," and recalls that on the day Barcelona fell to the Nationalists, she took the anguished Hellman into her dressing room and gave her a restorative shot of brandy.

Spain was a problematic issue for liberals because both sides of the civil war were funded by totalitarian regimes, the Spanish Fascist cause supported by Germany and Italy, the pro-democracy Republicans by the Soviet Union. "I wasn't too familiar with the politics of the civil war in Spain," Tallulah writes in *Tallulah*. "But I was concerned about the plight of the widows and orphans, innocent victims of the bloody business."

Hellman insisted that Finland was harboring pro-Nazi elements. But rather than being anti-Finland, Hellman may have simply been speaking as an apologist for the Soviet Union. She was among the American liberals who continued to defend the Soviet regime even after knowledge of Stalin's persecutions became undeniable. She had visited the Soviet Union during the 1930s and continued to visit it during World War II.

Hellman's propensity for near-pathological dissembling equaled Tallulah's, as was demonstrated by the scandal over the veracity of the "Julia" chapter in her *Pentimento* forty years later. In that same book, Hellman also claimed to have visited Finland in 1937 and been appalled at the Nazi sympathies she discovered there. However, her biographer William Wright doubts that any such visit took place.

Tallulah traded salvos in the press with Hellman and Shumlin. She told the *New York Times:* "I've adopted Spanish Loyalist orphans and sent money to China, both causes for which both Mr. Shumlin and Miss Hellman were strenuous proponents. . . . Why should [they] suddenly become so insular?" (Tallulah had not actually adopted the children but defrayed the expenses of their resettlement in the U.S.)

The Little Foxes remained profitable all the way to the end of its Broadway run, closing February 3, 1940 after 410 performances. Early the next month, it was to begin a tour of northeastern regions that would conclude with an open-ended run in Chicago. Tallulah continued her fervor of political-minded action, forwarding to her father a letter from a Jewish actor she knew whose son had been denied admission to the University of Alabama Medical School. Tallulah believed that he was being discriminated against and hoped that Will could somehow intercede with his alma mater. She was "thrilled beyond words at being with you and Florence for a full week in Washington. Rest up well, because I want to monopolize you!"

The Little Foxes opened in Washington on February 5, and Tallulah contributed her salary from the play's weeklong engagement at the National Theater to the Finnish relief fund. But her time with Will was again shadowed by illness and anxiety: while she was in Washington, he fell ill with what he later described as an attack of intestinal influenza. He con-

tinued, however, to exult in her success as Regina Giddens. "I was delighted with the very fine newspaper notices which you have received on your Boston appearance, and feel sure that your good success on the road will continue."

Anger—whether personal or political—undoubtedly energized Tallulah and distracted her from a more debilitating emotional malaise. Her determination to find enemies in her midst perhaps explains her adoption of a vehement anticommunism. She may have confused, as most Americans have done since, the abuses of the Soviet regime with the theoretical content of Marx and Engels's own writings. Or she may have felt, as of course many did, that Communist theory offered a real and dangerous threat of totalitarianism. In her autobiography she describes communism as a system of "state feudalism." "She was a little crazy about that," Estelle Winwood recalled. Nevertheless, she had the sense and the courage to condemn Joseph McCarthy in her autobiography, dictated in 1951, when he was the height of his influence.

Before it was shut down, the Federal Theatre Project had been denounced by opponents in the House as a hotbed of Communist sentiment. Tallulah apparently came to believe that its survival had been compromised by the insidious presence of a fifth column of Communists. Such an attitude may have been dictated to her by Will, who had grown increasingly liberal throughout his years in Congress, but was also adamantly anti-Communist. In March, he wrote Tallulah, gently advising her against allowing her name to be used by the organizers of a "so called National Sharecroppers Week," convened in Manhattan to benefit the Southern Tenant Farmers' Union, of which Tallulah was listed as a sponsor. "I dislike to make this suggestion to you, but it is my opinion that this organization is composed largely of Reds and Communists, and while it purports to be organized in the interest of white and colored tenant farmers, its leaders are subject to very grave suspicions." He was enclosing corroborative literature for her perusal. "I hope this is a matter upon which you will take my judgment and act accordingly." She did just as he asked, writing the National Sharecroppers' Week organizers to ask that her name be deleted from their publicity materials:

> I feel very deeply for the plight of the sharecroppers and it was my sincere desire to help them in any way I could, just as I tried to aid the actors in the WPA theatre project. Because of these same un-American tendencies at the head of that WPA endeavor and the vicious propa-

ganda, the innocent actors were deprived of their livelihood. I feel that the sharecroppers will suffer likewise if this set-up is not weeded out.

I know that there are many distinguished people sponsoring your organization and my accusation naturally does not refer to all of them. I am sure, if they knew the truth, many of them would also withdraw.

It is not clear whether the "vicious propaganda" Tallulah mentions refers to the smears against the Federal Theatre Project or instead to any alleged indoctrination attempts by its members. In any case, she enclosed a copy of the letter to Will, along with a note to him stating, "Here is a copy of the letter I sent. I hope it meets with your approval. All my love, Tallulah. Will write long letter soon, in such a hurry—"

In Boston, still furious with Hellman and Shumlin over the Finland incident, Tallulah behaved unprofessionally, refusing to participate when the director called the entire company for a rehearsal. After he had worked with the rest of the cast, she agreed to come onstage, Rawls recounted, and go through her part in front of him. Although the entire cast seems to have sided against Hellman and Shumlin on the issue of the Finnish benefit, no one except Tallulah had responded so vitriolically. Patricia Collinge felt indebted to Shumlin for bringing her back into acting, and was therefore his staunchest ally in the cast. "When he first talked to me about playing Birdie," Collinge later recalled to Gary Blake, "I hadn't acted for some time and I said to him that I thought I was a little afraid. And he said, 'Will you let that be *my* problem?' So I had no more fear."

She and Tallulah were on good terms. "Tallulah respected Pat so much," Florence Williams said, "and Pat was very gentle with her, very tactful and very good," without being at all deferential. "Pat had a wonderful, naughty sense of humor," Williams recalled. "She said she was like a rattlesnake, she couldn't keep from striking."

"Tallulah is the sort of person," Collinge observed to Williams, "who would chop your head off one minute and wonder why on earth it wouldn't stick back on the next."

On March 19, 1940, Collinge wrote Williams from Boston. "We had a bit of a scene, Tallulah being pretty rude to him. It all just makes me sick . . . to my heart and stomach, dear. All is peaceful at the theater for the moment. Tallulah is saving Finland and that keeps her busy. She and Herman not speaking. You know she attacked him terribly over the Finland benefit. We were all terribly upset. I finally explained that we were sorry he didn't agree with us about Finland but we still felt he had a right to his own

opinion and that we all loved and respected him and were prepared to say so. She took it very well and has stopped raging against him, at least around the theater. Peace—it's wonderful!"

Tallulah's impassioned, sincere, but frequently graceless crusades continued when she decided that spring to run for a five-year position on the governing council of Actors' Equity. Her husband was also running for a five-year term on the regular Equity ticket. Tallulah was forced to run as an independent, an unusual if not unprecedented event in Equity elections. Equity recorded in its monthly newsletter that Tallulah's nomination was submitted at "almost the last possible moment" by sixty "Senior Resident Members in good standing." She wanted specifically to challenge the candidacy of actor Sam Jaffe (not to be confused with Paramount's production manager of the same name), but Equity rules did not permit a direct opposition. Instead, it was up to any Equity member who wanted to elect Tallulah to specify which candidate on the regular ticket she would replace. Her determination to challenge Jaffe, who became in the 1950s a victim of the House Un-American Activities Committee (HUAC) blacklist, clearly meant that she was taking aim at the far left flank of Equity's membership. Tallulah must have believed that Equity, no less than Finland, was under siege by the totalitarian far left.

Equity was clearly thrown on the defensive. An editorial in its newsletter said that the nominating committee, six of whose nine members were elected in a special meeting, had "devoted considerable time and effort" to choosing a ticket that was "representative of all shades of thought and opinion in the membership." Tallulah had earlier been "seriously considered" by the nominating committee and passed over "with reluctance" because it had already been announced that she would be on the road for most of the upcoming 1940–41 theatrical season. In addition, seating both Tallulah and her husband at the same time would have violated Equity custom.

Equity's stated opinion was that Tallulah "would be a valuable member of the Council in more than one sense, even though her election would be at the expense of one of the nominees on the Regular Ticket." The editorial, however, urged the "preservation of harmony and unity," which Tallulah's election would surely have breached.

A year earlier, actor Philip Loeb had accompanied Tallulah to Washington to defend the Federal Theatre Project. He was at one point a member of the American Communist Party and became during the fifties one of the most tragic victims of the blacklist. At the Equity council's annual meeting on May 24, 1940, in New York, Loeb stood up to say that he was

"greatly perturbed" not only by Tallulah's nomination, but by "the conduct of the campaign on behalf of Miss Bankhead which had preceded this meeting." He defended Jaffe as "one of the finest, noblest creatures in the theatrical profession. . . ."

When the election was convened later in the meeting, the entire Equity ticket was voted in. Tallulah lost narrowly, receiving 246 votes, which siphoned off more from Jaffe than from any other candidate. He received 256 votes, while, for example, Walter Abel received 405 votes and Emery 376.

Tallulah's move was in some ways characteristically impetuous and confrontational, but it was so divisive that it would be interesting to learn how she made the decision to run, and at whose urging. Obviously there was sufficient opposition to Jaffe among Equity's membership to put her name on the ballot. But how easily it was to become the dupe of red-baiters well to the right of Tallulah was demonstrated almost immediately after her defeat. Republican Congressman William Lambertson of Kansas used the Equity election to buttress his accusations that Equity had now been infiltrated by Communists, as, he claimed, the Federal Theatre Project had been, thus justifying its demise. He cited as proof the victory of Jaffe, "an avowed Communist," over Tallulah, "an outstanding American actress." He circulated one of the little lists that were so effective in stirring anti-Communist hysteria, naming Jaffe, Loeb, and several others, including Tallulah's friend and adviser, agent Edith Van Cleve, despite Van Cleve's being a lifelong Republican. Van Cleve later told Lee Israel that Tallulah had furiously composed a denial on her friend's behalf and phoned it to the press.

Tallulah's continued success in *The Little Foxes* unfolded against an increasingly grim world stage. In Chicago she learned about the British catastrophe at Dunkirk, and soon after announced that she was going on the wagon until the British turned the tide of the combat. She was aware of the absurdity of her pledge, telling Rawls "it sounded as if she were bribing God, and nobody would believe her anyway, but she meant it." Cole insisted that Tallulah had instead done it "for herself" because her drinking was again reaching a danger point. In Toronto a month earlier, after a night of drinking, she had gone to board the train that was taking *Little Foxes* to Detroit. "Pat," she told Collinge, "if your mother came in now, I would be perfectly able to meet her graciously." She then proceeded to pass out.

With Stephan Cole

Determined to maintain her pledge publicly, Tallulah nevertheless hit upon substitute stimulants. She developed a regular habit of dosing her liquid refreshment with spirits of ammonia—"grain alcohol," as it's called in the South, where it has traditionally been a way for women to surreptitiously spike their drinks. Cole said that she never stopped drinking entirely; sometimes she hid liquor by disguising it in spirits-of-ammonia bottles. Yet she certainly cut down considerably during the war years.

On June 10, Will wrote Tallulah at the Ambassador East in Chicago. He evidently felt neglected. "It has been a very long time since I have heard anything from you, in fact since you were here in February when I was so sick has been about the last direct word I have heard from you. I know that you are extremely busy, and so long as I felt that things were going well with you it was all right." (She had, however, responded to his letter in March concerning National Sharecroppers' Week.)

> I have had a terrible time with the attack of intestinal influenza that I had when you here, and have had a terrible time in throwing it off and getting rid of its effects upon me. I had to go to Florida for a month to try to recuperate, but the truth is, I have not as yet gotten back to my normal health and weight, and have to be extremely careful about any exerting matters. I do not want you, however, to be worried about my condition, as I am thankful that I am so much better and able to attend to my duties here at the Capitol.

Will gingerly asked if he could delete $325 from a $900 payment that he was holding for Tallulah after handling the sale of a portion of the Sledge estate in Mississippi that had been willed to Eugenia and Tallulah by Adelaide's father. He explained that in addition to heavy state and federal income tax, his medical bills had been onerous. He had purchased for $1,500 a sixty-acre tract adjacent to a farm near Jasper that he had acquired earlier with an eye to his retirement. He needed $325 for the second payment on the land. He further offered to sell her half of the property for exactly what he'd paid. "I assure you that it will be a good investment for you, as the value of this land will never be less than what I agreed to pay for it." He simply did not have the $325, he confessed. "Please be perfectly frank about this matter. And if you had rather reserve the $900.00 which I hold for you as Trustee for some other purpose, it will be all right with me." He was hoping that Congress would soon adjourn, for he remained "pretty tired and worn out."

Losses

"I just *hate* her! She reminds me of myself."

Will had asked if there was a way for Tallulah to extend the Chicago run of *The Little Foxes* until mid-July, when he and Florence would arrive for the 1940 Democratic Convention, at which he was to deliver the keynote speech leading to FDR's renomination. But the play closed in Chicago on May 31 after a healthy run of five weeks. Tallulah chose not to take the summer off before beginning the national tour of *Little Foxes* in September, but instead to embark on an eight-week tour of *The Second Mrs. Tanqueray,* her second appearance in a play by Arthur Wing Pinero.

Tallulah was undoubtedly attracted by the opportunities for emotional and erotic display the play had offered since its 1893 premiere. A young woman who's already been the mistress of several men, Paula Tanqueray becomes the second wife of a gentle and tolerant man. But she is tortured by her stepdaughter's indifference, as well as by her husband's distaste at her social gaffes and her uncouth retaliations against those who shun her. The coup de grâce comes when her stepdaughter becomes engaged to a man she had once been involved with. She persuades her husband to break up the engagement, her stepdaughter turns on her viciously, and the second Mrs. Tanqueray shoots herself.

Pinero's reputation as a masterful theatrical technician aside, *The Sec-*

ond *Mrs. Tanqueray* is in many ways clunky and laborious, yet the play drives Paula convincingly to suicide by an impressively inexorable tide of persecution. Its spasms of late-Victorian angst over a fallen women's attempt at redemption would certainly not have had the relevance to audiences of 1940 that they had in 1893. "You can make it hold up," claimed Cole, who was stage manager, "but you've got to be an awfully strong actress. Very arresting. God knows she was." Tallulah was not averse to pulling out all the stops: "The more you got the audience involved, the better off the play was. Tallulah didn't really camp; she just made it bigger than it was."

Tallulah brought Rawls along with her, to play her unsympathetic stepdaughter. The diary that Rawls kept on the tour is included in her book, *Tallulah, a Memory.* She records that in Marblehead, Massachusetts, Sinclair Lewis came to visit Tallulah in the old house where she was staying. Cole was impressed at how many academic and literary figures visited her backstage. Perhaps it was the desire to make up for her dismal record in formal education that compelled her to be as driven and competitive in her reading as she was in every aspect of her life. Cole claimed that Tallulah had read every volume of Proust's *Remembrance of Things Past* despite finding it all a bit needlessly excessive. "She felt that it was there; it had to be done."

While they were playing in Stockbridge, Massachusetts, Tallulah spent several mornings watching Serge Koussevitzky rehearse at Tanglewood. She also made the acquaintance of the young Leonard Bernstein, then the great conductor's assistant, and he visited her at the house where she was staying. In later years he liked to suggest that they had been romantically involved.

In Dennis on Cape Cod, an unfledged Tennessee Williams came to see her about a play he'd sent for her consideration. It was the genesis of what became *Battle of Angels,* which subsequently closed before reaching Broadway with Miriam Hopkins starring. Tallulah complimented him on his writing but said that she didn't want to do the play because religion and sex were a fatal mixture onstage. (An odd opinion given how well they'd ignited in *Rain.*) Williams was bedraggled after biking down from Provincetown. By the time he was ready to go back, it had started to rain. Tallulah asked Cole to drive Williams and his bicycle back home.

Tallulah had been faithful to Emery while they were living together in New York, but she had now been on the road since the beginning of the year and both she and he were quickly moving apart. She was having an

affair with Colin Keith-Johnston, a distinguished British actor who played her husband in *The Second Mrs. Tanqueray*. Keith-Johnston was married and Tallulah had no intention of breaking up either his or her own marriage; indeed, her avoidance of intense emotional bonds was well served by her many affairs with married men. But Emery was more seriously involved with the Russian dancer and actress Tamara Geva, who had enjoyed many successes on Broadway since emigrating to the United States in 1927. Tallulah herself had known Geva casually for a number of years. Their mutual friend Clifton Webb had introduced them backstage at the Broadway revue *Three's a Crowd* in 1931, in which Geva and Webb starred. In 1993, Geva claimed that Webb had reported Tallulah saying, "I just *hate* her! She reminds me of myself." Whether or not Tallulah really said this, her words were all too true: Geva was talented, beautiful, intelligent, and just as determined as Tallulah to be on top.

In Rawls's *Tallulah, a Memory*, Keith-Johnston recalled his summer with Tallulah. "However extrovert—ebullient and irrepressible she was *outside* the theater—the moment she was in her work-shop she was the most complete, conscientious and professional of all the players I have worked with." Actor Romney Brent was credited with *Tanqueray*'s direction, but that had as much to do with the need to put down a name than anything else. Tallulah was certainly the dominant influence over the production. Keith-Johnston called her "an uncompromising and creative critic of even the smallest part and the most insignificant performer."

While Tallulah toured the summer resorts, Will insisted on attending the Democratic Convention in broiling Chicago despite the urgings of his friends, family, and doctors. One reason he insisted on going was the possibility that he would be nominated to run for vice president. According to the *Washington Post*, "a great drive" was made to secure the slot for him by his fellow politicians. Despite Will's long service to Roosevelt, the president insisted instead on Henry A. Wallace.

Tallulah listened to the nomination returns by radio in Maine, where *The Second Mrs. Tanqueray* was performing, and called Will to commiserate. Soon after, his sister Marie wrote him, "Everybody I have seen in Montgomery is seething with indignation because the President let you down at the Convention." But Will refrained from assigning blame. "Except for the President's intervention," he wrote back to Marie, "I might have been nominated, but, frankly, I had no assurance of it." Will nevertheless worked tirelessly for Roosevelt's reelection, once again ignoring the warnings of friends and family that he conserve his health.

The Second Mrs. Tanqueray closed in Massachusetts on August 31, and Tallulah returned to New York to rehearse for the national tour of *Little Foxes*. It was going to be a much more grueling tour than any she'd ever undertaken, including weeklong engagements in major cities, but also scores of one-night stands. On September 10, 1940, she and her sister were in New York sitting by the radio waiting for a live broadcast by their father from Baltimore. Over the air came news that his speech had been canceled due to a sudden illness. His chauffeur called to tell them that they should come immediately to Johns Hopkins Hospital in Baltimore. Will had been found unconscious in his hotel room shortly before he was scheduled to speak. An artery in his abdomen had burst, probably weakened by his influenza earlier in the year. That night the sisters sat outside his room until morning for fear that if he found them by his bed in the middle of the night he would realize how ill he was. By morning he had regained consciousness and wanted to return to Washington and the naval hospital there. His doctor asked him where his pain was. "I don't play favorites; I scatter my pain." Will was similarly playful when Tallulah asked him before leaving: "Daddy? Do you still love me?" "Why talk about circumferences?" he asked with a smile.

Tallulah returned quickly to New York, and then to Princeton, New Jersey, where *The Little Foxes* was going to open on September 15. On the day of the first performance, Keith-Johnston was in Princeton for a final good-bye before she left for the tour and he went back to his wife. In the afternoon, he and Cole scoured the town, increasingly worried when they couldn't locate her. Finally they found her at the theater, staring into the empty auditorium. She told them that Uncle John had called to tell her that Will was failing rapidly in Washington. Tallulah was convinced that she must fulfill her professional obligation, that it was what her father, who put work before nearly everything, would have wanted from her. It was not until after the performance that she and Cole boarded a train to Washington. She drank a little and steeled herself for what was to come. Steeling herself was also a way to gain leverage over Eugenia, who had gone ahead to Washington alone. Eugenia's public deportment now became a subject for Tallulah's concern. She was prone to public displays of emotion. Despite her own exhibitionism, Tallulah considered such things unseemly breaches of dignity and decorum. She said little to Cole on the way down, except to share her concern that Eugenia would be unable to exercise self-control. Tallulah's own emotions were perhaps a Pandora's box she dared not explore.

She had been told that Will was in a coma but thought she might be able to arrive in time to see him alive. When her train pulled in to Washington at 2:30 A.M., however, she was met at the station by family members who told her that he had died an hour earlier. Florence, Eugenia, and his brother John were at his bedside. The cause of death was given as "abdominal hemorrhage."

"He was a strong partisan, but he could appreciate the viewpoint of the opposition," House Minority Leader Joseph W. Martin Jr. said the next day. The *Washington Post*'s editorial page opined that Will had died, "a victim of his profound sense of loyalty and devotion to the party which, in honoring him, had honored itself."

At noon the next day, the House convened to elect Sam Rayburn House speaker. At twelve-thirty the chamber reopened for Will's memorial service, which was attended by FDR. At four-thirty a funeral train left Union Station for Alabama, with the president and many other dignitaries on board, including a sixty-strong delegation of representatives. Will's funeral was held on the following day at the First Methodist Church in Jasper. He had honored Florence by requesting that he be buried in Jasper with his parents rather than in Huntsville with Adelaide, who everyone around him knew had been the great love of his life. Twelve years later, Florence was also buried with the Bankheads.

Tallulah, as always, sought solace in work. Rather than proceed on to Jasper, she rejoined *The Little Foxes* the very evening of Will's House chamber memorial service. A police escort took her to Philadelphia for the September 16 performance. Tallulah always found pity unbearable and even expressions of sympathy left her feeling uncomfortably exposed. Tallulah's theater maid Rose Riley told Rawls that those around Tallulah needed to "be strong and not let Miss Bankhead see our sympathy." Yet Rawls could see how difficult it was for Tallulah to pronounce the lines in the script referring to Horace Giddens's illness and death. "I looked at her and held her hand, as Alexandra, and made myself not cry when I saw her eyes."

"I am just gradually coming around to normal," she wrote a friend a month after Will's death, but Tallulah was, as Cole recalled, "filled with sorrow" in the aftermath. Some of her grief must have been for the relationship that she and her father had never had, and she must have experienced some guilt. During his last months, she seems to have been largely out of touch with him. Since his influenza in February, it had been evident to Will's family and friends that his health was precarious. Tallulah found

the prospect of his dying so upsetting that once again it would have been easier for her to remain distant.

Much remained unresolved between them. She had never "lived under the same roof with my father for two uninterrupted years in my whole life," she wrote in a 1951 recollection for *Coronet* magazine. During her earliest years he had been intermittently depressed, drunk, and suicidal. She had suspected that he preferred Eugenia—"that always worried her," said her friend, actor William Roerick. Nor could she escape her childhood fear that he held her responsible for Adelaide's death.

He had exhibited fatherly concern over the course of her adult life, and they had certainly spent warm and festive times together, but during her eight years in England, she had seen him only twice. She seems to have been wary about establishing any sustained relationship with him after she returned from England. The mutual trust that would have enabled her to share her emotions with him was never established. "We haven't enough confidence in our parents when we are young," she told an interviewer in 1944. "We're so convinced that they won't understand. We forget that they have been through whatever it is we are going through, or its equivalent, and probably understand far better than we do."

Her career provided a way both to vicariously fulfill her father's thwarted dream of being an actor and to go him one better. In 1938 Tallulah was in Washington to watch Emery in the tryout of *Save Me the Waltz*. One night she and Will drove John to his theater. After John had gone in, Will sat looking at the stage door, then turned to her and said, "Tallulah, if I had only had one whack at it!"

"Too bad I can't go with you," she recalled his saying as she left for New York in 1917. He had seen her onstage only a half-dozen times. His congressional demands precluded many visits to New York, and money was tight. "I suspect, too, that seeing me in the theater would have stirred and revived his old regrets." Perhaps Tallulah had felt somewhat burdened by the need to live out Will's dream.

"He never, to my knowledge, exulted over any success I achieved. His was an inner satisfaction, the knowledge that his daughter had fulfilled his hopes—and in a degree his own ambition."

"I don't know a word, and I don't believe there should be any, for consolations," Hellman wrote Tallulah. "I only wanted to say how sorry I was to hear about your father, and to tell you that I send all good wishes for you." Despite this letter, Tallulah's relations with Hellman and Shumlin only worsened as the tour continued. Cole, who was traveling with Tallu-

lah throughout much of that tour, said that Shumlin and she would speak, but only professionally. "He'd have to knock at her door, be announced, say hello, get the amenities over, and say, 'Don't you think you're doing a little this, or doing that a little bit too long?' Sure she'd accept it."

Shumlin later wrote Florence Williams that, "I would on a number of occasions go out to watch the play, and re-rehearse it, principally because of Bankhead's changing performances. Her ugliness towards me was so distressing, so undignifying, that I gave up checking on the play. I would have preferred to close the play, but it had to go on."

In 1975, Hellman told Jan Allen that Tallulah had "turned out at first . . . perfectly splendid. . . . And later on in the run of the play, not very good." Cole said that she became "more Tallulah" as the tour went on. She took off the corset that had been pinching her back for months, substituting a waist cinch that gave the same line to the costume but didn't force her to stand as straight as she had had to do in the corset. Nevertheless, in his opinion she still accurately represented the character of Regina Giddens.

Tallulah always spoke admiringly of Hellman's writing and Shumlin's direction, but she now considered them both seditious Communists. Alienating them was, however, a terrible professional mistake. She had wanted all along to take *Foxes* to London, and was so excited about exhibiting her performance to old friends and fans that she was willing to brave the Blitz. Emlyn Williams, who was producing the play in England, cabled her asking if she was interested. "YES! YES! YES!" she cabled back. But Shumlin and Hellman told Williams that as far as Tallulah was concerned, the answer was No, No, No. Instead, it would be Fay Compton who played Regina Giddens in London. The movie rights were sold to Samuel Goldwyn, who had earlier filmed Hellman's *The Children's Hour,* and Bette Davis, not Tallulah, was going to play Regina Giddens. Emery later said that when Tallulah discovered she'd been passed over, she threw everything detachable against the walls of their suite. In October 1940, Davis came to watch Tallulah's performance in Cleveland, but didn't dare go backstage.

When *The Little Foxes* returned to Washington, D.C., on March 17, 1941, for a weeklong engagement, Hellman was in the audience with William Wyler, who was going to direct the film, and her ex-husband, Arthur Kober, with whom she was collaborating on the screenplay. Tallulah must have wanted to remind them what a mistake they'd made. Nelson B. Bell in the *Washington Post* wrote that, "Seldom, if ever, has the return

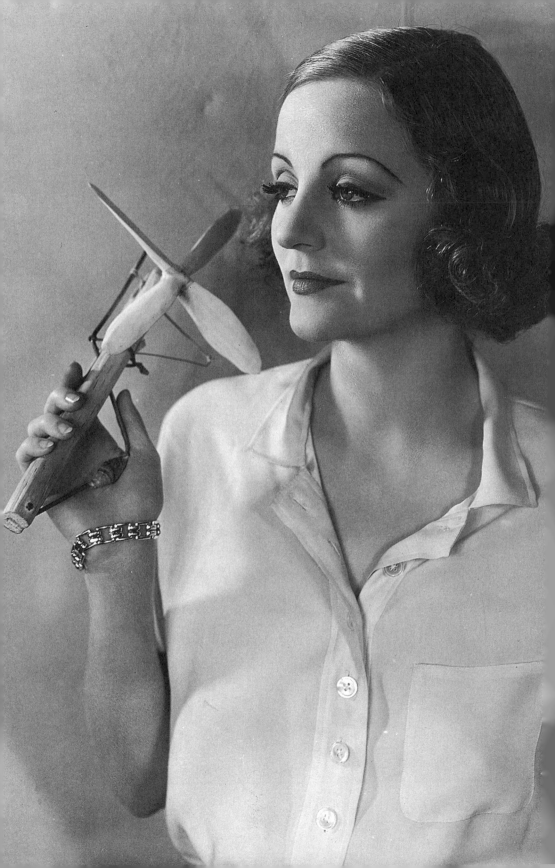

engagement of a major play so completely matched the excellence of its initial local performance. . . ."

The tour concluded with a return visit to Philadelphia early in April 1941. Emery now asked Tallulah for a divorce so that he could marry Geva. Tallulah agreed, having come to the realization that the marriage had always been pointless, although probably she would not have chosen to initiate a divorce, at least not yet. She had no intention of repeating her mistake, and was somewhat repelled, as were all the Bankheads, by her sister's multiple marriages. Etiquette of the time dictated that in an amicable divorce the woman would initiate an action, usually on the grounds of mental cruelty. Tallulah arranged to spend the requisite six-week residency in Reno, Nevada.

Tallulah now began to feel that if Emery remarried immediately, public perception would paint her as the injured party and she would be humiliated—and the public's perception of Tallulah was something that weighed on her a great deal. On her way to Reno, she arranged to stop in Los Angeles, where Emery and Geva were living together and both making movies. A meeting was arranged at George Cukor's. She and Emery went in a corner and talked quietly. Emery agreed to her request that he wait a year before marrying Geva.

In Reno, Tallulah and Cole rode horses and gambled. Called to testify, Tallulah produced the standard recital of vague accusations, fact, and conveniently manipulated fact that plaintiffs were compelled to compile in the days before no-fault divorce. Tallulah alleged that Emery was moody and morose, a defeatist with a violent temper, that he had hit her in public, and had once before her eyes tried to leap out of a window, with the result that she suffered insomnia and great mental strain. Through his attorney, Emery denied Tallulah's accusations, but naturally did not contest her action.

Out of court, Tallulah was conciliatory. After her decree was granted on June 13, she issued a statement that Emery was "a fine fellow" who had written her "a beautiful letter two days ago." She blamed a conflict of careers for the failure of their marriage. Tallulah and Emery did fulfill the cliché of friendly ex-spouses, acting together again in 1945. According to Geva, Tallulah didn't stop there. "When I married John, Tallulah was just dying to be a friend of mine, like crazy. She just didn't want anyone to know that anybody could leave her for somebody else. I played along always. I said, 'Why hurt her?'" Like Tallulah, Geva massaged and manipulated her own image relentlessly.

Before returning to New York, Tallulah also augmented her menagerie

of birds, dogs, and monkeys with a lion cub. She and Cole attended a circus performance staged for blind children by the Reno Lions Club. When it was announced that a star lioness was not performing because she was in the throes of childbirth, Tallulah requested an audience with the new mother. She was now very much involved in the campaign to bring the U.S. into the war on the Allied cause, and she named the cub "Winston Churchill" and brought him, heavily sedated, to New York. Stashed in a laundry basket, he was smuggled in and out of the hotel via the freight elevator for daily walks in Central Park.

Tallulah's sister loved animals as much as Tallulah did and also shared her penchant for exotic specimens. Eugenia was in New York that summer and had booked a suite at the Lombardy adjoining Tallulah's. It accommodated herself, a monkey, a red fox terrier, and a Pekingese, as well as perhaps her husband. She was now married to William Sprouse, a sergeant in the Marine Corps, "not educated but . . . a man of sterling quality," Aunt Marie described him.

Thirty years later, Eugenia described the way the lion stoked the resentment toward her younger sister that was so much a part of Eugenia's recollections of their relationship. One morning there was a knock at Eugenia's door and a sprucely attired hotel manager informed her regretfully that he would have to ask her to leave. "The health authorities will not allow us to turn this hotel into a zoo."

"My sister's got a lion next door," Eugenia protested. "Why I can't have three *harmless* little animals I don't know!

"Well, we've let Miss Bankhead have the lion under great protest. But she's been living at the hotel for a long time, and—"

"Yes, and she's famous and rich, that makes a little difference," Eugenia retorted, and slammed the door in his face.

Although lions are harmless when they are newborns, they grow rapidly. Part of Tallulah's enchantment with her new pet was undoubtedly the way it could frighten and surprise unsuspecting visitors, but Tallulah herself was terrified when Winston Churchill took an inopportune swipe at her. By the end of the summer, she had taken him to live at the Bronx Zoo. Cole also became attached to the lion, and claimed that it was he and not Tallulah who continued to visit Winston there. In November 1942, however, Tallulah would tell Robert Francis of the *Brooklyn Daily Eagle* that Winston had "grown so big you wouldn't know him. . . . I go up to see him every now and then. He always knows me. Gentle as a kitten."

During the summer of 1941, Tallulah again toured in summer stock,

reviving *Her Cardboard Lover*, with Harry Ellerbe in the part Leslie Howard had played opposite her in London in 1928. Like Tallulah, Ellerbe's experience with author/director George Kelly had been a high point in his career, when Ellerbe starred in Kelly's *Philip Goes Forth* in 1931. More recently, he had toured with Ethel Barrymore and Alla Nazimova, two of Tallulah's favorite theatrical matriarchs. In an unpublished memoir, Ellerbe writes that he had played André, the lover who proves much more enduring than cardboard, once before in summer stock, and he loved the part.

The revival's titular director was John C. Wilson, an American who had broken into the theater as a result of his long affair with Noël Coward in the 1920s and '30s. He was considered a man of great taste and his production banner guaranteed a high standard. But as a director he was less than a tyro.

Ellerbe writes that that Wilson treated the first rehearsal as "a social gathering where everything and anything was discussed except the play itself." Both Ellerbe and Tallulah were annoyed when Wilson continued to display "an appalling lack of preparation." On the third day, he told them he was taking several days off to attend the Lunts' "graduation." The University of Wisconsin was bestowing honorary degrees on them. "I'm sure you'll carry on beautifully without me," he told the company assembled onstage.

"But of course we will, darling." Tallulah assured him. "When are you leaving?"

"Right away, sweetie."

"Well, have fun, darling, and give Lynn and Alfred my love." Wilson threw kisses at Tallulah as he walked up the aisle of the Henry Miller Theatre. Once he was out of sight, Tallulah turned to the company and said, "Now, darlings, let's forget everything the sonofabitch said, and start from scratch. . . . !"

Wilson was not heard from again until the revival's opening night at the Westport County Playhouse on June 30. According to Ellerbe, it was Tallulah herself who "did a remarkable job in getting it on without director or figurehead." She certainly knew the play inside out, having performed it for an entire season in London and on tour.

For the first act, set in a French casino, Tallulah selected a Hattie Carnegie ice blue evening gown. She was very tan from her time in Reno and looked so striking in the gown that Cole, who was stage-managing, regretted decades later that he had not taken a color photo.

Ben Edwards, who became one of Broadway's leading set designers,

had graduated from Dartmouth three years earlier and was a summer apprentice in the resort town of Marblehead, Massachusetts, when Tallulah and her company came through. Edwards saw her at her best: "She used to hang around all of us working on the scenery," he recalled in 1992, "and go out and eat with us at little dives, and we'd go to her hotel. She sort of became one of the gang."

Each of the local theaters provided its own scenery and bit players for Tallulah's *Cardboard Lover*. At the Cape Playhouse in Dennis, the management wanted to show Tallulah the sets prior to the dress rehearsal. "Great God!" Tallulah shrieked when she saw what had been designed for her bedroom in acts 2 and 3. "It's the color of horse shit. I cannot play farce comedy in front of that, darling. You'll have to redo it."

Ellerbe agreed that the color was all wrong. Tallulah stomped off and the young designer responsible pursued her, protesting in tears that it would be impossible to change the shade before the next night's opening. Tallulah replied that in that case she would not open. The crew worked through the night to remedy the set. Tallulah proclaimed it "utterly beautiful" and sent the designer an expensive gift and a bottle of champagne.

Tallulah's "expertise as a *farceur* made *Her Cardboard Lover* a joy," Ellerbe recalled. "There was a 'hand-in-glove; give-and-take' between us that was exciting." Cole recalled that with Ellerbe, Tallulah enjoyed one of the most snugly fitting comedic partnerships of her career. One day during a break in rehearsals, Ellerbe found her in a reflective mood. "To be a success in the theatre, Harry, you must set a high standard for yourself and stick with—raise it but never lower it. Respect your own talent or nobody else will." If Tallulah regretted not fighting for better roles in the past, she was now determined to maintain the standard set by *The Little Foxes*. When she returned to New York, she let it be known that she was looking for a dramatic part to equal Regina Giddens, and before long accepted one of the most challenging of her career.

Drama by the Kitchen Sink

"The lady was too much of a lady for the part."

—CLIFFORD ODETS

Tallulah had asked Clifford Odets for a play back in 1935, when he had just burst into fame on Broadway. His *Waiting for Lefty* and *Awake and Sing!* brandished a populist banner, an affirmation of the possibilities of theater to arouse political will and social consciousness. Odets was the leading dramatist of the Group Theatre, a conclave of young idealists who had met while playing small parts for the Theatre Guild. They admired the ensemble cohesion possible in the state-subsidized theaters of Europe and the Soviet Union, and the agitprop exhortations of activist playwrights like Bertolt Brecht. The child of Romanian Jewish émigrés, Odets said in 1938 that he was not a member of the Communist Party but was "highly sympathetic to its aims." This was not Tallulah's customary milieu, which may have been what attracted her to Odets, and why they had been lovers in 1935.

But it was not until 1941 that he had a part and play for her: *Clash by Night*, in which Tallulah was to play Mae Wilenski, a housewife married to a WPA construction worker. Like all of Odets's work, it was flawed, untidy,

undeniably powerful, and possessed of a singular rhetorical eloquence, both flowery and brutish.

After ten years of existence, the Group Theatre was beginning to fracture as a result of the conflicting aims and ambitions of key members. Its egalitarian premise made it hard to enforce the disciplined hierarchy necessary to function. Odets's decision not to let the Group produce *Clash by Night* marked its virtual demise. Instead, Odets sold it to impresario Billy Rose, who had some experience in the theater by virtue of his now-dissolved marriage to Fanny Brice, but whose customary venues tended to be the World's Fair Aquacade and the Diamond Horseshoe nightclub in Times Square. Odets took with him two pillars of the Group: *Clash by Night* was directed by Lee Strasberg, and Lee J. Cobb played Mae's husband Jerry.

Clash by Night is a violent, seamy story unfolding over the torpor of a Staten Island summer. Mae Wilenski is a thirty-four-year-old Staten Island housewife tending to a newborn daughter. Over Mae's objections, her husband of six years insists that his best friend Earl, a movie projectionist subbing as a construction worker, rent their extra bedroom. Earl is after Mae right away, but she resists him for several weeks before they become lovers. Jerry discovers the truth, and Earl and Mae decide to run away together with her infant. Jerry tracks Earl down to the projection room of the movie theater where he is working and strangles him.

Life declared that Tallulah "alone among top-flight actresses of the U.S. stage would dare to face a role so brash and grubby." It was indeed a courageous choice, far removed from Regina Giddens: she had this time not fallen into the trap of her London years by trying to repeat a formula that had once proved successful.

Tallulah would have heard a lot about Billy Rose from Brice, with whom she was very friendly. She and the producer began to spar almost immediately. During rehearsals, Rose sent his sister Polly, with whom Tallulah was also friendly, to buy some cheap housedresses for Tallulah to wear as Mae. Polly did the best she could with the minuscule budget her brother allotted her, but when Tallulah tried on the dresses they didn't fit. She then proceeded to phone Hattie Carnegie's atelier and order three silk dresses that were so simple that seen from the audience they could pass for down-market. "They fit her," Cole said, "they fit the character, and she looked well in them." Tallulah charged them to Rose and gave him a lecture about not treating a star that way.

Relations reached a flash point because of Rose's refusal to install footlights on the stage of the theater. Footlights provided added illumination to

the front edge of the stage, which is where stars often tend to be positioned. But they did not accord with the aesthetic ideals of the new wave, which dictated that stage hierarchies be dissolved. Rose was very close to a nickel and was probably just trying to cut costs. But Tallulah had spent her entire career in front of footlights, believed that they were flattering, and liked the way they blinded her, making it easier for her to immerse herself in the stage action. After *Clash by Night* she had her contracts stipulate that they would be provided.

Odets limned a secondary romantic couple to counterpoint the triangle of Jerry–Mae–Earl. Peggy Coffee, a younger friend and neighbor of Mae's, has just lost her mother and looks to Mae for guidance; Peggy is in love with her neighbor Joe Doyle. Peggy and Joe are trying to decide what they really want from each other.

Joe was played by Robert Ryan, who had yet to make his movie debut. Katherine Locke played Peggy. "I should never have been in that play," Locke said in 1993 of the supporting role she played. For she had already scored a big hit starring opposite John Garfield in *Having Wonderful Time* in 1937 and had played Ophelia to Maurice Evans's Hamlet in 1938. In 1940, Strasberg had directed her and Lee J. Cobb in *Fifth Column,* the first and only play to which Ernest Hemingway signed his name. It was Strasberg's wife, Paula Miller, who convinced her to take the touching if undeveloped role of Peggy in *Clash by Night.* "Paula had a way of manipulating people," Locke recalled.

Locke liked almost no one connected with *Clash by Night.* She felt that Odets was "a miserable human being" whose affair with actress Frances Farmer had nearly destroyed her. Locke's feelings toward Tallulah were a mixture of condescension and compassion. "I think she was fond of me in her own crazy way," Locke said. Tallulah once invited her over to her suite and they were talking casually when Tallulah said, "By the way, darling, I was asked, 'What's the difference between beauty and charm?' and I said, 'Darling, I have beauty, Miss Locke has charm.'" Locke sensed Tallulah's engulfing loneliness and her fear of solitude. Once Locke came early to a rehearsal. Tallulah had arrived even earlier and was sitting alone, in a state of near panic. "Oh, I'm so glad, darling, you're here!" she said.

Locke didn't like Strasberg's direction, finding his approach "Talmudic" and "very confusing." She thought he was cruel to defenseless actors playing small roles. Along with the Group's Sanford Meisner and Stella Adler, Strasberg became a celebrated acting teacher preaching the "Method," a convenient umbrella for a constellation of systemizations of

Konstantin Stanislavsky's teachings. Locke recalled telling Strasberg, "Listen, there's more than one way to truth. There isn't just one road. Some of your actors—in spite of your work—will come out all right!"

Tallulah, however, followed Strasberg's direction closely, despite having no interest in becoming an adherent. Strasberg tried a Method conversion to which Tallulah listened politely but paid no attention. Yet the Method codified techniques used by virtually all actors, Tallulah included. It is inevitable that actors cull "sense memories" and emotional responses from their own experiences, whether consciously or not, whether or not they try to summon up these memories before or during each performance, as the Method teachers encouraged their pupils to do.

The refusal of Tallulah and most stars of her vintage to fall into Method line did not render their technique archaic, despite the popularity that Method acting would achieve. Rather, it could be argued that the Group and its disciples were guilty of claiming to reinvent the wheel, and it must be said that they did so with a moralistic fervor that was self-serving. Their determination to sweep away most of what they found before them was certainly an affront and threat to the established acting order, which frequently retaliated with withering scorn. Tallulah was dismissive on grounds that were perhaps more than simply defensive. To her, the Method may have seemed amateurish, a throwback to a primitive phase in her artistic development. "If you act on emotion you do it beautifully one night and the next night, it just doesn't come. . . . I did that once, but now I know I can reproduce the effect every night and it will be right. You must be conscious of yourself," she told the *New York Times* during *Clash by Night*'s Broadway run.

It is the eventual dominance of the Method doctrine—as well as Tallulah's own public shows of nonchalance about her work—that probably explains why, when Tallulah isn't being described as lacking in technique, she is reported to have been so coldly technical that she did not do any emotional preparation at all and simply walked from her dressing room and picked up her onstage cue. But Cole, who stage-managed *Clash by Night,* said that in this as in all her plays, Tallulah constructed an imaginary "closet for the character" that she could go into and retrieve the character whenever she wanted to. She also kept her dressing-room door open after the curtain went up so that she could hear how the performance was going when she wasn't onstage. She was able to insert herself into the play by standing in the wings and listening for a couple of minutes to the dialogue onstage. Tallulah's personal method certainly succeeded in establish-

ing every actor's goal of stage reality. In 1938, the *New York Herald Tri-
bune*'s Helen Orsmbee had written in her book *Backstage with Actors* that
Tallulah was:

> . . . particularly gifted at using imagination so that she extends the re-
> ality of a scene beyond the limits of the stage setting. Every time she
> comes in or goes out at a door, that next room, that hallway, that side-
> walk which cannot be seen, all become existent in the story. She makes
> you believe that they are there just out of view. From the first moment
> she steps into a play she brings with her a conviction of the reality of
> events that have been happening offstage.

In tune with the egalitarian and ruminative tendencies of the Group,
Clash by Night's rehearsals witnessed exhaustive analyses of Mae's character
by Tallulah, Strasberg, and other members of the cast. Cole and Tallulah
also talked about her between themselves. While Mae's socioeconomic
profile was alien, the role played to many of Tallulah's acting strengths:
Mae is salty and outspoken and simmering with discontent. She is a
woman trapped by circumstances and dogged by the knowledge of her
own shortcomings. She can't stop snapping irritably at her husband and
she can't help being angry at herself for being so short-tempered. She is not
entirely coherent or consistent; Odets crowds into her character too many
credos and dissatisfactions, from cosmic angst to pettiness. She has too
many different chips on her shoulder and we're not told by him what their
interconnectedness is and which we should pay most attention to. Mae is a
typically diffuse yet fascinating Odets statement.

Her speeches are leavened by dry quips that might have been written
especially for Tallulah. Perhaps they were. In the opening scene, Jerry tells
Mae, "Earl knows some of those movie stars in person." "They're not
happy," Earl says, "those movie people, none of them." "Yeah," Jerry replies
in what Odets describes as a customary tone of childlike bewilderment,
"all that money an' cars an' chauffeurs, an' what have they got?"

"They've got money, cars and chauffeurs. . . ." Mae replies.

Dominated by the Method, the production of *Clash by Night* became
one of the most heterogeneous mixes of acting styles and temperaments
imaginable. Cobb was a magnificent actor who embodied the best and the
worst traits of the new school of actors. His intensity and immediacy were
harrowing, but he was all but incapable of a light touch. His insistence on
living in the moment made him so improvisatory as to be maddening to

Tallulah. "He was so Method," Cole complained, "that he would take forever for his next idea to come to him and go all the way through the head." Cole claimed that Cobb exasperated everyone in the play, including Odets, who was a great friend of his but "had it out with him almost every night.

"Even Strasberg said to him: 'If you're going to make a sandwich, put it together. You put the bread here, and then you put all the ingredients over here and then you put another piece of bread down, but you never put it together. If you're going to do that, do it, don't wait forever. The audience has seen what you're going to eat.'"

Between the glower of Tallulah and the lumbering of Cobb was positioned the stylish swagger of Joseph Schildkraut's Earl. Schildkraut was returning to the stage after six years in Hollywood. It is often proposed that the exhibitionism of a theatrical "ham" precludes true acting greatness. Schildkraut may have been, as Cole claimed, "the whole hog," but at least on the evidence of his films, his propensity for displaying his chiseled profile doesn't detract from his consummate skill. He would have been perfectly at home in the role of Earl, who bluffs and preens and at first gets nowhere with Mae.

Locke found Schildkraut's "embroidered" acting interesting, but didn't think much of him offstage. "He was shallow. He was on the make before we'd been introduced, when I got in the elevator." Her sentiments were echoed by Cole, who called him "a terrible man," and expressed compassion for "his poor wife. He just ordered her around like a slave." Schildkraut asked Cole to come to his hotel and feed him cues while he worked on his lines. When Cole refused, Schildkraut asked why not and Cole told him, "The only person I've ever cued in my life is Miss Bankhead."

For three days before the October 27, 1941, premiere at the Wilson Theater in Detroit all concerned with *Clash by Night* hardly left the theater. Amphetamines were passed out like Life Savers, in the customary last-minute crunch to get a new production on the stage. From Detroit they went to Baltimore, Pittsburgh, and Philadelphia. Tallulah was becoming more and more exasperated at Cobb as he followed the dictates of his emotional experience so blindly that he never adhered to the same blocking in any two performances. "She never knew what he was going to do," Cole said. Tallulah herself never gave exactly the same rendition performance to performance, but she followed a consensual outline. With Cobb "she always played it absolutely the same, because then he couldn't come back and say, 'I didn't know what she was going to do.'" When she felt Cobb drifting out of her orbit, Tallulah took to perching upstage center, the most

powerful and visible station on the stage, until Cobb's survival instincts drew him back to a closer connection with her.

They opened in Philadelphia at the Locust Street Theater on November 17. But after the performance, Tallulah collapsed backstage. She had had pneumonia for at least twenty-four hours, but was too preoccupied with the play to realize how dangerously ill she was. She was rushed to the hospital and put into an oxygen tank, and for several days her life was in danger. By November 29 she was past the crisis. "It is remarkable to me that she pulled through," said her physician in Philadelphia, Dr. A. I. Rubenstone. In her autobiography, Tallulah blames her illness on Rose's harassment.

After being discharged from the Philadelphia hospital, Tallulah went with Cole to recuperate in Atlantic City. She was relieved at the prospect of a rest, but felt guilty about leaving the show. "There's no such thing as the show must go on," Cole assured her. "The show can go on with another actress. If you died, and they felt this was an important play, somebody else would do it."

Katherine Locke's response to Tallulah's Mae Wilenski was colored all along by her conviction that "Tallulah was wrong for the part. I was right for the part." Locke offered to play Mae while Tallulah was ill. "That was my mistake; of course I was turned down." She had refused an earlier play of Odets and believed that he was punishing her, but actually, the part would have been off-limits anyway. Like most of the biggest stars of the day, Tallulah did not have an understudy: if she was indisposed, the show closed.

Clash by Night finally opened on Broadway on December 27, 1941. *Women's Wear Daily* reported that one of the year's "largest and most fashionable audiences" flocked to the Belasco to see Tallulah try her hand at proletarianism. Pollock in the *Brooklyn Daily Eagle* described it Odets's "most intense play," and said it had "kept the audience holding on tight." The cast had performed "with the seriousness of actors in the grimmest of Eugene O'Neill's plays, for Odets has made his play taut and built it as carefully as a watchmaker." George Freedley in the *New York Morning Telegraph* wrote:

> There isn't a person writing for our stage today who can speak more pungently, with a hard brilliance which conceals tenderness, honest rage and a cold loathing of the poverty of the world and the maladjustment of wealth which causes it. This is exciting theater, if somewhat overwritten and, as acted by Miss Bankhead, Mr. Schildkraut and Mr. Cobb, is unquestionably the most interesting play in town, bar none.

Tallulah's reviews were nearly all excellent, although as might have been expected, some of the most enthusiastic included the proviso that it was difficult to accept her as a blue-collar housewife. Odets himself told Polly Rose, when she wrote a biography of her brother, that "the lady was too much of a lady for the part." But what is interesting is that several critics felt she was entirely convincing. Lockridge in the *New York Sun* wrote that, "Miss Bankhead has never, even in *The Little Foxes,* played better, with more sense of character or with more feeling and intensity."

Pollock wrote that Tallulah had acted "with great honesty, wanting very much to obliterate all characteristics that would make her Tallulah rather than drab Mae Wilenski of Staten Island, formerly of Scranton, Pa., ex-waitress. . . . it is probably the most difficult job she has ever undertaken and her greatest achievement."

Despite the auspicious opening, *Clash by Night*'s business flattened after the opening week. Pearl Harbor had been attacked while Tallulah was in Atlantic City. Cole thought that the country's instantly transformed mood was what ultimately doomed the play; the domestic triangle took on "a great unimportance."

Nevertheless, Tallulah's Mae Wilenski awakened considerable interest among her fellow actresses. Garbo came to see *Clash by Night;* Judith Anderson and Ruth Gordon each came several times. After one performance attended by both Anderson and Gordon, Tallulah and Cole went with them to Club 1-2-3 on East Fifty-fourth Street, where the three women talked shop and discussed the footlight issue: Anderson and Gordon both agreed with Tallulah.

Tallulah had begun *Clash by Night* extending civil pleasantries to Schildkraut that he mistook for sincere interest. Soon she began to find him dreadfully boring and then he began to grate mightily on her, and to feel the lash of her disgruntlement.

Clash by Night opens with Mae, Jerry, Peggy and Joe all sitting on the Wilenskis' porch. Tallulah was to sing some verses of "The Sheik of Araby." Her singing was flat. "She had a tin ear," said Locke, who had trained to be a pianist. "It drove me crazy." Tallulah discovered Locke's musical background and asked for her help. Locke told her not to sing full voice because of her pitch problems, not to "try to be an opera singer. It drives me crazy just to hear you."

She took Locke's suggestion and her singing improved, but "she fell in love with the sound of her own voice" and kept singing past one of Cobb's cues. Finally, at one performance Cobb yelled, "Shut up, Mae!" Later in the

scene they exited together, and "you could hear her out front, attacking him," Locke insisted. "I thought, 'Why don't they bring the curtain down?'"

Standing in the wings later in the performance, Tallulah was fuming at Locke about Cobb and "those Group Theatre actors!" "Listen, Tallulah, you did something very unprofessional," Locke told her. "I'm sorry that I even gave you the advice. You went on and on and on. I thought you'd never stop. Lee had to say his lines. You know what it's like to come to a cue if you're distracted by something."

"Well, I should have known better! You Group actress!"

"I've never been a Group actress to begin with, and I'll thank you not to talk to me in that tone." More words were exchanged and Locke bowed out by saying, "There is nothing in my contract that says I have to say any lines to you except those written by Clifford Odets, and I will thank you not to address me anymore."

Later during the performance, Locke noticed that Tallulah was coming much closer to her than she was supposed to, and with a smile on her face was soon covertly yanking at Locke's hair. "If you continue this," Locke told Tallulah out of the side of her mouth, "I'm going to hit you right in the mouth."

Tallulah seemed to be distressed by Locke's refusal to engage with her. Tallulah's usual "Hi," as they gathered on stage before the curtain became "Hi, *darling*." Locke turned her back. Tallulah sent Rose Riley to plead her case with Locke. Locke was unmoved.

"Darling, I have a compliment for you," Tallulah announced as they waited to begin another performance. "Ruth Gordon was out front with Thornton Wilder, and they came backstage and said, 'Tallulah, you sing so beautifully! What happened?' I said, 'Katherine Locke taught me.'"

"Tallulah, stop," Locke replied. "Don't give me that stuff. I'll talk to you. Not too often, but I'll talk to you."

"She sounded so pathetic," Locke recalled, "like a little girl. I wanted to say, 'Oh, you poor little thing.'" But Locke was willing to give as good as she got from Tallulah and almost enjoyed doing so. When Tallulah learned that Locke had filmed a screen test with actor Lloyd Goff, and that he was also a friend of Locke's husband, she asked the younger actress to introduce them. "Not on your life," Locke replied. "I wouldn't waste that on him, Tallulah. I'm sorry. He's a friend. I wouldn't do that to him."

Ticket sales rallied and *Clash by Night* was generating a small profit when Rose decided to close it after seven weeks on Broadway. It had been

a traumatic experience for all concerned. "Never did a final curtain fall on a more relieved actress," Tallulah later recalled. Both she and Katherine Locke immediately checked into private hospitals for a week of rest.

Radio was Tallulah's only medium for the next six months. She had signed with the William Morris Agency to handle all the work she did away from live theater. Although she negotiated her own stage contracts, she reasoned that networks dealt exclusively with agencies and would not hire an actress who was not represented. She was handled by agent Phil Weltman, who had recently joined the Morris office in New York.

Few of Tallulah's colleagues were indifferent to her: she alternately inspired the most belligerent derision or the most ardent devotion. Weltman was destined to have a long and warm association with her. One week in March 1942, Tallulah was a guest on *The Kate Smith Show.* Smith's manager Ted Collins came over to Weltman while Tallulah was rehearsing: "Are you representing Tallulah Bankhead? . . . Well, she can't do the show that way. . . . She isn't wearing a dress." Tallulah had become addicted to slacks while she was in Hollywood.

Weltman knew that the only people who would see Tallulah were a small studio audience, and he knew that it was too late for a substitute guest to be found for that night's broadcast. He told Collins that he wasn't even going to mention it to her. Later, however, Weltman and Tallulah were talking in her dressing room. She asked if he was having a problem with Collins. Reluctantly Weltman told her about their conversation. Ten minutes later, she told him that she had to run an errand and would be back in thirty minutes. When she returned she was wearing a dress. "She did this just so as not to cause me a problem," Weltman recalled in 1995. "This is the kind of a lady she was. I'll never forget her for that."

With Florence Eldridge and Dick Van Patten in *The Skin of Our Teeth.*

Multiple Personalities

"I have a death wish. But there's one thing about dying that has always troubled me: that you would not have told the people you love how much they mean to you."

During the summer of 1942, Tallulah rented a house in New Canaan, Connecticut, and enjoyed an idyllic vacation with Cole and Winwood. Every night after dinner they strolled into town, drank an ice cream soda at the local drugstore, then sauntered back. It was there that she received the script of Thornton Wilder's *The Skin of Our Teeth*. "It's an extraordinary thing to find yourself with a script that means a lot to you," she later told the *New York Herald Tribune*'s Helen Ormsbee. Wilder's play is a comic parable of humankind's endurance, written as an absurdist free-form carnival. In each of the three acts, Tallulah played Lily Sabina, an embodiment of the Bible's Lilith in the guises of chambermaid, bathing beauty, and camp follower. But, in addition, she played the actress ostensibly impersonating these roles, a "Miss Somerset," who would deliver a running commentary directly to the audience about her various dissatisfactions, voicing, as it were, the audience's own possible bewilderment.

"I hate this play and every word in it," Miss Somerset confides shortly after the curtain goes up. "I don't understand a single word of it, anyway. . . ." In the second act, she interrupts an adulterous seduction scene on the Atlantic City boardwalk, protesting to "Mr. Fitzpatrick," the stage manager, that she just cannot go through with it; she is too sensitive to the feelings of a girlfriend of hers who lost her husband just this way. In the third act, she joins her fellow actors in explaining to the audience that several cast members have come down with food poisoning and her maid Ivy and other backstage support staff will have to read their lines.

Despite Wilder's position as one of America's preeminent men of letters, *The Skin of Our Teeth* was pronounced too risky by every established producer on Broadway. Michael Myerberg was an impresario who had managed the conductor Leopold Stokowski for five years, and would now be making his debut as a Broadway producer.

Tallulah loved the play but was afraid it might baffle a Broadway audience. She gave it to Winwood and then to Cole to read, and both of them urged her to do it. The part of Sabina had originally been offered to Helen Hayes, who wanted to accept until playwright Edward Sheldon advised her that the part rightly belonged only to Tallulah. Hayes regretfully returned the script and relayed Sheldon's words to Wilder.

Hayes was pleased when Tallulah called: "They have sent me this script and they've told me that Thornton wanted you but that you had suggested me. Well, darling, I'm going to do it. I don't care who wants me or doesn't want me, or how low I'm in the line. I love this play and this part and I'm going to do it."

A phone call from Wilder made Tallulah feel wanted. From New Canaan she cabled Wilder on August 17 at the camp in Harrisburg, Pennsylvania, where he was in training to enter Air Force Intelligence.

DEAR THORNTON IT WAS SO SWEET OF YOU TO PHONE ME I WAS
SO PROUD TO BE IN YOUR WONDERFUL PLAY AND SO HAPPY THAT
YOU SEEM PLEASED ABOUT IT AND HOW I HOPE THAT YOU WILL
BE ABLE TO BE WITH US DURING REHEARSALS TO GUIDE US LOVE
TALLULAH

Tallulah surely knew that Wilder could not actively participate in rehearsals, and was probably alerting him to her anxiety about the fact that both Myerberg and the director he'd chosen, Elia Kazan, were neophytes.

Kazan, a young actor, a mover and shaker of the Group Theatre, had recently made two Hollywood films. But his directing experience was not extensive.

Fredric March was to play Mr. Antrobus, patriarch of an archetypal American family living in suburban New Jersey, beset in act 1 by talking dinosaurs and the onset of the Ice Age. Lily Sabina had been one of the mythological Sabine women, abducted by Antrobus and brought home, to his wife's chagrin.

March insisted that his own wife, Florence Eldridge, be hired to play Mrs. Antrobus, the timeless voice of domestic rationality. Both March and Eldridge had been signed months before Tallulah. She agreed to share co-star above-the-title billing with them—which she hadn't done with anyone since Grace George in *The Circle* four years earlier—provided she receive the leftward position, which is considered optimum. Eldridge and March agreed.

Wilder's sister Isabel was going to be his eyes and ears at rehearsals. Tallulah had "a rather maternal approach to me," she recalled in 1992. "'Little Isabel,' I was called, and she was going to make fun for little Isabel and do this and that. She seemed to think I needed to be given treats and things." Was she putting on a show for her? Isabel wondered. Was she trying "to be a great lady and take me into society?" It seemed to Isabel as though Tallulah were constructing a definite characterization on her behalf.

"I've never had the experience before of someone who felt that she had to take over, that 'little Isabel' needed looking after. I was a very quiet, I would say modest, person. On the other hand I had to perform pretty big things. I never thought that I was important in the sense of showing off, but I was important as the job I had of being Thornton's sister."

Isabel's life was very much spent in her brother's shadow, not due to a lack of her own ability—in 1928, she had received a master's in playwriting at the Yale Drama School—and perhaps not without some resentment on her part. Isabel never married, and she claimed to Wilder's biographer Richard Goldstone that her brother had sabotaged her relationship with the one serious beau she'd entertained as a young woman.

Tallulah told Cole, whom she had installed as assistant stage manager, that she wanted to make clear the differences in each manifestation of the eternal seductress/muse she impersonated. Despite the havoc that Lily Sabina threatens to wreak throughout the play, Tallulah was determined that the audience would find her in the end sympathetic. In the third act, Wilder had given her some of the most somber and poignant reflections in the play, and there were tears in the audience when Tallulah spoke them.

Mrs. Antrobus, too, offered both riotous and somber opportunities. Eldridge was an excellent dramatic actress, but was not the comedienne Tallulah was. Cole felt that Mrs. Antrobus was the part Hayes should have been playing, and she did just that, twelve years later, in a revival produced by Robert Whitehead. Whitehead recalled in 1993 that Hayes's performance demonstrated to him how much "mileage" the original production had "lost" with Eldridge. Hayes mined the role for laughs that Eldridge had never uncovered.

Tallulah quickly found Eldridge odious. Kazan writes in his 1988 memoirs, *A Life,* that Eldridge was "the perfect patsy for Tallulah," thanks to Eldridge's "rather artificial manners, society laugh, and inflated big-star posture." Kazan found her a "decent, honest, sincere, reliable woman, but how tedious those virtues can become when they're not leavened by doubt, self-deprecation, and openheartedness."

Eldridge warned Kazan repeatedly to be on his guard against "that bitch," and during rehearsals asked him on a nearly daily basis, "When are you going to do something about Tallulah?" Kazan felt she was terrified about sharing the stage with Tallulah, but says he "couldn't help . . . liking" Tallulah's work at rehearsals.

Yet Tallulah was the epitome of everything Kazan, born in 1909 to traditional Turkish parents, had been taught to revile in a woman. Lee J. Cobb said that Kazan "was always trying to get somewhere, and it seemed to many of us in the Group that he would do *anything, really, anything* to get there." But Tallulah's drive to dominate was as strong as his. "They were beyond stubborn and each had to be on top," Isabel Wilder said.

A lifelong resident of New Haven, Isabel had known Kazan when he attended the Yale Drama School for two years in the early 1930s. As a director, Kazan seemed promising, she recalled, but was untried, and no one knew he had as much talent as his subsequent career demonstrated. She was bewildered when he was hired and attributed it to the producers' concern for the bottom line; Kazan would not be expensive. "He did a very good job for such a young man but he was too new to have such a big show." She described him as "crude and cocky, a young man who didn't know how to conduct himself. He didn't take anything from anybody, and he was horrid to Tallulah." There was a chemical animosity between them: "She didn't go out to provoke him. Just the way she *was* provoked him. He hated her."

Kazan's account of *The Skin of Our Teeth* in interviews over the years and in *A Life* has been accepted unconditionally, in part because Tallulah

has become a reductive caricature in the public eye, and in part because the public has usually been willing to accept the word of aggressive, celebrated men over that of aggressive, celebrated women. But Kazan's book and his account of Tallulah veritably glow with the strong streak of macho posturing and even misogyny that was prevalent among many of the *machers* of the Group Theatre and the Method.

The actresses they seem to have valued most were those who projected helplessness, like Marilyn Monroe, or who were dedicated to the point of masochism, like Vivien Leigh, of whom Kazan writes approvingly that she would have "crawled over broken glass if she thought it would help her performance" in *A Streetcar Named Desire*.

Reviewers of *A Life* largely ignored the way Tallulah assumes in his recollection an allegorical importance within a larger sexual-psychic dynamic. But Eric Bentley, reviewing Kazan's *A Life* in *The Nation,* was disturbed by Kazan's insistence that the only two people in his life he'd ever hated were Tallulah and Lillian Hellman. Bentley identified the way Kazan opposed these two putative harridans with a flock of female angels, principally his first wife, who suffered through his numerous infidelities and died young of a stroke.

Oddly, despite the doorstopper size of his memoirs, Kazan says not a word in *A Life* about *The Strings, My Lord, Are False,* which he had directed on Broadway six months before *The Skin of Our Teeth*. It is as if he has nominated *The Skin of Our Teeth* to absorb a collective burden of maturation and experience. But this play, too, seems to have been difficult for him. Cast member Joan Shepard, who later played Tallulah's daughter in Philip Barry's *Foolish Notion,* remembered that "he was terribly at sea." During previews in New York, one of the producers, Alexander Kirkland, came to Shepard's dressing room and enjoined her, "Don't pay any attention to anything that Mr. Kazan says to you."

After Kazan was hired for *The Skin of Our Teeth,* Ruth Gordon, who had starred in *The Strings, My Lord, Are False,* wrote Wilder that Kazan did not have what was necessary to direct his play. She reminded Wilder that he himself had said that the great Jed Harris—who also happened to be her boyfriend—was the only suitable candidate. In his memoirs, Kazan admits that he was surprised he'd been chosen.

Cole saw Kazan's relationship with Tallulah differently. "They weren't the greatest pals in the world," he said, "but in the theater they got along beautifully. There may have been one or two blowups if something didn't go well, but she thought he was a wonderful director." And

Cole agreed with her: "Gadge [short for "Gadget," Kazan's nickname] knew *exactly*—he'd done all his homework."

"It was a collaborative effort," said Frances Heflin, who was cast as the Antrobuses' daughter Gladys. "There were certain scenes with Freddy March where they didn't quite agree," she recalled in 1983. "It didn't involve me, but Gadge prevailed. If he thought Tallulah was right he gave in. They always seemed in total agreement about her playing."

Kazan reports that on occasion Tallulah would simply walk out of rehearsals after a dispute, and on Myerberg's instructions, he would substitute her understudy. Tallulah's contract stipulated, however, that she would not have an understudy. Myerberg, however, had chosen Eve Scott, a twenty-year-old second-generation Slovakian who had a walk-on in the second act, and appointed her to be just that. Myerberg was reportedly sleeping with her at the time; a couple of years later she went to Hollywood and won fame as Lizabeth Scott.

Isabel Wilder had expected from the first that Tallulah would be trouble. "Great actresses always manage the whole show; that's what a star is." At one time or another, Wilder recalled, Tallulah "tried to have everybody fired. She tried to run everything. It wasn't nastiness, it was just the way she lived." They, too, had their disagreements. "I didn't fight with her outright. But when she came to a rehearsal and suddenly began to do it another way, or decided she thought they ought to come in the *other* door, I was going to get up there in time to hold her down."

But Isabel said that neither Myerberg nor Kazan was sufficiently prepared for the challenge of *The Skin of Our Teeth*, and that without Tallulah the show would never have reached New York. "She knew what she was doing. She was brighter than any of them. Things that weren't going right in the play she knew long before anybody else did."

The Skin of Our Teeth was to receive its world premiere in New Haven on October 15, 1942. As the show prepared to ship out of New York, "Everybody was getting along quite splendidly," Heflin recalled. "Tallulah was a terrible hypochondriac, as were all the actors in the show. Tallulah, Freddy, and Florence got together and decided who would find the various doctors in every town for the various ailments they might have: throat doctor, internist, chiropractor, masseuse." Despite the apparent camaraderie, however, tensions escalated.

It was in New Haven, Kazan recounted, that Tallulah "made a director of me," by provoking him to take off the gloves. He describes her complaining bitterly about the set all through the dress rehearsal. When it was

over at 3:00 A.M., Tallulah was leaving the theater, saw Kazan, and "was on me like a tiger, cursing me at the top of her voice for not standing by her" objections to the set. Kazan replied by telling her "at the top of my voice and in the crudest language how shamefully she'd behaved. I told her that I despised her and that everybody else did, too."

In Kazan's telling, the event reads as a tribal initiation rite, right down to an enveloping circle of approval-conferring mullahs, personified by the stage crew. He screamed Tallulah out of the theater and then, he recalls, "I walked into the center of that circle and looked at them all, acknowledging their endorsement. I'd made the grade."

"It was a terrifying part in the beginning," Tallulah recalled in 1963, "because I had to talk to the audience, and I'd never done such a thing; it was like being in vaudeville." She was disconcerted when her fellow cast members had stopped laughing at her asides after the first days of rehearsals. "I got a bleak feeling in my heart that I was very unfunny," she later recalled.

Wilder had written her: "It's necessary for the play that each of your changes of mood and especially the 'break-throughs' to the audience come with such spontaneous inner reality that they don't seem to the audience to be author's contrivances, but pure SABINA-NATURE. . . ."

Audience asides like these are taboo in the naturalistic aesthetic, where the "fourth wall" separating audience from actors is inviolate, but they have a hallowed place in theatrical tradition. "It's really the old Chinese technique," Tallulah recalled in 1949. Sharing with the audience the illusion-making infrastructure of the play is a staple of Eastern theater, which doesn't adhere to the same need to convince an audience to part with its disbelief. Wilder had adopted the same practice in *Our Town* four years earlier.

In Elizabethan, Restoration, and Romantic-era European drama, an actor often delivered asides to the audience in the guise of the character he or she was playing. In the twentieth century playwrights began exploring the technique of allowing the actor to simulate the intrusion of his own "self" into a parallel relationship with the character being enacted. This was a technique, as Tallulah noted, commonly employed in popular entertainment, music halls, and vaudeville. The most simple and direct means of communicating to the audience was also, at this point on Broadway, the most esoteric.

"It was a novel thing to an American audience, who's used to a certain tradition," Tallulah recalled in 1949. She found that some of her most recep-

tive audiences were servicemen from the American hinterland, many of whom had never seen a play before. "To them, who weren't cluttered up with conventions of the theater, they loved it because it wasn't unusual to them."

Tallulah opened the play alone, with a monologue, addressing the audience for perhaps as long, she recalled in 1949, as ten minutes, but "it may not have been ten minutes, it may have been six, you know a minute in the theater is longer than when an egg is boiling. Every night, until that went well, I couldn't quite relax because it was such a new experience for me."

Before the curtain went up, she mouthed the words to herself and vented some panic on Rose Riley, her theater maid. "She'd start shrieking to Rose, 'Get me this, get me that,'" Heflin recalled. "She didn't have the right bag, the stockings were hooked wrong, everything was wrong, it was going to be terrible, and it was all Rose's fault!"

"Shut up, Tallulah," Riley would say, standing by quietly. "Ssshhh . . . Behave yourself. . . . All right, Tallulah, you know if you keep on going like this you're going to wet your pants, and I'll have to change them for you."

The Skin of Our Teeth endured a rocky out-of-town reception. At the fall of the first-act curtain, audience members heckled up at the stage, "What's this all about? Give me my money back!" During one performance out of town, "We went up for the second act and most people had left," remembered Dick Van Patten who played a telegraph boy. Tallulah was unfazed, hurling newspapers bearing negative reviews across the room: "They don't know what they're seeing! They don't realize!" But there were mutinous feelings among the rank-and-file actors, who were "all moaning and saying that this is a turkey," Van Patten recalled, wondering how they'd gotten into this mess and if Myerberg didn't realize what a fiasco it was. "Eight out of ten agreed with the critics."

"They were all guilty," Isabel Wilder said about the star egos flaring across *The Skin of Our Teeth,* "especially Myerberg. I disliked him thoroughly." She objected to liberties he tried to take, including surreptitious attempts to alter the script. "He was a novice taking on this big thing, and so all the time he was shaking, shaking, shaking, and making quarrels, quarrels, quarrels."

"I don't know how many rules he broke," Heflin said, "but they were sufficient to cause arbitration before Equity. We all testified against Myerberg—to a man."

In Baltimore, Tallulah sent Kazan a letter: "Gadget! It is 4 A.M. I have been awakened from my troubled sleep like from a nightmare. . . ." She complained that March and Eldridge were "passionless and conventional

and have given up the ghost." Kazan says he was "shocked for the first time into some kind of respect for Bankhead." It was only then that he realized "that she did care passionately about the play."

From Baltimore on October 18, Tallulah cabled Wilder that "THE TWO FLORENCES FREDDIE KAZAN AND I ARE ALL IN TUNE LOVING EACH OTHER AND THE PLAY," but Myerberg was "BEHAVING LIKE A MADMAN."

They had arrived in Baltimore cheered by a bonanza advance sale, but bad notices dampened the grosses. Myerberg, who had put up 70 percent of the backing himself, was now trying to cut costs every way he could. He fired three actors playing small parts. Tallulah implored Wilder, who was now stationed in Hamilton Field, California, to come to Baltimore to mediate. She knew that such a request would not be looked upon kindly by his military superiors.

"BUT YOUR PLAY IS AN IMPORTANT FACTOR IN THE WAR EFFORT." She quoted from a speech by Mr. Antrobus in act 3: "I KNOW THAT EVERY GOOD AND EX-CELLENT THING IN THE WORLD STANDS MOMENT BY MOMENT ON THE RAZOR EDGE OF DANGER AND MUST BE FOUGHT FOR WHETHER IT'S A FIELD OR A HOME OR A COUNTRY," and added—"OR A PLAY."

Myerberg came to Tallulah and asked her for money to bring the show into New York. She told him she'd lost every penny she put into *Forsaking All Others* and wouldn't make the same mistake again. March, however, did buy an interest in the show.

Wilder was somehow granted permission to leave California. The following week, *Skin* opened in Philadelphia for a two-week run. A notice was posted backstage that "Captain Wilder" would be visiting and that the entire cast should stay onstage after the curtain calls. Wilder sat with Isabel and addressed the cast. "I know that my play has been receiving bad reviews, but that does not bother me, because I know it will be a tremendous hit in New York. But the thing that's disheartening to me is that *you*, the cast, have given up on the play. You're all acting depressed and wish you could get out of the show, and that's what hurts me. Maybe the trouble was you don't understand my play." He proceeded to deliver a thirty-minute explication of the text, to which they listened intently.

William Roerick was a young actor posted in Philadelphia on his way to perform overseas in the State Department's production of *This Is the Army*. In Philadelphia he watched a matinee of *The Skin of Our Teeth*. At the end of the first act, as the Ice Age descended on the Antrobus household, the theater auditorium itself became a playing field: actors dressed as ushers

pretended to rip up chairs for firewood and race them up to the stage. "Pass up your chairs, everybody," Tallulah appealed to the audience. "Save the human race."

"When Tallulah said that," Roerick recalled in 1982, "your breath caught, and you were moved and you shuddered." That night he attended a theatrical party in the basement restaurant of a hotel. Walking downstairs, natty in his uniform, he bumped into Tallulah coming away from the same party, an elderly man at her side. Tallulah looked up at him and smiled and he smiled back. He told her that he knew Emery, and how moved he'd been by her performance at the matinee. "*Moved!* Moved!" Tallulah expostulated to her companion. "Why don't the critics say *that!* Darling," she said, turning back to Roerick, "how terribly smart of you."

The result was an affair between them lasting for the duration of the Philadelphia engagement. One day Tallulah elected to tell Roerick's fortune by reading cards. "Darling, you're going abroad. I don't think anybody's going to be shooting at you in anger. . . . But you may be killed." He gasped. "Don't interrupt me!" she commanded. "I know you're not afraid of dying. Neither am I. In fact I have a death wish. But there's one thing about dying that has always troubled me: that you would not have told the people you love how much they mean to you. So before you go, sit down, write letters to your friends, and give them to someone to mail in case anything happens to you. And then you won't have that on your mind and it'll be perfectly simple."

Roerick complied, giving the letters to his sister, then tearing them up when he returned from the war. A decade later, he was acting with Tallulah in *Dear Charles;* watching the way her tantrums could insult friends for whom she actually cared, he thought to himself that it was Tallulah herself who needed to write letters like this.

Her manic volatility was undoubtedly exacerbated by chemicals. During *Skin,* Tallulah was not imbibing that anyone could see, but she was downing a great deal of coffee as well as umpteen bottles of Coca-Cola: "She had one in her hand constantly," Van Patten recalled. Perhaps she was spiking them, too. Kazan wrote his wife that Tallulah was sending the company manager to the drugstore to buy spirits of ammonia for her. "She looks loaded up with something, her eyes staring wildly at me when I talk to her." Isabel Wilder knew that Tallulah had a weight problem and "we knew she was taking something." But amphetamines were about the last possible prescription she should have received.

Montgomery Clift played the Antrobuses' bad-seed son Henry, a.k.a

Cain, who we learn early in the play has slain the Antrobuses' second son. Tallulah was fond of him and appreciated his talent. Clift had played with the Lunts in *There Shall Be No Night* in 1940 and his admiration for Lunt was reflected in unconscious mimicry. "If you didn't watch him, he'd fall right into it," Cole recalled. Tallulah called Clift into her dressing room and gently warned him about it.

She had advice, too, for fourteen-year-old Dick Van Patten. She summoned him into her dressing room one night to tell him that he should wait longer before saying one line, that he was killing a laugh in the scene he played with her, Eldridge, a dinosaur, and a mammoth. "Dickie, darling," Tallulah said, "you're getting automatic. When I give you your cue, take a second to think about what I just said to you and *then* say your line."

"Isabel and I are Ruth and Naomi," Tallulah wrote Wilder from Washington. "I don't know what I would have done without [her]. She has saved my life and her reward is being kept up until four of a morning. But she's holding her own better than any one else. God bless her—"

As deeply as Tallulah enlisted Isabel to her cause, Isabel was more than a sounding board for her. They talked about their childhoods; there was warmth and reciprocity between them. "She was very fond of me," Isabel recalled, "and often very generous," willing to change plans to suit her friend. She sometimes went out with Tallulah after the theater, when Tallulah was lonely, and Tallulah was grateful for that.

"Tallulah used to say outrageous things in front of Isabel," Roerick remembered. "She used more than the usual number of four-letter words. She thought Isabel both was astonished and secretly pleased."

"You know I don't have to go around talking like this," Tallulah told Roerick, "but I think it's good for Isabel."

Tallulah "knew in her heart she misbehaved," Isabel recalled, "but she did it on purpose—to be on top always. She knew she hurt people by being rude, and I think she often was sorry for it. At times she would really be ashamed of herself. Sometimes she even apologized to me. And I didn't like that—that she was so vulnerable. I'd rather she stayed her cussed self."

On November 9, *The Skin of Our Teeth* began a week's engagement at the National Theatre in Washington, D.C. A program note had been added, encouraging the audience to focus on the Everyman aspect of the allegory. "George Antrobus is John Doe or George Spelvin or you—the average American at grips with a destiny, sometimes sour, sometimes sweet. . . ."

The next day Tallulah mailed a letter to Wilder written from the Carlton Hotel. "Anything you want me to do I would do; but every day some-

thing arises that torments me so that I am almost ready to give up the ghost. . . . I really do enjoy myself once I am before the audience, but due to said Myerberg's conflicting and confusing 'orders,' I have a feeling of dreadful suspense up until the play begins; one is *never* told if something that directly concerns me is going to be changed. . . ." She was enclosing a carbon copy of a three-page, single-spaced letter she had sent Myerberg on October 28 "because he refused to contact me." In a handwritten post-script to Wilder she added, "I love you and treasure every word you have written me. Your letters are always close at hand and in my heart."

She apologized to Wilder for how "vitriolic" her letter sounded. She had told Myerberg that his "idea of authority is sadly dated; authority is not snapping your fingers at waiters, or in this case, actors . . . it is some-thing innate . . . something that springs from inner dignity; true knowl-edge, tolerance and simplicity. In your obviously frustrated desire to be at long last respected, your utter disregard for human relationships have [sic] succeeded only in making of yourself a figure of ridicule; for this sad state of affairs I am deeply sorry for you."

But most of her letter was a catalog of professional grievances rather than a personal attack. She chastised Myerberg for administrative lapses: no list of hotels was posted backstage in the out-of-town theaters, despite the shortages of rooms that Baltimore and Washington were suffering. In Baltimore, supporting members of the cast had to spend so much time looking for accommodations that they missed a rehearsal. The company manager was inadequate; the company traveled without a flyman to signal scenery changes; the slide shows that preceded each act were not being projected correctly.

But these things paled before staging blunders that she felt were mak-ing parts of the play incoherent. "The mechanical device used in the first act for the so-called effect of wind is infantile and in complete contradic-tion of the author's avowed intention of leaving those things to the imagi-nation of the audience and it completely dissipates the audience's chance of understanding the refugees." (These "refugees" were dispossessed custo-dians of civilization, Homer and the Muses—"a singing troupe!" Mrs. Antrobus complains—who sought sanctuary from the cold in Antrobus's household.) Tallulah castigated

the absurd effect at the end of the second act when the storm before the flood drowns out all the important lines of the play. The audience haven't the faintest idea that Mr. Antrobus is referring to the animals

when he says, "Jump up on my back, here, take the turtles in your pouch, etc." They can't hear him; they can't see him; and the impression is given that he is asking the audience to come with him.

Throughout the second act, a fortune-teller tolls chilling warnings to humanity, imploring them to recognize their folly and the imminent flood threatening their survival. These were intoned by Florence Reed, a great Broadway star now playing character roles. Tallulah complained to Wilder that Reed's "vitally important" lines at the end of the act were obscured, "and the whole end of the second act is complete chaos; a dreadful letdown for the audience; making it an up-hill fight in the third act."

"I'm so glad to be playing comedy," Tallulah told the *Herald Tribune* a few days before *Skin's* November 18 opening in New York, "for comedy seems to me to be the fresh creation of the actors at every performance. . . . To me it's a beautiful play and full of truth."

Wilder's script stipulated a ramp leading into the audience for the ark-like exodus from Atlantic City at the end of the second act. Myerberg had "fought like a demon" against it, Heflin recalled, because he didn't want to lose the seats; he couldn't bear the loss of revenue.

He proposed instead a short ramp into the center aisle. Facing the opposition of everyone else, including Isabel Wilder, Myerberg capitulated. But when *The Skin of Our Teeth* moved into New York's Plymouth Theatre for the first of two previews, the cast discovered that the ramp had been built the wrong way and had to be completely turned around. The curtain rose forty-five minutes late. The performance had been bought out by a benefit theater party, for which tickets were steeply hiked from the customary top of $3.85. The audience was angry by the time the curtain rose and even angrier when it fell. "When we took our curtain calls they shook their fists at us," Heflin recalled. But that was of no consequence, because at the November 18 opening night, Cole recalled, the play "went like a house afire!" And when the curtain calls came raining down, the naysayers among the cast were baffled.

"Miss Bankhead is magnificent," Lewis Nichols wrote in the *New York Times*. "She can strut and posture in broad comedy, she can be calmly serene." "Her portrayal of Sabina has comedy and passion," Freedley wrote in the *New York Sun*. "How she contrives both, almost at the same time, is a mystery to mere man. It is a great part and she rises to it magnificently."

Chatelaine

"Do you know why I've been telling you how good I am in this part?
Because I don't think I am."

Indications are that freak comedy is real click," *Variety* reported on
December 2, 1942. *The Skin of Our Teeth*'s box-office take was only
enhanced by the outrage it continued to inspire in some quarters. Broad-
way reviewers had on the whole acclaimed it as a major event, but some
considered it a pretentious bore. Frances Heflin recalled "a small fleet of
cabs that belonged to us" pulling up to the Plymouth after the first act and
after the second to accommodate disgruntled spectators.

Tallulah was feeling in the chips and could afford the generous tips she
liked to bestow. "She takes good care of me," a stage doorman told Van Pat-
ten. For Christmas she sent presents to the cast, giving Kazan a gold bill
clip bearing a Saint Christopher's medal. In *Tallulah,* she writes that she
was later incensed to read in a newspaper profile of Kazan that he and she
had not exchanged a single word after the show opened. Tallulah's rebuttal
was to reproduce in her book Kazan's thank-you response for the gold clip.
Assuming the letter actually existed—and it is doubtful that Tallulah
would have dared fabricate such a document—the letter adds another
wrinkle to the contradictory accounts of their relationship.

I was very touched by your gift. I carry it around with me, like praise from someone I respect. I want to thank you for it, and while doing so, thank you for a number of things. Things that took place a number of weeks ago. Thanks for being right those times when I was completely wrong.

Thanks for having the courage, being right yourself, to battle for what you believed in—battle against inertia, and unconcern, and sometimes just plain stubbornness. And thanks above all for a thing no one can thank you for—for your gifts akin to genius. What you have added to Wilder's play and to my production can only be reckoned one way—by sitting down and imagining what it would all have been without you.

Tallulah was onstage almost the entire play and the pace of the first two acts was punctuated by the hectic exits and entrances of farce. During the first months of the run, she was forced to fortify herself by spending as much time as possible resting in bed because she had been diagnosed with a gastric ulcer—an ailment she disdained as the property of "Hollywood agents and similar trash." It had started to bother her in Philadelphia. She blamed Myerberg, as she had earlier blamed Billy Rose for her pneumonia during *Clash by Night*.

The mutual dislike between Tallulah and Florence Eldridge also flared in New York. There was "a real jealousy" between the two actresses, Van Patten recalled, "more from Eldridge." "Florence always felt she'd been cheated onstage," said Stephan Cole, who stage-managed the Marches in another play on Broadway in 1950.

At the conclusion of act 2, the Antrobus family flees the floods overtaking Atlantic City. To escape the deluge, the Antrobuses and Sabina ran down the ramp reaching into the center aisle of the theater and fled to the back of the auditorium. As they went into the dark at the back of the theater one night, Heflin heard words being exchanged between Tallulah and Eldridge. She caught up to them to hear Tallulah saying, "Oh, why don't you stop being such a tight, neurotic bitch."

From that point a competition began between the Marches and Tallulah for the affection of the two junior leads, Clift and Heflin. The Marches "were a very family-oriented group," Heflin recalled, and she and Clift spent time with them away from the theater. "But we hung out a lot with Tallulah at the theater, so it was a little awkward. We always felt when we were sitting in the wings talking to Tallulah that Florence was eyeing us."

Tallulah's agent, Phil Weltman, was due to go into the service on a Monday. He had arranged for Tallulah to have dinner with him on the Saturday before, in between her matinee and evening performances. Weltman came to her shortly before act 3 was to begin. She told him as she walked to the stage that he should go into her dressing room and talk to her guest. Weltman thought he was an out-of-work actor who'd come to ask Tallulah for a loan; his shirt was a little dingy.

"Talk to Max," Tallulah told Weltman as she was changing after the performance. Outside the theater, Weltman expected she would say good-bye to Max. Instead she pushed both men into a waiting limousine. Weltman protested to Tallulah, "We've got a lot to talk about" as she took a seat between the two men.

"You two guys met, didn't you? This is Philip Weltman; this is Lord Max Beaverbrook." Beaverbrook had known exactly what Weltman was thinking. "I was having a little fun with you," the magnate admitted. He had come from Washington early in the afternoon and gone straight to the Plymouth without bothering to change, because he had to fly back to England that night.

After her ulcer abated, while *The Skin of Our Teeth* was continuing to reward her handsomely, Tallulah began shopping for a country home that would enable her to commute to Manhattan. She settled on a low-lying white-brick Tudor Revival on the border of Bedford Village and Pound Ridge in Westchester, New York. The house was not all that distinguished, but the $25,000 price tag was modest and the setting out of a Grant Wood canvas. Bedford at that time was composed largely of estates and both recreational and working farms. Tallulah's eighteen-acre estate was small by comparison, but bordering other estates, it provided an untrammeled view. When *Vogue* featured her home in July 1943, the magazine described Bedford as "the deep, almost wild country." Today the farms are gone, but many of the estates remain. Despite waves of subdivisions, it remains one of the most spacious and idyllic pockets of Westchester.

Tallulah subsequently told Adele Whiteley Fletcher of *Photoplay:*

Five years ago if anyone had offered me this place as a gift—and now I jolly well have to sweat for it—I would have asked, horrified, "But what can I do with it? I couldn't possibly live in it! My friends wouldn't travel over those icy hills in winter! I would be stranded. Oh, no! Besides, I must be close to the theater. I can't commute for an hour and more six midnights a week."

However, about the time her marriage to Emery was ending, she began to envision some other kind of domestic bulwark. "Growing older—I don't mean I'm Mrs. Methusaleh—I felt the same need to walk on my own land that all the farmers I spring from always have known." She didn't think of it as a vacation house but as her real home, the first she'd had since leaving London in 1931. The house was blanketed with no fewer than seventy windows, but that was not, Tallulah explains in her autobiography, why she named it Windows. She intended the name as a comment on the transparency of a life lived in the public eye, perhaps ironically so, since it was this relentless exposure that the house was meant to deflect.

There were five bedrooms. Hers was on the main floor next to a small bedroom where lovers were installed. Tallulah's was decorated in tones of rose and blue to match her Augustus John portrait, the centerpiece of the room, which she placed above her fireplace. Glenn Anders recalled a chorus of warnings from him and others that the rising smoke would destroy the painting, but "you couldn't change her mind." The fireplace was close to her bed and she loved being able to see the portrait the moment she woke up.

Decorator Alban Conway filled the house with sensuous upholstery and draperies: French blue damask in Tallulah's bedroom; painted white satin in the yellow-and-white dining room; tweed, velvet, and raw silk in the living room, which was furnished with walnut furniture from her Farm Street house in London.

She also began a massive landscaping effort. "Oh, she loved flowers," said Sylvester Oglesby, who tended the house with his wife, Lillian, from 1949 until Tallulah sold the house in 1955. "We had a grape arbor; we had *gorgeous* flowers." Soon after moving in, she contracted a gardener, Louis Venturi, who planted copses of dogwood and rhododendron, 150 rosebushes, and lavish stands of peonies, daffodils, tuberoses, lilies of the valley, gladiolus, tulips, hyacinths, hollyhocks, and other hardy perennials.

She hoped that life in the country would lead her in new directions. "I'd like to do something in private," Tallulah told columnist Emily Cheney. "I'd like to write. But let alone the talent, I haven't got the patience to sit down and work by myself." She did, however, take up painting and achieve some proficiency, and she also devoted time and effort to the meticulous art of flower arranging.

After moving into the house at the beginning of April 1943, she commuted daily to Manhattan for *The Skin of Our Teeth*. She had invited Estelle Winwood to stay with her. Winwood was appearing on Broadway in S. N.

Behrman's *The Pirate,* and she and Tallulah used to go back and forth to Manhattan together.

Late one night, after they'd returned from work, Tallulah built a fire and began to talk about her performance in *Skin of Our Teeth.* "She said, 'It really is marvelous what I can do with this part,'" Winwood recalled days after Tallulah's death in 1968. "She talked about the way she played this part for an hour." Winwood responded by telling her, "Tallulah, the time has come when you do not have to sit down and talk for one hour about how good you are. It's time you stopped and let other people tell *you.*"

Tallulah looked at Winwood quizzically, "as much to say, 'Well you're not very sympathetic.'" She lay down on the sofa. Neither spoke for a number of minutes. "Estelle," Tallulah finally said. "Do you know why I've been telling you how good I am in this part?" "No, I haven't the faintest idea." "Because I don't think I am."

Winwood's advice was good, and Tallulah's response was insightful about the inverse relation of her bravado to her internal doubts. But Tallulah didn't seem to want to probe further. She never sought psychiatric consultation, even though by the 1940s any stigma that attached to psychotherapy was fast disappearing. But the prospect of abandoning her many defenses and deflections and exploring her core motivations was undoubtedly too frightening. Perhaps she shared the belief of many in her profession at that time that sorting out her personal demons would make her a less compelling figure theatrically.

Tallulah's Sabina earned her best-actress honors from *Variety* and the newly formed New York Drama Critics Award. In May, *The Skin of Our Teeth* was awarded the Pulitzer Prize. The standard Equity run-of-the-play contract expired on June 1. Tallulah wanted to take *Skin* on tour, but both she and Myerberg gave each other one ultimatum too many. "I'll submit to wheedling, but never to bulldozing," Tallulah writes in her autobiography. She claimed the breaking point was reached when he demanded that she appear at a rehearsal between a matinee and an evening performance, which is forbidden by Equity except when special permission is granted. The result was that she left the show when her contract expired. She was replaced first by Miriam Hopkins and then by Gladys George before *Skin* closed on Broadway in September.

Almost immediately after she left the play, Alfred Hitchcock contacted her with an offer to star in his latest film, *Lifeboat.* She jumped at the chance. She had never met the director, but she believed that his film *Blackmail* had vastly improved the stage production she had starred in. In

Lifeboat she would play Constance Porter, a foreign correspondent adrift in a lifeboat on the Atlantic with a cross section of Allied citizenry. They're joined by a Nazi who becomes their virtual commandant. He exploits the conflicts between them, lulling them into submission until the scales fall from their eyes and they mutiny, beating him savagely and throwing him overboard.

Tallulah's Constance Porter "has been everywhere, seen everything, done everything," she explained to a reporter. "She has forgotten how to be afraid of life or of death. But life in a lifeboat changes her." Connie loses her worldly trappings as well as her arrogance and amour propre. We first see her swathed in mink and diamonds when first sitting alone in the lifeboat that she has, we might imagine, all but deigned to enter. By the time the boat is about to be rescued, she is soiled, tattered, parched, and stripped of much of her hardness and frivolity. Tallulah's nemesis aboard is a Marxist boiler stoker played by John Hodiak. Behind their antagonism smolders a mutual attraction that ignites during their voyage.

Constance Porter is the only passenger who can converse with the Nazi in his native tongue. Tallulah was so rabidly anti-Nazi that she refused to learn her German dialogue any other way but phonetically. She went to California with Lee Strasberg's wife, Paula, as her secretary/companion. Strasberg drilled her in her lines and she speaks them with nuanced inflection and accurate pronunciation.

Tallulah got along famously with Hitchcock. "He understood me, and understood everybody," she told John Kobal in 1964. They both enjoyed modern art and together they toured Los Angeles's galleries. Tallulah had a good record gauging the talent of young artists, probably in part because of her friendship with Betty Parsons, who owned one of Manhattan's leading galleries.

As a director, Hitchcock was "wonderful," Tallulah told a reporter. "Always calm and good-natured—not like some of them who have to bellow to let you know who the director is. When Hitch has something to say about the action, he sits down next to you and talks it over very quietly— almost in a whisper. It's very effective. You're never on edge when you're working with Hitch."

Only forty pages of the screenplay had been completed when Tallulah agreed to do the film. Jo Swerling and John Steinbeck were still working to finish the script as the production went ahead. The *Detroit News* visited a

Being made up for *Lifeboat*.

rehearsal late in August. "I haven't got a shirt on," Hodiak's character was to rebuke Tallulah, "or a mink coat, either." Hitchcock stopped the rehearsal. "Wouldn't John say 'fur coat,' instead of mink?" he asked. Tallulah thought that the line had more punch with "mink coat." Hitchcock asked skeptically whether "an oiler on a freighter [would] know a mink coat when he saw one?" "Of course, he would," Tallulah replied. "He goes to the movies, doesn't he?" Hitchcock conceded.

By this time, Tallulah's need to expose herself had begun to result in breaches of professional etiquette. On Broadway in *The Skin of our Teeth* earlier that year, "she never wore underpants, she hated them," Frances Heflin recalled. The management received letters from disgruntled patrons who had seen more of Tallulah than they wanted. Finally Equity sent down a mandate that she had to wear her underpants. Tallulah complied, but she used to take them off between scenes. "She got it into her head that they were uncomfortable, that no underpants were comfortable, so that was that." Similar exhibitions by Tallulah on the confined set of Hitchcock's film led to complaints that the director fielded with his much-quoted deliberation about whether the matter needed to be referred to the makeup or the hairdressing department.

In November, with a month of filming still to go, Tallulah again contracted pneumonia. This time she had no one to blame except smoking and the rigors of filmmaking. When the climactic storm scene was filmed, she was dunked for eight days with thousands of gallons of water—"I've never seen any big-name star take such punishment," *Lifeboat*'s cinematographer Glen MacWilliams told the press. She was treated with sulfa drugs and, jelly-legged, returned to the set too soon; after three days of filming her temperature was again stratospheric. But she was determined at all costs to get back to Windows. She had already made a reservation on the Super Chief train back to New York and was unwilling to face the inevitable wartime delay in booking another. After wobbling through the final days of shooting, Tallulah managed to make it home to New York safely.

In January 1944, *Lifeboat* opened nationwide to excellent reviews and business. It was an ensemble piece rather than a starring vehicle, but Tallulah's performance came in for its fair share of acclaim. The *New York Post* said that she "comes into her own on the screen in this picture . . . is supremely assured and appealing." Later that year, Tallulah received the New York Film Critics Circle Award for her performance.

"I did love *Lifeboat*," Tallulah told Kobal, "and I liked my performance,

thanks to Hitchcock." Tallulah's diction in the film is quite different than in her films of a decade earlier, displaying more of a slow gravitas that was perhaps born in *The Little Foxes*. She took pains to capture the character, and convincingly mans a newsreel camera and a typewriter, but on-screen the role seems closer to Tallulah's public persona than she wished it to be. "I told him, 'Don't make me say Darling, they'll say I'm playing myself,'" Tallulah recalled to Kobal. Hitchcock wanted as much Tallulah in her impersonation as possible, perhaps to capitalize on the incongruity of so glamorous a creature stranded in a storm-tossed dinghy. "I figured that trying to anticipate what Tallulah might do next would keep audiences in suspense for an hour and a half," he told actor Joseph Cotten.

The film also aroused controversy: it was accused of abetting the enemy cause by exposing the foibles and pettiness of the Allied representatives peopling the boat. Bosley Crowther in the *New York Times* wrote that "we have a sneaking suspicion that the Nazis, with some cutting here and there, could turn 'Lifeboat' into a whiplash against the 'decadent democracies.' And it is questionable whether such a picture, with such a theme, is judicious at this time." The Writers' War Board awarded it "four duds," and branded it "a credo of German super-intelligence and of the degeneracy of the democratic peoples."

To be sure, the criticism of *Lifeboat* as subversive was jingoistic hysteria. For it is a sham hegemony that the German musters. Yes, he is exceptionally competent, disguising that he is fluent in English until his prey are too enervated to care that he's understood every word they've spoken about him. But he is able to subdue the boat's inhabitants not because he belongs to a master race, but because he has secreted vitamin tablets and water that let him keep rowing as those around him grow weak with thirst and hunger.

What may have rankled many was the critique of capitalism throughout the film. Henry Hull plays Charles D. Rittenhouse, a captain of industry who embodies the greed and provincialism, as well as the plucky amiability, of a self-made American titan. Tallulah's Connie Porter is an emblem of the best and worst of capitalism. She also is a self-made woman, but she rose from the South Side of Chicago with the aid of a rich paramour.

Otis L. Guernsey Jr. of the *New York Herald Tribune* took Tallulah to lunch to discuss the controversy early in February. Was the German too suave, too attractive? "For heaven's sake, anyone would be distrustful of one of those whip-cracking, snarling von Stroheim types!" she retorted.

And the bickering between the lifeboat inhabitants, she declared, was deliberately intended to criticize the behavior of the Allies. "That's just what happened in Europe. . . . Of course if we can't face the truth about ourselves it's just too bad, that's all!"

In the final scene of the film, the lifeboat survivors witness the sinking of the U-boat to which their teapot fuhrer was rowing them. A young survivor of the downed ship hauls himself into the boat and pulls out a gun, which Connie swiftly seizes. At the film's conclusion the audience is unsure whether this one will be thrown back to the sharks. Guernsey asked, was the scene meant to imply that the Allies would be hoodwinked all over again? No, Tallulah said. It "just shows that there's no satisfactory answer to, 'What will we do with them after the war?' Do you want to match their brutality with brutality? Is America fighting for that—to kill them all when they're finally defenseless?"

By the mid-1940s, however, Tallulah's increasingly garrulous and domineering sessions with the press rarely produced coherence of the kind she had supplied Guernsey. Furthermore, her credibility about political affairs was compromised by her impulsive and indiscriminate epithet spewing. Among the smears that dropped too glibly from her mouth the dreaded *Communist* figured prominently. At a large press conference that winter to discuss *Lifeboat,* Tallulah turned nasty after being introduced to a reporter from *PM,* branding the daily paper a "vicious" and "dangerous" rag.

"For God's sake, Tallulah, what kind of talk is that?" shot back a *Collier's* staffer. "I thought you were a liberal. That's what *PM* is. . . ." No, Tallulah insisted, *PM* was "a dirty Communist sheet." But Tallulah's real beef with the daily was apparently much more personal. "And if I ever get my hands on that Bob Rice . . ." Tallulah vowed to all present. In 1942, Rice had written a profile of Tallulah for *PM* that hadn't pleased her. She eventually quieted down, telling the *PM* reporter that she reminded her of a close friend, but insisting, as always, on the last word: "She committed suicide."

Tallulah with Alfred Hitchcock.

Work and Play

"If it's possible to be happy with a movie camera in one's face, I'm happy."

Eugenia Bankhead and her then husband William Sprouse had adopted a son in 1942. During the war, Eugenia moved to Aunt Marie's farm in Alabama, which she converted into a boardinghouse for servicemen and their wives. At one point thirteen children and their parents were living with her. Her husband at the time was overseas. One day in the spring of 1944, Tallulah phoned Eugenia in Alabama, "a little on the high side," Eugenia claimed, although Tallulah was still officially on her wartime wagon. Tallulah asked Eugenia what she was doing. "I'm drinking a mint julep," Eugenia told her. "Oh, you're drinking one, too," said Tallulah. "Who makes your mint juleps? I bet I make better ones than you do."

She invited Eugenia to visit Windows and said she wanted to see Eugenia's adopted son, Billy, "I thought this was a little *late* to want to see him," Eugenia recalled, because he was now two and a half, but she decided to accept Tallulah's offer. When Eugenia and son disembarked at the Bedford Hills train station, Tallulah came on strong. "I ran to her," Eugenia recalled, "and started to speak and she said, 'Sssssh!'" as if there were eavesdropping hordes surrounding them. But Eugenia claimed that nobody was

near. Tallulah's deep voice prompted the title "sir" from her nephew. "He called her that until he could say 'sister.'"

She steered them to a black Cadillac limousine and, as they drove the few miles to Tallulah's, stopped at a store in Bedford Village and bought a great stash of toys for Billy. One of them was a miniature croquet set, with which he subsequently discharged an errant pitch toward Tallulah, who was reading on a sofa in her living room.

Eugenia heard a crash and a scream and came running. Billy was in tears and Tallulah clutching her nose. "It's all right, darling!" Tallulah called to the boy. "The bastard broke my nose!" she muttered to Eugenia while urging her nephew to "Go out and play, Billy, darling. Sister's all right, run out and play." Eugenia took her to the hospital, where it was confirmed that Tallulah's nose had been broken slightly, not enough to change its appearance. "Well, I heard about *that* for a long time, too," Eugenia said. "But she was awfully sweet with him when he was a baby." Tallulah remained a devoted aunt to Billy for the rest of her life. David Herbert recalled her "talking along about Billy all the time. One felt in a way that she wished Billy was hers."

Tallulah was back in Hollywood in the summer of 1944, portraying Catherine the Great in the film *A Royal Scandal,* based on the 1922 Broadway hit *The Czarina.* Edward Sheldon had adapted it from the Hungarian original of Melchior Lengyel and Lajos Biro. Ernst Lubitsch was going to produce and direct. One of the screen's greatest stylists and auteurs, Lubitsch had filmed a silent version of the play with Pola Negri in 1924. Although this boudoir farce was set in a specific Russian time and place, it might as well have been the fictional Middle European kingdom of Ruritania, a staple of operetta and drama to which Lubitsch was returning for the first time since *The Merry Widow* in 1934. Since then he had been concentrating on urban and contemporary settings.

The screenplay followed Sheldon's play quite closely. Chancellor Nikolai Ivanovich dances attendance on Catherine while pulling lots of strings behind her back, not without her peripheral awareness and even tacit approval. Catherine's young lady-in-waiting Countess Anna is engaged to a subaltern, Alexei. He deserts his regiment and breaks into the Winter Palace to warn Catherine of seditious plans being hatched in the military and in the palace. In gratitude and in lust, she makes him captain of the palace guard, and he quickly forgets about Anna. Alexei is in a swivet of reform fever, but he becomes disillusioned when he realizes that Catherine is far more interested in him as a bedroom firebrand than a political one. Now he

resorts to his own insurrection against her, but he is foiled by the chancellor. Catherine pardons Alexei, who is reconciled with Anna, because she has moved on to a dashing ambassador from France whom the chancellor has been trying to introduce her to all through the picture.

Lubitsch wanted to film in Technicolor, but said that color cameras were unavailable because so many had been loaned to the War Department. Not long before work was due to begin, Lubitsch suffered a heart attack. He decided to cede the direction to Otto Preminger, whose *Laura* was filling theaters across the country. Lubitsch remained the film's producer and took a codirecting credit. Tallulah and Preminger had known each other since 1938, when he was directing on Broadway. Tallulah had heard that his family, who were Austrian Jews, were not going to be allowed to resettle in the U.S. because of emigration quotas. She asked her father to intervene and he did, successfully, earning Tallulah Preminger's eternal loyalty.

Work was scheduled to begin in late July. Charles Coburn was cast as the chancellor, but was suddenly recalled to an earlier studio commitment. They debated replacing him, but "there was only one answer," said Tallulah, "because there is only one Coburn. And of course, you know, he'll steal every scene from me," she said, sighing ironically to Elizabeth Wilson of *Silver Screen*.

This occasioned more delay, now a six-week hiatus. Tallulah visited wounded serviceman in local hospitals and took tennis lessons in the morning from ex-champion Bill Tilden, whom she'd known since London. In the afternoon she took driving lessons, and earned the first license she'd had since moving back to the U.S.

Onstage Tallulah was still being called more beautiful than ever, yet onscreen the years of abuse were beginning to become visible on her face. She had always felt the presence of a movie camera intrusive, confessing to Preminger that it terrified her. She was convinced that her right profile was far inferior to her left. Preminger, in his 1977 autobiography, agrees: "One profile looked like Tallulah but the other like a completely different person."

Arthur C. Miller, one of 20th Century-Fox's leading cameramen, was "a humorous little man who had once been a jockey," Preminger writes. He installed a hoax light on his camera right over the lens. "I have invented this light especially for you," he told Tallulah. "In fact, we will call it the 'Bankhead.' It will make you look marvelous. You have nothing to worry about—just relax."

Tallulah in *A Royal Scandal*

"If it's possible to be happy with a movie camera in one's face," Tallulah told Wilson, "I'm happy."

Not long after *A Royal Scandal* began shooting with Tallulah, Lubitsch came to Preminger with news that Garbo had told him that she wanted to play Catherine. He insisted that Tallulah would have to be bought off so that Garbo could take her place. Preminger would have been thrilled to direct the film that lured Garbo out of retirement. But betraying Tallulah was out of the question.

It is puzzling why Lubitsch was so insistent, since Garbo was not the obvious choice for a comic role. But Lubitsch had directed her in *Ninotchka* and was probably the single director who could have coaxed another great comedic performance out of her.

But the front offices turned thumbs down on Lubitsch's impulse. Tallulah, who had never been a movie star, had just appeared in a success, while Garbo, one of the screen's greatest stars, had followed the flop of *Two-Faced Woman* in 1941 with three years' inactivity. Preminger writes that Lubitsch was so bitter over the studio's rejection of Garbo that he began to find Tallulah's presence noxious and to treat her cavalierly.

Alexei was played by William Eythe, who was then a juvenile on the rise, a good-looking and slightly kooky cub. His friend Lon McCallister recalled in 1993 that "Bill said she was a wonderful, giving, brilliant actress to play opposite. He loved the whole experience of working with her."

Anne Baxter was in a less enviable position, playing Tallulah's lady-in-waiting and love rival. One day Preminger returned from lunch to find Tallulah stretched out on the floor in her tent sobbing with rage. Her costume was in a heap in a corner. She told him that Lubitsch had visited her after seeing the "rushes" that day and accused her of stealing a scene from Baxter, deliberately distracting the viewer's attention by closing her eyes while Baxter was speaking. Preminger hadn't seen any evidence of undercutting on Tallulah's part during the shoot; in fact, he had directed her to close her eyes at that particular moment.

Tallulah repeated to Preminger the vitriolic response she'd given Lubitsch and insisted that she was going right to Darryl Zanuck, returning her salary and walking off the film. Preminger persuaded her to calm down and blamed Lubitsch's behavior on his illness. He asked Tallulah to apologize for her outburst and she did exactly that, humbly proffering to Lubitsch an olive branch, which he accepted without, however, apologizing for his accusation.

Baxter's uncle was the architect Frank Lloyd Wright. One day Wright

decided to visit the set. "Get that monster out of here" were Tallulah's first words to Preminger when she saw him that day. She impugned Wright's right-wing politics in the ripest language and said she would not work while he was on the set. Preminger cleverly worked out a compromise. Rather than actually film a scene, Tallulah and Baxter would rehearse it, which they did some twenty-five times, until Wright got bored and left, and Preminger could finally go ahead and shoot the scene.

A Royal Scandal opened in March 1945. Crowther in the New York Times said that despite Tallulah's "valiant efforts to fan the comic spirit," it was "oddly dull and witless." Indeed the film's reviews were unfairly derisive. There is wit and humor in the story and the dialogue, but the problem with A Royal Scandal is that it attempted to revive an outdated genre. An ornately stylized Ruritania—there are only a few fleeting exterior shots—had now become too airless for the World War II American audience.

In Tallulah, she says that the now penitential Lubitsch had told her that her Catherine was "the greatest comedy performance he had ever seen on the screen. Otto Preminger . . . can so testify under oath." If Lubitsch did indeed say this, he was certainly exaggerating, but Tallulah does give as glittering a display of comic virtuosity as could be imagined, ranging from knockabout farce to rarefied high comedy. She integrates all the different technical and stylistic engines at her command into a purring consistency.

Much as she liked Preminger, Tallulah realized that the nimbleness of the famed "Lubitsch touch" was not in Preminger's arsenal. Years later, she told John Kobal that if Lubitsch had directed the film it could have confirmed her viability as a movie star, which Tallulah knew was tenuous. She was willing in both Hitchcock's and Preminger's films to share above-the-title billing, something she was no longer doing on Broadway. It's true that A Royal Scandal suffered from Lubitsch's absence. But Tallulah was now forty-three, and as good as she looks in A Royal Scandal, she does not look any younger than her years. Leading screen roles for women of forty-plus were just as scarce then as they are now.

When the picture was finished, Miller gathered the crew together and they ceremoniously presented Tallulah with the "Bankhead," so she could use it in all her films. They wondered how she would react the next time she faced the cameras, when their ruse would surely have become clear to her. But Tallulah's rude awakening never came, because as it turned out, A Royal Scandal was the last time she appeared before the cameras as leading lady.

Flights of Fancy

"You don't know what I'll do for a laugh."

For twenty-five years, Tallulah had vowed never to work for the Theatre Guild after she had been tricked into rehearsing for *Heartbreak House* until the Guild's first choice became available. Soon after she got back to New York, however, she renounced her vow when the Guild offered her a play tailor-made by Philip Barry. *Foolish Notion* blended Barry's long expertise with drawing-room comedy and his intermittent flirtations with mysticism and the furtive workings of the human psyche. It provided Tallulah bravura displays of versatility, yet in some ways the play was almost biographical. She played a glamorous theatrical star, Sophie Wing, whose entire world is theatrical. Her father, Horatio, is a professor emeritus of dramatic literature. Her adopted twelve-year-old daughter, Happy, is studying at drama school.

After shipping out to Europe to support the Allied cause five years earlier, Sophie's husband, Jim, is listed missing and presumed dead by all but his daughter. Sophie is about to leave with Gordon Roark, her lover and leading man, for a tour of South America, where they are to be married. Sophie's maid brings in a cryptic phone message: Jim will finally be arriving home that evening with a certain "Flora." Four dream sequences follow

over the following two acts as Gordon, Horatio, Happy, and Sophie each imagine how Jim's return might play out. Flora is a cipher, and each one shapes her according to his or her own hopes and fears. Barry had named his play after a line from Robert Burns's "To a Louse on Seeing One Upon a Lady's Bonnet in Church": "O wad some power the Giftie gie us to see ourselves as others see us. It wad frae monie a blunde free us an foolish notion."

The cast had already been rehearsing for ten days—and the Theatre Guild would have to negotiate with Equity to allow a firing this late into rehearsals—when Tallulah decided conclusively that she could not warm to the girl playing her daughter. Twelve-year-old Joan Shepard was brought in to replace her.

Philip Barry was then forty-nine, five years from his death, but already wearing the earmarks of heavy drinking and high blood pressure. He looked to Shepard like he was about to burst at all times and particularly when he was upset about anything—which he was frequently during the preparation of *Foolish Notion*. Shepard saw how much Tallulah wanted the play to be a success and to be clear to the audience; amid the flashbacks and the multiple personae of the characters, there was a danger of confusion. Jack Wilson was directing. Wilson's entrée into the theater had been his affair with Noël Coward, but he had by now begun to direct as well as produce successfully. He certainly was more experienced than he'd been as titular director for Tallulah's summer 1941 revival of *Her Cardboard Lover*. Nevertheless, Wilson directed *Foolish Notion* "in a mild sort of way," recalled Shepard, who appreciated his suggestions to her about comedy timing and about maintaining stage reality. But what did *this* in the script *mean*? Tallulah would ask Wilson. What was the motivation? And if he couldn't answer her she'd ricochet her question back to Barry, with whom she was "*constantly* at loggerheads," Shepard said. "But it was kind of friendly loggerheads. They plainly liked each other but they were always dueling." But there were frequent "lovey-dovey moments, typically theater-people-hugging-each-other moments."

Foolish Notion received its world premiere on February 2, 1945, in New Haven. The Shubert was packed for the three-performance run, but notices were lukewarm. "Bone." in *Variety* complained that "Barry has gone off the deep end in expressing himself via fact and fancy. That the plunge has taken him into hot water was evidenced by the mixed reception accorded the

play's premiere. With proper revision, he can extricate himself to the extent of delivering a worthwhile box office and literary contribution."

From there they went to Boston. A few minutes before their second performance there, Shepard and Tallulah were talking onstage. "Did you see 'em?" Tallulah asked. "Did you see the reviews?"

"Of course," Shepard said proudly.

"Well, how do you feel?"

"Wonderful."

"Did you see that one that said 'Little Miss Shepard does some scene-stealing that Miss Bankhead wouldn't take from an actress just a few years older'?"

"Yes."

"Well, they're goddamn right!"

During another performance, Shepard was sitting onstage next to Tallulah when she suddenly felt her leg tingling and then felt the tingling turn to a strange pain. She looked down at her lap and saw a tiny circle of flame: Tallulah had accidentally set her dress on fire with a lit cigarette. Tallulah saw it the same moment and began patting out the flame as they continued with their stage dialogue, Tallulah whispering between lines, that it was "all right, baby, I'll take care of it. Don't worry about it. It's okay, it's all right." When they went off stage, Tallulah was contrite and next day gave Shepard a lavish present.

A portrait of Jim hung on the imaginary "fourth wall." Before each fantasy, the controlling character sat facing his portrait, thereby facing the audience. The audience could see the actual picture, however, because it was reflected in a mirror over the fireplace center stage. The entrance of characters walking backward reminded the audience that another fantasy was in place. In the first, Gordon sees himself as the outsider, watching Sophie and Jim in the first flush of connubial happiness. Jim comes home tipsy, Sophie takes him to bed, and there's nothing Gordon can do about it. Then, in Horatio's dream, Jim comes back to set Sophie free to marry Gordon as Horatio would like her to. Happy's dream reveals her anxiety about her father's being usurped. Sophie and Gordon appear as cartoon malefactors, plotting to rub out Jim. In Sophie's dream she confronts her conscience, in the form of rival actress Lily Spring, a grande dame who reproaches her for not being a better wife and a better actress. "We never seriously competed," Lily tells Sophie. "I am an actress, while you are— what do they call it?—a personality."

Sophie fires back:

Writers, sculptors, painters, actors—we're all the same—interpreters—and of the same of thing—of life! And if, while you're actually being Lady Macbeth—Phèdre—Roxane—what you will—I'm still just Sophie Wing, the personality again. Maybe I'm a spot or two closer to life than you are.

In Sophie's fantasy, Jim has been killed, and his "return" means only that his ashes are presented to Sophie in an urn. She grieves over it in a parody of the tragic grand manner that Lily Spring might be famous for. She shreds rose petals before it, loosens her hair, and lets it fall over the urn.

Finally Jim returns for real. He tells them that he'd enlisted because he knew Sophie and Gordon were in love even before they did. And he is in love with Happy's governess, Florence, who had been only seventeen when he shipped out. Having now to some extent each confronted his or her fears, Sophie and her family are able to resume their lives on the most satisfactory of notes.

Throughout rehearsals, the cast was aware that the last scene of Jim's homecoming was flawed. It was murky; it was—after all those speculations and projections—somehow anticlimactic. The *Boston Globe*'s Elliot Norton, who admired the play, nonetheless warned audiences they would find the final scene "thoroughly bewildering."

"Barry is working continually on that last scene, which is quite a problem," Tallulah told a Boston reporter. In Baltimore, Barry gave up his sleep to put it right, as did Tallulah and her party of guests. "We'd had a great evening with Tallulah," recalled her cousin Charles Crow, who was then doing a residency at Johns Hopkins. "We'd been up all night, drinking and having a wonderful time," and everyone present debated possible last-act revisions.

The next day Barry handed the cast a new version. Tallulah read through a few of the new lines and immediately flung the pages to the floor. "I will *not* say that!" she bellowed. One line that provoked her: something was described "as queer as Dick's hatband," which was a British archaism. Nobody would know what the hell she was talking about, Tallulah growled. Barry's play was already adorned with esoteric literary references.

In his autobiography, the Guild's Lawrence Langner writes that Barry "could match Tallulah with his own brand of temperament." This was certainly not the first time Barry had worked under such pressure—his greatest popular success, *The Philadelphia Story,* had been radically revised

during out-of-town tryouts. When Barry got agitated his face flushed, and on the afternoon that he presented the new pages to Tallulah, it went all the way to crimson. A blood vessel in his nose burst and he was taken to Johns Hopkins.

Foolish Notion moved to Washington, where Tallulah creatively explained away Barry's absence. "Poor darling, he's in the hospital with his sinus," she told a reporter, and offered soothing words to hasten his return. "It's a rare, extraordinary play," she said. "It recognizes the war, of course, but it's still not a war play. It's escapist, but it faces facts. I just adore the author, adore his mind, his work. Everything he does is so civilized."

In Washington, Tallulah came down with a virus, but told Langner not to worry because "the curious thing about me, darling, is that I give my best performances when I am slightly ill, because then my diaphragm is not quite so powerful." Presumably, in her weakened state, Tallulah was less prone to overstatement. She was traveling with Dola Cavendish, who called Langner and said that Tallulah had awakened feeling fine but was craving chicken for her midafternoon breakfast. Locating a fowl in wartime Washington was not as easy as it sounds, but one was produced. "Tallulah ate it for breakfast," writes Langner, "and thereupon behaved like an angel, accepting her new lines without comment, and played out the Washington engagement in the most beautiful manner."

Foolish Notion opened March 13 at the Martin Beck Theater in New York. A $200,000 advance sale allowed the play to survive critical notices that were again disparaging. In the *New York Times,* Lewis Nichols wrote that only Tallulah could have made many of Barry's "rag-tag, bob-tail notions about life, love, truth and beauty stand up in a dramatic structure. . . . The scenes forsake her, as they shuttle back and forth between fancy and fact. She never forsakes a scene. Her performance is a veritable triumph of the season."

Richard P. Cooke wrote in the *Wall Street Journal* that Tallulah "looks and is magnificent," likening the dazzle she emitted in her clinging, be-plumed, be-trained Mainbocher gowns to the aurora borealis. Barnes in the *Herald Tribune* wrote that, "She brings such radiance and feeling to the part of the tortured woman who has made a compact with destiny, and has to make it all over again, that the piece has genuine fascination." A dissenting note was sounded by Robert Garland, who wrote in the *New York Journal American:* "She is my favorite actress. To me, she can do no wrong. . . . But whisper it not around Longacre Square, but Tallulah goes a little bit ham on her customers."

Mildred Dunnock played Sophie's rival Lily Spring. One night Dunnock and Shepard were sitting in the wings when Dunnock told her, "You think Miss Bankhead is great. But she really isn't. She is not a real actress. She is just a personality, and you would be very unwise to copy her."

Dunnock got up for her scene, and Shepard noticed that Rose Riley was sitting behind her. Riley must have gone straight to Tallulah, because while Tallulah usually "gave the stage to Millie," during their scene, at the following day's matinee, she "walked all over her," Shepard recalled. "She let Millie say her lines, but just said, 'I'll show you who's an actress!'" Things returned to normal at the following performance, and Dunnock and Tallulah subsequently became quite good friends.

In Donald Cook, who played her lover Gordon, Tallulah had found one of her most simpatico leading men. He had starred in Barry's first big success, *Paris Bound,* in 1927, and his comic timing was as masterly as Tallulah's. "You'd think, 'Oh, my God, he's waiting too long to say this line,'" Dick Van Patten recalled, "and then he would just lay it into the audience and get the laugh."

Estelle Winwood's husband, Robert Henderson, recalled that "Tallulah always said that with leading men it should be from the bed to the stage," and Cook felt the same way about his leading ladies. Glenn Anders, who lived at Windows during several dry spells in his career during the 1940s, recalled deciding one day to thaw out Tallulah's industrial-size refrigerator. "It had gotten bad," he said, in part because of the frequent pandemonium of Tallulah's lifestyle. Friends might arrive unexpectedly, prompting Tallulah to yell to the cook to chill a bottle of Burgundy or champagne, which might freeze and then be put back in the refrigerator, or crack when left untended if the new arrivals didn't stay for dinner. Amid all the thawed and frozen potables and victuals, Anders thought with a laugh that "I'm sure I'm going to find Donald Cook down here somewhere."

Shepard had already worked with many leading ladies and found they had very sharp elbows when it came to children and the audience responding to them. But Tallulah used her eyes, her movement, her face, her hands to make Shepard feel mothered. "She gave you from herself," she recalled, in a way that she said very few actors, including some very fine ones, were able to do. Offstage as well, Tallulah was solicitous and involved. Her dressing room was always open to Shepard, and she attended the girl's graduation from the Professional Children's School, held at City Center.

Tallulah received a share of *Foolish Notion*'s profits and she realized

that the better the show was the more successful she was. "She wanted everybody to get all their laughs," said Shepard. "She was a fiend about it. If you missed a laugh, she wanted to know why," she recalled. "She'd call you into her dressing room and say, 'Look, what's happening here?'"

Despite Tallulah's vigilance, grosses slipped by the beginning of June, but *Foolish Notion* was still turning a profit when it closed that month after thirteen weeks in New York. Rather than prolonging the play through the hot weather, in those days when not all theaters were air conditioned, Tallulah preferred to sit out the summer at Windows. She would return to the play in September, when they would embark on an extensive tour, and in the meantime, Barry would have time to do some rewriting. When the cast convened to rehearse at the Guild's town house on West Fifty-third Street, Barry had not only produced a new and improved third act, but had made quite a few line changes throughout the play.

During the New York run, Tallulah had announced that she was staying on the wagon for the duration of the war, and as far as Shepard could see, that was true. But no sooner was peace declared than Tallulah picked up right where she'd left off. "There was a little personality change there," Shepard recalled. "She wasn't quite as attentive and loving." One evening, Tallulah, Cook, and company manager Peter Davies returned from a dinner break in rehearsals happily bombed. Drinking during working hours struck Shepard as "a great sin," and she was very disapproving at seeing Tallulah falling giddily over Davies.

For the tour, John Emery replaced Henry Hull as Sophie's husband, Jim. He and Tallulah seemed to Shepard to be on excellent terms. There were lots of all-day trips from city to city. The company commandeered its own railroad car, with Tallulah occupying the drawing room at one end. Eugenia also joined up with Tallulah from time to time. They seemed to be getting along famously, and the fact that Eugenia brought her son was perhaps a factor in their comity. Tallulah told Shepard to call Eugenia "sister," and Eugenia and Tallulah were happy that Shepard got along with Billy. Tamara Geva—now Mrs. Emery—also joined the tour at some points, drinking and playing cards with Tallulah, Emery, and Cook.

Foolish Notion opened in Wilmington on September 14, 1945, beginning a cross-country tour that lasted five months. The tour was phenomenally successful, perhaps in part because the script was better, but it scored land-office business even in cities that disliked the play. In Philadelphia, the second of a two-week run grossed "an amazing $29,000," *Variety*

reported, "the kind of figure generally associated with musicals" [for which prices are higher and theaters bigger] despite many tickets already sold at discount because the play had been included in a Guild subscription series.

Russell McLaughlin in the *Detroit News* wrote on October 16 that "Miss Bankhead is popularly believed to be playing 'herself' as the actress." That was "nonsense," for he considered her "a woman of the greatest and most polished professional skill who could play the Mona Lisa as convincingly as she could a tempestuous, temperamental star."

Over the length of the tour, Tallulah continued to maintain her own performance and everyone else's, too. "She cared for the production," Shepard said. "She was determined." She warned Shepard in the middle of the tour about garbling her lines, a common pitfall during a long run. On Tallulah's forty-fourth birthday, January 31, 1946, Shepard presented her with a poem incorporating remarks Tallulah had said to various members of the cast and crew. One stanza read: "Joan your talk is so garbled now / We cannot hear a word you say / The audience complains and how / Do better at the matinee." They played more than twenty cities, including four weeks in Chicago and two weeks each in San Francisco and Los Angeles, before closing in San Diego on February 24, 1946.

A year after World War II ended, musical-comedy star Dorothy Dickson, a friend of Tallulah's from her Algonquin days, visited the U.S. from London and was Tallulah's guest at Windows. "Miss Dickson hasn't eaten any good food in years," Tallulah told her cook. "Which was true," Dickson laughed, in 1982. " 'She must have lobster; she must have this and this and that.' Oh, I was the guest," Dickson recalled. "I was the one."

One night, Tallulah started to ask Dickson about London during the war. "Now living here, and going through what one went, you couldn't be a bomb bore. No one could tell a bomb story, because it was happening to everyone." But Tallulah not only wanted to hear every one of Dickson's own experiences, but those of many other people Tallulah had known in London. "All night long Tallulah was asking me. 'Ohhh, God . . . Go on, yes. And how about this?' and then be quiet. She really cared, and I never got over how moved I was."

Dickson was disconcerted on that visit by Tallulah's dogged attention to televised baseball (which was probably no more intense than the average American male's, although unusual in women of the time). "I'd look at it a

bit and I admire anyone who's successful at anything—big chaps doing something marvelous—but she would sit for *hours and hours*. I thought, 'How odd.'"

As Tallulah reached middle age, she was more than ever frightened of solitude. Cole felt that depression beset her whenever she was alone. At Windows, she built a sixty-by-twenty-foot pool and plied it as a lure to attract visitors. Yet she used her staff to buffer her in a cocoonlike environment in which she was sustained by her passionate interests, baseball among them. Cole believed that Tallulah had inherited from her father an enormous curiosity about the world. But he saw, too, a corresponding lassitude that he chalked up to good old Southern sloth. He told the story of Tallulah once coming home alone to her hotel apartment with a new dress from Hattie Carnegie's. She proceeded to try it on but found herself unable to undo the complicated fastenings. She wound up going to sleep in the gown and ruining it.

If Tallulah wasn't working, Cole recalled, she preferred not to make the rounds of chic nightspots. She was in her soul so competitive and insecure that public life was difficult for her, despite her impeccable deportment on many occasions, her salty bluster on many others, and the disruptive social dysfunction that set in especially when she was drunk.

Weeks after *The Skin of Our Teeth* opened on Broadway in 1942, Cole had shipped out to Europe as part of the American Field Service. After returning in 1945, he spent a lot of time at Windows with her. Together they hiked, picked flowers, and spent hours reading by the pool. She hired a young black man, Robert Williams, to drive for her and to cook, but she continued to drive herself around Westchester. Cole was predictably dismissive. "Everybody claimed, 'Oh, she's a wonderful driver.' It frightened the hell out of me." She was somewhere around five-three and her height placed her too far below the wheel for his comfort. Her driving wasn't reckless, but she kept turning to look at him as they talked, something she would never permit her drivers to do.

Once, while Cole was driving Tallulah and Estelle in a rented car, Tallulah persisted in criticizing his driving until finally he pulled over, got out, and hitchhiked home. "I have no idea what they did," he said. "It was never discussed again, and I never called," he insisted. "She called me. 'Aren't we going to play bridge tonight?'"

At times, their relationship took on a graphically parent-child dynamic. He recalled an occasion when she was at her dressing table in Windows and "said something I didn't like."

"I've told you not to talk to me like that, Tallulah."

"Oh, bullshit."

"I took her by the hair of her head, put her over my knee, and gave her a good spanking." Cole employed the smooth back of Tallulah's gold Cartier hairbrush while she cried, "You son of a bitch! I'll never speak to you again!"

"She was so taken by surprise she didn't know what to do," he said. She fell on her bed and "tried to cry; when that didn't work, she locked herself in the bathroom." But "it was all over in two minutes. Her feelings were hurt; she didn't really mind the spanking."

Tallulah ran her household along the lines established in the South, where house slaves and later domestic servants enjoyed the luxury of being treated if not as equals, then as companions rather than factotums, with the right to define their roles and even talk back to their white employers.

Behind closed doors, Tallulah returned to the symbols and patterns of her upbringing. One night at Windows, Cole noted her absence and thought she had gone to bed. Suddenly there was a knock at the door . . . I opened it and there was a colored mammy outside: "Aahs heah to see Mistuh Cole. He says he's white, but he's half colored." It was Tallulah, made up with shoe polish and a great big puffed out stomach. "Oh, she was funny! And she went on and on and I was red all over."

Tallulah "was just like a friend of ours," said Sylvester Oglesby, who began working at Windows with his wife Lillian in 1949. "She was a nice lady; she was just hot-tempered. You know I used to get a vacation practically every month or so. Miss Bankhead and I would have a fallin' out, something I did or something she did or something she said. And I'd be talkin' about quittin'. Then she'd give us a week off and her car. And we'd wait awhile, and then back there again, we started up again."

Tallulah indeed was prone to asking her servants to join the festivities. One weekend, Anton Dolin had driven to Windows with a sixteen-year-old nephew. William Skipper, the Denishawn dancer who had met Tallulah in 1939 when he delivered her photo proofs, was driving Beatrice Lillie up after her show let out. Skipper and Lillie arrived at 2:00 A.M. to find Windows lit up like a Christmas tree and the phonograph going full blast. Skipper was astounded when a friend of his opened the door: Lou, an actress in between engagements, had begun working as a cook at Windows just a week earlier. Tallulah, Dolin, and his nephew came to the door and found them in a tight embrace. Lou was told to instruct Robert Williams, to finish cooking dinner himself. Williams "had been trained for years to

expect almost anything," and was unflustered. Tallulah insisted that Lou sit down with the guests and a cocktail and explain exactly how she and Skipper knew each other.

As often happens with celebrities, sometimes Tallulah also blurred the boundaries between friends and retainers. She paid Glenn Anders's expenses during the many months he lived at Windows. Yet in his telling, the relationship was quid pro quo. "I did an awful lot of talking for her. I remember she made me do a lot of talking for her."

Once Tallulah was expecting three representatives from a major agency, which was trying to woo her away from William Morris. She told Anders she wanted him to be there, and when they arrived for lunch, it was he who went out to their car to greet them. Eventually Tallulah came downstairs and they settled down to lunch on her porch while Anders went back to his own affairs. He was walking downstairs just as Tallulah was entering the kitchen to tell her cook something. Apparently she wasn't pleased with the agents' pitch, and Anders found himself in the firing line of her irritation. Tallulah "came at me like a tigress," Anders recalled, "bouncing at me and grabbed me and smashed me against the wall. 'Goddammit! You have more integrity than anybody I know! Goddammit!'"

Bested by Brando

"If I have my history right, it is the heretics, the nonconformists, the iconoclasts who have enriched our lives, added both to our knowledge, our progress, and our happiness."

Tallulah met Marlon Brando on the opening night of *I Remember Mama* in October 1944. She had gone backstage to congratulate Mady Christians, who played the title role and was a friend of hers. Brando, then twenty, had played Christians's fifteen-year-old son. Tallulah invited him to visit Windows. "Don't go," warned Christians. "She will just chase you through every room in that house." "Don't worry; I can take care of myself," Brando replied, and he did spend an amorous weekend at Windows.

Two years later, Edie Van Cleve, who was Brando's agent at MCA and an informal adviser to Tallulah as well, recommended he play opposite her in Jean Cocteau's *The Eagle Has Two Heads,* which Tallulah had selected for the 1946–47 season. Despite her expostulations against the Group Theatre during *Clash by Night,* Tallulah did want to be au courant. She must have realized that Brando was not only a fantastic presence in his own right but an avatar of the coming epoch of acting. Tallulah agreed to hire him despite the fact that he auditioned badly, which had cost him the opportunity to play the Lunts' son in *O Mistress Mine* in 1945. The Lunts wanted very

much to act with him, and Lunt even coached him for his audition, but Brando's reading was so desultory that they couldn't bring themselves to hire him. Tallulah told Cole, who was to be *Eagle*'s stage manager, that she would be able to "fix" Brando, but he steered clear of her. Not only was she his mother's age, but his mother also had a drinking problem. There would be no resumption of their fling.

The Eagle Has Two Heads is set in a quasi-mythical kingdom at the end of the nineteenth century, something of a sister to the haunted castle Cocteau had just conjured up in his film, *Beauty and the Beast*. As the play opens, a queen is carrying on a conversation with her late husband's specter over tea. It is the tenth anniversary of both their wedding and of his assassination. She has not shown herself to her subjects since the murder, and is invariably veiled whenever in company. She is at odds with Baron Foehn, her kingdom's chief of police, who is plotting to dethrone her.

That night, the queen is surprised in her chamber by a would-be assassin, Stanislas, but he turns out also to be the pseudo-anonymous poet "Azareal," who had earlier written a poem denouncing her. She so enjoyed his verses that she circulated them to the court. She sees him now as the fated instrument of her death, and decides to shelter him only so that he can accomplish his objective. But his wrath is merely a defense against his long-suppressed love for her, which she soon reciprocates.

Cocteau's valorization of the poet was a theme of the play. "He is poor, he has no title," the queen explains to her majordomo. "No, I am wrong, he has the most beautiful title of all; he is a poet." Stanislas has brought the queen back to life, and she resolves to face her populace once more and even divests herself of the dose of poison she has carried on her person for years.

But the queen's redemption is dashed to bits when Stanislas is cornered by Baron Foehn, who shows him a warrant for his arrest that he intends to enforce. The hysterical young poet flees to the queen's room and swallows her poison. The queen is enraged, taunting him until he stabs her. She confesses that she had provoked him so that he would take her with him to a *Liebestod*-like eternity. "Death is love," she tells him as they expire together.

Static and macabre, the play was in some ways an odd choice for Tallulah, the setting dangerously close to the Ruritania she had flopped with in *A Royal Scandal*. But she was doubtless impressed by the cachet of Cocteau and the play's recent success in Paris starring Edwige Feuillère, and in London starring Eileen Herlie. Tallulah surely envisioned covering

herself in prestigious new laurels, for the play had the earmarks of the avant-garde. The first act featured a monologue by the queen that is perhaps the longest in contemporary drama, while the second act is dominated by Stanislas's long address to her. Several times the queen and he speak to each other in verse, and in the final act they engage in almost an operatic dialogue in recitative. Cocteau's text embodies the reflexive self-regard employed by Wilder in *The Skin of Our Teeth*. The queen rings down the first-act curtain by instructing Stanislas to "rest well and renew your courage for tomorrow you must help me to finish to write my tragedy, but we have done enough for tonight. This scene will do as a curtain."

Tallulah liked to play exceptional women, and the majestic complexities, not to say perversities, of this queen offered ripe theatrical fodder. Undoubtedly, she was also attracted by how she would look in the period costumes, which were designed by Aline Bernstein, who had designed her costumes for *The Little Foxes*. In act 3, Tallulah wore a riding ensemble, brandishing a whip, which carried a fillip of fin de siècle sadomasochism when she used it to vent her fury on Stanislas.

Eleanor Wilson, an actress in her late thirties, read before Tallulah and producer Jack Wilson for the role of Edith de Berg, the queen's duplicitous lady-in-waiting. After Wilson had read, Tallulah walked down to the stage and said, "Her face is too much like mine." "Well, I'll break my nose," Wilson said facetiously. She got the job; Tallulah later told her she was impressed by her spirit. Tallulah likewise found Brando's irreverence initially attractive. "If I have read my history right," she writes in *Tallulah*, "it is the heretics, the nonconformists, the iconoclasts who have enriched our lives, added both to our knowledge, our progress, and our happiness."

Brando already had established a pattern of erratic, insubordinate behavior in the few shows he'd been in. Like Tallulah, he was assailed by conflicts about himself and his vocation. "He hated acting," said Herbert Kenwith, who was Brando's roommate when they acted together in *I Remember Mama*. "He hated audiences. He just thought they were fools to pay money to see people on a stage playing."

Brando muttered and mumbled and stumbled and fumbled from the first day's reading of *Eagle* at the New Amsterdam Roof theater, but he had so much going for him that Tallulah and everyone else was willing to give him the benefit of every doubt. He and Tallulah were to some degree mirror incarnations in their heretical behavior, their ambivalent approach to their work, right down to their elocutionary idiosyncrasies. "If I were not a Queen, I should be a revolutionary myself," Cocteau's heroine confesses.

The maverick temperament shared by the established actress and her young leading man could have given exactly the right dynamic to their stage relationship.

Winter was approaching, yet Brando kept appearing in threadbare coverings. Finally Tallulah said, "Marlon, it's cold outside. Why aren't you wearing a coat?" "Haven't got a coat." So that day at lunchtime, Wilson's assistant, Martin Manulis, was assigned to go to nearby Brooks Brothers with Brando and buy him a coat. At the store, Brando delivered a performance far surpassing what he was doing in rehearsal. The very first coat they looked at was beautiful and fit him. Brando proceeded to look at a vast array of overcoats, before deciding that what he really wanted was none other than the very first coat they had seen.

In her autobiography, Tallulah describes Jack Wilson as her favorite producer—"charming, tactful, alert"—but says nothing about his directing. Wilson had brought her the play and perhaps his direction was part of the package. He certainly was by now much more experienced than he had been during her summer 1941 tour in *Her Cardboard Lover*. During *The Little Foxes* she had written that good direction was the most essential element in an actor's performance apart from good casting. "The more talent you have the more discipline you need." However, Tallulah's mental awareness of what she needed contended with her reflex instinct to rebel against authority. Perhaps by now more assertive directors did not want to subject themselves to inevitable wrangles with her. One should not, however, overestimate how much sway any director actually exercised over Broadway superstars.

Eleanor Wilson said that Tallulah "couldn't have been sweeter or nicer or kinder" to the cast, but "managing her would be quite a different problem, I think. She had to have her way—she had to have her way." Yet Jack Wilson had developed his own skills as a conciliator. "Once she rebelled against something. There was an argument and he sent her a present and so got his way in the end. She understood that, too, I think, that technique."

Cocteau's queen is so eccentric that one explanation for her behavior could be insanity. According to Cole, Jack Wilson advised Tallulah that this was how the queen had been interpreted by Herlie in London and Feuillère in Paris, although Feuillère's performance in the film is rather more ambiguous than that. Tallulah, however, was reluctant to portray the queen as fully demented because she was afraid she would look foolish. Manulis thought her decision may have been wise. Tallulah "playing a loony could be nervous-making; it could have been taken as funny." In any case, Cole

said that while Wilson couldn't quite get her to play *Eagle* as he wanted her to, "he got her to play it so he thought she was doing it his way."

Tallulah's publicist Richard Maney writes in his 1957 memoirs that Jack Wilson "had interpreted Marlon's trancelike conduct as a manifestation of genius. He hesitated to correct him lest he upset his mood." But Wilson's flash point was struck as Brando was mumbling his way through a dress rehearsal shortly before they went to Wilmington for the November 28, 1946, opening. "I don't care what your grandmother did," Wilson exclaimed, "and that Method stuff, I want to know what *you're* going to do!" Brando in turn raised his voice, and acted with great power and temperament. "It was marvelous," Eleanor Wilson recalled. "Everybody hugged him and kissed him. He came ambling offstage and said to me, 'They don't think you can act unless you can yell.'"

Variety's "Klep." turned in a report from the premiere in Wilmington. "Tallulah Bankhead triumphs over musty, outmoded material to turn in a superb performance. . . . Regal in bearing, she is always believable. Some of those speeches would floor a less able performer." There was some real poetry and magic to the play but also much tedium, said the reviewer. "A moderate run at best is all this one can expect."

Dipping into Method-ese, the reviewer assessed that Brando was "still building his character, but at present fails to impress." He received better reviews at subsequent tour stops, but what his colleagues recalled was only occasional indications of the brilliance he could have demonstrated. "There were a few times when he was really magnificent," Tallulah admitted in 1962. "He was a great young actor when he wanted to be, but most of the time I couldn't even hear him on the stage." Brando displayed his apathy by demonstrating some shocking onstage manners. He "tried everything in the world to ruin it for her," Cole claimed. "He nearly drove her crazy: scratching his crotch, picking his nose, doing anything."

The scratching got worse and worse. After several weeks on the road they reached Boston, by which time Tallulah was ready to dismiss him. Brando's third-act death roll down the stairs was balletically graceful and even somewhat effeminate. It was appropriate for the esoteric play, but was not to the tastes of the Harvard undergrads in the audience, who greeted his tumble with laughter. For Tallulah, this was the last straw.

Manulis was dispatched to New York to audition potential replacements and he decided on Helmut Dantine, the young Austrian actor who was familiar to film audiences from roles in *Mrs. Miniver* and a number of other popular films. On the final Friday of *Eagle*'s two weeks in Boston,

Brando was given his notice. Rather than subject him to two more weeks as a lame duck, he was paid the equivalent salary.

At the Saturday matinee, Manulis took a seat in the last row of the orchestra to watch Dantine's debut. Just before the theater darkened, down the aisle came Brando. He wore the sloppiest clothes, carried a little makeup kit, and dangled a jockstrap over his wrist. He had bought a seat in the front row. His feet perched on the orchestra rail, he spent the performance staring down his replacement and Tallulah. Less than a year later, his career would skyrocket with *A Streetcar Named Desire*.

Tallulah was glad that, offstage as well as on, she was getting more response from Dantine than she had from Brando. But she had to have realized that, handsome and competent as he was, "Helmut didn't have in his whole body what Marlon had in his thumbnail," as Manulis said. Charles Bowden, who saw the play in New York, found Tallulah exhibiting a searing Phèdre-like intensity, while "everything was so mingy around her." In act 2, Tallulah generated real menace when the queen engages in her pastime of target practice. But this was dissipated by Dantine's responses; it turned into "girls' games in a finishing school: What should we play next?"

Early in January 1947, Tallulah sent for Guthrie McClintic to come to Philadelphia and offer his diagnosis. McClintic was just the type of proactive director that Wilson was not. But "Guthrie was full of shit," Cole complained. " 'It's a Gothic thing,' Guthrie said, 'and it's all there; it just needs a little pulling together.' " Cole was sure that McClintic realized the play's ills were terminal and just didn't want to get mixed up in it.

Manulis felt that the play was deadly for American audiences. He saw Tallulah fighting to retain her belief in it, knowing the unlikelihood of its success should she admit to herself that she had made a mistake. Tallulah was terrified she wouldn't be able to hold the audience's attention for the entire span of her act 1 monologue, but she did. However, perhaps sensing some restlessness in the audience, she began giving the speech less value as the weeks went on. It had clocked in at thirty minutes in Wilmington, but Tallulah was reading it in 17 minutes by the time the show reached Broadway, where it remained a record-breaking stem-winder. Not every word was any longer distinct, Cole recalled, but he felt that the monologue should have been cut by half anyway. Cocteau, however, refused to allow any cuts.

Eagle stayed on the road for the next two months, a longer tryout than most Broadway shows enjoy. With all her lapses and vagaries, Tallulah was routinely able to call upon the sterling training in etiquette in which her grandmother had instructed her. At civic and social receptions on tour she

was invariably "the best-behaved woman in the group," Eleanor Wilson recalled.

Business was good, and Tallulah must have wanted to squeeze out as much of a run as she could before braving New York, where *Eagle* finally opened at the Plymouth on March 13, 1947. Stabbed in the back by Stanislas, Tallulah's queen climbed a baronial staircase center stage, stepped out upon a balcony to greet her subjects, grabbed a curtain for support and pulled it over her head in her dying agony, and fell halfway down the stairs. "The audience very nearly burst with enthusiasm," Pollock reported in the *Brooklyn Daily Eagle*. "But up to that moment it had small occasion for elation."

The Eagle Has Two Heads earned almost unrelieved scorn from New York critics, who condemned its melodrama while hardly acknowledging—even to condemn—that this was melodrama filtered by Cocteau's symbolism and cerebral detachment. In the *New York Post,* Richard Watts Jr. wrote that, "It is so good to see Miss Bankhead again that I hate to be ungrateful to the play that brings her back, but 'The Eagle Has Two Heads' is a preposterous bore." Barnes in the *New York Herald Tribune* opined that

> the play is worth witnessing merely for Miss Bankhead's consummate acting. Even when she is asked to carry on a long conversation with a ghost she gives the offering eloquence and dynamic power. The final scene, in which she taunts her lover into shooting her, finds her at the peak of her artistry. Performing such as hers is rarely seen on the stage.

William Hawkins in the *New York World Telegram* found unwise her attempt to sound funereal by limiting her usually agile vocal handsprings. "The result is that she sounds as if she did not in the least care what she was talking about." Freedley in the *Morning Telegraph* said that "no more serious piece of miscasting has taken place in a long time . . . she never convinces you of the character."

In her curtain speech, Tallulah confessed her anxiety that the play would never come off. "It'll come off, all right," Robert Garland assured his readers in the *New York Journal American*. "And sooner than expected." The first four nights sold out, and then the play coasted for two weeks on the strength of what advance money was not subject to refund. Most of the $80,000 advance sale disappeared very quickly, however. Tallulah, nursing bruises on the right side from the impact of her topple down the staircase, was glad that it was finally over.

Public and Private Lives

"I've fucked every man in this room except for Alfred, and I've had my eye on him for a long time."

Tallulah told David Herbert that *Eagle's* failure had been entirely her fault: she felt that she was just wrong for it. When it closed she was eager to go back to work, eager to reaffirm her viability, to herself above all. A revival of Coward's *Private Lives* started as a stopgap. She had taken the play on short tours of summer theaters in 1944 and again in 1946. Jack Wilson was keeping the Empire Theater dark all summer so that he could open a fall production there. To fill it, he suggested that Tallulah perform *Private Lives* on Broadway during the summer of 1947. First they would open in Westport, followed by a short season in Chicago, and then Broadway. But *Private Lives* turned instead into the longest run of Tallulah's career.

Private Lives tracks the amorous shenanigans of Amanda Pryne and Elyot Chase, who reconnect five years after their divorce while sharing adjoining honeymoon suites on the Riviera. They run away from their current spouses and live together in Paris. Their current legal mates track them down and they run away together one more time. Dismissed by most

critics as a bagatelle, it proved to be one of the century's most enduring comedies.

To direct, Wilson assigned his assistant Martin Manulis, who was convinced that the script should be rethought in terms of the time and the country in which they were performing. For example, throughout act 1, a running commentary is made upon the splendid yacht parked in the harbor beneath the couple's terrace. "Who's yacht is that?" Amanda asks Elyot. "The Duke of Westminster's, I expect," Elyot tells her. "It always is." When *Private Lives* had first been performed, the audience laughed, because the fabulously wealthy duke was a well-known yachtsman. Seventeen years later and a continent removed, the line seemed flat. "We thought it was so boring," said Manulis. " 'Whose yacht is that?' *Who cares?*" Cutting the two lines crossed their minds, but Coward refused to allow any cuts or changes.

Tallulah's solution was to tweak the line instead, asking "Whose *yaacht* is that?" in a tone of such high irritation that it became nearly a Dixie war cry. The source of her exasperation seemed not just the annoyance of the moment but a lingering, cumulative anxiety about exactly who *was* on that yacht, someone she might have had an affair with, and might or might not want to run into at that moment. At the first performance, Manulis was stunned by the way Tallulah's delivery turned on a dime. "She did it cleanly, so *boldly,* coming out of nothing." He admired her ability to find an emotional logic for a transition without needing to take a pause. It was a valuable facility shared by the experienced actresses of the older school. By contrast, he believed that the Method-influenced comers found it much more difficult to negotiate hairpin turns in mood.

As Elyot, there was no question that Tallulah would again retain Donald Cook, after starring opposite him in the play in Canada the previous summer. Charles Bowden, who stage-managed Tallulah's *Private Lives* during its Broadway run, said that Cook was "perfection" because "what Tallulah deeply wanted was the most ballsy, sexy guy in town who wasn't afraid of coming across as a sissy." Cook was partial to striking poses, hand across chest, and luxuriated in a succession of dressing gowns, yet he managed to seem unimpeachably virile in a way that Coward, who had played the lead in his own play, never could achieve. Cook "knew how to play with her and against her," said actor J. Frank Lucas, who caught the play in New York and acted with Tallulah in *Crazy October* ten years later.

Tallulah used Cook's sexual duality to enable her to assert her own. Bowden found Tallulah's "whole attack" on *Private Lives* fascinating—the

way she "played every possible masculine aspect of that woman. It was a wonderful reversal." Much of their coupling "had this kind of strange off-beat thing, where he was rather pliant and she rather aggressive. It wasn't necessarily physical, but in the interpretation of the lines and the color."

For her rival, Sibyl, Tallulah picked eighteen-year-old Buff Cobb. She was the granddaughter of humorist Irvin S. Cobb and her mother was an acquaintance of Tallulah's. Cobb had already appeared in the film *Anna and the King of Siam,* and was married to William Eythe, who had acted with Tallulah in *A Royal Scandal.*

A year earlier, Cobb and Eythe were driving near Windows one Sunday. Apparently thinking of Anne Baxter, he warned Cobb that Tallulah could be extremely rude to young actresses and so he'd better go in first and ask Tallulah if she wanted to meet his wife. He returned to say that Tallulah was very anxious to meet Cobb. In the spring of 1947, Cobb and Eythe ran into Tallulah walking on Fifty-seventh Street, and within an hour of their arrival back home, Tallulah was calling to ask Cobb to read for Sibyl the next day.

In Westport, a very rocky dress rehearsal began at 8:00 P.M. and lasted till dawn because of tantrums from Tallulah. "It was absolutely outrageous," Cobb recalled. "She just went bananas. Screaming and yelling: she wouldn't work in that set, and she couldn't do this and she couldn't do that." It was terrifying for Cobb. "Until then I had never seen anything except a hardworking lady who was very pleasant." According to someone else watching from the audience, Tallulah was slightly under the influence.

After a week in Westport, they opened in Chicago on July 22, 1947, where Claudia Cassidy wrote in the *Chicago Tribune* that *Private Lives* now seemed "a fairly repetitious exercise in trivia," but described Tallulah acting with a "gleeful exaggeration under control" that elicited from the audience roars so vociferous they might have stopped a passerby in his tracks. Despite feeling that the two stars overplayed the second act, Cassidy admired their slapstick: "Miss Bankhead is a stageful even when she loses control of her Mainbocher pajamas, perhaps even more so." At the final curtain, their reception was frenzied. "I've never seen anything like it," Cobb recalled. The audience stamped their feet, whooped, and screamed, reminding her of an audience at a prizefight.

Cobb stood in the wings at every performance, watching Tallulah and Cook wrangle, coo, sulk, and *rapproche* through the second act. "A great learning experience," Cobb called it. "You couldn't watch anything more brilliant than those two at work." She was fascinated by the way Tallulah's

stage business utilized personal trademarks to speak for the character: furious at Cook's Elyot, she slashed on her lipstick with savage intensity.

At the end of act 2, Amanda and Elyot's attempts to suppress their violent tempers collapse altogether, and slapstick fisticuffs ensue. Both Tallulah and Cook were in their midforties and not in the best of physical shape. Cook's drinking during the trip to Canada had gotten so alarming that Tallulah went to Equity and gained permission to fire him if he went too far. Their initial attempts to stage the fight were cautious, until Manulis told them he would have to bring in a stuntman to work with them. Rising to the challenge, they devised an appropriately rambunctious brawl. Tallulah toppled over a sofa with a dexterity to rival her acrobatics onstage during the twenties, but not without redoubled effort. She would come offstage soaking, often asking for rub-downs during the intermission.

Tallulah always felt that Coward had never written a good third act, and the final act of *Private Lives* is indeed something of an anticlimax. The second act curtain falls on Sibyl and Victor arriving in time to see Amanda and Elyot in the throes of their distemper. All four spend the night propped alone on various couches and beds. In act 3, they are forced by their unresolved affections to regroup at the breakfast table.

Cobb loved her interaction with Tallulah in this act. Amid the sullen quartet of present and former spouses, Amanda fills in the awkward lapses with desperately nonchalant chatter. To Cobb, Tallulah added some behind-her-hand mirth, slowly lowering her eyelashes in a wink into her upstage coffee cup. "She was so naughty, she tried to break me up every night."

The age difference between them was much greater than it had been between Gertrude Lawrence and Adrienne Allen in the original production, something Tallulah now made a virtue of. "Seeing the depths of degradation to which age and experience have brought you I'm glad I am as I am," Sibyl tells Amanda. She replies: "That was exceedingly rude. I think you'd better go away somewhere." And with that Tallulah dismissed Cobb with a vague wave of the wrist, not even giving Sibyl the importance of a command.

At eighteen, Cobb was a worldly young woman who had already been divorced after a brief first marriage. But she was not quite worldly enough at that time to solve the riddle of her marriage to Eythe. She is not quite sure to this day whether she was simply a cover for his homosexuality. Eythe had already begun a long relationship with a leading juvenile in Hollywood. Cobb kept wanting to leave the show and return to Eythe to figure

out what was going on between them. Tallulah tried to discourage Cobb's hopes without actually telling her that her husband was homosexual. During the run, Cobb met newscaster Mike Wallace, and by the time she left the show, she was engaged to him.

Cole said that Tallulah "got *Private Lives* by the ears, made it sit up and play. I don't know how she saw the things in it she did—even Noël didn't know they were there." Nor, perhaps, did Noël want to know. "Tallulah? In *Private Lives?* In New York? Are you out of your mind?" Coward had exclaimed. Always picky about casting, he was refusing to let Lillian Gish come to New York in a revival of his play *The Marquise.* Wilson tried to convey Coward's reluctance diplomatically, but Tallulah was nonplussed.

With Coward arriving in Chicago at the end of August to vet the production, Tallulah was eager for him to see exactly how much business they had been doing. (Wartime restrictions still in effect meant that Coward, perpetually in need of money, hadn't started getting his statements. Coward's royalty was 10 percent of the gross, already a hefty amount by then.) In the week before Coward's arrival, Cobb noticed Tallulah's performance getting smaller and smaller. "Nearly all the shtick was gone," and Cobb was perplexed. "By Thursday or Friday night I heard a rumor that Coward was showing up." She asked Stephan Cole, who was stage-managing, when Coward was expected. Cole was surprised she knew because Tallulah had been trying to keep everything quiet so as not to get everyone's nerves racing.

Coward arrived with a delegation of British colleagues, including his lover, actor Graham Payne, all-powerful producer Hugh "Binkie" Beaumont, musical comedy star Ivor Novello, as well as playwright Terence Rattigan, in whose *O Mistress Mine* the Lunts were starring next door to Tallulah. At dinner before Tallulah's performance, Coward scoured the ledger sheet, looked up, and quipped: "I think Tallulah's *absolutely* fine and should go to New York!" But Cole felt that Coward truly enjoyed the performance, seeing "a different play," performed in a style more suited to contemporary American audiences. Coward even told Phil Arthur, cast as Amanda's second husband, Victor, that Tallulah's was the best way to perform his play in that time and place.

"I went to the performance with some misgivings," Coward wrote in his diary. "Much to my relief, and a certain amount of surprise, Tallulah was extraordinarily good; she is a bit coarse in texture, but her personality is formidable and she played some of it quite beautifully and all of it effectively."

After the performance, when they went for drinks, Tallulah was "touchingly thrilled that I liked her performance and ecstatic when I said

she could play it in New York," Coward noted in his diary. She told him she was presenting him with an Augustus John portrait of Gerald du Maurier that she had purchased in London.

Later in the week, Tallulah celebrated their camaraderie by hosting a supper party in her suite for Coward, the Lunts, and other members of the British contingent. Tallulah sometimes went to the Lunts' theater to chat with them, but tonight she was discomfited by Fontanne's cool regality. Tallulah was a little high when she announced, "I've fucked every man in this room, except Alfred, and I've had my eye on him for a long time." "Lynn thought that was rather unnecessary," said Charles Bowden, who was a close associate of the Lunts. The evening wore on until Tallulah, by now "quite pissed," decided the time was right to reopen a long-standing debate along Broadway. "People discuss so constantly who's the better actor, Alfred or Lynn, or what would have happened to Lynn if she hadn't married, or what would have happened to Alfred, if he hadn't. . . . What do you think you'd be doing, Lynn, if you hadn't married Alfred, right now?"

"Probably playing *Private Lives*," Fontanne retorted. "Now it's late," she continued, "and we're all very tired. Did you know in a way you're working for me? Every Jack Wilson production has four partners: Jack, Noël, Alfred, and myself. So I'm sort of your boss, and I think you should go to bed, and be fresh for the matinee tomorrow." She stood up and Lunt followed suit. As they moved toward the door, the balance of Tallulah's guests rose to leave. In the elevator they all caroled in unison that Tallulah was just too much.

Tallulah was hardly pleased when the next night, after the evening's performance, the Lunts took their guests for a weekend at their home in Genesee Depot, Wisconsin. Still, when Coward and Payne went to check out, they discovered that Tallulah had already taken care of the bill for their weeklong stay.

"Darling Tallu," Coward wrote upon his return, accentuating the positive. "You were so gay and sweet and generous and your god damned vitality lights up all the world around you and I only hope they kept you away from the coast during the war on account of your magnetism triggering up any black out."

During her months in Chicago, Tallulah spent a lot of time with disc jockey Dave Garroway. They went out alone much more frequently than Tallulah did with most of her boyfriends, and she enjoyed his tutorials about jazz. "Dave was a brilliant man," said Cobb. "MIT graduate and all kinds of things, and he really knew his music. He was very good for Tallu-

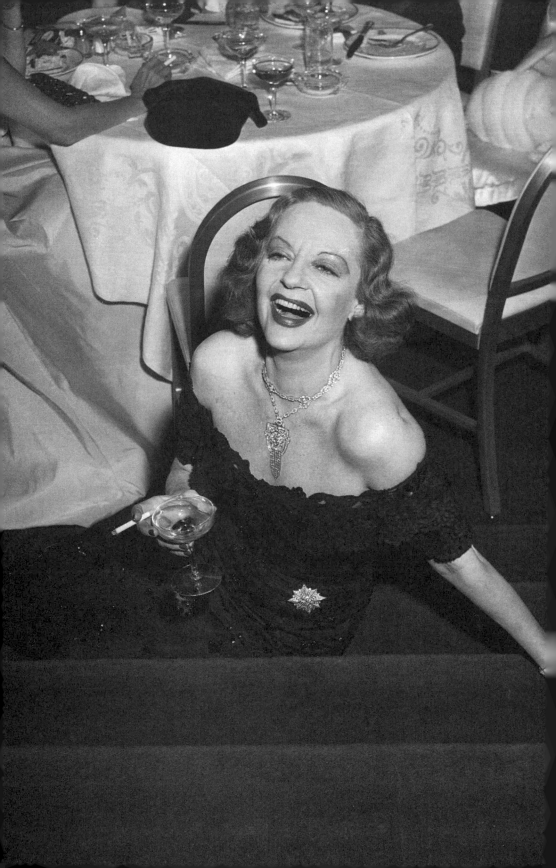

lah." Unfazed by anything she might do or say, Garroway had a lively sense of humor. He called her "Tiger," frequently tossing out greetings to her over the air, which particularly pleased her.

Over the summer, Tallulah asked Cobb how she was surviving the Chicago heat; Cobb said she was subsisting on cold seafood and white wine. Tallulah took Cobb more literally than she needed to, deriving all her sustenance for the next month on lobster and white wine. That may have brought on an attack of neuritis that she suffered in October, forcing the show to close for two weeks while she went into traction. Later in the Chicago run, a superbly talented and very strong-willed twenty-four-year-old actress named Barbara Baxley was hired as Cobb's understudy. By that point, Tallulah and Cook had ended their relationship, but she was none too pleased to watch him begin an affair with Baxley. Cook was living with Cole in a district of small houses that had been populated in the 1890s by the city's kept women. Cook's dresser kept house and prepared dinner. On one occasion, Tallulah showed up without warning, ostensibly curious about how they were living but really, Cole suspected, trying to catch Baxley in flagrante delicto. It wasn't that Tallulah would have punished Baxley, Cole believed, "Tallulah just would have had something on her."

After a performance, Tallulah could not tolerate being by herself. Nobody could match her ability to sit up drinking for hours night after night after night. The company used to take turns going back to the Ambassador East and babysitting her into the wee hours. It became something of a joke among the company, Cobb recalled. "It's your turn," Cole would say to her. "No, it isn't; I did it last night!"

The Harris Theater was packed every night, bursting at its seams with hilarity. Each laugh encouraged Tallulah to try to embellish a gag for bigger responses, and she could get carried away. "I'm going to try to get her over that," Wilson confided to Manulis during a performance, watching a bit of Tallulah's stage business. "Fat chance," Wilson corrected himself with a chuckle.

If Wilson preferred to stage these plays in the manner that Coward and Lawrence had created them, he was not displeased at the enormous grosses generated by Tallulah's own approach. From time to time, various notables of the theater world would catch the show on their way through Chicago, calling Wilson to sniff, "You ought to see what she's doing now!" Then Wilson would order Manulis, who was receiving a modest percentage of the box-office take, to "go and earn your money."

At a party in 1954

Manulis never felt, as others did, that Tallulah's highjinks were more appropriate to vaudeville than the high-comedy stage, but she "was certainly rough-and-ready compared to what Gertie had done." The director said that he could "talk to her about particular points." If he told Tallulah something was "as close to dropping your drawers as you can get, and you mustn't do that," she would laugh, but she was "smart enough to think over what was said," and ultimately "she would calm down."

Some parts of the performance were in a different mood altogether. Tallulah's delivery of the lines in which Coward allows Amanda to establish the poetry of her soul were done without any irony or bravado. They were "all sweetness, beautiful and lovely, not tough, not funny." Manulis found himself bewitched by her moment on the balcony when she hears the hotel orchestra play "Someday I'll Find You," as it had been played in St. Moritz on her honeymoon with Elyot. As Manulis watched her, he felt that Tallulah, too, was calling on something in her past to make Amanda's moment of recollection extraordinarily real. Whatever Tallulah herself called up, the scene "was youthful, it was fresh, it was very poignant. You cared very much."

Offstage, Tallulah spent her afternoons in bed reading, doing needlepoint, listening to the radio, with only the occasional outside excursion, a walk around the city. A scarf and sunglasses swallowing most of her face, she trotted unrecognized around the Loop, sometimes winding up at a movie.

On her Sunday night off, Tallulah liked going with Cole to the Chicago Symphony. One Sunday they argued about whether a certain instrument was a viola or a violin, and he accused her of pretending to know more about music than she did. That was about as much insult as Tallulah could bear from him, and they didn't speak for two days.

In fact, Tallulah had played violin and piano as a child, and she could still read music; Cole would sometimes see her perusing a score if she happened upon one, and she had played a few measures on the piano in *The Second Mrs. Tanqueray*. In Chicago, Tallulah also went to see Kirsten Flagstad sing Wagner's *Tristan und Isolde,* in her return to American opera. The *Liebestod,* "that was *her* music," Cole said with a chuckle; for her it was a rapturous experience that affected her almost like a drug. During her early days in New York, Tallulah had been invited several times by muralist Paul Draper to musicales given by Robert Chandler, a wealthy music buff who was married to soprano Lina Cavalieri. At Chandler's home, Jascha Heifetz and Artur Rubinstein performed the *Leibestod* as an instrumental duet. "If my breast was savage, those boys charmed it."

For Tallulah, the onstage workings of comic byplay could be as

thrilling and mysterious. During one exchange in *Private Lives,* Cobb spoke a feed line to Cook that aroused a snicker from the audience before he said his punch line and reaped an enormous laugh. One night, however, it was Cobb's line that provoked the bigger laugh. "That put him into a state," Cobb recalled. "That had been a surefire laugh." Cook said something to Tallulah, who watched the scene from the wings for the next couple of performances. Then Tallulah called a rehearsal, suggesting different adjustments. That night the big laugh remained on Cobb's line. Eventually Cook got used to it. But some weeks later, Cobb said her line, and the audience snickered, but when Cook said his line the house fell down around their ears. The laugh was back where it had been originally. The same thing happened the next night. However, Cook was disconcerted all over again, because by now he was accustomed to Cobb getting the laugh. He returned to Tallulah, and back they all went to another rehearsal.

"What are you doing that's different?" Tallulah wanted to know, but Cobb couldn't tell her. After another session working over it, Tallulah declared, "Well, that ought to fix it." But Cobb's laugh never came back, while Cook's stayed right where it should have remained all along. "Nobody could explain it," Cobb said.

Also in Chicago that fall was British comedienne Florence Desmond, who'd known Tallulah since the 1920s, when Tallulah had approved Desmond's impersonation of her. Desmond was performing in a London revue. While Desmond was appearing at Chicago's Palmer House hotel, she saw a lot of Tallulah. On Christmas Day, missing her family desperately, Desmond decided to drop in on Tallulah midafternoon. She found her alone in her suite with Dola Cavendish, her room in its "usual state of disorder," books and magazines strewn on chairs, tables, and across Tallulah's bed.

"Merry Christmas, darling," Tallulah said.

"This is a hell of a Merry Christmas," Desmond said, and burst into tears. Tallulah asked her many questions about her husband and child, "as if she too craved a little family life on that day, even if it were only talking about it," Desmond recalls in her 1953 memoirs. Tallulah wouldn't let her leave, even asking her to keep her company while Tallulah bathed before the evening's performance; finally they ate and went on to their work. "It was certainly an odd Christmas," Desmond writes, "and I honestly believe that Tallulah was every bit as lonely as I was."

Skidding

"Well, I'm the star of this play, and I can do whatever I want to."

At the beginning of February 1948, Tallulah and *Private Lives* folded up their tents and left Chicago for a five-month cross-country tour that was as smashing a success as the Chicago run. But it would prove a fateful turning point in Tallulah's life. In Cincinnati, Baxley told Tallulah that she was going to have an abortion, saying she had become pregnant when a boyfriend visited her in Pittsburgh. Convinced that Cook was actually the father, Tallulah confronted her costar, who stonewalled, saying that he knew nothing about it. "Tallulah was having a great time," Cole recalled, as she tried to trick Baxley into confessing that it was actually Cook. Baxley was determined to thwart Tallulah's enjoyment in taking charge and administering care, making all the medical arrangements herself. Not being in charge frustrated Tallulah completely.

As the tour went on, Tallulah began veering toward self-parody all the way through the second and third acts: exploiting her vocal acrobatics, ostentatiously blinking her eyes, her upstage wink to Cobb growing increasingly lewd. Her antics emboldened Therese Quadri, cast as the maid in their Paris love nest.

Quadri, who had played the same role in the original Coward–Lawrence production, and had her own one-woman show, felt that her tal-

ents were being stymied in the inconsequential role of Louise. As she brought in the breakfast in act 3, she improvised a long gibbering monologue to herself. With every performance, Quadri continued to pad her part. One night, while serving the couple, Quadri missed the table entirely, sending the tray and its contents spilling all over the floor. Tallulah and then Cook dissolved in laughter. "That is perfectly disgusting," Cobb interjected, in character as the fusty Sibyl. "Go away and bring us some more coffee." That sent Tallulah and Cook into further hysterics, along with the audience. As the crew raced around backstage to set up another tray, Quadri walked off, returning to try again.

The character of Victor is a hopelessly hearty prig. Like Sibyl, Victor is a fairly thankless straight man to two scintillating leads; Laurence Olivier had hated playing the part during the original production in 1930. But Phil Arthur had been so eager to work with Tallulah that he'd extricated himself from a commitment to Lucille Ball, who was furious. A true company man, he had no problem with his supporting role. "Anything I do that you don't like just tell me," he told Cook.

Tallulah lived up to his expectations—and then some. He found her "very kind and generous and a lot of fun—but very demanding." As the tour progressed, Tallulah's romantic interest in him became clear. While Arthur found her attractive, he wanted to be taken seriously as a good actor, not as "the star's stud. I was married, too." A writer as well, he was also finishing a play that would later be performed by the Chicago Stage Guild.

Tallulah was persistent. She would invite him to watch the circus with her, or include him in a festive evening with the ballet's Anton Dolin and Alicia Markova. At one point during that evening, Dolin looked over and asked Tallulah, "Have you had this marvelous boy?" Tallulah paused.

"No. I've had everybody else in the company *but* him," Tallulah replied, "and his wife's in town." Indeed, Arthur's wife appeared without warning more than once during the tour. Tallulah was on her best behavior with him. "Some people talk all the time," he said, "but she'd listen to you." She revealed the shy side of herself, confiding to Arthur that "The reason I talk so much is that I hate to have dead air, the silence." Over a quiet dinner in her suite in Minneapolis, she told him she didn't like going to the theater "because people stare at me instead of the play."

"Phil," she said, "if anybody behaved like I do, I'd dislike them intensely."

They were in the Midwest that winter when Cobb came down with a

severe virus. After Baxley stood in for her, Cobb decided not to return to the show. Tallulah was happy to have Baxley onstage with her, because of her talent and because she wasn't the competition in the looks department that Cobb had been.

Tallulah was beginning to question how long her own looks and stamina would hold up. "How long can I keep this up?" she asked Cole, who had begun to notice her energy dwindling. Tallulah's anxiety about the future was partly what was keeping her on the road with *Private Lives,* since she was now determined to make enough money for her retirement. As the tour approached the West Coast, she found some reassurance with Arthur's understudy, William Langford, a Canadian actor in his late twenties, with whom she began an affair that lasted five years.

Midway through the first act of *Private Lives,* Amanda goes into her suite to change for dinner. While she is offstage, ex-husband Elyot appears, sauntering around his end of their adjoining terraces. To make this quick costume change, Tallulah repaired to a special booth in the wings, where she shed the printed dressing gown she wore for her first entrance and donned designer Mainbocher's floor-length "Bankhead blue" crepe dinner dress. Her maid zipped her in, fastening a new pair of shoes while Tallulah fixed her hair. In a minute, she was back onstage and bumping into her ex-husband.

In San Francisco, Tallulah began taking longer to make the change. Forced to cool his heels, Cook improvised some stage business while he and the audience waited. The intermissions got longer, the curtain coming down later and later. The delay was atypical for Tallulah. "She'd keep us waiting," Cole recalled grimly, "having a drink." These were slugs from a flask of brandy. Cole blamed her affair with Langford—for Tallulah, sex and liquor went hand in hand—as well as a general loosening of restraint tied to her anxiety over the future.

Before, Tallulah had always prided herself on not drinking before or during a performance—though her standards were perhaps not as stringent as some. Glenn Anders said that during the 1926 run of *They Knew What They Wanted,* she engaged in the widely practiced British custom of imbibing a split of champagne during intermission. She was still doing it during *Forsaking All Others* in New York in 1933. But Jean Dalrymple, the show's publicist, didn't find it detrimental to her performance. "I never noticed that it did anything except maybe liven her up a little bit."

In *Private Lives,* however, the effects were more deleterious. As the waits got longer, her speech slightly thickened, to the point where her

comic timing was slowed. Instead of confronting her directly, Cole showed her the running tally he made of each performance, asking her to help solve the riddle of why the performance could be getting progressively longer.

In Los Angeles, the final stop on the tour, Tallulah had Phil Arthur fired in order for Langford to take his place. Jack Wilson sent his deputy Eddie Knill all the way out from New York to tell Arthur he would not be going to Broadway with the show. Arthur recalled Knill's discomfort: "He said, 'This is so unfair.' They all knew the score." Cole discussed with Arthur Tallulah's unbearable loneliness. "It was the first indecent thing I'd ever seen her do in the theater," Cole recalled in 1982.

The two had heated exchanges in Tallulah's dressing room. He reminded her that she'd always said she would never stoop to what she accused Gertrude Lawrence of doing: "firing somebody so some boy could take his place."

"Well, I'm the star of this play, and I can do whatever I want to," Tallulah retorted.

"You are and you can, but it's not very nice, and it's not very honorable."

One night before a performance, Tallulah called Arthur into her dressing room. Spread on a tray was an array of gold bibelots from a local jeweler. "Take your pick, darling."

"Tallulah, under any other circumstances I'd just be thrilled to have something," he told her, but as matters now stood it was no thank you.

Tallulah later complained to Charles Bowden that Arthur had been impossible to act with. "It's like playing with a brick wall. There's no impression; there's no give. And so you decide what's the use?" Whether or not she really felt that, Arthur was certainly a better actor than Langford. Although Langford received decent notices for his performance in *Private Lives,* Tallulah later admitted to Bowden that onstage he "just can't get it up."

The whole incident brought to an end one of Tallulah's longest and most significant relationships with a man. After the play closed in Los Angeles on July 26, 1948, Stephan Cole handed in his notice. While Tallulah and the cast booked passage for New York, Cole left Los Angeles on a later train. He would speak to Tallulah on only a few occasions until her death twenty years later.

Not really a love affair, Tallulah's friendship with Cole was virtually as intimate as a marriage; he was probably closer to her in many ways than

Emery had been. Although she and Cole had squabbled frequently in the past, this time, neither would relent. Given how obstinate each of them was, an irrevocable breach was perhaps inevitable, but she considered his departure a cruel desertion. Cole learned later that she had told friends that during his overseas tour in World War II, he had kept prisoners tied to a mast in the broiling North African sun.

In September, Tallulah returned to *Private Lives* with short engagements in Boston and Philadelphia before Broadway. She cut her hair, which she'd worn longish for the past decade, because she felt it more appropriate to her forty-six years, and kept it short for the rest of her life. The New York reception to her performance as well as her looks was worrying her. "I just don't want a kick in the ass," she told Charles Bowden, who replaced Cole as stage manager.

After a performance in Philadelphia, Bowden and Baxley were in Tallulah's suite when at around two in the morning, Tallulah capped a night of drinking by downing five Seconals with a brandy chaser. Bowden picked her up, seemingly unconscious, and carried her into her bedroom. Baxley watched in horror, venting her disgust that someone so talented would behave this way.

At the theater the next night, Tallulah revealed that she had overheard the ingenue's criticism. "That Baxley broad isn't happy, is she? If she thinks I'm abusing myself, maybe she ought to go elsewhere." Tallulah's insomnia and addictions had gotten to the point where short of a lethal overdose, nothing could shut down her senses altogether.

By this point Tallulah was so reckless that one part of her must not have cared whether she woke in the morning. She provoked concern from people less prone to put her on the defensive than Baxley, the much-younger actress not only playing Tallulah's love rival but carrying on with Tallulah's ex-lover and leading man.

"Take care of yourself," Coward himself had written, "and for Christ's sake don't be a silly bitch and ruin your health by ramming 'reefers' up your jacksie. . . ." Kindly admonitions were tossed aside by assurances from Tallulah that she knew what she was doing. Cole believed she did know, and that she was playing as recklessly as she could, convinced there was nothing left for her in her life. "When she died I felt, this is what she's been trying to do for twenty years."

Private Lives opened on Broadway at the Plymouth on October 4, 1948. Martin Manulis thought her opening-night performance in New York was tidier than it had been on tour. Tallulah delegated rising star

Carol Channing, with whom she had struck up a friendship, to come back at both intermissions and tell her how she thought it was going. Channing assured her she had the audience eating out of her hands. "But is it Amanda?" Tallulah kept asking Channing about the performance she was giving.

In the *Daily Mirror,* Robert Coleman toasted her virtuosity: "She takes Coward's taut situations and scintillating wit, and makes them sparkle like perfect diamonds instead of the paste jewels they really are."

"Gracious, what a voice that woman has!" John Chapman exclaimed in the *Daily News.* "It's a baritone, mostly—but with it she can wheedle and simper and entice, as well as bellow. . . . As I watched her I wondered how it was that she missed in the role of Cleopatra."

There was controversy about how much of the alluring Tallulah of old had survived her farcical shenanigans. The *New Leader* compared her performance to "the antics of a lively and lickerish mountain goat." But William Hawkins of the *Journal American* declared that, "For all her abandon and athleticism in this role of the overly married Amanda, there are moments when Miss Bankhead moves in an aura of inexplicable glamour which is beyond comparison with the allure of any other figure in the theatre."

The play itself was dismissed. Almost alone among New York reviewers, Watts of the *Post* had a longer perspective, saying that Coward's plays of two decades earlier were in truth "valuable social comedies, which have important comment to make on the vital between-wars period in British annals. Eventually, done in the costumes of their day, they are likely to occupy a place in dramatic writing not infinitely inferior to the words of Wilde and Congreve."

Shortly before *Private Lives* opened on Broadway, David Dubinsky, the president of the International Ladies' Garment Workers' Union, invited Tallulah to introduce President Truman in a radio address sponsored by the union that was to air on October 21, immediately prior to the presidential election. She accepted eagerly, toiling over many drafts of her speech, doubtless with the help of her publicist, Richard Maney. The curtain went up ten minutes early so that Tallulah could be on the air at ten o'clock rather than wrangling with Cook in the second-act finale. Truman's seven-minute speech was preceded by three minutes from Tallulah.

She began by invoking her family's long record of public office (which had ended two years earlier with the death of Uncle John). Delivering an ad hominem attack against Thomas Dewey, the Republican presidential

candidate, she used tones of high comedic irony. "Mr. Dewey is neat," she conceded. "Oh so neat. And Mr. Dewey is tidy. Oh, so tidy . . . It seems a great pity to risk exposing Mr. Dewey to the smells and noises and ills of humanity." Praising Truman's policy and personality, she mentioned his "passionate pleas for veteran housing, for curbs on inflation, for legislation to aid and comfort the great mass of our population."

Political concerns were never far from Tallulah's mind. In December, she sent the great Wagnerian soprano Kirsten Flagstad a charming letter containing an appeal from the Honorable Nathan D. Perlman, chairman of the fund-raising committee for the Foster Parents' Division of the Labor Zionists' Commission. When Flagstad sent a donation, having also given in Europe to the same organization, Tallulah asked if she could send Flagstad's letter on to columnist Walter Winchell, self-appointed judge and jury of celebrities' moral and political shortcomings.

Flagstad's husband, a Norwegian businessman who had died in prison, had been accused of being a collaborator with the Nazis. Flagstad claimed to have known nothing of her husband's activities, and her accompanist and biographer, Edwin McArthur, wrote that he believed her in his 1965 biography of the singer. Nonetheless, her performances were picketed, and although she sang at the Chicago Opera—where Tallulah had just heard her Isolde—and across Europe, New York's Metropolitan Opera still refused to rehire her.

Learning that Flagstad was expected at a performance of *Private Lives* on Broadway, Tallulah wrote a note begging her to ignore her own fleeting attempts at singing in the play. After the show, Tallulah went back to Flagstad's apartment with McArthur and his wife, where they talked until six-thirty the following morning. Each diva wanted the other to tell her about her very different career. "Kirsten was much taken by Miss Bankhead's rough magnetism," McArthur writes, "and her warmhearted anger at the antagonists Kirsten was still facing."

Dancer William Weslow was introduced to Tallulah in Ethel Merman's dressing room at the Imperial Theater, where *Annie Get Your Gun* was playing to packed houses. "Oh, darling, I just wanted to tear that jockstrap off you!" she confided. The jockstrap that had aroused Tallulah was actually a buckskin loincloth, in which Weslow scampered through the show's "I'm an Indian" ballet.

He took her out many times. She never, he recalled gratefully, tried to press him to drink. But there was no doubt that the drinking, like everything else about Tallulah, was reaching critical mass. "She's one of my

dearest friends," Beatrice Lillie told Weslow. "I love her and she loves me," the elfin star of musical comedy and revue confided, "but I cannot put up with her lewd, lewd vulgarity. But she only does that when she gets about eight or ten drinks."

"I'm going to leave with the car if she gets too outrageous," Lillie warned Weslow. "I can't stand when she lifts up the dress." Keeping Tallulah's dress down had become a major problem for anyone who signed on for the duration of an evening. Tallulah's need to exhibit could erupt, of course, when she was cold sober, but after she'd had enough to drink, it became an imperative.

Like a unicycle, Tallulah's conversation changed direction on a dime, moods and responses segueing and doubling back on one another. Staggering assaults were often followed by retreats to the polite manners her grandmother had so diligently instilled. Flying her skirts at half mast brought maître d's running. "Oh, Miss Bankhead, you can put the dress down now. We've seen that so many times."

"It's boring you?"

"Oh, yes. And your table is ready now."

"Oh, thank you, darling. Bill," she apologized, "I have to put down my dress now. You don't mind, do you?"

"Really, Miss Bankhead, we'll have to pull a screen around you," waiters would chide, when her language went from blue to aquamarine. Tallulah accepted that they, too, had a job to do; she was, Weslow noted, too versed in noblesse oblige to castigate service people. She was sensitive to the vulnerabilities of people who had not been given license, as she had, to talk any way they wanted to anyone they pleased.

The young, beautiful, and unlettered are indispensable decoration at the tables of the celebrated, but there they enjoy only yeoman's status. There was a night when Noël Coward mouthed a snippy dismissal to Weslow, then showed him a summarily turned back. Tallulah laced into the playwright. "I know you wear your skirts to the ground, darling . . . When you're nasty to people I hate that!"

Floating in her banter was Tallulah's awareness that something was very wrong. Weslow remembered a paean by her to Frances Farmer— Farmer's beauty, her talent, her desirability—that Tallulah capped with, "Of course she had an alcohol problem, a mental problem. So do I. Who doesn't?"

The fog of alcohol relieved her social anxieties, but distorted her ability to accurately gauge her environment. "When she was drunk everyone

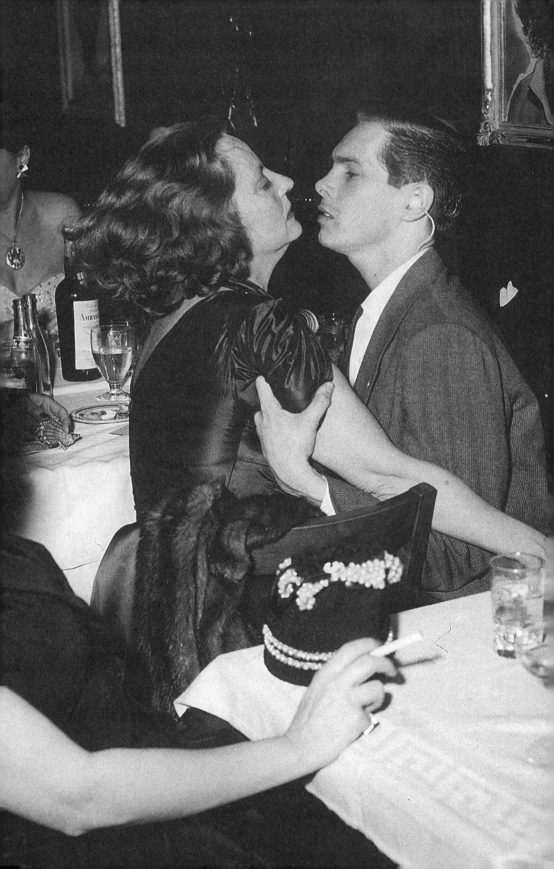

looked like they were enjoying themselves and liked her," Weslow said. Those who were genuinely fond of Tallulah much preferred her sober.

"My heart goes out to people of talent and brains who never achieve their professional due because of flaws of conduct," she writes in *Tallulah*. Undoubtedly she was able on some level to recognize herself in their vagaries. Since the early 1930s, Billie Holiday had attracted Tallulah's deepest personal and professional affection. "Tallu and Lady were like sisters," musician Harold "Stump" Cromer recalled to Linda Kuehl, whose research forms the basis of several biographies of Holiday.

Tallulah's relationships, of course, seldom observed clear-cut boundaries, and it appears that during the late 1940s she and Holiday were also lovers. Perhaps they had been all along. Holiday later told William Dufty, who ghostwrote her autobiography, that when Tallulah visited backstage at the Strand Theatre, the thrill she took in exhibitionistic sex made her insist on keeping Holiday's dressing room door open. Holiday later claimed that Tallulah's brazen show of affection almost cost her her job at the Strand.

John Levy was also Holiday's lover as well as her manager at the time, and although he was one of the abusive strong men to whom Holiday gravitated, Levy was intimidated by Tallulah and her connections. When Tallulah came around, all he could do was get out of the way. Once at a nightclub he sat at a nearby table watching Tallulah express her affection to Holiday. "Look at that bitch, Carl, look at that!" he exclaimed to musician Carl Drinkard. "That bitch is going out of her fucking mind, she's all over her."

In a letter to J. Edgar Hoover written on February 9, 1949, from the Élysée, Tallulah issued an appeal on Holiday's behalf that remains slightly mysterious, since Holiday was at liberty at that time, although she may have been under surveillance. Until now the letter has been buried in Tallulah's FBI files. Tallulah cagily both protects herself from guilt by association and enhances her leverage on Holiday's behalf by denying any personal involvement with the singer.

> I am ashamed of my unpardonable delay in writing to thank you a thousand times for the kindness, consideration and courtesy, in fact all the nicest adjectives in the book, for the trouble you took re our telephone conversation in connection with Billie Holiday.
>
> I have met Billie Holiday but twice in my life but admire her immensely as an artist and feel the most profound compassion for her

Tallulah with singer Johnnie Boy

knowing as I do the unfortunate circumstances of her background. Although my intention is not to condone her weaknesses I certainly understand the eccentricities of her behavior because she is essentially a child at heart whose troubles have made her psychologically unable to cope with the world in which she finds herself. Her vital need is more medical than the confinement of four walls.

Private Lives closed in New York on May 7, 1949, its 256 performances a substantial tally for a Broadway revival. Soon after, the show began a tour of the summer theaters in the Northeast. At the end of June the company was in Princeton.

Herbert Kenwith, then artistic director of the McCarter Theater in Princeton, was impressed that Tallulah diligently rehearsed a play she had already done for two years. Her behavior outside the theater was another matter. One night the front desk of the Princeton Inn called him at 4:00 A.M. and asked him to please get his star inside the inn. Tallulah was rolling across their lawn naked. On a hot night after another performance, she was being driven back to Manhattan along US 1 when she told her driver to let her out. He was to putter along while she ambled behind on foot. Soon she had stripped down to stockings and shoes, strolling with her arms swinging casually. A truck driver spotted her in his headlights and began tailing her. Another truck pulled abreast of him and they inched along, creating a traffic jam. Eventually a member of the local police precinct pulled up, intending to arrest her for indecent exposure. After the officer called Kenwith, who offered a season pass for him and his family, the matter was dropped.

Two weeks later, they opened in Marblehead, Massachusetts, where they enjoyed a fantastically successful week's run, which was climaxed, however, with more havoc by Tallulah. The company had rented rooms in an eighteen-room summer mansion owned by Harry Blaisdell, a Boston manufacturer of elevator parts. After the closing performance Saturday night, Tallulah threw a party that became so rambunctious Blaisdell called the police. In the course of their discussion, Tallulah struck one of the officers. She was arrested, remanded into the care of her theater maid, Evelyn Cronin, and told to leave town immediately.

In August came a chance to put herself back on track. She was asked to test for the role of Amanda Wingfield in Tennessee Williams's *The Glass Menagerie*, which Warner Brothers was planning to transfer to the screen. Laurette Taylor had given an already-legendary performance in the original

Broadway production, but died soon after the play closed in 1946. Tallulah was now forty-seven; Taylor had been sixty-two when she played Amanda. Tallulah might have been diffident about playing a dowdy woman in late middle age, but the role was one of the greatest women's parts of the day, and any path trodden by Taylor, an idol since Tallulah's early days in New York, was hallowed for Tallulah. She loved Taylor's luminous transparency as much as she did the spine-tingling aplomb of Ethel Barrymore. "You could never catch her acting," Cole said about Taylor.

Both Barrymore and Taylor also played bridge with Tallulah. Their lives suffered from long periods of alcohol-soaked disarray, but in front of Tallulah they were careful to maintain their dignity. "Laurette was like an Irish grandmother," Cole recalled, while Barrymore appeared to be impersonating a firm, wealthy aunt.

During *Antony and Cleopatra* in 1937, Charles Bowden had told Tallulah about encountering Taylor while he was on the staff of the Sutton Theatre on Fifty-seventh Street. Taylor was living in a residential hotel nearby. He was punching tickets when a disheveled drunk staggered into the theater's lobby, propelling herself along the mirrors that lined a long hallway. He alerted the manager, who told him that there was nothing to worry about: it was Taylor, who showed up plastered every week or so, snoozing in the last row.

"It's just horrifying," Bowden had told Tallulah. "I can't believe a woman with any talent could get that low." "She's a great talent," Tallulah replied, "and you're a smart-ass, and one day I'm going to jam those words down your throat."

One day in December 1938, Tallulah called Bowden, asking if he was free that night and whether he had enough cash to lay out the money for a set of rented evening clothes. Emery was sick and Tallulah wanted Bowden to escort her to a Broadway opening, but she was evasive about what they were going to see.

When they pulled up at the Playhouse Theater, the entrance was crowded with first-nighters. By the time Tallulah had signed autographs and they'd settled into aisle seats, the houselights were dimming, and Bowden still hadn't had a chance to pick up a program. When he saw the actors onstage, he realized that they were seeing Sutton Vanes's *Outward Bound,* which was being revived fourteen years after its Broadway premiere. The house quickened as Laurette Taylor made a humble yet electrifying entrance, pushing herself backward through swinging doors at the center of the stage.

During the first intermission, Tallulah and Bowden stayed in their seats. Many people came over to talk to her and request autographs. As the house-lights again went down, she reached over and gave Bowden a playful cuff on his cheek. At the final curtain, he and the rest of the audience went into mad bravos over Taylor's comeback. "Are you sorry?" Tallulah asked him about his earlier criticism of Taylor. "With all my heart," Bowden assured her. "Then I'll take you back to meet her," Tallulah said. Six years after that, in 1944, Taylor had scored an even greater success in *The Glass Menagerie*.

Irving Rapper, who was going to direct the film adaptation, had spent most of his twenty years in Hollywood as a dialogue director. During the 1940s Rapper had directed several Bette Davis vehicles, including the clas-sic *Now Voyager*. He went to Windows to discuss with Tallulah her upcom-ing film test for Taylor's role. Tallulah wanted the part desperately. "I never saw an actress so cooperative and intelligent," Rapper later told Denis Brian. Tallulah spent several days getting ready for the test, then two days on the actual filming. The heat was oppressive but she performed at the summit of her artistry. "You just had to give her a suggestion and she al-ways built on it," Rapper said to Lee Israel.

On Friday, the second and final day of shooting, Tallulah worked well in the morning, but when she came back from a lunch break in her dressing room, the crew suspected that she had had something to drink. After lunch she filmed one scene with Pamela Rivers, who was testing for the role of her daughter, Laura, but Tallulah refused to continue on to the scheduled scenes with Ralph Meeker. He was being tested for the role of Tom, her son. Tallu-lah claimed that she hadn't had enough time to prepare her scenes with him, but after the studio enlisted Dola Cavendish to intervene, Tallulah agreed to simply feed the lines to Meeker while sitting out of camera range. Tallulah went back to her dressing room, only to reappear reeling drunk and cursing a blue steak. Bellowing that Meeker was the next Barrymore, she demanded to be allowed to direct his scenes herself. "You have absolutely no idea of the disgraceful state Miss Bankhead was in late Friday afternoon," Harry Mayer, in Jack Warner's New York office, wrote on August 22 to Warner's executive assistant, S. B. Trilling, in Hollywood. "Incidentally, it was this that caused us to go into two full hours of overtime at the studio."

The tests were sent ahead to California. As impressed as the West Coast office was, Tallulah's behavior was cause for concern, and Gertrude Lawrence was hired instead. Jack Warner's son-in-law, William Orr, who worked for Warner at the time, was among those at the studio who saw the test. He considers what happened one of the "three or four things that up-

set me during the course of my career at Warner Brothers. Tallulah was perfect for the part, and Gertrude Lawrence was not," Orr insisted in 1993. "To me she wasn't believable; Tallulah was fantastic."

About a month later Rapper called William Morris executive John Hyde, and asked how Tallulah had handled the rejection. "There was the longest pause," Hyde told Rapper. "You could hear a pin drop." Tallulah reacted to her disappointment by embarking on one more tour of *Private Lives*. Back in May, a brief tour had been announced for the fall.

Tallulah all but apologizes in her memoirs for spending three years of her life dedicated to "so feathery a trifle" as Coward's play, claiming that she needed the money and a better play was hard to find. Despite her many manifestos asserting the sacredness of comedy, it seems she fell prey to the common critical perception that it was a lesser genre.

It is true that great women's roles were becoming harder to snare for all the major leading ladies of the prewar era. Brando in *A Streetcar Named Desire* and Cobb in *Death of a Salesman* were the iconic performances of the late 1940s, and the 1950s were to see a generally more misogynistic temperament take hold.

Tallulah wasn't the only one forced to compromise. "It's all right for you," Gertrude Lawrence told Anton Dolin soon after the end of the war. "You can keep dancing these wonderful old ballets over and over." Lawrence herself was forced to take refuge in revivals of Shaw's *Pygmalion* and Coward's *Tonight at 8:30*.

Tallulah's last *Private Lives* tour was blighted for all concerned by her dissipation. Baxley later told Buff Cobb that Tallulah had become an outrage, drinking, sniffing cocaine, and smoking pot on a regular and indiscriminate basis. With Donald Cook's own sobriety shaky—his alcoholism was such that it was now impossible for him to work and drink—his Italian wife, Gioia, was worried. "I don't care how many times they sleep together each night," Gioia had told Manulis before the first tour in 1947, "just don't let her get him to drink again."

But the show again did sensational business. "A box office riot," *Variety* reported from Charlotte, North Carolina. "Town has gone off its rocker." Tallulah was scheduled for a one-night stand there December 6, and the performance had been sold out weeks in advance. Tallulah had said she wouldn't do two performances on a one-day stop, but after the mayor appealed to her, she agreed to add a matinee. During stops in Alabama, Tallulah reportedly pandered to her local fans by waving a Confederate flag during curtain calls.

While her own self-control was fast degenerating, Tallulah discovered that Evelyn Cronin, who had worked as her theater maid on tour and lived at Windows as general factotum, had bilked her out of $35,000 over the past several years. Tallulah paid all her bills by check and Cronin had been routinely kiting them. In Manhattan, Tallulah's accountant, Benjamin Nadel, showed her a pile of checks Cronin had kited. Tallulah asked Donald Seawell, her attorney, to go to Windows and confront Cronin. Cronin immediately confessed, adding defiantly that Tallulah wouldn't dare do anything about it, because if she did Cronin would say that she raised the checks in order to get money for "cocaine, marijuana and sex." Her accusations would be enough to ruin Tallulah.

Tallulah had always suspected that Cronin was not an entirely savory character. More than once she had been picked up for shoplifting during the tour of *Private Lives;* each time Tallulah had gotten her off, and taken particular pride in keeping the matter quiet. Cole, who'd learned from Cronin what had happened, had to resist blurting out, "And I know about Evelyn!" during his parting feuds with Tallulah.

Tallulah requested that the New York District Attorney's Office put together a case against Cronin. Nadel advised her against it; the amount she'd lost was minor in the context of her income, and Tallulah had to have known that a trial would put her under great stress. There was a lot about her life that Tallulah would have preferred the public not to know. Yet she maintained that blackmail was "the worst crime in the world," according to Seawell, and Tallulah felt that if she let Cronin get away with it, she would try the same tactic on another victim. Cronin "misjudged her victim," Seawell said. Had she "simply admitted her guilt and asked forgiveness . . . Tallulah would have told her to forget about it. . . ."

But Tallulah herself may have had some resistance to prosecuting Cronin. The district attorney's office would not have been able to proceed without Tallulah's cooperation, and the *Times* had reported that District Attorney Frank S. Hogan had "censured Miss Bankhead for not reporting the alleged offense promptly." In January 1951, Hogan facetiously told guests at a testimonial dinner that he had made peace with "that Alabama darling"—Tallulah had promised to appear on his program and he had promised to appear on hers. By his "program," Hogan referred to the general sessions court in Manhattan. Additional delays meant, however, that the case was not going to come to trial until December 1951.

As the *Private Lives* tour reached its conclusion, Tallulah made a rare appearance on New York's hallowed "subway circuit": she was at the Flat-

bush Theater in Brooklyn at the end of April, before moving to Washington, where she played the Gaiety, because the more prestigious National remained segregated. Passaic, New Jersey, was next. Finally, the tour concluded with more subway-circuit engagements in the Bronx. The strain of this last tour had been too much even for Tallulah. On June 3, from her dressing room in Passaic, she made an announcement that her final performance of *Private Lives* would be the last she'd ever give onstage.

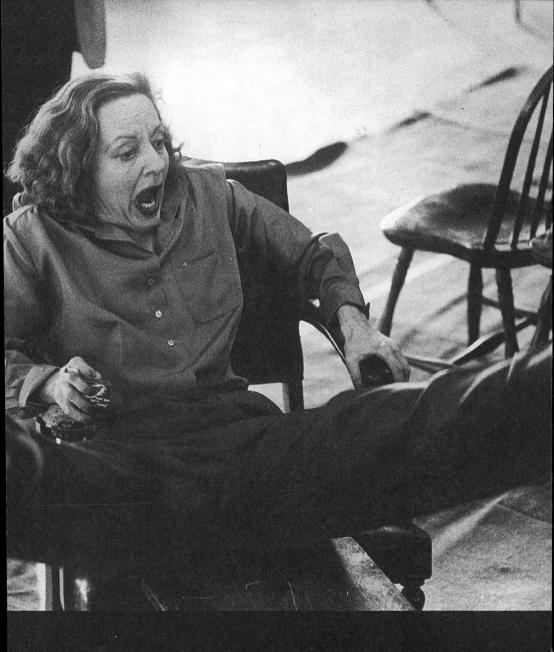

Part IV
1950–1968

Tallulah during a rehearsal break in the *Ziegfeld Follies*, 1956

Mixed Highs and Lows

"I have nightmares in which I drop every page of the script and can't think of a thing to say into the microphone."

Following her announcement, NBC approached Tallulah with an offer to star on radio in *The Big Show*, a weekly ninety-minute variety spectacular. With CBS having recently raided NBC's stable of talent, the network needed to stage a comeback. So did the medium of radio, which was rapidly being outflanked by television. *The Big Show* promised to be easy work for Tallulah—rehearsals Friday, Saturday, and Sunday, then a broadcast Sunday evening—as well as fabulous money. Yet it was a daring, risky, and uncharted move.

Tallulah had made many radio appearances in the 1940s, acting in sketches or trading patter with Hildegarde, Fred Allen, Kate Smith, and others. *The Big Show* would continue that pattern, except that Tallulah would be the host and fulcrum of a lavish extravaganza, impersonating no other role but her own public persona.

Tallulah agreed to try it for four weeks, hedging her bets. "I'm going to do some broadcasts. . . ." she mentioned vaguely to Ward Morehouse at the end of September 1950. Despite her vow to leave the stage, she was

also considering another play, this one by Edward Justus Mayer, who'd written *A Royal Scandal*. In the weeks leading up to the November 5 premiere of *The Big Show*, she grew nearly paralyzed with anxiety. NBC had lined up a heavyweight assemblage of celebrities for the first show and was billing it "All This—and Tallulah, Too." Tallulah felt that her segues, introductions, and patter didn't justify such a buildup.

To her astonishment, however, the broadcast was a triumph, Tallulah's efforts earned glowing reviews, and she let the Mayer play go. For the moment, *The Big Show* had solved the problem of how to find an alternative to a theatrical career she had diminishing inclination or energy to sustain.

As the weeks went on, her broadcasting persona was crystallized by a team of first-class writers: Mort Green, Goodman Ace, Selma Diamond, and George Foster. Their task was made easier by the fact that Tallulah had a whole dossier of verbal tics and quirks that she had eagerly flaunted for public delectation. While other stars were sanitizing themselves for public view, with Tallulah, there was always the possibility that too much revelation would end her career. But her eagerness to flaunt her foibles was refreshing; her characteristic self-deprecation coupled with an air of bravado bordering megalomania won the public's affection.

Her role on *The Big Show* presented an altogether original antiheroine. In place of the usual fawning over guest stars, she traded acid barbs. "Thank you, Ethel, and better luck next time," she told Merman on the first show after the studio audience had greeted her song with a rousing reception. The guests, in turn, were expected to parade a comparable litany of their vanities and affectations. When Dietrich appeared, Tallulah chided her for shaving years off her age. Dietrich defended herself by explaining that she had recently discovered that her daughter was two years older than she.

In January 1951, *Collier's* editorialized:

> We'd like to congratulate the person who had the inspiration to think of Miss Bankhead . . . for the richly talented and combustively temperamental Tallulah is scarcely the master- (or mistress-) of ceremonies type.
>
> In a field noted for the folksy exuberance of its practitioners, Miss Bankhead specializes in the deadpan and often deadly squelch. Her general air of graciousness is never completely reassuring. For there is always the possibility that that marvelous voice of hers is about to pass from a purr of honeyed hospitality to an outraged bellow of professional rage. She is, in a word, terrific.

Private Lives had taught her a treacherous lesson: the harder she worked her comic persona, the more she spoofed herself, the more vociferously her audience responded. Air checks of The Big Show reveal that she often delivered lines with masterly subtlety, but her more raucous comic frequencies were more frequently tapped. Stephan Cole recalled that during a theatrical rehearsal some years before, Tallulah read a scene using her deepest voice. The director thought it was good, but Tallulah feared it might provoke unwarranted laughter. But in Private Lives she showed no similar circumspection about her comic tricks, and on The Big Show she exaggerated them all the more, suddenly letting the bottom register drop out of her voice so that she descended to subbaritone depth.

A recurring comic theme on The Big Show exploited Tallulah's purported disorientation at being forced to cope with the varied indignities of prosaic reality. In one monologue, she told of a night her driver was off and she found herself having to show up for an appointment in upper Manhattan. Calling the airports, she discovered that her destination was off the flight route. A friend told her to descend into "a dark hole in the ground," and when she ventured into the subway, she was shocked when the clerk at the booth refused her check. A series of rude awakenings followed as Tallulah encountered the rough-and-tumble world of subterranean mass transit.

The Big Show was the biggest radio hit of the year, pulling in a fantastic lineup of guest stars. George Baxt, whose agency was always trying to book clients on The Big Show, found that Tallulah was "having constant battles about the blacklisting." The House Un-American Activities Committee was at the height of its influence. Tallulah fought for the likes of Judy Holliday and Edward G. Robinson. Even Tallulah was considered suspect by some for having appeared in plays by Hellman and Odets.

Holiday became a semiregular, performing a running dialogue with Tallulah in which the younger woman and the older woman tried to give each other advice that neither wanted to hear. Another semiregular was Fred Allen, who had performed a classic "Mr. and Mrs. Broadcasting" sketch with Tallulah on his own show, prefiguring her vinegary Big Show humor. Its satire on husband-and-wife talk shows had a married duo making sugary patter over breakfast, complete with endless sponsor plugs. Then the veil was drawn back: the audience eavesdropped on the surly squabbling and sponsor bashing that might take place when the microphones weren't plugged in.

Tallulah's new radio success made her position in the theater world,

always somewhat equivocal, even more controversial. Tallulah was only doing what many of the biggest stars in show business had done, deploying a persona and a recurring series of tropes delivered in the person of her own self.

Having achieved the status of one of the theater's great ladies in the 1940s, she hit a different nerve than Jack Benny or Martha Raye did. She reawakened a long-standing cultural anxiety over the breaching of boundaries between democratic and aristocratic genres. (Tallulah's entire career did just that, in fact; she had always freely interwoven the highest and driest comic modes with the earthiest.)

Tallulah met the same disapproval that greeted Helen Traubel and Ezio Pinza when they descended from the even "higher" art of grand opera to appear in Broadway musicals. It is hard to imagine this today, when the most popular, accessible genres are the ones that dominate the field. Also, the Broadway of today barely resembles the one that existed in 1950, having slowly contracted since the advent of talking pictures.

Tallulah herself was perhaps never totally comfortable with her role or her new medium. "I have nightmares in which I drop every page of the script and can't think of a thing to say into the microphone." Tallulah told Murray Schumach of the *New York Times*. Rather than be called "mistress of ceremonies," she wanted to be billed as *conférencier,* as the Russian impresario Nikita Balief called himself when he hosted the renowned *Chauve-souris* revue in Europe and America during the late 1920s. Not surprisingly, this was too esoteric for NBC.

A couple of months after *The Big Show* premiered, Bert Cowlan joined the show as a commercial announcer for Reynolds Metals. He was present for Sunday rehearsals only. Starting in the late morning, they would perform a run-through, a dress rehearsal, and then the live broadcast before a studio audience. Cowlan recalled these rehearsals as "sheer fun. They were wild. It was Tallulah's playground." She kept a glass close at hand, but while he was sure it contained only tea, Tallulah would pretend it was liquor, constantly calling attention to it or sipping from it ostentatiously. Many of the guests were entertainers she'd known for years. "If you put Tallulah and Groucho Marx together, things could get outrageous fast."

One Sunday during *The Big Show*'s second season, Peter Lorre was among the guests rehearsing when a woman Tallulah knew showed up with her baby. Oohing and aahing, Tallulah was so enchanted that she made a spontaneous gift of a wad of cash. She kept running offstage to play with the baby, until Lorre walked over to the microphone. He said,

"Please take that out of here before I eat it." Tallulah laughed and the mother finally left and the rehearsal went on. "You never knew what Tallulah was going to do," Cowlan recalled in 1993, "except that underneath all of the posing that was one thorough-going professional."

Dee Engelbach, a boy-genius type in his early thirties, who produced and directed the show, had alleviated Tallulah's panic during the weeks before the first broadcast. In her autobiography, she calls him "one of the ablest and most understanding men ever to weave coherence out of chaos." Cowlan thought that Engelbach was clever to give much of his direction over the intercom. His disembodied voice was perhaps able to exert more authority over Tallulah than his boyish presence; this way, she could not try to break him up with some of her own shtick, or climb all over him with hugs and kisses.

Tallulah maintained a suite at the Élysée and lived there during the days she was working, but the rest of the time she stirred from Windows as little as possible. "It was very quiet," said Fran Bushkin, who had married Tallulah's good friend, musician Joe Bushkin, in 1947. The Bushkins visited frequently during these years. "If the Giants were playing, that was probably the most exciting thing that went on in her life at the time," Bushkin recalled in 1993. If the team was winning, Lillian and Sylvester Oglesby would jump up and perform a soft shoe, and Tallulah would join them in a Charleston.

Some of her reclusiveness was due to the fact that she was losing faith in her appearance. One reason Tallulah liked the radio show was that she didn't have to worry about her looks. "It's just a relief," she told Bushkin. She had always disliked her breasts because she felt they were too big for her height; now she underwent breast reduction surgery because she worried that they were sagging. The operation resulted in severe scarring, and afterward she felt it was "a sort of minor tragedy," Bushkin recalled.

Windows was quiet, too, because people were becoming wary of visiting Tallulah. After many years in England, Cathleen Nesbitt was acting again on Broadway in T. S. Eliot's *The Cocktail Party*. She went to the Élysée to visit Tallulah, who seemed lonely and needy, less giving than the woman she'd acted with in 1924. Reluctant to let Nesbitt leave, Tallulah followed her downstairs in a nightgown to see her into a cab, talking all the while.

When Nesbitt spent several weekends at Windows, Tallulah's insomnia and loneliness were again an issue. "Lock your door at night," Nesbitt was warned by friends, "because Tallulah likes to wander." One weekend, expecting Nesbitt, Tallulah planned a formal dinner, including entertain-

ment by magician Fred Keating, who'd acted with her in *Forsaking All Others*. "The servants had gotten out the best of everything," recalled Glenn Anders, who was also invited. To calm her excitement or anxiety, however, Tallulah started drinking before her guests arrived. By the time champagne was served at the dining-room table, Tallulah's head had dropped into the soup as she passed out. Carried off to bed, she did not wake up until late the next afternoon, long after her guests had cut apple blossoms and beat a retreat.

One night Tallulah had dinner served earlier than usual. "The sunset's so beautiful," she told Bowden, Anders, Winwood, and Edward Baylis, an old friend who'd stage-managed *Private Lives* after Bowden left the show. "We'll have dinner here and enjoy it." They sat by a bay window, all on one side of the table, to catch the sun's retreat behind Tallulah's rolling hills. Hostess and guests sipped white wine. After dinner, some watched television, still a novelty in those days, while others played bridge. Tallulah repaired to her bedroom on the ground floor. The others retired to guest quarters upstairs, where several bedrooms lined a hallway. As Bowden got into bed, taking out a book and thinking how charming a hostess Tallulah was when sober, an unmistakable sound filled the house. Bowden recognized the snort Tallulah bleated out when she was smashed. Telling himself it was his imagination, he heard another fearsome guffaw. Bowden opened his door, and watched as each door down the hallway opened and horrified faces peered out.

Last to come out was Robert Williams, Tallulah's manservant, whose room was at the far end of the hallway. "It's all right," he told the bathrobe-clad assemblage, "the bird's cover must have slipped."

"The *what?*"

"It's the only thing the bird can do: laugh just like her." As Williams went downstairs to cover the unruly member of Tallulah's menagerie, the guests all sank, relieved, back into bed.

Fran Bushkin herself was at something of a disadvantage with Tallulah, being the much younger wife of a man whom Tallulah had some history with. An heiress, Bushkin undoubtedly brought her own sense of entitlement to the relationship. Even so, an alliance of convenience and even a genuine friendship developed. "We both were mad for dogs—animals in general," Bushkin recalled.

Bushkin gave Tallulah a Maltese that she named Dolores. To a reporter, Tallulah extolled the breed, saying "Queens loved them," and among their regal owners, Cleopatra had called hers "my little comforters." At night Do-

lores slept on Tallulah's head, a privilege extended to all her favorite pets. Dolores was never spayed, and Bushkin knew exactly when Dolores was in heat. Tinges of blood would daub Tallulah's graying ash-blond hair. Dola Cavendish told Bushkin that she had become partial to Pekingese because of the one called Napolean that Tallulah had had back in London when they first met. Dola now went everywhere with an elderly Pekingese and his oxygen tank. Guests in Cavendish's company were frequently alerted that the dog couldn't survive one more night. Tallulah endured many false alarms until "after a whole night of hysteria and oxygen" at Windows, the dog finally died.

"We will find Dola the greatest Pekingese puppy on earth," Tallulah announced, sending Bushkin to make the rounds of breeders. Finally Bushkin located the perfect puppy, and Tallulah presented it to Cavendish to great rejoicing.

Poolside at Tallulah's, Pimm's cups were served and glasses were continuously replenished. Tallulah was drunk one day when she handed Bushkin's toddler daughter a Pimm's cup. "I exploded at her," Bushkin said. "She felt awful. If you reprimanded her about anything that she felt she deserved, she was just so apologetic. She'd just crumple up."

Joe Bushkin had talked to Mitch Miller at Columbia about the idea of Tallulah's cutting some novelty records, for she was singing frequently on *The Big Show*. In the first month, Meredith Willson's "May the Good Lord Bless and Keep You" was introduced, and each week the show closed with Tallulah and her guests singing a stanza in turn. Inviting Mr. and Mrs. Miller to join her and the Bushkins one Saturday night for dinner, Tallulah ordered a long, elaborate continental meal to be catered. Cocktails were to be served at seven, dinner at eight. When eight o'clock rolled around and the Millers still had not arrived, however, Tallulah grew furious. "People should always be prompt, or at least the first time they meet you." At eight-fifteen Tallulah said they would go ahead and eat the dinner, which was getting cold. At eight forty-five, they heard a car drive up.

"I don't know who you think you are," Tallulah told Miller, "but you are the rudest man I've ever known." Mitch's wife, Frances, was apologetic, but Miller was not. "I am standing," Tallulah said, "and that means that you and Mrs. Miller must leave." Joe Bushkin told Tallulah to forget about the record date. After another miserable hour picking over their meal, they went to bed at ten-thirty.

Later that night the Bushkins heard a timid knock at their bedroom door. A small voice said, "May I come in?" It was Tallulah; she couldn't sleep.

"I was so awful tonight. I just humiliated you, didn't I, Joe? Acting the way I did, and it was insufferable." Lighting a fire, she told them how reassuring she found a blazing fireplace if she was upset about something. She'd written several drafts of an apology note to the Millers, which she showed them.

The next day, Tallulah wanted Sylvester Oglesby to drive the note into Manhattan to Miller's office immediately. Fran Bushkin reminded her that Miller wouldn't be in the office on a Sunday. Tallulah finally agreed to wait. "But she was like a child about it," Bushkin recalled. "A child who'd behaved terribly and wanted to do anything to make up for it."

The note healed relations and Tallulah went on to record with Bushkin and Miller. As she relaxed between takes, someone left a tape recorder running. Her unguarded words make for fascinating listening today. "I hate my voice," Tallulah confesses. "It's supposed to be my greatest asset but I'm always shocked. I am not supposed to be a musician." Sometimes she issues pleas to be controlled—"I'm going to be telling you how to play it in a minute, if you don't—for God's sake, don't let me!"—as well as wild statements of bravado: "I'm going to sing at Café Society tonight. I'm going to get those gangsters there to pay your week's salary. I'm going to hold 'em up, brother! I'm going to say, 'Listen, I get five thousand *per* performance, and if you riddle me, dear, you've got Truman to answer to, and [musicians' union head James] Petrillo for that matter'—*I'll find you in the morning sun and when the night is new, I'll be looking at the moon but I'll be seeing you.*"

At one point she cries, "Let me get barefoot. I'm an Alabama hillbilly, for Christ's sake, why I have all these modern contraptions I don't know. Plus I've got the prettiest foot in civilization, too."

"I'm a foot man myself," says Miller.

"So was Cleopatra," Tallulah replies.

"Did you ever catch athlete's beard?" Bushkin asks Miller. "Athlete's tongue."

"Did you hear that, Bill?" Tallulah calls to her boyfriend William Langford. "It doesn't make babies, but it's fun."

Tallulah's androgyny, her capacity for double entendre, and her graphic talk about sex made her a favorite with an urbane male homosexual audience, and her *Big Show* appearances fanned their approval into wildfire popularity. Invariably intrigued by fringe cultures, Tallulah had always cultivated every audience she could.

In the recording studio, Joe Bushkin tells Tallulah that her records will

be "something every fag in America must have in their home—and there are twenty million of them."

"Me and the ballet, dear," Tallulah says tartly. "If it weren't for them, I'd be dead."

Yet she also felt some ambivalence about her following. Perhaps she realized she was getting in over her head. Gay culture of the 1940s and '50s encompassed the hostility of an ostracized and persecuted minority, and there was a decided strain of misogyny among the ranks of Tallulah's adorers. If she validated gay male territory, she also intruded upon it.

Early in 1951, *The Big Show* was transmitted from Hollywood. Tallulah and Dola Cavendish were flying back to New York following the broadcast. After an early dinner at George Cukor's, Tallulah's agent, Phil Weltman, was going to drive them to the airport. Several of the young men in Cukor's retinue plied Tallulah with liquor throughout dinner, deriving a good deal of pleasure out of seeing her decline into sloppiness. As Weltman pulled his convertible up to the house, he saw Tallulah walking out when "one of these bastards" approached Tallulah with a full glass and put it in her hands. This last slug was enough to make Tallulah seriously disorderly, so much so that the airline pilot refused to let her board. He had flown a previous flight on which Tallulah had fallen asleep with a lit cigarette in her hand. It was an audience of men like those at Cukor's who would foreclose Tallulah's theatrical career and reputation over the course of the 1950s.

Stateless

"After twenty years I return to the scene of my triumphs. Of course, most of them are married now."

F or the opening broadcasts of its second season, *The Big Show* went to Europe, taping at London's Palladium on September 16 and from the Empire Theatre in Paris on September 24, 1951. Tallulah returned to London for the first time since 1937 overcome with excitement and trepidation. Particularly concerned with how her looks would compare to the woman she had been, she went on the wagon all during the summer of 1951, if her autobiography can be believed. Her return received enormous attention in the British press, which toasted her in a reception at the Ritz.

"After twenty years I return to the scene of my triumphs," she announced on air. "Of course, most of them are married now." The broadcast featured an all-star lineup including Vivien Leigh and Laurence Olivier, who acted a scene from Shaw's *Caesar and Cleopatra*. What Tallulah hoped would be received as a token of her love for Britain turned out to be a disaster, however, as she recited Gene Fowler's poem "Jervis Bay," saluting the heroism of a World War II freighter that chose to slip out of a convoy so that other ships might escape attack. The British were appalled by her reminder of their wartime losses. "Oh, it was dreadful," said Una Venning, Tallulah's colleague in *The Dancers* twenty-eight years earlier. "The more it

went on, the more you said 'How *can* she do this?'" Venning had been looking forward to seeing Tallulah again, but she debated with herself over what she could say. Finally she went to visit Tallulah at the Ritz, where she was received warmly. "Well did you hear it?" Tallulah brought up the subject herself. "Yes." "Well, it was a mistake, wasn't it?" Venning agreed: "But I thought you'd heard it so much that it was better not to mention it. Well, you've had an awful press, haven't you?"

"Yes."

In *Tallulah* the actress apologizes "for this unwitting blunder," committed against "a people for whom I have nothing but respect and affection." Yet London had acclaimed her as a still-handsome woman, which to Tallulah was probably as important a yardstick of her success as anything.

The previous May, Tallulah and her attorney, Donald Seawell, had reported to general sessions court in downtown Manhattan to begin the trial against her former maid Evelyn Cronin, only to be told that Cronin was in the hospital and the trial would have to be postponed. When it finally commenced, Fred Morritt, Cronin's defense attorney, warned prospective jurors that "with the greatest reluctance and regret" he would be forced to support his defense with details of "foul language, profanity, perversion and criminality."

On December 11, Tallulah's eyes teared and she shook her head as Morritt made his opening statement. Cronin's defense rested on claims that she had been forced to reimburse herself for innumerable and sometimes clandestine purchases, including drugs. "The next thing they'll have me doing is vivisecting my dog without an anesthetic," Tallulah snorted from her seat in the courtroom.

"I expect to prove all this in the trial," Morritt said.

"And I expect to disprove it," Tallulah announced.

Morritt complained to Judge Harold Stevens that Tallulah was "making facial gestures and sounds." "I coughed, Your Honor," Tallulah explained. "I have a bronchial condition." *Time* reported: "Theatergoers who watched fully expected her to pull a small, pearl-handled revolver from her handbag and with a triumphant and scornful baritone cry, shoot both counsel and defendant."

Judge Stevens denied Morritt's request for a mistrial and refused to reprimand her. But by the third day of the trial, all reporters were barred, as well as all witnesses, of whom there was no one except Tallulah.

Before the trial began, Cronin had contacted Phil Arthur, asking him to testify about how and why Tallulah had fired him from *Private Lives*.

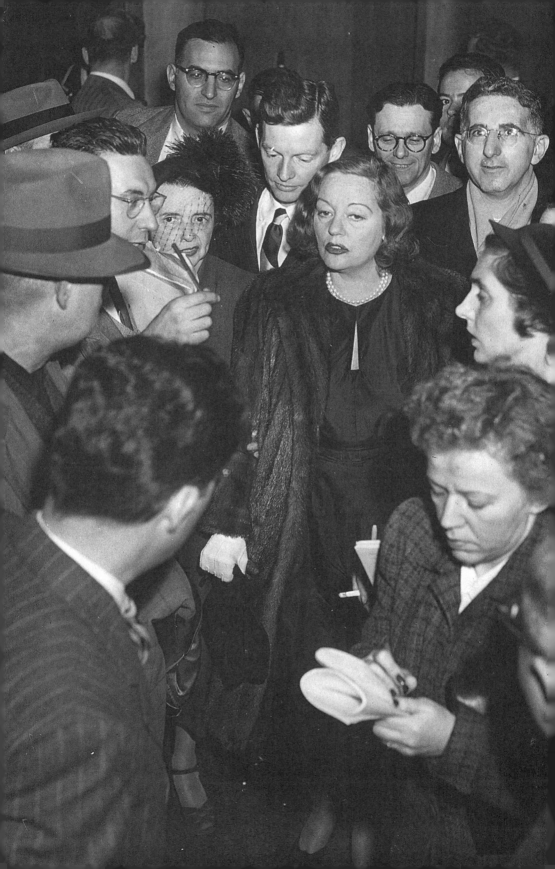

Arthur refused. Cross-examining Tallulah's accountant, Benjamin Nadel, Morritt asked him to supply the names of people in whose bank accounts he had deposited money on Tallulah's instructions. Morritt volunteered the name of William Langford.

By the very nature of the transactions for which Cronin claimed she deserved to be reimbursed, she could produce no supporting paper trail. Tallulah's checkbooks recorded minutely itemized expenses. Cronin claimed that she had paid for shoes Tallulah bought when she didn't have her checkbook. Tallulah's checkbook, however, recorded approximately $1,500 paid for shoes bought over an eighteen-month period.

Cronin claimed that during the run of *Private Lives,* nightclub owner Dickie Welles had brought Tallulah some cocaine backstage at the Plymouth. Since Tallulah didn't have any cash, Cronin said she had paid him fifty dollars. But when he went back with Tallulah to the Élysée, Tallulah gave him a check for fifty dollars. Cronin insisted that the check wasn't payment, but was written only because Tallulah knew he was broke.

Although never asked to testify, Eugenia Bankhead later asserted to Cal Schumann, mutual friend of the Bankhead sisters, that Cronin had stolen from Tallulah on a grand scale. One day in Buffalo, where Eugenia was visiting Tallulah, she and Cronin were going to go out shopping. Cronin told Tallulah that they needed cash. Tallulah told her to go down to the front desk of the hotel and ask them to charge $100 to her account. At the front desk, Cronin asked for $600; at the time, Eugenia assumed Tallulah had authorized Cronin to ask for this amount when Eugenia had been out of the room.

Tallulah and her legal team countered Morritt's vilification with some of their own. She claimed to reporters that Cronin had "been in burlesque before I was born." That was an exaggeration, since Cronin was fifty-nine, but she had done some low-grade stripping decades earlier. When Assistant District Attorney Jerome Kidder cross-examined Cronin, he got her to acknowledge the full scope of her performing experiences. Asked about her shoplifting record, she also conceded that she had been questioned in a San Francisco store about a brooch that she said she had "found on the floor."

After a thirteen-day trial, Cronin was convicted by an all-male jury. Tallulah, however, asked the court to show leniency toward her former employee, and Cronin's sentence was suspended. It turned out, she was indeed ill with heart trouble, and died a year later.

Battling a crowd of reporters during her trial.

As late as 1994, Morritt continued to insist that Cronin had, in fact, kited checks on Tallulah's orders. "She ordered her. She authorized her. It was more than that. I recall that she beat the hell out of her." Morritt had made the same argument in court in 1951. Perhaps this was what Cronin told him. Tallulah could slap or strike out at people on occasion, and she could throw or break things in a fit of fury, but there has been no indication that she ever administered beatings to her staff or anyone else. As terrifying as Tallulah's violent temper could be, she was slightly built and Cronin would have been able to take care of herself in a physical confrontation.

Calling herself "old and tired," in the court corridors Tallulah told reporters, "I lose everything if I lose the goodwill of the public." Yet surprisingly, Tallulah's reputation suffered not at all. The public, which had spent the previous year laughing at her vagaries, declined to censure her for them even when documented in the frankest terms from a witness stand. The gratuitous cruelty of Morritt's attacks also helped her cause. Edie Smith, who had returned to work for Tallulah, told a reporter that they had received stacks of supporting mail. Even so, the trial was as much of a trauma as Tallulah had been warned it would be, "perhaps more so because she kept so much inside herself," Seawell wrote to Lee Israel in 1971.

After its glorious debut year, *The Big Show* began to sputter, along with the medium of radio. Robert Lewis Shayon in the *Christian Science Monitor* wrote that Tallulah's "vain, rude, and temperamental role has worn very thin. She would be well advised to try something fresh." Tallulah agreed. In a long letter to director Engelbach, she pleaded for more challenging material. "I'm sincere when I say I'm grateful and lucky that I don't have to play eight times a week," she wrote. "But I'm not yet so old, fat and tired that integrity doesn't rear its ugly head."

The Big Show concluded its second season on April 20, 1952, and was not renewed by NBC. Tallulah's plans for the fall included her television debut, as well as the publication of her memoirs, which she had planned to begin in the fall of 1949. It wasn't until the summer of 1951 that she began dictating them at Windows, the book ghosted by Richard Maney, her personal publicist since 1939. It wasn't the first time Maney had spoken for Tallulah. Broadway's foremost publicity agent, he handled most of the leading shows, and on more than one occasion he had drafted articles bearing Tallulah's byline.

Maney's style was ornately embellished, dripping with erudite allusions, a rather different timbre of flamboyance than Tallulah employed when speaking firsthand to the press. Yet his words give Tallulah a voice in

which her sensibility echoes as reverberantly as his. She dedicated the book to Will, but Maney received a citation page of his own.

Published at the end of September 1952, *Tallulah* went straight to the top of the best-seller lists. Much of what she disclosed was racy for the time. An entire chapter covers her dalliances with drugs and alcohol, though she omits and denies as much as she discloses. Indeed the book could be seen as a way of countering the kind of scrutiny she had received in a number of long profiles published during the previous decade.

At this point in her life, Tallulah seemed to care about decorous press coverage at least as much, if not more, than she had when her father was alive. Almost any major profile of her was now guaranteed to contain things that could infuriate her. *Time* magazine's 1948 cover article on her, for instance, mentioned her use of sedatives and stimulants as well as her drinking. Armchair analysis was ladled out heavily in middlebrow and highbrow celebrity profiles of the day. Concurrent with *Tallulah*'s publication, the *American Weekly* commissioned Maurice Zolotow to revise a profile of her that he'd done for the *Saturday Evening Post* in 1947. Reviewing her extensive history of physical ailments, he wrote that it was "no coincidence that all of these diseases are the kind known as 'psychosomatic'— the kind that are physical expressions of repressed emotional frustrations, hostilities and resentments."

Reverting to Southern-belle type, she seems in *Tallulah* to be afraid of being perceived as a bluestocking intellectual. But the country's anti-intellectualism bothered her. She had written that whereas *intellectual* was "once a flattering term, the rabble-rousers and reactionaries now use the word as an epithet. Too many of our countrymen rejoice in stupidity, look upon ignorance as a badge of honor."

"Her writing about her stage career is a pallid recital of parts played and notices received," Lee Rogow complained in the *Saturday Review*. It is true that above all Tallulah wanted to be perceived as someone who spent her career winging it. As she had throughout her life on so many different issues, she simplified herself for public consumption. Yet her autobiography shows her to be more insightful about herself than one would have expected. About communism, she confessed a phobia so great that "more than once I've lashed out at innocent people, liberals and rationalists who have no more sympathy for the Reds than I, but who point out to me that capitalism is not lily white." She found McCarthy "a disgrace to the nation. He has held us up to more ridicule, more contempt at home and abroad, than the reddest Red in the land."

On October 11, 1952, Tallulah made her television debut as hostess of NBC's *All-Star Revue*. Scheduled to feature a revolving roster of hosts, the program was slotted to have Tallulah host one show per month. She had retained key people from her *Big Show* team: writers Mort Green and George Foster, music director Meredith Willson, director Dee Englebach. A prestigious selection of guest stars participated.

One the debut show, Ethel Barrymore joined Tallulah in a sketch Tallulah had earlier performed on *The Big Show*, a pointed satire on the vanities of the star performer. Tallulah played an actress who appeals to Barrymore for honest response to her latest performance, and then proceeds to belittle every candid thing her friend says. Finally her friend gives up, serves up unalloyed praise, and the actress thanks her for supplying exactly the objective critique she needed.

After the taping, entertainment celebrities, joined by executives from NBC and Harper & Brothers, celebrated the publication of *Tallulah* at the Pen and Pencil restaurant. Two days later, Tallulah left for Hollywood to film the supporting but pivotal role of "Tallulah Bankhead" in the film *Main Street to Broadway*. A coming-of-age fable of a young writer trying to get a play staged on the Great White Way, *Main Street to Broadway*'s young hero is a fledgling writer who produces a script tailored to Tallulah's demand for a role that would not stereotype her. The film was produced by MGM, directed by Tay Garnett, and written by Samson Raphaelson, one of the foremost playwrights and scenarists of the time. In addition to Tallulah, numerous theater greats, ranging from Ethel and Lionel Barrymore to Rodgers and Hammerstein, made supporting appearances.

That fall Tallulah campaigned vigorously for Adlai Stevenson's presidential bid, telling William Hawkins of the *Herald Tribune,* "I hope the book doesn't hurt the Democratic party. They might say, 'That Monster. If she likes it, it must be wrong.'"

After Stevenson lost to Eisenhower, Tallulah wrote in the *New York Times* that, "As distinguished from the bilge, the double-talk, the gibberish, the cliché-cluttered balderdash that politicians spout in an election year, the addresses of the Illinois Governor were models of clarity, sanity and good taste. In heretic fashion Governor Stevenson spoke to the American people with humility, with respect for their intelligence."

Tallulah ends her autobiography by saying that, "Earlier in this odyssey I beat my breast and swore I'd never act on a stage again unless so crushed by professional disasters I had no alternative did I hope to survive. Don't bet on that." Her appetite for performing in the theater turned out to

be unquenchable. Soon after, she was considering starring in *Dear Charles,* a drawing-room comedy she found "very charming." She was to play the mother of three grown illegitimate children who invites each child's fathers for a reunion, with an eye toward marrying the one she most fancies in order to please her children's prospective in-laws.

A production of the play had just opened in London, starring Yvonne Arnaud. Tallulah had been interested in starring in the London production, but was committed to *The All-Star Revue.* She was thinking of trying out the play in California over the summer of 1953, and she wanted Englebach to direct her.

At the end of the season, Tallulah pulled out of *All-Star Review,* which lasted one more year without her. Soon afterward, she accepted an offer to perform a nightclub act at the Sands Hotel in Las Vegas. It was an unprecedented move for Tallulah, yet a logical outcome of the popular venues she had been involved with since 1950, garnering her highest salary ever: $20,000 per week for a three-week run. She told Dean Fuller, who accompanied her on piano, that she needed the money to cover her income-tax arrears.

A young composer and Yale graduate, Fuller impressed Tallulah, who never forgot that she had not finished high school. Fuller had also done some work for producer/director Gus Schirmer Jr., a friend of Tallulah's who was overseeing the engagement. Two days after their arrival in Las Vegas, Tallulah confessed to "a terrible night": she had lost a huge wad of money at the casino tables, then slept with "a perfectly strange woman from Hartford." Developing a case of shingles, which she attributed to nerves, she feared having to delay her opening.

When she went on as scheduled on May 20, 1953, Sands manager Jack Entratter found his audience filled with counterparts from rival hotels, come to gloat over the folly of bringing a theatrical star to Las Vegas. Their derision melted away with her success. "Contrary to some pessimistic feeling," wrote *Variety*'s "Soho." "Bankhead . . . proves to be socko as an entertainer in a medium which has heretofore been completely strange to her. . . ."

Her opening monologue was pure stand-up comedy, including her baffled reaction to hitting the casino tables for the first time. Though Tallulah had actually been gambling for decades, the monologue reprised the winning formula from her *Big Show* monologues, making comic fodder out of a Tallulah so spoiled and insulated that she was almost pathologically unable to face mundane existence. Like her maiden voyage on the subway, her "first"

visit to a casino bewildered and outraged her. "I'm faded!" Tallulah bellowed. "What do you mean I'm faded?" The audience loved every minute of it.

Her act also included a slightly condensed version of Dorothy Parker's "Telephone Call," a dramatic monologue in which a woman waits for a phone call from an ex-lover that never comes. This material would ordinarily seem most dubious for nightclubs," *Variety* stated, "particularly in the far west, but the artistry of her delivery carried it unfailingly, and brought her a near ovation from the capacity crowd."

What made the segue into the dramatics of that monologue was Tallulah's ability "to go from yellow to dark green *immediately*," Fuller recalled. At first speaking quickly and glibly, she began taking long pauses as the reality sank in. Her voice trailed off. Her eyes filled with tears. She prolonged pauses to the point where the audience seemed to be holding its breath, almost afraid that she might break down.

Tallulah also sang "I'll Be Seeing You" and "Bye Bye Blackbird," which was the one part of the act that *Variety*'s correspondent called "questionable." Ray Sinatra led an eleven-piece orchestra, with Fuller on piano.

Despite her reception, Tallulah wasn't satisfied. "You're kind," she told well-wishers who trooped backstage, "but to tell the truth, I was lousy." "I've never seen anyone quite so nervous," wrote "My New York" columnist Mel Heimer, who went backstage to find her shaking. (Entratter had sponsored a junket of journalists from both coasts to cover Tallulah's debut.)

Each night at 11:00 P.M. and 1:00 A.M., she performed her thirty-two-minute turn. A half hour before the first show, Fuller would arrive at the Sands and drop into her dressing room, where Tallulah would pick at dinner and drink a split of champagne. Fuller's presence didn't inhibit her from studying herself in the mirror as she went over the performance in her mind. Invariably she was concerned with the Parker monologue. She would mention what they had done the night before and how they might slightly change it that night.

As always, after the show Tallulah needed somebody to talk to. She and Fuller would go back to her room and drink champagne and cognac. Sometimes, if he wandered off, she would have him paged. She also spent time with Marlene Dietrich, who was working in Las Vegas at the time. Fuller was with them one night as they sat on Tallulah's bed, drinking champagne and lightheartedly discussing the respective merits of homosexuality and heterosexuality.

Tallulah's stint in Vegas contributed to her uniquely medium- and genre-spanning career. For purists, however, it was the nadir of her spiral

into popular vulgarity. Watching her perform the Parker monologue, Heimer had "scratched my head and wondered again—-why here?" He stopped wondering when he remembered "that all of us . . . have sold our souls at one time or another."

Main Street to Broadway, the film in which she starred as "Tallulah Bankhead," opened July 22 to derogatory reviews. Though the *Saturday Review* called Tallulah's performance "foolish [and] strident," as with all of Tallulah's film work, her performance deserves another look today. The edge of hysteria she cultivated beginning with *The Big Show* is there, but she delivers a nuanced as well as garish self-portrait, performed alongside actual figures from her own life. Estelle Winwood is seen talking to friends in the lobby on Tallulah's opening night. "Tallulah's got a wonderful heart," she says. "Only sometimes it pumps the wrong way." In her dressing room Tallulah cringes and cowers as she hears the Giants take a beating at Ebbets Field. She phones Leo Durocher midgame to challenge his dugout tactics.

Early in the film, aspiring playwright Tony Monaco, played by Tom Morton, visits his agent, played by Agnes Moorehead. "He has a lot of talent," Moorehead tells her assistant, "but we might make him into a moneymaker yet." Tallulah bursts in, threatening to fire Moorehead unless she can find her a wholesome role instead of the harridans that she's being offered.

In the mind of the young playwright, Tallulah acts out his different dramaturgical ideas. He envisions her as a sugar-cured Southern housewife, but Tallulah can't help but be "herself." Laughing her own raucous laugh, she then corrects herself, neatly demonstrating the central issue of her career: her sometime struggle against, sometime acquiescence to an overwhelming personality that both made and undid her.

"Let's try an entirely different approach," suggests Tallulah in the guise of his superego. The limits of credibility can be strained only so far. Now he sees her as a comic tabloid murderess, ultimately poisoned by her husband and partner in crime. Presenting the script to Tallulah, she rejects it as playing the same song she is tired of singing. Then John van Druten tells her he will direct and Tallulah changes her mind. Alas, the play strikes out on opening night. Attended by Rose Riley in her dressing room, Tallulah consoles Morton after the audience's disappointing response. "I doubt if anyone will have as many flops as I've had." This flop, she tells him, is only the beginning of his life in the theater.

Pearls Before Swine

"After all, darling, we can't go around showing people what we're really like. I mean, pearls before swine, darling, pearls before swine."

I bsen's *Hedda Gabler* was a role that many felt Tallulah was destined to play. As early as 1930, she was rumored to be considering the role in London, and during the 1940s Robert Henderson all but begged her to do it, although he hadn't put together a production. In fall of 1950, she found a translation that she liked, and Robert Lewis, artistic director of the Westport Country Playhouse, wanted her to try it out there. Her friend Charles Bowden pleaded with Tallulah to accept, saying she'd be superb, and Lewis would communicate exactly the best way to play the role. Tallulah declined, however, and "I think that's when I really became disenchanted with her," Bowden said.

No doubt Tallulah recognized *Hedda* as a problematic, not to say virtually unstageable, play. It takes the compression of melodrama to such extremes that it becomes symbolist drama, while still simulating adherence to naturalism. Tallulah was by now two decades older than Hedda as Ibsen describes her. Plus, she had already failed in Cocteau's *The Eagle Has Two Heads,* playing the queen, a woman as morbid as Hedda, but more sympathetic.

Tallulah's real mistake was insisting on starring in a television adapta-

tion of *Hedda* that compressed its four acts into an hour, less time out for commercials. The sponsor, U.S. Steel, had suggested a comedy, but Tallulah insisted that January of 1954 would be the ideal time to take a stab at playing Hedda.

Tallulah had talked about the role at length with Lewis, who overlooked her having turned down his production and gave his blessing to her doing the play on television. Disappointed by her performance, he wasn't looking forward to her inevitable call the morning after the live telecast. "All I can say, Tallulah," Lewis told her diplomatically over the phone, "is that when Ibsen wrote the play he had you in mind. I can't say anything other than that." Bowden found her dreadful, "especially because you knew how superb she could have been," and John Crosby in the *New York Herald Tribune* commented that in even "the most intense and tragic" scenes "there were faint mocking overtones of the All Star Revue." Columnist Larry Wolters suggested in the *Chicago Tribune* giving her "back to Milton Berle and Jimmy Durante . . . where she belongs."

Yet Harriet Van Horne in the *New York World-Telegram and Sun* saw "a fine actress," who showed "dignity, beauty and passionate conviction." And Lawrence Langner of the Theatre Guild was sufficiently impressed that he told a reporter he was pursuing her for a stage production. Nothing came of this. Years later, Tallulah would admit that although she hadn't watched a kinescope of her performance, "frankly, it was very bad."

Four years after her last performance in *Private Lives,* Tallulah agreed to step onto the "legitimate" stage again, finally consenting to star in *Dear Charles,* a script that had traveled one of the most circuitous paths imaginable. Based on a play by Roland Bottomly that had never reached Broadway, it had been adapted for Broadway in 1944 by Frederick Jackson and renamed *Slightly Scandalous*. It failed in New York, but the script was translated into French by Marc-Gilbert Sauvajon and became a success in Paris. It was then successfully adapted by Alan Melville for British audiences, and Tallulah had considered doing it in America in late 1952, but ultimately turned it down. In the fall of 1953, it was tried out on the road with Lili Darvas, but found wanting. The producers returned to Tallulah, who committed to a tour of summer theaters in 1954.

Dear Charles is a frequently amusing, sometimes coy and strained drawing-room comedy. Tallulah played a popular Parisian novelist, Dolores Darvel, who leads an avant-garde existence. She quaffs fresh vegetable juice on a daily basis. Working in her study, she indicates to her

three children that she is not to be disturbed when she pastes literary quotations on her drawing room wall. Having had three children by three different men, Dolores forgoes marrying any of her children's fathers, choosing to stay independent. One man isn't enough. "If I did choose one of you," she says, "I'd spend the rest of my life regretting the other two." The play surely appealed to Tallulah as a testament to her own lifestyle.

Arthur Penn, who later did outstanding work on Broadway and in Hollywood, directed the piece. A strange candidate to direct Tallulah, Penn was then twenty years her junior, product of the alien technique and aesthetic of the Actors Studio. He was then working primarily in television, and *Dear Charles* would have marked his Broadway debut. Penn found directing Tallulah "a nightmare," the star "willful and out of it. I didn't expect her to be so drugged out," he said in 1995.

By contrast, Werner Klemperer, cast in the role of a temperamental Polish piano virtuoso who is the father of Tallulah's only daughter, considered her work ethic impressive. Tallulah was "the first one in the theater, the last one out of rehearsal," he recalled in 1992. Although Klemperer had played on Broadway in *Twentieth Century,* this would be his first lead comedy role. Klemperer learned a great deal about the genre from Penn, who he felt was totally in charge during rehearsals. The director, however, felt toyed with by Tallulah, if subtly so. "It was not a dead-on confrontation from day one," Penn recalled. "It was 'Oh, baby, oh, daddy, oh sweetheart.' A lot of that bullshit went on." Penn found her shrewd in her manipulations, "as are all deeply disturbed people," but mainly "just plain panicked" over her return to the stage.

Hugh Reilly played Jeffrey, the father of Dolores's younger son, a man she found waiting in her hotel suite to madly profess his love. Dolores discovers that he'd intended to rob an adjoining suite, but her fascination with him lasts the two decades since their one night together. Tallulah, who called Reilly "the black Irish," respected his gumption. "When you don't like something that's going on in the play, when you don't like something *I* do, you come right up and talk to me about it. You're not afraid to argue for what you think. You don't know how much I admire that."

Her conflicts with Penn, however, could not be resolved. "Tallulah knew what she wanted and so she was going to kind of take over," said Mary Webster, who played Lucienne, Dolores's prospective daughter-in-law. Penn ultimately asked that his name be removed from the production,

and Tallulah's old friend Edmund Baylis, the show's stage manager, was the nominal substitution. *Dear Charles* played around Cape Cod and other resort spots on the Eastern Seaboard, proving a much more robust success than anyone had suspected.

Grace Raynor, who played Dolores's daughter, Martine, was roommates with Mary Webster. Once Tallulah asked if the two were having an affair. They told her that they were not. "You should try everything once," she advised them.

The cast was struck by how frail Tallulah was. "A couple of times she was really out of it, even onstage," Webster remembered. When a hurricane blew out the power during a performance in Ogunquit, Maine, they resumed the performance by candlelight. The experience was magical, but Tallulah's colleagues worried that she would fall or hurt herself.

Patsy Kelly, the marvelous Hollywood comedienne of the 1930s, had fallen on hard times and was traveling with Tallulah in that typically ambiguous space between employee, friend, and lover. One Sunday summer morning over a cast brunch, two cast members brought out some pot and smoked it in a corner. Tallulah put some in a little pipe and smoked it, growing mellow rather than giddy. As the others were offered some, Kelly, hardly one to abstain herself, nevertheless thought that Tallulah had crossed the line and was corrupting her younger colleagues: "Oh, no, you're not giving these kids anything!"

Right up until the tour's end, it was unclear whether Tallulah would agree to bring the play to New York. Webster and her friends in the cast sensed Tallulah's apprehension over how it would be received on Broadway, since her performance could only be praised at the expense of the play. Yet the play's fluffiness was no doubt comforting: they suspected Tallulah was not ready to take on the challenge of something less safe.

On September 15, 1954, *Dear Charles* did open on Broadway at the Morosco. In the *New York Times,* Atkinson noted that the star who could "give the average author a tussle for command of the stage" was here "an easy winner." Louis Schaeffer wrote in the *Brooklyn Eagle* that she was "relatively subdued," at times "taking the easiest way to a laugh with one of her familiar vocal mannerisms," but for the most part using her "full, artful technique to fatten a skinny play."

Others found her performance disturbing. John Mason Brown wrote in the *Saturday Review* that she had dominated the evening, "not by stealing the show, but by turning what little show there is into a sizable sideshow.

With Tallulah the divine spark is a fire at once flaming and dangerous. The extraordinary endowments which distinguish her also imperil her. She is as much the victim of her talents as she is the product. Her gifts outdistance her taste. Most players have to learn to act. Her problem is to keep from overacting. This she seems to find harder and harder to do.

For the bulk of the run, Tallulah's behavior was good, although not irreproachable. One afternoon before a matinee, she arrived at the Morosco somewhat under the influence. Stage manager Baylis ripped her clothes off, put her into a shower, and kept her screaming under the spout until she had sobered up.

At another performance, Herbert Kenwith, for whom Tallulah had worked in Princeton in 1949, watched from the second row as Tallulah sat on a very low pouf, fluffing her skirt so that it billowed up to reveal that she had no underclothes on. The priest and three nuns seated in Kenwith's row soon got up and walked out of the theater.

Despite such incidents, "when it was time to work she worked harder than any actress I ever saw," recalled co-star Hugh Reilly. Reilly appreciated her almost avid willingness to work or rework a scene that was not playing as well as she or someone else thought it could.

Regular rituals that she observed unnerved her when broken. In one scene, Tallulah exited up a staircase; backstage she walked down a corresponding flight. During a dress rehearsal, Klemperer happened to be backstage when she came off. He walked up the steps behind the set, took her hand, and helped her down. "I have the habit when I do certain things in the theater once, I do them every time," Klemperer said. Every performance he would leave his dressing room, go down to the stage, and wait, holding her hand as she descended into the backstage murk.

One night, however, his habitual practice slipped Klemperer's mind. He was sitting in his dressing room when he heard a clumping up the stairway. Huffing and puffing and curses echoed down his hall. The stomps got louder, nearer, and a tempest crashed into his dressing room.

"Where the *fuck* have you been?" Tallulah shrieked.

If her life was ordered to satisfy expectations that verged on the compulsive, her need for companionship was just as pressing. "At night," Klemperer said, "after the play, she was always hoping somebody would say, 'Come with us, Let's do this.'" She often had cast members back to the Élysée after the performance, and Reilly noticed her on the phone quite a bit with Willie Mays, a titan of her favorite team, the Giants, as well as a

fellow Alabamian. She could be counted on to be up most of the night, even when she wasn't entertaining. More than once, Klemperer called her when he couldn't sleep or was troubled by something. She was in a cab and at his apartment almost instantly. "She was interested in everything. She tended to froth at the mouth a little bit more than other people, but she was a good listener, too."

After five months of good business, Tallulah was ready to take *Dear Charles* on the road. With Reilly leaving the show, William Roerick was considered for the role of the American father. "Oh, darling you don't have to introduce *us!*" Tallulah said gaily, when Roerick was presented for her vetting. It was twelve years since they had been lovers during *The Skin of Our Teeth.* "Now just a minute," he finally told her, "before you decide that you want me to go with you, three things: I will not stay up all night and drink, I don't play bridge, and I don't know anything about baseball. And I don't want to be taught!"

He was happy to spend time with her on tour so long as his boundaries were honored. "She loved being educated," Roerick said, "and she remembered everything you told her." She listened for three hours as Roerick lectured her on Egyptology on a train ride between tour engagements. One night after a show, Roerick found her working in her suite on a wire urging the passage of an arts appropriation bill being debated in Congress. Also in her suite were several actors from the company and some people she'd met in the elevator. As she worded the wire, Tallulah struggled over whether Hamlet had said "is a consummation devoutly to be wished" or "'tis a consummation devoutly to be wished." Turning to Roerick, she beseeched him, "Now, you're a Shakespearean, you tell me, which is it?" He didn't know. "You'll just have to rattle over it."

"Oh, I can't do that," she told him, insisting that her father "would never forgive me if I misquoted Shakespeare." She had Roerick call down to the desk for a copy of the collected works of Shakespeare. After midnight, no such anthology could be procured. Around two o'clock, Roerick finally proposed that she compromise and just make her wire read, "and it is—*quote*—a consummation devoutly to be wished—*quote closed.*

"She thought that was cowardly," Roerick says, "but finally she bought it."

When *Dear Charles* opened in Washington in mid-February, Mamie Eisenhower came to see the show. Hearing that she was in the audience, Tallulah overlooked her loyalty to Stevenson and invited her backstage. Things went less smoothly in St. Louis, where intestinal flu forced Tallulah

to cancel the opening night performance after the first act. The next night, Tallulah called the company onstage. "I've been throwing up and running to the bathroom all day, so I'm going to have to cut out all the clowning and just sit still. Please bear with me. I don't know what I'll be able to do, but I'll be doing as little as possible." For the next two nights, she omitted everything raucous or slapstick, sitting still and reaping laughs with her verbal delivery, a delivery Roerick felt only Ina Claire could have matched. He found it one of the most delicious high-comedy performances he had ever seen. When he asked her why she didn't perform *Dear Charles* that way all the time, Tallulah said, "Oh, no, that's not what people want. No, no, no." Once she was cured, she summoned the company back onstage. "All right, darlings, back to the clown act."

Brooks Atkinson had noted that audiences would have been "confused and disappointed" if Tallulah had been anything except her own theatrical persona. Indeed, Roerick saw that the audience wanted to believe Tallulah's performance onstage was an accidental extension of her own life. "Now, you can't tell me she wasn't drunk tonight," visitors backstage would insist to him. "She fell over the sofa. And that huge laugh." All of these moments were of course "rehearsed, rehearsed, rehearsed" before being performed with such apparent spontaneity.

In one city where *Dear Charles* played, John Barrymore's troubled daughter Diana was appearing in another play. Having known her since she was a teenager, Roerick went to see her, but that night the curtain never rose. Roerick later learned that Barrymore had been so terrified at the thought that Tallulah might be in the audience that she had started to drink. He went again to see Barrymore perform, reporting back to Tallulah about her amateurish makeup. Tallulah invited Barrymore over one night after their performances. She told her that she'd heard Barrymore's makeup "didn't read well." She offered to give her a tutorial and took her into her bedroom to show her what she should do. Seeing the difference Tallulah's techniques made, Barrymore walked out of the bedroom nearly in tears. After their shows diverged to other cities, Tallulah encouraged Roerick to write Barrymore on tour. "Tell her we're thinking of her. I think she's terribly lonely."

When they arrived in Los Angeles, Roerick had dinner before a performance with a cousin who kept insisting over Roerick's protests that he linger over coffee. As a result, he didn't get to the theater until a few minutes after the half-hour check before curtain time. As they drove up to the theater, he saw Tallulah waiting in her dressing gown outside the stage

door. "Darling, where have you been? I've been almost frantic! I wanted to be the first to tell you. Diana's killed herself." He groaned in pain. "No, she hasn't actually," Tallulah said, "but she tried to."

"She was punishing me for being late," Roerick recalled wryly. Hustling him into the theater, Tallulah explained that Barrymore had taken an overdose of sleeping pills. Tallulah had found out which hospital Barrymore was in, and she told Roerick, "The last thing the poor child needs is a wire from me with the press watching, so *you* send her a wire, and say, 'Please learn to count to two. The madam sends her love, as do I. Bill.'"

The tour concluded with four weeks in San Francisco. After their final performance, as Tallulah and Roerick were saying good-bye, he told her, "I won't be seeing you anymore."

"You have your farm and I have Windows," Tallulah said, "but we'll be seeing each other."

"No, we will *not* be seeing each other." While he was devoted to her, and would always be there if she needed him, he confessed that "I cannot stand your public personality."

"Darling, isn't it awful? I make *vows* I'm going to stop all that nonsense," Tallulah said, "but it's what people expect of me, and when they come 'round it takes over, *it takes over.*" Just as they were sitting, that very persona emerged as if it were a doppelgänger.

"After all, darling, we can't go around showing people what we're really like." Tallulah drew herself up. "I mean, pearls before swine, darling, pearls before swine."

The Hallelujah Chorus

"I've always wanted to die onstage."

Now more than ever, Tallulah dreaded being alone at night and was unable to sleep. At Windows she would run alongside the car of departing guests, hanging on to delay their leave-taking. On the *Dear Charles* tour she had spent a lot of time with the Raynor siblings, Grace and Tom, who played her daughter and younger son. Once she asked Tom to give her twenty-five minutes' notice before he planned to leave her hotel suite so that she could take her pills and already be halfway to sleep by the time he left. Her dependence on barbiturates made her existence in Bedford perilous; routinely falling asleep with a cigarette in her hand, she'd burned so many holes in the carpet that a parquetlike pattern was imprinted.

Ray Foster, a young man whose mother cleaned for Tallulah when she was in Manhattan, spent time at Windows, gladly using her pool and, with Tallulah's permission, often inviting guests. The house was not as pristine as it should have been. Sitting all day with a glass, Tallulah was in no condition to oversee her staff. Guests usually made her boisterous and dominating, although with stimulating company she could elude her own need to be "on."

One afternoon she and Gladys Cooper, who was now starring on Broadway in *The Chalk Garden,* had a quiet lunch by the pool. Another time Foster brought W. H. Auden to see her. She treated the poet with reverence, though other times she seemed disgusted with everything to do with herself, her life, her myth. "I have to go to a *fucking* ball game!" she complained once to Foster. "How do I get myself into these *fucking* things?"

Working was the only thing that propelled Tallulah to exert control over her addictions, her personal demons. In late 1955, she made the decision to move back into Manhattan, purchasing a town house at 230 East Sixty-second Street, between Second and Third Avenues. At the same time, she accepted an offer to star at the New York City Center, playing Blanche DuBois in a revival of Tennessee Williams's *A Streetcar Named Desire.* Jean Dalrymple, who had handled Tallulah's press for *Forsaking All Others* in 1933, had directed the City Center drama and opera program since its inception in 1943, producing limited runs of proven repertory starring Broadway names at popular prices. Tallulah's *Streetcar* would rehearse and try out in Florida, before coming into New York for a two-week run in February 1956.

Tallulah had also signed a contract a month before to be mistress of ceremonies in a new attempt to resuscitate the *Ziegfeld Follies,* which had not been produced since the mid-1940s. Shortly after signing, Tallulah joked to the press that she had been "brainwashed" for six months by Richard Kollmar, who was producing the show with Richard Gardiner. "I said, 'Darling, I CAHN'T do anything.' He bullied me. He has a darling sense of humor. I'll have 3 or 4 sketches and I'll come down in a beautiful dress and probably trip right over my feet." She would begin work on it immediately after *Streetcar* closed.

Rumor has it Tallulah had been offered the role of Blanche in the original production of *Streetcar,* which opened on Broadway in December 1947. Tennessee Williams said that he had suggested Tallulah to producer Irene Selznick, who felt that she was too strong for the part. Had Tallulah been offered the part then, at age forty-five, she might well have found that the role of a Southern woman who drinks too much, is concerned about aging, and is promiscuous would have left her too personally exposed. Most likely she would have been reluctant to abandon the torrential success she was having in Chicago in *Private Lives,* as well.

Before Dalrymple approached her with *Streetcar,* Tallulah had been considering starring in a revival of *Déclassée,* Zoë Akins's romantic melodrama about the downward spiral of a British noblewoman. Ethel Barry-

more's performance in the original 1919 *Déclassée* had so enthralled Tallulah that she sneaked into the Empire Theatre during intermissions to watch her again and again. But *Streetcar* meant more to her. Reading the play in 1955, she was in tears by the time she finished.

Dalrymple felt that the play was Williams's greatest, and Tallulah shared her enthusiasm. She may still have had apprehensions about the parallels that could be drawn to her own life, but she'd learned from *The Big Show* to take preemptive comic strikes on just such delicate matters.

Williams had agreed to supervise the production, choosing thirty-three-year-old Herbert Machiz to direct in his Broadway debut. Twenty years later, when Machiz died, he still had not become a major Broadway director, something his many detractors blame on a shortfall of talent. Many first-rate actors admired him, however, working season after season at his summer theater in Lake Hopatcong, New Jersey, and off-Broadway at his Artists' Theatre, where he presented experimental plays funded by his lover, prominent Manhattan art-gallery owner John Bernard Myers. Williams continued to believe in him, clearly, later choosing Machiz to direct the premieres of *Suddenly Last Summer* and *The Milk Train Doesn't Stop Here Anymore.*

Streetcar's City Center cast included several members of the original production. Edna Thomas again played the Mexican Woman. Rudy Bond, who in 1947 had played Stanley's poker partner, Steve, was now Blanche's suitor Mitch. Gerald O'Loughlin, an up-and-coming actor in his early thirties, was making his Broadway debut as Stanley. Frances Heflin, who had been Gladys Antrobus in *The Skin of Our Teeth* thirteen years earlier, would again be acting with Tallulah, this time as Stella.

As they were scheduled to rehearse only two weeks in Florida, Tallulah asked Heflin to come to the Élysée to work on their scenes together. For Heflin, Tallulah would have made a perfect Blanche had she been ten years younger; Tallulah seemed a little old for the first two scenes, in which Blanche arrives and immediately sends up Stanley's guard. Blanche is meant to be five years older than Stella, but Tallulah had twenty years on Heflin. Tallulah tried to get Heflin, whom she felt looked like she "just fell out of the nest," to wear her hair so that she looked older. After Heflin resisted, Tallulah dropped the matter. She needn't have worried; her age never became a factor in critical notices. Onstage, Tallulah "never looked old to me," said Dalrymple. Tallulah's more mature Blanche strengthened the impression of a woman who has exhausted her opportunities.

During the original Broadway run of *Streetcar*, Sandy Campbell had

taken over the role of the Young Collector. Blanche, waiting for her date with Mitch, opens the door to a young man selling subscriptions to a local newspaper. She gently flirts with him before sending him on his way. Despite Tallulah's suggestions that he hire one of the young men in her retinue, Williams still wanted Campbell.

On the flight to Florida, Tallulah and Campbell became friendly. Together with Rose Riley and Robert Williams, Tallulah was being put up in a gloomy Spanish-style mansion that Campbell recalled as something out of *Sunset Boulevard*. The lawn extended three hundred feet to the bay. Tallulah invited Campbell to live with her. After a few days, kept awake by her coughing and the radio she had on at all times, he decamped to an outbuilding on the estate. Edna Thomas moved into the house, but Campbell remained part of the household, driving Tallulah to the theater and dining with her frequently at the house. During their five weeks in Florida, Campbell sent bulletins about the production to author Donald Wyndham, and they were eventually published privately.

Williams told Campbell that he thought Tallulah was on her last legs; it was for that reason that he had had approved this revival only reluctantly. Although she was on the wagon when she arrived in Florida, she took pills throughout the day; at night she downed a powerful barbiturate that rendered her incoherent within ten minutes. When Tallulah stepped out onto the lawn to walk her dogs, she said she was tired after ten yards. Yet her mind was startlingly retentive. Campbell remembered her quoting something he said on the plane "when I didn't think she had heard me."

By Tallulah's own admission, she didn't care whether she lived or died. One night she, Williams, and Campbell played the 1920s game of Truth, in which one was obligated to respond "truthfully" to any question posed by a fellow player. "I wish always, always, for death," Tallulah said. "I've always wanted death. . . . That's why I take sleeping pills. They're very close to death." Later on in Florida, she told Williams that *Streetcar* was the story of her own life.

Both the Coconut Grove Playhouse and the mansion where Tallulah stayed were owned by a Texas oilman. He told the cast not to use the theater's back entrance because it was being paved, but blacks working in the production were told that they could not use any other entrance. This sent Tallulah into a rage. She announced that she would only use the back entrance, insisting that everyone else in the cast follow suit. Soon after, the theater management saw fit to relax its rules.

In his letters to Wyndham, Campbell recorded Tallulah's whims,

quirks, mood swings, and conflicted emotions, many of which perplexed him. He didn't understand why Tallulah and Williams were so often at each other's throats. He knew that she was furious that Williams had brought his friend Maria Britneva, a young actress of Russian descent, to Florida with him. Britneva had auditioned for Stella, but Tallulah felt she was a brown nose and rejected her.

Williams loved the wry humor that marked Tallulah's interpretation of Blanche. Neither Jessica Tandy nor Elia Kazan, star and director of the original *Streetcar,* had recognized Blanche's humor, he felt. Yet during rehearsals Williams told Campbell that Tallulah's performance was "disgraceful." Over the years, Williams would give conflicting accounts of Tallulah's *Streetcar* in articles, interviews, and his memoirs. Anything he said about Tallulah in Florida cannot be trusted, according to Heflin: "He was smashed the entire time," she recalled. "He'd be drunk by one, go for a swim in an icy pool, and then stay sober for a couple of hours. He was sweet, he was nice, but I don't think he knew or remembered anything about that production."

Williams rarely attended rehearsals, and when he did, he was not much help. Once Tallulah was in a state of hysteria over where she should move on one line. "Move there," Williams told her.

"But that's where the wall and door are."

"This is not a realistic play, completely," Williams said. "We can take that license."

"But there's a real door there. I know it's not a realistic play, but the door is real and the wall is real."

"Oooh, I didn't know the door was real." Williams had nothing more to say about the matter.

"What an insensitive ass he is," Campbell complained to Wyndham about Machiz. "His directing so far comes out of the printed acting edition of the play, which he reads to the cast." Heflin agreed that the director "had no concept of what the play was about, of what actors were like. He was a dreadfully destructive influence and he made Tallulah very unhappy." Yet Tallulah "didn't dislike him as much as I did," Heflin said. "She allowed herself to be directed by him up to a point."

"We were all in agony," Heflin recalled. "None of us felt we were any good, that we were getting anywhere with our performances. 'I don't know what the hell I'm doing!' Tallulah said. 'I don't think any of us do.' " One day before rehearsal Tallulah walked past Heflin without even a greeting. "I thought, 'Uh, oh, we're in for it today, kids.' "

In rehearsal, Tallulah moved Campbell to tears with Blanche's mono-logue about her husband's suicide. Yet he felt that she was playing his scene with her "at surface value," afraid that it would be taken as personal confession: "There's Tallulah trying to make a young boy."

Campbell watched her suffer a sudden setback in rehearsals. "She for-gets her lines, her pace is bad, there's no energy, and she can't remember a single prop. Perhaps this is how she works," thought Campbell, when, mysteriously, Tallulah pulled herself together. A couple of days later, at dress rehearsal, she was "marvelous."

Williams had told Tallulah that the young bill collector's scene was his favorite, urging them not to rush it needlessly. "I love my scene now," Campbell wrote Wyndham. "She plays it beautifully, and I can take as much time as I want. In fact, in one spot she wants me to take more than I want to."

One friend of Williams, author Gilbert Maxwell, had known Tallulah casually since 1934, when Stephan Cole showed her Maxwell's first book of poems. A day before the Miami opening, Maxwell sat with Williams to watch a run-through. Tallulah came on with her suitcase, "looking fragile and lovely," as Maxwell recalls in his book *Tennessee Williams and Friends*. "Her first lines, plaintively spoken, sent a chill down my spine." As the scene progressed, Williams "was as moved" as he was. Unhappily, at the opening, the presence of a new element, the most strident members of Tal-lulah's gay following, made themselves felt with a vengeance. They laughed at Tallulah's humor in the part, but they also insisted on laughing at any line that could be construed as a double entendre. "I sat grinding my teeth," Maxwell writes, "marveling that any star could carry on in the face of such ribald bad manners."

In Tallulah's dressing room after the performance, Williams put his head in her lap. "Tallulah," he told her, "this is the way I imagined the part when I wrote the play." Yet only hours later, he contradicted himself during a party in a nouveau riche mansion replete with an enormous indoor pool. Williams announced fortissimo to Dalrymple that if Tallulah "continued to give such an appalling performance he would not allow the play to open in New York." He claimed that she was "playing it for vaudeville and ruining my play." Campbell felt he'd been influenced by Britneva, who had sat with Williams offering a running stream of invective against Tallulah's work throughout the performance.

The next day, when Williams visited Tallulah, they talked alone about how she could deflect the laughter. "I want to do what Tennessee wants,"

she told Campbell, "but he is so vague and changeable and doesn't watch enough, so that I'm confused and don't know what to do."

When William Hawkins of the *New York World-Telegram and Sun* came to Coconut Grove to interview her, Tallulah told him that the role of Blanche was "harder than 18 King Lears, with a Hamlet thrown in." As usual, when Tallulah spoke about the difficulty of a part, she did so in terms of physical rigor. She had a costume change for each of *Streetcar*'s eleven scenes—particularly difficult since she was beginning to experience the first symptoms of emphysema. "If I had played it in the original run, I'd have died. But then I've always wanted to die onstage." Whatever the cost, Tallulah was determined "to prove I'm a dramatic actress before I do the revue."

The suggestion of some Miami reviewers that her personality had subjugated Blanche upset her. "What can I do?" she asked Campbell. "Other personalities had the same problem: Jack Barrymore, Irving, Bernhardt." Campbell told her that when he was onstage she was Blanche and not Tallulah. She continued to experiment night after night; at one performance, she played the role "in a lower key—very different."

During the tryouts of *Streetcar*, Jean Dalrymple visited Florida several times. Together she and Tallulah reviewed every sound and movement Tallulah made, excising anything that was distracting or inappropriate. Tallulah "carefully weeded out every Tallulahism—the change of voice, the head tossing, the quick hand motions. . . ."

"We were all very nervous," Heflin recalled, "but her stage fright was extraordinary." Tallulah's nerves even caused her to lock herself out of the set at one matinee. (A local propman had installed a real lock on the door of the set, an invitation to mishap that would not have been tolerated by a New York stage manager.) "Goddamn, I can't get this fuckin' thing open," Heflin heard Tallulah muttering offstage. Finally Heflin said, "Try a window, honey." Tallulah found an opening to climb through, entering improbably through a stage closet. Trying very hard not to laugh, Heflin ad-libbed, "I'm so glad you came in through the window." "Yeah, I never saw a window in a closet before," Tallulah replied.

The stairs to the Kowalski apartment hadn't been built very securely. As they wiggled and wobbled, Tallulah would clutch Heflin and hiss under her breath, "Frances, don't get me killed! We're both going to get killed!" Tallulah muttered warnings about broken necks, broken backs, unaware that Heflin was six months pregnant at the time.

Williams had left for a short vacation in Key West. Machiz also went back to New York for a week, though Heflin suspected he was asked to

leave. Afterward, "he wrote these ridiculous letters. He said he felt Stella should be the kind of woman who perhaps used too much makeup and had lipstick *smeared* all over her face."

After three weeks at the Coconut Grove Playhouse, the production left for a week in Palm Beach; there, Tallulah was taken seriously by the audience. At the first-night party thrown by Mrs. Jane O'Malley-Keyes, she sank exhausted into a chair, remaining uncharacteristically quiet.

During her most agonizing days in Florida, Tallulah had asked Estelle Winwood not to come see her play Blanche in New York. Now she called Winwood and asked her to come. "I have been working on this thing every performance. I don't know whether it's any good or not, but I've tried as hard as I can and I think maybe some things are pretty good."

On February 15, 1956, however, when *Streetcar* opened at City Center after one preview, the contours of her Blanche were obliterated by the response of her audience. The laughter at City Center was oceanic, drastically more vociferous than in Florida. "Each passing reference to anything stronger than Coke brought forth gales of uproarious, pseudo-sophisticated laughter," *Cue* reported a week later. "These gay lads had come to see a travesty, and despite Miss Bankhead's sturdy refusal to commit one, they applauded, as though by their actions they could call it into being."

Patience Cleveland, a young actress, was in the audience that opening night. At the beginning of scene six, Blanche stands outside the Kowalski apartment and looks at the sky, making conversation as Mitch stands nervously behind her. "I'm looking for the Pleiades, the Seven Sisters, but these girls are not out tonight. Oh, yes they are, there they are! God bless them! All in a bunch home from their little bridge party." Tallulah spoke those lines with wistful coquetry, but no sooner had they come out of her mouth than the auditorium was upended by hilarity. "When that got a laugh, I wanted to stand up and scream," Cleveland recalled. "They turned it into their private Hallelujah Chorus," says Anne Meacham, who was understudying Stella.

Backstage, Tallulah was furious, barking at Rose Riley, roaring that the audience was a bunch of horses' asses. As the evening wore on and the audience refused to back off, Tallulah grew shakier and shakier. "She hung on to me a lot that night," Heflin recalled, "even though I was as scared as could be."

"I have seen many actresses play Blanche DuBois," Dalrymple writes in *From the Last Row,* "but by comparison they were sparrows. Tallulah was

an eagle. At the end of the play, pinioned to the floor, she was like that great bird brought down. . . ." Heflin found Tallulah's descent into an abyss of near insanity in the final scenes "truly brilliant . . . so totally truthful. She tapped an extraordinary emotional reserve. It was the best I'd ever seen it played. I was wiped out by her every night."

The newspaper reviews were decidedly mixed, however. "They only listened to the audience," said Meacham. Robert Coleman in the *Daily Mirror* asserted that Tallulah "took the first act of 'Streetcar,' and kidded the pants off it. She satirized it unmercifully. . . ." Other critics felt she was simply wrong for the part. The *Times*'s Brooks Atkinson said that "Miss Blanche and Miss Bankhead do not have much in common," complaining that Tallulah was "playing an introspective tragedy in the style of melodrama." Walter Kerr wrote in the *Herald Tribune* that Tallulah was patently miscast, because she was

> . . . as a person and as a performer, notoriously indestructible. Blanche DuBois is a girl who deceives herself. There is no self-deceit anywhere in Miss Bankhead. She is a woman patently wise in the ways of the world, obviously without illusions of the sort called for throughout the play; she is shrewd and sharp and no one to tangle with. Try as she will she cannot disguise the fact that she is candid. And the attempt to disguise it—by letting her sentences float off into the breeze, by never striking a period by babbling hastily through the more affected passages—simply end in monotony.

As always, Tallulah provoked wildly divergent opinions. Hawkins in the *New York World-Telegram and Sun* found that she used "a superhuman degree of taste, restraint and control. . . . One can only be amazed at the way the star edits her own experience for her performance." Thomas R. Dash in *Women's Wear Daily* called Tallulah's "a performance that evokes all the subtle facets of Blanche's character," distilling "the anguish, the heartbreak and the pathos of a woman of tender sensibilities. . . ."

The second night, with no cult present, there was not one unwanted laugh in the audience. The second-night critics—those who didn't have to file for a newspaper deadline—passed Dalrymple with tears streaming down their faces, unable to speak. Saul Colin, the New York correspondent for the British monthly *Plays and Players* found Blanche the best thing Tallulah had done since *The Little Foxes*. Tallulah was "deep and tender, violent and sufficiently insane to appear normal, moving and coy, suffering

yet concealing pain . . . a new dimension never encountered during the magnificent performances of Jessica Tandy, Uta Hagen or Vivien Leigh."

Tallulah's *Streetcar* was a bonanza for City Center. The enormous theater was sold out for the two-week run and the possibility was discussed of bringing the show to Broadway. Apparently, Tallulah could not extricate herself from the *Follies* commitment because the show did not transfer. The constitution of the audience varied from performance to performance. Director Herbert Kenwith, who was in the audience at a later performance, claims that Tallulah did resort to the direct appeal she had resisted on opening night. Responding to gales of laughter, she came to the front of the stage at one point and said, "Will you please, please give me a chance!"

According to Heflin, the audience's sabotage "broke her heart. She never did get over it." At the party given for the New York opening, Tamara Geva, who had attended together with Emery, walked by a room and saw Tallulah trying to hide the fact that she was crying. Yet Tallulah had done everything to cultivate this fringe, and she was perfectly willing to exploit her talent to satisfy them, always looking for the "hot" spots in an audience to pitch her performance to, knowing that they would trip a contagious response throughout an auditorium. Ted Hook, a dancer on the bill at the Sands Hotel, remembered Tallulah asking him, "Are there any gays out there? Where are they sitting?" She should have detected the hostility beneath her cult's adoration long before. Yet only now were the consequences to her reputation and her possibilities as an actress becoming unmistakably clear.

The Nadir

"The Germans blitzed it twice during the war, but it took me to close it." [referring to the Café de Paris in London]

Three weeks after *Streetcar* closed, Tallulah was working on the *Ziegfeld Follies,* which was complex enough to require five weeks of rehearsals. The *Follies* gave Tallulah the chance to do more singing, which she loved but struggled with. Challenged by her sense of pitch, she had spent hours practicing the few lines of "Paper Moon" Blanche DuBois riffs on throughout *Streetcar.* (Ultimately she'd substituted "Bye Bye Blackbird," which she had been singing for decades.) "She couldn't really carry a tune," said Peter Howard, *Follies* pianist for the often "troublesome" rehearsals. "I had to plot things out for her constantly."

The revue's sketches were directed by Christopher Hewett, who, like Howard, became a good friend of Tallulah's. Hewett had begun directing while an actor in a British repertory company. After coming to New York in 1954, he had directed the *Shoestring Revue* with Beatrice Arthur, who was also featured in the *Follies.* Tallulah's frequent vituperations against the theater notwithstanding, Hewett sensed that she "loved her profession" but "felt somehow that it hadn't come out right." "My fans really didn't help me, did they?" she said, shaken by her experience with *Streetcar.*

Tallulah loved revues, which she had been watching avidly for more

than thirty years. "Somerset Maugham once said that a play should have a beginning, a middle and an end. A revue doesn't. A revue is the queen of non-sequiturs—which is what I am anyway." The *Follies* followed that tradition without bearing the stylistic imprint of the best examples of the genre. "It actually wasn't a bad show, in retrospect," Howard said. "Of course, it wasn't a good show, either."

One day, Tallulah showed up for a rehearsal very much the worse for wear. "I apologize for Miss Bankhead," Hewett announced to the assembled actors. "She's not prepared to rehearse today and you're all standing around doing nothing." He dismissed the cast, saying, "I'm sorry I called you in. It's my fault."

"You shouldn't have done that," Tallulah said angrily when they were alone. "I've done it," he said. "You can rectify it very easily tomorrow by saying that you are awfully sorry." "I certainly will not," she insisted, yet the next day she did exactly that.

Choreographer Jack Cole, of wide renown both on Broadway and in Hollywood, directed the dance and musical numbers. "She adored him," Hewett said. "She would try anything for him and did," particularly in the first-act finale. Cole devised a three-ring circus of acts, whirlpools of activity in which Tallulah would stumble or be engulfed, to her simulated surprise and shock. She'd tell the audience she was just crossing the stage to get a drink of water, then get caught up in a dance act and be thrown from man to man.

After the show, when Hewett and Tallulah would go out, she invariably asked how certain things had gone. "I think this is a bit over-the-top," he would say if he felt she was overplaying. "All right, let's pull it back." If he told her a scene wasn't working, invariably Tallulah had ideas about how it could be improved. "She was wonderfully inventive," Hewett said. "She'd have been a wonderful coach," if only to a select few, because "I think her patience would run out with a lot of people."

Unfortunately, Tallulah's sketch material was not really first-rate; some of it was shopworn. Nonetheless she could still be "remarkably funny," as in a sketch where she played a maladroit stewardess, or when her *Big Show* subway monologue was fleshed out and imaginary characters from the radio monologue visualized.

At one point, she drew a mustache on a subway car poster of Bette Davis. A purported feud between them, justified by Davis's assuming Tallulah's roles in *Jezebel, Dark Victory,* and *The Little Foxes,* had become a part of Tallulah's public shtick since *All About Eve,* where costume designer

Edith Head had explicitly styled Davis's appearance to resemble Tallulah's. Privately, Tallulah spoke admiringly of Davis's talent, but insisted on the superiority of her own Regina Giddens in *The Little Foxes*.

Hewett complained of "various and sundry problems" he had with the *Follies* producers. They had commissioned lavish sets for the musical numbers, but designer Raoul Pène du Bois had not bothered, or hadn't been asked, to design sets for many of the revue's sketches. At the eleventh hour before the Boston opening, Pène du Bois whipped up some velvet draperies with "plugs" into which a door or window could be inserted.

At the April 16 opening, the "anxious-to-enthuse first-night tryout audience" was so unimpressed that many of them left early, according to *Variety*'s "Guy." The paper did note Tallulah's "rousing reception" for "a slick and compelling performance in this new medium for her."

"As far as I was concerned, she was perfectly nice to work with," Jay Harnick, who sang in the *Follies* chorus, recalled in 1994. "She was never critical of her fellow performers." On the other hand, she was totally preoccupied with her frustrations in the show. On the few occasions that Harnick had a chance to speak to her, "it was always what was happening to her, why the gods were against her? Or why this device was not centered around her? Don't they know that *I* can or can't—' Life lived at such an intense level that it was a little terrifying."

Philadelphia brought more bad reviews. Traveling with fifty-two stagehands, the show's overhead was enormous. At New York's Winter Garden Theater, a sold-out house would reap a gross of $70,000 weekly, but it was going to take an "unprecedented" $55,000 a week just to break even.

Further troubles plagued the show. Star dancer Carol Haney left because of a kneecap injury, while the show's leading vocal attraction, Joan Diener, quit. Their scheduled third week in Philadelphia had to be canceled after they were forced to refund $26,000 in advance orders. As a result, the producers could not raise the money to bring the show to New York, and the *Follies* closed.

Tallulah invited Hewett to ride back to New York with her. Harnick and some friends were also driving back; while eating at a roadside Howard Johnson, Tallulah and Hewett popped in. To Harnick, Tallulah seemed relieved that the fate of the show had been decided. She "could not have been more gracious and generous and charming," he recalled. As they were leaving, she swooped up all the toy animals in the souvenir shop, distributing them among Harnick and his friends.

That summer, the revue *Welcome, Darlings* was put together for Tallu-

lah by some of the displaced *Follies* performers. Harnick, in therapy at the time, recognized his own "problem with dominating women," and figured, "Hey, I'll make a job that forces me to deal with one of the most dominating women in Western civilization—but for two days a week." As advance director, every Sunday he would conduct a dress rehearsal in whichever new town they were playing. The show would open on Monday; Harnick would leave the next day, then catch up with the show on the following weekend.

Tallulah was busier than in the *Follies,* performing in fourteen of the twenty-five numbers, including the finales of both acts. The show opened with the song "I've Heard a Lot About You," in which a male chorus saluted Tallulah, who performed some "startling high kicks," William Peper reported in the *New York World-Telegram and Sun.* She gave a hilariously pointed reading to Dorothy Parker's "The Waltz," an acerbic monologue in which a woman wryly complains about her dance partner, even though she can't bear to part from him.

There were new sketches, including one devised by Neil Simon, then writing for television, and his brother Danny, together with Joseph Stein. Playwright and screenwriter Patricia Coleman devised a *Peter Pan* satire that was called "Love and Thimbles." Mary Martin's *Peter Pan* had just finished its successful Broadway run, which made it ripe for ribbing. Coleman had been introduced to Broadway after graduating from Vassar in 1933, thanks to purported love affairs with both Charles MacArthur and Tallulah. At one point in the late 1940s, Tallulah had seriously considered producing another play of Coleman's.

A poignant note was introduced into *Welcome, Darlings* when Tallulah sang "I Don't Want to Be Hurt Again" after reading a farewell note from a lover. She again returned to her subway monologue, as well as a similar scene pitting her against the perils of an unstaffed kitchen. A passel of writers contributed to the musical score, including Harnick's brother Sheldon, who later wrote the lyrics for *Fiddler on the Roof.* "Regardless what the material was," Jay Harnick said, "she could illuminate it in the way that few others could."

Welcome, Darlings opened in Westport on July 16, 1956, then began weeklong engagements at summer theaters around New England. Tallulah had instructed Harnick to make an appointment for her at the local beauty parlor on the day of each opening. Manicurists were to have four different shades of red nail polish for her to choose from. Although the scenery was minimal, supplied by the local theaters, Tallulah insisted on footlights in

every theater, as well as a neutral-colored "traveler" curtain behind her for her songs. Tallulah told Harnick it was as the best possible backdrop to disguise the ravages of age.

In Fitchburg, Massachusetts, the local designer provided the footlights, but the theater could not afford to rent a special curtain. He offered Harnick use of a white organdy curtain, which would absorb whatever color light was trained on it, or they could use the gray burlap backing, if Tallulah preferred.

When Tallulah arrived, it was obvious that she and her traveling companion had been drinking all the way from their previous stop. Harnick met her limousine, explained about the curtain, and she gurgled a hazy acknowledgment. That night at the dress rehearsal, Tallulah was still a little shaky. Harnick thought the white organdy looked fine and he hoped that they could get through the dress rehearsal without a scene from Tallulah. Unfortunately, halfway through the first act, he had to call a time out for some reason. Tallulah looked around and focused on the organdy for the first time. "Where's Jay Harnick?" she growled, blinking ferociously. Then came an explosion. She was fifty-three years old. She couldn't allow the public to see her as she really was. She had specified the traveler in her contract. Harnick had betrayed her.

Standing in the back of the theater, Harnick started to approach the stage, signaling to the local designer so that as he reached it, the curtain had started to come down from the batten. Tallulah looked around and saw the gray burlap. "All right," she said, "I'm fifty-five," exaggerating her age for greater comic effect. The air was cleared so stylishly that Harnick forgave her everything.

Variety reported that Tallulah's salary was a flat $5,000 per week, which tipped ticket prices to a high of $4.20. Although several dollars less than a prime Broadway seat, this was steep for summer theaters. Nevertheless, *Welcome, Darlings* did well wherever it played. *Variety* reported that the show was "cautiously eying Broadway," but felt the material was "just not good enough for the Main Stem." At the last stop, Ivorytown, Connecticut, the show reaped a "smash" gross and closed on September 1.

That fall, director Herbert Machiz persuaded Tallulah to play Eugenia, Baroness Munster, in Henry James's early masterpiece *The Europeans,* which playwright Randolph Carter had adapted for the stage. Machiz had just directed a tryout of Carter's dramatization at Machiz's summer theater in Lake Hopatcong, New Jersey. James's character is superlative, as fascinating as Regina Giddens or Blanche DuBois. A cosmopolitan adventuress,

she is the daughter of an expatriate American woman and an Italian father, who leaves a morganatic marriage in Germany that has gone sour. Crossing the Atlantic, she seeks her fortune on the estate of her mother's half brother, a New England Puritan named Wentworth. Traveling with her is her younger brother, Felix, an easygoing bohemian who dabbles in painting. They enchant, repel, and utterly transform Wentworth and his three children. Eugenia also attracts William Acton, a wealthy businessman, who is a friend of the Wentworths but several notches more tolerant than they. Having traveled the world, Acton is now settling back in his native New England, where he would like to add Eugenia to his luxurious home, teeming with curios. Ultimately she is a specimen too exotic even for him.

Carter credits Machiz's ability "to talk great theater. I've never seen anyone who expressed himself better." But Carter's script had problems that even Machiz's salesmanship could not disguise. He had transposed too much of James's dialogue wholesale, and James's complex rhetoric sounded stilted when spoken. Moreover, Carter chose not to dramatize a crucial denouement between Eugenia and Acton, a decision that could be justified on literary grounds, for James liked leaving the fireworks out of view, tilting the mirror away from the peephole. Yet theatrically, Carter had made a major mistake. Audiences were likely to feel shortchanged, waiting for a confrontation that never came.

Machiz and his lover, John Bernard Myers, gave a young writer friend, Waldemar Hansen, Carter's script to read. "It's neither fish, flesh nor fowl," said Hansen. Machiz defended the script, claiming that Tallulah would be able to paper over deficiencies in her material.

Casting the play at Lake Hopatcong from his colony of devoted young performers, Machiz had chosen Irma Hurley to play the juicy role of Gertrude, the younger Wentworth daughter, simmering with rebellious thoughts that disturb her as much as they do her family. Gertrude is pursued by the painfully earnest young reverend, Alfred Brandt; it is with Eugenia's brother, Felix, however, that she eventually pairs off. For Broadway, Machiz selected the slightly more experienced Anne Meacham for Gertrude, casting Hurley as Gertrude's prim but loving sister Charlotte. (At first only Eugenia realizes which sister is the reverend's proper companion, but by the end of the story Charlotte is betrothed to him.)

Like Tallulah, Hurley had been raised in Catholic schools, and was evidently well-bred. Throughout the production, it amused Tallulah to call Hurley by her decorous character's name, confusing role and interpreter. Weeks later in New York, as the cast was trailing out the stage door, Tallu-

lah saw Hurley hop on the back of cast member Jay Barney's motorcycle. "Oh, my God!" Tallulah squealed, grabbing hold of her escort and swooning to the ground in feigned shock. "That's *Charlotte*"—she giggled—"that's Charlotte on that motorcycle!"

Meacham believed that casting Barney as Eugenia's suitor Acton was a mistake. Though Barney was a very good actor, there was no chemistry between them; Tallulah needed another Donald Cook. Machiz's *Streetcar* casting of Gerald O'Loughlin, not the powerhouse presence to strike sparks from Tallulah, had struck her the same way.

With Tallulah starring, it was only natural to enlist Jack Wilson to produce. Unfortunately, the years had treated Wilson no more kindly than they had treated Tallulah. He was no longer only a steady social drinker; before long the cast realized that he was a full-blown alcoholic. At their first reading, Hurley watched him, wondering if he could last the length of the show. Carnation in buttonhole, body held rigid, a flaming face "that just sort of hung there"—it was all too easy for her to picture him embalmed.

To Hurley's surprise, the rehearsals were "absolutely marvelous," with Tallulah "making a great effort to be the character and not do a star turn," Hurley recalled in 1993. Asking Hurley and Meacham not to articulate quite so crisply, she had the idea that as the foreigner, the precision of *her* speech should mark her as alien. She was working on making sure that the baroness, despite her past indiscretions, would always remain cloaked in comme il faut. She had a way of reminding the cast that the breeding of the baroness was in Tallulah's own bloodlines as well. It almost seemed that by staying within the limits of propriety in her characterization, she would be reclaiming something that in the public's eye—perhaps also in her own—she had lost.

James's humor in the *The Europeans* is dry and delicate, and the laughs Tallulah was honing were going to be more subtle than the raucous ones the public had come to expect. "It wasn't camp for a second," Meacham said; rather, Tallulah's approach was high comedy, "of the same calibre" as the kind Meacham had witnessed onstage with Ina Claire and Jane Cowl, or when she watched Lynn Fontanne from the audience.

Wilson gave *Eugenia,* as the adaptation was called, a deluxe production, with two supremely gifted designers, Oliver Smith and Miles White, designing sets and costumes. For Tallulah's first-act entrance, White planned a black traveling costume. Pleased with the sketch, Tallulah corrected the color: her own Victorian grandmother told her always to travel in brown to hide any dust. To conform to James's evocation of Eugenia's

raven-haired mystery, Tallulah donned a black wig—bangs, chignon, and spit curls. She hated sweating under hot wigs but, White recalled, "she cared about being perfect" in the part.

In the third week of December 1956, *Eugenia* opened its six-week try-out tour in New Haven. Robert Leahy in the *New Haven Register* described it as "a wry little comedy, with appropriately poignant undertones," in which Tallulah was "given a delightful chance to glitter, to glower, and to pass amusing commentary upon the deadliness of propriety." The beauty of her gowns was extolled by most critics. "Once she got everything pinned," Carter recalled, "she was absolutely glorious: quite as glamorous as Garbo." The cast was briefly puzzled by the buckets of ice Rose Riley was seen bringing into Tallulah's dressing room before every performance. Eventually they realized that Tallulah must be using them as a restorative, dunking her face and neck, which explained how onstage her neckline magically tightened. Critics and cast alike found her ravishing onstage. "The woman had magnificence," Carter declared, and an emanation, strange and hypnotic.

On her first Saturday matinee in New Haven, Tallulah marshaled her confidence and commitment to give "the most beautiful performance I've ever seen in my life," recalled Carter. The stage was spinning with seduction and intrigue, and the cast was galvanized.

Soon after they arrived in Boston the following week, she invited the cast to her suite at the Ritz-Carlton, serving drinks and sandwiches. Warm and engaged, Tallulah told everyone to order anything else they wanted from room service. When Tallulah "was relaxed, she listened," said Meacham. The star was anything but relaxed the next night when they opened, however. Elliot Norton in the *Post* described an edgy Tallulah who "threw her lines like so many harpoons, sometimes before her opposite number on the stage had finished speaking his or her final words." While Tallulah's Eugenia was "a genuinely glamorous and sophisticated creature; cool and controlled, haughty and contemptuous, capable of savage irony," she needed to make the character "a good deal more sympathetic." None too complimentary about the rest of the cast, Norton saved his harshest comments for Carter's script and its "air of clumsy contrivance." It followed the novel's narrative "closely, without penetrating to the heart of the matter. In adhering to the line and even the lines of Henry James, Mr. Carter has missed the light and the life."

While the four other dailies were kinder to the play, Norton was the dean of Boston critics, one of the most reputed in the nation. Waldemar

Hansen found himself summoned to Boston for a rewrite. Then in his early thirties, Hansen was a published poet who had been Cecil Beaton's amanuensis since 1950, finessing several books Beaton wrote during the fifties.

After watching a performance in Boston, Hansen was escorted to a rather intimidating meeting. There sat Wilson, Tallulah (calm as Hansen would rarely see her again), Carter, Machiz, Myers, and none other than Thornton Wilder, a writer Hansen revered. Wilder had been visiting Tallulah in Boston and been recruited for this confabulation.

Hansen shared his views that the play was diffuse, beleaguered by problems of structure and focus. "There's no *drama* here, you've got to keep some of the Jamesian elegance, but tool it to give it a dramatic shape," even one James might not have approved of. Ruth and Augustus Goetz had done this in *The Heiress,* violating the ending of James's *Washington Square* for a more effective third-act resolution, and achieving a great success on Broadway.

As Hansen spent his first night on the job rewriting vigorously in his room at the Ritz-Carlton, the still morning air and rat-a-tat of his typewriter were broken by a ringing phone. "Darling," a voice fogged over with intoxicants announced, "it's Tallulah. You've got to make this play a hit for me and for Jack." Semicoherent babble followed until Hansen was able to ease her off the phone and go back to the typewriter, where he hammered away until dawn.

After a few hours' sleep, Hansen reported to the theater with his new pages. A few minutes into the rehearsal, however, Tallulah fell victim to a classic addicts' mistake, growing flummoxed by a line, then a detail, until soon the entire session ground to a halt. "I'm afraid we're going to have a disaster on our hands," Wilson told Hansen, "but I owe this to Tallulah."

"She was frantic; she was desperate," remembered Meacham. Tallulah knew better than anyone that this could very well be her last chance on Broadway. Turning on Machiz at a technical dress rehearsal, she hissed with cold, dry, what-have-you-got-me-into fury, "Look, *you're* wearing the skirts in this play, anyway." The cast cringed.

As the weeks passed, Tallulah's performance echoed the show's emotion-fraught climate. "When Tallulah felt she was going to have to carry the show," Hurley recalled, the star who had wanted so much to preserve decorum started going into burlesque, doing things she wouldn't have dreamed of before. Poking another character with her umbrella to provoke a laugh, she manipulated line readings for maximum humorous

dividends. "Such a delicious garden!" Eugenia nightly exclaimed to her hosts at their first meeting. "One can see that you have done nothing whatever to improve it. *C'est tout au naturel.*" In her early performances she made the slight so subtle it could go completely over the heads of her hosts. Now her voice slammed down on "nothing," the woofers on Tallulah's basso profundo turned all the way up.

As the delicacy seeped away to gales of laughter, Irma Hurley wondered how many members of the audience had ever read *The Europeans*, or cared in the least about Henry James. Crowds loved the outrageous, boisterous Tallulah, even if the critics remained lukewarm.

Miles White, the show's costume designer, remembered a rather unsavory younger man attending Tallulah in New Haven. It may have been actor Don Torillo, Tallulah's live-in secretary/companion at the time. White suspected some drunken fisticuffs when mysterious bruises started appearing on the star. As the tour went on, there were further injuries. Tallulah fractured her finger in Philadelphia banging her hand against the set for emphasis. Doctors recommended a cast, but Tallulah refused because she had to change gloves four times in the play. After her hand was operated on, she fell in her hotel, breaking several ribs and forcing the show to cancel more performances. *Cue* hailed her as "a valiant figure . . . triumphant over broken ribs and fractured bones," claiming "her heroic behavior in the face of the slings and arrows of outrageous fortune" proved her "an indestructible woman." Alas, Tallulah was all too mortal, leaving the hospital taped together and loaded up on painkillers and her standard diet of amphetamines, barbiturates, and liquor. When Hansen learned she was using carbon tetrachloride to quickly remove heavy stage makeup, he told her in horror that she'd die from the fumes. She only laughed: "Oh, really?"

As her confidence in her material waned, Tallulah's enunciation once again began to suffer. Backstage Machiz and Hansen spoke to her one night, telling that "the first law in the theater is audibility." When Hansen stood at the back of the orchestra to watch, "I couldn't hear what you were saying." Tallulah seemed genuinely concerned. At the next day's matinee she somehow pulled all the unraveling strands back together to give an "extraordinary" performance of elegance and style, Hansen noted. "It was audible, it was *everything*." The Tallulah Bankhead he knew by reputation was back.

The hopes of the cast revived, but Tallulah's performances soon started to veer erratically once more. Still, "she could be great at any unex-

pected moment," remembered Carter, and Meacham would see her "pull herself together again and fight to give a straight legitimate performance."

One moment that did stay consistently focused was a silent passage in the first act. Eugenia wanders into the guest cottage to which she and Felix have been assigned while the rest of the family visits outside. Are the Wentworths keeping her at arm's length, in surroundings less palatial than she desires? Tallulah's eyes panned across the cottage and its furnishings, surveying, assessing what it was all worth and what it augured for her chances. Tallulah's take was a forty-second tour de force.

For Waldemar Hansen, Baltimore was "Custer's Last Stand." After she cut short another rehearsal, Hansen exclaimed, "Miss Bankhead, you're defeating me. I can't go on writing pages if you're constantly going to reject everything. I told you what I wanted to do with this play and you agreed. You've got an opening in New York in one week. If you don't do what I ask you're going to have a flop on your hands!" For the next few days in Baltimore, Tallulah gave him the silent treatment.

On the train to New York from Baltmore, Machiz was forced to run relays, taking new dialogue from Hansen up to Tallulah, sprinting back and reporting which lines had passed muster, which were no go. One line she would accept—"I'm tired of being an influence; I wish somebody would influence *me*"—particularly pleased Hansen. It seemed to confirm the belief shared by so many in Tallulah's life that beneath her combativeness, she was looking to be controlled. As the train rolled toward New York, Tallulah bellowed at Machiz, "You can tell that GODDAMN SON OF A BITCH AND BASTARD"—her voice dipped respectfully—"that he has improved this play."

On January 30, 1957, *Eugenia* opened at New York's Ambassador Theatre. The next day, Tallulah spent her fifty-fifth birthday reading the reviewers' consensus that she had blown what was left of the play right out of the water. "James's meticulous study of manners cannot cope with performing on this tumultuous scale," wrote Atkinson in the *Times*. "Hobe." in *Variety* compared Tallulah's performance to the "self-parodying, tragic, final days of John Barrymore," calling her "wanton abandonment of once-fine gifts" a "sad spectacle."

The play itself was also panned. Charles McHarry in the *Daily News* claimed that *Eugenia* burdened Tallulah with "a ream of the flattest lines in recent theatrical history." *Variety* called for a boycott of Henry James dramatizations. After failed attempts to stage *The Portrait of a Lady* and *The Wings of the Dove*, *Eugenia* was "perhaps the worst yet."

Chastened by her reviews, Tallulah tried playing it straight a few days into the New York run. But once more, her devoted cult appeared and "did to her what they did in *Streetcar,*" Meacham recalled. "They didn't accept the fact it was legitimate." For the sold-out first Saturday matinee, Tallulah was nowhere to be found as curtain time approached. A search party was sent to her home, where they found Tallulah in her bathtub, having taken another fall and scraped her head. The matinee was canceled.

That night, the cast realized that the house of cards had finally collapsed. Tallulah played the evening performance, but she seemed somewhere beyond reach. Rose Riley was furious at her employer, hissing to Meacham that Tallulah should pay every member of the cast the money the company had lost. The week's houses had been not bad, but Jack Wilson now had to cut his losses, and the closing notice went up that night. The next week, *Eugenia* was put out of its misery.

In the weeks following the closing the phone often rang in Hurley's tiny Greenwich Village apartment, and she was greeted by a smoky, "Hello, darling . . . I thought maybe you'd like to come up for dinner." The invitations were spur-of-the-moment, always for that very same night; Tallulah seemed to live day to day. Even on such brief notice, Hurley felt compelled to accept. She was sure that Tallulah was genuinely fond of her. Several years later, when she moved to California, Tallulah insisted on writing letters of introduction to power brokers in the film community. But the young actress felt her friendship with the legend sprang from Tallulah's need to keep empty time at bay, to keep herself from dwelling on how she had been stranded.

In New York they'd sit in the library of Tallulah's town house, eating dinner served on trays by a discreetly retiring cook. The fare was classic American and the amusement was television, which occupied a great deal of Tallulah's time. A year earlier, asked if television should be abolished, Tallulah had said, "No, but I wish it had never been invented. Thanks to it there are fifty unread books in my living room, to say nothing of ten unread plays." Her favorite shows were Dr. Baxter's Sunday afternoon discussions of the classics; *Meet the Press;* Edward R. Murrow's *See It Now; Kukla, Fran and Ollie;* as well as the Giants games. She also had a predilection for soap operas and game shows. Together Tallulah and Hurley tuned in to "To Tell the Truth," Tallulah bringing the full weight of her mental concentration to winnow out impostors from the real McCoy. Suddenly she'd sit bolt upright, jabbing her finger at the set. "He's the one! That one—remember that! Now that's the one I picked."

Other times, other evenings, they were joined by Tom Ellis, a mischievous young actor who had played Clifford Wentworth in *Eugenia*. On those nights, with Ellis escorting Hurley home, she would stay later. After Tallulah would send the cook home, she would plead with her guests to stay until she got into bed. Evenings dwindled into early morning, Tallulah becoming drunker and sadder, crying bitterly about growing old, invoking the memory of Will Bankhead as Hurley and Ellis helped her unsteadily to bed. "Look at me, Daddy!" she cried, just as she had fifty years earlier, cartwheeling to cajole her father out of his grief. Now the old cry for attention was a plea for commiseration. "Look at me, Daddy: I'm fifty-four years old. . . . *Look at me!*"

Tallulah grew less and less inclined to leave her home. When Miles White, who had designed the costumes for the film *Around the World in 80 Days,* arranged for Tallulah to see it, she found watching the epic not only a pleasure but a relief. Unable to imagine any better film, she said felt she never had to go to see another movie.

White spent a lot of time with her that spring; Tallulah asked him to design several gowns for an upcoming appearance at the Café de Paris in London, where she had been invited to bring her nightclub act for a five-week run. One of London's toniest nightspots for years, the café had been the site of a 1927 charity benefit, an evening of cabaret, which Tallulah had organized. In 1955, she'd turned down an offer to return to share a bill with Dietrich, saying she couldn't bear her beloved Maltese Dolores being quarantined for six months. (Perhaps Tallulah knew enough not to risk her friendship with Dietrich by sharing a nightclub stage.)

Now, to return to London in the highest style, Tallulah commissioned White to forge a new diamond necklace from some of her old pieces. Together they went to Tallulah's vault. There were "nice 1920s bracelets," White recalled, "a brooch, a few big-sized diamonds," tributes from past admirers whose generosity Tallulah credited as she prepared to melt them down into a parure she hoped would dazzle the city she had once captivated.

She opened in London on May 27 before an audience that included Adlai Stevenson. A recording of her opening performance survives. She shares a song, "I've Heard a Lot About You," with the gentlemen of the chorus, delivers a funny and raffish monologue, performs Parker's "The Waltz," and does some more crooning.

It was the custom for nightclub entertainers to disappear up the café's great stairway at the end of their act, then descend again to take more bows

if the applause warranted. But with emphysema dogging Tallulah, she told the audience, "Well, darlings, you can give me a big hand now, 'cause I'm not going all the way up there and down again."

During her last week's run, Ward Morehouse came from New York to review Tallulah. At midnight, she appeared at the head of the café stairs in a royal blue gown, long white kid gloves, and her new necklace. Her physical plight became grist for repartee. "God, that everlasting stairway!" she quipped once she had managed to descend.

"I was once quite the rage in England," she mentioned during her patter, "and had dukes and earls and princes running after me." As "a delighted roar" rose from a corner, she paused, looked toward it, and said: "Maybe you, dahling, were one of them." Shortly after Tallulah returned to the U.S., the Café de Paris closed for good. "The Germans blitzed it twice during the war," Tallulah said to her friend David Herbert, "but it took me to close it."

Tallulah may have been incapable of sustained effort on Broadway, but she could still deliver brilliant performances of short duration. Her agent Phil Weltman found many bookings for her on television, although communicating with his client was increasingly a challenge. "It got to the point where I told the maid, 'Look, don't have her call me in the afternoon because I don't understand what she's saying.' "

Dubs survive of several of her television appearances that year. The May 12, 1957, *Steve Allen Show* can be viewed at the Library of Congress. In the first of two skits she performs, Tallulah and a man keep trying to postpone getting out of an elevator so that they can pick each other up. In the second skit, she ventures for the first time into an automat. "Well, I don't care what the rules of this establishment are, I will not put my mouth under that spigot!" she rants when directed to a coffee spout by an invisible waiter. She is hilarious, yet there is something almost forlorn about her characterization, someone so bewildered and nonplussed by the most pedestrian demands of mechanized existence. In both sketches, Tallulah maps out an intricate infrastructure of facial reactions and vocal transitions known only to great comic virtuosos. Unlike her work in *Eugenia,* her diction here is impeccable.

Tallulah found television just as trying as Broadway, however. "I'd rather go over Niagara in a barrel. The chaos that precedes a single TV appearance—if you're lucky you may have three days of rehearsals—the clutter and confusion with which the star must contend leaves her numb."

In December, she was the guest star on "The Celebrity Next Door," the second Lucille Ball–Desi Arnaz show, an episode now available on com-

mercial video. The story line has Tallulah renting a house next to the Ricardos in Westport. For a dramatic presentation by the local PTA, Tallulah agrees to sound the jeremiads of a storm-tossed Renaissance queen. After a falling-out between the two madcap women, Lucy sabotages Tallulah's histrionics mercilessly. But Tallulah forgives her, and suggests that they incorporate all of Lucy's scene-stealing antics and turn the playlet into a satire. "You don't know what I'll do for a laugh!" Tallulah explains.

Because of the show's monthly broadcast, Tallulah actually had an extra day to rehearse, but she was unable to avail herself of the luxury, for according to various biographies of Ball, Tallulah was fully conscious only one hour out of their rehearsal days. Nonetheless, she mustered herself for the live filming, performing with so much assurance that Ball wondered if Tallulah had spent the week lulling her into a false sense of complacency. No one could ever steal a scene from either comic talent, and the two play off each other superbly.

On December 28, Tallulah made her second of two appearances that year on *The Arthur Murray Party,* dancing a waltz with Rod Alexander, who with his wife, Bambi Linn, formed one of the most popular ballroom teams of the day. (The episode is preserved in a kinescope at the Library of Performing Arts in New York.) Tallulah plunges into their ballroom adagio with an abandon that precludes any thought of the physical infirmities she was experiencing, bringing an ardor to the various falls and swoons that makes this pas de deux as affecting as any dramatic performance by her that can still be seen today.

Halloween Madness

"I went home to Alabama not long ago and found some of my relatives to still be racist Dixiecrats, and I loathe them, too."

T allulah continued her fraught existence on Sixty-second Street. In February 1958, she developed a high fever that alarmed Dr. Rodgers, who remained her personal physician, so much that he had her checked into Lenox Hill hospital. In July, she cut her arm on a lamp, necessitating five stitches. She was about to begin a tour of a mystery play by George Batson entitled *House on the Rocks,* in which she was to play Alexandra, the reclusive chatelaine of a mansion on the upper Hudson River. It was a revision of Batson's earlier play *Celia,* which Jessie Royce Landis had tried out at the Bucks County Playhouse in the summer of 1953, to reviews insufficiently encouraging to warrant a Broadway production. Tallulah was returning to the comedy-mystery genre for the first time since 1924's *The Creaking Chair,* and again the possibility was entertained that the play would go on to Broadway.

Both Batson and the director, Arthur Sircom, were experienced but not first rank. Sircom had been resident director at Cape Playhouse in Dennis, where he directed many stars, undoubtedly perfecting the tactics of accommodation. "He concentrated on making her look good," cast member Joseph Campanella recalled in 1994. "He would give her all kinds

of leeway." Campanella played the red-herring villain. Under thirty, Campanella was thrilled at the prospect of working with Tallulah. Warren Kemmerling played the detective, a former lover of Tallulah's Alexandra, who turns out to be the real killer. Kemmerling was in his thirties, with extensive experience in Broadway musical comedy, and he, too, had eagerly anticipated working with Tallulah. Unlike Campanella, however, he found her behavior appalling and told her so. In his recollection, Tallulah was sober "off and on" during rehearsals, and after about a week, Sircom realized that directing her "was a lost cause. She took a little blocking and that was about it."

They opened an eight-week tour at the Tappan Zee Playhouse in Nyack, where Helen Hayes invited several members of the cast over to her home. Kemmerling, who'd started to clash with Tallulah during rehearsals, saw her prepare to wash down four pills with a slug of liquor. "What are you doing?" he said. "You don't need the goddamn things." After she told him this was none of his business, he tried again, but she refused to answer him. Kemmerling knew firsthand how potent her narcotics were: once when they'd had two days off between performances and he was suffering with flu, Tallulah had given him a sleeping pill that knocked him out cold for eighteen hours.

She asked him whether he would have appeared on *The Big Show* had he been asked. "I doubt it." The conversation came around to "May the Good Lord Bless and Keep You," with which Tallulah and her guest stars signed off each episode. He told her, "Nobody could do it as badly as you did and still have come off as well as you did. You were fucking awful!"

Campanella was much less critical; he found himself bewitched by a moment in *House on the Rocks* in which Alexandra, who had been a nightclub singer, listened nostalgically to a recording she had once made. The performance used was Tallulah singing a torch song that sounded as though it had been recorded privately at a party. Melancholy, yet resilient and erotic, it suited her exactly. "I'm sure she was touched by it, too," Campanella recalled. "There was something about it that reached her. It was perfect in the play."

"She *was* marvelous, as an actress," said Kemmerling, even if their animosity carried over onstage. During one scene he was across the stage from her, recollecting their mutual past. She was supposed to be sitting stage left listening. At one performance, however, she got up and started arranging flowers. He went over to her, throwing in an "Oh, my dear" as he steered her back to the couch, then directed the rest of their dialogue sit-

ting next to her. Sotto voce he told Tallulah, "You don't arrange fucking flowers for me, honey!"

"Those eyes of hers would look right into you," Campanella said. "It was Tallulah but it was the character, too." Her behavior in the wings belied the shibboleth that Tallulah did no preparation before going onstage. She watched the action onstage so that a couple of seconds before she walked on she was already in the scene. "In every way, shape, or form she was a professional," Kemmerling noted, "up to the point where her ego got in the way." They had a climactic struggle at the end of the play, scrambling up the set's grand staircase, where Tallulah was supposed to push Kemmerling out a window. Immersed in the scene's *Sturm und Drang*, knowing exactly how to engineer the fight so that it would be most effective, Tallulah was nonetheless too frail to protect herself from her own exertions. She struggled so vehemently Kemmerling thought he was going to hurt her; he was forced to devise a way to go out the window on his own.

After a week in Detroit, they spent half a day traveling by bus to Warren, Ohio, where they were booked at a well-known summer theater managed by John Kenley, whom Tallulah had known when he was working for the Shuberts during the 1930s. Tallulah drank throughout the trip. When they pulled up to the theater, stage manager Ed Strum saw Kenley standing with a clutch of journalists and television cameras. Running to the door of the bus, he pulled Kenley inside and showed him Tallulah. Kenley ordered the driver to pull away, and they fled the parking lot to return only after the press had dispersed.

A technical rehearsal was in progress that night at eleven when Tallulah arrived at the theater and weaved up to the stage. "Where are the footlights?" she demanded. It turned out they had not yet been installed. Turning to the head carpenter, Tallulah said, "You fucking stagehands know how to make an old cunt look good. Get me the footlights!" The theater's summer apprentices "almost went flying into the night," Kenley's production associate Leslie Cutler remembered. "Miss Bankhead," Kenley intoned from the back of the theater, "we do not use that language in my theater."

Tallulah spun around. "Shut up, you big faggot!"

"I am *not* a faggot!" Kenley insisted. "Well, *I* am," Tallulah camped. As their hostilities escalated, "a terrible scene" ensued, recalled stage manager Ed Strum. The horrors were only beginning.

Shortly before noon on the first matinee day of the week, Tallulah's companion Don Torillo came running to Strum's room after having tried

unsuccessfully to wake Tallulah. Strum went to her rooms, then called Kemmerling, as someone went out for ice. Filling the bathtub, they dumped Tallulah into it. After an hour, she was still unconscious. They walked her around her rooms.

The parking lot was packed with buses conveying theater parties from all over the region. Kenley could not afford to refund the audience's tickets; he was not about to cancel the performance. Calling his doctor, he had coffee poured into Tallulah until they got her to the theater. Kenley's doctor administered vitamin B_1.

After the curtain had been held an hour, Tallulah finally made it to the stage on her hands and knees. Strum warned the stagehands to be ready to bring the curtain down should some disaster occur. Tallulah got to her feet. "Are you okay, Madam?" Strum asked.

"Yeees," rumbled out of Tallulah.

"We're going to do this fuckin' play." Strum impressed upon her that she was playing to a sold-out house of several thousand. "Yeees," Tallulah croaked in assent. For the first two-and-a-half acts, until she went to the top of the stairs for her climactic struggle with Kemmerling, Tallulah moved minimally. Although she spoke the lines with complete accuracy, she read them in a disembodied, exhausted voice, and she read at such a snail's pace that the performance ran about a half hour overtime. The audience watched in disbelieving silence.

The more Tallulah drank, the less she ate, and at this point in her life she was seriously malnourished. When Kenley went to visit her later in the week, he threatened to leave if she didn't eat something. As she swallowed a little of the consommé that he ordered in, Kenley scolded her. "God once gave a woman all the beauty in the world and all the brains. He'll never do it again, because of you, Tallulah."

Along with director Sircom, Batson, who was thrilled that Tallulah was starring in his play, joined up with the show intermittently. Yet the playwright didn't seem interested in rewrites or any of the usual pre-Broadway attention. *House on the Rocks* was a dead end, and Tallulah knew it. "Oh, Joseph, this is *not* going to Broadway, you know that," she told Campanella.

At the end of the summer, Gertrude Macy, Katharine Cornell's longterm producing associate, sent Tallulah a new black comedy by a young writer, James Leo Herlihy. *Crazy October* was based on Herlihy's short story "The Sleep of Baby Filbertson." He was also going to direct his play. Earlier in 1958, *Blue Denim*, a comedy/drama of adolescent angst Herlihy had written with William Noble, had been well received on Broadway.

Tallulah said she wouldn't do *Crazy October* without Ed Strum. The stage manager had grown attached to Tallulah despite his harrowing summer with her, and he agreed immediately. A brave departure from her customary realm of sophistication and glamour, the role was absolutely right for her. Once more she was playing a woman of ingot-bending tenacity from down south, but this time she was going to flout that cardinal taboo of a Southern belle and turn "common." Her character was Daisy Filbertson, the blowsy proprietress of a roadside dive in West Virginia who scraped out a living with the same ferocity with which her neighbors gouged coal from the earth. Like Tallulah, Daisy wouldn't scruple to use any manipulative wile at her disposal, running the gamut from terror to seduction. Paid by Miz Cotton, the grieving widow of a miner, to bury her husband, Daisy interred him in a parking lot, then dug up his skeleton when an interstate was run through it. Gulling the bereaved woman into believing that she owed her money for the interment, she forced the widow's daughter, Dorrie, to work off the extorted debt. So had she also manipulated her adult son until he was almost infantilized. The play was as dependent on mood as on action, and what plot there was centered on a last-gasp Halloween party that Daisy throws to drum up business at the inn, and the worm-turning rebellion of her son, who helps finagle an elopement between Dorrie and a drifter named Boyd.

At Tallulah's urging, Estelle Winwood returned to the U.S. to play the widow, although she was too old for the part. Winwood had been working in England, where she had just completed the film *Alive and Kicking,* acting with fellow septuagenarian Sybil Thorndike. Strum suspected Tallulah wanted Winwood there as a companion.

Meanwhile, Eugenia Bankhead's wanderlust was now taking her to Morocco, where she would spend a great deal of the next few years. Tallulah's old friend David Herbert had been living in Tangier for a decade. Tallulah wrote to him asking him to look after her sister, warning him that she would "take a lot of looking after and wear you to death." Before leaving for Morocco, Eugenia tried to effect a reconciliation between Tallulah and Stephan Cole, bringing him unannounced to the town house. Opening her door, Tallulah said, "You are not welcome in this house." The next day she called him to apologize, asking if he'd please come back to visit.

"Tallulah," he said, "I really don't want to."

"Let's be friendly like the old days," she pleaded through tears. After reminding her that those days were gone, Cole agreed to return for a visit. The next day, he came back with a friend, who talked with Estelle, Euge-

nia, and Louisa Carpenter in Tallulah's drawing room while Cole took his place at the foot of Tallulah's bed. She asked him all about his life, then read him the entire script of *Crazy October,* playing all the parts. She was looking forward to the first proletariat role she had created since they had done *Clash by Night* together seventeen years earlier. The visit stretched on until six in the morning. Now forty-four, running a flower shop at the Sherry-Netherland Hotel in New York, Cole was unable to be what Tallulah wanted: "a fixture in her life."

Fast becoming a fixture in Tallulah's life was author Herlihy. Herlihy "was charismatic, and knew it," Strum recalled. Thirty-one, tall, handsome, playful, he was very much "on." Yet beneath his high-key persona, Strum sensed a real vulnerability and love for the theater. Another William Inge, Strum wondered, a new Tennessee Williams?

Tallulah trusted and loved the writer, and her dedication to his play was a far cry from her approach to *House on the Rocks.* Before rehearsals began, Strum, Herlihy, and Tallulah met frequently at her house to discuss the play. Tallulah "really wanted to be and convey the character Jamie had written," Strum recalled, she wanted to get under the skin of this battered but indomitable woman. She was all ears and all eagerness, listening with an intensity Strum had seen only a few times before, when Tallulah had asked Strum about his childhood. At times her head would crane forward as she lapsed into a responsive silence as powerful as her usual battery of words. Other times she plied Herlihy with questions about her character's motivation and history.

Alvin Colt, a leading costume designer since *On the Town* in 1945, was hired to design *Crazy October.* One day finding himself in Tallulah's drawing room—a sea of beige and ecru at twilight—he listened as she told him there would be no Mainbocher gowns in *this.* "I'm not going to look like Tallulah at all," the woman said of the institution. "No one's ever going to have seen Tallulah looking like this." That meant a pair of honky-tonk wedgie shoes she'd found, and "skins," the word she invented for panty hose, which had just come on the market.

Colt talked about wraparound Hoover aprons for Daisy to wear at work, with perhaps a long-sleeved sweater underneath to protect against drafts in her dilapidated roadhouse. Perhaps a *red* Hoover apron, he suggested. "Oh, put me in red, darling," Tallulah cried, "no one will look at anybody else on the stage!" There would be two aprons, one wine, one green.

The second-act Halloween party gave Colt the most latitude. What

masquerade to put her in . . . what character to make her? He decided upon the most unlikely: she would be dressed as an angel. As all costumes were ostensibly homemade, Daisy's robes were improvised from a long-sleeved nightgown, "not a Tallulah nightgown," but a negligee bought at Sears, and adorned with jewelry fashioned from leftover Christmas tree tinsel. To top it all off, there would be wings made out of wire coat hangers, with the hooks left on them. Tallulah burst into laughter when saw his sketch. "She liked it so much that she put a line in the play: 'I made these wings myself; I made them out of wire coat hangers.'"

Macy was producing *Crazy October* in association with Walter Starcke, a protégé of John van Druten. Macy and Starcke had already coproduced two plays written by van Druten. They were having trouble casting the role of Thelma, a middle-aged belle perpetually nursing her wounded pride after episodes of loving well but not wisely. Strum had recommended his friend Joan Blondell.

During their first day's rehearsal at the Belasco in New York, Tallulah pulled Blondell into her dressing room. "Joan, I'm going to wear my hair this way. What are you going to do with *yours*?" She grabbed a hank of Blondell's hair for emphasis.

At the end of the day, Blondell took Strum aside and told him he was going out for a drink with her. Was she going to become dead meat, the latest target for Tallulah's free-floating hostilities? Could she get out of this contract? Strum assured her that this was just Tallulah's normal behavior, her way of showing Blondell that she loved her.

The two stars did quickly become good friends. Tallulah respected Blondell's theater experience, and she was easy to like. "Mother Earth" Strum called her. "If you met her, in two minutes you'd be telling her your life story." Both actresses cherished their experiences with playwright/director George Kelly, for whom Blondell had starred as a Broadway ingenue in 1929's *Maggie the Magnificent*.

Blondell was very close to her two children, Norman and Ellen Powell, as well as her stepson Mike Todd Jr. and her grandchildren. Her luck with her husbands was less than stellar; June Allyson had walked off with Dick Powell, her second husband. Her third, Mike Todd, used Blondell's money for his exploits, leaving her penniless. Still, Blondell was a strong woman who liked herself, and considered herself very attractive at age fifty-two. And indeed she was.

During the weeks of preproduction, an overriding anxiety had preoccupied Starcke and Macy: Tallulah's ability to keep her drinking under

control. Yet rehearsals, however, were propitious, with Tallulah embodying "truly the ideal of what theater could and should be." Tallulah's chores on-stage were plentiful: there were pots of coffee to be made, Coke bottles to be pried open, ice cream sodas to be blended. Strum knew that mechanical props could unnerve her. He told Macy and Starcke they would all save themselves a lot of tribulation by hiring the propman a couple of weeks earlier than usual. Plunk went Tallulah's little finger on the keys of Daisy's cash register, out shot the big bad drawer, and Tallulah recoiled as if from an electric shock. But she persevered. "She was very worried about rehearsing with the props and getting them right," assistant stage manager Joe Ponazecki recalled, but she finally grew comfortable with each appliance.

Coming as it did on the heels of those rehearsals, it was that much more disheartening that the premiere in New Haven was "one of the most horrific openings" that Strum had ever experienced. The process is a rocky one, whether it's a musical with thirty sets or a kitchen-bound domestic drama, as the actors find their stage legs. "They're holding a teapot in their hand and they think they've got a baby without its head," or they don't seem to realize there is going to be a door where before, in rehearsal, there had only been a chalk outline.

When Tallulah's stairs materialized at the dress rehearsal, they proved an insuperable obstacle. She couldn't walk up them, let alone be carried up them as she was supposed to be at the end of the second act. Designer Ben Edwards, who had been her apprentice in Marblehead, Massachusetts, for *Her Cardboard Lover* in 1941, kept reassuring Tallulah that she could do it. "After all, they were just stairs, they weren't nine-inch risers." An hour or so was wasted. "Everybody was involved, stagehands standing in the wings, time going by, overtime."

But actor J. Frank Lucas said that the stairs were indeed too steep, and it was he who had to carry Tallulah up them. Moreover, from the top of the stairs, where they performed one scene, they were out of view of patrons at the back of the balcony. Yet another reason Tallulah couldn't navigate the stairs, according to Strum, was that her insecurities had led her to hit the bottle. He had seen it many times: actors assuming that one little glass of bourbon would give them the courage to face down their nerves, when it was exactly the kind of stimulation they didn't need. Strum suspected that Rose Riley had brought a bottle to Tallulah as she waited in an "escape" perch behind the set. His suspicions were corroborated as Tallulah began slurring Herlihy's words, until Herlihy erupted, "Get the fuck out of here!"

and Tallulah stormed off. "We never, ever finished dress rehearsal," Strum sighed. After an effusive reconciliation between Tallulah and Herlihy, the cast opened cold the following night, October 8, 1958.

They played the first act to bewildered silence. The audience was not laughing; they were not sure they were *supposed* to be laughing. The act ended with Tallulah preparing for the Halloween festivities by lowering a skeleton from the balcony of the Blue Note, which is later revealed to be the remains of widow Miz Cotton's husband. It was meant to be a big "boffo" laugh, a crescendo to bring the act to a rousing close. But the gag elicited silence, and the curtain came down to barely polite applause. Tallulah stole back to her dressing room; the rest of the cast milled around onstage, dazed. Blondell looked around at the cast and said, "Well, kids, don't send your laundry out."

The audience seemed to be expecting an evening closer to Tallulah's more habitual arena of drawing room hilarity, another *Dear Charles* or *Private Lives*. But *Crazy October* was something else altogether, and Tallulah was giving a different performance than her audience had come to expect. "Tallulah had worked so hard to discipline herself so that she could carry out the intentions and purpose of the play," Strum recalled. "Everyone in the cast was working toward that aim." Perhaps an explanatory note like the one Richard Maney had provided with *The Skin of Our Teeth* would have helped, or the more venturesome public of the next decade; it was in 1969 that Herlihy achieved his greatest success, with the film of his novel *Midnight Cowboy*.

Designer Edwards had used myriad shades of umber and tan for Daisy's Blue Note Inn, to convey walls and surfaces soiled by years of smoke and grease. After the notices, the producers decided that the set was too somber to serve as a backdrop for comedy. Edwards threw up his hands and walked out, and a crew of scene painters sloshed on a washed-out blue. "Terrible," Strum called the blanket of sludge that "took the character out of the play, the performers, and the performances." But the cast's J. Frank Lucas, however, felt that the overhaul was justified. What Strum found marvelously atmospheric he found simply depressing, with "no particular character for Southern gothic."

Crazy October was also Herlihy's first stab at directing, and Lucas felt that he was not the right director for his own play. "It was his baby. He couldn't see what was wrong with it. He would go out and watch the show with the audience and not get a clue why this thing wasn't working."

From New Haven they went to Washington. Herlihy was in Tallulah's

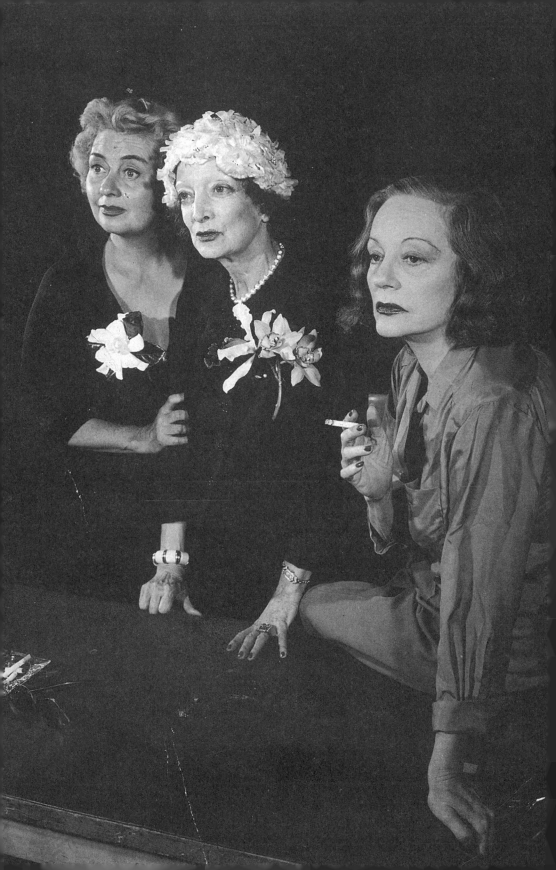

dressing room when Cal Schuman, a friend of Tallulah's from Baltimore, came back after a performance.

"Well?" Tallulah demanded.

"I think it's an avant-garde camp," Schuman told her.

"Did you hear that, darling?" Tallulah asked Herlihy. "He thinks it's an avant-garde camp, and everybody doesn't quite get it!"

Strum had noticed in Tallulah's suite drugstore bills for rolls and rolls of three-inch adhesive tape. It turned out Rose was taping Tallulah's wrists together at night to prevent her from taking more pills during her frequent intervals of wakefulness. In Washington Tallulah, Blondell, and Starcke were staying at a small, chic hotel, while Strum's digs were less expensive. After leaving a small party Blondell had given in her suite, Strum found himself waiting and waiting for an elevator. Finally, the doors swung open: standing before him was a Tallulah even he had never quite seen before— "a wild woman, like a caged chimp." Straggle-haired, barely wrapped in a thin robe, she flailed at the walls, sputtering "Where am I?"

"Madam! What are you *doing?*" Strum asked. "Why are you in this elevator without any clothes on? It's two o'clock in the morning."

Tallulah seemed to be searching for Herlihy or Starcke. "I've got the most wonderful idea for a rewrite." She had managed to claw the tape off her wrists and stagger out, while Rose slept soundly. Jabbing at all the elevator buttons, Tallulah kept the car opening on one unfamiliar floor after another.

When Strum took Tallulah back to her suite, they discovered Dolores, her Maltese, yapping furiously. She had fallen behind the headboard of Tallulah's bed and trapped herself. Strum woke up Rose and liberated Dolores. Tallulah was taped back into bed, Strum went on his way, and that evening belatedly came to a close.

In Washington, a considerably more composed Tallulah also spoke at several Democratic luncheons, one of which was attended by the Trumans and Eleanor Roosevelt. Tallulah did a lot of Republican bashing, calling Vice President Nixon "a dangerous man" and saying she loathed Dixiecrat Governor Orval Faubus of Arkansas as well. She didn't hesitate to point the finger closer to home: "I went down to Alabama not long ago and found some of my relatives to still be racist Dixiecrats, and I loathe them, too."

After the first week of the two-week Washington run, the producers announced that they were not going to bring *Crazy October* to Broadway. By telephone, Tallulah expressed her regret to the *New York Post*. "It rather

Joan Blondell, Estelle Winwood, and Tallulah rehearsing *Crazy October,* 1958.

baffles the audience. . . . I think in Europe it would be a success. They dig that kind of thing.

"Everyone put a lot of heart into it," she said. "And heart is about the only thing we have, isn't it, darling? Not brain. If that's all we had I'd have cut my throat long ago." Putting the show on two-week hiatus while Herlihy did some rewriting, the producers decided to try again in Detroit on November 10.

From Detroit, they boarded a train to Los Angeles. After they'd gotten under way, Strum came around to alert the cast that Tallulah was still smashed from the prior evening's revelries. In fact, she intended to stay smashed the entire train ride to the West Coast. Twice Strum brought Lucas down to sit with her. For the first time Lucas saw how Tallulah drunk meant an uninterrupted monologue that brooked no response. After an hour, Lucas's arm was sore from her grip on his wrist and his soul chilled by her frenzied, fearful chatter.

Crazy October opened a three-and-a-half-week run in Los Angeles with the biggest advance sale since Helen Hayes's revival of James Barrie's *What Every Woman Knows* in 1954. The stars flocked to Tallulah's first Los Angeles stage appearance in three years. Yet Lucas felt a resistance, a "show me" chill from the house, although Joan Crawford, Alfred Hitchcock, and Lucille Ball trooped backstage to see the play's stars and then gathered for a champagne reception in the lobby.

Tallulah and Don Torillo had just broken up, and her relationship with Rose Riley was finally beginning to unravel. In Los Angeles she invited Ted Hook, a dancer who had been in the chorus at the Sands Hotel with her, to become her secretary/companion. Now Hook stood guard outside her dressing room door, announcing visitors. John Emery identified himself. "John, darling!" Tallulah bleated from inside.

Emery marched over to her: "I was married to that old bag! How are ya?" he said, sweeping her into his arms, up the twelve inches it took to bring them eye to eye.

Onstage, Tallulah's anxiety over the play had led her to seek refuge in the safety of her tried-and-true theatrical trademarks. But they did not overpower her performance as they had *Eugenia*. Lucas thought Tallulah was doing to a great extent what the part and the play required. "She played it, shall we say—common. She was not a congressman's daughter here." Nothing she did onstage matched her rehearsals, as far as Strum was concerned. Yes, she maintained her characterization, but it wasn't as focused; nothing equaled what she had done in rehearsal.

When Strum arrived at the theater at 7:00 P.M the stage was still dark, lit only by a single work light. Tallulah, Rose, and the doorman were the only people present, and Tallulah was already fully made up. She sometimes asked him about the performance, and there was enough concern in her voice that he felt he could gently criticize. "I think the intention here was not what you were doing. It doesn't matter if you don't get a laugh there. It's okay to sacrifice."

"Oh, yes, I see what you mean." Tallulah nodded.

"There's a subtext here that has been discussed that you're not paying attention to," he told her about a fine point which had gotten lost. Tallulah was responsive.

But the constant attention that Tallulah and the play needed were beyond Herlihy's staying power. "I think I just gave up," he recalled to Strum when they talked shortly before Herlihy's death in 1993.

Strum was impressed by Tallulah's emotional commitment onstage: "She gave you eyeball to eyeball: contact, emotion, feeling. She would really dredge it up." Ponazecki remembered the pocket-size notebook Daisy kept by the cash register in which she could take down orders, scribble inventory. He looked it over and discovered that Tallulah was actually making the appropriate jottings that Daisy would have made.

Strum retained a copy of the script originally distributed by Starcke's office, but it was Ted Hook who for some reason wound up with Strum's own script. Hook let me read this script but not photocopy it. It was a patchwork of line changes and larger revisions in Strum's often illegible handwriting, so that it is difficult to say how the script evolved. The reviews of *Crazy October* did not improve, however. In the *San Francisco Examiner*, Charles Einstein wrote that the play had been "chased by saddened reviewers and not saddened audiences wherever it went. Along the line, Bankhead became more Bankhead, Blondell more and more Blondell, Winwood more and more Winwood," to the enhancement of its entertainment value. "They are completely wonderful on stage, to the point where the audience laughs not only at unfunny lines but, from time to time, even before the lines are delivered."

In San Francisco, Strum escorted Tallulah to a famous transvestite nightclub, Finocchio's, much to the vociferous delight of the performers, who dedicated their show to her. The next day they turned out in force for a matinee of *her* show. After the Christmas Eve performance, the cast peered through the curtains as Tallulah made an appeal for the Actors' Fund. In diamonds and a voluminous pink gown, she evoked *The Gold*

Diggers and 1926, hiking up her skirt and dancing a mad Charleston. After insisting that she wasn't giving any presents this year, Tallulah sent Ted Hook at the last minute to buy a dressing gown and a bottle of liquor for all the men in the cast and crew, and two cashmere sweaters for each woman.

Entertaining some of the cast in her hotel room, she sang two of her favorite songs a cappella: "Bye Bye Blackbird" and "Silent Night," which she intermingled with tears welling up in her eyes. *"Pack up all my cares and woe, Here I go, swinging low—Siiilent night, hooolly night . . ."*

On New Year's Eve, the company played a special matinee. Tallulah had been running a fever the night before, which had worsened by show-time. Lucas carried her up the stairs, depositing her in the offstage escape area. Tallulah was sweating profusely. Lucas ran to Strum, who came up and asked if they should put on her understudy for the next act. "No, no, no, Ed, you cannot do that," Tallulah insisted. "I've got to finish this performance. If you go out there and tell them I'm sick, everybody's going to hoot and howl. *Sick?* She just got drunk last night. She's hungover, that's all that's wrong with her."

In Los Angeles, Starcke had put out feelers to Preston Sturges about taking over as director. Sturges's film career was in eclipse, but he'd been trained on the stage, and his absurdist genius might have provided the ideal diagnostic tools to fix *Crazy October*. Unfortunately, Herlihy resisted being dismissed from his own project.

Business wasn't as good in San Francisco as it had been in Los Angeles. Macy and Starcke were feuding and, along with Herlihy, they went back to the East Coast. It wasn't long before they sent word that the plug was to be pulled for good this time.

In Retreat

"No curtain has ever been rung down on *me*!"

B y the time *Crazy October* gave its final performance in San Francisco on January 3, 1959, Tallulah seemed to have conceded defeat to her personal and professional demons. Returning with Ted Hook to Los Angeles, she taped an appearance on Milton Berle's TV show before heading back to her Manhattan town house. Rose Riley, who had worked in Tallulah's home and her dressing room on and off for twenty-five years, had determined to end her increasingly grim tour of duty. Since Tallulah couldn't bear to part with her entirely, she invented a job for Rose processing her expenses. Every month she sent checks up to Riley's apartment in the Bronx for her to sign, including one made out to Riley herself.

Later that January, Jean Dalrymple dedicated a gala evening to Tallulah at the City Center. The New York City Ballet danced, and the City Opera performed, while, in addition, Lotte Lenya sang excerpts from *The Threepenny Opera*. Mike Nichols and Elaine May performed a skit. Tallulah and Sandy Campbell reprised the young collector scene from *A Streetcar Named Desire*.

In April, an addled Tallulah testified before Congress to advocate a bill providing unemployment insurance for actors. The political appearance compared sadly with some of her earlier ones. "I haven't heard a bloody

word you've said," she told the committee, "so I don't know whether you're for us or agin' us."

Not long after that appearance, Jackie Gleason cited Tallulah as an example of performers with whom he wouldn't share a stage because they'd had curtains rung down on them when drunk. With her habits common knowledge throughout the profession, she had sunk to new lows in her most recent productions, yet she had always been able to perform, as she had in Ohio in *House on the Rocks* the preceding summer. "No curtain has ever been rung down on *me!*" she insisted to Ted Hook. "I'm not Jeanne Eagels," whose behavior at the end of her career had sometimes made such misfortune obligatory. Gleason's remark—hypocritical above all—so upset Tallulah that she remained in bed in for a week in a near-catatonic depression.

One night she once again fell, breaking several ribs. After she was checked into Flower Fifth Avenue Hospital, it was reported that she had entered for "a general checkup." Hook told reporters that Tallulah was simply getting herself a clean bill of health before her next venture in summer theater. It was true that she was thinking of working that summer, and had called up Ed Strum asking him to stage-manage. She was not well enough, however, to go on the road again in the summer.

The death of Billie Holiday that July affected Tallulah deeply, although they had been estranged for some years. Tallulah and Holiday had fallen out over Holiday's autobiography, *Lady Sings the Blues*. Holiday had tried repeatedly to reach Tallulah on the phone to tell her that she was mentioning her in her book. Unable to get through, she finally gave up. After a trip out of town, she returned to New York to discover that Tallulah had informed Doubleday that she wanted Holiday's mentions of their friendship omitted from the book. "I thought I was a friend of yours," Holiday wrote Tallulah in January 1956, shortly before the book went to print. "That's why there was nothing in my book that was unfriendly to you, unkind or libelous."

Friendship with Holiday had become too risky for some of her celebrated admirers. During the 1950s, for instance, Tallulah had attended a party thrown by Fran and Joe Bushkin, but when Holiday arrived she was in no condition to be guest of honor. But on the matter of *Lady Sings the Blues,* Holiday was as outraged by Tallulah's hypocrisy as Tallulah had been at Jackie Gleason's, for Tallulah's own behavior with Holiday had been anything but discreet. Holiday reminded Tallulah that if she wanted to embarrass her, she certainly could. Plenty of people could testify to Tallulah's

flagrantly amorous activities with Holiday's dressing room propped open, the times she "carried on so you almost got me fired" from the Strand Theatre in 1949. "And if you want to get shitty," Holiday taunted Tallulah, "we can make it a big shitty party. We can all get funky together."

Three years later, Holiday's tribulations had finally come to an end. During Holiday's last hospital stay, William Dufty, who had ghosted Holiday's autobiography, planted a news item about floral tributes from Lena Horne, Frank Sinatra, and Tallulah in order to shame the rich and famous who now avoided her. But Tallulah could not dismiss their relationship as cavalierly as she had the singer, however. Going to the Campbell's funeral home to pay her last respects, she was seen speaking to Holiday's remains by a friend to whom Tallulah later alluded to her relationship with the singer. She sent twelve dozen long-stemmed roses to the funeral.

The gregarious woman who feasted on the world's audience was now largely her own audience; the symbol of glamour spent most of her day in a dressing gown. Tallulah's routine remained unchanged during the almost four years she lived with Hook. She talked to friends on the phone and occasionally entertained. She didn't wake until late afternoon, after 3:00 P.M. After a bath, she'd watch two soap operas that she followed religiously, *The Edge of Night* and *The Secret Storm*. She sat down to dinner with Hook, not eating "enough to keep a bird alive." Then she'd watch the six- and seven-o'clock news shows. As an actress, she realized how much information was biased by the newscasters' delivery; if she didn't trust the reports, she liked the visuals. Usually she and Hook would talk until the ten- and eleven-o'clock news, followed by Jack Paar's talk show. At 1:00 A.M. she got back into bed and read until dawn or later. She told Hook that she always included passages from the Bible and her autobiography, "the two greatest books ever written!" When she slept, the radio was turned on for white noise, her personal sleep machine. But her sleep was always fitful, alternating with patches of wakefulness. Her loneliness flared in the watches of the night; sometimes she would summon Hook to her room, needing reassurance that she was loved.

Hook was gay, a fact that didn't necessarily deter Tallulah, but there was nothing sexual between them; he was more a conduit to the outside world that she increasingly shunned but remained acutely curious about. She lived vicariously through him. If he came home late, she'd call him into her room: "Well, darling, *tell!*"

"She'd want a *full* report of everything I had done, both in and out of

bedrooms, and bars, and you name it." She also wanted a scene-by-scene breakdown of every Broadway show he saw, although from time to time she accompanied him to movies at the local theater. On their cook's night out, Hook sometimes pleaded with her to go out to eat; eventually she would relent, groaning, "Oh, all right, darling, if we must."

Much of her reclusiveness had to do with her insecurity about her appearance. If someone on the street asked, "Aren't you Tallulah Bankhead?" her reply was, "I'm what's left of her, darling."

Often the strangers were actors, with whom Tallulah chatted graciously, but she was more interested when her admirers were from different professions altogether; in that case, she might very well extend an invitation to visit her home. As always, she was hungry for information. Similarly, on the occasions when Tallulah agreed to attend a party, Hook saw her deliberately eschew center stage. It seemed both a defense against having to make small talk and a sign of her exhaustion with her own compulsive need to be "on." She would buttonhole the most interesting guest and say, "Come over here, darling, let's talk."

One day she asked Hook to name the two people he'd most like to dine with; he told her Dorothy Parker and Truman Capote. It was arranged, and the four enjoyed dinner together at the town house. "The whole evening was totally outrageous," Hook recalled. Tallulah and her guests continued a round robin of quip and counterquip as if enacting a rerun of the Algonquin Round Table. "I would have given my soul to have had a tape."

While she continued to have assignations with some men at the town house, sex was not the consuming pastime it had been. "No one wants to be Mr. Bankhead," Tallulah said to Hook. "I'm just too much for a man."

Harvey Shain, an actor then in his early twenties, recalled taking her out occasionally during these years. He had met Tallulah a decade earlier when he was a child actor at a summer theater where she was appearing. There was no part for a child in *Private Lives,* and so instead he was assigned to be her valet. She took him under her wing: "She just thought I was like the kid she wanted to have." One day he barged into her dressing room with her mail and found her on the couch in a romantic clinch with a female stage manager. Tallulah threw something and yelled, "Get the fuck out of here!" "You're going to grow up very fast," she subsequently told him, and proceeded to explain some of the facts of life.

She would call him and his parents once every several years, until he found himself as a young adult tapped to be an escort. She took him to a

gallery opening of an exhibit of Cubist painters. They went to a couple of small parties. But mostly they went out to dinner, and sometimes danced. By Tallulah's choice they never went to high-profile places, but instead neighborhood restaurants in the theater district or, since Shain owned a car, in the suburbs. Invariably he'd have to fight to pay the check. She trudged to his walk-up apartment once because he wanted to show her his new espresso machine. She suggested scenes for him to study and he read for her. She reminded him of all the reasons that rejection in the theater might have nothing to do with lack of talent.

"Is David Merrick gay?" he asked her.

"Yes!"

"He wants me to go to Philadelphia with him."

"You have to make up your own mind about those kinds of things."

Sometimes when he picked her up she looked as if she had been crying. Sometimes he thought she was drugged: her eyes were glassy and she was melancholy, but she hadn't had a drink. But over dinner Tallulah invariably became a little tipsy. After several dates, "she started to turn me on: the sensuality that she had," he recalled in 1995. Driving back from a restaurant on Route 4 in New Jersey, Tallulah was a little high when she asked, "Do I attract you? Would you make love to me?" "Sure, yes," he said, and giggled. On later occasions they sometimes kissed, but according to him, that was as far as it went.

Tallulah wasn't looking to act again on Broadway unless offered something too good to pass up. She told Hook that she hated reading scripts because she didn't think she could tell from the printed page what the theatrical possibilities might be. "I usually make the wrong choices," she would tell John Kobal in 1964. "Now, I won't say I know a very great play when I see one, although I read avidly, and I think I read good books."

Tallulah delegated Hook as her gatekeeper. Early in 1960, she received a new script by Mary Chase, author of the immortal comic fantasy *Harvey*. Chase's *Midgie Purvis* chronicled the escapades of a middle-aged matron who has spent her life as a free spirit. Her soon-to-be-married son chastens her for her high jinks and tells her to act her age. She takes a flier, disguising herself as an elderly babysitter, and discovers simulated old age more fun than the transitions of middle age. "I just flipped over it," Hook recalled. "I ran downstairs in the middle of the night to tell her about it."

"I think it's the only part I've ever had to characterize," Tallulah later told the *New York Herald Tribune*. While that was an exaggeration, she was

certainly aware of the acclaim that could accrue from a dual role requiring her to spend most of her performance radically disguised.

If Tallulah found the depredations of age torturous to watch, she may have been attracted to the script's tacit embrace of the freedoms of maturity over a compulsion to retain one's youth. Her character's escapades with the three siblings for whom she babysits surely appealed to Tallulah's frustration at not being able to bear children after her hysterectomy. She told Hook that she would have gone ahead and had children out of wedlock, would the stigma not have harmed her career as well as hurt her family. "I wouldn't have minded having illegitimate children," she had told a reporter in 1957, "but, you see, I had relatives in politics."

With *Midgie Purvis,* Tallulah once again saw the possibilities of a great performance. She told producers Robert Fryer and Lawrence Carr, who were then riding high, that *Midgie's* gentle whimsy would show another facet of her that the public didn't know. Concerned that her trademark mannerisms had hampered her ability to act, she sought "a strong director with a discerning eye, someone who won't let me fall into tricks."

José Ferrer met with Tallulah's approval; not only was he one of the leading actors of the day, he had directed several major hits on Broadway over the past decade. She told Ferrer that she understood the character, and knew she could portray her accurately without resorting to reprising trademark Tallulahisms. "Don't let me be strong," she told him. "You be strong, I don't want a director who's going to say yes to everything I decide to do."

Tallulah had a history with Mary Chase, who had originally wanted her as the lead in her comedy *Harvey,* about a woman with an imaginary friend. Tallulah wasn't available at the time, and the premise changed en route to Broadway in 1944: the woman became a man, and the friend an invisible rabbit. During *The Big Show,* Chase had offered Tallulah the lead in another comic fantasy, *Mrs. McThing,* but Tallulah couldn't see herself in a role that Helen Hayes went on to play, a matron who learns to appreciate her unruly son after a witch turns him into an impeccably behaved automaton.

The germination of *Midgie* came one day when Chase noticed her college-student son's unguarded face reflected in a store window as they walked together and realized that he wanted to be away from her and with his friends. "The boy was a man," she had thought. "His mother was out of a job." She sat down to write *Midgie Purvis* as yet another vehicle for Tallulah, putting into Midgie's mouth her own feelings about how parents

should enter their children's own world and cherish their children's all-too-fleeting youth.

Tallulah signed for *Midgie Purvis* in March, committing herself to the play for two years following its Broadway opening. There is no question that she saw this as a valedictory vehicle. Time was running out; she was not yet being treated for emphysema, but she was already experiencing symptoms. With an eye toward *Midgie Purvis,* she retained nurse Anne Sargeant to travel with her on tour. Tallulah had been an intermittent patient of Sargeant's for two years, since she'd been hospitalized after falling in her bedroom and breaking several ribs. Sargeant tried valiantly to reduce Tallulah's drug addiction. "Tallulah you don't need this," she would say. "Anne, I do!" "But no you don't."

Chase became a frequent visitor to the house on Sixty-second Street before the play began rehearsals. She had much to say about the script and character, having based Midgie's experiences on her own. "Mary really was Midgie," Hook said. Rehearsals were scheduled to begin at the end of May, after which they would embark on a long tryout tour to the West Coast, dropping anchor at the Lyceum in October.

When booking difficulties and the possibility of a strike by Actors' Equity delayed rehearsals until August, Tallulah returned to the "straw hat" circuit of summer theaters, starring in a revival of George Kelly's *Craig's Wife,* which had received the Pulitzer Prize in 1925. A supremely assured demonstration of the well-carpentered play of the 1920s, *Craig's Wife* was a better play than Kelly's *Reflected Glory,* in which Tallulah had starred in 1936. The tale of a woman who drives everyone around her away from the sterile retreat she makes of her home in a small city remains a fascinating study in compulsive behavior bordering on the pathological—only slightly exaggerated from the societal ideal of woman's proper forum, as it existed at the time.

Kelly visited on Sixty-second Street, thrilled by Tallulah doing his play. He read the entire script aloud to her and gave her some tips on the role. The director was going to be Ron Winston, a young man whose experience had been in television and who later went on to films. They began the run in Nyack during the first week of July, opening the Tappan Zee Playhouse season. Nancy Kelly, Sylvia Sidney, and Helen Hayes were in the audience. "The play is unimportant," wrote the *Bergen Daily Record.* "The fact is that Tallulah was there. For all the theater buffs cared, she could have been Goldilocks or Mrs. Wiggs of the cabbage patch."

Amiable and well-meaning, Winston was too awestruck to be fully effective with Tallulah. She turned to Hook for advice as to whether she was speaking clearly enough. Most of Kelly's dialogue in *Craig's Wife* is beautifully honed and paced, but he included gobs of small talk to establish the rhythm of his particular realism. Hook told Tallulah that yes, she was indeed garbling some of the dialogue. "Well, darling, a lot of those lines are just throwaways," Tallulah said, "you're not meant to hear them anyway. "Well, then why did George Kelly write them?" Hook demanded. "Touché, you're right," she admitted. But it became clear that the play had not been the best choice for summer stock: too long, not a lighthearted trifle at all. Tallulah's love for Kelly and his excitement about her performing the play had clouded her judgment.

They spent a week in Chicago at the Edgeware Beach Playhouse, then went to Kennebunkport, Maine. Tallulah "overwhelmed 'Craig's Wife,'" Boston's Elliot Norton commented after seeing the play in Kennebunkport, "she being a far more consequential person than Mrs. Craig ever was." Bette Davis came to see the play in Kennebunkport and went backstage, where she and Tallulah had a friendly visit, absent of any of the professional jealousy Tallulah had fanned publicly. *Craig's Wife* went on to Ontario for its final engagement, where it closed August 6. Rehearsals for *Midgie Purvis* were scheduled to start ten days later. Just as they were about to start work, however, 20th Century-Fox exercised an option over Ferrer, recalling him to Hollywood to direct *State Fair*. Fryer and Carr bowed out. They were succeeded by the equally distinguished producing team of Robert Whitehead and Roger Stevens.

"I loved Tallulah's ruthless honesty, her sensitivity, her intelligence," Whitehead said in 1993. When Whitehead went over to talk to her about the play, she was a good deal more agitated than she had been in her early talks with Fryer, Carr, and Chase. She talked and coughed and carried on so that Whitehead didn't feel that she was listening to what he said. Only weeks later did he realize that she'd heard everything—when she would "suddenly nail me to the wall" with a statement he'd made on that first visit.

Having dealt with many great stars, Whitehead understood both their abilities and their limitations. "I think great actors read a script and they say, 'I can play that; I can play that . . . that and that. That's what I'll play.' And all the things in between that you'd love to see them do, they won't do. But what they do, nobody else in the world would be able to do. And then you'll get an actor who'll get all of it, but he'll be about half as good."

Distraught that Ferrer was leaving, Tallulah suggested various directors, but with the season about to begin, the ones she chose were already committed elsewhere. Whitehead took a gamble on another celebrated actor, Burgess Meredith, who had considerably less directing experience than Ferrer but had known Tallulah since their fling back in 1935.

For set designer, Whitehead installed Ben Edwards, who had designed most of Whitehead's shows dating back to Judith Anderson's *Medea* in 1947. Edwards felt that while Chase "had one of one of the most original comedy minds and wits," her work was customarily "disorganized and needed to be put together." Director Antoinette Perry had spent much time with Chase rewriting *Harvey* before they went into production. Earlier, Fryer had already asked Chase for some revisions of *Midgie Purvis,* which she had executed to his satisfaction. Now it was Meredith who was demanding far more substantial reworking, which Hook blamed on Meredith's anxiety caused by inexperience.

Meredith's own account in his 1994 autobiography contradicts Hook's, and includes Meredith's questionable assertion that Whitehead cast Tallulah despite Meredith's reluctance, whereas Tallulah had, of course, been part of the play from the beginning. The problem with the rewrites, Meredith claims, is that Chase was supplying too much new material.

Tallulah had told Ferrer that among the crutches she didn't want to rely on in *Midgie Purvis* was waving a silk handkerchief, a trademark of many of the leading actresses of her day that had now acquired an arch overtone that wasn't conducive to Tallulah working against type. But by the time *Midgie* reached Broadway, however, Tallulah's first entrance came complete with handkerchief. "She realized that that was the path of least resistance," said Hook, "and so she went along with it. With all the rewrites, and the fact that the direction was so sketchy, this was all that really was left: she had to pull out the old bag of tricks. But she still didn't pull out that many."

During the opening scene, Tallulah slid down a banister in full evening dress, the first of an evening of stunts she managed to perform despite her declining health. In the hideaway that Midgie rents behind a local candy store, she frolicked on a swing and slid down a firemen's pole. But Tallulah typically fretted, fumed, and lamented onstage at the dress rehearsal in Philadelphia, refusing to swing out over the apron of the stage until Mary Chase got up and tried the stunt herself. Once Tallulah had mastered her fear, however, she was eager to exploit the device, asking the designer and stage crew to devise a way for her to swing out even farther.

Midgie Purvis opened in Philadelphia on December 26, 1960, as a work in progress, and it became more so after the play received bad reviews. "'Midge Purvis' hardly ever delivers," Ernie Schier complained in Philadelphia's *Evening Bulletin,* "because, chiefly, the playwright is almost totally lacking in a sense of direction." After each night's performance, Whitehead, Stevens, and Edwards would go back to Tallulah's suite to mull over what could be done to fix the play. Meanwhile Chase was sending Tallulah reams of new material; Tallulah was sometimes given pages after a matinee and expected to perform new scenes that same night.

Hook believed that Meredith's relative inexperience made him insecure, and that he was drinking during *Midgie Purvis;* Hook and Tallulah discovered bottles Meredith had hidden on the set. Edwards was taken aback when Meredith told him that the sets, which he'd requested be designed to resemble illustrations from children's books, might now have to be entirely reconceived because of the rewrites.

Edwards recalled a "funny perversity" in Meredith, "kind of an Irish leprechaun mischievous character." Meredith "did some rather naughty things," such as the time he called a rehearsal for what turned out to be only one member of the cast: Tallulah. "You just don't do that with a star," Edwards said. Even if all the work is done with her, "you've got to have at least four or five of the other people there to set the scene"; you can't blatantly pick on the star. Tallulah was livid, and Whitehead—"quite rightly"—canceled the rehearsal.

Necessary or not, the rewrites did not help. After the play opened at the National on January 10, 1961, Richard L. Coe of the *Washington Post* called it "too good not to be good enough," and Tallulah "one of our great natural resources." Despite noting that Chase had "a lot to say about cliché-thinking and rut-behavior," Coe termed the condition of the script "almost incredibly sloppy and undisciplined."

"Tallulah. . . . strives mightily to lose her own celebrated personality in the character of Midgie Purvis," Tom Donnelly wrote in the *Washington Daily News,* concluding that she would have been better advised to be herself, since Tallulah was a much more sharply defined character than Chase's Midgie. Indeed, Tallulah spent most of *Midgie Purvis* in disguise; the matron beneath the old lady did not seem to be sufficiently defined.

Until the opening night in New York, Tallulah continued to accept new material, but in her dressing room on tour she heatedly told Meredith that the rewrites were making this the most grueling pre-Broadway experience of her career. As far as Tallulah was concerned, *Midgie* was now no

longer the play she had originally agreed to do. Chase, too, complained to Tallulah about Meredith's demands for rewrites. Tallulah said, "Well, Mary darling, I can't get in the middle of this with you, because you're the writer and I'm the actress, but I think the director is the captain of the ship. You either have to get rid of him or go along with him."

John F. Kennedy's inauguration was taking place while Tallulah was in Washington. Having campaigned for Kennedy, she was invited, but decided to forgo political activity to concentrate on the play. "I think Kennedy is going to make a *great* president," she had told the *New York Times* in August. "I do what I can to sell the Democratic ticket to train porters and cab drivers—but they're all Democrats, anyway. All artists, intellectuals and minorities are Democrats." Of course she hastened to hope "the Republicans won't hold this against me. Some of my best friends are Republicans . . . they're the ones who can afford to buy tickets to my play."

On the train back to New York, Whitehead and Tallulah shared a compartment. In the midst of arguing about the play, Whitehead suddenly "blew my top," and proceeded to give her a stinging dressing down, calling her "selfish, indulgent, drunk, and an outrage."

"You've spoiled yourself and you've been spoiled," he hectored. "You've destroyed something which was really a superior thing and you've made it into a goddamn joke." When he'd settled down, she fixed him with a Borgia look. "You can't touch me!" Tallulah spat out at him. But Whitehead saw that she'd understood him—and didn't disagree.

At the time, Tallulah's drinking was not a problem. She would drink after a performance, but not to the extent she had done during previous plays. This explained why despite everything she was able to give her best performance since *A Streetcar Named Desire*.

After a week of previews, *Midgie* opened on Broadway on February 1, 1961. Tallulah and her colleagues mustered everything and gave what Meredith recalled as "a miraculous first night performance." Even while deep banks of snow were being shoveled in front of the Martin Beck, Tallulah's fans were out in force, greeting her appearance with an ovation so intense that she had to wait several minutes before she could speak. The *Christian Science Monitor* reported that the entire evening was punctuated by "hysterical outbursts from the star's volunteer claque," yet the poignancy Tallulah wanted to impart was able to survive. The *Saturday Review* reported that, "Two or three times during the evening she allows her special and overwhelming ability for expressing a reluctant wisdom to grip both her and us."

Indeed, most of Tallulah's reviews were glowing, although all the critics, even those who liked the play, found it deeply flawed and amorphous. In the *Herald Tribune* Walter Kerr called Tallulah's Midgie her "best performance in years." *Theatre Arts* described her as "a wonderfully accomplished actress" who had "enlarged her usual range." Yet, as ever, some critics felt her personality upstaged her acting potential. In the *Wall Street Journal,* Richard P. Cook recognized her "restraint," but found her "still too strong an individual to be merged into Midgie Purvis. We constantly feel that her old woman's disguise is not really that but a cloak for the redoubtable Miss Bankhead. . . ."

Hook recalled that much of the show's charm was lost on the way to Broadway. Tallulah may have been attracted to the whimsy of Chase's original, but farce and roughhousing had intruded. Howard Taubman of the *New York Times* blamed Meredith, whose direction had "an air of noisy desperation," but Tallulah most of all. "Instead of a fey, childlike creature, Midgie Purvis has become a vulgar clown. . . . The public personality of Miss Bankhead, as it has manifested itself on radio, television, and the gossip columns, has been catered to."

During *Midgie Purvis*'s first week, the weather was so bad that no private cars could go in or out of Manhattan. This on top of its reviews doomed the play after twenty-one performances. Hook was reduced to tears every time he watched the play, "for what it was and for what it could have been," until he became unable to see it in its entirety. "I'd just watch certain scenes and then wait in the dressing room."

Midgie Purvis's closing sank Tallulah into another deep depression. For the next month, she hardly bothered to get out of bed at all. The part nevertheless garnered her a Tony nomination for best actress of 1960–61, losing to Joan Plowright's performance in *A Taste of Honey.*

"When I read *Midgie,* I knew there was magic there," Hook insisted in 1983, "and I still say that if Buzz Meredith hadn't made poor Mary Chase change it so much and if José Ferrer had directed it, it probably would have been her swan song classic." But the revision that Chase submitted for publication in 1963 is structurally even weaker than the one played by Tallulah in New York, as the 1961 script is evoked by contemporary reviews. In 1978, Hook tried to pass Chase's latest revision on to Elaine Stritch. Chase had reinserted puppets that had shared the stage with the actors in a preliminary draft. Hook never heard from Stritch. Chase's *Midgie Purvis* remained a delightful premise doomed never to reach fruition.

Last Train

"My God, what kind of party is this? I stop by to pay my respects to the hostess, and I wind up in bed with her!"

For the rest of 1961, the only work Tallulah did was to appear a few times on *The Jack Paar Show*. In many ways an exceptionally resilient woman, she was nevertheless prepared to keep trying. While *Midgie Purvis* failed to provide her career's crowning triumph, she considered Arthur Kopit's *Oh Dad, Poor Dad, Mamma's Hung You in the Closet and I'm Feelin' So Sad*, a surrealistic caper in which she would play a grotesque dominatrix, something of an aburdist spin on *Crazy October's* Daisy. Although Ted Hook hated *Oh Dad* and told her to turn it down, Tallulah, who kept abreast of new movements in the theater, was fascinated. Yet its language and transgressions of propriety proved too big a stumbling block. "She said her daddy would turn over in his grave," recalled Hook; though Tallulah was convinced that it would succeed, "it's not for me," she decided. "I can't say things like that onstage."

Oh Dad, Poor Dad opened off-Broadway early in 1962 with Jo Van Fleet, running for a year. Producer Roger Stevens offered Tallulah a production in San Francisco or London. Again she turned him down, though she did accept his invitation to see the play in New York, which she pro-

nounced "beautifully staged" by Jerome Robbins, who was an occasional bridge partner of hers.

Not long after that, Hook left to accept a job in theater production, with Tallulah's encouragement. "There's less fun and more nursemaid in your job every day," she had told him, although the two remained in touch until her death.

With Hook's departure, Tallulah decided that the responsibilities of a town house were too onerous. Selling her house, she bought a two-bedroom apartment at 447 East Fifty-seventh Street, near Sutton Place and the East River. The decor remained the neutrals and pastels she had preferred since her Farm Street home in London. Augustus John's 1930 portrait of Tallulah at the peak of her beauty dominated the living room, the only image of herself on display. The distinguished and eclectic small collection of art she'd accumulated over the years covered the walls.

While Tallulah had no permanent housemate in the apartment until 1966, she was more or less looked after by a circle of younger men, called "caddies," by Tallulah's publicist Richard Maney. Also in daily attendance was a cook, Maria Brown, and Emma Anthony, who cleaned and waited on her. Anthony was an elderly black woman whose presence Tallulah found comforting, perhaps a nostalgic reminder of her childhood in Alabama. "'Mamma,' I call her," Tallulah explained to a friend, "and she calls me 'daughter.'"

In the spring of 1962, Tallulah appeared on television in a dramatic special, *A Man for Oona,* that brought Nancy Carroll out of retirement to costar with her. Soon after, Tallulah elected to return to the stage in a summer theater tour of George Oppenheimer's *Here Today,* a madcap drawing-room comedy that Ruth Gordon had starred in on Broadway in 1932. The genre was far more familiar to Tallulah than *Oh Dad, Poor Dad,* and the play had become a staple of summer theater.

Tallulah would be Mary Hilliard, a prototypical screwball heroine dancing circles around propriety. A successful playwright, she arrives in the Bahamas with her sidekick Stanley Dale to frolic with her ex-husband and current good friend Philip Graves. Philip is trying to woo Claire Windrew, daughter of a starchy Boston family, whose stuffy fiancé is also on his way to the Bahamas. Mary and Stanley come to Philip's aid, constructing a fantasy pedigree for him, but of course Mary soon decides she wants Philip back.

For the role of Mrs. Windrew, Claire's mother and Mary's crusty adversary, Tallulah recruited Estelle Winwood, marking the third and final

time they acted together. Both Tallulah and Winwood were decades older than their roles, yet no one seemed to mind, and the twenty-year gap between them was perfect for their onstage relationship. James Kirkwood Jr., a good friend of Tallulah's from *Welcome, Darlings* in 1956, recommended director Jack Sydow. "We had a wonderful time," Sydow recalled in 1993. Directing her was simply a matter of "guiding her and giving her opportunities. Her sense of the character was extraordinary."

"She had confidence in me," he said, and once called him "Daddy," as she had years before referred to Herman Shumlin as "Teach" during the rehearsals of *The Little Foxes*. The honorific was freighted with the full ambivalence of her lifelong response to authority. But with Sydow her ambivalence was good-natured.

Tallulah and Winwood each separately warned Sydow about her costar: Winwood accused Tallulah of speaking too quickly and Tallulah cautioned him against Winwood speaking too softly. Winwood was now seventy-nine, but at sixty, Tallulah's hearing was beginning to fail. "It's very important that she be able to hear you," actor Bill Story was told before he successfully auditioned for the juvenile lead of Claire's younger brother.

Oppenheimer was present for some rehearsals of his play. He kept flagging what he said had been the play's biggest laughs in earlier productions, but by accident or design they never turned out that way as Tallulah acted the part. Other laughs that she got, nobody had ever dreamed of getting.

During the summer of 1962, *Here Today* played to great success at summer theaters all over the East Coast. After seeing a performance in Ogunquit, Maine, the *Boston Record*'s Elliot Norton called Tallulah "an unchallenged mistress of comic technique. . . . Watching her dazzle her way through three acts is like watching a great fencer demonstrate his entire repertory. . . ." Her scenes with Winwood were "as funny as any on view on any stage today. . . . The pair of them, both brilliant craftsmen, stand toe to toe exchanging thrusts and counterthrusts, uttering insults," Winwood "grandly as through a lorgnette," while Tallulah did so "bluntly with lowered head and jutting jaw."

Tallulah's entrance in *Here Today* was not until the middle of the first act, which meant that as Sydow gave notes to the company after a run-through, Tallulah often got restless, bringing up scenes later in the play with Winwood. The afternoon of one opening night, Sydow was giving notes to the cast while Tallulah continued to talk privately with Winwood. "Tallulah?" Sydow called. "I promised you that we would be out of here by

five"—Tallulah wanted to be go home, nap, eat and be at the theater no later than ninety minutes before the eight-thirty curtain—"but if you don't keep your big fucking mouth shut, we're going to be here until curtain time." Sydow believed she appreciated his discipline. "She never said another word."

She also enjoyed jokes played at her expense by people she liked. One day in her house in the woods of Ogunquit, she entertained a group including Jimmy Kirkwood and cast member Bill Story. Going upstairs to use the loo, Tallulah kept talking, as was her habit. Meanwhile, Kirkwood and Story prompted all the guests to walk out of the house so that when she came back downstairs she realized she had been chattering to an empty house. "She died laughing," Story said, once they all came traipsing back.

Tallulah's sister also visited her on tour. The two sisters had fought over Eugenia's living in Tangier, the men she was involved with, the money she spent, and the fact that for at least part of the time Eugenia's teenage son remained in America, albeit in the capable hands of du Pont heiress Louisa Carpenter. Eugenia and Carpenter had been sharing a household since the mid-1940s. Now, with relations between the Bankhead sisters restored, Tallulah was eager to impress Eugenia. "Now everybody be good," Tallulah went around telling the cast, "because Sister's out front, so we've got to be good for Sister!"

Once again, Tallulah insisted that she was working only to pay her bills. "I don't care whether you're doing this only for the money or not, Tallulah," director Sydow would sometimes say after a particularly good performance, "you are a superb artist." Work continued to be her lifeline, saving her from the depression and inertia that set in when she was idle.

The production's success raised the possibility of bringing *Here Today* to New York. Tallulah asked Elliot Norton for his critical opinion; he advised her to wait to return to Broadway in an original play. And that fall, Tallulah decided that she very much wanted to play Flora Goforth in Tennesse Williams's *The Milk Train Doesn't Stop Here Anymore*. She had previously been reluctant to embody the most extreme of Williams's heroines, and none is more gaudy and grotesque than Flora Goforth.

Tallulah had been in Miami in 1956 for *A Streetcar Named Desire* when Williams had tried to interest her in a dramatization of his novella "The Roman Spring of Mrs. Stone," whose heroine's addiction to sex takes precedence even over her own self-preservation. Tallulah was skeptical, and it was eventually filmed with Vivien Leigh.

Tallulah claimed to have been offered the role of Alexandra Del Lago

in Williams's *Sweet Bird of Youth,* although it is not clear what actually transpired with the role. Williams did admit in a 1963 article that he wrote it with her in mind. *Sweet Bird of Youth* opened in New York on January 10, 1959, a few days after Tallulah's long and trying tour with the abortive *Crazy October* closed in San Francisco. When John Kobal interviewed Tallulah in 1964, she said that she turned down Williams's play "because I'd promised my friend [Herlihy] to do *his* play and he said, 'I'll release you from your contract,' but I didn't think that was right."

But Tallulah may well have made a big mistake in not accepting *Sweet Bird of Youth.* To the role of the dissipated, debauched ex–movie queen, Tallulah might have lent a humanity that Geraldine Page doesn't manage to do, and a far more sensual glamour. The character may have been repellent to her, though; Alexandra is parasitical in a way that Blanche DuBois is not. Both women are promiscuous, but Alexandra's stances are brassier and more masculine. She coldly objectifies men in a way that Tallulah might have felt uncomfortable revealing herself doing before an audience.

Milk Train's Flora Goforth is Alexandra Del Lago circling the drain. Tallulah's avid interest in the role was surely in part due to her inevitable awareness of how few leading roles were being written for women of her age. The potential of this role is considerable, moreover; Mrs. Goforth is an ex-*Follies* girl grown fabulously wealthy on the inheritances from her many, mostly unloved husbands. Living on a private island in the Mediterranean, she is in frantic denial of her imminent death until visited by an angel of death in the guise of a handsome young poet.

Tallulah went "virtually on hands and knees" to request the role, according to the *Washington Post,* "a most uncharacteristic posture for that tigress who walks alone." Although Williams claimed again to have written his latest role for Tallulah, earthy British comedienne Hermione Baddeley starred in the world premiere in the summer of 1962 at Italy's Spoleto Festival. When it was decided to bring the play to Broadway, Williams approved Baddeley enthusiastically. Tallulah saw the production and found Baddeley's performance in it "superb."

That winter, Tallulah went back out on the road in *Here Today.* Although she brought Sydow at her own expense twice to check the show and her performance, she compromised her professionalism by going onstage one night in La Jolla, California, "drunk as a skunk," according to actor John Carlyle, who was in the audience. "All she could really do was get every line wrong and toss her head and make sure we all knew it was real hair." Afterward, Winwood read Tallulah the riot act. Tallulah promised to

never let it happen again: "But I was funny, wasn't I?" In her protests there is an echo of her behavior on social occasions, when drunkenness let her mistakenly believe she was more appreciated than she really was, simply because she herself was more relaxed.

Shockingly and uncontrollably rude as Tallulah frequently was, she still considered rudeness a cardinal violation of civilized mores. Patience Cleveland was now playing Tallulah's rival Claire Windrew, and Peter Hobbs was their mutual vis-à-vis, Philip. Cleveland and Hobbs became involved and later married. During the tour, Tallulah was party to a disagreement between the two of them, in which Cleveland told Hobbs, "You bore me." Tallulah reproached her angrily, saying, "It was the worst thing you could say to anybody, darling!"

Cleveland had written a children's book, and her publisher asked her to request a blurb from Tallulah. Tallulah responded with a quote that was as much confessional as endorsement: she recommended it as "the most enchanting book I've read since 'Charlotte's Web' and E. B. White is my favorite author. If I could have lived my life as gracefully as he writes, I would have nothing to regret." But Cleveland's publishers had never heard of E. B. White and sent the sheepish Cleveland for a second blurb. Tallulah salved Cleveland's embarrassment by saying that she'd probably gone overboard and delivered a second, more straightforward endorsement.

As she would for the rest of her life, Tallulah struggled with trying to cut down on smoking, if not quit. On one occasion Story took a puff of the British brand Tallulah smoked, a potent mix of Turkish and Virginia tobaccos, and was shocked at how strong it was. Sometimes Tallulah could go nearly the entire day without a cigarette. Her hunger for palliatives was fierce, however. Anytime someone took out a bottle of medicine for any reason, she wanted to know what it was for, insisting that, whatever the ailment being treated, she was suffering similarly. "I've got a weak heart, darling, give me some . . . Oh, I know I've got gout, darling, the way I live."

At one point, Tallulah was feted by a wealthy Tucson businessman, a prominent Republican booster whose invalid wife spent her days sitting or prone in an enormous Mediterranean-style bed. During the party, Tallulah went into the woman's ground-floor bedroom to sit at the edge of the bed and chat. The top drawer of one of the bedside tables was open, crammed with a battery of medications. Tallulah promptly sampled some of everything and passed out on the floor. When the nurse in attendance quickly

Richard Kendrick, John Granger, and Tallulah in *Here Today*.

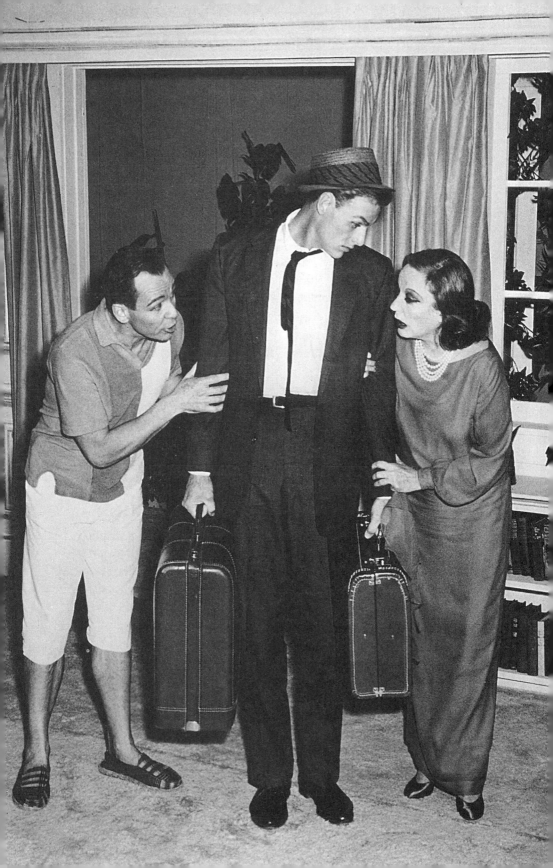

determined how much she had taken of what, she predicted that Tallulah would be unconscious for several hours, unaware that she had overlooked Tallulah's robust nervous system and high tolerance. Cast members were summoned to lift Tallulah into the invalid's bed. Thirty minutes later, they were in the living room whispering about how to explain her prolonged absence to the rest of the assembled guests when the great oak doors swung open. There stood a miraculously restored Tallulah, resplendent in a red chiffon pantsuit. Closing the doors behind her, she leaned up against them dramatically. "My God, what kind of a party is this?" she cried. "I stop to pay my respects to the hostess, and I wind up in bed with her!"

The second tour of *Here Today* was not well publicized or managed, the cast recalled, and business suffered. Isabel Sanford, who would later win fame in television's *The Jeffersons,* had been chosen in Los Angeles to play the role of a native Nassau maid, but the management was leaning toward local actresses to cut expenses. Ultimately, Sanford was summoned to Phoenix and asked to join the tour. Trying to keep the play running, Tallulah plowed her own salary back into the production on weeks when the grosses were low.

At that point, Tallulah was traveling with Robert Williams, who had been her manservant and driver on and off for twenty years. Before the show traveled to Alabama, she called Sanford and Williams into her dressing room and told them that if they experienced any racial incidents there to let her know immediately. Before the show could reach the South, however, the producers cut short the tour.

The Milk Train Doesn't Stop Here Anymore had been hurt on Broadway by a newspaper strike that precluded coverage and advertisements. The critics who were able to publish reviews considered the play a distinctly minor addition to the Williams canon, and it closed after sixty-nine performances. Later that year, Williams produced a revision at the Barter Theater in Virginia, starring Fred Astaire's onetime Broadway dance partner Claire Luce. Williams's revision framed his script in the conceits of Kabuki theater: two of the characters in the play are stage assistants who change scenery before the eyes of the audience, but are visible to the other characters only when they assume a spectrum of bit roles. In October 1963, Williams asked Tallulah to star in it on Broadway. David Merrick was willing to produce it, an unprecedented move a scant year after its initial failure. To direct, Merrick selected Tony Richardson, then a top star of stage and film; his film *Tom Jones* was one of that year's biggest successes.

Tallulah was thrilled at the prospect of working with Richardson. She

taped a radio show in her apartment with interviewer Paul Berman, host of a radio show in Baltimore, where the play was going to try out. She seemed to be sending propitiatory tributes Richardson's way, listing his credits and even declaring herself capable of accepting direction. "If I get a director I respect I'm grateful for his advice and I will certainly follow it," Tallulah said. "There may be certain little arguments back and forth; I don't mean fights or rows or things one usually hears about, but I mean just saying, 'Well, darling, I don't understand it this way,' or 'Help me,' I might say, 'I don't know what to do here.' "

The part of Mrs. Goforth is immensely long, longer in the revision than in Williams's first script, thanks to a number of digressive monologues he added in which she recounts her past, dictating her memoirs into a tape recorder. "I thought I was a quick study," she told Berman, but for the first time, learning her part was difficult. Age and alcohol had already taken a toll on her memory, concentration, and energy; after exploding matches burned her right hand, she was also physically disabled. It was going to heal better if left unbandaged; onstage, however, Tallulah used her customary chiffon handkerchief to hide the eyesore.

"Part of my job as an actress was to protect that awful, helpless hand," writes Marian Seldes, who played Blackie, Mrs. Goforth's much-abused secretary, in her 1978 memoir, *The Bright Lights*. Tallulah asked Seldes to come over and work with her on lines before rehearsals began. Seldes visited twice, finding Tallulah so apprehensive and distracted that she "never did learn the lines as they were written," Seldes writes. "She knew most of them and some of her cues. . . ."

"She tried, she really did, I have to give it to her," recalled *Milk Train*'s lighting designer Martin Aronstein, "but I don't think at that point she was capable of performing." Tallulah was "favoring every bone in her body." Her voice was weak, her hands trembled. Konrad Matthaei, who played one of the stage assistants, agreed that they were basically working with a cripple. The painkillers Tallulah was taking dried out her mouth, making it difficult for her to project her voice intelligibly. Given her condition, the production should have been postponed if not canceled, especially once it became apparent that her new director did not want her in the part.

Richardson's memoirs claim that he'd barely heard of Tallulah before being told by Merrick that Williams wanted her for Mrs. Gorforth. After meeting Tallulah at her apartment and seeing her hand, Richardson decided that she wasn't up to performing the play. On a short trip to California to discuss several film projects, he determined to find a substitute for

Tallulah there, preferably Katharine Hepburn, who'd had great success in another Williams property, the film adaptation of *Suddenly Last Summer.* Yet Mrs. Goforth is entirely different from Mrs. Venable in *Suddenly Last Summer,* and Hepburn an odd choice to play an aging hedonist. Not yet ready to leave her life in retirement with Spencer Tracy, Hepburn turned down the role, making the question moot.

For the role of Christopher Flanders, the enigmatic young poet, Richardson wanted Anthony Perkins. Perkins wasn't interested, but through him, Richardson met Tab Hunter, who was Perkins's lover at the time. In the introduction to her father's book *Long Distance Runner,* Natasha Richardson recalls finding the manuscript written out in long-hand on legal pads the day Richardson died in 1991. Although the manu-script was probably not intended for publication, Richardson is nevertheless circumspect in it about his bisexuality, giving only coded hints throughout. "Cocksure" that he could get a performance out of Hunter, making his Broadway debut after a long career as a screen juvenile, Richardson claimed he'd "surprise the world by the way I could make Tab act."

Richardson had screened *Lifeboat* and, after watching it, had the ex-traordinary response that Tallulah was "no livelier in that than when we had met." What he doesn't say is that she must have represented every-thing he and his generation found frivolous in British theater. The era of Noël Coward was anathema to Richardson, whose success was inextricably tied to the rise of Britain's Angry Young Men playwrights. Still, he agreed to accept Tallulah, provided that Williams agree to Hunter, to whom he told Williams he had "a moral obligation." "Tony was out to make Tab, in every sense of the word," recalled a member of the production, one of sev-eral company members to note the "private tutoring sessions" Richardson gave Hunter. Hunter's stage inexperience was readily visible to everyone, as was a trepidation equal to Tallulah's. One day they were rehearsing a scene together when he neglected to deliver one of her cues. Tallulah po-litely reminded him that he had one more line to say. Hunter flailed his arms, yelling, "What the fuck difference does it make?"

"This would be a moment to be Tallulah," his costar announced, "but I'm going to go to my dressing room." To clear the air, Tallulah invited him over for dinner. Touched by his account of a beloved brother who had been killed fighting in Korea, she invited him back several times for dinner during rehearsals.

Relations between Tallulah and Richardson, however, quickly grew fruitless, a fact that doomed the play as much as Tallulah's physical condi-

tion. Richardson had "no respect" for Tallulah, Aronstein recalled, and Richardson himself admits as much in his memoirs. He describes her "a spectre from the past. . . . The most unpleasant person I've ever worked with—or let's blame her senility and decay."

Richardson instructed Aronstein "not to give her anything she wants." At one point, Tallulah sidled up to Aronstein and confided that this was the first time in twenty years her contract had not stipulated that she would be given footlights. Nevertheless she wanted to know if he could provide them. He told her he would speak to Richardson. "Absolutely not," the director replied. When Aronstein suggested they use balcony lights, which would blind her just as effectively, the director vetoed them as well.

One day, Tallulah stepped out into the orchestra to watch Ruth Ford, who was playing the Witch of Capri, a catty socialite who is all too happy to inform Mrs. Goforth about Christopher Flanders's reputation for "helping" the elderly rich over the final threshold. "Oh, she looks gorgeous," Tallulah said as she watched Ford, "I must look okay." Though she never brought it up again, Aronstein was distressed because he felt that Tallulah looked "the worst she had ever looked in her life." "That's exactly what I want her to look like," Richardson said to him; Flora Goforth is meant to be as ravaged as Tallulah actually was.

Tallulah's only requests of her director were "loud" or "soft," according to Richardson, but Seldes recalled Tallulah requesting more fine-tuned pedal work. "How shall I say this?" she asked about a speech. "Any way you want," he replied. "You're the director," she said. "Well, invent," Richardson insisted; "you are the actress." "I signed the wrong contract," she retorted. "I'm sending you back to Oxford."

"She was begging for direction," said George Hyland, one of Tallulah's closest friends from her circle of younger men, whom she had installed as assistant stage manager. "Begging for direction and not getting it."

"Now, Tony," she implored him at one rehearsal, "I can do this next scene on my head or on my back or doing a cartwheel, but I want you to tell me how to do it!"

"You're the actress," he repeated.

Richardson's behavior baffled cast member Konrad Matthaei. "Another director who had had a star forced on him would have found a way to try to make it work," he said. Matthaei called rehearsals "a train wreck to hell," wondering if Richardson got "some strange amusement" from baiting and mocking Tallulah. "It was suicidal for the play." Thirty years after the fact, he wondered if Richardson had any interest in the job other than to supply

Hunter with his Broadway debut. Richardson's plate was more than full at the moment. Not only was he involved in preproduction on the film *The Loved One,* and trying to barter a reprieve from Merrick for the Broadway closing of his production of Brecht's *Arturo Ui,* but his marriage to Vanessa Redgrave, waiting in England with their newborn daughter, Natasha was troubled, requiring further attention.

Williams explores mercilessly the carnality and rapacity of *Milk Train's* Flora Goforth. Everything has been projected outward: to solve her spiritual bewilderment, she looks to sensual and material gratification. "She's more afraid of being robbed of her jewelry than her life," her secretary Blackie says. As the play progresses and death fixes her in its sights, Flora becomes more and more bedizened. Finally, in the fifth of the play's sixth scenes, she suffers an attack, climbing out of her sickbed to cover herself defiantly in mink and a blaze of jewelry.

Because of the burn on her hand, Tallulah dreaded having to put on the rings, as much as she knew that the jewelry was essential to Williams's portrait of a grasping woman. Sara Neece, a drama major who'd taken a leave from college to work as Tallulah's dresser, applied the rings at every performance. The task required each of them to steel herself. "Okay, Miss Bankhead, here we go. We've just got to do it."

Preoccupied with *Hello, Dolly!,* which was also headed for Broadway, the show's producer had essentially given up on the play before it finished rehearsals. Merrick was rarely at *Milk Train* rehearsals. Tryouts were minimal; a few days in Wilmington, followed by a week in Baltimore.

By the time it reached the stage, Tallulah had come to like the part of Flora Goforth, but not the play itself. Before she had agreed to star, she had shown the script to Hyland, who thought it read beautifully, seconding Tallulah's interest. "That's where I was wrong," he said in 1992. "It *was* beautifully written, but it didn't play. I always had a tinge of guilt about that." Meandering, diffuse, and very wordy, *Milk Train* simply didn't hold the stage as well as it read on paper.

Tallulah and Tab Hunter had grown to develop a mutual respect; as a result, she protected his inexperience as he did her physical depletion. As Neece stood in the wings, marveling that Hunter was speaking his whole part in a monotone, she watched Tallulah "find some tiny variance in his rhythm and bring it back. She'd make him look a lot better than he was, by verifying or compounding the way he was reading those lines."

The *Baltimore Sun's* R. H. Gardner praised Tallulah but found the play lacking "the poetry, magic and emotional peaks characteristic" of Williams's

best work, finding Richardson's "usually dexterous" directorial hand "somewhat unsure here." Expecting Tallulah to be an ideal match with Flora Goforth, Richard L. Coe in the *Washington Post* was disappointed: "As if aware that she has trapped herself in something beyond our ken, if not her own, Miss Bankhead races through her words as though imitating some kind of congealed vocal scales and I got about one word in 20."

The Merrick office canceled the play's New York booking at the end of the week in Baltimore, only to reinstate it an hour later. *The Milk Train Doesn't Stop Here Anymore* did open on Broadway on January 1, 1964, at the Brooks Atkinson. Critics again turned thumbs down on the play. Tallulah's notices were again mixed, although most were frank about her debilitation. "She strides about her stage with her garish clothes and mannerisms streaming behind her," Martin Gottfried wrote in *Women's Wear Daily,* "barely intelligible and mostly a clown. If the character she plays could be played (and this is dubious), Miss Bankhead has not even bothered to try. Her performance is dreadful." While, as Richard P. Cooke in the *Wall Street Journal* noted, "it was hard to understand a good deal that she was saying" at first, "her performance sharpened up considerably" in the second act. Her predecessor Hermione Baddeley's performance was declared superior.

No doubt Tallulah did most justice to those elements in the role that she identified with at this moment in her life. For Cooke the highlight of the play was her final dialogue with Flanders, in which she attempts to seduce him but winds up instead capitulating to his gentle coaxing that she surrender to death. Playwright George Oppenheimer, who had become *Newsday*'s drama critic, found "moments when Miss Bankhead brings depth to the shallows of the play, especially when she is finally forced to face the reality that she is dying." In the *Newark Evening News,* Edward Sothern Hipp described the way she "changed mood magnificently to reflect the heartbreak of a woman who has known many men but still gropes for love or the fright of a doomed human who has no more hiding places."

John Chapman in the *Daily News* called the opening-night audience "one of the queerest . . . since the early days of the Ballet Russe [sic] de Monte Carlo." Years later, Seldes told the *New York Times* how Tallulah's cult followers "shrieked with laughter at the most inappropriate moments. . . ." Knowing full well by now the ambivalence of their adoration, Tallulah must have offered herself to her claque with a certain amount of cynicism and despair. It was her customary default strategy, an acknowledgment that the production had defeated her. Yet it also perhaps

fulfilled her on some of her darkest levels, these fans a fun-house mirror reflecting her own distorted picture of herself.

Even so, Neece found working with Tallulah an unforgettable education; the aspiring actress peppered Tallulah with questions about acting at every possible opportunity. "You can only tell the truth and you can only tell the truth about what you know," Tallulah told Neece. "Use what you know, what you've lived." She encouraged her student not to shy away from drawing upon painful experiences that could inform her work, something Tallulah had done "to the hilt," Neece recalled in 1983. "She sucked herself dry." Neece cited the final scene of act 1, when Mrs. Goforth shakes off the fumes of a nightmare she's had recalling the death of her first husband: "You were there with her; it was real: her breathing pattern, the way she focused, the way she tried to come back to reality." Neece watched from the wings as Tallulah's sense recollection "flashed through her."

The Brooks Atkinson was a particularly unlucky theater for Tallulah. *Milk Train* did not close after two performances, as Richardson says in his book, but instead managed to eke out five. It was the same theater where she had endured the other briefest run of her career. In 1937, when it was called the Mansfield, *Antony and Cleopatra* had run for only five performances as well.

Yet *Milk Train,* undeniably pungent and vigorous, has survived. The play is occasionally revived: in 1994, Rupert Everett played Flora Goforth in drag in a production in the United Kingdom.

After the closing notice was posted before the second performance, Tallulah's friend and colleague William Roerick decided to catch the show while he still could. He noticed her difficulty projecting her voice, and backstage after the show he saw how weak she was. Yet despite the posted notice, that night she gave "a marvelous, courageous performance," her professionalism admirable, with her "not looking back, that the thing was a failure."

From his home in Key West, where he fled after *Milk Train* closed, Williams wrote Tallulah, "We all did all we could. It is pointless to consider the curious behavior of the director. He probably thought he was doing the right thing. . . . What is there to say?"

Home to London

"Daddy always said that gentleman was two words."

While *The Milk Train Doesn't Stop Here Anymore* was Tallulah's final appearance on Broadway, it was not her last performance onstage. By the summer of 1964, she was in good enough shape to return with a tour of Edward Mabley's *Glad Tidings,* starting in Miami and then moving on to summer theaters in New England. Originally performed on Broadway in 1951, with Signe Hasso and Melvyn Douglas, *Glad Tidings* is an amiable comedy, thematically similar to *Here Today* in its restoring of a long-sundered romance. Its heroine, star actress Maude Abbott, takes a detour on her way to perform on Cape Cod through a New England resort town, visiting her long-ago flame Steve Whitney—a maverick editor about to be married to the conservative doyenne for whom he now works. Her two teenage children in tow, Maude reveals to Whitney that he is the father of her daughter. With both children experiencing a crisis about their paternity, Whitney rises to the occasion, eventually ditching his too-starchy fiancée and choosing Maude.

Eight years after the *Ziegfeld Follies,* Christopher Hewett was again directing Tallulah. Disoriented at losing a lifelong mastery of her material, she seemed to him to be deliberately avoiding having to knuckle down. "We'll stay here and rehearse until you know your lines," he told her dur-

ing one rehearsal. When Tallulah protested about the heat, he told her, "It's hot for us all. The sooner you know your lines the sooner we can all go out for a cool drink."

Actors were still eager to share the stage with Tallulah, as traumatic as working alongside her could be. Emory Bass, who played Gus, Maude's tagalong manager, whose scrutiny she is perpetually trying to elude, left another show to work with her. Bass was also Southern, and Tallulah told him that he was exactly the type of dignified representative that she herself would be pleased to have: "Daddy always said that gentleman was two words." She thanked Hewett for her supporting cast. "The cast is wonderful. I particularly like that Emory Bass. I *love* our two-handed scene, except I never know which one of us is talking!" Not only was his Southern accent pronounced, Bass had a tendency to fall into Tallulah's own rhythms during their dialogue.

Still, her audiences could foil her. One matinee in Coconut Grove, peeping out at the crowd before they went onstage, Tallulah told Bass, "You're not going to get anything today, dear. This is one of *my* houses. They're going to go after everything I say." Her entrance was greeted with rapture; from that point on, no attention was paid to any other actor on stage. Bass thought she was both resigned to and embarrassed by this. "There was nothing she could do about it," he recalled in 1993. "It threw the performance, threw the show for everybody."

No record has been found of *Glad Tidings,* but Bass remembered one performance being filmed in Miami, and a bonus in his paycheck. The film, which has never surfaced, would be an invaluable record of Tallulah, aged sixty-two, in her final stage production.

During the mid-1950s, Tallulah's friend and volunteer amanuensis Dola Cavendish had moved back to British Columbia. Tallulah had begun a series of long visits to her, often accompanied by George Hyland. In the past Tallulah had both exploited Cavendish's adoration and been mightily irritated by it. ("Make way for Miss Bankhead; make way for Miss Bankhead!" Cavendish once boomed officiously at the airport, when Tallulah arrived in Canada with Hyland. Tallulah had turned to her in the car: "Dola, don't ever meet me at the airport again.") Their relations were much calmer and more loving now, however. Cavendish turned over her own bedroom to Tallulah in her magnificent house that looked out on equally sumptuous grounds. Tallulah was delighted to avail herself of two long hallways entirely lined with books. Cavendish's alcoholism had not abated: she began drinking gin with rock sugar at ten in the morning. At least, she

never smoked or drank in bed. "I wish she'd stay in bed all day," Tallulah told Hyland.

Tallulah was visiting Cavendish after *Glad Tidings* finished its run in August 1964 when she received the script of *Fanatic,* a movie Columbia was coproducing with Britain's Hammer Films. Hammer ran one of the most durable cinematic franchises devoted to horror and gore. After the 1962 success of *Whatever Happened to Baby Jane?,* Hammer decided to explore a new avenue of horror stories starring great leading ladies of the past. Purchasing rights to a gothic thriller called *Nightmare* by British author Anne Blaisdell, they asked American Richard Matheson to write the script. Matheson, whose classic horror novel *The Shrinking Man* was famously filmed as *The Incredible Shrinking Man,* had written many screenplays as well.

Nightmare was the story of an actress whose Welsh sea captain husband brings her to a remote farm, converting her to evangelical Christianity, and unleashing in her the zeal of the newly indoctrinated. After his death, Mrs. Trefoile's fanaticism leads her son to flee her grasp, ultimately committing suicide. His ex-fiancée, Patricia, comes to visit the widow for a brief and dutiful condolence call—except Mrs. Trefoile imprisons and terrorizes the "lapsed sinner" in an attempt to purify her, assuring her son's redemption. When Patricia reveals that he had actually committed suicide, Mrs. Trefoile is driven over the edge, and prepares a ritual sacrifice to send Patricia to join her son.

Hammer had approached Columbia, hoping that a joint production would give them entrée to the type of leading lady they were seeking. Joyce Selznick, the niece of David O. Selznick, was then a casting executive at Columbia. It was she who sent the script to Tallulah. Several years earlier, Tallulah had turned down the role that Joan Crawford went on to play in *Baby Jane.* By now, however, she was more inured to the thought of playing gargoyles, and Selznick's was a reputable recommendation. Even more attractive was the opportunity to return to England, the country that Tallulah customarily referred to as "my home." She'd told Ted Hook how much she wanted "to go back to my home once more before I die." Dola Cavendish's niece Laura Mitchell agreed to accompany Tallulah, who was eager to see London and its many personal landmarks. Among them would be her old house on Farm Street and the Ritz Hotel, where she was going to stay as she had on first arriving in London in 1923.

The Hammer executives were apprehensive about assigning one of their directors to work with Tallulah, recognizing that, as a grande dame

from a bygone era, she was an altogether different animal from their own familiar pool of horror stars. Silvio Narizzano, a director active in Canadian television who had worked with a number of high-powered stars, was asked to make his film debut with *Fanatic*. Anthony Hinds produced. The son of the cofounder of Hammer Films, Hinds had taken over his father's share of the business. After Tallulah was signed, Hinds rewrote the script to accommodate her theatrical persona, developing the idea of a basement refuge to which Mrs. Trefoile retreats. Papered with old stills and theatrical mementos, it is an archive of the life she had allegedly renounced. Most specifically tailored to Tallulah was a scene in which Mrs. Trefoile backslides to avail herself of a secret stash of liquor and makeup.

Several months before production was to start, Narizzano went with his wife on a holiday in Spain. Apprehensive about his upcoming work with this "monster lady," he was reluctant to do too much preparation, fearing that being too set in his ideas would lead to confrontations.

"Could Miss Bankhead be intending to play it for comedy?" the *New York Times* had asked before she left for England. "No, God, no," she insisted. "If anyone laughs, it will be because of my bad acting. . . . I do hope this will be more serious, a bit better than the usual."

With a very tight shooting schedule, *Fanatic* had all the cost-cutting hallmarks of a B movie. The cast was very good, however. A new ingenue, Stefanie Powers, was cast as Patricia. Maurice Kaufman, a fashionable leading man of the day, played Alan, Patricia's current boyfriend and ultimate rescuer. In one of his first major film parts, Donald Sutherland played a half-wit servant in Mrs. Trefoile's house.

Contrary to Narizzano's expectations, Tallulah was willing to depend on him almost unquestioningly. Her chief concern was with what was going to be filmed the next day. Laura Mitchell made sure to get her next day's lines from Narizzano, running over them with Tallulah at the Ritz that night and in their car on the way to the studio in the morning.

In one of the first scenes they shot, Tallulah brings Powers food in the attic to which she is confined. "I feed her the porridge?" Tallulah asked Narizzano. "Oh, yes, that's right, Laura told me something about the porridge."

"You have a gun in your hand," Narizzano told her.

"I have to carry the porridge and the gun? How am I going to do that?"

"No, the maid comes up with the porridge and you'll have the gun."

"Well, what hand should I have the gun in?"

"*Tallulah,* I don't know. What hand do you normally carry a gun around in?"

"I'm ambidextrous, darling."

Tallulah asked him to demonstrate, a common practice in her youth that had come to be derided as the epitome of monkey-see mechanical repetition. Tallulah had profited from the practice at times, especially when working with directors who had been accomplished actors, like George Kelly and Gerald du Maurier. She would watch Narizzano intently, remembering every detail of what he'd done, then using his blueprint to develop her own interpretation. "Oh, that's good, dear. Marvelous!" she'd chirp, serenading Narizzano with praise. "Better than you are, Tallulah!" the crew hooted at her.

"Why, of course, darlings!"

"She was very easy, very amenable, always ready to rehearse," Narizzano recalled in 1982. "It's better I play full out," she said of her rehearsal process, "and you tell me what you don't like." After the first take, she would respond to his comments and would always ask if he wanted another take before the end of any shot.

Sometimes she would pull Narizzano aside and suggest some business she wanted to supply to another actor. Her ideas were usually very good. "I would say, 'Yes, that's fine,' and she would ask, 'Can I tell her?'" Narizzano would call the cast together. "Tallulah has an idea. Tallulah, you explain it."

Once he got angry with her for asking too many questions. "I *don't* know, Tallulah. I'm just the director," he burst out. "*You're* the actor." "I am *not* an actor," she replied, "I am a *star*." Her rejoinder was equal parts self-mockery and conviction. Despite a decade of trying to break out of typecasting, she considered herself above all a personality. He asked her why she thought she had been such a star. Comparing herself to Garbo and Dietrich, she told him, "It's all bone structure."

"But you were such a great actress!" he cried, remembering *The Little Foxes,* which he had seen in Toronto when he was a teenager. "Yes, I was good in that," she said, "but that was almost the only decent role I ever had." She referred to their film as "this piece of shit we're doing," telling her stock myth about needing to work for the money. She did prefer earning to living on her capital; nothing else was being offered her and she did want to work. "What else am I going to do?"

In her view, the great theatrical stars had all magnetized their audiences by harnessing outsize personalities. Recalling her youthful ambitions to be a "serious" actress, she noted the hegemony of the star system, which had dominated theater when she started working. Actresses whose names went in klieg lights on the marquee of a theater built loyal followings no

matter the intrinsic worth of their play. Indeed the entertainment world to-day remains dominated by the star system, even as the culture of stage stars that existed in Tallulah's youth has completely disappeared.

Tallulah admired those who did transform themselves to accommodate a role. "She thought Olivier was fantastic," Narizzano recalled, but she thought he was more popular with the public now that he had started to use less makeup and other radical disguises. Narizzano later worked with Olivier and found that "he in a way had come to the same sort of conclusion. He hated makeup and wigs or anything like that. He said, 'When I was young, I thought, "I can't get on the stage unless I'm something different." ' " By the 1970s, he doubted whether this meant anything to the audience.

In *Fanatic,* however, Tallulah had no choice but to function as a character actress. Decades before, she had told Stephan Cole that, offered the choice of playing an ugly woman or a beautiful one, she would play the ugly woman if hers were the better part. Yet with her looks crumbling, she was appalled at the degree of verisimilitude Narizzano insisted upon: makeup A. H. Weiler in the *New York Times* would describe as "darling only to a mummy." Off went Tallulah's lipstick for almost the first time in her professional life; to Mrs. Trefoile, red was "the devil's color." Ironically, the first day's shooting was delayed when the makeup man could not get the red off Tallulah's lips. Ultimately he had to apply a lightener to disguise the red tone.

Tallulah had been asked to bring theatrical stills of herself that would be plastered around the walls of Mrs. Trefoile's basement refuge, where she stockpiles paraphernalia of her life prior to conversion. Yet while Mrs. Trefoile has renounced mirrors altogether, Tallulah had not. Leafing through a scrapbook of photos, Tallulah clucked, "Oh, my, wasn't I beautiful? And look at me now!" Turning to a mirror, she let a theatrical moan escape. "Oh, my God!" But she was resigned. "It all goes, doesn't it? You can't hold on to it."

Nostalgic about her years in London, Tallulah still didn't want to dwell on them too much: "Everybody's dead. It's a very sad place for me now." Riffling through her phone book, she found the numbers still listed but many of the names were now gone. She and Kenneth Carten had had a tearful reunion at the airport when she arrived in London. "Thank God you're still alive!" she'd said to him, although he was only fifty-five. However, his sister Audry, Tallulah's contemporary and colleague in *The Dancers* in 1923, had slowly lost her mind; she was now completely homebound in her brother's apartment.

On-screen, Tallulah's vitality seems undimmed, save for an occasional difficulty in having enough breath to finish a line as suavely as she might have liked. Doubtless this reflects her determination to husband her energies for the set. Yet, visiting Tallulah for the last time after forty years of friendship, Gladys Henson found her in bed at the Ritz "so ill I couldn't *bear* it. She couldn't breathe. I don't know how she got out of that bed."

Tallulah appeared hardy enough to be approached by a British producer who wanted to bring her to London in *Glad Tidings*. She told him she didn't want to return to the British stage in a play that wasn't first-rate.

All her life Tallulah had depended on those who escorted her and waited upon her. Now the programmed dependence of the Southern belle was not only emotional but physical. "Laura did everything for her," Narizzano said. "If she had to go to the bathroom, she'd ask Laura to help her unzip the back of her trousers." Once Tallulah asked Narizzano to perform the same function. "I'm not your dresser; I'm your director, Tallulah. I'm not going to do that for you." "Oh, darling," Tallulah scolded, "you're a devil!"

When the shoot ended, Tallulah presented the cast and crew with keepsakes in engraved silver from Tiffany's. Narizzano received a cigarette box and a medallion engraved with a devil's head on it, and on the other side: "From one devil to another. Love, Tallulah."

Although his time and energy were fully consumed by the process of directing his first film, Narizzano indulged her loneliness. Evenings, Tallulah would routinely phone to invite him and his wife to play poker with her, asking them about their lives, freely sharing her own trove of anecdotes. "Oh, you've probably heard these stories," she said, unsure "what I've told anybody anymore" and which stories were true. She shared one notorious incident that wasn't true, but was so funny that she adopted it: how one Christmas season, she had slipped a Salvation Army solicitor a twenty-dollar bill with the injunction, "Don't thank me. I know it's been a rotten season for you flamenco dancers."

Narizzano saw her shocking and outrageous behavior as preemptive compensation against a certain shyness. "Why don't we have new people in for our 'pokey' tonight?" Tallulah would ask him, but when he brought friends, they would have to endure a long thaw while Tallulah stayed silent, her head buried in her cards. One evening, Narizzano brought over a young actress named Kathy Beck. Tallulah wouldn't talk to her for a long time. Suddenly she leaned over and touched Beck's face. "You could have a very good career, darling. I don't know whether you're a good actress, but

you have beautiful bone structure." She then very pleasantly gave Beck extensive advice about how she should make up her exemplary bones. Many a night they'd play until 11:00 P.M, when Narizzano would force her to break off, reminding her that they had to work the next day.

Most difficult was getting Tallulah back to the set after she'd returned to her dressing room. Narizzano's first assistant director was in a tizzy over his proximity to the legend. "I'd say, 'Claude, go up and get Miss Bankhead. We're ready for her now.' He'd never come back. I'd go up and say, 'Claude, come on,' and he'd say, 'Well, she's doing this, doing that.' She'd be talking to people: endless, endless jabber."

When asked if he could handle Tallulah, Narizzano's second assistant director, Peter Deal, a man barely out of his teens, asked him what he needed. "I want you to get her down here." Deal took the direct approach, barging into her dressing room, insisting, "Miss Bankhead, Silvio wants you now," taking her by the hand and leading her back to the set.

"Oh, my baby, my baby assistant is taking me onto the floor," Tallulah cooed. "You won't let me trip on any wires, will you, darling?"

Narizzano watched as every day at four o'clock, Laura Mitchell brought Tallulah a cup of tea. Increasingly suspicious about its actual contents, he intercepted the cup one day, tipping it to his lips only to discover that it had been dosed with a slug of bourbon. Distressed that she'd been found out, Tallulah was reassured when Narizzano agreed the late drink wasn't affecting her work. "If you started drinking at lunchtime—" "Oh, no, no, darling, I won't do that, I won't do that. . . . You don't mind?" "On the contrary, would Laura bring me a cup of tea, too?" From then on they shared "tea" together every afternoon.

Tallulah insisted that the film was really more Patricia's story than Mrs. Trefoile's, and she seemed very jealous of Stefanie Powers. The two actresses never chatted, never sat next to each other on the set. "Is the girl going to do this?" Tallulah would ask Narizzano. "Is this the scene where I do this with the girl?"

During a struggle that occurs toward the end of the film, Tallulah was required to slap Powers fiercely across the face. Powers didn't want to fight back too violently: "She's an old woman now," she told Narizzano. Though Powers was intimidated by Tallulah, she liked her and was learning a great deal about acting by working with her. Tallulah, however, insisted. "Just fight me!" she commanded as they rehearsed. "Fight me! . . . No, *hit* me. You've got to hit me like *that!*" She reassured Powers that, "On stage we'd have to be a little more careful, but if you hurt me, the director will just

call 'Cut,' and they'll wait twenty minutes until I'm all right." Tallulah walloped her, and was quite prepared to be hit with equal ferocity. "She didn't feel you should hold back," Narizzano said.

During a long sequence Tallulah's character had to drag Powers's unconscious body down to her basement hideaway; Narizzano needed about eight shots for coverage, intending to use a stand-in to lug Powers, tall and an ex–swimming champion. He told Tallulah that she didn't have to come until late because he would film the long shots with the stand-in. In the close-ups she would be pulling only a pillow. But Tallulah would not hear of it. Going to her stand-in, she said, "I'm sure you do it very well, darling, better than me, but I'm going to do it." She insisted on doing all the rehearsals herself as well.

Eventually Powers was able to break down Tallulah's defenses, and the two became friends. Later, long after the film was completed, Narizzano visited Tallulah in New York and she asked after the actors, using the names of the characters they'd played—with one notable exception. "Stefanie always comes to see me when she's in New York," she mentioned, the first time he ever heard Tallulah use her name.

Tallulah found the dubbing process very difficult. Just how annoying it had become to her by the time the film was finished is revealed in an audiotape someone made of one session. Tallulah is required to repeat over and over again three phrases that were judged not sufficiently distinct in the sound track. She complains, laments, bellows, and insults. (It is impossible to imagine that a woman with this much lung power was actually in the advanced stages of emphysema.) She complains that she's in pain, that the pills she's been given "are nothing but talcum powder," while Narizzano humors her, finally letting out a few vitriolic zingers.

Interestingly, what Tallulah—so often portrayed since her death as an emotionally detached and clinical performer—is most incensed about is having to re-create an emotional state needed to deliver lines out of context. "Oh, I can do this from the very beginning, but you're going to take all the emotional content out of the whole thing! . . . I can't pick up the middle of a sentence in the middle of eighteen verses and get any feeling in it."

Over Tallulah's objections, *Fanatic* was retitled *Die! Die! My Darling!* for American release in the spring of 1965. Tallulah by now bristled at anything to do with her "darling" shtick. As mechanically as she could repeat her trademark phrases, she was loath to do so. She had been asked to go to England to promote the movie's opening, but told her friend Cal Schumann, "I'd rather be dead than get out there and say, 'Hello, darlings.'"

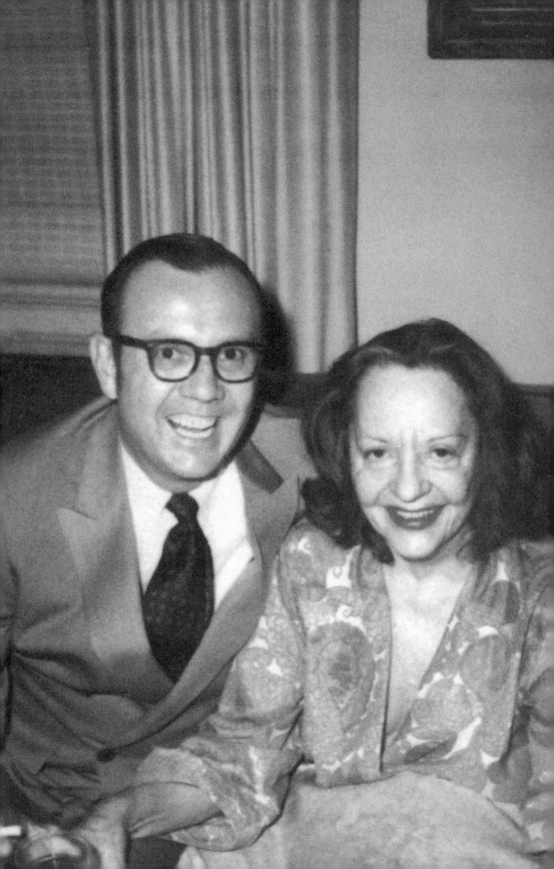

Tallulah "thought the picture was dreadful," Narizzano says, "and she was happy that I thought it was pretty awful, too." But in 1982, seventeen years after its release, he said, "I think it's quite not a bad film except for about the last ten minutes" of flagging pace. "Quite not bad" is perhaps the fairest description of *Fanatic*. There is a terminal cheesiness to it, and at ninety-seven minutes it seems oppressively longer, one sadistic episode following another. Tallulah's performance is an almost heroic marshaling of talent and experience, however. Not only is she deglamorized as far as possible from a "Tallulah" performance, but the character is different from any other that she had tried. When discovered by Powers perusing her long-ago theatrical portraits, Tallulah is chilling as she insists with the desperate righteousness of the convert, "God was good. He led me from that evil. . . . Yes, a pit of evil. A place for the lost and the damned. The devil's entertainment. God's anathema . . ."

Her Mrs. Trefoile is complex and ambiguous: sometimes malicious, sometimes pitiful, capable of both deranged duplicity and rational cunning. At times her movements are slow and rather dreamlike, demonstrating her absorption in her own imaginary universe. Sometimes she is brisk and jaunty as she demonstrates her complete dominance over her household of freaks. She also is able to create an extraordinary effect standing stock-still.

At times her stentorian crescendos evoke the bravura actresses of her youth. Tallulah has never been more magnificent than when she turns around to find Harry, a sinister employee with his own designs on Patricia, stalking her and shoots him dead, then washes blood from her hands, crumpled in a paroxysm of guilt that sends her to her secret trove of lipstick and booze. "Stephen . . . Don't look at me!" she cries out to her dead son in a lather of shame. Had she been able to bring to *Milk Train* the variety and strength of her performance here, her final appearance on Broadway might have been remembered as one of her best.

Fanatic was greeted by most critics with, at best, indulgence. Few recognized the tour de force Tallulah had achieved, although Dora Jane Hamblin wrote in *Life* that, "Her superb acting is the saving grace of the film." But *Fanatic* was released in May 1965 directly into second-tier theaters to little business, and sank quickly.

A month before she died, Tallulah entertained Cal Schumann in her 57th Street apartment.

Winding Down

"I think we all ought to be put out in the garden. It would be wonderful to think that someday a flowering tree would grow around me."

Tallulah had four years left to live, during which time her work dwindled to a trail of a crumbs and her mobility diminished as her emphysema progressed. "If you knew how this tires me," she told George Hyland one day as she stood in her bathroom brushing her teeth. Dr. A. L. Loomis Jr., who practiced at St. Luke's Hospital in Manhattan, began treating her in 1965 for this painful and debilitating disease. Phoning him frequently "to ask for medication and ask if anything further could be done," Tallulah "wanted to do what she could to help," Loomis remembered, "except to stop drinking or smoking." Actually, during her final years, she tried desperately not to smoke, resorting to the novel strategy of asking people who were smoking in her vicinity to blow their exhaled smoke at her.

Not long after Tallulah returned from London, in November 1964, John Emery died of cancer at fifty-nine. Their lives had stayed entwined, since his ex-wife, Tamara Geva, had become a prime mare in du Pont heiress Louisa Carpenter's stable of mistresses. Carpenter was most attracted to women who were more heterosexual than homosexual. For twenty years, her harem had also included none other than Eugenia

Bankhead, although Tallulah insisted that her sister was "not a lesbian! She just does it for the money."

Although she'd told Silvio Narizzano that she wasn't quite sure why she had ever married Emery, Tallulah was certainly fond of him, sending flowers to his funeral and venturing out to attend the service.

During the 1960s, Tallulah ended her long-term association with agent Phil Weltman, moving to New York–based agent Milton Goldman. Goldman and Arnold Weissberger were one of Manhattan's foremost homosexual power couples. Goldman loved Tallulah and wanted her to be seen. He talked her into venturing more often to Hollywood for television appearances, assuring her that the work would be easy. But learning new material, even in the small doses required for TV sketches, continued to be a problem for Tallulah.

In 1965, Hyland accompanied her to Hollywood for appearances on *The Andy Williams Show* in May and *The Red Skelton Show* in December. During their trips the two would commandeer the card table installed in the front of passenger cabins to play "Russian Bank" together. On one return flight, during a layover in Las Vegas, two gaming-table veterans boarded the plane. "Hi, Tallulah!" they said. "Hi, fellas. You want a game?" The four of them played poker. Hyland said that Tallulah was "awfully good" at the game. "She could keep that poker face." But when they played bridge at home, her "card playing was brilliant, but I didn't like her bidding." Bidding in bridge is "legitimately giving your partner information about your hand," and for Hyland's taste, her bidding was too instinctive, too impulsive, not informative enough.

During her appearance with Andy Williams, Tallulah still had sufficient stamina to do a razzmatazz song-and-dance number. "She loved being surrounded by these beautiful boy dancers," Hyland recalled. "Picked the best looking one to be her partner." Sex no longer was a salve, but she continued to find ways to indulge her hedonism.

For Red Skelton's show, the two friends stayed at a motel in the San Fernando Valley only a few minutes' drive from CBS's studios. A quarter dropped into a slot next to the beds caused the mattress to vibrate. Tallulah loved availing herself of that stimulation. One night Hyland told her he was going to go out and asked if there was anything he could get her. "Bring quarters!" she replied.

While she was in Hollywood, producer Paul Gregory, who had married ex–movie star Janet Gaynor, a long-standing acquaintance of Tallulah's, called and asked if they could visit. Tallulah invited them to dinner.

Ordering in from the motel restaurant, they ate sitting on the floor around the cocktail table. Gregory said that he wanted to put Tallulah, Gaynor, and Agnes Moorehead into a horror movie together, but Tallulah had had her fill with *Fanatic.*

In October 1965, Tallulah spent a week in Philadelphia cohosting Mike Douglas's afternoon talk show. Douglas "did everything right with her," Hyland recalled. The night that they arrived, he arranged for dinner to be served in her suite, bringing his wife and daughters. For each day's dress, she was brought a selection of clothes from a chic dress shop. Tallulah, who no longer indulged in clothes-buying blitzes, was delighted to learn that she could keep the dresses she wore. Her on-air questions to her guests were uninhibited. "She'd ask them anything she wanted," Hyland recalled. "Mike would roar laughing."

"I never even go to the theater anymore," Tallulah told the *New York World-Telegram and Sun* in March 1966. "I hate the crowds and the traffic. It takes so long to get crosstown, and I feel too much respect for the theater to come late. So I get there an hour early and then I'm exhausted." As so often, however, Tallulah exaggerated. She did go infrequently; she had seen *Luv* and *The Odd Couple* during the same week the previous December.

Tallulah had not always demonstrated respect for the theater any more than for herself. But this was an issue on which she was now at pains to show contrition. In the personal papers that her attorney, Donald Seawell, collected from her apartment and gave to the Players' Club library is what looks like an introduction to a reprint of her autobiography. (But this introduction does not seem ever to have been printed.) "In the past my admittedly flippant approach has protected me from ever being unduly over-awed by anybody or anything," she wrote. "But the great thing about mellowness is that it allows you to pay that respect without embarrassment—with, in fact, the delicious relief that comes with declaring a love too long hidden." She now insisted that "I do have respect, and I have admiration, and I have love" for artists in general and the members of her own profession in particular.

For a while, Tallulah still considered that she might have one more chance at a Broadway hit. She told actor Emory Bass that she had a play she wanted to do and asked him to read it. It turned out to be a period piece that had something to do with suffragettes; Bass was amazed that she wanted to go through the rigor of wearing bustles again. Tallulah had called Agnes Moorehead, who had played her agent in *Main Street to Broadway,* and Moorehead had agreed to costar. The play never got off the

ground, however. Bass doubted that anybody she showed it to liked it," he said, "or they couldn't get up the money. Or she decided she wasn't up to it after all."

In 1966, Tallulah was approached to star in a revival of George S. Kaufman and Edna Ferber's *Dinner at Eight,* directed by the great British director Tyrone Guthrie. While she'd seen both the original Broadway production in 1932 and George Cukor's 1933 film adaptation, she wasn't sure which of the matron-age roles she was being offered. She told Bass she was interested in joining the production but that she would have to have solo star billing, which she had not had in *The Milk Train Doesn't Stop Here Anymore.* "Tallulah, it's an all-star revival," Bass attempted to reason with her. "How can you possibly have sole star billing when everybody in the cast is a star?" Tallulah didn't quite agree, telling Schumann, "They're ten so-called stars of which four I've never heard of!"

She also demanded, incredibly, that whichever role she played was to be given the final line of the play, spoken, as written by the dinner's host, Mr. Oliver. "They're not going to rewrite the play for you," Bass told her, "in spite of how wonderful you are." He suspected that she was deliberately setting up conditions that could not be met; she both wanted to work and suffered terrible doubts about being able to get through the run of a play. "I think she was frightened. I just think she was nervous about doing anything."

Dinner at Eight opened without Tallulah on September 27, 1966, and Tallulah went to see it. Backstage she embraced the great character actress Blanche Yurka, who had played the Swedish cook in the apartment where dinner is to be served. After Tallulah left, Yurka was led to contemplate the way that Tallulah had squandered her talent, beauty, and physical stamina. Many other performers shared this view, which has been absorbed into legend but remains an unfair simplification of her life's work.

Tallulah herself certainly did have regrets. When Ted Hook visited her close to the end of her life, she spoke of her complicity in creating the garish caricature by which the public had come to recognize her. "The boys didn't do it to me," she said, referring to her gay claque, "they did it *for* me." Sometimes she and Christopher Hewett, who'd directed her in the *Ziegfeld Follies* and *Glad Tidings,* would talk about a play that was currently running, and Tallulah would say, "I could have done that." If it was a classic script that was being bruited, she'd add, "Perhaps."

Tallulah's career had spanned from the heyday of vaudeville to the dawn of the rock festival. She made an effort to appreciate the changing

cultural landscape. Hook recalled watching a performance on TV by a leading hard-rock group. Their raucous noise bewildered Tallulah, but she was interested in what the phenomenon was all about. When Richard Lamparski interviewed her in the fall of 1966 for his Pacifica Radio talk show, she told him that she had recently gone to see the "mod" films *Darling* and *Morgan* and loved them.

One evening, Richard Burton's ex-wife Sibyl called to invite Tallulah to Arthur, the new discotheque she had just opened. Tallulah asked the Seawells' daughter Brook (eventually Brook Ashley) to accompany her. Tallulah had a great time and was perfectly at home: "Tallulah was so adaptable," Ashley said in 1994. Also present at Arthur that night was a celebrity of Tallulah's own generation, chanteuse Mabel Mercer, whose singing Tallulah adored. Tallulah could no longer dance, but she and Mercer talked.

Silvio Narizzano came to New York and asked to visit; Tallulah told him not to come during the hour when her two soap operas were shown. "That's my family now, and I've got to see my soaps." She stayed in contact with her biological family as well, and had never stopped making short visits to Alabama. In 1962, Dr. Wernher von Braun, director of the Marshall Space Flight Center in Huntsville, invited her to witness the launching of a space satellite named for her. She was excited at the conferring of a different kind of immortality than her fame as an actress, gleefully repeating to friends that she'd been told her satellite would remain in orbit "a *thoouusand* years!" as she repeated with glee to friends. At last she allowed herself to visit the Huntsville grave of her mother. She had never been able to shake her sense of complicity in her mother's death.

Tallulah took her family responsibilities seriously. "Sister's not at all well," she told Schumann in 1966, several months after she'd last seen Eugenia. "She's got so thin, and she's got a boyfriend who's a drunk and a liar. . . ." Eugenia's primary residence was now heiress Louisa Carpenter's estate in Chestertown on the Eastern Shore of Maryland, where Eugenia lived in a comfortable two-bedroom house, next to an adjoining guest cottage; Tamara Geva lived in a larger house called "the castle." Louisa allowed Eugenia some freedom in pursuing her extracurricular romances with men.

The Bankhead sisters were not overly fond of Geva, and the feeling was mutual, but all were properly cordial when they socialized. Carpenter had also bought a farm for Eugenia's son, Billy, who had graduated from

the Cornell Agricultural College. Tallulah and Eugenia were both conscious that neither had finished high school, while their father's sisters and other women in their family had graduated from college. Eugenia evinced a snobbism about the rural roots of the family, mildly lamenting to Schumann that she wished she'd been able to bring her son up "to be an educated gentleman instead of a farmer."

Tallulah was planning to go to Maryland at any moment, because Billy's wife, Cindy, was expecting their second child, and Tallulah thought that Eugenia wasn't going to be able to be present. "I should be there; Sister can't." Their firstborn daughter had been christened Mary Eugenia; Billy asked Tallulah's permission to name the newborn Tallulah Brockman. Tallulah gave her consent enthusiastically.

Schumann, a playboy with a private income, began to tape the calls he made to Tallulah and Eugenia from his Baltimore apartment. During one conversation, Tallulah seemed to allude to the censorious superego her upbringing had instilled. "We've got in our heavens that awful Saturn," the Aquarian Tallulah said, that "schoolteacher who's always shaking his finger at you!" She also touched on a belief in her own invincibility that she'd felt had enabled her to live on the razor's edge: "But we are always saved by the eleventh hour."

A long visit with Dola Cavendish in British Columbia brought mortality close to Tallulah's thoughts. As she and Hyland sat waiting for the flight back to New York, Tallulah started to cry. "I don't think I'll ever see Dola again." Cavendish died of a stroke soon after, and Tallulah herself seemed ready for death. "All my friends are dead," she told Emory Bass. "I can't do the things that I want to do anymore. I've done everything there is to do." Having talked about her "death wish" for forty years, Tallulah could not have been unaware of how the destructive forces massed within her had often worked to thwart her own well-being.

Her interest in keeping on going waxed and waned according to how she felt. Her physical plight naturally increased her irascibility. One day she had been so unpleasant to one of her "caddies" that she told Schumann that "if he killed me I'd be grateful. He has every right to." Growing more hermitlike with every passing day, she didn't leave her apartment for weeks at a time, hardly even stirring from her living room sofa, where she sat "cross legged in her almost yogi position," as her friend William Skipper, the Denishawn dancer she'd met in 1939, recalled. Yet she was not exactly a recluse. She entertained at home, dressed in satin caftans of different colors. She communicated with friends by telephone and tele-

gram, speaking regularly to Estelle Winwood in Hollywood. Winwood visited, as did Tallulah's *Fanatic* costar Stefanie Powers, who one night brought her mother. Singing was heard in the hallway: Eddie Fisher was dating Powers at the time.

For most of her adult life, insomnia had dogged Tallulah. She had never made a serious effort at defeating it, choosing the palliative of barbiturates rather than trying to confront the possible psychological causes. "I haven't slept all night," she told Schumann one day. "I read two books, and *Life* and a few things I'd piled up." She was increasingly prone to accidents as she got older; she never looked down, Bass recalled, and never looked where she was going—perhaps a capsule description of the way she lived her entire life.

One time Bass took Tallulah to a party thrown for writer Anita Loos. "Whatever you do, don't let me speak to Lillian Hellman if she's here," Tallulah told him. Although she was still angry at the playwright, she didn't want to get into a public brawl. Before Bass knew it, Hellman was at Tallulah's table greeting her. Tallulah turned around, saying "Hello, darling" reflexively. "Oh, my God," Tallulah blurted out, when she realized whom she'd addressed.

In the fall of 1966, Hellman again approached her at Truman Capote's masked ball at the Plaza Hotel; this time Tallulah responded happily. Her breach with Hellman had been a mistake, she had decided, even if their dominating personalities made clashes inevitable. When *The Little Foxes* was revived by the Repertory Theater of Lincoln Center a year later, with Anne Bancroft starring as Regina Giddens, Hellman wrote a piece for the *New York Times* recalling incidents from the original out-of-town tryout in Baltimore. Tallulah wrote a letter to the *Times* amiably refuting her. Outliving Tallulah by fifteen years, Hellman was able to have the last laugh, writing in *Pentimento* that she found an amicable Tallulah as exhausting as an adversarial Tallulah.

At the Capote party, Tallulah was reunited with Jesse Levy, an acquaintance in his midforties who lived on a pension for service in World War II and the proceeds of friendships with the globe-trotting rich. Tallulah asked him to move in with her not long after as her secretary/companion, the first full-time live-in companion she'd had in four years. Distinguished-looking, and affecting a somewhat self-mocking lockjaw, Levy could be both quite campy or act butch enough that women were attracted to him. Tallulah, whom he called "La Belle," was amused by how he referred to his

plans to go out cruising: "I think I'll go out scampering." Levy played piano well, sometimes playing for her; ultimately she willed him her Baldwin grand piano.

For Tallulah, Levy was her own Christopher Flanders, although unlike *Milk Train*'s angel of death, he was more amusing than spiritual. Shrewd and mercenary, he nevertheless became genuinely attached to Tallulah. He was not a caretaker, however, never trying to curb her regimen of drugs and alcohol, or alter her almost complete disdain for food.

When she wasn't working, Tallulah began her day with an Old Grand-Dad and ginger ale. Her drinking was sporadic, sometimes heavy, sometimes not. Possibly her quasi-domestic arrangement with Levy provided an element of stability. On social occasions she insisted that drinks prepared for her be weak, and in her current condition, she found drunkenness around her particularly unnerving.

By 1967, Tallulah was accepting that her illness now made stage work impossible. "I could never do a play again," she admitted to Schumann. "I couldn't make a quick change." She had done almost no work in 1966 beyond supplying the voice of the "Sea Witch" in *The Daydreamer,* an animated adaptation of a Hans Christian Andersen tale narrated by many noted performers. Invited to appear on the television show *Batman,* she declined at first, although the series was the sensation of the 1965–66 television season. "I didn't understand it," she told Schumann, "and I think they made me a grandmother, and I said, no, please, not after this last picture I did," referring to *Fanatic.*

Batman was predicated on the same wickedly knowing tone of subversive irony that Tallulah had championed all her life. After Estelle Winwood told Tallulah what fun her own guest appearances on *Batman* had been, executive producer William Dozier received a late-night call: *"Darling, oh, I must do it!"* Robert Mintz, a member of the postproduction team, created a character for her: the Black Widow, who has turned to a life of crime after the death of her husband, Max Black. Living in a grottolike hideaway—"The Web"—she sallies forth to rob banks, disarming attendants with a brain-wave short-circuiter.

The *Batman* production staff awaited Tallulah's arrival with some apprehension. They had heard stories of her behavior on *Lifeboat,* recalled Dozier's wife, actress Ann Rutherford, yet Tallulah took to the show with "almost a childish glee." Her difficulty breathing, though it relegated her to sitting between takes and setups, didn't stop her from smoking. Yet Tallu-

lah "didn't want you to think she was frail, not in a million years!" Dozier's assistant Charles Fitzsimmons noted. "She was just a consummate professional in every sense of the word."

As in *Fanatic*, Tallulah marshaled everything she had for a performance she must have known would be one of her last. Even in her ravaged state, she still manages to ring some new variations on her characteristic reprobate swagger. She bounces around the set so blithely that once again she is able to disguise her infirmity. Photographed in soft focus, she looks very attractive. Her voice gives away her condition, however, rendered a hollowed-out husk by age, illness, cigarettes, and liquor. Unable to take deep breaths, she speaks laboriously, yet produces some new vocal effects suitable for the snarling creature she plays.

If Tallulah had sometimes violated her own understanding of stylistic distinctions in comedy, here her discernment is fully evident. Deadpan, her cartoonish exaggeration provides a different stripe of broadness than her past exercises in farce. Mintz's script was good, and as he said in 1993, Tallulah's delivery adds "a level and a half" to his dialogue. One of the Black Widow's henchmen asks, "But didn't your husband Max always say that money can't buy happiness?" Tallulah corrects him: "Happiness can't buy money."

While she was shooting the show in Hollywood, George Cukor hosted a dinner party for her. Among the guests was Katharine Hepburn, who several months later received a wire of condolence from Tallulah after Spencer Tracy died in June. Hepburn responded on July 22, 1967, thanking Tallulah for her "dear sweet wire."

That October, Tallulah visited the Broadway theater for perhaps the last time when she went to the opening night of Marlene Dietrich's one-woman show, and also attended the after-theater party at the Rainbow Room. On November 24, 1967, she signed her will. After the windfall generated by *Private Lives* and *The Big Show,* she had started to save money seriously, and in the subsequent two decades her estate had grown to nearly $2 million.

Tallulah had mothered many young people during her life, but one of the her most enduring bonds was with her two godchildren, the Seawells' daughter, Brook, and son, Brockman, who had been given Tallulah's middle name. Each received one quarter of her estate. Eugenia's two grandchildren were also well taken care of; together they received another quarter of her residual estate. Tallulah's namesake great-niece also received her gold Cartier dressing table set, including the brush with which

Stephan Cole had administered his spanking twenty-five years earlier. The last quarter of Tallulah's estate she bequeathed to Levy, who eventually moved in with Will Rogers's daughter Mary in San Francisco.

Before executing her will, Tallulah had summoned Louisa Carpenter to Fifty-seventh Street. Carpenter piloted her plane to Manhattan, where Tallulah asked how well Louisa was prepared to provide for her sister. Eugenia was a spendthrift, and was almost recklessly generous to men she was interested in; as Cole recalled, she "would spend her last dime to get laid." Tallulah accused Eugenia of being "cock crazy." Louisa assured Tallulah that Eugenia would be well taken care of, but according to Cole, together they made sure "she didn't get enough to waste."

Tallulah left Eugenia $5,000 cash, canceled a debt Eugenia owed her, and set up an annuity that would pay her sister $250 a month. After Tallulah's death, Eugenia was angry that she hadn't been left more. She heeded Cole's suggestion that she should never have taken Tony Wilson away from Tallulah in London in 1928. "I suppose that's the inexcusable thing I did," she told Schumann, but the vindictive tone in which she added, "I *bet* she'd never tell anybody I'd managed to get a man away from her!" suggested a complex and torturous rivalry that neither sister had been able to defuse.

To Winwood and a number of other friends, Tallulah left cash bequests or jewelry and artwork. Perhaps as a posthumous tribute to Dola Cavendish, she chose to will the nineteen-carat star-sapphire ring that Jock Whitney had given her in the 1930s to Judy Joy, a niece of Cavendish's; the ring, along with other valuable pieces of Tallulah's, was auctioned at Parke-Bernet in 1969. What jewelry was not bequeathed was sold at auction at Sotheby's in 1969. Friends and retainers from the distant past, such as John and Mary Underdown, Tallulah's live-in servants on Farm Street, were remembered with small cash bequests. Her former secretary and companion Edie Smith received $10,000 as well as several pieces of jewelry.

Some were hurt that Tallulah had not left them more; Ted Hook, who was left $1,000, believed that the will had been tampered with. Surprisingly, Tallulah neglected to specify the fate of her portrait by Augustus John, and it, too, was eventually put up for auction. Jock Whitney purchased it secretly and donated it to the National Portrait Gallery in Washington.

During the last two years of her life, Tallulah would call Merv Griffin, whom she met while appearing in Las Vegas in 1953, whenever she had something she wanted to publicly hold forth about. Despite her protests to the contrary, her need to perform was clearly a drive she couldn't

completely curtail. Griffin would book her on his show, appearances she seemed to take as seriously as Broadway openings.

In December 1967, Tallulah made her last trip to Hollywood to appear on *The Smothers Brothers Comedy Hour*. Her final professional appearance was on *The Tonight Show* on May 14, 1968. That night guest host Joe Garagiola presided. In the past, Tallulah had been received by Johnny Carson, but she didn't like Carson as much as Griffin or Mike Douglas, finding him too intent on outpacing her.

She had said all her life that she believed in God. Her phobia about communism, which had abated considerably by the 1960s, was due in part to its atheism. Christopher Hewett, a devout Catholic, gave Tallulah a statue of the Madonna that she kept by her bed. "You know I was raised by the nuns," she reminded him. But her religious beliefs were extremely syncretic. "I get nervous when I hear Billy Graham saying 'Jesus,'" she told biographer Denis Brian, "when I think of all the Jews in the world and all the other religions."

She expected to have to confront her transgressions in some realm. "None of us can go through life swindling, lying and outraging our fellows and escape retribution," she declared in her autobiography. She leaned to Eastern philosophy as well: "I have a suspicion we go through dozens of reincarnations."

On December 31, 1967, Tallulah called Tamara Geva, inviting her over for a drink. Planning to see some friends in Connecticut, Geva said she'd stop on the way. She found Tallulah sitting alone in a red caftan, very sad, obviously having sampled from an open magnum of champagne. As they were talking, Tallulah suddenly burst into tears. Geva was at a loss: "It was like seeing a mountain fall apart." The tears Geva had seen after the opening night of *A Streetcar Named Desire* in 1956 were an exhalation of relief. What Geva now saw looked to her like an existential despair. She held Tallulah's hand before leaving for her party.

That summer, Richard Maney, Tallulah's longtime friend and publicist, died. She attended his memorial service in Connecticut and contributed an obituary to the *New York Times*. She'd been grateful for his support; he understood her, and that was good, "because I don't understand myself."

In July, Jesse Levy drove Tallulah to Maryland for a long visit with Eugenia and her family. It was the last time the two sisters would spend time with each other. Instead of discussing the traumas they had endured together as girls, they distracted themselves with competing grievances. Tallulah regularly confronted Eugenia with the fact that in childhood Eugenia

had been their father's favorite, a charge that Eugenia never tried to deny. "I was Daddy's favorite because I needed him more," Eugenia told Cal Schumann.

That October back in New York, Tallulah attended the premiere of the film *The Subject Was Roses* and then the party at Sardi's. Later that month Otto Preminger escorted her to a Democratic luncheon, which tired her so much that she was leaning on him by the time he took her home. On Election Day she phoned Hewett and asked him to go with her to vote. The polling place was close to Tallulah's apartment; even so, she walked very slowly. Tallulah "would vote if she had to crawl," noted George Hyland. For president she was voting, naturally, for Democrat Hubert Humphrey. Tallulah abhorred the U.S. involvement in Vietnam; at one point, she'd vowed to stop smoking until America's boys came home. Even so, after Lyndon Johnson had declared his intention not to seek reelection earlier that year, Tallulah sent him a note of support.

In December, Tallulah came down with a flu that turned so alarming, Levy called Dr. Loomis, who prescribed an ambulance to St. Luke's. On Friday, December 6, Levy checked in Tallulah and called Hyland in tears: she was not doing well. Her flu turned into double pneumonia and on Sunday night she was moved to intensive care. "I think she knew it was fatal," Dr. Loomis told Denis Brian, noting Tallulah's request that they inform her sister. "I think she knew the end was coming and she accepted it, with some dramatization." During the week she spent in St. Luke's, she was put on a respirator, her heart gave out and was restarted, and she was given a tracheotomy. "She demanded a lot of sedation," Dr. Loomis recalled, suspecting Tallulah "could have got several from different physicians."

Tallulah was losing consciousness by the time Eugenia arrived with her son. Her last words were "codeine—bourbon," presumably a garbled request. She sank into a coma, and died at 7:45 A.M. on December 12, 1968. Levy called Hyland sobbing loudly, "She's left us.'"

Tallulah died of the "dread pneumonia" that Mrs. Bankhead had cautioned her against fifty years earlier. She might have survived, as she had her previous bouts decades earlier, had the illness not been exacerbated by emphysema. An autopsy reportedly revealed that she had died of malnutrition in addition to pneumonia and emphysema. Eugenia withheld this from public announcements, perhaps feeling it reflected badly on her own sisterly attentions.

Tallulah died at sixty-six, the same age as her father. As she had not left any instructions for the disposal of her remains, Eugenia chose not to bury

her sister in Jasper with their father, but instead in the ancient cemetery attached to St. Paul's Church near Louisa Carpenter's estate in Maryland. Tallulah had not allowed Eugenia to express her grief at their father's funeral, but the older sister was now able to mourn openly. Weeping, she threw herself on Tallulah's casket.

During her life Tallulah had rebelled against the pieties of her Southern roots as much as she has honored them in the breach. Her hunger for information forced her to never stop entertaining alternatives to the certitudes of her youth. "I think this modern embalming and burial is ridiculous," she had written in 1962. She was willing to donate her eyes "or any other part of me that someone might need." But she wanted to be cremated and have her ashes scattered. "I think we all ought to be put out in the garden. . . . It would be wonderful to think that some day a flowering tree would grow around me."

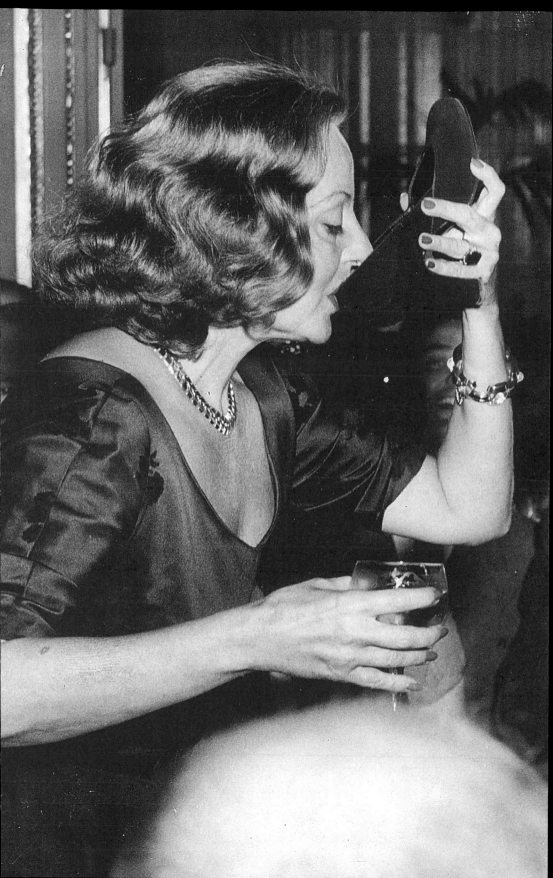

Notes

Author's note: In these notes I've tried to be as economical as possible, supplying only those attributions not given in the text. That is to say, if a letter is identified with a date in the text, I do not repeat it in the Notes. Similarly, I only provide an author's interview citation, the first time I quote from a subject's recollections.

I have not tried to correct Tallulah's idiosyncratic punctuation, nor changed reviews to make them consistent with text formatting. I have not included explicit dates for the voluminous citations of theatrical reviews from daily and Sunday newspapers. In Tallulah's time, the daily reviews invariably came out the next day after the opening, followed by the weekend reviewers. Sometimes I have consulted articles included in clippings files and scrapbooks without any identifying information, in which case I have not made any citation.

All correspondence by Tallulah and the Bankhead family, except as otherwise noted, is at the Alabama Department of Archives and History. All quotes from Eugenia Bankhead are from a taped conversation in March 1971 with Cal Schumann. All Thorton Wilder correspondence is at Beneicke Library at Yale University.

Numbers printing below refer to the page number where quotation appears.

ABBREVIATIONS:

LPA = Library of the Performing Arts at Lincoln Center
BL = Manuscript Division, British Library
SE = Bankhead, Tallulah "My Confessions," Sunday *Express* [London], March 11, March 18, March 25, 1928
TB = Bankhead, Tallulah, *Tallulah*

Lace Curtains

3 "All the Bankhead women were outspoken," interview with Kay Crow, January 1995.

4 "an old Elizabethean word," radio interview by Richard Lamparski, "High Tea with Tallulah," October 1966.

4 "Will Bankhead's diary," Alabama Department of Archives and History.

5 "a class in elocution," Alumni Affairs Office, Salem College.

5 "how she loved to doll up," included in Eugenia Rawls, *Tallulah, a Memory*. Birmingham, AL: UAB Press, 1979.

6 "prospect of twins," Tex and Jinx syndicated column, September 28, 1952.

6 "never lack for friends," letter from Marie to Tallulah, May 16, 1925.

8 "disconsolate for years," Adele Whiteley Fletcher, "Banking on Bankhead," *Photoplay*, April 1944.

8 "laughing raucously," Marie West Cromer, "Old friend recalls Tallulah as 'showoff,' showstealer," *Birmingham News*, January 8, 1990.

9 "low timbre of her voice," author's interview with Dr. Milton Reder, September 1983.

10 "I never went through any of that," Lamparski, op. cit.

10 "that's all we talked about," idem.

11 "the duck," author's interview with David Herbert, February 1993.

12 "policemen, burglars, and ghosts," SE.

12 "astonished at Tallulah's ability," author's interview with Stefanie Powers, October 1992.

12 "We were always," Lamparski, op. cit.

13 "They could not fit in," letter from Marion Bankhead to Lee Israel, LPA.

13 "place for people to give impersonations,"*New York Tribune*, October 1, 1992.

14 "I received your lovely letter," letter from Tallulah to Mrs. Bankhead, November 12, 1915.

15 "Grandmother was very old fashioned," Helen Orsmbee, "Miss Bankhead Leaves Art Out of It," *New York Herald Tribune*, April 17, 1938.

16 "She had promised to wait," "A Bantam from Alabama," *Photoplay,* March 1919.

16 "the best cure," *Billboard*, September 10, 1921.

16 "my father's godchild," William M. Drew, *Speaking of Silents*. New York: Vestal Press Ltd., 1989.

16 "a *force* in her," letter from Marie Bankhead to Ernest V. Heyn, editor of *Modern Screen*, January 25, 1932.

Debutante

20 "what sort of film this is," *Variety*, February 15, 1918.

20 "like you meant business," letter from Will to Tallulah, February 19, 1918.

20 "I thought it a terrible thing," SE.

20 "Bankhead characteristic," letter from Marie Bankhead to Edie Smith, March 28, 1932.

20 "enjoyed the floor show," Lamparski, op. cit.

21 "so intelligent and so amusing," author's interview with Ann Andrews, November 1982.

22 "I have made my debut," letter from Tallulah to Mrs. Bankhead, March 16, 1918.

22 "selfishness, vanity and rapacity," *Theatre* magazine, May 1918.

22 "the privileged Hattons," "A Bantam from Alabama," op. cit.

22 "with sincerity and feeling," *Motion Picture News*, June 15, 1918.

22 "brains are better than experience," quoted in TB.

22 "excellent acting," *Motion Picture World*, November 23, 1918.

22 "the great beau of Washington," Lamparski, op. cit.

23 "And there was this Tallulah," interview with Estelle Winwood, August 1982.

23 "as though I was the most important person," unpublished interview with Estelle Winwood, transcript supplied by Robert Henderson.

24 "I was such an idiot," Lamparski, op. cit.

24 "She didn't look right," author's interview with Dorothy Dickson, February 1982.

25 "I am nearly dead now," February 8, 1919.

25 "in time to have supper with Jobena," letter from Mrs. Cauble to Louise, quoted in a letter from Louise to Captain John, April 23, 1919.

27 "It is a fine thing," letter from Will to Tallulah, February 19, 1918.

27 "I am giving up pictures," letter from Tallulah to Will, 1919.

29 "Why are you an Equity member?" *Billboard*, op. cit.

29 "charged with the conviction," TB.

29 "to tour was to quote oblivion," TB.

30 "she felt uneasy," unpublished transcript, read at the Player's Club library.

Making Her Way

33 "I wanted to spare you any anxiety," letter from Tallulah to Captain John, January 1920.

33 "I will keep my eye on the girls," letter from Henry Bankhead to Captain John, January 8, 1920.

33 "to save some expense," letter from Will to Florence, January 21, 1920.

33 "If you can't get what you want," letter from Will to Tallulah, February 19, 1920.

34 "Tallulah needs new clothes," letter from Will to Marie, February 26, 1920.

34 "your heart and your purse need a rest," letter from Tallulah to Captain John, February 1920.

34 "a peculiar child," letter from Captain John to Darwin James, Jr., December 2, 1919.

34 "a dear little apartment," letter from Tallulah to Mrs. Bankhead, May 1920.

35 "had talked up Tallulah," Zoë Akins, "Happy Birthday, Dear Tallulah," *Town and Country*, January 1951.

36 "the teaching of acting was still in its infancy," Steve Vineberg, *Method Actors: Three Generations of an American Acting Style.* New York: Schirmer Books, 1991.

37 "the stage itself was the best place," *Zit's Weekly Newspaper*, April 9, 1921.

I'm a Lesbian, What Do You Do?

40 "If you have any shoes or stockings," letter from Tallulah to Mrs. Bankhead, fall 1920.

40 "I have missed you so much," letter from Tallulah to Mrs. Bankhead, October 9, 1920.

41 "much too charming," letter from Tallulah to Mrs. Bankhead, October 19, 1920.

41 "No wonder Scotty wants you," Rachel Crothers, *Nice People*. New York: Brentano's, 1921.

42 "I have been busy every minute," letter from Tallulah to Mrs. Bankhead, February 28, 1921.

42 "might have daunted Shakespeare," *The Weekly Review*, April 13, 1921.

42 "a pleasant and mythical world," *The Bookman*, May 1921.

42 "All the assisting parts," *Theatre* magazine, May 1921.

42 "the despair of her elders," *Vanity Fair*, July 1921.

42 "in the way of a career," *Zit's Weekly Newspaper*, op. cit.

42 "I want emotional roles," "On Stage Two Years, Miss Bankhead's Career Promising," *New York Telegraph*, April 10, 1921.

43 "I'm a lesbian. What do you do?," author's interview with Fiona Hale, June 1993.

43 "I have been a nervous wreck," letter from Tallulah to Mrs. Bankhead, May 8, 1921.

44 "quite a few of the boys," December 1963 radio interview with Paul Berman, WBAL, Baltimore.

45 "I feel that they are all my daughters," Rachel Crothers interview by Colgate Baker, unidentified clipping, LPA.

45 "to displace the eternal triangle," *Baltimore News*, November 1, 1921.

46 "the stupidity of life itself," ibid.

46 "an ideal choice," *Christian Science Monitor*, December 6, 1921.

46 "kings and queens are really kind of a joke," Rachel Crothers, *Everyday*, typescript in Museum of the City of New York Theatre Collection.

47 "There's someone!," interview with Ruth Hammond, February, 1979.

48 "worth the price of admission," *Baltimore News*, June 20, 1922.

49 "You look like a human rummage sale," Martin Brown, *The Exciters*, typescript, LPA.

50 "an engaging touch of reality," unidentified clipping, LPA.

50 "If you don't say she is great," *The New York Globe*, September 23, 1922.

50 "sophomoric Young Intellectual," unidentified clipping, LPA.

50 "nonchalant and insolent," *The New York Tribune*, October 1, 1922.

Madcaps in London

53 "taking a chance on me," Berman, op. cit.

54 "a wise old man," idem.

54 "a fair chance of being engaged," letter from Will to Marie, January 1923.

55 "I thought I was going to Mars," Berman, op. cit.

55 "she had no occupation," Scotland Yard files.

56 "The telephone's just rung," Estelle Winwood, University of Southern California symposium, "Tallulah," March 25, 1977.

56 "what a sensation it made," author's interview with Una Venning, January 1982.

58 "shuffled around the floors," Frances Donaldson, *New York Times Book Review*, September 15, 1991.
59 "Although naturally temperamental," SE.
61 "Mrs. Patrick Campbell recalled," author's interview with Charles Bowden, November 1992.

Naps

64 "I started to walk down the stairs," John Churchill Aubrey, "Love—and What Then?" *Picturegoer Weekly*, May 21, 1932.
65 "a dog at the table," interview with Douglas Fairbanks Jr., July 1992.
66 "obsessed with death," correspondence with Paul Busby, 2002.
67 "All my theories go to pieces," Hubert Parsons [Gerald du Maurier and Viola Tree], *The Dancers*, typescript, BL.
70 "since the days of Mrs. Langtry," W. Macqueen-Pope, *The Footlights Flickered*. London: H. Jenkins, 1959.
70 "A very beautiful and charming young lady," letter from Gerald du Maurier to Will, March 5, 1923.
70 "I have not become a snob," letter from Tallulah to Will, spring 1923.
72 "paying marked attention," *Zit's Weekly Newspaper*, June 29, 1923.
72 "Gerald adored her," author's interview with Gladys Henson, January 1982.
72 "the most divine woman," letter from Tallulah to Will, spring 1923.
73 "the most beautiful woman," author's interview with Stephan Cole, November 1982.
74 "I dreamed of being a star," Denis Brian, *Tallulah, Darling*.
75 "frequently in the company," Michael Baker, *Our Three Selves: The Life of Radclyffe Hall*. London: Hamish Hamilton, 1985.
75 "sang really bawdy songs," author's interview with Quentin Crisp, January 1993.
75 "I want my Tallulah baby!," author's interview with Anton Dolin, August 1978.

Risky Behavior

76 "I had been especially cast," SE.
77 "a serious young actress," included in Gill, op. cit.
77 "a series of romantic plays," *The Era*, March 26, 1924.
77 "a silent figure scrubbing floors," Edward Knoblock, *Conchita*, typescript, LPA.
78 "the monkey scored his success," SE.
78 "we stole the play," author's interview with Clifford Mollison, February 1982.
79 "a great admiration for Tallulah Bankhead," *New York Post*, April 26, 1924.
79 "I felt rewarded," SE.
80 "stung by the play's failure," Edward Knoblock, *Round the Room*. London: Chapman and Hall, 1939.
80 "the most obscene thing," author's interview with Waldemar Hansen.
80 "tears of shame," Tallulah Bankhead, "Tallulah's Almanac," *Show Business*, January 2, 1962.
82 "How clever she is," author's interview with Cathleen Nesbitt, August 1978.
82 "We saw a great deal of Tallulah," letter from Will to Marie, August 8, 1924.
83 "an eloquent defense of his cause," Allene Tupper Wilkes, *The Creaking Chair*, published script, Samuel French.

84 "was far too well informed," author's interview with Joseph O'Donohue, February 1993.

86 "quasi-maternal," author's interview with Kenneth Carten, August 1978.

Modern Wives

87 "She was so magnificent," Berman, op. cit.

88 "a habit of pretending indifference," Basil Dean, *Seven Ages: An Autobiography, 1888–1927*. London: Hutchinson, 1970.

88 "I simply broke down and laughed," SE.

89 "Frustrated and miserable," TB.

89 "I had the bother," letter from Maugham to Bertrani Alanson, May 17, 1975. Ted Morgan, *Maugham*. New York: Simon & Schuster, 1980.

90 "if she needed more time," SE.

90 "I don't give a good godamm," TB.

91 "came flying into rehearsals, Noël Coward, *Present Indicative*.

93 "psycho-analytic neurotics," Coward, Noël, *Fallen Angels*, typescript, LPA.

93 "the impudently witty lines," Seymour Hicks, *Night Lights: Two Men Talk of Life and Love and the Ladies*. London: Cassell, 1938.

94 "sweetest and nicest," SE.

94 "Best was rather awed by Tallulah," author's interview with Sarah Marshall, October 1994.

95 "never drank so much so fast," *Show Business*, op. cit.

95 "She was totally undisciplined," author's interview with Lord Jeffrey Amherst, January 1982.

95 "Coward later claimed," Peter Daubenay, *My World of Theatre*. London: Jonathan Cape, 1971.

95 "a minor, controlled spat," S. N. Behrman, *People in a Diary*. Boston: Little, Brown, 1972.

95 "And I thank Noël for that," John Kobal, *People Will Talk*. New York: Alfred A. Knopf, 1986.

Femme Fatale

96 "I was born in love," SE.

99 "I despise our England," Michael Arlen, *The Green Hat*, typescript, LPA.

99 "spending considerable of her spare London moments," *New York World*, December 21, 1924.

99 "I was very shy," author's interview with Barbara Dillon, February 1982.

100 "dignity and air of tragedy," *Theatre World*, October 1925.

102 "I couldn't bring myself to speak the stuff," John Hobart, "The Speaker's Daughter Takes the Floor," *San Francisco Chronicle*, September 18, 1938.

102 "the play was undoubtedly bad," SE.

102 "as realistic and as natural," Lamparski, op. cit.

103 "I do not personally think," SE.

104 "the most creative and original thing," Kobal, op. cit.

Something Different

105 "Jack was very good to them," author's interview with Bernard Bashwitz, February 1982.
105 "unlike that enjoyed by any other actress," *Theatre World*, September 1928.
106 "the embodiment of their dreams," Dean, op. cit.
107 "I always found Tallulah extremely charming," Patrick Hastings, *The Autobiography of Sir Patrick Hastings*. London: W. Heinemann, 1948.
108 "one of the most mordant portraits," Patrick Hastings, *Scotch Mist*, published script, Duckworth.
110 "Stop giggling, Tallulah," author's interview with Glenn Anders, March 1981.
110 "giving them every inflection and tone," John Gielgud, *Early Stages*. New York: Macmillan, 1939.
115 "Why should I go?" Sidney Howard, *They Knew What They Wanted*, published script, Doubleday, Page.

Skylarking

118 "Angry Young Men Playwrights," author's interview with Silvio Narrizano, January 1982.
118 "Over here they like me to Tallulah," Milton Bronner, "American Girl Fibs Her Way into Britain's Highest Favors," unidentified newspaper, August 29, 1926, LPA.
118 "the finest role ever written," *New York Telegraph*, April 10, 1921.
120 "all the music in Romeo and Juliet," *The Graphic*, February 28, 1928.
121 "I worked myself woozy," Jack F. Sharrar, *Avery Hopwood, His Life and Plays*. Jefferson, NC, and London: McFarland and Company, 1989.
121 "he is only here for a couple of days," *New York American*, October 8, 1926.
121 "bloody awful," author's interview with John Perry, February 1982.
121 "In spite of its shortcomings," Avery Hopwood, *The Gold Diggers*, typescript, LPA.
124 "which I think is rather remarkable," Sharrar, op. cit.

Sex Plays

126 "Williams had had other affairs," author's interview with Robert Flemyng, February 1982.
128 "a sensation in Berlin," *New York Herald Tribune*, August 26, 1926.
128 "that eccentric old fossil," Avery Hopwood, *The Garden of Eden*, typescript, LPA.
129 "the cost will be too great," *Theatre World*, July 1927.
130 "Hold up your shoulders," Tallulah Bankhead, "Actress," included in *The Theatre Handbook and Digest of Plays*, edited by Bernard Sobel. New York: Crown, 1940.
130 "some of the dialogue is delicious," *The Graphic*, June 11, 1927.
131 "as good as might be expected," *Film Weekly*, February 11, 1929.
131 "I was sick of this type of play," SE.
131 "You never knew whether he was talking to you," author's interview with Charles Bennett, December 1992.

132 "they decided instead on Blanche Sweet," *Variety*, February 29, 1928. But it was Greta Garbo who eventually starred in MGM's *A Woman of Affairs*, the film based on *The Green Hat*.

133 "Get that Bankhead broad off my back," Raymond Massey, *A Hundred Different Lives: An Autobiography*. Boston: Little, Brown, 1979.

136 "I was tremendously glad," SE.

Surveillance

137 "compounded of mud," Benn Levy, *Mud and Treacle*, typescript, BL.

139 "I'm sure they got along," author's interview with Robert Harris, February, 1982.

140 "it is impossible to hear what is said," *Theatre World*, December 1927.

141 "She had a lot of fun," author's interview with Ben Welden, January 1994.

143 "The highlight of the play," P. G. Wodehouse and Valerie Wyngate, *Her Cardboard Lover*, typescript, LPA.

143 "devoid of a single witty line," Michael Mok, "Dammit! Write a Good Play! I'll Buy It! Shouts Tallulah," *New York Post*, May 5, 1935.

Betrayals

148 "reverse the performance of Lady Astor," quoted in TB.

148 "seem to be pretty close on Tallulah's heels," letter from Marie to Will, January 1929.

148 "where did you get that marvelous voice?" Taped recollection by Sara Mayfield, ca. 1970, sent to Cal Schumann. Mayfield was planning a book on Tallulah, but died without completing it.

149 "Tallulah sent Will a telegram," letter from Will to Marie, January 11, 1929.

149 "it was the best thing you could have done," letter from Tallulah to Will, March 1, 1929.

149 "I broke all previous records," letter from Tallulah to Will, September 1929.

150 "kept crowding in," idem.

151 "no need to worry," author's interview with George Howe, January 1982.

156 "On the basis of its script," Arthur Wimperis, *He's Mine*, typescript, BL.

156 "girls will be boys!" *Theatre World*, December 1929.

Constrained by Crinolines

157 "My dear Tallulah," unpublished memoir by Harry Ellerbe.

158 "the Americanisation of the London stage," *Theatre World*, April 1928.

159 "by means of a trick," *The Stage* [London], December 5, 1929.

160 "I've undressed in but two plays," Ward Morehouse, "The Blonde Tallulah Bankhead and the Place She Holds in the London Theater," *New York Sun*, May 3, 1930.

160 "Looking like Queen Victoria," author's interview with Joan Matheson, January 1982.

160 "I had a ghastly time," *San Francisco Chronicle*, op. cit.

161 "a lover of poet Siegfried Sassoon," Philip Hoare, *Serious Pleasures: The Life of Stephan Tennant*. London: Hamish Hamilton, 1990.

161 "a tiny little thing," author's interview with Ellen Pollock, February 1982.

163 "Does he love me, I wonder?" *Camille*, English translation by Edith Reynolds and Nigel Playfair, published script, Ernest Benn.

163 "still take a hideous delight," *Our Theatres in the Nineties*, London: Constable and Co., 1932.

London Farewell

166 "London's my home," Morehouse, op. cit.

167 "men may come and men may go," Rachel Crothers, *Let Us Be Gay*, published script, Samuel French.

171 "throwing technique to the winds," St. John Ervine, "At the Play: Miss Bankhead Turns the Tide," *New York World*, September 23, 1928.

173 "always a profligate spender," Frances Marion, *Off with Their Heads: A Serio-Comic Tale of Hollywood*. New York: Macmillan, 1972.

173 "beady eyes for all the various stars," author's interview with Sam Jaffe, June 1992.

173 "a bit nearer to my favorite man," letter from Tallulah to Will, fall 1930.

174 "I am frightfully well," Gill, op. cit.

174 "Fresh from her bath," Sunday *Express*, fall 1930.

175 "It is all slight but noisy," *London Times*, December 19, 1930.

175 "a most divine thing to have said of you," William McKegg, "A Lady for Legends," *Pictureplay*, May 1932.

Paramount

179 "Don't let ambition kill you," letter from Florence to Tallulah, dated "Thursday," [fall 1941], included in Rawls, op. cit.

179 "We're all working for money," "Here *Comes* Tallulah!" *Photoplay*, May 1931.

180 "I was full of inhibitions," Gladys Hall, "Has Hollywood Turned a Cold Shoulder on Tallulah Bankhead?" *Motion Picture Story* magazine, August 1932.

180 "I sounded so affected," Lamparski, op. cit.

180 "St. Vitus's dance," Kobal, op. cit.

180 "still adjusting," letter from Marie to John Emery, May 10, 1938.

180 "I am sure you need no help," letter from Marie to Tallulah, January 22, 1931.

180 "I would love very much," letter from Marie to Will, January 22, 1931.

181 "made a hit," letter from Marie to Will, March 7, 1931.

182 "I can't bear to watch it," Louis Sobol, *The Longest Street*. New York: Crown, 1968.

182 "I managed to get out of the theatre," Hall, op. cit.

182 "in a poor picture," *New York American*, April 30, 1931.

183 "I lost a certain naturalness," Kobal, op. cit.

183 "trying to 'do a Garbo,'" Hall, op. cit.

183 "an ordinary young actress," D.C.M., *The New Yorker*, May 9, 1931.

183 "You will never know," letter from Marie to Tallulah, May 2, 1931.

183 "heavy comedian," idem.

184 "You are the life line," letter from Marie to Tallulah, June 19, 1931.

184 "I miss your motherly presence," letter from Edie Smith to Marie, August 2, 1931.

184 "all of us connected with it," author's interview by Marguerite Tazelaar, *New York Herald Tribune*, May 24, 1931.

184 "self-consciously eccentric," author's interview with George Abbott, September 1982.

185 "I want to take this opportunity," letter from Mrs. Locke to Will, July 17, 1931.

186 "offers additional evidence," *Film Daily*, September 6, 1931.

186 "MAKE ANY ARRANGEMENTS ABOUT YOU," telegram from Tallulah to Marie, October 23, 1931.

187 "Perhaps I shouldn't say that," letter from Edie Smith to Marie, December 30, 1931.

187 "Eugenia has a good imagination," letter from Edie Smith to Marie, December 19, 1931.

189 "what a star," letter from Edie Smith to Marie, December 30, 1931.

Hollywood

191 "she looks like a film star," *Graphic*, March 10, 1928.

191 "we seem to want to give her the boot," Elizabeth Wilson, "The Toughest Break in Pictures," *Silver screen*, February 1932.

192 "if Tallulah had stayed in London," *Picturegoer Weekly*, quoted in idem.

192 "Some of the angles used," *Variety*, March 21, 1928.

192 "her mouth didn't look graceful," Gavin Lambert, *On Cukor*. New York: G.P. Putnam's Sons, 1972.

193 "I never found it," author's interview with Artie Jacobson, May 1992.

193 "I never get used to myself," *Photoplay*, Dorothy Spensley, "A Sizzling Comet Among the Twinkling Stars," unidentified clipping courtesy of Tony Grillo.

194 "it is very fortunate," letter from Marie to Tallulah, January 28, 1932.

194 "steady and unextravagant," *London Times*, July 18, 1932.

Gary Cooper and Others

200 "You call that acting?" Frances Marion, op. cit.

201 "something out of the ordinary," *New York Times*, August 31, 1932.

201 "reality and poignancy," *Daily News*, August 31, 1932.

202 "no one seems to know what they are doing," letter from Edie Smith to Marie, July 27, 1932.

I Want a Man!

203 "a swift impersonation of Sarah Bernhardt," Marcella Burke, "The Truth About Tallulah," *Screen Book*, January 1933.

206 "Clara Bow tooling around Hollywood," interview with Lina Basquette, October 1993.

208 "had reprimanded Hall," *Time*, August 22, 1932.

208 "You have made your own reputation," letter from Marie to Tallulah, May 13, 1931.

208 "He was going to write to you," letter from Marie to Tallulah, August 13, 1932.

208 "I SHALL REFUSE ALL MAGAZINE INTERVIEWERS," telegram from Tallulah to Marie, August 6, 1932.

208 "as loving and devoted a father," letter from Marie to Tallulah, August 13, 1932.

211 "The reason I use my lids as I do," Dorothy Spensley, op. cit.

211 "I honestly feel it is good," Marcella Burke, op. cit.

211 "the fate of Faithless," *Variety*, August 30, 1932.

211 "neither is capable of disguising it," Thornton Delehanty, November 21, 1932.

211 "Put me on a lighted stage," *Silver Screen*, op. cit.

Back on Broadway

213 "I'm still an optimist," "Miss Bankhead Comes to Town," *New York Sun*, December 5, 1932.

215 "a department of utter confusion" author's interview with Jean Dalrymple, December 1992.

215 "I should have played to the audience," *New York Herald Tribune*, May 7, 1933.

217 "Maybe I'll join the circus!" Edward Barry Roberts, and Fred Morgan Cavett, *Forsaking All Others*, typescript.

217 "until three and four in the morning," *The Stage* [New York], May 1933.

217 "has to hold herself back," idem.

218 "the two boys join her," author's interview with Fayard Nicholas, March 1993.

219 "not been at all well," letter from Will to Tallulah, March 24, 1933.

Disaster

220 "she will not play simple women," *The Stage* [New York], April 1933.

221 "Bette Davis's waitress role," unpublished transcript, read at the Player's Club Library.

221 "She's such a sport," *Evening Post*, August 26, 1933.

223 "something ferocious about the loyalty," *Telegraph*, September 20, 1933.

223 "All I want in the world," *New York Sun*, September 20, 1933.

223 "all this time the doctors promised," letter from Edie Smith to Will, December 1, 1933.

225 "Normal women go into melancholia," author's interview with George Hyland, August 1992.

226 "I have been having an affair with Tallulah Bankhead," Laurence Whistler, *The Laughter and the Urn*. London: Weidenfeld and Nicolson: 1985.

227 "even so talented an actress," *The Stage* [London], June 21, 1934.

228 "a great burden on me," letter from Will to Tallulah, June 23, 1934.

228 "THIS REALLY IS WORTH YOUR WHILE," telegram from Jock Whitney to Tallulah included in E. J. Kahn, *Jock: The Life and Times of John Hay Whitney*. Garden City, N.Y.: Doubleday, 1981.

Recovery

230 "filming *Dark Victory* with Garbo," Ronald Haver, *David O. Selznick's Hollywood*. New York: Alfred A. Knopf, 1980.

230 "We get along splendidly," Lucius Beebe, "Robert Milton: The Director's Art and Mystery," *New York Herald Tribune*, November 4, 1934.

232 "could not experience an orgasm," Sandy Campbell, *B: Twenty-nine Letters from Coconut Grove*. Verona, Italy: Verona, 1974.

232 "reading through the night," Burke, op. cit.

236 "nearly all of my friends," *New York Tribune*, February 17, 1935.

236 "I'm in quite a spot," "Miss Bankhead Fears Ghost of Jeanne Eagels," unidentified clipping, LPA.

236 "seeming to borrow anything," *New York Tribune*, February 17, 1935.

236 "the bravest or the most conceited," *Philadelphia Ledger*, February 2, 1935.

236 "as good an opening night performance." In the April 1956 *Woman's Day*, Tallulah wrote: "The fate of a play and its actors rests on the first New York performance. Wearied by rehearsals, demoralized by the boorish first-night audience, many players mess up the play and their performance A week later they'll be relaxed and at the top of their form. But a week later doesn't count."

237 "willing to accept negative criticism," author's interview with Elliot Norton, October 1995.

238 "with all her strength," *New York Sun*, March 13, 1935.

238 "completely be guided by him," author's interview with John Kenley, May 1993.

239 "back to the plate," *Life*, July 1935.

239 "I'll make you a proposition," Michael Mok, *New York Post*, May 4, 1935, op cit. *Something Gay* continued to be performed in summer stock over the next decade, however.

Jock

241 "I regret having to quote the scriptures," Margaret Brenman-Gibson, *Clifford Odets, American Playwright: The Years from 1906 to 1940*. New York: Atheneum, 1981.

241 "some men as well," Charles Higham, *Cary Grant: The Lonely Heart*. New York: Harcourt Brace Jovanovich, 1989.

241 "I can't quite make out," ibid.

241 "She answered the door stark naked," Burgess Meredith, *So Far, So Good: A Memoir*. Boston: Little, Brown, 1994.

243 "He knew exactly what would work," author's interview with Anne Meacham, June 1993.

243 "as soon as you begin drawing that armchair up to the fire," *Reflected Glory*, published script, Samuel French.

245 "Most of the letters," author's interview with Marcella Rabwin, January 1994.

246 "panting like a little old lady," Michael Mok, "Dash It, Tallulah's Turned Pure!" *New York Post*, October 5, 1936.

247 "I had everything I wanted in London," unidentified clipping, LPA.

247 "fascinating and restful," letter from Tallulah to Will, February 27, 1937.

247 "I will send her something," letter from Tallulah to Will, November 1936.

247 "it seemed like a lifetime companion," author's interview with Dorothy Manners, January 1994.

248 "The tests are very promising," December 24, 1936, included in Rudy Behlmer, *Memo From David O. Selznick*. New York: Viking Press, 1972.

248 "every word is distinct," January 14, 1937.

249 "In a way I'm disappointed," letter from Tallulah to Will, February 27, 1937.

Getting Married

253 "the more your independence is threatened," interview by Gertrude Bailey, unidentified clipping, LPA.

254 "I nearly dropped dead," Winwood, unpublished interview, op cit.

255 "bemoaned the fact that he had never married her," Cecil Beaton, *The Wandering Years: Diaries 1922–1939*. Boston: Little, Brown, 1961.

256 "I am just an Alabama hillbilly," *The Literary Digest*, May 29, 1937.

256 "MY VERY WISE AND LOVELY SUMMER," telegram from Tallulah to George Cukor, July 6, 1937, posted on eBay, April 2004.

258 "He could be pretty rough," Brian, op. cit.

258 "Tallulah had once struck him," *Time*, November 22, 1948.

258 "the First Gold Digger," Hicks, op. cit.

258 "love-menace," Lily Mae Caldwell, *Birmingham News-Age Herald*, September 2, 1937.

261 "both gorgeous to look at," author's interview with Charles Crow, January 1995.

261 "She turned a lot of people off," interview with Barbara Bankhead Oliver, January 1995.

261 "He was pretty strait-laced," author's interview with Charlotte Taggert, January 1995.

262 "You know he's a bit mad," Caldwell, op. cit.

263 "I shall do all in my power," letter from John Emery to Marie dated "Thursday," [September, 1937].

Cleopatra Pissed

264 "*Variety* was reporting," *Variety*, September 1, 1937.

264 "I'm tired of hearing about it," *New York Post*, September 2, 1937.

265 "I believe you must be natural," Sobel, op. cit.

266 "must have had a lively sense of humor," *Rochester Democrat and Chronicle*, October 13, 1937.

266–67 "blood-curdling ineptitude," Margaret Webster, *Don't Put Your Daughter on the Stage*. New York: Alfred A. Knopf, 1972.

Serving Time in Drawing Rooms

275 "worst enemy," David Herbert, *Second Son: An Autobiography*. London: Owen, 1972.

277 "Sheldon proposed," E. W. Barnes, *The Man Who Lived Twice: The Biography of Edward Sheldon*. New York: Scribner, 1956.

277 "she looked all of sixteen," Hedda Hopper, syndicated column, February 27, 1944.

277 "I know just what to leave out," Edward Knoblock, *Round the Room*. London: Chapman and Hall, 1939.

277 "other people have all the laughs," Orsmbee, April 17, 1938, op. cit.

278 "magnificent," idem.

278 "just lie back on the author," author's interview with Robert Henderson, August 1982.

280 "I can't be happy in a part," *San Francisco Chronicle*, September 18, 1938.
280 "a crowd of surpassing size," *Los Angeles Times*, August 23, 1938.
280 "calling for water," *Los Angeles Herald-Express*, August 23, 1938.
280 "What passes for acting," Tallulah Bankhead, "My Friend, Miss Barrymore," *Colliers*, April 23, 1949.
281 "I can't rest on my laurels," *Los Angeles Examiner*, August 6, 1938.

The Little Foxes

285 "I never got personal with Herman," author's interview with George Slavin, October 1994.
286 "He has done more than interpret these plays," Lillian Hellman, Introduction to *Six Plays*.
286 "both very nervous about her," Gary Blake, *Herman Shumlin: The Development of a Director*. New York: City University of New York, 1973.
287 "wonderful vitality. . . ." Michael Mott, "The Man Who Made a Hit for Tallulah Just Made Her Forget She Was a Star," *New York Post*, February 28, 1939.
287 "as though he knew he had a classic," author's interview with Florence Williams, February 1992.
289 "seething under the surface," *New York Herald Tribune*, February 12, 1939.
290 "Didn't I have a letter from," *The Little Foxes* published script, Random House.
291 "try to find the comedy," John Gielgud, *The New York Times*, October 28, 1993.
291 "I was very close to that character," author's interview with Joseph Campanella, July 1994.

Triumph

299 "taking more interest than he usually does," *New York Sun*, February 22, 1939.
300 "how I wish you were here," quoted in Emanuel Levy, *George Cukor: Master of Elegance: Hollywood's Legendary Director and His Stars*. New York: Morrow, 1994.
302 "you have your life to live," included in Rawls, op. cit.
304 "I'm going to start art classes," unpublished memoir by William Skipper.
306 "it is hard for me to keep in character," included in Gill, op. cit.

Tilting Her Lance

309 "why safety devices weren't installed," biography of Shumlin issued by his office, LPA.
311 "mingled serious appeals for restoration," *The New York Times*, June 21, 1939.
312 "I've adopted Spanish Loyalist orphans," *New York Times*, January 20, 1940.
312 "defrayed the expenses of their resettlement," Tallulah Bankhead, as told to Henry La Cossitt, "My Daughter, Barbara," *Collier's*, April 1954.
312 "thrilled beyond words," letter from Tallulah to Will, January 11, 1940.
313 "delighted with the very fine newspaper notices," letter from Will to Tallulah, March 11, 1940.
313 "so called National Sharecroppers Week," ibid.
314 "many of them would also withdraw," letter from Tallulah to National Sharecroppers' Week, March 20, 1940.

314 "I hope it meets with your approval," letter from Tallulah to Will, January 1940.
317 "an avowed Communist," *New York Times*, July 9, 1940.
317 "it sounded as if she were bribing God," Rawls, op. cit.
318 "I know that you are extremely busy," letter from Will to Tallulah, June 10, 1940.

Losses

319 "Will had asked," idem.
321 "I just *hate* her!," author's interview with Tamara Geva, March 1993.
321 "a 'great drive,'" *The Washington Post*, September 16, 1940.
321 "seething with indignation," letter from Marie to Will, July 19, 1940.
321 "Except for," letter from Will to Marie, July 23, 1940.
323 "abdominal hemorrhage," *Washington Post*, ibid.
323 "He was a strong partisan," idem.
323 "a victim of his profound sense of loyalty," idem.
323 "when I saw her eyes," Rawls, op. cit.
323 "I am just coming round to normal," Tallulah to Mark Barron, October 14, 1940, LPA.
324 "for two uninterrupted years," Tallulah Bankhead, "My Life with Father," *Coronet*, November 1951.
324 "that always worried her," author's interview with William Roerick, March 1982.
324 "We haven't enough confidence," Fletcher, op. cit.
324 "how sorry I was," letter from Lillian Hellman to Tallulah, September 1940.
325 "Her ugliness towards me," letter from Herman Shumlin to Florence Williams, December 25, 1976.
325 "later on in the run of the play," conversations With Lillian Hellman.
325 "she threw everything detachable," Lawrence Quirk, *Fasten Your Seatbelts. The Passionate Life of Bette Davis*. New York: William Morrow, 1990.
327 "completely matched the excellence," *Washington Post*, March 18, 1941.
328 "a man of sterling quality," Marie to Tallulah, June 30, 1948.
328 "I go up to see him," *Brooklyn Daily Eagle*, November 29, 1942.
329 "everything and anything was discussed," Ellerbe, op. cit.
330 "She used to hang around," author's interview with Ben Edwards, April 1992.

Drama by the Kitchen Sink

331 "sympathetic to its aims," *The New Yorker*, January 22, 1938.
332 "a role so brash and grubby," "Billy Rose Stages Explosive Sex Tragedy," *Life*, November 24, 1941.
333 "never have been in that play," author's interview with Katherine Locke, December 1993.
334 "You must be conscious of yourself," Hughes, Kathleen, "Leading—and Vibrant—Leading Ladies," *New York Times Magazine*, January 4, 1942.
335 "They've got money, cars, and chauffeurs," *Clash by Night* typescript, LPA.
337 "that she pulled through," *New York World Telegram*, November 29, 1941.
338 "was too much of a lady," Polly Rose Gottlieb, *The Nine Lives of Billy Rose*. New York: Crown, 1968.
341 "the kind of lady she was," interview with Phil Weltman, July 1995.

Multiple Personalities

343 "I hate this play and every word in it," *The Skin of Our Teeth*, published script, Harper & Bros.

343 "They have sent me this script," Helen Hayes, *My Life in Three Acts*. New York: Harcourt Brace Jovanovich, 1990.

343 "SO PROUD TO BE IN YOUR WONDERFUL PLAY," telegram from Tallulah to Thornton Wilder, August 17, 1942.

344 "a rather maternal approach to me," author's interview with Isabel Wilder, November 1992.

344 "the one serious beau," author's interview with Richard Goldstone, March 1993.

345 "lost mileage," author's interview with Robert Whitehead, March 1993.

345 "always trying to get somewhere," Brenman-Gibson, op. cit.

346 "he was terribly at sea," author's interview with Joan Shepard, June 1992.

346 "Kazan did not have what was necessary," Gilbert Harrison, *The Enthusiast: A Life of Thornton Wilder*. New York: Liveright, 1983.

347 "It was a collaborative effort," author's interview with Frances Heflin, August, 1983.

348 "a terrifying part in the beginning," Paul Berman, op. cit.

348 "I got a bleak feeling," Tallulah to Earl Wilson, *New York Post*, fall 1942.

348 "don't seem to the audience to be the author's contrivances," Thornton Wilder to Tallulah, fall 1942, quoted in a letter from Tallulah to Michael Myerberg, October 28, 1942, Beinecke Library.

348 "It's really the old Chinese technique," unidentified radio interview in Princeton, New Jersey, June 1949.

348 "a novel thing to an American audience," idem.

348 "a minute in the theater is longer," idem.

349 "most people had left," author's interview with Dick Van Patten, November 1992.

349 "I have been awakened from my troubled sleep," included in Kazan, op. cit.

350 "LOVING EACH OTHER AND THE PLAY," Tallulah to Thornton Wilder, October 18, 1942, Beinecke.

352 "Isabel and I are Ruth and Naomi," Tallulah to Thornton Wilder, November 10, 1942.

353 "I am almost ready to give up the ghost," Tallulah to Thornton Wilder, idem.

354 "I'm so glad to be playing comedy," Helen Orsmbee, "New Drama, and Comedy Role, A Delight to Tallulah Bankhead," *New York Herald Tribune*, November 15, 1942.

Chatelaine

356 "I was very touched by your gift," letter from Elia Kazan to Tallulah, included in TB.

358 "Oh, she loved flowers," author's interview with Sylvester Oglesby, November 1992.

358 "I'd like to do something in private," undated column, "Only Human, by Emily Cheney," LPA.

359 "what I can do with this part," taped recollection by Estelle Winwood, December 1968.

360 "has been everywhere," unidentified clipping, LPA.

360 "always calm and good-natured," ibid.

362 "I haven't got a shirt," *Detroit News*, September 2, 1943.

362 "take such punishment," *Liberty*, February 26, 1944.

362 "supremely assured and appealing," Archer Winston, *New York Post*, January 13, 1944.

363 "a sneaking suspicion," *New York Times*, January 13, 1944.

363 "Von Stroheim types," Otis L. Guernsey Jr., "Miss Bankhead for the Defense," *New York Herald Tribune*, February 4, 1944.

365 "I thought you were a liberal," Irving Drutman, *Good Company: A Memoir, Mostly Theatrical*. Boston: Little, Brown, 1976.

Work and Play

369 "he'll steal every scene from me," Elizabeth Wilson, "Tallulah's Royal Scandal," *Silver Screen*, February 1945.

369 "a completely different person," *Preminger: An Autobiography*. Garden City, N.Y.: Doubleday, 1977.

370 "He loved the whole experience," author's interview with Lon McAllister, December 1992.

371 "oddly dull and witless," *New York Times*, March 12, 1945.

Flights of Fancy

375 "could match Tallulah," Lawrence Langner, *The Magic Curtain: The Story of a Life in Two Fields, Theatre and Invention, by the Founder of the Theatre Guild*. New York: Dutton, 1951.

375 "I'm still just Sophie Wing," Philip Barry, *Foolish Notion*, published script in Burns Mantle, ed., *The Best Plays of 1944–45*.

375 "thoroughly bewildering," *Boston Post*, February 6, 1945.

379 "the kind of figure," *Variety*, October 3, 1945.

Bested by Brando

384 "in some ways an odd choice," Jean Cocteau, translated by Ronald Duncan, *The Eagle Has Two Heads*, playscript, LPA.

385 "I'll break my nose," author's interview with Eleanor Wilson, July 1992.

385 "He hated acting," author's interview with Herbert Kenwith, September 1994.

386 "a performance far surpassing," author's interview with Martin Manulis, April 1993.

387 "he was really magnificent," *Show Business* magazine, op. cit.

Public and Private Lives

391 "Who's yacht is that?" Noël Coward, *Private Lives*, published script, Doubleday.

392 "It was absolutely outrageous," author's interview with Buff Cobb, February 1994.

394 "a bit coarse in texture," Graham Payn and Sheridan Morley, eds. *The Noël Coward Diaries*. Boston: Little, Brown, 1982.

395 "You were so gay and sweet," included in Rawls, op. cit.

398 "If my breast was savage," TB.

399 "as lonely as I was," Florence Desmond, *Florence Desmond*. London: Harrap, 1953.

Skidding

401 "Anything I do that you don't like," author's interview with Phil Arthur, October 1994.

404 "Take care of yourself," included in Rawls, op. cit.

405 "the audience eating out of her hands," Carol Channing, *Just Lucky I Guess: A Memoir of Sorts*. New York: Simon & Schuster, 2002.

406 "Mr. Dewey is neat," speech reproduced in TB.

406 "Miss Bankhead's rough magnetism," Edwin McArthur, *Flagstad: A Personal Memoir*. New York: Alfred A. Knopf, 1965.

406 "wanted to tear that jockstrap," author's interview with William Weslow, July 1993.

409 "Tallu and Lady were like sisters," Donald Clarke, *Wishing on the Moon: The Life and Times of Billie Holiday*. New York: Viking, 1994.

409 "Holiday's dressing room door," author's interview with William Dufty, August 1994.

409 "she's all over her," Clarke, op. cit.

410 "she is essentially a child at heart," letter from Tallulah to J. Edgar Hoover, FBI Tallulah Bankhead file.

412 "I never saw an actress so cooperative," Brian, op. cit.

412 "she always built on it," Irving Rapper to Lee Israel, LPA.

412 "the disgraceful state Miss Bankhead was in," included in Rudy Behlmer, *Inside Warner Brothers (1935–1951)*. New York: Viking, 1985.

412 "three or four things that upset me," author's interview with William Orr, November 1993.

414 "Cronin immediately confessed," Donald Seawell to Lee Israel, February 22, 1971, LPA.

414 "censured Miss Bankhead," *New York Times*, January 17, 1951.

415 "the last she'd ever give," Gill, op. cit.

Mixed Highs and Lows

419 "I'm going to do some broadcasts," *New York World Telegram and Sun*, September 29, 1950.

420 "outraged bellow of professional rage," *Collier's*, January 13, 1951.

422 "I have nightmares," *New York Times*, November 26, 1950.

422 "They were wild," author's interview with Bert Cowlan, December 1993.

423 "It was very quiet," author's interview with Fran Bushkin, October 1993.

Stateless

429 "shoot both counsel and defendant," *Time*, December 24, 1951.

429 "with the greatest reluctance and regret," coverage of the trial comes from the *New York Times*, December 11–29, 1951.

432 "vain, rude, and temperamental," *Saturday Review, Christian Science Monitor*, October 9, 1951.

432 "She ordered her," interview with Fred Morritt, May 1994.

432 "she kept so much inside herself," Donald Seawell, op. cit.

433 "frustrations, hostilities and resentments," *American Weekly*, October 5, 1952.

433 "a pallid recital of parts played and notices received," *Saturday Review of Literature*, September 27, 1952.

434 "distinguished from the bilge," *New York Times Book Review*, December 7, 1952.

435 "very charming," *New York Times*, December 23, 1952.

435 "a perfectly strange woman," author's interview with Dean Fuller, June 1993.

435 "proves to be socko," *Variety*, May 27, 1953.

437 "at one time or another," undated clipping, San Francisco Performing Arts Library.

437 "foolish, strident," Hollis Alpert, *Saturday Review*, July 18, 1953.

Pearls Before Swine

439 "dignity, beauty, and private conviction," Harriet Van Horne, *New York World-Telegram*, January 6, 1954.

439 "faint mocking overtones," *New York Herald Tribune*, January 6, 1954.

439 "where she belongs," *Chicago Tribune*, January 6, 1954, unidentified clipping, LPA.

439 "a fine actress," *New York World-Telegram and Sun*, January 6, 1954.

440 "willful and out of it," author's interview with Arthur Penn, February 1995.

440 "talk to me about it," author's interview with Hugh Reilly, July 1992.

440 "knew what she wanted," author's interview with Mary Webster, July 1994.

440 "the first one," author's interview with Werner Klemperer, April 1992.

442 "the victim of her talents, John Mason Brown, *The Saturday Review of Literature*, October 2, 1954.

The Hallelujah Chorus

447 "go to a *fucking* ball game," author's interview with Ray Foster, January 1993.

447 "a darling sense of humor," *New York Post*, December 9, 1955.

452 "to prove I'm a dramatic actress," interview by William Hawkins, *New York World-Telegram and Sun*, February 11, 1956.

452 "weeded out every Tallulahism," Jean Dalrymple, *From the Last Row: A Personal History of the New York City Center of Music and Drama Inc.* Clifton, N.J.: J.T. White, 1975.

453 "I've tried as hard as I can," author's interview with J. Frank Lucas.

453 "pseudo-sophisticated laughter," *Cue*, February 22, 1956.

453 "All in a bunch home from their little bridge party," *A Streetcar Named Desire*, published script, New Directions.

455 "a new dimension never encountered," *Plays and Players*, April 1956.

455 "Are there any gays out there?," author's interview with Ted Hook, May 1983.

The Nadir

456 "couldn't really carry a tune," author's interview with Peter Howard, December 1993.

456 "it hadn't come out right," author's interview with Christopher Hewett, September 1993.

457 "Somerset Maugham" quoted in Jeffrey L. Carrier, *Tallulah Bankhead: A Bio-Bibliography*. New York: Greenwood Press, 1991.

458 "perfectly nice to work with," author's interview with Jay Harnick, February 1994.

458 "unprecedented," *Variety*, May 9, 1956.

459 "startling high kicks," *New York World-Telegram and Sun*, July 19, 1956.

461 "who expressed himself better," author's interview with Randolph Carter, March 1993.

462 "making a great effort," author's interview with Irma Hurley, April 1993.

463 "she cared about being perfect," author's interview with Miles White, October 1992.

465 "fractured bones," *Cue*, February 9, 1957.

468 "I'm fifty-four," Even in extremis, apparently, Tallulah was coy about her age. Hurley explicitly recalled her saying "fifty-four," but she had just turned fifty-five.

Halloween Madness

472 "She took a little blocking," author's interview with Warren Kemmerling, June 1993.

473 "went flying into the night," author's interview with Leslie Cutler, May 1993.

473 "a terrible scene," author's interview with Ed Strum, April 1993.

476 "I'm not going to look like Tallulah," author's interview with Alvin Colt, October 1992.

481 "still be racist Dixiecrats," *Washington News*, October 18, 1958.

481 "rather baffles the audience," *New York Post*, October 19, 1958.

483 "not saddened audiences," *San Francisco Examiner*, December 28, 1958.

In Retreat

485 "I haven't heard a bloody word you've said," *New York Herald Tribune*, April 14, 1959.

486 "a general checkup," *The Daily News*, May 23, 1959.

486 "I thought I was a friend of yours," January 12, 1955 [actually '56], included in Robert O'Meally, *Lady Day: The Many Faces of Billie Holiday*. New York: Arcade Publishing, 1991.

488 "the kid she wanted to have," interview with Harvey Shain, September 1995.

489 "I read avidly," Kobal, op. cit.

489 "I think it's the only part," Joseph Morganstern, "A Hurricane Heads Here on the Double," January 29, 1961.

490 "I had relatives in politics," unidentified clipping, LPA.

490 "a strong director," author's interview with Robert Fryer, March 1993.

490 "The boy was a man," Mary Chase, "How Midgie Was Born," *The Philadelphia Inquirer Magazine*, December 18, 1960.

491 "Tallulah's drug addiction," author's interview with Anne Sargeant, September 2003.

492 "a far more consequential person," review printed in souvenir program for *Here Today*, LPA.

492 "Tallulah's ruthless honesty," author's interview with Robert Whitehead, March 1993.

495 "make a *great* president," *New York Times*, August 14, 1960.

495 "her special and overwhelming ability," Henry Hewes, *Saturday Review of Literature*, February 25, 1961.

496 "a wonderfully accomplished actress," Alan Pryce-Jones, *Theatre Arts*, April 1961.

Last Train

498 "beautifully staged," unpublished memoir, read at the Player's Club.

498 "less fun and more nursemaid," Lee Israel, *Miss Tallulah Bankhead*. New York: G.P. Putnam's Sons, 1972.

499 "We had a wonderful time," author's interview with Jack Sydow, March 1993.

499 "be able to hear you," author's interview with Bill Story, May 1994.

501 "I'd promised my friend," Kobal. op. cit.

501 "virtually on hands and knees," Richard Coe, *Washington Post*, October 26, 1963.

501 "pronounced it 'superb,'" Tallulah Bankhead, "Tallulah Tells All," *New York Herald Tribune*, December 15, 1963.

501 "drunk as a skunk," author's interview with John Carlyle, March 1994.

502 "You bore me," author's interview with Patience Cleveland, March 1994.

504 "Sanford was summoned," author's interview with Isabel Sanford, March 1994.

505 "I have to give it to her," author's interview with Martin Aronstein, March 1993.

505 "working with a cripple," author's interview with Konrad Matthaei, February 1995.

508 "She's more afraid of," *The Milk Train Doesn't Stop Here Anymore*, published script, New Directions.

508 "Miss Bankhead, here we go," author's interview with Sara Neece, September 1983.

510 "What is there to say?," January 15, 1964, included in Rawls, op. cit.

Home to London

512 "It threw the performance," author's interview with Emory Bass, September 1993.

514 "a bit better than the usual," interview by Eugene Archer, *New York Times*, July 19, 1964.

516 "darling only to a mummy," *New York Times*, May 23, 1966.

521 "the saving grace," *Life*, April 9, 1965.

Winding Down

522 "wanted to do what she could to help," Brian, op. cit.

524 "I never even go to the theater," *New York World-Telegram and Sun*, March 28, 1966.

525 "Yurka was led to contemplate," Blanche Yurka, *Bohemian Girl: Blanche Yurka's Theatrical Life*. Athens, OH: Ohio University Press, 1970.

526 "Tallulah was so adaptable," author's interview with Brook [Seawell] Ashley, May 1994.

528 "Hellman wrote a piece," "The Time of the Foxes," *New York Times*, October 22, 1967.

528 "amiably refuting her," *New York Times*, October 29, 1967.

529 "I must do it," author's interview with Ann Rutherford Dozier, July 1993.

530 "just a consummate professional," author's interview with Charles Fitzimmons, July 1993.

530 "a level and a half," author's interview with Robert Mintz, July 1993.

533 "I don't understand myself," *New York Times*, July 14, 1968.

534 "a flowering tree," *Show Business*, op. cit.

In addition to those cited above, I conducted interviews with: Ted Allan, Bill Blackard, Thelma Carpenter, Ann Marie Chamberlain, Virginia Cherrill, Peggy Clark, Nancy Coleman, Lenn Curley, Dortha Duckworth, Charles Elson, William Fitzula, Charles Forsythe, Ted Goldsmith, Mary Rodgers Guettel, William Hackett, Ann Hirshberg, Rose Hobart, Peter Hobbs, Richard Hughes, Gilbert Ireland, Ted Jacobson, Alice Jernigen, Don Koll, Jack Larson, Roddy McDowall, Aline MacMahon, David Manners, Tony Manzi, Madeleine Marfield, Mary Anna Marten, Mitch Miller, Ivan Moffat, Obelia Myers, Roger Myers, Mildred Natwick, Bibi Osterwald, David Parsons, Colin Wilcox Paxton, Martha Pennington, Nella Ponazecki, Philip Reed, John Robinson, Mary Percy Schenck, Henry Sember, Betty Shirley, Alan Shulman, Edith Simmonds, Peter Stackpole, Will Stutts, Florence Sundstrum, Paul Vroom, Michael Wager, Teresa Wright, Alexei Wycoff, Jo Zeigler.

Bibliography

Abbott, George. *Mister Abbott*. New York: Random House, 1963.

Allen, David. *Sir Aubrey: A Biography of C. Aubrey Smith, England Cricketer, West End Actor, Hollywood Film Star*. London: Elm Tree Books, 1982.

Baker, Michael. *Our Three Selves: The Life of Radclyffe Hall*. London: Hamish Hamilton, 1985.

Bankhead, Tallulah. *Tallulah*. New York: Harper and Row, 1952.

Barnes, E.W. *The Man Who Lived Twice: The Biography of Edward Sheldon*. New York: Scribner, 1956.

Barrow, Kenneth. *Helen Hayes: First Lady of the American Theatre*. New York: Doubleday, 1985.

Beaton, Cecil. *The Wandering Years: Diaries, 1922–1939*. Boston: Little, Brown, 1961.

Beaton, Cecil. *Cecil Beaton's Scrapbook*. New York: Scribner's, 1937.

Behlmer, Rudy. *Inside Warner Brothers (1935–1951)*. New York: Viking, 1985.

Behlmer, Rudy. *Memo from David O. Selznick*. New York: Viking Press, 1972.

Behrman, S. N. *People in a Diary*. Boston: Little, Brown, 1972.

Blake, Gary. *Herman Shumlin: The Development of a Director*. New York: City University of New York, 1973.

Brando, Marlon, with Robert Lindsey. *Brando: Songs My Mother Taught Me*. Toronto: Random House of Canada, 1994.

Brenman-Gibson, Margaret. *Clifford Odets, American Playwright: The years from 1906 to 1940*. New York: Atheneum, 1981.

Brian, Denis. *Tallulah, Darling*. New York: MacMillan, 1980.

Bricktop, with James Haskins. *Bricktop*. New York: Atheneum, 1983.

Brown, Jared. *The Fabulous Lunts: A Biography of Alfred Lunt and Lynn Fontanne*. New York: Atheneum, 1986.

Byer, Jackson R. *Conversations with Lillian Hellman*. Jackson, MS: University Press of Mississippi, 1986.

Callow, Simon. *Charles Laughton: A Difficult Actor*. New York: St. Martin's Press, 1988.

Campbell, Sandy. *B: Twenty-nine Letters from Coconut Grove*. Verona, Italy: Verona, 1974.

Carey, Gary. *Judy Holliday: An Intimate Life Story*. New York: Seaview Books, 1982.

Carrier, Jeffrey L. *Tallulah Bankhead: A Bio-Bibliography*. New York: Greenwood Press, 1991.

Channing, Carol. *Just Lucky I Guess: A Memoir of Sorts*. New York: Simon & Schuster, 2002.

Churchill, Allen. *The Theatrical '20s*. New York, St. Louis, San Francisco: McGraw-Hill, 1975.

Clarke, Donald. *Wishing on the Moon: The Life and Times of Billie Holiday*. New York: Viking, 1994.

Cocteau, Jean. *Past Tense: Diaries*. San Diego: Harcourt Brace Jovanovich, 1987.

Cornell, Katherine. *I Wanted to Be an Actress*. New York: Random House, 1939.

Coward, Noël. *Present Indicative*. London, Toronto: W. Heinemann, 1937.

Cronyn, Hume. *A Terrible Liar: A Memoir*. New York: Morrow, 1991.

Dalrymple, Jean. *From the Last Row: A Personal History of the New York City Center of Music and Drama, Inc.* Clifton, NJ: J.T. White, 1975.

Daubenay, Peter. *My World of Theatre*. London: Jonathan Cape, 1971.

Dean, Basil. *Seven Ages: An Autobiography, 1888–1927*. London: Hutchinson, 1970.

Desmond, Florence. *Florence Desmond*. London: Harrap, 1953.

Dolin, Anton. *Last Words: A Final Autobiography*. London: Century, 1985.

Donaldson, Frances. *Freddy Lonsdale*. London: Heinemann, 1957.

Donaldson, Frances. *The Actor-Managers*. London: Weidenfeld and Nicolson, 1970.

Drake, Fabia. *Blind Fortune*. London: Kimber, 1978.

Drutman, Irving. *Good Company: A Memoir, Mostly Theatrical*. Boston: Little, Brown, 1976.

Du Maurier, Daphne. *Gerald: A Portrait*. London: V. Gollancz, Ltd., 1934.

Eyman, Scott. *Ernst Lubitsch: Laughter in Paradise*. New York: Simon & Schuster, 1993.

Fairbanks, Douglas Jr. *The Salad Days*. New York: Doubleday, 1988.

Gielgud, John. *Early Stages*. New York: MacMillan, 1939.

Gill, Brendan. *Tallulah*. New York: Holt, Rinehart, & Winston, 1972.

Goldstone, Richard. *Thornton Wilder: An Intimate Portrait*. New York: Saturday Review Press, 1975.

Gottlieb, Lois C. *Rachel Crothers*. Boston: Twayne, 1979.

Gottlieb, Polly Rose. *The Nine Lives of Billy Rose*. New York: Crown, 1968.

Griffin, Merv and Peter Barsocchini. *Merv*. New York: Simon & Schuster, 1980.

Harding, James. *Gerald du Maurier: The Last Actor-manager*. London: Hodder & Stoughton, 1989.

Harding, James. *Emlyn Williams: A Life*. London: Weidenfeld and Nicolson, 1993.

Harriman, Margaret Case. *The Vicious Circle: The Story of the Algonquin Round Table*. New York: Rinehart, 1951.

Harris, Radie. *Radie's World*. London: W.H. Allen, 1975.

Harrison, Gilbert A. *The Enthusiast: A Life of Thornton Wilder*. New York: Liveright, 1983.

Haskell, Molly. *From Reverence to Rape: The Treatment of Women in the Movies.* New York: Holt, Rinehart and Winston, 1974.

Hastings, Sir Patrick. *The Autobiography of Sir Patrick Hastings.* London: W. Heinemann, 1948.

Haver, Ronald. *David O'Selznick's Hollywood.* New York: Alfred A. Knopf, 1980.

Hayes, Helen. *My Life in Three Acts.* New York: Harcourt Brace Jovanovich, 1990.

Hellman, Lillian. *Pentimento: A Book of Portraits.* Boston: Little, Brown, 1973.

Herbert, David. *Second Son: An Autobiography.* London: Owen, 1972.

Hicks, Seymour. *Night Lights: Two Men Talk of Life and Love and the Ladies.* London: Cassell, 1938.

Higham, Charles. *Cary Grant: The Lonely Heart.* New York: Harcourt Brace Jovanovich, 1989.

Hirsch, Foster. *George Kelly.* Boston: Twayne, 1975.

Hoare, Philip. *Serious Pleasures: The Life of Stephen Tennant.* London: Hamish Hamilton, 1990.

Horne, Lena, with Richard Schickel. *Lena.* Garden City, NY: Doubleday, 1965.

Israel, Lee. *Miss Tallulah Bankhead.* New York: G.P. Putnam's Sons, 1972.

Kahn, E.J. Jr., *Jock: The Life and Times of John Hay Whitney.* Garden City, N.Y.: Doubleday, 1991.

Kazan, Elia. *A Life.* New York: Alfred A. Knopf, 1988.

Kennedy, Harold. *No Pickle, No Performance: An Irreverent Theatrical Excursion from Tallulah to Travolta.* Garden City, NY: Doubleday, 1978.

Keppel, Sonia. *Edwardian Daughter.* London: Hamish Hamilton, 1958.

Kidd, Janet Aitken. *The Beaverbrook Girl: An Autobiography.* London: Collins, 1987.

Knoblock, Edward. *Round the Room.* London: Chapman and Hall, 1939.

Kobal, John. *People Will Talk.* New York: Alfred A. Knopf, 1986.

Laffey, Bruce. *Beatrice Lillie: The Funniest Woman in the World.* New York: Wynwood Press, 1989.

Lambert, Gavin. *On Cukor.* New York: G.P. Putnam's Sons, 1972.

Lanchester, Elsa. *Elsa Lanchester Herself.* New York: St. Martin's Press, 1983.

Langner, Lawrence. *The Magic Curtain: The Story of a Life in Two Fields, Theatre and Invention, by the Founder of the Theatre Guild.* New York: Dutton, 1951.

Lehmann, John. *In My Own Time: Memoirs of a Literary Life.* Boston: Little, Brown, 1969.

Levy, Emanuel, *George Cukor: Master of Elegance: Hollywood's Legendary Director and His Stars,* New York: Morrow, 1994.

Lillie, Beatrice. *Every Other Inch a Lady.* Aided and abetted by John Philip. Written with James Brough. Garden City, NY: Doubleday, 1972.

Maney, Richard. *Fanfare: The Confessions of a Press Agent.* New York: Harper, 1957.

Manso, Peter. *Brando: The Biography.* New York: Hyperion, 1934.

Marion, Frances. *Off with Their Heads: A Serio-Comic Tale of Hollywood.* New York: Macmillan, 1972.

Maxwell, Gilbert. *Tennessee Williams and Friends.* Cleveland, OH: World, 1965.

Massey, Raymond. *A Hundred Different Lives: An Autobiography.* Boston: Little, Brown, 1979.

McArthur, Edwin. *Flagstad: A Personal Memoir.* New York: Alfred A. Knopf, 1965.

McClintic, Gurthrie. *Me and Kit*. Boston: Little, Brown, 1955.

McGilligan, Patrick. *George Cukor: A Double Life: A Biography of the Gentleman Director*. New York: St. Martin's Press, 1991.

McGilligan, Patrick. *Alfred Hitchcock: A Life in Darkness and Light*. New York: ReganBooks, 2003.

Macqueen-Pope, W. *The Footlights Flickered*. London: H. Jenkins, 1959.

Meredith, Burgess. *So Far, So Good: A Memoir*. Boston: Little, Brown, 1994.

Merman, Ethel, with George Eels. *Merman*. New York: 1978.

Moody, Richard. *Lillian Hellman, Playwright*. New York: Pegasus, 1972.

Morgan, Ted. *Maugham*. New York: Simon & Schuster, 1980.

Nesbitt, Cathleen. *A Little Love and Good Company*. London: Faber and Faber, 1975.

Nichols, Beverly. *The Sweet and Twenties*. London: Weidenfeld and Nicolson, 1958.

O'Meally, Robert. *Lady Day: The Many Faces of Billie Holiday*. New York: Arcade Publishing, 1991.

Ormsbee, Helen. *Backstage with Actors, from the Time of Shakespeare to the Present Day*. New York: Thomas Y. Crowell, 1938.

Paris, Barry. *Louise Brooks*. New York: Alfred A. Knopf, 1989.

Payn, Graham, and Sheridan Morley, eds. *The Noël Coward Diaries*. Boston: Little, Brown, 1982.

Peters, Margot. *The House of Barrymore*. New York: Alfred A. Knopf, 1990.

Preminger, Otto. *Preminger: An Autobiography*. Garden City, NY: Doubleday, 1977.

Quirk, Lawrence. *Fasten Your Seatbelts: The Passionate Life of Bette Davis*. New York: William Morrow, 1990.

Rawls, Eugenia. *Tallulah, a Memory*. Birmingham, AL: UAB Press, 1979.

Richardson, Tony. *Long Distance Runner: A Memoir*. London, Boston: Faber and Faber, 1993.

Rosen, Marjorie. *Popcorn Venus: Women, Movies & the American Dream*. New York: Coward, McCan & Geoghena, 1973.

Schanke, Robert A. *Shattered Applause: The Lives of Eva Le Gallienne*. Carbondale, Ill.: Southern Illinois University Press, 1992.

Schildraut, Joseph, as told to Les Cania, *My Father and I*. New York: Viking, 1959.

Seldes, Marian. *The Bright Lights: A Theatre Life*. Boston: Houghton Mifflin, 1978.

Sharrar, Jack F. *Avery Hopwood: His Life and Plays*. Jefferson, NC, and London: McFarland & Company, 1989.

Shaw, George Bernard. *Our Theatres in the Nineties*. London: Constable, 1932.

Sheehy, Helen. *Eva Le Gallienne: A Biography*. New York: Alfred A. Knopf, 1996.

Smith, Liz. *Natural Blonde: A Memoir*. New York: Hyperion, 2000.

Smith, Wendy. *Real Life: The Group Theatre and America, 1931–1940*. New York: Alfred A. Knopf, 1990.

Sobel, Bernard, ed., *The Theatre Handbook and Digest of Plays*. New York: Crown, 1940.

Sobol, Louis. *The Longest Street*. New York: Crown, 1968.

Spoto, Donald. *The Dark Side of Genius: The Life of Alfred Hitchcock*. Boston: Little, Brown, 1983.

Stenn, David. *Clara Bow Runnin' Wild*. New York: Doubleday, 1988.

Taylor, John Russell. *Hitch: The Life and Times of Alfred Hitchcock*. New York: Pantheon Books, 1978.

Trewin, J. C. *The Gay Twenties: A Decade of the Theatre*. London: MacDonald, 1958.

Tunney, Kieran. *Tallulah: Darling of the Gods: An Intimate Portrait*. London: Secker & Warburg, 1972.

Vickers, Hugo. *Cecil Beaton: A Biography*. Boston: Little, Brown, 1986.

Vineberg, Steve. *Method Actors: Three Generations of an American Acting Style*. New York: Schirmer Books, 1991.

Webster, Margaret. *Don't Put Your Daughter on the Stage*. New York: Alfred A. Knopf, 1972.

Whistler, Laurence. *The Laughter and the Urn: The Life of Rex Whistler*. London: Weidenfeld and Nicolson, 1985.

Wilk, Max. *Every Day's a Matinee: Memoirs Scribbled on a Dressing Room Door*. New York: Norton, 1975.

Williams, Emlyn. *George: An Early Autobiography*. London: Hamish Hamilton, 1961.

Williams, Tennessee. *Memoirs*. New York: Doubleday, 1975.

Wright, William. *Lillian Hellman: The Image, the Woman*. New York: Simon & Schuster, 1986.

Yurka, Blanche. *Bohemian Girl: Blanche Yurka's Theatrical Life*. Athens, OH: Ohio University Press, 1970.

Zolotow, Maurice. *No People Like Show People*. New York: Random House, 1951.

Index